ATTALOS, ATHENS, AND THE AKROPOLIS

This volume examines the "Little Barbarians," ten highly expressive Roman marble figures of Giants, Amazons, Persians, and Gauls that were found in Rome in 1514 and are now recognized as copies of the Small (or Lesser) Attalid Dedication on the Athenian Akropolis. Manolis Korres's recent discovery of the monument's pedestals, fully published in this volume, has led Andrew Stewart to a complete reconsideration of the statues' form, date, and significance. He demonstrates that this is the only Hellenistic royal donation of sculpture whose donor, location, and form are all known; the only one securely identified in copy; and the only one whose life can be glimpsed from beginning to end, a period ranging over 2,200 years. Illustrated with new photographs of all ten Barbarians and twenty-six new drawings by Manolis Korres, the book systematically traces the Barbarians' impact upon Roman and Renaissance art, and the intellectual history of Hellenistic art and archaeology.

Andrew Stewart is Professor of Ancient Mediterranean Art and Archaeology at University of California at Berkeley. A recipient of fellowships from the Getty Center for the History of Art and the Humanities and the Guggenheim Foundation, he is the author of numerous works on aspects of Greek art, including *Greek Sculpture: An Exploration; Faces of Power: Alexander's Image and Hellenistic Politics;* and *Art, Desire, and the Body in Ancient Greece.*

Emmanuel (Manolis) Korres is Professor of Architecture at the National Technical University of Athens (Polytechneion). The recipient of many awards and honors, he directed the Theater of Dionysos Restoration Project from 1980 to 1983 and the Parthenon Restoration Project from 1983 to 1997. He is the author of numerous works on Greek architecture of all periods, including a four-volume *Study for the Restoration of the Parthenon; From Pentelicon to the Parthenon;* and *The Stones of the Parthenon.*

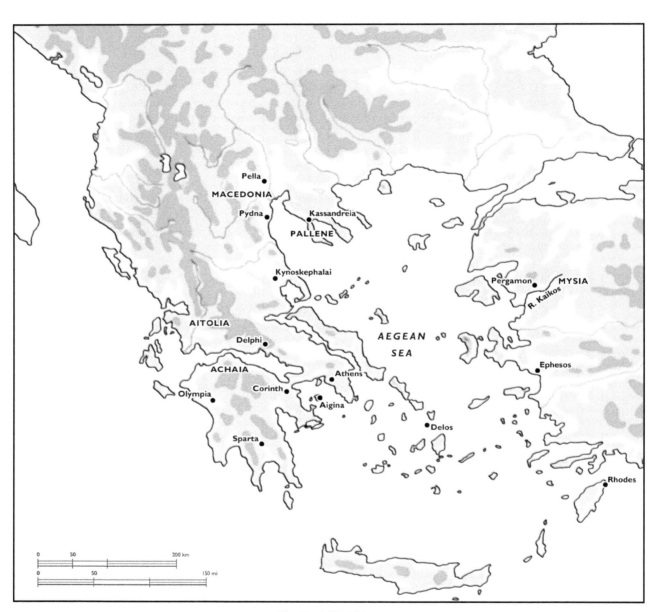

MAP: The Greek World in 200 BC.

ATTALOS, ATHENS, AND THE AKROPOLIS

THE PERGAMENE "LITTLE BARBARIANS" AND THEIR ROMAN AND RENAISSANCE LEGACY

∽∂ ∽∂ ∽∂

ANDREW STEWART
University of California at Berkeley

with an Essay on the Pedestals and
the Akropolis South Wall by
MANOLIS KORRES
National Technical University of Athens

CAMBRIDGE UNIVERSITY PRESS
Cambridge, New York, Melbourne, Madrid, Cape Town,
Singapore, São Paulo, Delhi, Mexico City

Cambridge University Press
The Edinburgh Building, Cambridge CB2 8RU, UK

Published in the United States of America by Cambridge University Press, New York

www.cambridge.org
Information on this title: www.cambridge.org/9780521831635

© Andrew Stewart 2004

This publication is in copyright. Subject to statutory exception
and to the provisions of relevant collective licensing agreements,
no reproduction of any part may take place without the written
permission of Cambridge University Press.

First published 2004

A catalogue record for this publication is available from the British Library

Library of Congress Cataloguing in Publication Data
Stewart, Andrew, 1948–
Attalos, Athens, and the Akropolis : The Pergamene "Little Barbarians" and Their Roman
and Renaissance Legacy / Andrew stewart.
p. cm.
Includes bibliographical references and index.
ISBN 0-521-83163-6
1. Marble sculpture, Roman – Expertising. 2. Sculpture, Permanene – Reproduction.
3. Galatians in art. 4. Victory in art. 5. Bergama (Turkey) – Antiquities.
6. Acropolis (Athens, Greece). I. Title.
NB115.S74 2004
733´.5 – dc22
2003063509

ISBN 978-0-521-83163-5 Hardback

Cambridge University Press has no responsibility for the persistence or
accuracy of URLs for external or third-party internet websites referred to in
this publication, and does not guarantee that any content on such websites is,
or will remain, accurate or appropriate. Information regarding prices, travel
timetables, and other factual information given in this work is correct at
the time of first printing but Cambridge University Press does not guarantee
the accuracy of such information thereafter.

"By their own follies they perished, the fools."

Homer, *Odyssey* 1.7

"A statue on its base, like a good, well-intentioned man, should remain immovable."

Sokrates, in *Paroemiographi* 2: 287, no. 98c

CONTENTS

List of Illustrations — ix
Preface — xvii
Abbreviations — xxi
Some Important Dates — xxiii

Little Barbarians: An Encounter — 1

1. Rediscovery: Scholars, Sleuths, and Stones — 11
 1. Leake, Penrose, and Brunn — 12
 2. Excursus on Positivism — 18
 3. From Milchhöfer to Bienkowski — 23
 4. From Lippold to Krahmer — 43
 5. Excursus on Formalism — 62
 6. "In the Mirror of the Copies" — 66
 7. Skeptics and Revisionists — 69
 8. Renaissance Echoes — 75
 9. Problems and Prospects — 76

2. Appropriation: Gladiators for Christ — 81
 1. Discovery — 81
 2. Dispersal — 86
 3. Appropriation — 94
 4. Rome (I): Raphael — 100
 5. Rome (II): Peruzzi, Parmigianino, and Michelangelo — 115
 6. Venice (I): Sansovino, Titian, and Pordenone — 120
 7. Venice (II): Veronese and Tintoretto — 127
 8. Envoi — 133

3. **Reproduction: *Vae Victis!*** ⚭ **136**
 1. Date and Workshop ⚭ 136
 2. Provenance ⚭ 142
 3. Display ⚭ 144
 4. Fear and Loathing in Barbary ⚭ 152
 5. Beyond the Pale ⚭ 160
 6. "Fatal Charades" ⚭ 163
 7. Of Wounds ⚭ 166
 8. Roman Echoes? ⚭ 170
 9. Greek Echoes? ⚭ 177

4. **Genesis: Barbarians at the Gates** ⚭ **181**
 1. Location and Display ⚭ 181
 2. Iconography ⚭ 198
 3. Of Authors and Makers ⚭ 213
 4. Date(s) ⚭ 218
 5. Of History and Memory ⚭ 220
 6. "For the Security of the City" ⚭ 226
 7. Rhetoric ⚭ 228
 8. Responses ⚭ 232

Conclusion. "The Truth in Sculpture" ⚭ **237**
 1. Looking Backward ⚭ 237
 2. Looking Again ⚭ 237
 3. Looking Forward ⚭ 239

Essay. The Pedestals and the Akropolis South Wall, by Manolis Korres ⚭ **242**
 1. Identification ⚭ 242
 2. Documentation ⚭ 244
 3. Classification ⚭ 268
 4. Arrangement of the Blocks ⚭ 270
 5. The Area to the South and East of the Parthenon ⚭ 272
 6. The South Wall ⚭ 274
 7. The Parapet ⚭ 279
 8. The Wide Summit of the Wall and the Unfinished Terracing ⚭ 280
 9. Position and Form of the Pedestals ⚭ 281

Appendix 1. The Sources ⚭ **287**

Appendix 2. The Statues ⚭ **293**

Notes ⚭ 303
Bibliography ⚭ 339
Index of Sources: Greek, Latin, and Biblical ⚭ 345
Index of Inscriptions ⚭ 349
General Index ⚭ 351

LIST OF ILLUSTRATIONS

෯ ෯ ෯

Map: The Greek World in 200 BC ෯ *frontispiece*

1	Naples Giant, Amazon, Persian, and Gaul (Roman copies)	2
2	Venice Falling Gaul ("Breakdancer"), Dead Gaul, and Kneeling Gaul (with Ulysses)	2
3	Vatican Persian	3
4	Aix Persian	3
5	Paris Gaul	3
6	Vatican Persian	3
7	Vatican Persian from below	4
8	Right thigh of the Vatican Persian	4
9	Drapery of the Naples Amazon	5
10	Head of the Venice Kneeling Gaul	5
11	Waist of the Venice Dead Gaul	5
12	Torso and head of the Venice Dead Gaul	6
13	Breast and head of the Naples Amazon	6
14	Naples Giant's lionskin	6
15	Back view of the Naples Dying Gaul	7
16	Side view of the Venice Kneeling Gaul	7
17	Side view of the Venice Falling Gaul	7
18	Side view of the Naples Amazon	8
19	Side view of the Naples Giant	8
20	Venice Dead Gaul	9
21	Side view of the Naples Persian	9
22	Left side of the head of the Aix Persian	10
23	Venice Dead Gaul	10
24	Head placed on the Naples Dying Gaul	10
25	Head placed on the Naples Dying Gaul, back view	10
26	Athenian Akropolis (plans by Penrose [1851] and Leake [1854])	13

27	Suicidal Gaul and his wife	15
28	Dying Gallic Trumpeter	14
29	Naples Giant	19
30	Naples Giant, side view	19
31	Head of the Naples Giant	20
32	Head of the Naples Giant, side view	21
33	Naples Amazon	24
34	Naples Amazon, side view	24
35	Head of the Naples Amazon	25
36	Head of the Naples Amazon, side view	26
37	Naples Persian	27
38	Naples Persian, back view	27
39	Head of the Naples Persian	28
40	Head of the Naples Persian, side view	29
41	Naples Dying Gaul	31
42	Naples Dying Gaul, back view	31
43	Head placed on the Naples Dying Gaul	32
44	Head placed on the Naples Dying Gaul, side view	33
45	Vatican Persian	34
46	Vatican Persian, back view	34
47	Back of the Vatican Persian	34
48	Head of the Vatican Persian	35
49	Venice Kneeling Gaul	37
50	Venice Kneeling Gaul, back view	37
51	Head of the Venice Kneeling Gaul	38
52	Head of the Venice Kneeling Gaul, side view	39
53	Venice Falling Gaul	41
54	Venice Falling Gaul, back view	41
55	Head of the Venice Falling Gaul	42
56	Head of the Venice Falling Gaul, side view	43
57	Venice Dead Gaul	44
58	Venice Dead Gaul	44
59	Head of the Venice Dead Gaul	45
60	Head of the Venice Dead Gaul, side view	46
61	Paris Gaul	47
62	Paris Gaul, back view	47
63	Head of the Paris Gaul	48
64	Head of the Paris Gaul, side view	49
65	Giustiniani–Torlonia Persian	50
66	Wilton Amazon	50
67	Athenian Akropolis from the southeast	51
68	Zeus fights Porphyrion and two other Giants, from the Gigantomachy of the Great Altar of Pergamon	52
69	Athena fights Alkyoneus, from the Gigantomachy of the Great Altar of Pergamon	52
70	Fallen Gaul from Delos	52
71	Loggia of the Palazzo Medici–Madama in the 1530s, by Maarten van Heemskerck	53
72	Naples Amazon and other statues in the 1540s, by Frans Floris	53
73	Naples Giant, drawing in the collection of Cassiano dal Pozzo	54
74	Naples Amazon, drawing in the collection of Cassiano dal Pozzo	54
75	Naples Persian, drawing in the collection of Cassiano dal Pozzo	55

76	Naples Dying Gaul, drawing in the collection of Cassiano dal Pozzo	55
77	Aix Persian, side view	57
78	Aix Persian, back view	57
79	Head of the Aix Persian	58
80	Head of the Aix Persian, side view	59
81	Wife of the Suicidal Gaul	60
82	Amazon falling off her horse	61
83	Laokoon and his two sons, by Athanodoros, Hagesandros, and Polydoros of Rhodes	63
84	Heads of Chrysippos and the Aix Persian	66
85	Amazon fighting a Gaul	67
86	Etruscan ash urn with the story of Olta	69
87	Herm of Antisthenes, after a portrait by Phyromachos of Athens	70
88	Head of the Naples Giant, left profile	70
89	Plywood cutouts of figures attributed to the Lesser Attalid Dedication, placed on the Akropolis wall	71
90	Plywood cutouts of figures attributed to the Lesser Attalid Dedication, seen from below	71
91	Model in corian of the Great Altar of Pergamon	73
92	Giovanni Dosio, drawing of the Wilton Amazon	77
93	Woodcut by Martin Rota after Titian, *Martyrdom of Saint Peter Martyr*	82
94	Study for *Martyrdom of Saint Peter Martyr,* by Pordenone	82
95	Venice Falling Gaul	82
96	View of Rome in 1557 by Francesco Paciotti	83
97	Plan of the modern streets of Rome and Palazzo Medici–Madama, superimposed upon the ancient topography	83
98	Alfonsina Orsini's six Little Barbarians, 1514	84
99	Recumbent guard, study by Raphael for the Chigi *Resurrection*	85
100	Plan of the Vatican in 1514	87
101	Plan of the upper floor of the Palazzo Ducale, Venice, in 1523	89
102	*Creation, Temptation, and Fall,* by Mariotto Albertinelli	90
103	Ulysses	91
104	Figures in a classical landscape, by Amico Aspertini	92
105	Figures in a classical landscape, by Amico Aspertini	92
106	Aix Persian	93
107	*Adoration of the Shepherds,* by Amico Aspertini	93
108	Detail of cartoon for *Sacrifice at Lystra,* by Raphael	94
109	Laokoon, as restored by Giovanni Montorsoli in 1532–33	95
110	Belvedere Torso, signed by Apollonios son of Nestor of Athens	95
111	Venice Falling Gaul, with restorations removed	96
112	*The Scream,* by Edvard Munch	97
113	*Terror of War,* by Nguyen Kong (Nick) Ut	99
114	Cartoon for *Death of Ananias,* by Raphael	101
115	Paris Gaul	101
116	Naples Dying Gaul	101
117	*Death of Ananias,* tapestry by Pieter van Aelst after Raphael	102
118	*Stoning of Stephen,* tapestry by Pieter van Aelst after Raphael	103
119	*Conversion of Saul,* tapestry by Pieter van Aelst after Raphael	105
120	Vatican Logge, designed by Raphael and frescoed and stuccoed by his workshop	107
121	Vatican Logge: *God the Father Separating the Sun and the Moon,* by Giulio Romano after Raphael	108

122	Vatican Logge: *Original Sin*, by Pellegrino da Modena and Tommaso Vincidor after Raphael	109
123	Vatican Logge: *The Flood*, by Giulio Romano after Raphael	109
124	Vatican Logge: *Abraham and Melchisedek*, by Giulio Romano after Raphael	110
125	Vatican Logge: *Jacob's Dream*, by Giulio Romano after Raphael	111
126	Vatican Logge: *Joseph Interpreting His Brothers' Dreams*, by Giulio Romano after Raphael	111
127	Vatican Logge: *Joshua Stopping the Sun and Moon*, by Perino del Vaga after Raphael	112
128	*Transfiguration*, by Raphael	113
129	Layout design by Raphael for *Transfiguration*	112
130	*Creation of Eve*, by Baldassare Peruzzi	114
131	*Presentation of the Virgin*, by Baldassare Peruzzi	115
132	*Vision of Saint Jerome*, by Parmigianino	117
133	*Last Judgment*, by Michelangelo	118
134	Ascending soul, detail from Michelangelo's *Last Judgment*	119
135	Damned soul, detail from Michelangelo's *Last Judgment*	119
136	Saint Sebastian, detail from Michelangelo's *Last Judgment*	119
137	*Resurrection*, bronze relief by Jacopo Sansovino	121
138	*Cain Slaying Abel*, by Titian	123
139	*Tantalus*, woodcut by Giulio Sanuto after Titian	124
140	*Martyrdom of Saint Lawrence*, by Titian	125
141	*Rape of Europa*, by Titian	127
142	*Christ and the Centurion*, by Veronese	128
143	*Scorn* (or *Disillusion*), from *Four Allegories of Love*, by Veronese	129
144	*Saint Augustine Healing the Forty Cripples*, by Tintoretto	131
145	*Theft of Saint Mark's Body*, by Tintoretto	132
146	*Saint Mark Saving a Saracen from Shipwreck*, by Tintoretto	133
147	*Saint Michael and the Devil*, by Tintoretto	134
148	*Last Judgment*, by Tintoretto	134
149	Resurrected souls, detail from Tintoretto's *Last Judgment*	135
150	Head of the Venice Falling Gaul	137
151	Head of the Fauno Rosso	137
152	Head of the Naples Giant	138
153	Head of an Old Centaur	138
154	Portrait of the Emperor Nerva	139
155	Head of a Dacian from the Great Trajanic Frieze	139
156	Relief of a Dacian	140
157	Portrait of the Emperor Nerva	140
158	Head on the statue of a Dacian (Figure 161)	141
159	Tunic of the Venice Kneeling Gaul	141
160	Relief of the goddess Roma	141
161	Colossal statue of a Dacian	141
162	Plan of the Campus Martius, Rome	142
163	Model of the Campus Martius in the Constantinian period	143
164	Reconstruction of the *praetorium* or *kaisareion* at Side	144
165	Hypothetical reconstruction of the Little Barbarians displayed in the Saepta Iulia, Rome	145
166	Niobe and her youngest daughter	146
167	Dying Gallic Trumpeter	147
168	Bronze plaque from Pergamon with battle scene	148

169	Pergamene relief kantharos with Galatomachy	149
170	Roman circular relief with the Slaughter of the Niobids	149
171	Frieze with procession and *ferculum* bearing barbarian captives and a trophy, from the Temple of Apollo Sosianus, Rome	151
172	Jupiter Tonans, from the frieze of Trajan's Column	153
173	Colossal statue of Hadrian and a barbarian	154
174	Head of Hadrian	155
175	Head of the Naples Giant	155
176	Head of the Naples Persian	156
177	Head of the Vatican Persian	156
178	Head of Priam from the Temple of Asklepios at Epidauros	157
179	Head of the Venice Kneeling Gaul	157
180	Head of the Venice Falling Gaul	158
181	Head of the Venice Dead Gaul	158
182	Head of Alexander the Great	159
183	Head of the Paris Gaul	159
184	Alexander the Great in battle, from the Alexander Mosaic	159
185	Roman relief bowl with the suicide of Decebalus and chained Parthian captives	164
186	Roman relief bowl with the suicide of Decebalus and Parthian captives savaged by wild beasts	165
187	Naples Dying Gaul, three-quarter view	166
188	Naples Dying Gaul, wound under right shoulder blade	166
189	Venice Dead Gaul, wounds	167
190	Naples Amazon, wound	167
191	Naples Giant, wound	167
192	Wounded warrior from the east pediment of the Temple of Aphaia at Aigina	169
193	Little Barbarians: restorations	171
194	Man falling off a mule, from Trajan's Column	172
195	Amazonomachy, from an Amazon sarcophagus	173
196	Venice Kneeling Gaul, with restored right arm removed	174
197	Scenes on the northwest side of Trajan's column	174
198	Dacians in battle, from Trajan's Column	175
199	Battle, with supplicating Dacian, from Trajan's Column	175
200	Suicide of Decebalus, from Trajan's Column	175
201	Battle, with supplicating Dacian, from Trajan's Column	175
202	Dacian commits suicide, from Trajan's Column	176
203	Romans fight barbarians, front panel of the "Ammendola" battle sarcophagus	176
204	Romans fight barbarians, right side panel of the "Ammendola" sarcophagus	177
205	Fragment of a statue of a Roman emperor (Trajan?) and captive barbarian	177
206	Head of the barbarian from the statue, Figure 205	177
207	Head of a barbarian, probably from a statue of a Roman emperor	178
208	Fragments from an Athenian battle relief	178
209	Fragments from an Athenian battle relief	179
210	Fragments from an Athenian battle relief, with Athena and two standing women	179
211	Inscribed portrait herm of Olympiodoros	182
212	Plan of the Akropolis after the excavations of 1885–90	183
213	Section of the Akropolis excavations, 1885–90	183

214	Cornice blocks from the Attalid Dedication in the Chalkotheke	184
215	Cornice blocks from the Attalid Dedication in the Chalkotheke	184
216	Cornice block from the Attalid Dedication in the Chalkotheke	185
217	Blocks from the Attalid Dedication built into the Akropolis South Wall	185
218	Attalid Dedication, reconstruction of the pedestals in the center of the top of the Akropolis South Wall	187
219	Attalid Dedication, reconstruction of the pedestals against the parapet of the Akropolis South Wall	187
220	Base of the equestrian statue of Aristainos at Delphi	188
221	Gigantomachy, on an Attic red-figure volute krater from Ruvo	189
222	Reconstruction of the Amazonomachy on the shield of Pheidias' Athena Parthenos	190
223	Persianomachy from the south frieze of the Temple of Athena Nike	191
224	Pergamenes fighting Gauls and Seleukids, reconstruction of a dedication by King Attalos I at Pergamon; signed by Epigonos of Pergamon	191
225	Alexander Sarcophagus	191
226	Attalid Dedication, visibility from outside the Akropolis	193
227	Panorama of the Attalid colossi, Attalid Dedication, and adjacent monuments	194–95
228	Conjectural plan of the Attalid Dedication and colossi on the Athenian Akropolis	196
229	Sanctuary of Athena Polias Nikephoros at Pergamon in the late third century BC	197
230	King Eumenes II of Pergamon and the Dioskouroi, on a Pergamene silver tetradrachm	198
231	Portrait head, perhaps of King Attalos I of Pergamon	199
232	Portrait head, perhaps of Queen Apollonis of Pergamon	199
233	Collapsing Giant, from Marino	201
234	Fighting Giant, Roman bronze statuette	203
235	Panorama of Athens and the Saronic Gulf in the 1880s	205
236	Artemis and Apollo fight the Giants, from the Gigantomachy of the Great Altar of Pergamon	207
237	Suicidal Gaul	208
238	Head of the Suicidal Gaul	208
239	Head of the Suicidal Gaul's dying wife	208
240	Capitoline (Dying Gallic) Trumpeter	209
241	Head of the Trumpeter	209
242	Head of the Trumpeter, side view	209
243	Torso of a falling Gaul	210
244	Head of a Gaul	210
245	Profile view of the Gaul, Figure 244	210
246	Head of a dying barbarian (Gallic?) woman	211
247	Head of a dying Persian	211
248	Stoa and terrace of Attalos I at Delphi	211
249	Herm of Antisthenes, after a portrait by Phyromachos of Athens	214
250	Herm of Antisthenes, after a portrait by Phyromachos of Athens	215
251	Terra-cotta statuette of Antisthenes, after a portrait by Phyromachos of Athens	216
252	Asklepios Soter, on a Pergamene bronze coin	217
253	Portrait bust of Chrysippos	217
254	Centaur and Lapith, metope from a *heroon* at Limyra	221
255	Naples Giant	221

ILLUSTRATIONS

256	King Philip V of Macedon, on a Macedonian silver tetradrachm	221
257	Gorgoneion, detail of a Gnathia-style jug	229
258	Tombstone of Dexileos	231
259	Frieze of Greeks and Romans fighting Gauls	235
260	Frieze of Greeks and Romans fighting Gauls, detail	235
261	Frieze of Greeks and Romans fighting Gauls, detail	235
262	Head of a Gaul from the frieze, Figure 259	235
263	Vatican Persian	239
264	Rider from the west frieze of the Parthenon	239
265	Cornice blocks from the Attalid Dedication: reconstruction of jointing techniques using both clamps and dowels, and clamps only	243
266	Cornice blocks from the Attalid Dedication: perspective view of moldings	244
267	Cornice blocks from the Attalid Dedication: profiles of moldings	245
268	Attalid Dedication, cornice block Γ1	246–47
269	Attalid Dedication, cornice block Γ2	248–49
270	Attalid Dedication, cornice block Γ3	250–51
271	Attalid Dedication, cornice block Γ4	252–53
272	Attalid Dedication, cornice block Γ5	254–55
273	Attalid Dedication, cornice block Γ6	256–57
274	Attalid Dedication, cornice block Γ7	258–59
275	Attalid Dedication, cornice block Γ8	260–61
276	Attalid Dedication, cornice block Γ9	262–63
277	Attalid Dedication, cornice block Γ10	264–65
278	Attalid Dedication, cornice block Γ11	266–67
279	Attalid Dedication: key to Tables 9–10: clamps, dowels, and measurements	268
280	Attalid Dedication: hypothetical reconstruction of doweling arrangements for eight of the copies	271
281	Relation of the Older Parthenon and the Parthenon to the ground around them	273
282	Ludwig Ross's stratigraphic section to the south of the Parthenon viewed from the east	274
283	Plan and elevation of the Akropolis South Wall, indicating the original structure's main parts and later additions	275
284	Theoretical sections through the Akropolis South Wall	277
285	Restored elevation and plans of the constructional stages of the Akropolis South Wall	279
286	Attalid Dedication, upper side of a plinth block (**A2**)	283
287	Attalid Dedication, restored cut-away isometric view of one of the pedestals	285

Foldout: The Ten Little Barbarians ◎◎ *back of book*

PREFACE

◎◎ ◎◎ ◎◎

THE LITTLE BARBARIANS of my subtitle are ten Roman marble figures of Giants, Amazons, Persians, and Gauls (see Figures 1–25, 29–64, 77–80). Two-thirds life-size, startlingly expressive, and finely carved, they apparently caused quite a sensation when discovered in Rome at the height of the Renaissance. The ancient and Renaissance documentation about them and about the Athenian monument that they copy is assembled in Appendix 1 (ancient *testimonia*, AT1–8; Renaissance *testimonia*, RT1–13), and a catalog of the statues themselves appears in Appendix 2.

Six of the Barbarians – originally seven, but one vanished soon after its discovery – were found in Rome in 1514 and are now in Naples, the Vatican, and Paris (RT1–2; see Figures 1, 3, and 5). Three more probably emerged immediately afterward but were documented only in 1523, after their transfer to Venice, where they still remain (RT3–4; see Figure 2). A tenth, now in Aix-en-Provence, was noted first only in 1738 (see Figure 4), but might just possibly be the lost seventh statue of the 1514 find. For clarity's sake, when distinctions are needed I follow Brunilde Ridgway in labeling the figures that are recorded during the Renaissance the "core group," and I call the documented find of 1514 (RT1–2) its "kernel."

Renaissance connoisseurs immediately and colorfully identified this seven-figure "kernel" as the battling Horatii and Curiatii of Roman legend and the Horatii's murdered sister (RT1–2, 6–8). The three Venetian statues, however, were thought to be gladiators (RT4, 9, 12). After the "kernel" was dispersed, however, the Horatian "sister" eventually became an Amazon; one of the Curiatii also became a gladiator; and the rest became nameless (RT10).

The "core group" was not reunited until 1865, when the German archaeologist Heinrich Brunn assembled plaster casts of the Little Barbarians in Rome and attributed them to a dedication on the Athenian Akropolis seen by the traveler Pausanias around AD 170 (AT6). Pausanias locates this monument "by the South Wall" of the citadel; describes its subjects as the battles against the Giants, Amazons, Persians, and Galatians – as in the surviving copies; and names its dedicator as "Attalos," presumably either King Attalos I (r., 241–197 BC) or Attalos II (r., 158–138 BC) of Pergamon.[1] Fortunately he also notes that its figures are "about two cubits" high: two Ionic cubits of ca. 52.5 cm or about four English feet.

Since this is exactly the scale of the "core group," the monument is generally – if somewhat misleadingly, given its length and complexity – called the Small (or Lesser) Attalid Dedication. Until recently, though, its precise form and location were matters of conjecture. In the early 1990s, however, Pausanias' vital snippet of information as to its reduced scale led the then-director of the Parthenon Restoration Project, Manolis Korres, to identify some cornice blocks with sockets for bronze feet of exactly this size (see Figures 214–16) as remains of its long-lost pedestals. His Essay herein offers a catalog and thorough study of these pedestals and of their setting, the South Wall of the Akropolis.

Now Pausanias (AT6) correctly calls the Pergamenes' originally northern European opponents "Galatians" (*Galatoi*); the mainland Greeks called their cousins, the invaders of 279, "Celts" (*Keltoi*); and the Romans called all of them "Gauls" (*Galli*). Since it would be confusing to switch back and forth among these names, and our surviving Little Barbarians are Roman, I will risk the wrath of purists by calling them all "Gauls." And for clarity's sake too, I distinguish the four Akropolis groups by Roman numerals, beginning with the one that is both earliest "historically" and the first in Pausanias' sequence: the Gigantomachy (I). Then come the Amazonomachy (II), Persianomachy (III), and Galatomachy (IV).

A thing of violence created amid threats to Athens's very existence, the Attalid Dedication remains contested even today, albeit in the less sanguinary arena of modern scholarship. Strangely, though, since Brunn published his conclusions in 1870 only Beatrice Palma has studied the ensemble in its entirety, in 1981. She collected most of the ancient sources and modern bibliography and cataloged almost all the statues ever attributed to it (thirty-two in all). In a subsequent article in 1984 she traced the history of these statues since their discovery, again citing most of the Renaissance and modern bibliography. These two studies are invaluable, but there is more to be said. For – the monument's newly discovered pedestals apart – both it and its copies stand at the intersection of several different subdisciplines, including art history, topography, cultural history, ideology, religion, politics, and intellectual history. They have many different stories to tell.

At times this study has felt like a six-year exercise in detection, Sherlock Holmes style; hence the whimsical epigraphs to most chapters. It began as an article but swiftly outgrew its origins when in June 1997 I stumbled upon Korres's discovery (modestly announced in a single sentence) while reading one of his Parthenon reports in the American School's Blegen Library.[2] Our collaboration started soon afterward, eventually resulting in the retrieval of dozens more blocks from the pedestals, his Essay included here (between my Conclusion and the Appendixes), the superb drawings reproduced in Figures 217–19, 226, 265–81, and 283–87, and last but not least, a fundamental reevaluation of the entire monument.

Simultaneously, however, as I began to do my homework and to delve into the scholarship, I realized that this monument and its ten surviving replicas, the Little Barbarians, have led no fewer than four lives: Hellenistic Greek, imperial Roman, Renaissance, and modern. The first of these required a complete rewrite; the second, all but totally overlooked, needed to be investigated from scratch; the third had attracted much interest, but chiefly from historians of collecting and iconographic source hunters; and the fourth raised some intriguing questions about the intellectual history of the discipline. Moreover, scrutiny of the traditional kind had diverted attention from the statues themselves – from the ten little marbles that we actually possess (see Figures 1–25, 29–64, 77–80). For by viewing them as mere windows to their lost originals, scholars had generally refrained from addressing them as sculptures in their own right – from attending to them as individual, arresting, and challenging works of art per se.

So I decided to begin the book with a direct encounter with these little marbles – a much-edited and highly impressionistic version of my own personal engagement with them over the years – and then to write the main part of it in reverse chronology. My four chapters attempt to peel away, like archaeological strata, the four successive levels in the Dedication's history and reception, beginning with the modern scholarship and ending on the Hellenistic Akropolis. They can then be reread in proper chronological order; but for those with no time or inclination for such a marathon, some concluding remarks revisit them in this fashion. Researching them has led me to make a deeply satisfying acquaintance with some of the masterpieces of Renaissance art; to read what I can of the literature on them and to develop (hesitantly and with genuine diffidence) some ideas about them; and to rethink some of my old thoughts about Roman and Hellenistic art, and about the discipline in general.

Chapter 1 begins in nineteenth-century Athens and Rome, examining the modern scholarship from the pioneering work of Leake, Penrose, and Brunn to the present. Of course, this way of introducing the subject is as conventional as it is convenient. Yet since "all history is contemporary history" and some of the discipline's best minds have wrestled with these problems, a study of this kind can also illuminate the field's wider concerns over the past century and a half. So en route and inter alia, the chapter considers the successes and limitations of positivist historicism and of formalism; the roles of photography and of the corpus in the consolidation of the discipline; the contest between contemporary neopositivism and deconstruction; and the discipline's methods, aims, and prospects at the beginning of the third millennium. It allows us to see the successive incarnations of our statues (artistic and scholarly) as culturally embedded, as contingent products of an ongoing discourse, and indicates that the present study is no different.

Chapter 2 retreats to the Renaissance. It chronicles the Little Barbarians' discovery, their identification, and their subsequent odyssey through the great collections of

sixteenth-century Rome and Venice. Since the narrative given them when they came to light was never codified – contrast (for example) the Belvedere Apollo and the Laokoon (see Figure 82) – they stagger unsteadily from role to role, from heroes to villains to saints. So what impact did they make on Renaissance artists, from Raphael, Michelangelo, Sansovino, Titian, Veronese, and Tintoretto to others such as Albertinelli, Aspertini, Peruzzi, and Pordenone? Under what description(s) did they engage these statues? What did they see in them that was so compelling? And what uses did they make of them?

Chapter 3 steps back another fourteen hundred years to the Roman Empire and considers the Little Barbarians as works of Roman art. Why did the Romans select these particular statues? When were they made? Where and how were they displayed? Why did the selection apparently include no victors? This omission compels us to focus on them *as barbarians,* as generic representatives of the world "beyond the pale." It forces us to take a virtual step into the two main locales where the Romans' eternal conflict with barbarism and the barbarian body was played out: the outlands beyond the frontiers and the Roman arena. And it brings the ensemble's two model spectators – emperor and citizen, authority and ourselves – into alignment, using the insistent specter of barbarian chaos to create a bond of solidarity between them. Finally, what impact did the Barbarians – or their types – have on Roman art?

Chapter 4 regresses, at last, to the Little Barbarians' originals and to Athens of the years around 200 BC. What did Attalos' Dedication look like and where did it stand? Who made it and when? Which Attalos donated it and why? What purposes did it serve at this time of national near-disaster and equally uncertain prospects? How might its various intended or unintended audiences have received it? What new light can it shed upon the core agenda of Athenian–Pergamene cultural chauvinism: their spatiotemporal construction of "true" Hellenism in an age of Greek upheaval and Roman expansion, and their own self-anointed mission as its only true guardians?

As mentioned earlier, an Essay by the discoverer of the Attalid Dedication's pedestals, Professor Manolis Korres, follows the main text. In addition to publishing a catalog and study of the numerous surviving blocks (almost sixty at last count), this essay investigates in detail the history and topography of their setting: the Akropolis South Wall. It thereby offers en passant a contribution to Akropolis studies that will remain definitive for the foreseeable future, until the Parthenon Restoration Project is completed and reexcavation of the area can commence.

☙

Three research assistants, Celina Gray, Becky Martin, and Kristin Seaman, have materially aided this project in numerous ways. Becky and Kris have also read and commented generously on much of what I have written, as have Erich Gruen, Christopher Hallett, and Loren Partridge, to whom I owe more bibliographical references than I can acknowledge individually. (But all mistakes and indiscretions remain, as always, my own.) Erin Dintino graciously and unstintingly provided expertise in computer graphics, scanning, drawing, and reconstruction. And finally, my partner Darlis Wood has sustained me with companionship and enthusiastic assistance, as have Lyle, Lola, Maximus, Polly, Dinah, Shadow, and the late, lamented Claudette and Rosebud.

To Manolis Korres I owe a great debt of gratitude for making the Akropolis pedestals that he discovered available for study; for alerting me to much about them that would otherwise have escaped my attention; for providing his many superb drawings; for producing a comprehensive catalog and evaluation of the pedestals' components; and, last but definitely not least, for graciously consenting to publish all of this in the essay that follows the main text of this volume. On the Akropolis itself, Alkestis Spetsieri-Choremi kindly permitted me to study them and allowed their publication in the present volume; I also thank Christina Vlassopoulou for facilitating my access to them. The American School of Classical Studies at Athens was as always my congenial base of operations, and I thank James Muhly, Stephen Tracy, Maria Pilali, Nancy Winter, and Camilla Mackay for their kind assistance in obtaining permits, expediting access to the material, and providing the necessary library support. David Scahill generously assisted me on the Akropolis and elsewhere, also alerting me to much that I would otherwise have overlooked, producing interim working drawings and reconstructions, and greatly speeding communication with Professor Korres. An impromptu seminar held on site in June 2000 with Tom Brogan, Michael Djordjevitch, Celina Gray, and Anne Stewart clarified many problems and defined others.

In Rome, Paul Zanker graciously put the formidable resources of the Deutsches Archäologisches Institut at my disposal. I thank him, Letitia Abbondanza, Osvaldo Böhm, and Luciano Pedicini for the superb photos of the Naples and Venice Barbarians; Paolo Liverani and Alain Pasquier and their photographic staffs for those of the Vatican and Paris ones; and the Centre Camille Jullian for those of the Persian in Aix-en-Provence. The Millard Meiss Publication Fund of the College Art Association and U.C. Berkeley's Committee on Research provided

PREFACE

generous grants for the expanded program of illustrations.

In addition, for help on particular points I must thank Bernard Andreae; Joan Barclay-Lloyd; Judith Binder; Robert Bridges; Richard Brilliant; Eliana Carrara; Annette Cayot; Diane Conlin; Denis Coutagne; Georgios Despinis; Michael Djordjevitch; Christopher Faraone; William Fitzgerald; Julian Gardner; Robert Gaston; Katherine Gill; Michael Glazeski; Celina Gray; Erich Gruen; Christopher Hallett; Evelyn Harrison; Chrystina Haüber; Norman Herz; Wolfram Hoepfner; Natalie Kampen; Erich Kistler; Martin Kreeb; Jack Kroll; Ann Kuttner; Mary Alice Lee; Evelyn Lincoln; Paolo Liverani; Anna Magnetto; Dan Marcus; John Marszal; Marie Mauzy; Richard Neer; James Packer; Olga Palagia; Loren Partridge; Alain Pasquier; Jerome J. Pollitt; Josephine Crawley Quinn; Maria Luisa Ravagnan; Brunilde Ridgway; Molly Richardson; Geoffrey Schmalz; Kristen Seaman; Bert Smith; Anthony Snodgrass; Regina Stefaniak; John Stenzel; Anne Stewart; Ronald Stroud; Leslie Threatte; Ismene Trianti; Carolyn Valone; Paul Zanker; seminar and lecture audiences at Berkeley, San Francisco, Yale, Ann Arbor, Austin, Columbia, Paris, Sydney, Hobart, and Christchurch; two anonymous readers for Cambridge University Press; Beatrice Rehl; and Michael Gnat, *editor optimus*.

I must also gratefully acknowledge permission to reproduce the following copyrighted material:

The quotation on pp. 62–64 is reprinted, by kind permission of the publisher, from Margaret W. Conkey and Christine A. Hastorf, *The Uses of Style in Archaeology* (New York and London: Cambridge University Press). Copyright © 1990 by Cambridge University Press.

The quotations on p. 64 are reprinted, by kind permission of the publisher, from *The Collected Papers of Charles Sanders Peirce,* vols. VII and VIII, edited by Charles Hartshorne, Paul Weiss, and Arthur W. Burks (Cambridge, Mass.: The Belknap Press of Harvard University Press). Copyright © 1966 by the President and Fellows of Harvard College.

The quotations on pp. 76–77 are reprinted, by kind permission of the publisher, from Michael Baxandall, *Patterns of Intention: On the Historical Explanation of Pictures* (New Haven and London: Yale University Press). Copyright © 1985 by Yale University.

The quotation on p. 224 is reprinted, by kind permission of the publishers and the Trustees of the Loeb Classical Library, from *Livy, Volume IX,* Loeb Classical Library vol. 295, translated by Evan T. Sage (Cambridge, Mass.: Harvard University Press, 1935). The Loeb Classical Library® is a registered trademark of the President and Fellows of Harvard College.

Manolis Korres adds: I would like to thank Dr. Alkestis Choremi, Director of the Akropolis Ephorate, for publication permission, and likewise to acknowledge her supportive interest in my work. I also acknowledge the contributions of my old colleagues K. Zambas and P. Koufopoulos, with whom I had the pleasure of discussing some important aspects of the Akropolis Wall. I would also like to thank Prof. Andrew Stewart for the pleasure of joining him in this project, and for editing my English text as well. David Scahill's involvement, brief though it was, was greatly stimulating. To N. Toganides, architect in charge of the Parthenon Restoration Project, I am indebted for technical support in moving the heavy blocks. I would also like to thank Telemachos Souvlakis, photographer of the Akropolis Ephorate, for his superb photographs (not included in this volume) and the publisher, Cambridge University Press, for reproducing my drawings at proper size and at good resolution. To Prof. Ch. Bouras, the moving spirit behind the Akropolis restoration projects, I am, as always, most deeply indebted both for his valuable suggestions on the subject and for his constant support and encouragement.

ABBREVIATIONS

⦿ ⦿ ⦿

AA	*Archäologischer Anzeiger, Herausgegeben vom Deutsches archäologisches Institut*
AAA	*Archaiologika Analekta ex Athinon/Athens Annals of Archaeology*
AJA	*American Journal of Archaeology*
AkrM	*Akropolis Museum*
AM	*Mitteilungen des Deutsches archäologisches Institut, Athenische Abteilung*
AnSt	*Anatolian Studies*
ANS–MN	*American Numismatic Society – Museum Notes*
AntK	*Antiker Kunst*
ArtB	*The Art Bulletin*
AvP	*Altertümer von Pergamon.* Berlin, from 1885
AZ	*Archäologischer Zeitung*
B–B	Heinrich Brunn and Friedrich Bruckmann (eds.), *Denkmäler griechischer und römischer Sculptur.* Munich 1888–1900
BCH	*Bulletin de Correspondence Hellénique*
Bd'A	*Bollettino d'Arte*
BICS	*Bulletin of the Institute of Classical Studies, University of London*
BJb	*Bonner Jahrbücher*
BM	*British Museum*
BSA	*Annual of the British School of Archaeology at Athens*
BurlMag	*The Burlington Magazine*
DocIn	*Documenti inediti per servire alla storia dei Musei d'Italia.* Rome 1878–80. 4 vols.
EA	Paul Arndt et al., *Photographischer Einzelaufnahmen antiker Skulptur.* Munich 1893–1947
EAA	*Enciclopedia dell'Arte Antica.* Rome, from 1958
FGH	Felix Jacoby, *Die Fragmente der griechischen Historiker.* Berlin, from 1923
GRBS	*Greek, Roman, and Byzantine Studies*

Helbig[4]	Wolfgang Helbig, *Führer durch die offentlichen Sammlungen klassischer Altertümer in Rom.* 4th ed. by Hermine Speier, Tübingen 1963–72. 4 vols.
HSCP	*Harvard Studies in Classicial Philology*
IG	*Inscriptiones Graecae.* Berlin, from 1913
JdI	*Jahrbuch des Deutsches archäologisches Institut*
JHS	*Journal of Hellenic Studies*
JRA	*Journal of Roman Archaeology*
JRS	*Journal of Roman Studies*
JWCI	*Journal of the Warburg and Courtauld Institutes*
LIMC	*Lexicon Iconographicum Mythologiae Classicae.* Zürich 1981–99
NM	National Museum, Athens
OGIS	Wilhelm Dittenberger, *Orientis graeci inscriptiones selectae.* Leipzig 1903–05
ÖJh	*Jahreshefte des Österreichisches archäologisches Institut*
RA	*Revue Archéologique*
REA	*Revue des études anciennes*
REG	*Revue des études grècques*
RhM	*Rheinisches Museum für Philologie*
RIA	*Rivista dell'Istituto Nazionale di Archeologia e Storia dell'Arte*
RM	*Mitteilungen des Deutschen Archäologischen Instituts, Römisches Abteilung*
RPAA	*Rendiconti della Pontificia Accademia romana di Archeologia*
SEG	*Supplementum Epigraphicum Graecum*
ZPE	*Zeitschrift für Papyrologie und Epigraphik*

SOME IMPORTANT DATES

∽∽ ∽∽ ∽∽

GREECE (ALL DATES BC)

—	(Giants assault Olympos)
—	(Herakles and Theseus attack Amazon territory of Themiskyra; abduct Antiope/Hippolyte)
—	(Amazons attack Athens; death of Antiope/Hippolyte)
490	Persians invade Attica; Battle of Marathon (Figure 223?)
480	Persians invade Greece; Battle of Salamis
Ca. 450	Stoa Poikile (Athens)
447–432	Parthenon (Athens) (Figures 67, 212–13, 218–19, 227–28)
404	Athens defeated in Peloponnesian War
338	Philip II of Macedon defeats Athens and Thebes at Chaironeia
334–323	Alexander the Great (Figures 182, 184, 225) conquers the East
320–280	Breakup of Alexander's empire
279–278	Gauls invade Greece, attack Delphi, and invade Asia Minor
Ca. 275	Ptolemy II destroys rebellious Gallic mercenaries in Egypt
268–262	Chremonidean War; Macedonians defeat and occupy Athens
241	Attalos I ruler of Pergamon
Ca. 237	Attalos I defeats Gauls by River Kaïkos; proclaims himself king
229	Macedonians withdraw from Athens
223	Attalos I commissions Epigonos to commemorate his victories over Gauls and Seleukids (Figure 224)
221	Philip V (Figure 256) king of Macedon
211–205	First Macedonian War
202–197	Second Macedonian War:
201	Philip V ravages Pergamene Asklepieion and Nikephorion

SOME IMPORTANT DATES

200	Philip V ravages Attica; Attalos I visits Athens (AT1)
197	Flamininus defeats Philip at Kynoskephalai; Attalos I dies; accession of Eumenes II (Figure 230a)
192–188	Antiochos III of Syria invades Greece; Romans defeat him and expel him from Anatolia
189	Romans under Manlius Vulso and Pergamenes attack Gauls in Anatolia
178–175	Antiochos IV of Syria resides in Athens
172–168	Third Macedonian War; Romans abolish Macedonian kingdom; Aemilius Paullus visits Athens
168–166	Eumenes II of Pergamon suppresses Gallic revolt; commissions Great Altar of Pergamon (Figures 68–69, 91, 236)?
158	Eumenes II dies; accession of Attalos II
138	Attalos II dies; accession of Attalos III
133	Attalos III dies, willing Pergamon to Rome
88	Mithradates VI of Pontos invades W. Asia Minor and Greece; Athens joins him against Rome
86	Sulla besieges and takes Athens
31	Omens foretell disaster for Antony and Kleopatra (AT5, 7); Octavian defeats them at Actium
Ca. 20	Athenians resolve to restore their ruined sanctuaries (AT2)

ROME (ALL DATES AD)

80	Fire destroys most of Campus Martius (cf. Figures 162–63)
81	Emperor Titus dies; accession of Domitian
88–89	Romans defeat Dacians under Decebalus; Domitian celebrates Dacian triumph
92–93	Romans defeat Sarmatians
96	Domitian assassinated; accession of Nerva (Figures 154, 157)
98	Nerva dies; accession of Trajan
101–02	First Dacian War
105–06	Second Dacian War; suicide of Decebalus
107	Trajan celebrates Dacian triumph
111–13	Hadrian (Figures 173–74) visits Athens
113	Trajan dedicates his Forum and Column (Figures 172, 194, 197–202)
114–17	Trajan invades Parthia; reaches Persian Gulf; forced to retreat by revolts; dies; accession of Hadrian
118	Hadrian and his generals suppress revolts in Syria, Judaea, Dacia, and Mauretania; Hadrian enters Rome, celebrates Trajan's Parthian triumph; Hadrian begins work on the Pantheon (Figures 162–63) and his villa at Tivoli
131–35	Jewish (Bar-Kochva) revolt
138	Hadrian dies; accession of Antoninus Pius

SOME IMPORTANT DATES

THE RENAISSANCE

1506	Discovery of the Laokoon (Figures 83, 109)
1508–12	Michelangelo's Sistine Chapel ceiling
1512	French invasion of Italy; battle of Ravenna
1513	Death of Pope Julius II; accession of Leo X Medici; Leo commissions tapestry cartoons (Figures 108, 114) from Raphael
1514	Little Barbarians discovered in Rome (RT1); seven sold to Alfonsina Orsini, who gives one to Leo (RT2)
1515	French invasion of Italy; battle of Marignano
1516	Raphael completes tapestry cartoons, begins design of Vatican Logge (Figures 120–27)
1517–19	Raphael's workshop decorates Vatican Logge; Raphael begins his *Transfiguration* (Figures 128–29)
1519	Peruzzi's Volta Dorata in the Palazzo della Cancelleria (Figure 130)
1520	Alfonsina Orsini, Leo X, and Raphael die; Cardinal Domenico Grimani begins to transfer his collection to Venice
1523	Domenico Grimani dies, leaving his collection to Venice (RT3, 4)
1525	Sala delle Teste opened in Venice (RT5)
1526	Parmigianino's *Vision of Saint Jerome* (Figure 132)
1527	Sack of Rome; Parmigianino, Peruzzi, Sansovino, and others flee the city; Titian's *Martydom of Saint Peter Martyr* (Figure 93)
1529	Sansovino appointed *proto-magister* of the Procuratia di San Marco de Supra in Venice
1536–41	Michelangelo's *Last Judgment* (Figures 133–36)
1537	Margaret ("Madama") of Austria inherits Alfonsina's palazzo and collection
1542–44	Titian's *Santa Maria della Salute* cycle (Figure 138)
1545–46	Ceiling of Sansovino's library collapses; Sansovino tried and punished; given contract for San Marco sacristy doors (Figure 137)
1548–59	Titian's *Martyrdom of Saint Lawrence* (Figure 140)
1550	M. Ulisse Aldrovandi visits Rome (RT6); Vasari publishes his *Lives of the Artists*
1553	Sansovino's *Resurrection* (Figure 137)
1556–59	Jean Jacques Boissard visits Rome (cf. RT13, published 1597)
1559–62	Titian's *Rape of Europa* (Figure 141)
1562–63	Tintoretto's *Last Judgment* (Figure 148–49)
1562–66	Tintoretto's *Saint Mark* cycle (Figures 145–46)
1566	Pius V banishes all pagan statues from the Vatican
1586	Margaret ("Madama") of Austria dies; Alessandro Farnese inherits her estate; Giambattista de'Bianchi restores her collection (RT10). In Venice, Sala delle Teste closed (RT9); Giovanni Grimani donates his collection to the city
1589	Alessandro Farnese dies
1593	Giovanni Grimani dies (RT11); Tiziano Aspetti restores his collection (RT12)
1597	Statuario Pubblico opened in Venice

xxv

LITTLE BARBARIANS

An Encounter

༄ ༄ ༄

THEY STARTED OUT TOGETHER but now are scattered among five European cities in three countries. Four of them – the best known – alternate between the aging galleries of the Naples Museum and a stygian basement, displaced by a series of far glitzier temporary exhibitions (Figure 1). Three more sprawl in a sunny room in Venice's Museo Archeologico, overlooking Italy's most glorious public space, the Piazza San Marco (Figure 2). An eighth cowers claustrophobically amid a crowd of marbles in the Vatican's Galleria dei Candelabri (Figure 3). The ninth squats under a staircase in the Musée Granet in Aix-en-Provence, fearfully eyeing the descending visitor (Figure 4). And the tenth kneels defiantly in the middle of a huge room of Greco-Roman sculpture in the Louvre, shadowboxing the crowds of passing tourists (Figure 5).

Let's put them together, and begin again.

Not one of them stands upright. They kneel, cower, sink, or sprawl in attitudes of corporeal abandon, pain, despair, and death. One or two grimace and gesture wildly in my direction as if trying to catch my eye. Several are naked or only half-clothed. And they're small, only four feet tall (Figure 6). No opponents in sight, either: That's odd. They look as though a thunderbolt hit them and another's on the way.

Venturing closer, I notice their strange combination of knobby, aggressive muscles and contorted, often concave postures (Figure 7). But the marble's high polish reflects my gaze. Bouncing back, it never quite returns to the same place (Figure 8). Flicking against the shiny, glancing surface of the stone, it animates it. Flesh puckers, muscles ripple, bodies writhe, and cloth flutters (Figure 9) as I scan them. A primitive world of brute strength and savagery throbs, clashes, and collapses before my eyes. A giant among midgets, I've walked into a battlefield. The fighting is almost over, and the massacre has begun.

Towering over them and getting used to their glossy surface, I linger awhile. As I look closer, the crisp, dramatic, puckered modeling begins to thrust the individual parts into prominence. They begin to detach themselves from the whole, to float independently before my eyes, to jostle for my attention. I scrutinize the grimacing faces and recoil at the open, gaping wounds (Figures 10–11). One man screams dumbly; another snarls; a third gasps in pain; and several are frozen in death (Figure 12). Blood spurts out of the gashes, stickily coating the skin; it grabs my attention and makes me more than a bit uneasy.

Now almost myopically close, my glance is snared by the tactile: woven cloth, shiny swords, smooth skin, coarse hair. I notice textures, fissures, gouges, nicks, scratches, and holes: some rasping here, some drilling there (Figure 13). But on occasion the light still plays tricks, bringing the polished, semitranslucent stone to life and softening the men's coarse features and rocklike muscles, and the cruel paraphernalia of war. Breaks and signs of weathering obtrude, along with a plethora of telltale seams, patches, and abrupt changes of stone color. A woman's breast juts skyward, perfectly conical and startlingly white (Figure 13). Oho, the repairman at work! But decay's sordid legacy snaps at his heels: Chipped

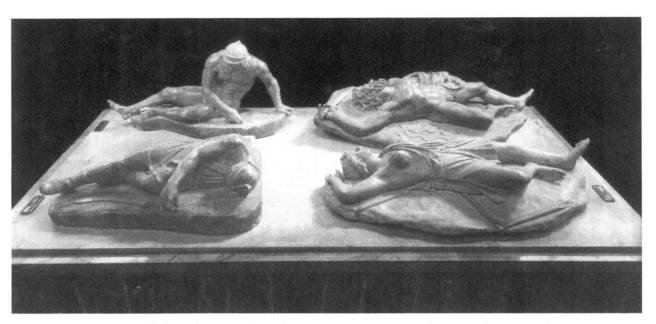

FIGURE 1. *(clockwise from top right)* Naples Giant, Amazon, Persian, and Dying Gaul (Roman copies). From Rome; originals, ca. 200 BC. Marble; length of each figure, ca. 1.16 m. Naples, Museo Nazionale FAR 6013, 6012, 6104, 6015. Photo: Alinari/Art Resource 5270.

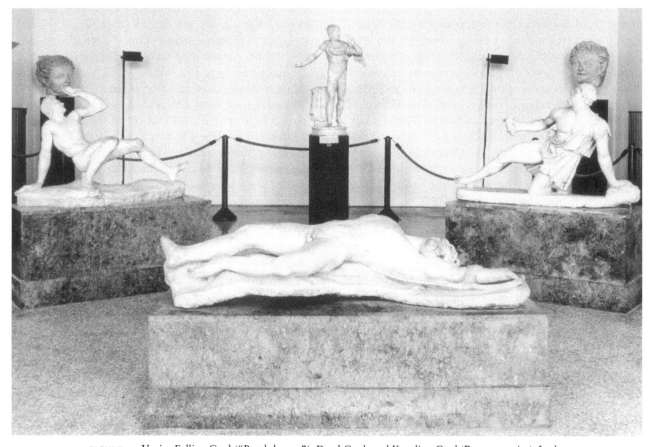

FIGURE 2. Venice Falling Gaul ("Breakdancer"), Dead Gaul, and Kneeling Gaul (Roman copies). In the background, the Ulysses, Figure 103. Rome; originals, ca. 200 BC. Marble; height 69 cm; length 1.36 m; height 76 cm, respectively. Venice, Museo Archeologico 55, 56, 57. Photo: Osvaldo Böhm.

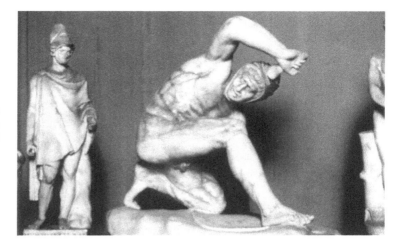

FIGURE 3. Vatican Persian (Roman copy). From Rome; original, ca. 200 BC. Marble; height 73 cm. Vatican, Galleria dei Candelabri 2794. Photo: Author.

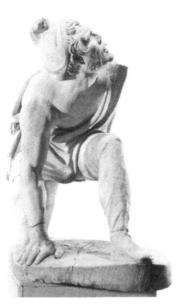

FIGURE 4. Aix Persian (Roman copy). From Rome or Frascati; original, ca. 200 BC. Marble; height 64 cm. Aix-en-Provence, Musée Granet. Photo: Centre Camille Jullian.

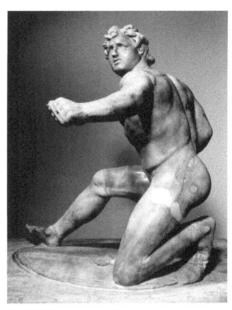

FIGURE 5. Paris Gaul (Roman copy). From Rome; original, ca. 200 BC. Marble; height 87 cm. Paris, Musée du Louvre Ma 324. Photo: Chuzeville.

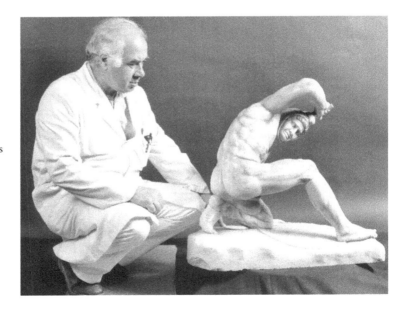

FIGURE 6. Vatican Persian. Photo: Vatican Museums XXXVI.27.25/1.

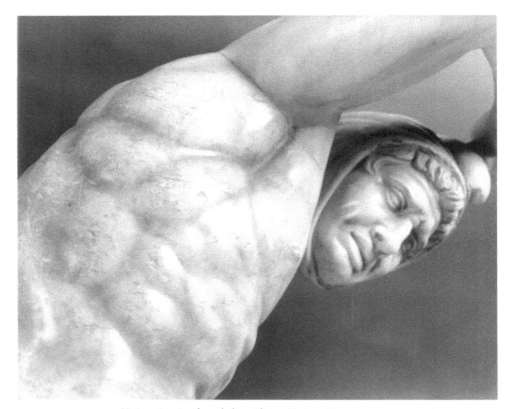

FIGURE 7. Vatican Persian from below. Photo: Vatican Museums XXXVI.27.25/10.

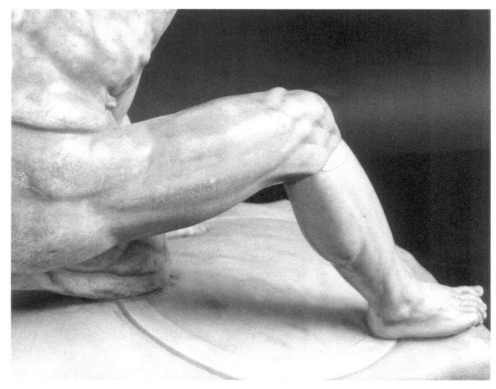

FIGURE 8. Right thigh of the Vatican Persian. Photo: Vatican Museums XXXVI.27.25/11.

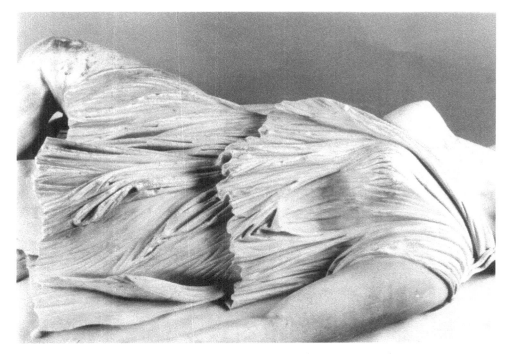

FIGURE 9. Drapery of the Naples Amazon. Photo: Luciano Pedicini.

FIGURE 10. *(right)* Head of the Venice Kneeling Gaul. Photo: Osvaldo Böhm.

FIGURE 11. *(below)* Right side at waist of the Venice Dead Gaul. Photo: Osvaldo Böhm.

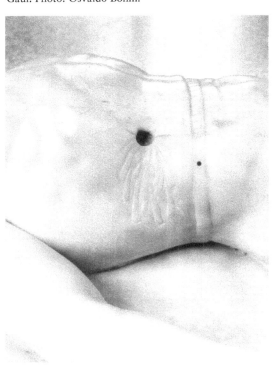

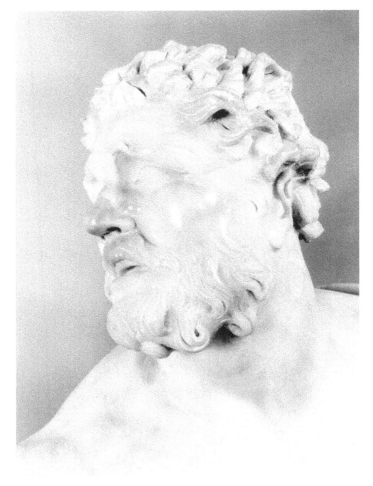

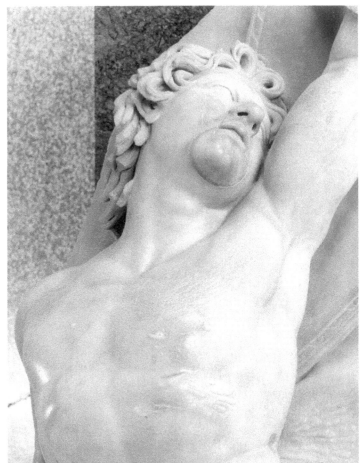

FIGURE 12. Torso and head of the Venice Dead Gaul. Photo: Osvaldo Böhm.

FIGURE 13. *(right)* Breast and head of the Naples Amazon. Photo: Luciano Pedicini.

FIGURE 14. *(below)* Naples Giant's lionskin. Photo: Luciano Pedicini.

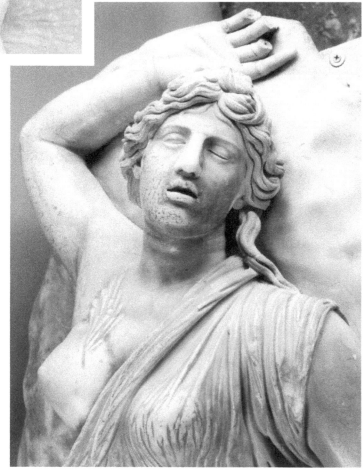

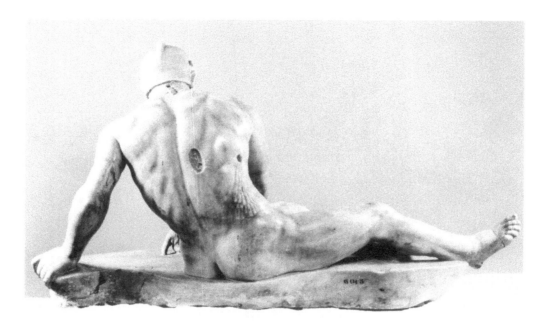

FIGURE 15. Back view of the Naples Dying Gaul. Photo: Luciano Pedicini.

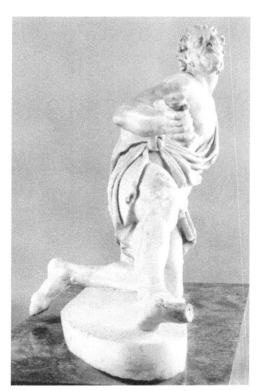

FIGURE 16. Side view of the Venice Kneeling Gaul. Photo: Osvaldo Böhm.

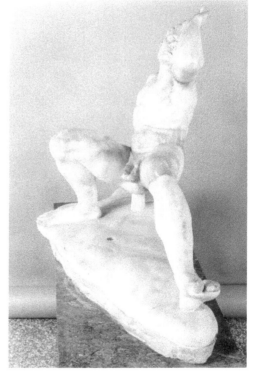

FIGURE 17. Side view of the Venice Falling Gaul. Photo: Osvaldo Böhm.

plaster, hidden grime, and rusted iron jutting from amputated fingers, wrists, and scarred folds of clothing (Figure 14).

Curious to learn more, I begin to walk around them. Interesting: Their backs are completely finished, and one or two even have wounds there (Figure 15). But several are much less three-dimensional than I thought. From the front they're wild and wanton, all jagged diagonals and zigzags, but from the side they look like flats for a stage play (Figures 16–17). Theatrical enough from in front,

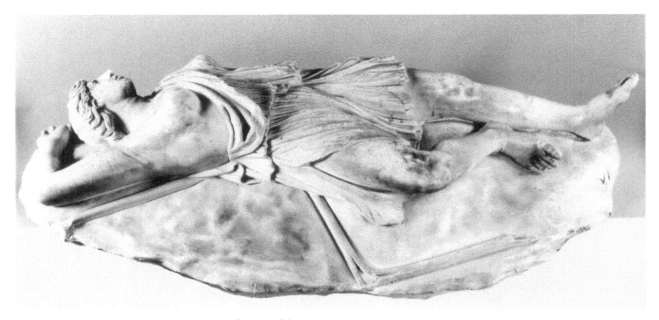

FIGURE 18. Side view of the Naples Amazon. Photo: Luciano Pedicini.

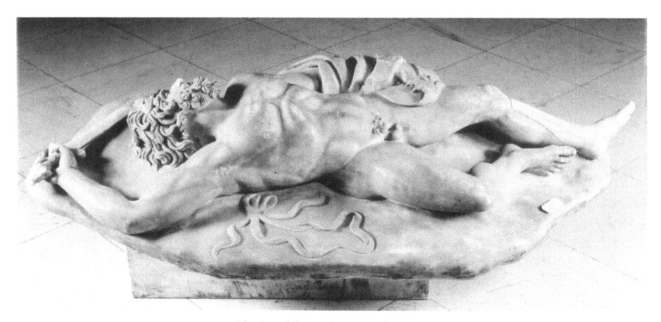

FIGURE 19. Side view of the Naples Giant. Photo: Luciano Pedicini.

they seem surprisingly more so when I view them anamorphically.

Pulling back and taking stock, I start to see patterns. The white-breasted woman and a hairy, bearded man both sprawl on the ground, stone dead, with right legs jerked up in pain, right arms outflung, and heads turned away from me (Figures 18–19). The legs of another echo theirs (Figure 20), and so do those of a fourth – more or less (Figure 21). Several support themselves on one arm, hand flat on the ground. Two, kneeling, are mirror images of each other. And three more wear what looks comically like a "gangsta" cap (Figure 22).

Only then do I begin to think seriously about exactly who they are, to look for signs of identity, and to dredge my memory for parallels. The bearded dead man sports body hair and an animal skin: evidently a Giant. The

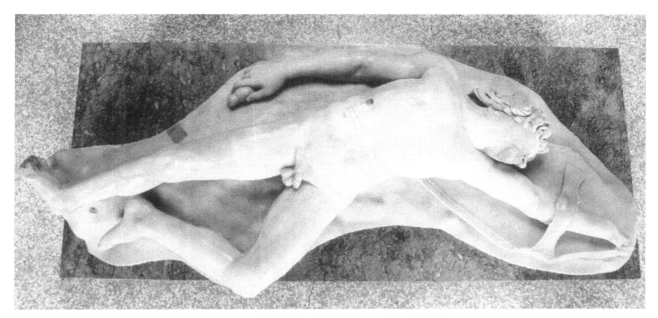

FIGURE 20. Venice Dead Gaul. Photo: Osvaldo Böhm.

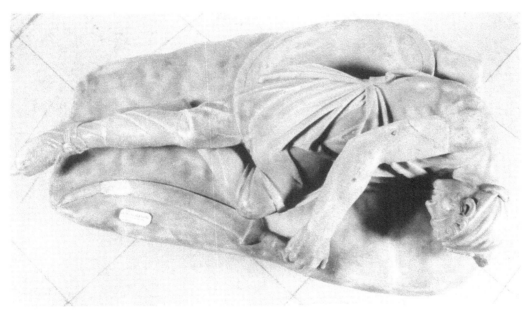

FIGURE 21. Side view of the Naples Persian. Photo: Luciano Pedicini.

white-breasted woman, wearing a short tunic and lying on a broken spear, can only be an Amazon. The three fellows with the caps should be Persians. Two wear trousers and slippers and one even has a scimitar, but why is the third stark naked except for his cap? And why does one of the clothed ones have a suspicious-looking bulge between his legs (see Figure 4)?

As to the others, one has a rope tied around his waist and a long coffin-shaped shield: Definitely a Gaul (Figure 23). A second kneels on a similar shield and a third wears a distinctive helmet (Figure 24). But wait! His neck and torso don't join properly, and aha! – a crude iron clamp bites into his spine (Figure 25). Damn: another restoration. The rest are nondescript: Barbarians certainly, Gauls probably, but perhaps another Giant lurks among them.

It's time to hit the books.[1]

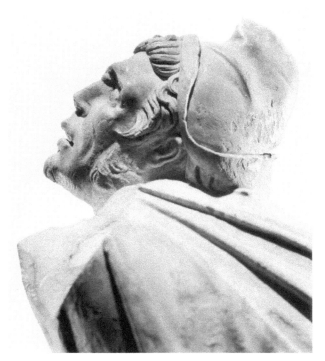

FIGURE 22. Left side of the head of the Aix Persian. Photo: Centre Camille Jullian.

FIGURE 23. *(right)* Venice Dead Gaul. Photo: Osvaldo Böhm.

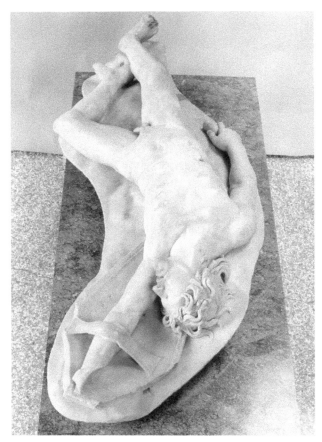

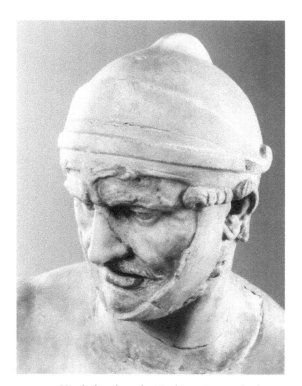

FIGURE 24. Head placed on the Naples Dying Gaul. Photo: Luciano Pedicini.

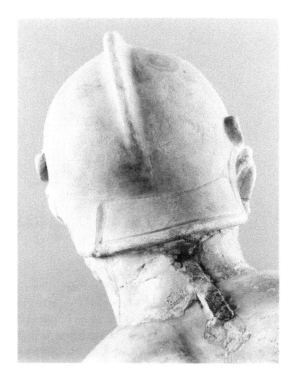

FIGURE 25. Head placed on the Naples Dying Gaul, back view. Photo: Luciano Pedicini.

1. REDISCOVERY

Scholars, Sleuths, and Stones

֍ ֍ ֍

> "[T]he great tragedy of Science – the slaying of a beautiful hypothesis by an ugly fact...."
>
> THOMAS HENRY HUXLEY, "Biogenesis and Abiogenesis"

THOUGH SOME MAY WONDER who in this epigraph is the criminal, the theorist or his assailant, a history of scholarship need not be a mere catalog of vendettas. It offers richer rewards. Researching earlier interpretations of course allows us to understand and applaud scholarship's successes – to observe clever and perceptive minds in action and to assess their debt and occasional contributions to the great intellectual debates of the past two centuries.

Moreover, it helps us to see blind spots and mistakes and perhaps also to avoid them. (As a former mentor of mine once remarked, "We may laugh at these past follies, but they are also a warning to look for equal follies of our own.")[1] Reviewing history helps us to avoid repeating it. Most important, though, it alerts us to the essential plurality of interpretation – to the inescapable fact that, despite all of archaeology's discoveries and advances (in fact, because of them), the past cannot be neatly packaged for the market like a Christmas gift. Instead (to shift metaphors), it is the product of many voices – a scholarly Tower of Babel.

Since this chapter is a critical history of critical writing, it may venture from time to time into criticism. But first, there are two traps to avoid: the Hegelian and its updated twentieth-century version, the sociology of error. In the first case, the writer castigates his predecessors for their anachronisms and distortions while promoting his or her own work as somehow more "objective" and true; and in the second, he or she patronizes them for haplessly succumbing to some distorting social influence such as class or ideology.

In fact, intellectual mapping of this kind is essential for almost the opposite reason. First, because all explanation is underdetermined by fact, it always contains a personal and social supplement. Second, because historians are in the business of translating the past so that it makes sense to their readers, they naturally filter all historical knowledge through their own consciousness, recoding it so that it speaks to their own cultural milieu. As Benedetto Croce famously remarked, "All true history is contemporary history." All knowledge claims are products of their time and place, the present book included.[2]

The same goes for writing about the past's material culture, about *artifacts,* of which artworks are a particularly overcoded class. Artifacts are not absolutes – inert relics awaiting calm, detached, objective assessment – but dense, semantically opaque, evolving entities that live only through human discourse. Artworks, in particular, do not "speak for themselves" as once I was taught to believe; we ventriloquize them. We look at them and speak about them under a description. So our simplest statement about them comes freighted with personal memories, beliefs, and agendas. As Michael Baxandall has put it, all seeing is theory-laden.[3]

So our Little Barbarians will *look different* according to whether we understand them as:

1. Roman heroes – the legendary Horatii and Curiatii;
2. Roman gladiators;
3. *Pergamene* Giants, Amazons, Persians, and Gauls from a battle dedication on the Athenian Akropolis;

4. *Roman copies* of Pergamene Giants, etc., from a battle dedication *in bronze* that *once stood* on the Athenian Akropolis;

5. Roman copies of Pergamene Giants, etc., from a *battle dedication in Pergamon that duplicated* the one on the Athenian Akropolis;

6. Roman copies of Pergamene Giants, etc., that *preceded* the Great Altar of Pergamon;

7. Roman copies of Pergamene Giants, etc., that *postdated* the Great Altar of Pergamon;

8. Roman copies of Pergamene Giants, etc., whose originals *stood alone and isolated,* without victors;

9. Roman copies of Pergamene Giants, etc., whose originals stood alone, isolated, *and silhouetted on the top of the Akropolis wall;*

10. Roman *adaptations* or even *free evocations* of Pergamene Giants, etc., that modernized their models for a Roman audience.

Informed and intelligent viewers have held every one of these opinions at some time since the Little Barbarians' discovery in 1514, and each one colors the statues in bold or subtle ways.

One way in which to demonstrate this is to perform what philosophers call a "thought experiment." The game proceeds as follows:

(i) The reader chooses one of these propositions – (1), for example – and then looks up from the page.

(ii) The reader internalizes it and for the sake of the experiment accepts it as true, then scrutinizes *and contextualizes* Figures 1–25 from this perspective.

(iii) The reader puts the proposition aside and chooses another – (4), for example.

(iv) The reader performs the same ritual again.

These images should *look different* in each case; if not, a central argument of this book will be somewhat elusive.

Of course, while internalizing the Renaissance interpretations of the Little Barbarians as Roman heroes (1) and gladiators (2) is vital to understanding the sixteenth-century material discussed in Chapter 2, one cannot deny that propositions (3)–(10) are better grounded historically than they are. Knowledge of antiquity *has* grown since 1514, and the work of the past century or so has certainly invalidated (1), (2), and even (3), and has cast doubt on several more. But others still remain in play, and each new discovery or critical turn generally opens up as many perspectives as it forecloses. In the words of a tongue-in-cheek archaeological aphorism (the so-called Third Law of Archaeology), "Only the future is immutable; the past is always changing."

Since we are perforce heirs to this ever-evolving discourse, to investigate it puts these little statues and our heritage of opinions about them into perspective. For both statues and discourse are historical artifacts – products of particular historical situations – and *qua* artifacts, statues are always the objects of discourse. They can be known, understood, and described only through discourses that are of the present. They are *suspended* between past and present. By adopting this historicocritical perspective one begins to understand that a good many of the "facts" advanced about our Barbarians over the years are actually what Norman Mailer has wittily called "factoids" – culturally embedded assertions repeated so often that they have acquired the status of facts.

Yet to attempt to keep ourselves unpolluted, to ignore the scholarship, and to try to "let the art speak for itself," is to court a different fate. As mentioned earler, one risks reinventing the wheel or (worse) proudly inventing a square one. Moreover, the longevity of these opinions does suggest that they often encode some form of interpretational truth. By interrogating them we can begin to see our objects as both protean *and* strange, to look at them afresh, and to craft new interpretations that also make sense; and there are always intriguing byways to explore.

The first two sections of this chapter introduce Leake's, Penrose's, and Brunn's pioneering nineteenth-century work on the Barbarians, addressing it in the context of early scholarly attempts to bring order to the then-chaotic landscape of Greek art, and of the nineteenth-century positivism that sustained many of these ventures. The third section proceeds to the beginning of the twentieth century and discusses the impact upon them of two salient manifestations of the positivist method: the late nineteenth-century hunt for "hard" evidence and its obsession with encyclopedism. Sections 4 and 5 examine the revisionist work of the early twentieth century, empowered by the universal acceptance of photography as a research tool and driven by the new formalist agenda that the latter encouraged. The next pair traces the gradual disintegration of this formalist edifice under the pressure of new ideas, resulting in the refragmented landscape of the present day. A penultimate section surveys the Renaissance literature, and the last one explores some lessons to be learned from the entire tale.

1. LEAKE, PENROSE, AND BRUNN

Donated almost certainly in 200 BC, Attalos' Dedication stood on the Akropolis for at least four hundred years. Although it may have survived into the fourth century AD

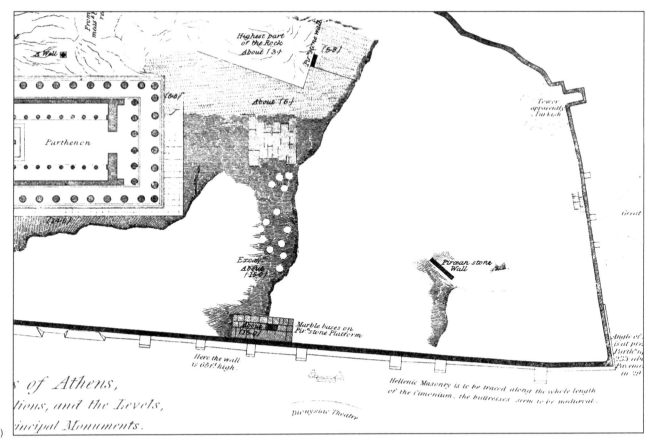

FIGURE 26. (a) Plan of the eastern end of the Akropolis in 1847. From Francis C. Penrose, *The Principles of Athenian Architecture* (London 1851/1888 [2nd ed.]): pl. 2. Notice the "Marble Bases on Pirean Stone Platform" by the South Wall just to the southeast of the Parthenon. (b) The Akropolis. Detail of Penrose's plan as republished and labeled in William M. Leake, *The Topography of Athens* (London 1821/1841 [2nd ed; repr. 1854]): pl. 3, showing the Attalid Dedication along the South Wall.

(AT8) or even later, it is last mentioned explicitly around AD 170, when Pausanias described its subjects and dedicator (AT6). Yet when its copies – the Little Barbarians of my subtitle – were rediscovered in Renaissance Rome, they were promptly misread as figures from Roman legend (RT1–2) and then as gladiators (RT4, 9–10). Further progress would have to wait for another three centuries and three brilliant tours de force of nineteenth-century scholarship.

In 1821, the indefatigable Colonel William M. Leake (1777–1860), who had traveled extensively in Greece for two decades, published the first detailed, scholarly

account of the topography of ancient Athens. Retracing Pausanias' route on the Akropolis, he determined the exact location of the Attalid Dedication from the Periegete's text and from a corroborating note in Plutarch's *Life of Antony* (AT5, 6). For after passing the Parthenon's east façade, Pausanias remarks as follows:

> By the south wall Attalos dedicated (I) the legendary battle of the Giants, who once lived around Thrace and the Isthmus of Pallene; (II) the battle of the Athenians against the Amazons; (III) the affair against the Persians at Marathon; and (IV) the destruction of the Galatians in Mysia – each figure being about two cubits high.

Plutarch further notes that just before the battle of Actium in 31 BC, a great storm blew "the Dionysos of the Gigantomachy" (I) from the Akropolis into the Theater of Dionysos (see Figure 67). So the Attalid Dedication stood to the south and southeast of the Parthenon, with the Gigantomachy (I) at its easternmost extremity, above the theater auditorium. Uncannily anticipating Figure 227, Leake's plan showed the four groups occupying virtually the entire eastern portion of the wall.[4]

Exactly thirty years later, the British architect Francis C. Penrose (1817–1905) published his pioneering study of the principles of Athenian architecture. Prefacing it with a brief account of the topography of the Akropolis as he had observed it after Ludwig Ross's excavations of 1835–36, he remarked that "upon the edge of the Cimonium [i.e., the South Wall], is a platform of Peiraic stone, which contains two plain marble slabs, perhaps connected with the sculptures relating to the story of Attalus and the Gauls, evidently the broad summit of the wall (see Leake, p. 349). A small portion of a similar platform is discovered close to the eastern wall of the Acropolis." Penrose's new plan (Figure 26a) placed the first "platform" 275 ft. (84 m) from the eastern corner of the wall,

FIGURE 27. *(facing)* Suicidal Gaul and his wife (Roman copy). From Rome; original, ca. 230–200 BC. Marble; height 2.11 m. Rome, Museo Nazionale Romano, Ludovisi Collection (Palazzo Altemps) 8608. Photo: Soprintendenza Archeologica di Roma 188 241. The Gaul's right arm and both of his wife's arms are restored.

FIGURE 28. *(below)* Dying Gallic Trumpeter (Roman copy). From Rome; original, ca. 230–200 BC. Marble; height 93 cm. Rome, Museo Capitolino 747. Photo: Soprintendenza Archeologica di Roma. The right arm, sword, and adjacent section of the plinth are restored. He wears a torque; his trumpet lies broken on the plinth.

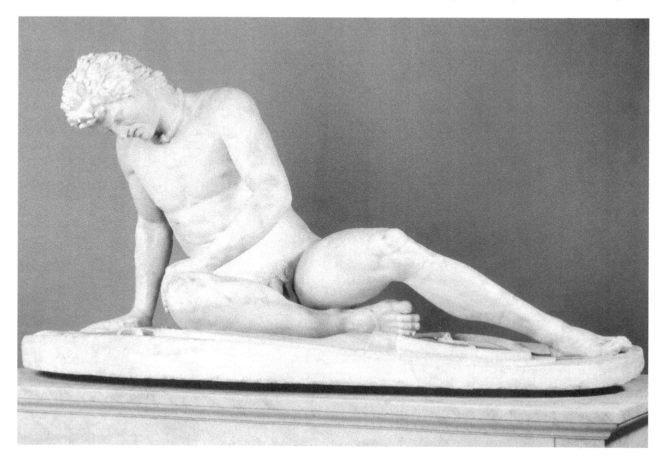

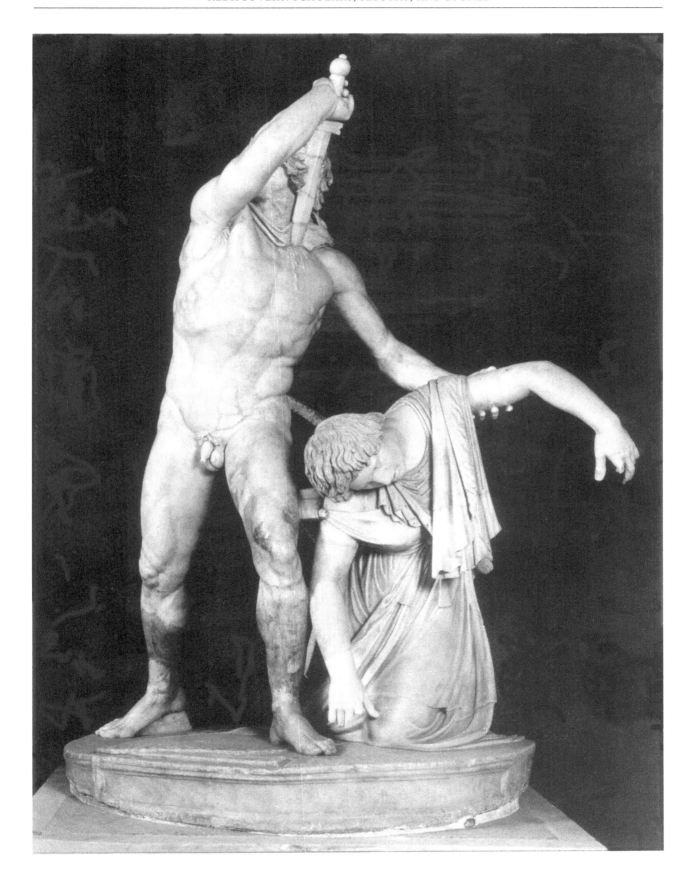

directly behind the fifth buttress from the east. In 1854, Leake duly incorporated this plan into a reprint of a revised edition of his *Topography of Athens,* adding the four Attalid groups (Figure 26b).[5] So by the midcentury, the Dedication's position and form were well established in the archaeological literature. What of its appearance?

On April 21, 1865, Heinrich Brunn (1822–94) gave the thirty-sixth annual lecture in celebration of the foundation of the Istituto di Corrispondenza Archeologica in Rome (later the Deutsches Archäologisches Institut). By no coincidence, April 21 was also the anniversary of the supposed foundation of Rome itself, celebrated in ancient times by the festival of the Palilia. And discourse about art – particularly about artist and patron, model and copy, authenticity and originality – was in the air, for the great annual exhibition of paintings old and new at the Pantheon had opened only a month before. Brunn's topic was "I doni di Attalo," and during the next hour he rescued the subject of the present book from seventeen hundred years of oblivion.

This lecture was Brunn's Roman swan song. War threatened, and he soon left for Munich and its prestigious chair of Classical Archaeology. Swamped by his new responsibilities, he got around to publishing it only in 1870 – the year that Bismarck's Germany crushed France at Sédan, and that Vittorio Emanuele's troops finally took Rome and created modern Italy.[6]

Educated at Bonn and employed at the Istituto from 1843 to 1853, Brunn had been its Second Secretary for a hectic and productive nine years. In 1857 this "Nestor of Greek archaeology" (as his American pupil, Lucy Mitchell, wittily called him)[7] had produced the field's first scholarly history: a monumental, two-volume *Geschichte der griechischen Künstler*. It embraced the synoptic approach or *Totalitätsideal* of his teacher, Friedrich Welcker, who believed that one could not properly understand antiquity without mobilizing all resources – philological, historical, and archaeological – for the task. *Plus ça change*. . . .[8]

In his dissertation of 1843 (the basis for the *Geschichte*), Brunn had tackled the chronology of Greek artists before Alexander. He had established this chronology largely from texts, for like the discipline's founder, the aesthete and historian J. J. Winckelmann (1717–68), he never visited Greece. In this dissertation, Brunn condensed Welcker's philosophy into one programmatic aphorism: *Sine philologiae lumine caecutire archaeologiam,* "without philology's light, archaeology is blind." He then supplemented this aphorism with two statements that were longer and more problematical: (1) "The history of art will mature to real perfection only if a history of the artists provides it with a foundation, upon which analysis of the monuments can build in consciousness of absolute security"; and (2) "I would rather err methodologically than hit upon truth without method."[9]

Brunn's favored method was in essence positivist. Since positivism in one form or another has dominated the study of Greek art ever since, but now is often employed as a term of abuse, it is good to be clear about what it meant to German academics of the 1860s.

The term "positivism" is semantically slippery since its original referent, the philosophy of Auguste Comte and his disciples which promulgated a systematic religion of humanity, was quickly replaced, especially in Germany, by any view that restricted knowledge to what could be attained using the methods of observation, induction, and mathematical analysis found, paradigmatically, in the empirical science of nature.[10]

Brunn's lecture of 1865 at the Istituto was a classic exposition of these principles. He opened with a ritual bow to the Palilia and the observation that Rome's real history emerged from darkness only after the Gallic sack of 396 BC. He proceeded to summarize current scholarship on the statues of the Big Gauls – the famous, over-life-size Ludovisi and Capitoline figures (Figures 27–28). His predecessors had already connected these figures with Pliny's tantalizing remark that "several artists made the battles of Attalus and Eumenes against the Gauls: Isigonus, Pyromachus, Stratonicus, and Antigonus, who wrote books about his art" (*Natural History* 34.84; here AT3a). They dated them to the reign of Attalos I of Pergamon (241–197).[11]

Brunn then proceeded to assign nine more statues to the Pergamene School – the "core group" of Little Barbarians in Venice, Paris, the Vatican, and Naples (Figures 1–25; and see Figures 29–64) – using plaster casts to make his points. Beginning with the Venetian trio and the Naples Dying Gaul, he demonstrated their similarity to the Big Gauls (Figures 27–28) and to the well-known descriptions of the Gallic race by Diodoros, Livy, and Pausanias; and he tentatively identified their material as Asian marble.[12]

Brunn noted that all nine statues came from Rome and corresponded exactly in material, scale, and workmanship. One of them, however, was clearly an Amazon, and the others differed enough in feature and costume that they must represent three different races: five Gauls, two Persians (by comparison with the Persian soldiers in the Alexander Mosaic [see Figure 184], which had been discovered in 1836), and one Giant. And lo and behold! They corresponded exactly in scale and subject with the four Attalid groups that Pausanias had seen on the Akropolis around AD 170 (AT6).

So Brunn argued that these nine figures must be *originals* from the Attalid Dedication. The Romans must have confiscated them after Pausanias' visit, which explained why the excavators of the Akropolis had found no trace of the monument. As a final flourish, he attributed the Uffizi Scythian Knife-Grinder to the same school, together with the Marsyas "so often replicated in the museums of Europe."[13]

Brunn's lecture ended at this point. In his publication of 1870, however, he noted with satisfaction that two recent handbooks on Greek sculpture had accepted his thesis without reservation. He gave full descriptions of the statues, eight of which he simultaneously published in splendid, quarter-size engravings in the Istituto's *Monumenti inediti*.[14] (Owing to the war, the ninth, in Paris [see Figures 5, 61–64] was currently inaccessible.)

Next, after hunting through the comte de Clarac's magisterial collection of line drawings in his *Musée de sculpture* of 1851, he added a pair of figures now in the Museo Torlonia, pronouncing them copies since they were in Pentelic marble and one was signed by a certain Philoumenos "in letters of the reign of Hadrian." He eliminated another statue, also now in the Museo Torlonia, because a cast showed it to be too big: the Persian reproduced in the 1631 publication of the *Galleria Giustiniana* (Figure 65). And finally, he tentatively suggested a Pergamene "association" with several more Amazons, including one in Wilton House (Figure 66) and another in Naples falling off her horse (Figure 82).[15]

Brunn then remarked that all the statues identified so far were of the vanquished. This, he remarked, "could give birth to the suspicion" that the Dedication had omitted the victors if it were not for Plutarch's mention of the Actium incident involving the Dionysos from the Gigantomachy (I), which incidentally proved that the Dedication stood right above the theater (AT5; Figure 67). Lamenting that he had failed to find this statue or any other victor, Brunn noted that since Dionysos was a relatively minor combatant, his presence argued for a large number of figures indeed. Because the five surviving Gauls would have required one Pergamene opponent each, the Galatomachy (IV) must have contained at least ten figures and the entire Dedication at least four times that. Forty figures would have been the absolute minimum.

Brunn then started to build castles in the air. Overlooking the work of Leake and Penrose (see Figure 26), and using instead an inaccurate thirdhand plan of Carl Boetticher's (see Manolis Korres's Essay in the present volume), he then began to speculate about the Dedication's form. Since the in situ evidence was problematic and the sculptures had been donated by a Pergamene king and were of non-Attic (Asian?) marble, could they originally have stood somewhere else? The Athenian Amazonomachy (II) and Persianomachy (III) would not contradict this hypothesis, since Athens had become the School of Hellas long before. The vanquished must have been arranged below eye level with the victors standing on the wall above them, which would explain why the Dionysos got blown into the theater.

So (he proceeded to argue) maybe the original monument was some kind of stepped, four-sided Asian one like the Nereid Monument, the Mausoleum at Halikarnassos, and Hephaistion's Funeral Pyre, with a chariot group elevated on a pedestal at its center and groups "like" these around and below it.[16] Its inspiration, though, must have come from the fifth-century Stoa Poikile at Athens, where the battles of Marathon and Oenoe had been given a similar boost by juxtaposition with the Amazonomachy and Sack of Troy.

Yet (he continued) regardless of the Little Barbarians' original location and despite some stylistic "defects" when compared with the Big Gauls (Figures 27–28), they are uniformly Greek and original. They must be workshop pieces that scale down the Big Gauls (and others?) by half. So Attalos was probably sending half-size *reproductions* of his own huge victory dedications at Pergamon itself, which could not be replicated entire on the Akropolis. As for the Dedication's date, why not around 200, when Attalos' relations with Athens were strong, and the Pergamene School's increasing fame would make this a worthy gift?

But Pliny discusses the artists who made the Pergamene Gauls (AT3a) in *Natural History* book 34, which is devoted to work in bronze. Since both the Big and Little Gauls are in marble, does his citation disqualify them as Pergamene originals? The answer is simple. Pliny's scheme was a straitjacket, and his comments, sandwiched between two long catalogs of artists and expressed in quite general terms, by no means prove that the four men worked for the Attalids only in bronze.

Finally, Brunn turned to the Pergamene School's development. The Big Gauls are certainly masterpieces, and now that we have the Little ones (which echo them) and can date them around 200, to attribute the Big ones to great masters active under Attalos I rather than to their pupils active under Eumenes II (197–158)[17] is the obvious course. Indeed, two of Pliny's quartet – P[h]yromachos and Antigonos – certainly lived in the third century. Pliny puts P[h]yromachos in 296–293,[18] and if Antigonos is the same man as the target of a (lost) polemic by Polemon the Periegete, he must substantially predate Eumenes' Gallic War of 168–166.

I have summarized Brunn's essay at length because it was truly pioneering. In several key respects it marked a

major leap forward in the professionalization of the discipline. To quote Donald Preziosi:

> The modern discipline of art history might be viewed in one sense as a reaction, within the frameworks of the nineteenth-century dreams of scientificity, to the Romanticist entanglements with the double binds of the intentional–affective fallacies, resulting in a displacement of the problematics of production and reception beyond the purview of the new formalist, historicist science . . . [It] endeavored to demonstrate that its practice was as disciplined and rigorous as any other academically instituted science . . . by mounting a discourse that was tough-minded, logical, detached, objective, and grounded in expertise.[19]

So – to borrow a concept from Michel Foucault's work of the 1970s – this new discourse was a technology of power. Resolutely object-oriented, it programmatically replaced opinion with fact, speculation with induction, dilettantism with expertise, and romanticism with science. The German archaeologist Eduard Gerhard had formally inaugurated this project in 1850 with his sixteen "Archaeological Theses," and this essay marked its coming of age.[20]

One is instantly impressed by Brunn's careful autopsy of the originals and by his painstaking accumulation of plaster casts, ancient texts, and Renaissance documents to build his thesis. But his formidable research skills should not overshadow his unrivaled command of positivist methodology. One cannot help admire his forthright and sober statements of principle; his discriminating, rigorous, and objective application of material, formal, and historical analysis; and his end result – a tightly reasoned and historically plausible construct complete with its own criteria for inclusion and exclusion. To use a favorite positivist metaphor, he had indeed contributed a brick – indeed, a whole course of bricks – to the edifice of knowledge.

This last contribution was the real breakthrough, the more remarkable because it took place not in the relatively familiar territory of the classical period, which Brunn knew well and had done a great deal to map, but in the terra incognita of the Hellenistic. The historian Johann Gustav Droysen had coined the word "Hellenistic" only thirty years before; Hellenistic art was still virtually unexplored; and systematic excavations at Pergamon would not begin until 1878. Yet at one stroke Brunn had found a major Hellenistic – indeed Pergamene – monument, attributed it, pinpointed it to the year, and contextualized it. He had found a milestone in a chaotic and jumbled landscape and had created a history from it.

Still, Brunn's strongly positivist, object-oriented approach was far from unproblematic. It demands a closer look.

2. EXCURSUS ON POSITIVISM

As Jonathan Hall has explained:

> Positivism may be defined as the philosophical belief in an objective knowledge governed by laws akin to those postulated for the natural sciences, that can be arrived at through empirical induction. In historical terms, positivism proclaims both the existence of a real, objective past that is external to the historical analyst, and the possibility of describing it in its most accurate details. For R. G. Collingwood, such ideas were symbolized by the *Cambridge Ancient History* which, apart from setting itself up as an authoritative and comprehensive account of antiquity, subscribed to a positivist vision of history as an assemblage of isolated and easily ascertainable facts through its practice of farming out chapters (or sometimes even subdivisions of chapters) to different authors. The compilation of contributions by authors from varying cultural, social, political, and intellectual backgrounds, working in disciplines with their own unique methodologies and goals, was not perceived as problematic precisely because the past that they were describing was real, objective, and unitary.[21]

This problematic objectification of the past, born as nineteenth-century scientific optimism was reaching maturity, tended to reduce vision to mere observation and the positivist scholar to a mere passive recorder of reality. It regarded the world as a spectacle to be viewed from afar by a detached, disembodied mind that was now just a mere object like all others. It thereby denied the body's immanence in the world and the mind's role in actively shaping the reality it witnesses. And since it believed that every artifact (statue, building, poem, novel, or symphony) was explicable by the sum of its historical conditions, it promptly plunged into the infinite regress of the study of origins.[22]

Correspondingly, under the influence of nineteenth-century scientism plus the great tradition of mimetic art criticism from Xenokrates of Athens (ca. 300 BC), Pliny the Elder (AD 23–79), and Vasari (1511–74) through Winckelmann (1717–68), positivist scholarship attributed an equally empiricist and evolutionist character to the artworks it studied. Examining art's "primitive" origins like these men had done, it assumed that Greek art sought naturalism or realism (rarely distinguishing them) above all else and thus gradually evolved toward this goal. But although all agreed that this evolutionary process climaxed in the Hellenistic period, the tradition's

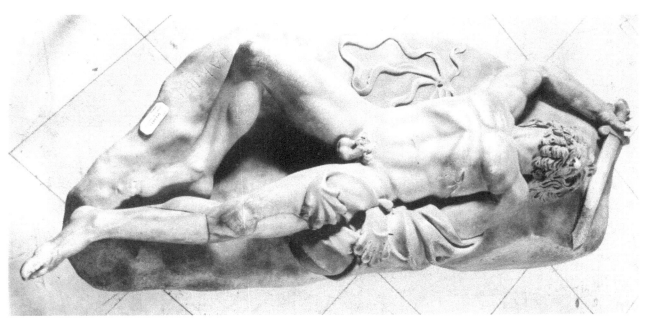

FIGURE 29. Naples Giant. Photo: Luciano Pedicini.

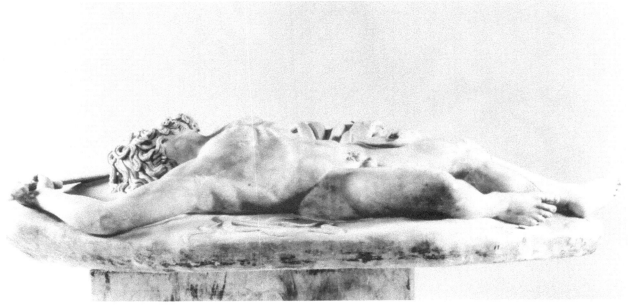

FIGURE 30. Naples Giant, side view. Photo: Luciano Pedicini.

idealist bias led them to privilege Pheidian classicism above all else. The summit of perfection in the visual arts, the Pheidian style exemplified the Aristotelian mean between two extremes – the "primitive" Archaic and the "degenerate" Hellenistic.[23]

Strict positivism also entailed other distressing consequences, often collectively termed the "positivist fallacy." Brunn's remark about the missing victors hints at the problem. Positivism's strictly "scientific" focus upon the objects – upon what survives – immediately turns the historian into a doubting Thomas: truly the *Ur*-positivist! Indeed, some extreme positivists became professional devil's advocates, arguing (for example) that Pausanias (AT6) had lied systematically about his travels, had used earlier (conveniently lost) writers instead of visiting the places he said he had visited, and often had misreported what little he did see! Even the more moderate ones found themselves severely constrained by the materialism

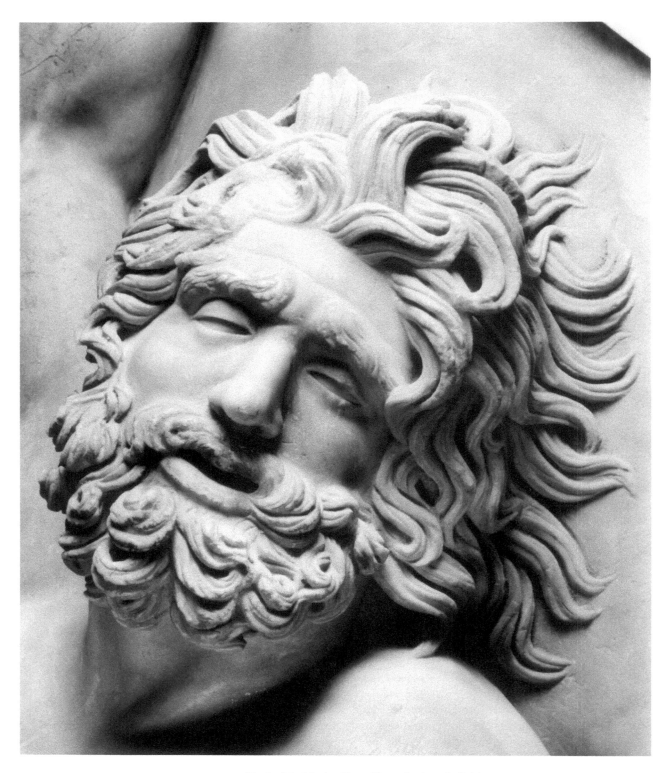

FIGURE 31. Head of the Naples Giant. Photo: Luciano Pedicini.

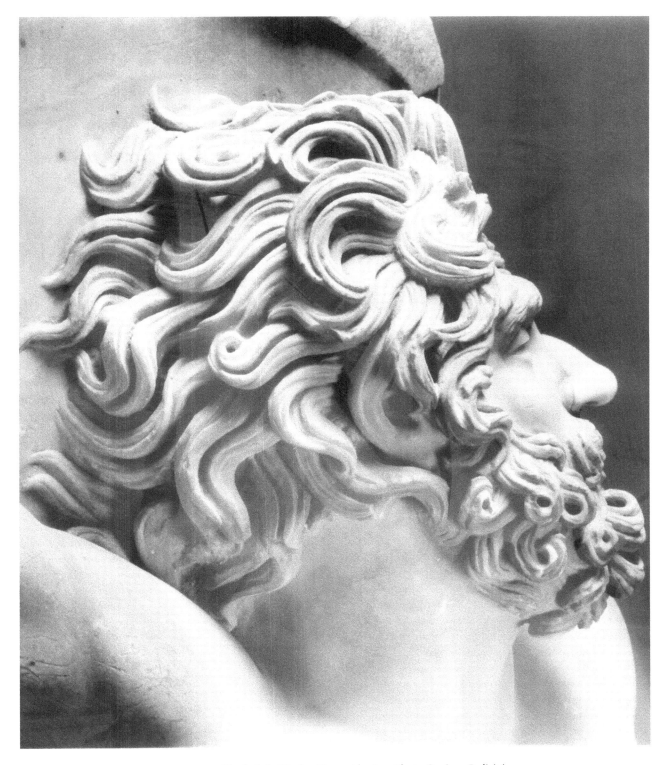

FIGURE 32. Head of the Naples Giant, side view. Photo: Luciano Pedicini.

of their discipline. For in order to remain properly "scientific" and (literally) "objective," they had to stick with the objects; and unless these were archaeologically *and* historically significant in proportion to their rate of survival, one could draw no "scientific" conclusions from and about them at all.[24]

Now the objects of the natural sciences are infinitely plentiful and are governed by the laws of nature. But ancient material culture obeyed no such laws, and over 99 percent of it is irretrievably lost, including whole classes of artifacts like Greek clothes and Hellenistic tragedies.[25] Survival rates for the rest are utterly lopsided and usually unrelated or even inversely related to their value in antiquity. For example, we have vast quantities of pottery and barely a scrap of any gold and ivory statue. Though the ancients themselves preselected some important survivals, they did so not because these were typical but because they were special or collectible, like seven tragedies each of Aischylos, Sophokles, and Euripides, and the *opera nobilia* of classical sculpture reproduced in Roman copy. The thousands of Hellenistic private portraits in bronze attested by inscribed bases and decrees, on the other hand, are 99.99 percent lost, since only a couple of heads and a few other miscellaneous fragments have survived the melting pot, and they generated no copies. Gone too are the victors from the Attalid Dedication, with apparently no copies of them surviving either.

But absence of evidence is not evidence of absence, and any argument *e silentio* can both be countered by *comparanda* and always refuted by new evidence.[26] Take, for example, artifacts or practices that we know definitely existed in the Greco-Roman world, such as victor statues, "melon" hairdos, and democracy (as opposed, e.g., to computers, Mohawk hairdos, and tobacco smoking).[27] *Without positive, corroborating testimony* it is hazardous to assert either that lack of evidence in a particular ancient context for these otherwise well-attested artifacts or practices shows that they were definitely absent from that context, or that lack of evidence for them before a particular year shows that they cannot predate that year. Making such assertions all but ensures (in a special case of Murphy's Law) that the required evidence to the contrary will turn up someday to embarrass one.[28]

So, for example, in the case of portraits of Roman emperors it is not an argument *e silentio* to assert that because all our evidence postdates 31 BC, no new emperor portrait can predate that year; for positive, corroborating testimony tells us that all such portraits *must* postdate 31. Yet (to anticipate some key themes from the remainder of this chapter) in the case of our Little Barbarians we cannot positively assert: (1) that the Attalid Dedication *must* postdate the Giants of the Great Altar (Figures 68–69) because in some respects our copies look more advanced in anatomy and expression than they and no earlier parallels for these features currently exist; (2) that the Attalid Dedication *must* have lacked victors because no obvious copies of them have appeared in the century and a half since Brunn's lecture; or (3) that our copies themselves *must* be free Roman adaptations of the Attalid Dedication and not proper replicas of it because we lack specific pre-Roman *comparanda* for the dress, weaponry, and coiffures of some of them.

We may *suspect* that one or more of these statements are true, and we may like the feelings of order and tidiness that we experience as a result; for our very human urge to systematize – to avoid what the French critic Georges Didi-Huberman has called *anachrony* (the disturbing messiness of real history) – creates what he aptly terms *euchrony*.[29] But since in all three instances we are arguing *e silentio*, our case will be necessarily weak, provisional, and dependent upon the continuation of the archaeological status quo. In addition, a wider array of *comparanda* (the generally nonlinear development of Hellenistic art and the proven existence of victors in other Hellenistic victory monuments) will weigh heavily against us. In fact (as will appear) in this case the required stylistic parallels and "hard" evidence of the victors have now at last emerged, disproving assertions (1) and (2); the iconographical problems (3) are mostly chimerical.

So strictly positivist interpretations (which Brunn's was not) are necessarily minimalist and timid. By refusing to "go beyond the evidence" they prejudge their own conclusions, are self-limiting, and impoverish the world they study. And no amount of such evidence – of bricks new or old – tells us anything about the meaning of the edifice itself. Despite positivism's utility as a heuristic device – as a method of recovering brute facts about the past – it offers no guide to interpretation. As Albert Einstein famously remarked in 1936:

There is no inductive method which could lead to the fundamental laws and concepts of physics. Failure to understand this fact constituted the basic philosophic error of so many investigators of the nineteenth century. . . . We now realize with special clarity how much in error are those theorists who believe that theory comes inductively from experience.[30]

Or, as he put it more colorfully on another occasion, in order to scratch productively one must first have an itch. Induction neither mandates nor proves particular conclusions. It always tempts one to stop being a mere passive observer and to step out from the facts but never specifies the direction. In careless hands it thus can easily produce monstrosities – like Brunn's fantastic "original"

Little Barbarians' monument at Pergamon. And since induction is a purely mechanical process, positivist ideas about cause and effect tend to be purely mechanistic.[31]

Furthermore, Brunn's very success immediately tempted lesser folk to add bricks of their own – to multiply attributions and inferences, and thus inevitably to turn his tightly constructed edifice into a ramshackle, tottering slum. Indeed, his pages even contain some of the more dubious tricks practiced by his followers: Arguing from silence or in circles; special pleading; hunting for famous names; serial attributions (statue $A \rightarrow B \rightarrow C \rightarrow D$, but by now statue D has little to do with A); building pyramids of hypotheses (quite literally in the case of his postulated Pergamene original!); and basing historical judgments on personal views of artistic quality and the normative status of the classical – all these are products of positivism's hunger to create facts at any price, of its thirst for "positive" results, and Brunn was by no means free of them. Moreover, his disregard of all English scholarship on the Akropolis – setting a trend for the following century – betrays an ominous parochialism at work.

3. FROM MILCHHÖFER TO BIENKOWSKI

The next thirty years produced a tornado of activity over the Attalid Dedication that is all the more extraordinary when one considers the obstacles. The material was scattered; travel was inconvenient, slow, and expensive; photography was little used and cameras cumbersome; illustrated museum catalogs were almost nonexistent; and Hellenistic specialists were few and somewhat marginalized within the field. Yet Brunn's article caused a greater stir than even he could have hoped, as his successors weighed his ideas, developed them, modified them, and in some key respects flatly contradicted them.

A number of scholars had stubbornly maintained all along that Attalos had dedicated a set of reliefs, not freestanding figures, but in their handbooks of 1881 and 1883, Johannes Overbeck and Lucy Mitchell accepted Brunn's ideas in their entirety.[32] The first to challenge in print his conviction that the Little Barbarians were Greek originals was Arthur Milchhöfer (1852–1903). Milchhöfer was one of a new generation of German scholars. After a conventional philological and museum education in Germany and Rome he had studied in Greece and had trained as a field archaeologist at Olympia, where the German Archaeological Institute in Athens had begun to dig in 1875. Like many others, he was soon drawn to Pergamon and its rich haul of Hellenistic sculpture. For as Karl Humann had remarked upon discovering the Great Altar and its sculptures (Figures 68–69) in 1878,

"Wir haben eine ganze Kunstepoche gefunden!" – "We have found a whole new era in art!"

Milchhöfer had a sharp mind and a discriminating eye for style and technique. In his 1882 publication of a group from Pergamon showing the Freeing of Prometheus,[33] he noticed that the Little Barbarians were clearly similar in style to it and to the Great Altar friezes (see Figures 68–69, 236), which he dated to the reign of Eumenes II (197–159/58). Yet the Barbarians were harder, more finicky, and more highly polished. Now the excavations at Pergamon had yielded many inscribed bases of Gallic victory monuments that were clearly in bronze; Pliny lists the Attalid dedications (AT3a) in his book about bronzes; the Little Barbarians' marble was non-Attic; and they were unweathered and hence must have stood indoors. So the Athenian statues were surely bronzes, and Brunn's Barbarians are presumably Pergamene copies – but not of the Athenian Dedication.

For (he continued) the Barbarians are isolated figures, intended for individual scrutiny, and there was still no sign of the victors. So what if the Barbarians did not copy the Athenian Dedication itself but depended along with it upon a *common* source: a bronze original at Pergamon? (Milchhöfer ignored the fact that half of their four themes were Athenian: AT6). Moreover, what if they *and* the Big Gauls were eclectic citations from such monuments for an audience of historically aware Greeks, at a time when victory iconography was essentially exhausted and a new initiative was needed to recapture the jaded observer's attention? Suggestive parallels include the Uffizi Scyth, the Borghese Warrior, and the new fallen Gaul from Delos (Figure 70), each of which had been found alone.[34] Brunn had unwittingly proved that such citations were actually a Pergamene invention, not a late Hellenistic or Roman one.

Brunn knew that his statues had all come from Rome, and had found the Venetian trio in a Grimani inventory of 1523 (RT4, which actually mentions only two of them). But when and where had they been discovered? Other scholars were quick to supply answers. In 1876, A. Klügmann published two important Renaissance eyewitness accounts of them, buried in the French humanist Claude Bellièvre's report of his visit to Alfonsina Orsini's home (now the Palazzo Medici–Madama) in winter 1514–15, and in M. Ulisse Aldrovandi's Roman gazetteer of 1556 (RT2 and 6).[35]

These texts cast no new light on the Barbarians' exact provenance and omitted the three Venetian figures entirely. Yet they did prove that the rest were indeed a tight-knit ensemble; they chronicled their early peregrinations; they showed that the Naples Dying Gaul was headless in 1556; and they added the startling informa-

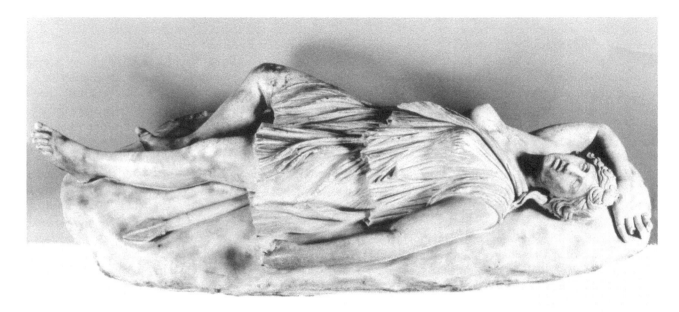

FIGURE 33. Naples Amazon. Photo: Luciano Pedicini.

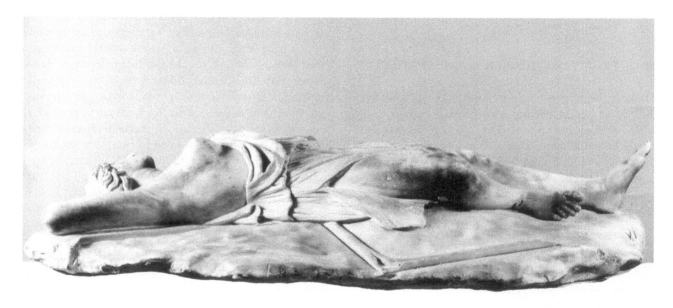

FIGURE 34. Naples Amazon, side view. Photo: Luciano Pedicini.

tion that between 1514 and 1556 the Amazon (see Figures 33–34) had a baby at her breast.

Klügmann promptly provenanced the group to the vicinity of Alfonsina's palazzo, suggesting the Baths of Alexander Severus among whose ruins it stood (see Figures 96–97), and proposing that Severus (r., AD 222–35) had been responsible for their removal from Athens. He also queried the baby, since (1) Amazons were bad mothers; (2) they did not travel or fight *en famille;* and (3) Livy 1.26, cited by Bellièvre (RT2) as his source for identifying the girl as one of the Horatii, calls her a virgin. So the baby must have been added immediately after the figures' discovery at the behest of some Renaissance scholar who knew Pliny's two accounts of just this kind of group (AT3b and *Natural History* 35.98). Klügmann ended by dismissing a suggestion that AT8 referred to the Attalid Dedication, preferring to connect it with the west pediment of the Parthenon.[36]

Eugen Müntz added another major piece of the documentary puzzle in 1882. He noticed that a letter written

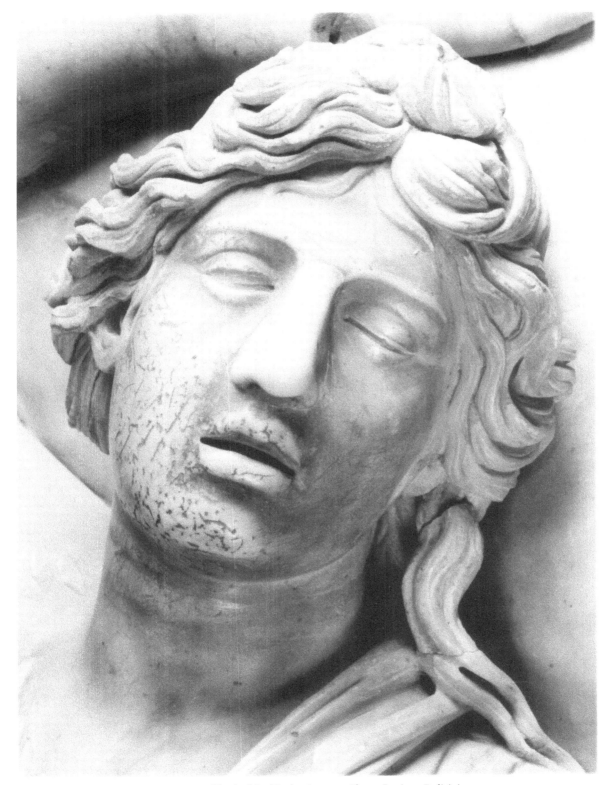

FIGURE 35. Head of the Naples Amazon. Photo: Luciano Pedicini.

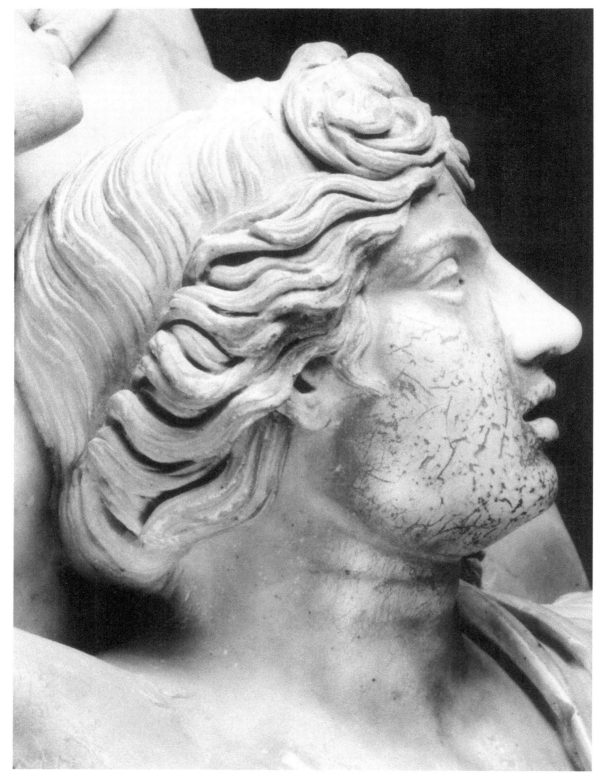
FIGURE 36. Head of the Naples Amazon, side view. Photo: Luciano Pedicini.

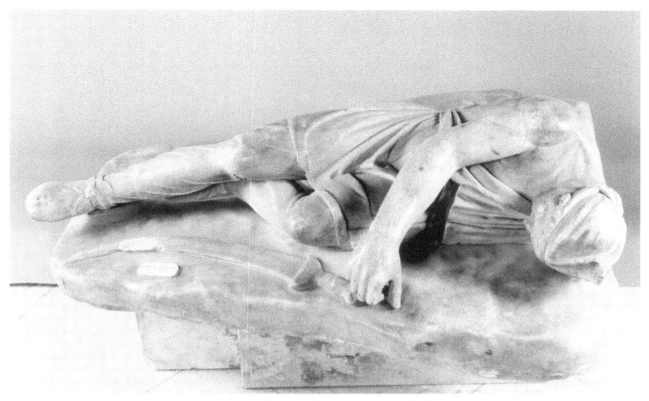

FIGURE 37. Naples Persian. Photo: Luciano Pedicini.

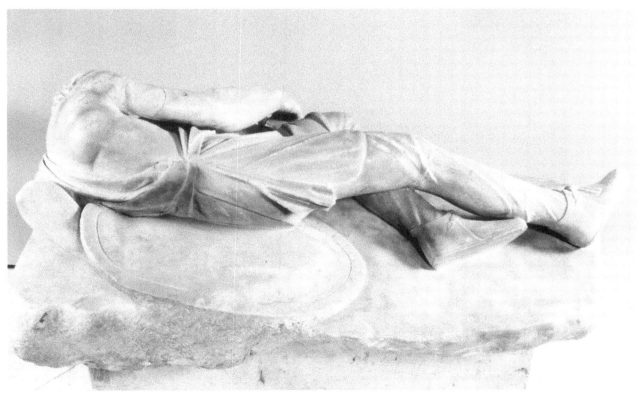

FIGURE 38. Naples Persian, back view. Photo: Luciano Pedicini.

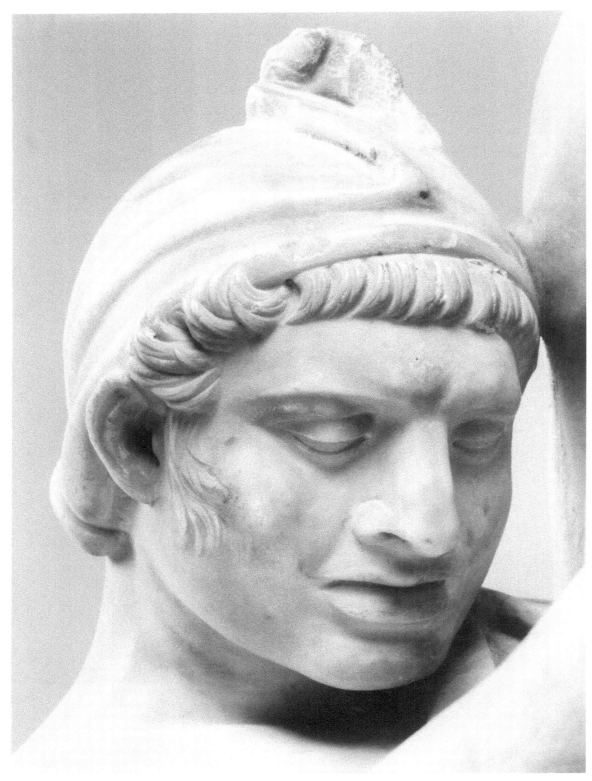

FIGURE 39. Head of the Naples Persian. Photo: Luciano Pedicini.

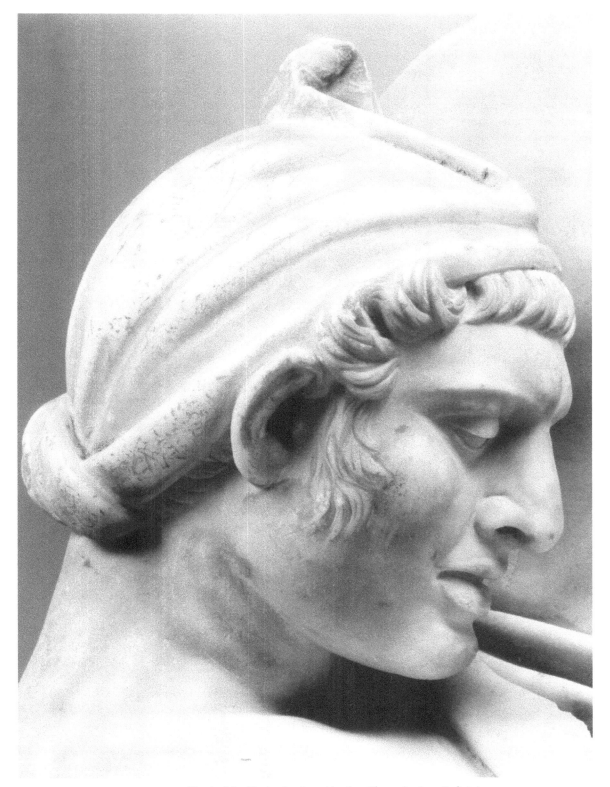

FIGURE 40. Head of the Naples Persian, side view. Photo: Luciano Pedicini.

by Filippo Strozzi in September 1514 identified the statues' findspot as a Roman nunnery (RT1). Unfortunately, though, Strozzi failed to name this nunnery and only mentioned "at least five" statues.³⁷ A lively discussion ensued. The French scholar Salomon Reinach, for example, soon pointed out that Bellièvre's "one who has a fillet on his head and stands stooped to the earth as if killing someone beneath him" (RT2) neatly fitted the Vatican Persian. This in turn meant that his "sole survivor and victor . . . Marcus Horatius, whose statue was taken to the Pope" must describe a *second* papal statue, now lost.³⁸ No one believed him – a lone Frenchman (and a Jew) writing about Gauls at a time of intense nationalistic rivalry – but he was right.

In 1886 W. Malmberg examined the wounds of the Venice Dead Gaul (see Figures 11, 58) and the Naples Dying Gaul (see Figures 15, 41–42, 187–88) and concluded that they had been skewered right through by spears. Echoing fin-de-siècle positivism's enthusiasm for forensic semiology, he even deduced the exact nature of their opponents from the angles of these wounds. A foot soldier had allegedly caused the Venice Gaul's wounds and a rider the Naples Gaul's, "proving" that the Dedication's Galatomachy (IV) included both Pergamene infantry and cavalry.³⁹ This deduction, though hardly conclusive per se, also happened to be right.

All this activity prompted the art historian and classicist Adolf Michaelis (1835–1910) to produce the most original and authoritative article on the Attalid Dedication since Brunn's.⁴⁰ Remembered today only for his sourcebooks on the Parthenon (1871) and Akropolis (1880) and his comprehensive catalog of English collections of sculpture, *Ancient Marbles in Great Britain* (1882), Michaelis had been investigating ancient and Renaissance sources on Greek sculpture for some time. In the synoptic tradition of Welcker and Brunn he now proceeded to show how systematic investigation of Renaissance texts and drawings in tandem could greatly augment the stock of resources available to the patient scholar-sleuth.

In an earlier article on Pausanias and the Akropolis, Michaelis had already demolished the argument that Attalos had dedicated not freestanding statues but a set of reliefs. Citing Leake but not Penrose, he then argued that in AT6 Pausanias' use of the preposition *pros*, "by," indicated that the four groups were arranged in a row against the South Wall's parapet (Figure 67). Attacking Brunn's two-stepped arrangement as unparalleled and unworkable, he nevertheless conceded that the victors must have overtopped the parapet sufficiently for the Dionysos to have fallen victim to the storm of 31 (AT5). To those who doubted Plutarch's account of this event, he retorted that the great storm of 1852 had even brought down one of the Olympeion's colossal columns (see Figure 235 and Korres's Essay) and the west façade of the Erechtheion. Next, in *Ancient Marbles,* he traced the Wilton Amazon (Figure 66) back to the seventeenth century, commenting that its larger scale and different style excluded it from the Attalid Dedication.⁴¹

Michaelis's new article, published in 1893, contained much new evidence and some important new conclusions. He began by summarizing the documentation and castigating Reinach and others who doubted that the Vatican Kneeling Persian (see Figures 3, 45–48) was the victorious "Marcus Horatius" sent to the pope and later seen in the Vatican by Aldrovandi (RT2 and 6), to whose account he now added Boissard's (RT13). He next introduced a number of Renaissance drawings of the "core group" and others:

(1) A drawing of 1532–36 by Maarten van Heemskerck (Figure 71) showing the *giardinetto* of the Palazzo Medici–Madama. This includes two of the statues, the Naples Dying Gaul – headless – just visible under the fountain basin, on the low wall to the left, and the Paris Kneeling Gaul, propped against the balustrade in the loggia at right. Bellièvre describes both statues (RT2); the first was exactly where Aldrovandi later saw him (RT6), but the second had disappeared by his time – presumably sold to the Borghese, whence it later made its way to the Louvre.

(2) A drawing of ca. 1540 by the so-called Basel Anonymous (Figure 72) – probably Frans Floris – that shows the Naples Amazon with a baby at her right breast, exactly as Bellièvre and Aldrovandi describe her (RT2 and 6).

(3) Four drawings from the collection of Cassiano dal Pozzo (d. 1657) showing the four Naples figures. The Amazon has now lost her baby, and the Gaul is still headless (Figures 73–76).

(4, 5) Two more Heemskerck drawings, one of an unknown Roman collection (perhaps the Villa Madama at Montemario) and one of the Palazzo Santacroce. These show the Wilton Amazon (Figure 66, though surprisingly Michaelis failed to recognize it as such); and another now lost but also described by Aldrovandi and also kneeling and headless.

Michaelis then added more citations of the four Naples figures in inventories of the Medici–Madama (RT7) and Farnese collections, concluding that the Amazon's baby was probably removed around 1560. Although Bellièvre had seen it in 1514–15, Floris around 1540 (Figure 72), and Aldrovandi around 1550 (RT2 and 6), it was missing from the Medici–Madama inventory of the 1560s (RT7)

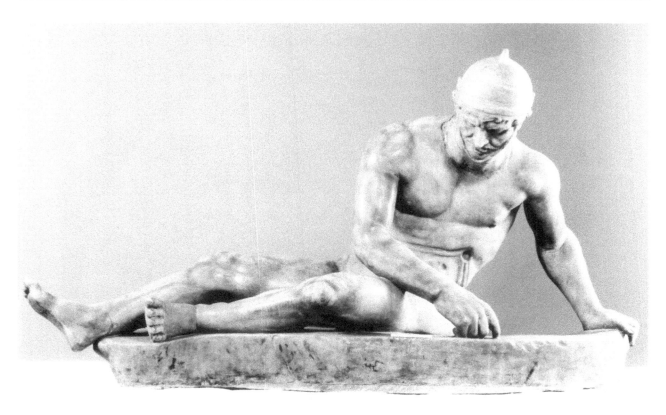

FIGURE 41. Naples Dying Gaul. Photo: Luciano Pedicini.

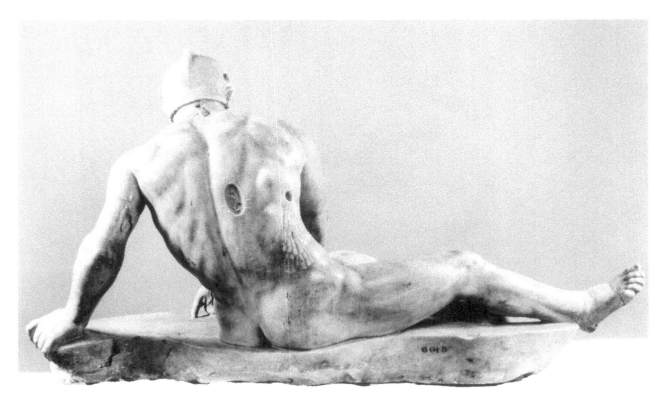

FIGURE 42. Naples Dying Gaul, back view. Photo: Luciano Pedicini.

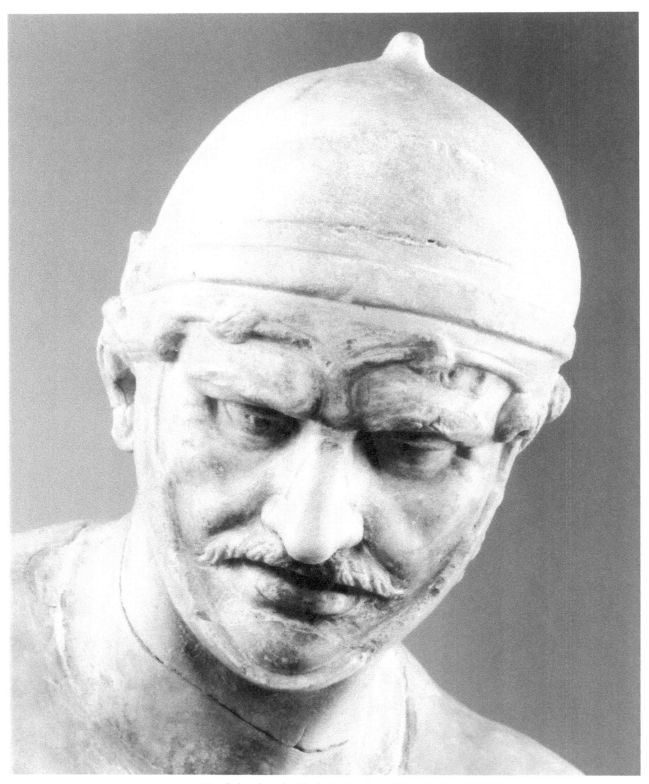

FIGURE 43. Head placed on the Naples Dying Gaul. Photo: Luciano Pedicini.

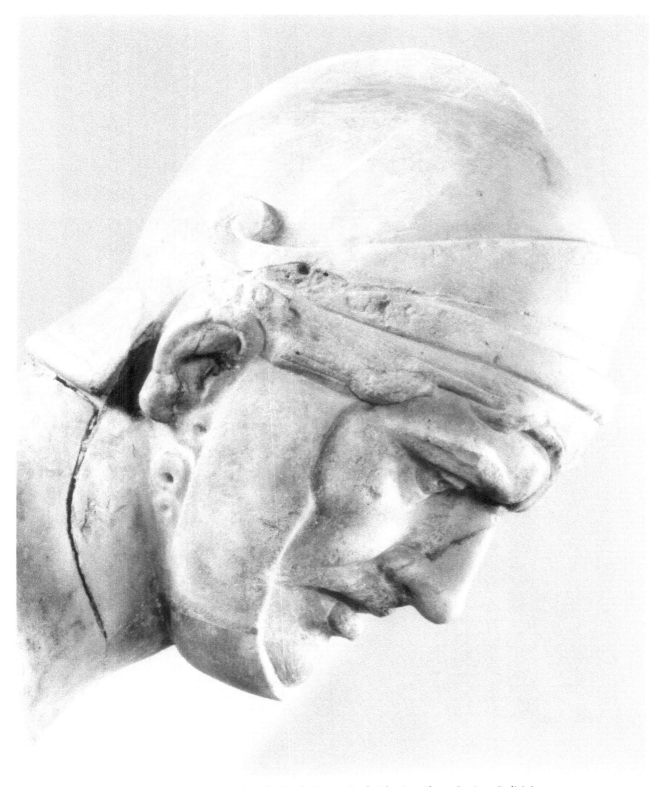

FIGURE 44. Head placed on the Naples Dying Gaul, side view. Photo: Luciano Pedicini.

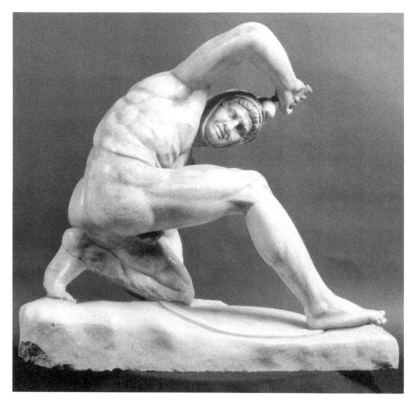

FIGURE 45. Vatican Persian. Photo: Vatican Museums XXXVI.27.25/4.

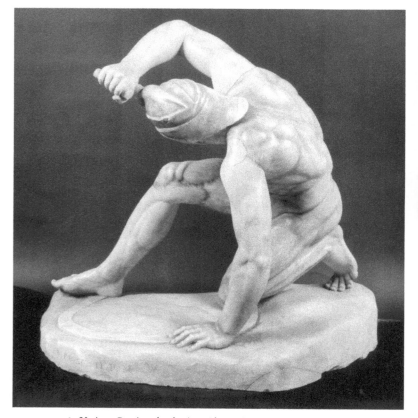

FIGURE 46. Vatican Persian, back view. Photo: Vatican Museums XXXVI.27.25/7.

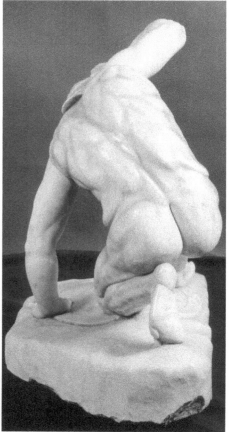

FIGURE 47. Back of the Vatican Persian. Photo: Vatican Museums XXXVI.27.25/6.

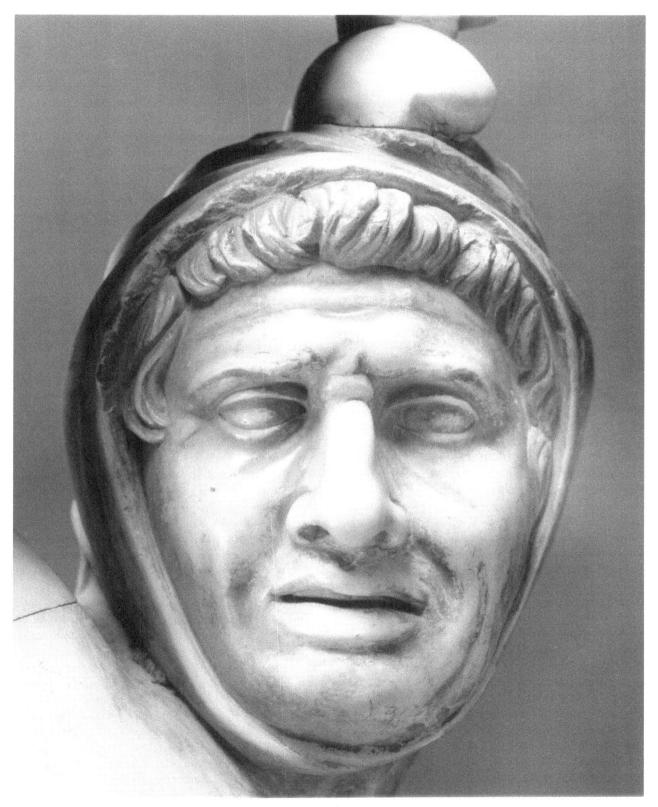

FIGURE 48. Head of the Vatican Persian. Photo: Vatican Museums XXXVI.27.25/8.

and from Cassiano dal Pozzo's drawing (Figure 74). Indeed, a 1697 Farnese inventory even misidentifies the statue as a gladiator! Finally, he traced the quartet's later history through its journey to Naples and final restoration in 1796 (see Figure 193).

The foregoing researches and an autopsy of the Amazon by Bruno Sauer convinced him that (*pace* Klügmann) the baby had been original to the statue, whose right breast and adjacent drapery are indeed reworked (see Figure 13). Yet this did not mean that she had to be a Gallic woman, as Maximilian Mayer had recently argued, for her short dress was not Gallic (Figure 27; cf. Figure 81).[42] But since the Amazon-and-child motif could not be Attic, it must be East Greek, where, in fact, the tradition of Amazons mating and having children was strong. So the Dedication showed the Athenian Amazonomachy through Pergamene eyes. This theory soon sparked a lively controversy, with various eminent scholars declaring for and against the baby.[43]

Michaelis next turned to Pliny's notice about how Epigonos "excelled in his Trumpeter and his Infant Pitiably Caressing Its Slain Mother" (AT3b). Pointing to five newly published Pergamene bases celebrating Attalos I's Gallic victories, signed by Epigonos,[44] he strongly endorsed the attribution of the Big Gauls (see Figures 27–28, 81, 237–42) to this sculptor, and proposed that his name should be substituted for the otherwise unknown "Isigonus" of AT3a (i.e., ΕΠΙΓΟΝΟC for ΕΙCΙΓΟΝΟC). He then opined that while the Akropolis Dedication certainly cited motifs from these Pergamene monuments, it was essentially a new product, with no Pergamene precedents for its Amazon (II) and Marathon (III) groups at all. Though he refrained from saying so explicitly, this torpedoed the Brunn–Milchhöfer theory of a lost Pergamene original for *all* the groups.

Finally, adducing Attalos' letter to the Athenians in 200 with its mention of his previous benefactions to them (AT1), Michaelis tentatively proposed to raise the Akropolis Dedication's date to the 230s. For Attalos would surely have promoted himself as the champion of Greece as soon as possible after his great victory over the Gauls by the sources of the River Kaïkos, which Michaelis dated to ca. 239. This, in turn, made it even more likely that Epigonos would have worked on both the Big and Small dedications and did indeed make the originals of both the Capitoline Trumpeter (Figures 28) and the Naples Amazon (Figures 33–36, 72) – baby included – just as Pliny hints (AT3b). His source of inspiration for the latter was pictorial (as so often in Hellenistic sculpture), since Pliny mentions just such a figure by the fourth-century painter Aristeides of Thebes.[45] So Epigonos' contribution to Hellenistic art was to re-create in bronze these great fourth-century battle paintings, at Pergamon and on the Akropolis.

This article fulfilled Welcker's *Totalitätsideal* in spades, but Michaelis did not stop there. The final edition of his *Arx Athenarum*, published in 1901, not only included all the main literary sources on the Dedication (AT1, 5–8), but even noted that the Augustan decree for the restoration of the Attic sanctuaries (AT2) might mention it too.[46]

Meanwhile the hunt for other replicas had intensified. Of all of them only Otto Benndorf's discovery in 1876 of the Aix Persian has stood the test of time. Probably from Rome, he can be attributed to the same workshop as the "core group" but cannot be documented before 1738. Although in 1885 Fritz von Duhn noticed a possible echo of him in *Les Très Riches Heures du duc de Berry*, illuminated in 1413–16, this idea now looks like a red herring. Even so, Duhn had inaugurated the study of the postantique reception of the Little Barbarians – a fruitful field, as the next chapter shows. Others soon joined the chase. In 1880 Ulrich Koehler added a marble torso of a dead warrior in Athens, and in 1913 Joannes Svoronos matched it with nineteen (!) more in high relief (see Figures 208–10) and declared that these were the *originals* of the Attalid Dedication. This idea found no takers and is now completely forgotten; I return to it in Chapter 3.[47]

In 1883 Carl Robert suggested that the Attic Amazon sarcophagi of the Roman period imitated the Dedication, an idea that has gained many followers over the years. In 1889 Reinach added the Ammendola battle sarcophagus (see Figure 203), proposing that the Venice Kneeling Gaul, whose right arm is restored (see Figures 49–50, 193, 196), should echo its central figure, a Gaul about to commit suicide. Michaelis promptly rejected this idea, caustically observing that a victory monument featuring an army of suicides would hardly glorify the victor, but it has sometimes found favor since and likewise resurfaces in Chapter 3.[48]

In 1887 Maximilian Mayer added yet another Amazon – riding down two hirsute *barbarians* – and proposed yet another version of Brunn's stepped arrangement. Since many of the copies were so flat, and elevating the victors above the vanquished was so awkward, both sides surely stood on the same level. Yet since the Dionysos had to be high up in order to be blown down (AT5), the Amazonomachy (II), Persianomachy (III), and Galatomachy (IV) perhaps stood in front of and below the Gigantomachy (I) in a pyramidal, relieflike arrangement.[49]

The first British scholar to study the Dedication after Brunn's publication was Lewis Farnell. Keen to position himself as Britain's answer to German *Kunstgeschichte*, he visited Germany several times in the 1880s and produced several articles on Pergamene art, culminating in

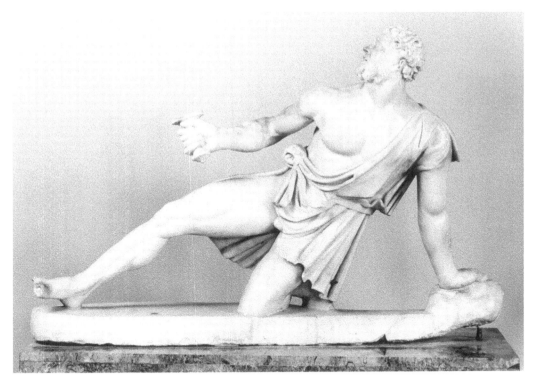

FIGURE 49. Venice Kneeling Gaul. Photo: Osvaldo Böhm.

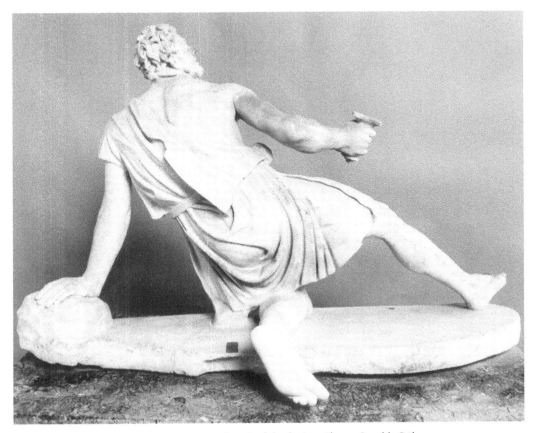

FIGURE 50. Venice Kneeling Gaul, back view. Photo: Osvaldo Böhm.

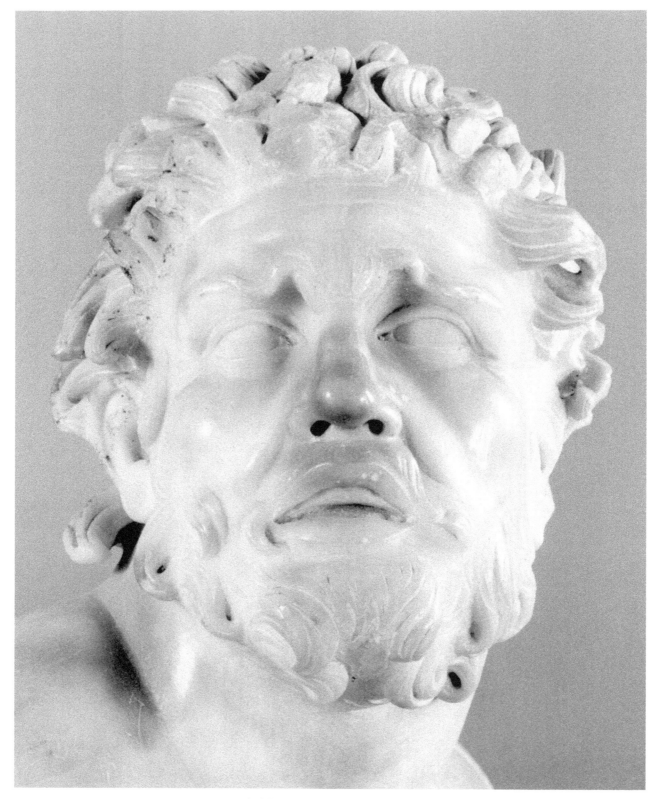

FIGURE 51. Head of the Venice Kneeling Gaul. Photo: Osvaldo Böhm.

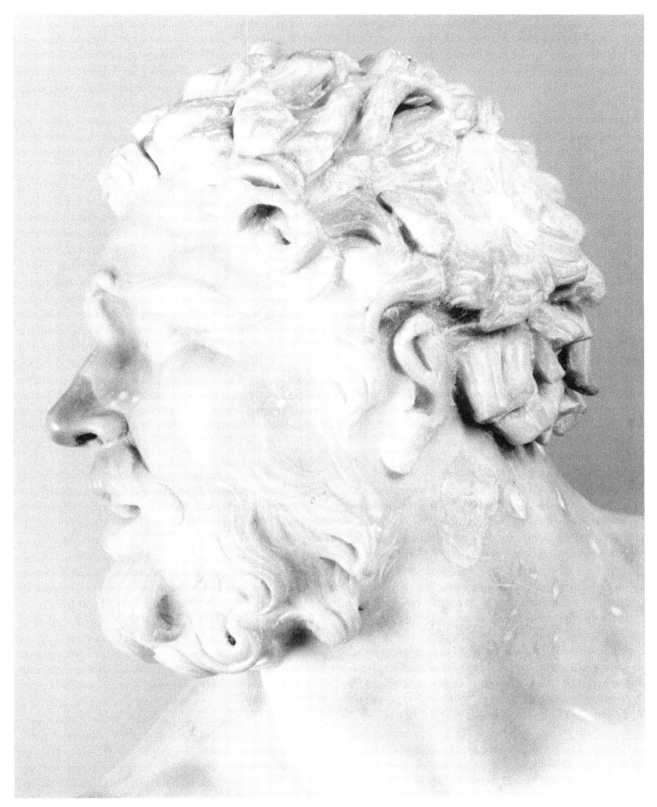

FIGURE 52. Head of the Venice Kneeling Gaul, side view. Photo: Osvaldo Böhm.

a rambling study of "Various Works in the Pergamene Style" in 1890. After condemning the Naples quartet as "very poor copies . . . of the Greco-Roman age," he reintroduced the Athens torso and added another candidate, a Giant in Karlsruhe from the villa of Voconius Pollio at Marino in Italy (see Figure 233). Farnell's chief contribution was that he systematically tackled the issue of style, using photographs instead of drawings or engravings. Unfortunately, his somewhat jejune conclusions show just how much remained to be done and how far the dilettante British connoisseurs lagged behind the disciplined, rigorous Germans. Later, after the First World War and just before his death, he brushed off these early articles as "over-Teutonic in style."[50]

In 1896 Georg Habich, one of Brunn's last pupils, produced a whole thesis on the Dedication's Amazonomachy (II). In it he championed Klügmann's dismissal of the Naples Amazon's baby and discussed Brunn's other attributions (e.g., Figure 82), accepting some and rejecting others. He also noted the similarities between some of these riders and the Amazon frieze of the Temple of Artemis at Magnesia – then variously dated from 200 BC to AD 300! And in 1908 the Polish scholar Piotr Bienkowski (1865–1925) followed up this monograph with an even more extensive study of the Celts. Based on his dissertation *De simulacris barbararum gentium,* this was the first volume of a promised *Corpus barbarorum,* of which only one other appeared. Published posthumously, it treated the Celts in the minor arts of Greece and Rome.[51]

Bienkowski's project was modeled on enormous corpora like Brunn's own *Denkmäler griechischer und römischer Sculptur* (from 1888); Carl Robert's *Die antiken Sarkophagreliefs* (from 1890); and Alexander Conze's *Die attischen Grabreliefs* (from 1893). This sudden burst of activity was generated by nineteenth-century positivism's obsession with taxonomy and the encyclopedic mapping of knowledge. For the corpus both facilitates comparison (the art historian's basic tool) and furnishes the classic foundation for inductive reasoning (the positivist's basic tool). "Induction is based on a comparative process. It is a comparison of homogeneous facts, samples of a certain class; from this comparison, it enunciates general properties."[52]

In the natural sciences, this meant the collection of all relevant "hard" data under the scholar's "panoptic gaze" and their evaluation according to a strict set of rules. In anthropology, it led to Franz Boas's huge collections of "reliable" anthropological facts. In ancient history, it produced Theodor Mommsen's equally massive corpora of inscriptions and other historical data. And in classical archaeology it resulted in a drive to collect, classify, and publish all the monuments of a given type or class, in folio form wherever possible. Collections of ancient *testimonia* and sculptors' signatures soon followed. Also announced in Gerhard's "Archaeological Theses" of 1850 (see section 1 above) and wholly laudable in itself, this vast collaborative project produced what are essentially huge illustrated databases that created a solid foundation for further research.[53] Still indispensable today, they determined the discipline's research goals for generations. Many are still ongoing, for reasons that must now be examined.

One does not need Michel Foucault's *The Order of Things* or Jacques Derrida's observations on deferral and supplements to spot the contradictions in this enterprise. Often these corpora became ends in themselves – monsters that devoured their creators. Because new evidence kept on appearing, they could never be completed. So not only were their compilers driven to keep collecting material for endless supplements to their work, but all conclusions (inductions) they drew from it were necessarily and eternally provisional. At any time a rival could produce a new item that modified or contradicted one's ideas and showed that one's research had been less than diligent. This was distinctly unnerving, especially for convergent thinkers, as many classicists still tend to be. But fortunately for them, the positivist slogan *primum monumentum, deinde philosophari* ("first the monument, then the philosophizing") could authorize the cautious researcher to procrastinate for eternity.[54]

So no corpus could ever be complete or definitive – the whole point of embarking upon it in the first place. Yet the contacts, resources, knowledge, labor, and patience required to produce such volumes were vastly intimidating, creating the impression that they were the highest form of scholarship to which one could aspire. Indeed, their ostensible objectivity, encyclopedic scope, imposing size, and obvious utility tended to suggest that work of this kind was the *only* legitimate occupation for the really serious mind. And if the compiler maneuvered ably, it could guarantee a lifetime job, since administrators were often reluctant to cancel funding for such projects for fear of being labeled philistine. Corpus compilation was thus a technology of power in itself, since all other kinds of library-based scholarship could be stigmatized as more or less provisional, limited, ephemeral, and speculative by comparison – attitudes that occasionally still haunt the field.

So Bienkowski produced a corpus of Gauls, mixing copies and originals indiscriminately but diligently republishing all the material in a relatively systematic form. Accompanied by numerous high-quality photographs, using all available evidence, and citing all authoritative opinions, his corpus brought the nineteenth-century discus-

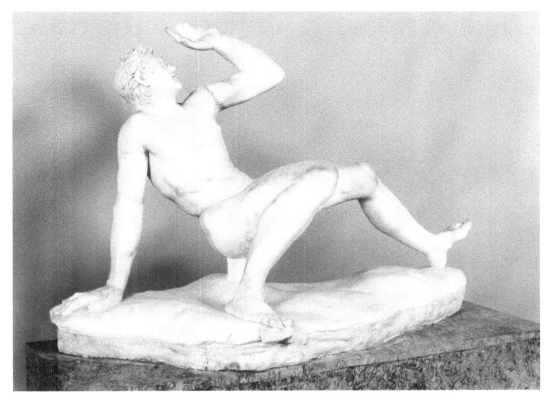

FIGURE 53. Venice Falling Gaul. Photo: Osvaldo Böhm.

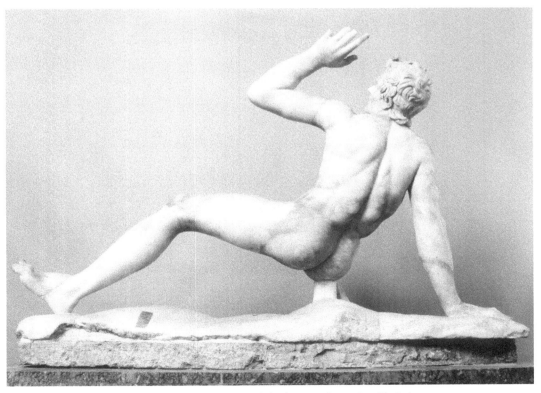

FIGURE 54. Venice Falling Gaul, back view. Photo: Osvaldo Böhm.

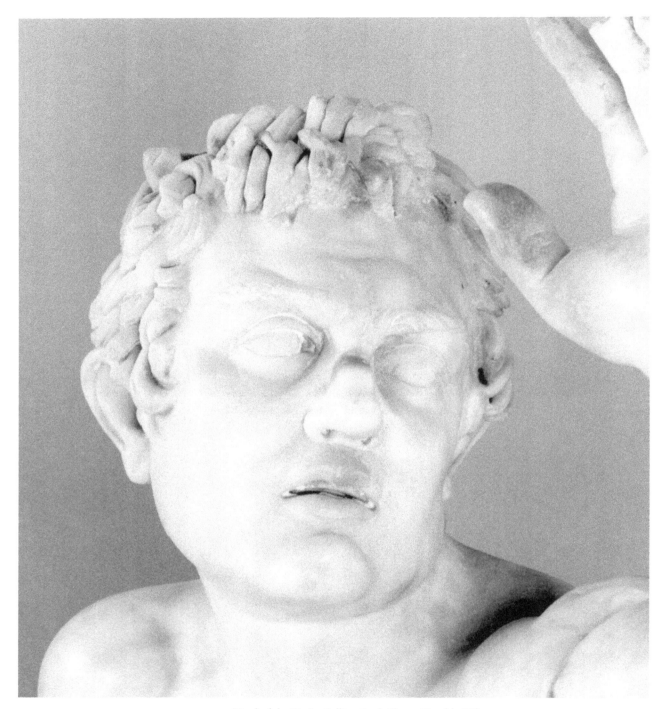

FIGURE 55. Head of the Venice Falling Gaul. Photo: Osvaldo Böhm.

sion to a close, and his book is now regularly cited as a classic. In the Little Barbarians' case he divided the material into statues that "certainly" copied the Attalid Dedication (the Venice, Naples, and Paris Gauls); statues that "probably" did so; and statues that "presumably" did so. En route he threw nothing out and added one cloaked warrior in the Palazzo Doria Pamphili that "might" copy one of their Greek opponents. Inter alia, he attacked Malmberg's inferences from the wounds and endorsed Reinach's interpretation of the Venice Kneeling Gaul as a suicide, but offered no general conclusions whatsoever.[55]

After all this activity it is not surprising that work on the Attalid Dedication temporarily slowed. The major

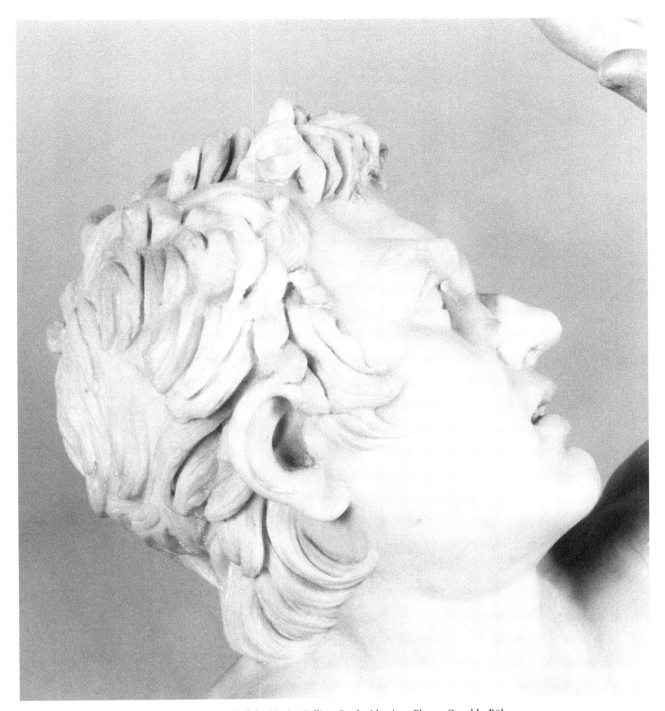

FIGURE 56. Head of the Venice Falling Gaul, side view. Photo: Osvaldo Böhm.

documents had been recovered; its location had been pinpointed; its date had been narrowed with great probability to ca. 200; its copies had been thoroughly scrutinized; the museums of Europe had been scoured for more of them; and most of the peripheral issues had been explored. What was there left to do?

4. FROM LIPPOLD TO KRAHMER

The answer came from a much younger scholar: Georg Lippold (1885–1954). In a review published in 1914, Lippold pointed to the Little Barbarians' "unbridled realism of posture and form," and in his magisterial study of

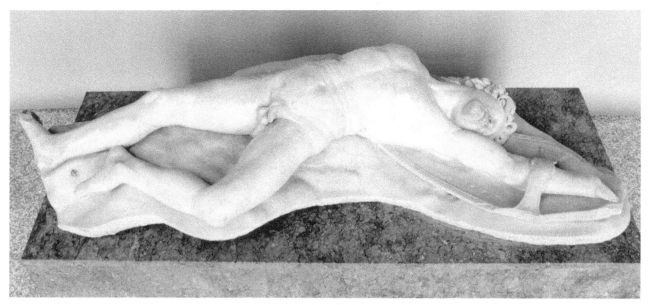

FIGURE 57. Venice Dead Gaul. Photo: Osvaldo Böhm.

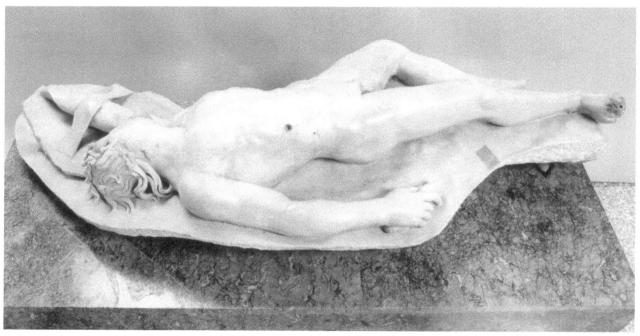

FIGURE 58. Venice Dead Gaul. Photo: Osvaldo Böhm.

the ancient copying industry in 1923, he tackled the vexing question of their Asiatic marble. Giving a new twist to an old idea of Brunn's and Milchhöfer's, he concluded that the "core group" indeed copied a monument "parallel" to the Akropolis one, erected in Pergamon not in Athens, and not around 200 but around 150, after the Great Altar (see Figures 68–69).[56]

Lippold thus became the first scholar to apply the "laws" of positivist archaeology – the alleged linear evolution of Hellenistic sculptural style and the basic principles of copying technique – to the Little Barbarians, producing bold, new, and exciting results. Moreover – another novelty – he based his argument on stylistic comparisons using photographs. Mid-nineteenth-century

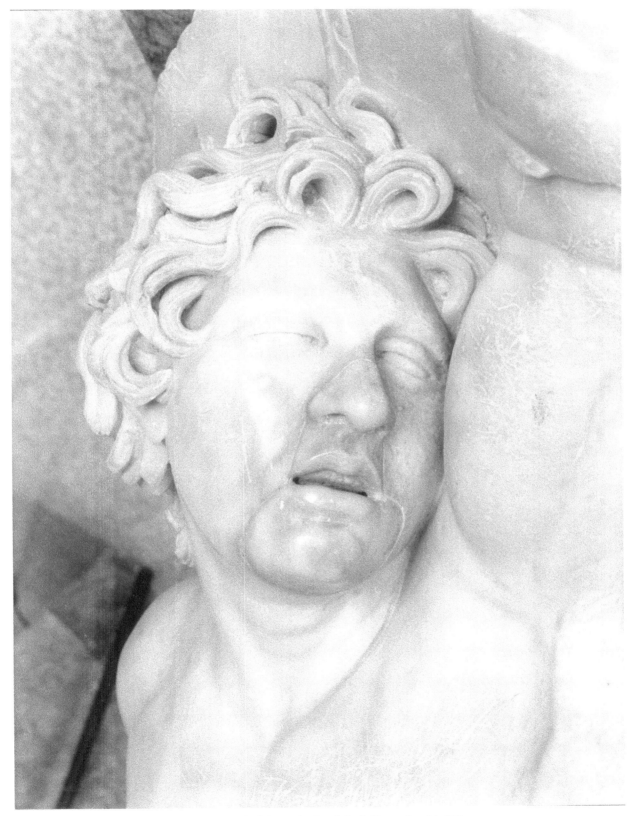

FIGURE 59. Head of the Venice Dead Gaul. Photo: Osvaldo Böhm.

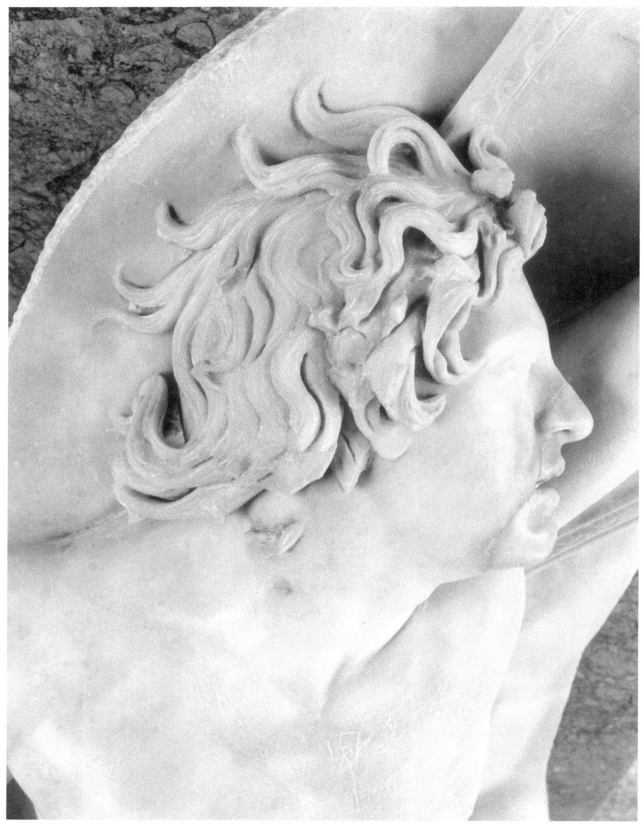

FIGURE 60. Head of the Venice Dead Gaul, side view. Photo: Osvaldo Böhm.

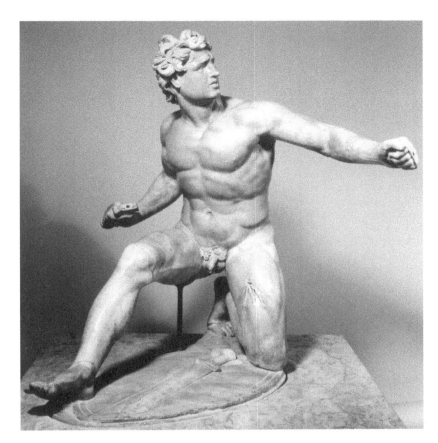

FIGURE 61. Paris Gaul. Photo: Chuzeville.

FIGURE 62. Paris Gaul, back view. Photo: Chuzeville.

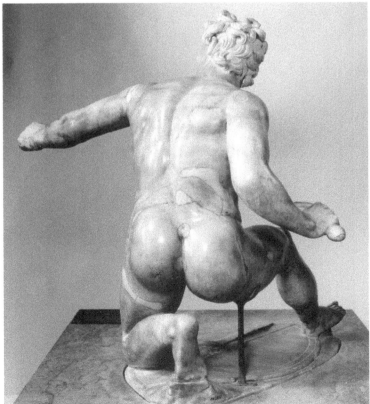

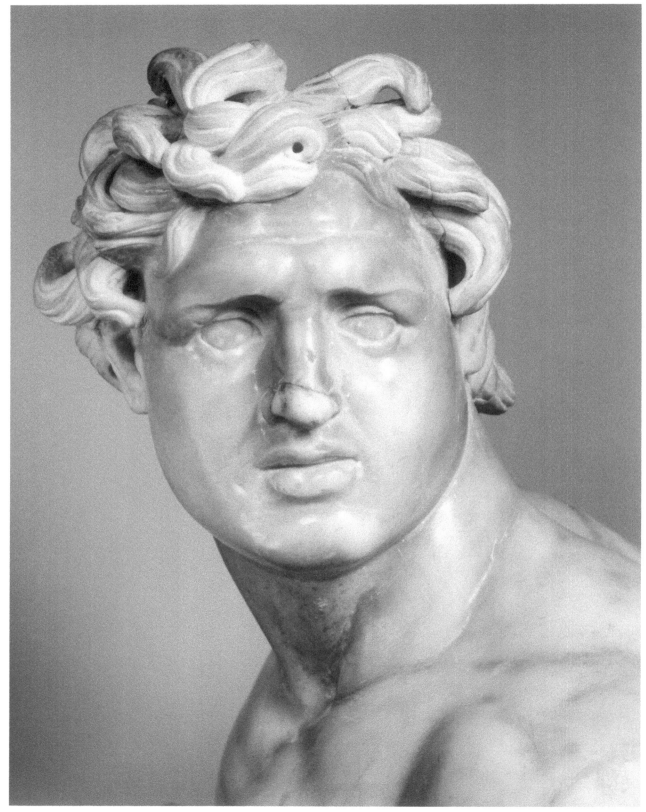

FIGURE 63. Head of the Paris Gaul. Photo: Chuzeville.

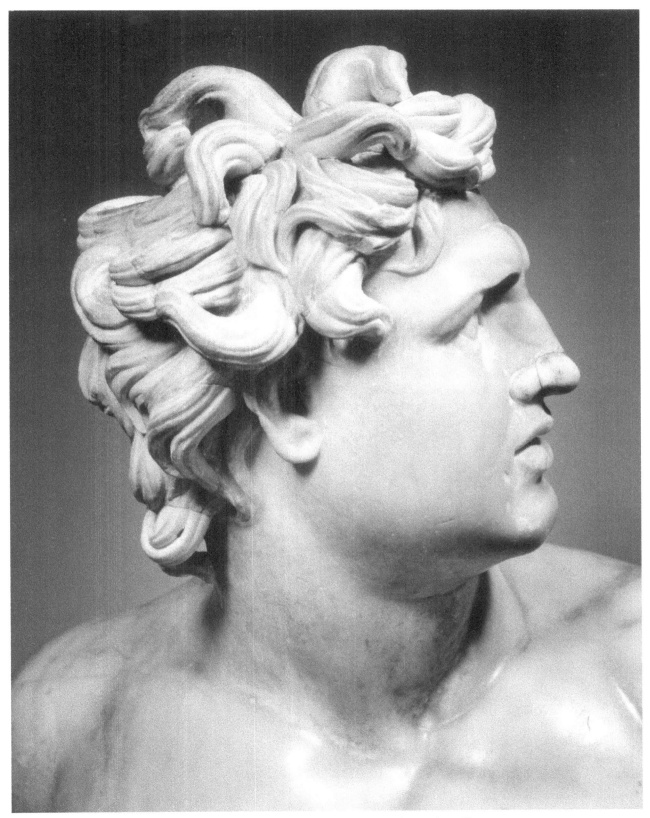

FIGURE 64. Head of the Paris Gaul, side view. Photo: Chuzeville.

scholars had ventured little in the way of such analysis, since most of them still continued to rely on drawings. But ambitions soon grew. In 1878, for example, Brunn himself produced a comparative anatomical study of the British Museum's "Strangford Apollo" and the Aegina pediments in Munich (see Figure 192) in order to attribute both to the same sculptural school. Yet he still used only drawings, not photographs.[57]

The breakthrough came in 1893 with Adolf Furtwängler's *Meisterwerke der griechischen Plastik*. This bold attempt to reconstruct the output of the great classical masters, penned by Brunn's star pupil, caused a sensation. Furtwängler used the methods of the positivist genius Giovanni Morelli (1819–91), who from 1874 had published hundreds of reattributions of Old Master paintings that tabulated and compared the formulae their authors employed for anatomical details, drapery, and so on. In his preface Furtwängler declared that only photography could sustain such a program, and documented his attributions by an impressive array of no fewer than 140 halftone photoengravings in his text and 32 deluxe ones in a separate folio album. His address to the ancient sources, however, was deliberately casual – a slap at the old philological school of classical archaeology, for which Brunn's *Geschichte* of 1857 had been the bible.

This sudden conversion to photography was long overdue. Hippolyte Bayard had produced the world's first

FIGURE 65. Giustiniani–Torlonia Persian. Probably from Rome. Marble; height ca. 90 cm. Rome, Museo Torlonia. From Vincenzo Giustiniani, *Galleria Giustiniana* (Rome 1631): pl. 118. See Appendix 2.3(iv).

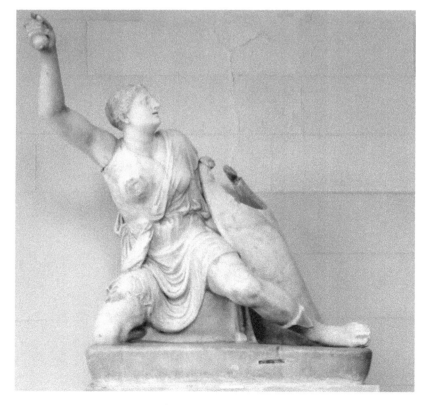

FIGURE 66. Wilton Amazon (Roman copy). From Rome; original, ca. 350–250 BC? Marble; height 92 cm. Wilton House (England) M170 (MAZ 42). Photo: Author. The head and right arm are restored. See Appendix 2.3(iii).

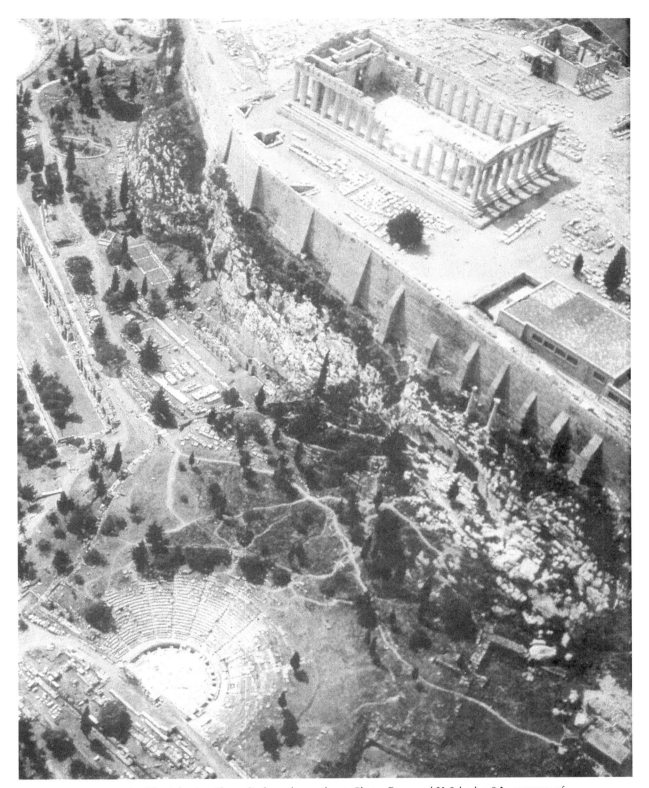

FIGURE 67. The Athenian Akropolis from the southeast. Photo: Raymond V. Schoder, S.J., courtesy of Loyola University, Chicago. The citadel wall thickens from 2 m to 6 m at the deep triangular pit adjacent to the third buttress from the west. The Attalid Dedication stood on it, beginning between the pit and the nearby tree and continuing to the east (rightward) alongside the present museum (at far right). The bases built into the top of the wall can be seen just above the right-hand buttresses.

FIGURE 68. Zeus fights Porphyrion (at right) and two other Giants. Relief from the Gigantomachy of the Great Altar of Pergamon, ca. 180–160 BC. Marble; height 2.3 m. Berlin, Pergamonmuseum. From Hermann Winnefeld, *Die Friese des groszen Altars* (Berlin 1910) (*Altertümer von Pergamon* 3.2): pl. 11.

FIGURE 69. Athena fights Alkyoneus; Ge comes to the Giant's aid while Nike crowns the goddess. Relief from the Gigantomachy of the Great Altar of Pergamon, ca. 180–160 BC. Marble; height 2.3 m. Berlin, Pergamonmuseum. From Hermann Winnefeld, *Die Friese des groszen Altars* (Berlin 1910) (*Altertümer von Pergamon* 3.2): pl. 12.

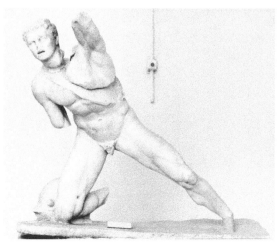

FIGURE 70. Fallen Gaul from the Agora of the Italians on Delos, ca. 100 BC. Marble; height 93 cm. Athens, National Museum 247. Photo: Author. The head, allegedly found on Mykonos, almost certainly belongs to the statue.

FIGURE 71. Loggia of the Palazzo Medici–Madama. Page from a sketchbook by Maarten van Heemskerck, 1532–36. Pen and ink; 17.9 × 21.4 cm. Berlin, Staatliche Museen – Preussischer Kulturbesitz, Kupferstichkabinett 79D2, fol. 5r. From Christian Hülsen and Hermann Egger, *Die römischen Skizzenbücher von Marten van Heemskerck* (Berlin 1913–16): vol. I: pl. 6. The Paris Gaul kneels propped up against the table at right rear; the Naples Dying Gaul is on the low wall, just below the fountain-basin.

FIGURE 72. Naples Amazon and other statues. Page from a sketchbook by Frans Floris, 1540–47. Pen and ink; 21.6 × 29.2 cm. Basel, Öffentliche Kunstsammlungen, Kupferstichkabinett U.IV.19, fol. 23v. Photo: Martin Bühler, Öffentliche Kunstsammlungen Basel. Note headless baby at the Amazon's breast.

FIGURE 73. Naples Giant. From a drawing in the collection of Cassiano dal Pozzo, 1657. Royal Collections, Windsor Castle. Vol. 8, fol. 31, no. 8732. Photo: The Royal Collection © 2002, Her Majesty Queen Elizabeth II.

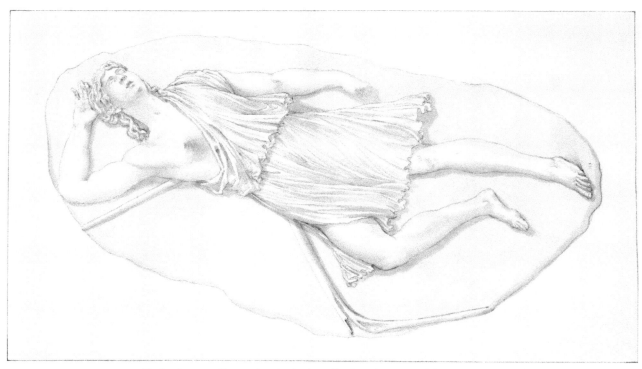

FIGURE 74. Naples Amazon. From a drawing in the collection of Cassiano dal Pozzo, 1657. Royal Collections, Windsor Castle. Vol. 1, fol. 68, no. 8227. Photo: The Royal Collection © 2002, Her Majesty Queen Elizabeth II. The baby, seen in Figure 72, has disappeared.

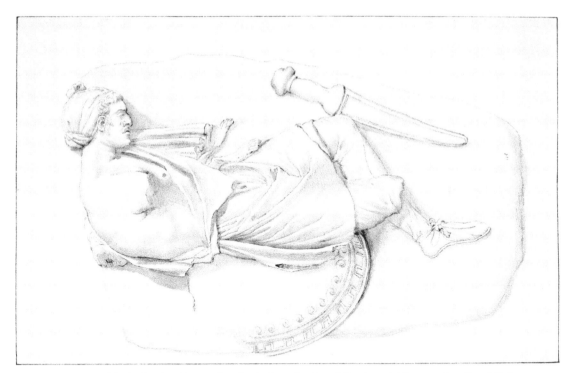

FIGURE 75. Naples Persian. From a drawing in the collection of Cassiano dal Pozzo, 1657. Royal Collections, Windsor Castle. Vol. 1, fol. 66, no. 8225. Photo: The Royal Collection © 2002, Her Majesty Queen Elizabeth II.

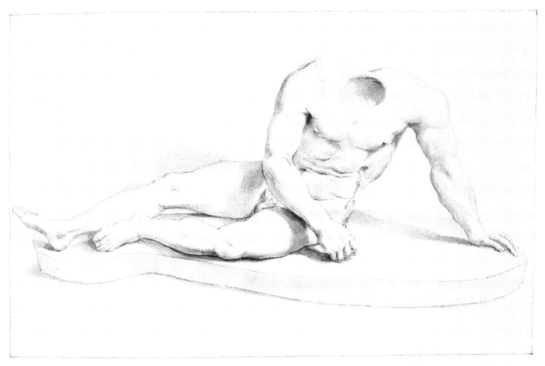

FIGURE 76. Naples Dying Gaul. From a drawing in the collection of Cassiano dal Pozzo, 1657. Royal Collections, Windsor Castle. Vol. 9, fol. 31, no. 8814. Photo: The Royal Collection © 2002, Her Majesty Queen Elizabeth II. Note the missing head.

photograph of a group of sculptures as far back as 1839, and Henry Fox Talbot had published the first reproducible print of one from a negative in 1844. Bayard's ensemble included the Medici Venus, and Fox Talbot used his own plaster cast of the so-called Patroklos in the British Museum – actually a copy from Hadrian's Villa of one of Odysseus' companions in the Polyphemos group at the Sperlonga grotto.[58]

Soon, Leopoldo and Giuseppe Alinari started to produce high-quality albumen prints of antiquities in Florence and then in Rome; in 1859, James Anderson began to publish his prints of Roman antiquities; and in 1863, Robert Macpherson produced an album of three hundred superb ones of the Vatican marbles. By 1870, commercial photography of antiquities was well established in Italy, and high-quality images of important new discoveries of ancient sculpture were commonplace. They far outclass contemporary photos of paintings, whose subtle colors could not be captured by the techniques then available. Many of them even put present-day efforts to shame, and a dozen or so are reproduced in the present volume (e.g., Figure 1). So why did nineteenth-century scholars refrain for so long from using them?[59]

Unfortunately few of these individuals ever discussed the matter in print, and none of those who tackled the problem of the Little Barbarians did so. The evidence is meager, but historians usually attribute the delay to a mixture of academic conservatism; Winckelmannian aesthetics, which ranked line and contour above all other modes of artistic expression; a related conviction that photography was mechanical and soulless, and that drawings more accurately captured the true spirit of the subject; and the lack of any cheap and effective way to publish photographs in books. Huge double- or triple-folio albums of photographs of ancient sculpture, produced independently or as adjuncts to handbooks, had appeared as early as 1881. Brunn himself inaugurated a superbly authoritative corpus of them, the *Denkmäler griechischer und römischer Sculptur,* in 1888. Yet their very size and cost severely restricted their currency. The real breakthrough came only with the invention of halftone photoengraving in the 1880s and its adaptation to commercial use in the early 1890s.

Yet to focus upon representational and technical problems is to overlook another serious rival to photography, at least in the academic world: the plaster cast. Fox Talbot's earliest photograph was of a cast in his own collection; Gerhard had made casts the cornerstone of the discipline in his "Archaeological Theses" of 1850; and Brunn had used specially ordered casts to illustrate his "I doni di Attalo" lecture of 1865 and to develop his "Strangford Apollo" essay of 1872.

So casts were a venerable and tested scholarly resource. Renaissance scholars and artists had made, owned, studied, and used them, and the Ancienne Académie Royale in Paris had begun to collect them as early as 1648 and the Berlin Kunstakademie in 1696. Soon Enlightenment neoclassical, humanist aestheticians lit upon them as the royal road whereby scholars could study and artists re-create the glories of the classical past. For the blank, white plaster of the cast is a powerful leveling device. Translated into this common lingua franca, purified of distracting blemishes, and displayed together in the even light of the cast gallery, sculptures of different times and places could be compared and assessed with calm objectivity. Some extremists even preferred casts to originals, now stained and damaged by time.[60]

As a result, from the late eighteenth century all self-respecting German universities with programs in classical archaeology began to amass such collections. In the nineteenth century French, Swiss, British, and American ones gradually followed suit; the Berlin Museums started a truly vast one in 1856. Brunn himself was instrumental in founding the Munich collection, and in the 1870s even satisfied himself that his casts of the newly discovered Olympia sculptures obviated the need to visit Greece to see the originals.[61] In 1909 Munich alone owned fifteen hundred of them, and its collection was by no means the largest.

To many late nineteenth-century academics, then, the choice must have been simple. Why use the expensive, still unsatisfactory, and essentially two-dimensional medium of photography when one already possessed the next best thing to the original in the round, and one's peers only had to walk into their own cast galleries to check one's ideas? Yet there remained the problem of how to reach would-be viewers – the knowledge-hungry public included – situated away from the great cast collections, and from the 1880s influential voices began to criticize as excessive the reliance on them. Alexander Conze, director of the Berlin Museums, and his assistant, Wilhelm von Bode, thought them too costly and unaesthetic, and pointed out that the molding process could damage the originals. Better a tiny fragment of a Greek original, Bode argued, than the most complete plaster reproduction. In Britain, the influential historian and critic John Ruskin added his stentorian voice to this small but increasing chorus, and the growing "art for art's sake" movement further reinforced it.

Yet in academic circles Furtwängler's *Meisterwerke* was still the prime mover. Soon after its publication in 1893 all serious scholars began to use photographs as a matter of course. Michaelis, for example, had originally opposed them, but in his popular account in 1908 of the

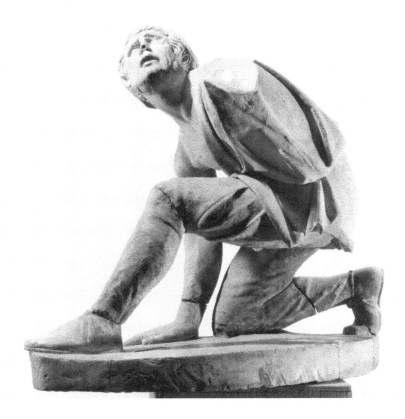

FIGURE 77. Aix Persian, side view.
Photo: Centre Camille Jullian.

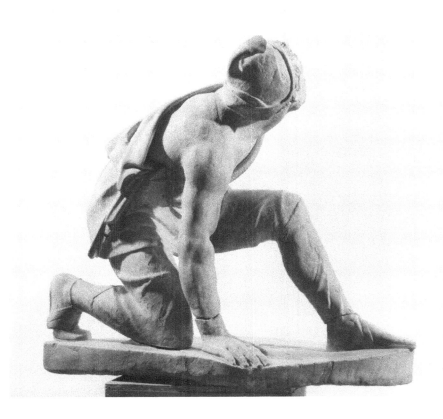

FIGURE 78. Aix Persian, back view.
Photo: Centre Camille Jullian.

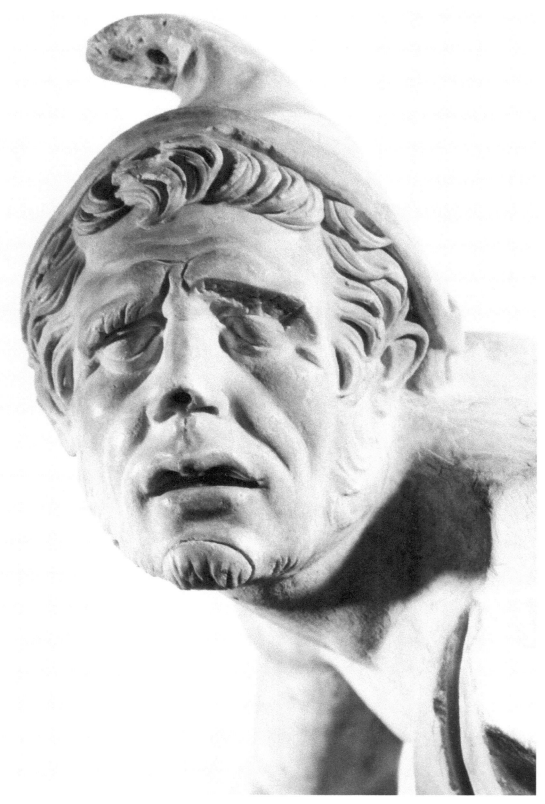

FIGURE 79. Head of the Aix Persian. Photo: Centre Camille Jullian.

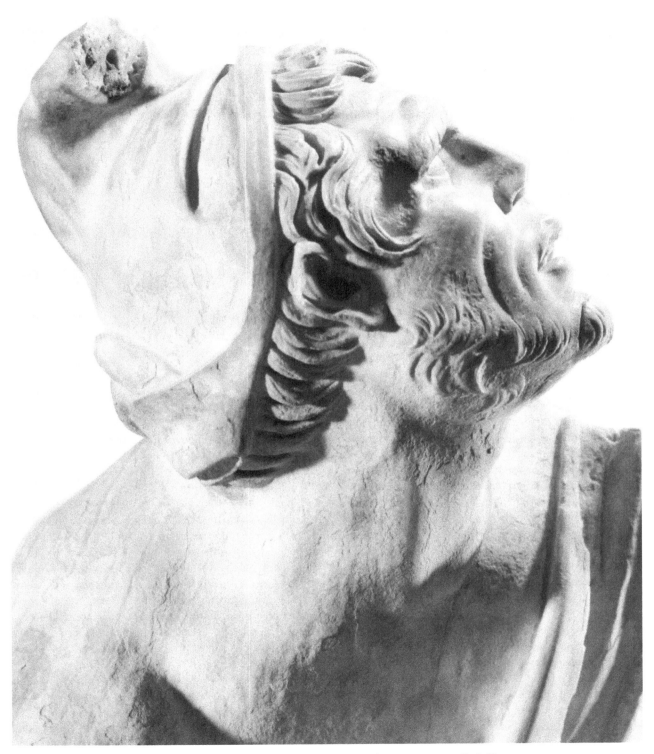

FIGURE 80. Head of the Aix Persian, side view. Photo: Centre Camille Jullian.

previous century's archaeological discoveries he recanted. While noting how instrumental they had been in converting the discipline from a text-based to a style-based methodology, he nevertheless issued a stern warning: Furtwängler's attributions were both inflated and inattentive to the texts, and his imitators were beginning to arrive at wildly contradictory ones for the same pieces. In the absence of external controls, stylistic analysis was treacherous indeed.[62]

To return to the Little Barbarians. Brunn had referred readers of his 1870 article to a simultaneously published collection of superb folio-size engravings at 25 percent scale; Overbeck had used smaller but still serviceable engravings from woodcuts (see Foldout at back of book); Mitchell a photoengraving from a woodcut of the Aix Persian; and Reinach his usual sketches the size of postage stamps. Furtwängler had omitted the ensemble because it fell outside his chosen period, so it made its photographic debut only in a *Denkmäler* volume of 1898, four full years after Brunn's death; coverage was limited to the Vatican Persian and the quartet in Naples. In 1908, however, Bienkowski proudly illustrated his corpus with large numbers of Alinaris (cf. Figure 1), and it was upon these two publications that Lippold's ideas were based.[63]

As Furtwängler's pupil, Lippold had no objections to photographs at all. Armed with an ample supply of them, he realized that the "core group" not only was more advanced stylistically than the Big Gauls (Figures 27–28) but perhaps even more so than the Great Altar of Pergamon (Figures 68–69, 236). Eumenes II apparently had built this mighty structure around 180, or at any rate between his first great successes of 192–188 and his death in 159/58. And as for the Akropolis Dedication, Pausanias (AT6) says only that "Attalos" had dedicated it. So why not Attalos II (reigned, 158–138)? An Athenophile, he had given a magnificent stoa to Athens (rebuilt in the 1950s by the American School of Classical Studies to house the Agora Museum) and could have given more.

Still, the Little Barbarians were only copies. In his *Meisterwerke,* Furtwängler had paid only lip service to the problem of treating Roman copies as if they were Greek originals – another lapse for which his reviewers criticized him. Lippold was not about to make the same mistake. Instead – in a project supported by the Bavarian Academy of Sciences – he devoted himself to creating an inductively based science of copies, or *Kopienkritik.* His chosen method was to scrutinize and match details among copies; to compare them with dated Greek and Roman works; and to filter out anachronisms. Informed critics could thus ascertain the copy's degree of fidelity (for which Lippold created a specialized vocabulary) and perhaps even its date of manufacture. They could trace

FIGURE 81. Wife of the Suicidal Gaul, Figure 27. Photo: Soprintendenza Archeologica di Roma.

copying schools (Athenian, Aphrodisian, Pergamene, etc.); determine period styles and tastes in copies (Augustan, Julio-Claudian, Flavian, Hadrianic, Antonine, etc.); and even construct family trees of them, like the manuscript stemmata of the philologists.

The "core group" threatened to undermine this glittering edifice, for two reasons. No figure was replicated elsewhere and, as Brunn had already observed, the marble was apparently from Asia Minor, not – as a monument located in Athens would suggest – from the Attic quarries on nearby Mount Pendeli. Uniqueness meant no controls, no way to filter out anachronisms; and Asian marble should mean manufacture in Asia after an original located there. As mentioned earlier, Lippold's solution was simple: He revived Milchhöfer's old idea that the Little Barbarians copied bronzes that stood not in Athens but in Pergamon.[64]

Yet *pace* Brunn, Overbeck, and Milchhöfer, and despite Michaelis's warnings, rigorous stylistic analysis could now show that the Attalid Dedication had been erected in the reign of Attalos II (159/58–138). It could also demonstrate that its copies – the Little Barbarians themselves – were not Hellenistic but Roman in date. Indeed (Lippold thought) they and the Big Gauls were

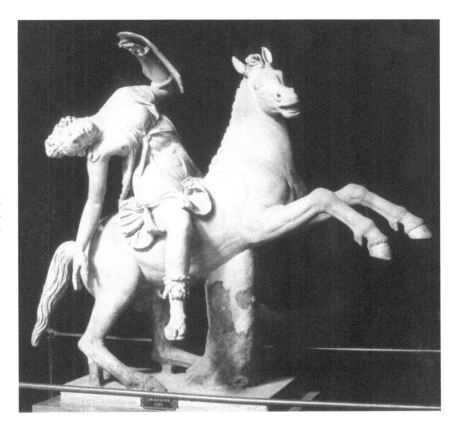

FIGURE 82. Amazon falling off her horse. From the Farnese Collection; Roman imperial period. Marble; height 1.34 m. Naples, Museo Nazionale FAR 6405. Photo: Alinari/Art Resource PIN 11033.

probably made by the same workshop, whose distinctive techniques and mannerisms – like the profiled plinth of the Ludovisi Gaul – pointed to the second century AD.

As for the Pergamene monument, it need not have copied the Athenian one exactly, for several of the Barbarians were too three-dimensional for a relieflike composition set against or (in the gods' case) perhaps even on a wall. In fact – as W. B. Dinsmoor had recently suggested for its Athenian counterpart, unwittingly reviving another old theory of Milchhöfer's – it too could even have omitted the victors entirely.[65] This idea effectively reversed the relationship between the two monuments. Instead of the one at Pergamon being the original (as Brunn and Milchhöfer had suggested) it was now by implication derivative. And had the Athenian version also generated copies? Should one assign to it those statues attributed over the years that were clearly different from the "core group" in material (Pentelic marble) and more suavely decorative in style (Figures 82, 85)?

The boldness and elegance of Lippold's theory, backed up by the magisterial sweep of his work, gained it immediate acceptance. Yet there was a simpler alternative that he failed to consider. What if the copies of both the Big Gauls and the Little Barbarians were made in or near Rome using imported stone and plaster casts of the originals?

Lippold was well aware that ancient copyists had used casts. Yet he preferred to believe that in general a copy found in Italy but made of Asian marble (for example) should be an import from a workshop in Asia Minor devoted to copying works displayed locally. After all, casts were far more fragile and harder to transport than marbles and (to be cynical), if one accepted their widespread use, any hope of mapping the various copyists' workshops, traditions, and sources would all but disappear.[66] One would face too many unknowns. But what if the training of the workshop's personnel, not its location, determined the choice of stone? What if (for example) an Aphrodisian sculptor in Rome, unable to get his own local marble, simply went out and bought whatever was closest to it in grain size and structure, rather than shift to the harder, unfoliated, more intractable, and completely unfamiliar local Italian marble from Carrara?

Toward the end of his life, Lippold repudiated his own downdating of the Attalid Dedication, but by then it was too late. The genie had escaped from the bottle and has remained at large ever since. For his ideas found an immediate following, especially among the more extreme formalists, whose agenda as regards Hellenistic art was simple. Whereas Furtwängler's disciples in the field of classical Greek sculpture continued to play the "attribution game" ad nauseam (and still do), connoisseurs of

Hellenistic art first had to tackle its chaotic chronology. For because the classically biased Greek and Roman critics disdained the period (Pliny, for example, simply announces that bronze sculpture "ceased" between 292 and 156),[67] they often ignored its artists and their works, and the market for copies was thin.

To the formalists, the obvious remedy for this informational drought was to find overarching formal changes that had escaped earlier, less sophisticated observers, and to create chronologies out of them. Their databases were the arsenals of photographs in the published corpora and in the archives of the German Institutes at Rome and in Athens, and their idols were master formalists like Adolf Hildebrand (1847–1921), Alois Riegl (1858–1905), and Heinrich Wölfflin (1864–1945). In this brave new formalist world, Michaelis's stern warning about "the great insecurity which exists as soon as we have only stylistic analysis as a guide" was blithely ignored.[68]

Hildebrand, Riegl, and Wölfflin had all begun to publish before 1900, and their ideas quickly took root in German-speaking academe. All serious art historians soon became intimately familiar with Hildebrand's observations on depth perception and the "relief conception" of sculpture. They quickly internalized Riegl's antithesis between the closed/circumscribed/tactile and the open/suggestive/optic. And when it suited them they also happily took up Wölfflin's antithesis between Renaissance (classic) and baroque and its five (!) key dichotomies – linear and painterly, planar and recessional, formally closed and formally open, unified and multiple, clear-cut and complex. To students of Hellenistic sculpture, starved of names, dates, texts, history, and even copies, this dualistic framework had instant appeal.

In the Hellenistic field, formalism's high priest was Gerhard Krahmer (1890–1931), a brilliant connoisseur and powerful writer whose career was prematurely truncated by the aftereffects of wounds suffered in World War I. His dissertation, grandly entitled "Stilphasen der hellenistischen Plastik," was published in 1924. Three years later, in a magisterial study of what he called "one-sided" groups, he briefly focused his formidable analytical skills upon the Little Barbarians.

Krahmer saw flat, "one-sided" groups like the Laokoon (Figure 83) as a typically late Hellenistic classicizing retreat from the extreme three-dimensionality (or "open form") of the mid-Hellenistic period, exemplified by the early second-century Nike of Samothrace. In his view Hellenistic art gradually abandoned the extreme openness, unboundedness, and overdetermination of the Pergamene high baroque. Rather, it cultivated a Hildebrandian ideal of well-bounded clarity and purity of form where (despite an often "baroque" content and considerable internal complexity – as in the Laokoon) contour again reigned supreme and all internal relations – however conflicted – were again completely intelligible from the frontal plane. The Little Barbarians inaugurated this retreat, for though some of them were still aggressively three-dimensional, others like the Venice Kneeling Gaul (see Figure 16) were virtually flat. So their originals indeed should belong in the mid-second century BC.[69]

5. EXCURSUS ON FORMALISM

Since the historiography of Hellenistic art still often leans either overtly or covertly on Krahmer's "Stilphasen" and his "one-sided groups" still thrive as well, his work deserves a brief excursus. His formalist method, as we have seen, had deep roots both in nineteenth-century positivism and in the "great tradition" of Western art criticism from Xenokrates to Winckelmann. Furthermore, after him, and until the intrusion of Marxism in the 1960s and of French structuralism and poststructuralism in the 1980s and 1990s, the field slowly turned to more narrowly archaeological concerns. Yet it seldom challenged either Krahmer's results or the formalist agenda per se.

Essentially, both are untenable as stated yet rich in insights even so. As Richard Wollheim notes:

[The formalists] had far too narrow a conception of the range of devices operative in art: symptomatic of this would be, for instance, Wölfflin's failure to account for, or, for that matter, to see that he had to account for, Mannerism in his stylistic cycle. Secondly, they had no theoretical means of fitting together stylistic changes on the general or social level with changes of style on an individual or expressive level: Wölfflin's famous program of "art history without names" is in effect the denial that there is any need to make the fit since all change occurs primarily or operatively on the more general level. Thirdly, all these writers were confused about the status of their investigation. From the fact that it is in the nature of art that it changes or has a history, they tried to move to the conclusion that the particular history it has, the particular changes that it undergoes, are grounded in the nature of art.[70]

In fact, neither the particulars under consideration (Hellenistic sculptures) nor general principle (art's alleged essential nature) allows one to argue *a priori* that Hellenistic styles must have evolved linearly. As Whitney Davis has explained in another context:

'Style' is a description of a polythetic set of similar but varying attributes in a group of artifacts ... [where] (1) each artifact possesses a (large) number of the attributes of the group; (2) each attribute may be found in a (large) number

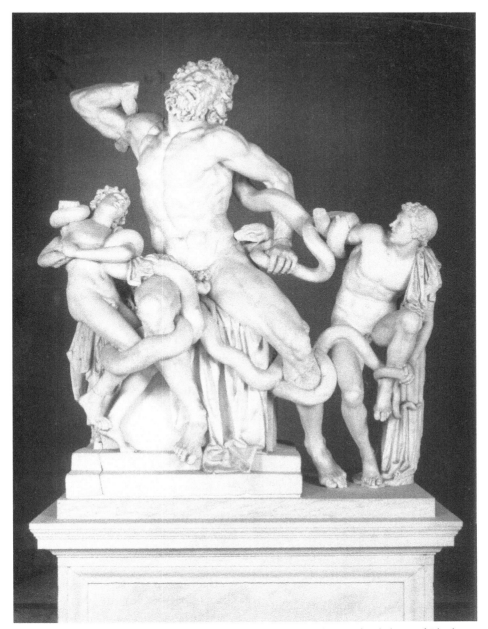

FIGURE 83. Laokoon and his two sons by Athanodoros, Hagesandros, and Polydoros of Rhodes, as restored in the 1950s by Filippo Magi. From Rome; ca. 40 BC or later. Marble; height 1.84 m. Vatican, Cortile del Belvedere 1059, 1064, 1067. Photo: Vatican Museums XXXIV.22.9.

of the artifacts in the group; and (3) no single attribute is found in every artifact in the group....

[M]any art historians ... have claimed to find regular temporal and spatial structures in styles. These structures were commonly conceived as connected series of slightly varying artifacts – lines of variation or evolution connecting two or more fixed temporal or spatial points, such as a line between a point of 'origins' and a point of 'fulfillment'....

[But many of these] life-histories of style were erected on a slight base of independent dates and contexts. They depended frequently upon dubious procedural prescriptions not inherent in the theory of style itself – for example, that it is best to begin the search for similarities to the attributes of an artifact with the very next artifact (in either or any direction) in sequence of distribution. In fact, in the absence of archaeological evidence, sometimes artifacts were initially positioned next to each other in sequences or distributions on the basis of morphological similarity, making possible, by definition alone, a coherent stylistic description with a satisfyingly linear structure. Teleological notions – "the fine arts spend much of their course evolving toward their ideal or goal" (Alfred Kroeber), ultimately 'attained' and then

'exhausted' – at the extreme gave rise to almost mystical conceptions, like Riegl's *Kunstwollen* or 'will-to-form.' In evolutionist or diffusionist enthusiasm for regular lines of temporal and spatial variation, especially when further and closely cross-cut by narrative biography and chronicle, much of the power and flexibility of polythetic classification was forfeited.

None of these difficulties at all proves that regular temporal or spatial structures cannot be found in styles or will not be confirmed archaeologically in some instances.... However, they are certainly not universally or essentially immanent. *The representation of matched or similar attributes in a population does not always change in any single linear direction but may oscillate or fluctuate in complex ways.* In fact, the theory of style makes no inherent predictions about the rate, pace, direction, or degree of change. Erected *a priori* or by hypothesis alone, the life-historical structures of style do not reliably make available a history of style from within.[71]

In other words, pattern recognition – archaeology's meat and drink – cannot be simply or unproblematically converted into chronology. One reason for this is that all classifications contain an element of arbitrariness and therefore of uncertainty.[72] Which criteria are important and which less so? Which can be safely disregarded? Where do marginal or idiosyncratic pieces belong – inside or outside, before or after? Finally, having produced the desired classification, how does one *interpret* it? Since archaeologists (among whom, for these purposes, one can classify art historians) are in the business of constructing history from objects, to turn classification into chronology was – and still is – the obvious first resort.

In terms of logic the formalists regularly confused *induction, deduction,* and *abduction*. They believed that their theories grew logically from the facts – and thus were positively *sustained* by the facts – whereas in reality they were mere intuitive guesses based on a few *surprising* facts and a prior assumption (that stylistic variation equals chronological change). Confusion of this kind was not unique. Most of Sherlock Holmes's famous "deductions" were actually guesses of this sort. (But then, he could hardly have said "I abduce" or "I guess" with such intimidating authority!) Even the father of semiotics, Charles Sanders Peirce (1839–1914), admitted to making a similar mistake "in almost everything [I] printed before the beginning of [the twentieth] century." In his words:

Accepting the conclusion that an explanation is needed when facts contrary to what we should expect emerge, it follows that the explanation must be such a proposition as would lead to the prediction of the observed facts, either as necessary consequences or as very probable under the circumstances. A hypothesis then, has to be adopted, which is likely in itself, and renders the facts likely. This step of adopting a hypothesis as being suggested by the facts, is what I call *abduction*. I reckon it as a form of inference, however problematical the hypothesis may be held.... The early scientitsts, Thales, Anaximander, and their brethren, seemed to think that the work of science was done when a likely hypothesis was suggested....

The first thing that will be done, as soon as a hypothesis has been adopted, will be to trace out its necessary and probable experiential consequences. This step is *deduction*.... Having [thus]... drawn from a hypothesis predictions as to what the results of experiment will be, we proceed to test the hypothesis by making the experiments and comparing these predictions with the actual results of the experiment. Experiment... begin[s] with that positive prediction from the hypothesis which seems the least likely to be verified. For a single experiment may absolutely refute the most valuable of hypotheses.... When, however, we find that prediction after prediction... is verified by experiment... we begin to accord the hypothesis a standing among scientific results. This sort of inference... is alone properly entitled to be called *induction*.[73]

So abduction "enables us to formulate general predictions, but with no warranty of a successful outcome."[74] Therefore, ideally, not only must one support these intuitions with sufficient data but continually test them by deducing their consequences, seeking more data outside the original sample (especially data that might falsify them), and reasoning inductively from these data to check the theory again.

Unfortunately the formalists tended to overlook these later steps. They often confused "some" and "all"; reasoned from insufficient and/or unreliable data; selected their facts to fit their theories; ignored or argued away evidence that might falsify them (special pleading); and failed to pursue the chain of guessing, inferring, testing, and reguessing to its conclusion.[75] And their idealist and totalizing theories of organic formal development tended to bracket out the complex domains of genres, functions, purposes, and contexts on the one hand and of human initiative (aims and intentions) on the other.

In Krahmer's case, he noticed a surprising fact: that despite their internal complexity, the Laokoon (see Figure 83) and one or two other apparently "late" sculptural groups looked "one-sided." He then built a theory on it, that *all* such groups were "late," and deduced a consequence: that Hellenistic taste evolved first toward multifaciality and then gradually retreated into neoclassical one-sidedness. Finally, he proceeded to test his results inductively by appealing to dated monuments and to other groups outside his original sample.

Unfortunately, the dated monuments were too few and too diverse to be of much help, and when evaluating undated *comparanda,* his theory usually guided his selection of traits for analysis. Finally, the theory itself rested on concepts borrowed from Hildebrand and Wölfflin that are alien to antiquity and problematic even on their home turf of the Renaissance and baroque. The pattern is all too familiar. An originally flexible heuristic device becomes a rigidly predictive one – a way of creating ironclad typologies – and a familiar specter lurks in the shadows. Krahmer's agenda implicitly assumes some kind of Zeitgeist at work in all places and presumably in all media too.

Riegl, Wölfflin, and their contemporaries had thought hard about what they called the "two roots of style" – the internal and external, the formal and the social – and in the end Wölfflin even envisaged the absolute antithesis of Brunn's historicist agenda, an "art without artists." This notion soon crossed the Atlantic, finding a ready apostle in the charismatic American scholar and critic Rhys Carpenter (1889–1980).[76] Seduced by its appealing simplicity and obvious utility for solving the problem at hand, the more extreme formalists – Krahmer and his continental followers and Carpenter and his anglophone ones – simply gave up on both artists *and* society without offering any substitute account of causation or any justification of their teleologies. Why did the trends they saw begin, develop, and end as they did? Having done away with the artist as an individual with agendas and intentions of his own – as a social being – they failed to produce a plausible group psychology to take his place.[77]

Worse, as regards Hellenistic art, they overlooked a forest of signs indicating that its development is nonlinear and its styles not successive but cumulative and often genre-specific. And since the period is woefully short on "hard" evidence compared with the classical, they lacked a broad foundation of facts (i.e., secure contexts and dates) upon which to rest and test their totalizing theories. So they homogenized works from different genres and even different continents into a single, monolithic development; relied excessively upon a few well-dated sculptures; and dated others to suit their a priori theories. This meant that the Little Barbarians had to belong around 150 BC (though Krahmer's relegation of them to a footnote could suggest a lurking unease); the Magnesia frieze ca. 130; and the Laokoon (Figure 83) around 50.

Interestingly, the formalists' most distinguished ancient predecessor, the early Hellenistic critic Xenokrates of Athens, had used the same method on his material, with equally problematic results. Indeed, if Pliny's account in *Natural History* 34.54–67 truly reflects his evolutionary scheme, it certainly went badly wrong. Apparently lacking independent dates for Myron and Pythagoras of Rhegion, on purely formal grounds he placed them in that order between Polykleitos (fl., 420–417 BC) and Lysippos (fl., 328–325 BC), whereas in reality they preceded both, and Pythagoras predated Myron.[78]

Furthermore, the formalists failed to see that their a priori systems could never determine the particular case. Why should an observation about a particular characteristic of *some* Hellenistic groups be generalized into a teleological account of the development of *all* Hellenistic groups, let alone into a prediction about the dates of other, *as yet undiscovered* Hellenistic groups? There will always be exceptions to the rule.

So what Krahmer and his disciples produced was an elegantly argued, autonomous theory of internal stylistic evolution. Yet unlike (for example) three of their four great predecessors – Pliny, Vasari, and Winckelmann – they offered no account of causes, motivations, contexts, or goals and were arbitrarily restrictive in their selection of "significant" traits for analysis. For example, since sculptural groups necessarily involve interpersonal relations, why not select increases (or decreases) in melodrama, pathos, violence, humor, or eroticism, or at least crosscheck these with their supposed formal, compositional, and spatial evolution? If this suggestion seems comically subjective, it is no more so than privileging a selection of traits based on Hildebrand's transcultural theories about relief and plane, or Wölfflin's pendulum of "closed" to "open" form and back again.

In the case of the Little Barbarians, a plausible reason for what Krahmer rightly discerned as their tendency to "one-sidedness" had been proposed over half a century earlier and had nothing to do with any formalist teleology. Since Pausanias (AT6) explicitly says that they were related to a wall surface ("by the South Wall Attalos dedicated . . .") perhaps their designer produced a relieflike composition, or at least one not always fully developed in the round. Their recently recovered pedestals now show that this was exactly what he did. Rediscovered by Manolis Korres in 1992,[79] they are less than three feet (80 cm) wide at the top and stood right by the wall (see Figures 214–19, 226–28). Yet even so, cuttings on one of their cornice blocks (see Korres's Essay, catalog no. Γ1; Figure 268) prove that a "one-sided" figure very like the Vatican and Aix Persians terminated one of the battle scenes *side-on* to the spectator. This alone proves that the theory, even if admitted, cannot predict the particular case.

So like all such dogmas, early twentieth-century formalism was not only pseudoscientific, totalizing, and idealist, but it was also dictatorial. It conscripted history, culture, context, the individual, and especially the art-

FIGURE 84. Heads of (a) Chrysippos (d. 208–205 BC) and (b) the Aix Persian. The Chrysippos is a Roman copy; marble; height 30 cm. Florence, Uffizi 398. From Rudolph Horn, "Hellenistische Köpfe 1" *RM* 52 (1937): pl. 35.

work itself into its quest for order or "euchrony." Like all such idealist schemes it effectively denied "anachrony" – the sheer jagged messiness of history.[80] One is tempted to call it the perfect creed for the Age of the Dictators, but that is probably unfair.

For the formalists cared deeply about the artworks they appraised. They attempted to understand and explain them, not merely to catalog and categorize them; and when they put aside their obsession with stylistic evolution and chronology they achieved some signal successes. Acute and sensitive observers of detail who were equipped with a sophisticated and complex vocabulary with which to describe it, they noticed much that had hitherto been overlooked, undervalued, or misunderstood, and their perceptive and carefully crafted descriptions still speak eloquently today. Taken individually and freed from the tyranny of the dating game, these descriptions are eye opening – in critical terms, *ostensive* – in the best sense of the word.[81]

6. "IN THE MIRROR OF THE COPIES"

Krahmer's formalism soon gained some powerful allies, who proceeded to use it as a means to recover (as far as they could) the Attalid Dedication's original style and appearance. In this enterprise the copies were subjected to near-microscopic scrutiny and often treated once again as all but transparent to their originals.

In an almost forgotten study of the nude in ancient art, published in 1930, the Italian scholar Alessandro della Seta took up Lippold's remark about the Little Barbarians' realism. Della Seta focused on anatomical minutiae. Comparing the Barbarians with the Great Altar's Gigantomachy (see Figures 68–69, 236; then dated to ca. 180), and treating them essentially as originals, he called attention to their greater separation of structure from surface and of muscle from muscle; their greater formal elaboration and exaggeration; and their abandonment of any unifying fluidity of line. These characteristics pointed, once again, to a later date than the Altar and thus to the reign of Attalos II (159/58–138).[82]

Shortly thereafter a younger scholar, Rudolf Horn (1903–84), drove what he intended to be the final nail into the coffin of Brunn's early date. In his Heidelberg thesis of 1935, taking up an unfulfilled promise of Krahmer's, Horn had traced the formal development of Hellenistic male and female heads. Publishing it in 1937, he explicitly aligned himself with Krahmer's formalist agenda; withdrew his previous opposition to the later date for

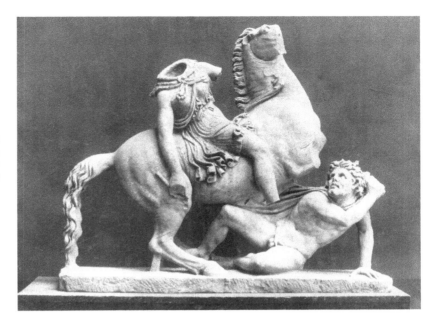

FIGURE 85. Amazon fighting a Gaul. From Nero's Villa at Anzio; Roman imperial period. Marble; height 1.1 m. Rome, Museo Nazionale Romano 124 678. Photo: DAI Rome DAIR 34.1930.

the Dedication; and included a set of superb new photographs of the Little Barbarians' heads, alongside others of similar style, to support his argument (Figure 84).[83]

In a long, complex analysis, Horn developed della Seta's ideas about the Barbarians' advanced style, as reflected "in the mirror of the copies" – a revealing phrase. Like Lippold he dated the extant statues to the second century AD, and noted that their makers had simplified, sharpened, and hardened the original modeling. He also remarked that the Aix Persian seemed to stand a little apart from the others; its richer modeling perhaps put it closer to its Hellenistic original.

Yet he too immediately proceeded to treat the Barbarians like originals, in a long series of detailed comparisons with other copies, the Great Altar (Figures 68–69, 236), and the Laokoon (Figure 83). En route, he explained – or explained away – the formal similarities between, for example, the Aix Persian and copies of reasonably well-dated third-century works like the portrait of the aged Chrysippos (Figure 84a), which was presumably erected near or just after the philosopher's death in 208–205. Appealing to the Wölfflinian categories of closed and open form, he argued that the comparison was superficial and misleading. For the Chrysippos lacked the Persian's "axial divergences, its co-ordination of anatomical details realized to the highest degree into overarching patterns of movement," and so on.

Predictably, Horn opted for the later date. Yet because the closest resemblances he had found were to other copies and specifically to the Chrysippos, his work actually pointed in a completely different direction. Ironically, as will appear in Chapter 3, his superb photographs and acute observations are perhaps most helpful in dating these Roman copies and in pinpointing the origins of their carvers.[84]

Meanwhile, in 1933 the Austrian scholar Arnold Schober (1886–1959) had joined the stampede, applying Krahmer's methods to the Amazon riders attributed long before by Mayer and Habich, to which he added a new one in Pentelic marble from Nero's villa at Anzio – now riding down a Gaul (Figure 85)! Developing Habich's old comparison with the Magnesia frieze, then dated to ca. 130 (but now often to ca. 200!), he satisfied himself that all of them must echo the original Attalid monument in Pergamon, via its Athenian counterpart.

As for the Athenian Dedication itself (he continued), whereas the figures' position along the Akropolis wall had long been thought to determine their relieflike form, Krahmer's 1927 article on "one-sided" groups had definitively proved the opposite. Hellenistic form had unquestionably evolved independently of function. So how were the Barbarians displayed? Since the ancient wall was higher than today's, and the vanquished could not have been in shadow while the victors were mostly or fully in sunlight, one could satisfy the entirety of the evidence only by lining them all up at the level of the *top* of the wall. This would require a series of steps capped by a long, low base, so that the public could climb up and look down on the dead and dying.[85]

Schober's Amazon riders soon met their match. In a stinging rebuttal, the polymath and critic Bernhard Schweitzer (1892–1966) rejected their attribution to the Pergamene monument because their date was too late (he liked Brunn's early one); their style too decorative; their

mood too sentimental; their scale either too big or too small; and their marble Greek.[86] (In fact, they are now usually seen as Roman decorative pieces; their closest relatives appear on Attic Amazon sarcophagi of the Antonine and Severan periods.)

Three years later, Schober counterattacked. He protested Schweitzer's dismissal of the Amazons, then – in default of any new evidence, arguments, or ideas – rehashed the major issues one by one. These included the Barbarians' supposed echoes on sarcophagi and in the minor arts; their possible attribution to a series of bases from the Pergamene Akropolis; their possible connection with the future Attalos II's campaign against the Gauls in 189–188 *and* Eumenes II's suppression of the great Gallic revolt in 166 (against Pausanias' explicit testimony, AT6); and their Athenian counterparts' location and relation to the Attalid colossi nearby (AT5 and 7). A follow-up article banished Pliny's four artists (AT3a) to the second century; dismissed the fact that Pliny lists their royal patrons as Attalos and Eumenes, not the other way around; argued away conflicting epigraphical evidence when possible; and posited homonymous ancestors in an alternating sequence when not. Schweitzer did not bother to reply.[87]

When World War II ended, Schober was forced into early retirement. His final contribution, a survey of Pergamene art published in 1951, retracted his earlier reconstruction of the Akropolis Dedication. He now opted for the same four-sided one that Brunn had conjectured, but transferred to the Akropolis itself and supporting the two colossi! This idea apart, he added only a stricter division of the copies between the Pergamene monument (the ten-figure "core group" of Asian marble) and the Athenian one (the riding Amazons and others, of Greek marble), and some remarks upon the stylistic divisions within the former, which he ascribed to the presence of Pliny's four artists (AT3a).[88] Yet though his prodigious output on the Little Barbarians was largely derivative, he had done some service by reexamining their setting; by inadvertently revealing the historical implausibility of the supposed Pergamene duplicate and the later date; and by reintroducing the Attalid colossi (AT5 and 7), by then almost forgotten.

Schober had dismissed the Roman battle sarcophagi (see Figures 203–04) in his brief discussion of the Dedication's echoes. En route, he had also demolished Reinach's interpretation of the Venice Kneeling Gaul (Figure 49) as a suicide by the simple observation that the preserved shoulder muscles show that its Venetian restorer, Tiziano Aspetti, was correct. The statue's upper arm was withdrawn a little, whereas a suicide's would have been angled forward in order to make the fatal stroke (see Figure 16; compare Figures 202–03).

But in 1956 Bernard Andreae took up the issue in a book devoted to the iconography and sources of the sarcophagi, arguing that the relationship was more complicated. These sarcophagi do not echo the Little Barbarians – the differences are too great – but what if all of them depended upon a single *common* source: a *painting*? Specifically – since Andreae subscribed to the Milchhöfer-Lippold theory that the Akropolis Dedication itself copied a bronze original in Pergamon – a *Pergamene* battle painting? In fact, a Pergamene battle painting *by Phyromachos*, whom Pliny lists both as one of the four bronzeworkers who "did the battles of Attalus and Eumenes against the Gauls" and as a teacher of painters (AT3a and *Natural History* 35.146)? Indeed, what if *all four* of the Akropolis groups and the corresponding sarcophagi (see Figures 203–04) ultimately depended upon a Pergamene cycle of *four* battle paintings that themselves inspired *four* sets of Pergamene bronzes, all by Phyromachos and his circle?[89]

In essence Andreae's elaborate theory depends upon an inference based on a hypothesis. It takes a now-lost painting of a Galatomachy at Pergamon mentioned by Pausanias around AD 170 (Paus. 1.4.6), and posits that a pattern-book reproduction of it circulated around the Roman sarcophagus workshops at exactly that time. Indeed, in its most elaborate form it depends upon this scenario being replicated *fourfold*, once for each of the Little Barbarians' four themes.

So the skeptics soon began to close in. The Marxist scholar Filippo Coarelli, eager to promote indigenous sources for Roman art and disliking Andreae's pattern books, sidelined Pausanias' Pergamene painting and instead turned to Livy's mention of Asian *artifices* in early second-century-BC Rome (Livy 39.22) in order to posit a hypothetical picture painted and exhibited there. Others questioned Andreae's chain of inference and the un-Hellenistic look of his reconstructed Galatomachy when compared with (for example) the Alexander Mosaic (see Figure 184), and either substituted a Trajanic relief (one equally hypothetical) as the putative model for the sarcophagi or jettisoned it altogether.[90] But nobody suggested dropping the Pergamene set of Little Barbarians, which by then had become canonized.

Relocating the prototype to Rome neatly eliminated the need for the pattern books but introduced other complications. For in the early second century BC, Galatomachies had been a popular subject on Etruscan architectural terra-cottas and burial urns (cf. Figure 86). These Etruscan compositions bear no resemblance to those on the Roman sarcophagi (see Figures 203–04), but many of them share motifs in common and one series, showing Gauls surprised while plundering a sanctuary, is so

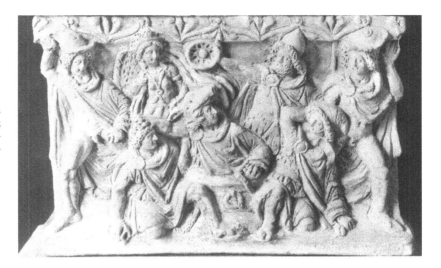

FIGURE 86. Story of Olta. Etruscan ash urn from Perugia; second century BC. Terra-cotta; length 50 cm. Perugia, Museo Civico 367. Photo: Alinari/Art Resource 47593. The squatting figures may quote the Aix Persian.

homogeneous that it too is often thought to echo yet another monumental painting.[91] But whereas this Etruscan tradition behaves much as one would expect, lasting for a century and then fading away, Coarelli's Roman one is most eccentric, completely disappearing for 350 years only to burst forth into the limelight during the high empire.

Unfazed, Andreae stuck to his guns and vigorously counterattacked. His recent publications make the Little Barbarians only one among a whole series of mid-second-century Pergamene and Rhodian victory dedications throughout the Aegean. Constructing a complex, interlocking pyramid of stylistic and thematic arguments, he attributes the originals of the Laokoon (Figure 83), the Farnese Bull, and the Sperlonga sculptures to this Pergamene–Rhodian golden age; links them with specific historical events; and reconstructs an entire policy of mythopropaganda crafted by Eumenes II (197–158 BC) to follow that of his father Attalos.[92]

Meanwhile, the hunt for more replicas continued, and new evidence emerged concerning the Vatican Persian. In 1934, Otto Brendel had thought that he had at last found one of the gods from the Gigantomachy (I). His candidate was a Dionysos in Copenhagen, presumably copied before the god nose-dived into his own theater in 31 (AT5). In 1959, Luigi Beschi endorsed his attribution and added another, the Rospigliosi Artemis, known in more than twenty copies. Unfortunately, at around 1.5 m tall the two of them overtop the Barbarians by about 25 percent, and it is suspicious that the Artemis should have generated so many copies when all the other figures – Brendel's Dionysos included – are unique. Finally, in 1951 and 1955 Carlo Pietrangeli published documentation that the Vatican Persian (see Figures 45–48) had been acquired not in 1514 from Alfonsina Orsini but in 1771 from the Giustiniani family via the sculptor Bartolommeo Cavaceppi. He refrained, however, from pursuing the consequences of his discovery. In 1954, Ludwig Curtius thought that he had discovered an echo of it in a painting of ca. 1450 by Dierick Bouts.[93]

In 1961, however, Tobias Dohrn showed that Curtius's observation and Duhn's similar idea of 1885 concerning the Aix Persian and the *Très Riches Heures* merited another explanation. These painters were looking not at the Little Barbarians but at some second-century-BC Etruscan funerary urns that pick up some of the Attalid Dedication's motifs (Figure 86). These urns were evidently above ground and available for study in some numbers after 1400. Since Dohrn also liked the late date for the Attalid Dedication, he then used it to establish a *terminus post quem* of ca. 150 BC for the urns, arguing for a migration of underemployed Pergamene artists to Etruria after finishing work on the Great Altar (see Figures 68–69, 236) and Small Dedication. In 1967 Brendel, who had earlier produced an essay on Titian's debt to antiquity that included the three Venice Gauls (see Figure 2), enthusiastically endorsed Dohrn's thesis and further explored its medieval and early Renaissance implications. It is now generally accepted.[94]

7. SKEPTICS AND REVISIONISTS

Most English-speaking scholars had never believed either the later date or the a priori formalism on which it was based. Yet they had never been able to produce any decisive arguments against it. In 1929 A. W. Lawrence had bluntly called it "unfortunate," since the last two Attalids' "uneventful reigns would have offered slight excuse for such a monument." In 1947 the historian Esther V. Hansen labeled Lippold's and Schober's arguments "extremely weak"; proposed that the *copies'* late date

FIGURE 87. Inscribed portrait herm of the philosopher Antisthenes (Roman copy). From a villa at Tivoli; original by Phyromachos of Athens, ca. 250–150 BC. Marble; height 56 cm. Vatican, Sala delle Muse 288. Photo: DAI Rome 77.463.

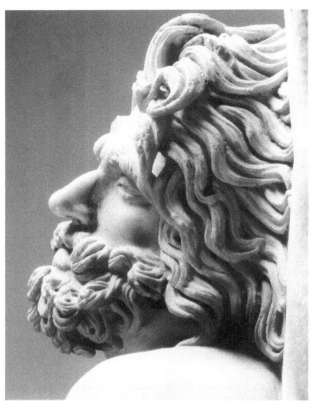

FIGURE 88. Head of the Naples Giant, left profile. Photo: Luciano Pedicini.

explained the anomalies; and concluded that "an unprejudiced reader of Pausanias . . . would certainly conclude that the group . . . represented the first great victory of Attalus I." In 1955 Margarete Bieber remarked that "the relation between the large and the small figures is too close for such a long interval." And finally in 1960 Rhys Carpenter even resorted to Pliny's remark (*Natural History* 34.24) about the popularity of three-foot *portrait* statues *in Rome* around 230 BC to support the earlier date.[95]

Only new discoveries could help. In 1969, three inscribed statue bases had appeared at Ostia, of which one read: "Antisthenes the Philosopher: Phyromachos made it." In 1971, Gisela Richter presented them to an English-speaking audience and associated this base with a portrait type of the philosopher Antisthenes that was identified by inscription, preserved in numerous copies (Figures 87, 249–50), and generally dated around 200. In 1979, I pointed out that the philosopher and the head of the Naples Giant (Figure 88) shared some significant traits and suggested that Phyromachos may have been responsible for both. In 1980 Andreae independently did the same and deployed a persuasive array of photographs in support. In doing so, we independently extended Furtwängler's "attribution game" to this corner of Hellenistic art.[96]

My observation was made during a reexamination of Athenian Hellenistic sculpture that reaffirmed the Akropolis Dedication's early date but remained open to a possible Pergamene duplicate. The argument was based not only on this new evidence but also on a strong resemblance between the Barbarians and terra-cotta figurines from the Athenian Agora dated by their archaeological context to ca. 200. In my view Horn's dissociation of the Aix Persian from the Chrysippos (see Figure 84) pointed to a difference not of date but of genre – of barbarian versus philosopher. So just as Brunn had argued, Attalos probably dedicated the Barbarians around 200 in response to the honors that the Athenians heaped upon him when he came to support them against Philip V's attacks.

Andreae, on the other hand, interpreted the find as confirming the late date for the Akropolis Dedication and thus for Phyromachos too. The results were predictable.

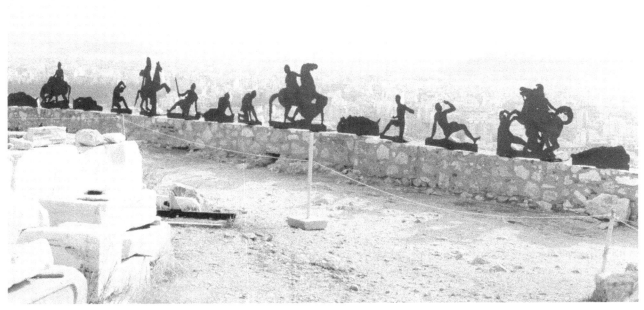

FIGURE 89. Plywood cutouts of figures attributed to the Lesser Attalid Dedication, placed on the Akropolis wall by Bernard Andreae in the 1990s. Photo: Klaus Anger, by permission of Bernard Andreae.

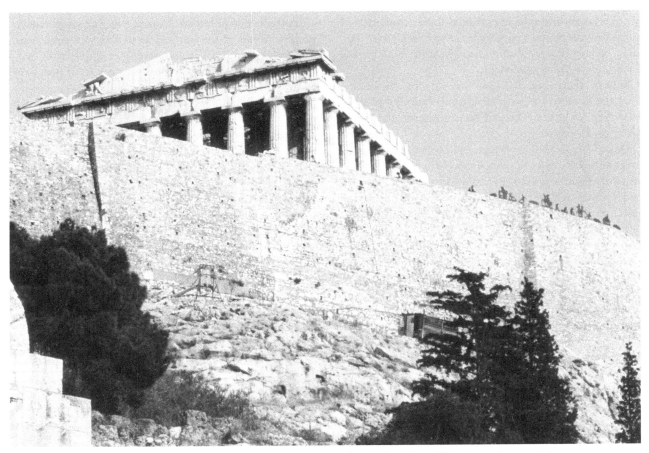

FIGURE 90. Andreae's plywood cutouts, Figure 89, seen from below. Photo: Klaus Anger, by permission of Bernard Andreae.

A German reviewer dismissed my ideas (ignoring terracottas, genre-styles, and context), and now German scholarship usually cites only Andreae. In 1985 a comprehensive review of the *Kulturpolitik* of Attalos I (r., 241–197) indicated how deeply entrenched this orthodoxy had become. It relegated the Akropolis Dedication to a footnote, since its later date was "proven." This is a classic case of what postprocessual archaeologists call "black-boxing": "Interpretation is made, accepted, then put away, out of sight and often out of mind, in a black box."[97]

In the early 1980s Beatrice Palma brought out her two invaluable articles on the Barbarians. These cataloged, illustrated, and discussed all previous attributions to the Attalid Dedication, totaling no fewer than forty-two statues; quoted most of the Renaissance documentation; referenced the important modern scholarship; and endorsed the later date. Palma accepted some previous additions to the "core group" yet balked at taking the final, decisive step. Instead of declaring the rest – especially the Amazons (see Figures 82, 85) – Roman decorative pieces with no proper Hellenistic precedents, she called them "elaborations" of Attalos' bronzes. Yet a growing number of scholars were already promoting the *Romanitas* of much Roman-period sculpture hitherto considered "copies" and investigating Roman neoclassicism as an artistic phenomenon in its own right.[98]

Shortly thereafter, the German side of the debate bounced back to life with new contributions by Tonio Hölscher, Andreae again, and the architectural historian Wolfram Hoepfner.

Discussing victims of violence in Hellenistic art, Hölscher argued in 1985 that like (allegedly) the Big Barbarians (see Figures 27–28, 81), the Akropolis Dedication had also omitted the victors. For they are still elusive despite over a century of searching, and Plutarch's attribution of a Dionysos could have been a mistake – a confusion with the Mark Antony–Dionysos of the refurbished Attalid colossi, which had also pitched into the theater in 31 (AT5 and 7). Furthermore, the sheer number of dead and dying would inflate the roll call of combatants to an incredible total; the figures' wounds and actions are sometimes contradictory; and the Aix and Vatican Persians' actions locate their opponents exactly where their composition ("a characteristically late Hellenistic union of centrifugal movement and one-sided design") demands that the spectator stand (see Figures 45, 77). Clearly, then, they were meant to be seen alone.[99]

Next, in 1990 Andreae published a large, multiauthored monograph on Phyromachos, inter alia restating his earlier attribution of the Naples Giant; and in 1993 he secured a permit from the Greek authorities to place plywood silhouettes of the Barbarians on the top of the Akropolis South Wall – but unfortunately at the wrong end of it (Figures 89–90). And in the same year Hoepfner used a series of cuttings on the cornice of the Great Altar's inner or sacrificial altar to argue that the Little Barbarians' supposed Pergamene originals stood there. He put the gods on the roof of the Altar's interior court (Figure 91) and, in the Athenian Dedication, on top of the Akropolis wall, with the vanquished on a low base at its foot.[100]

Others had already proposed all these ideas in one form or another, and rebuttals soon appeared. The critics countered that Plutarch (AT5) knew Athens well and explicitly says "the Dionysos from the Gigantomachy" (I) and that Pausanias (AT6) specifically lists the second of the Dedication's four subjects as "the battle *of the Athenians* against the Amazons" (II). He also states that the statues were "by" (*pros*) the South Wall, not on it – as Manolis Korres's discovery in the early 1990s of their pedestals all but confirms (see Figures 214–19 and Korres's Essay).[101]

Unfortunately, too, at Pergamon the riot of cuttings and dowel holes on the inner altar's cornice is impossible to reconcile either with bronze feet or with marble plinths. Some of the cuttings even overlap, indicating that elements of the display were later changed. In fact, comparison of a similarly cut but now inscribed base from the citadel shows that these cuttings were for an exhibition of military booty – armor, weapons, and other loot taken from Pergamon's numerous foes. The changes were presumably made in order to accommodate an ongoing influx of spoils from new victories.[102]

Finally, to return to the Akropolis Dedication, the cornice blocks of Korres's pedestals have interlocked footprints (see Figures 214–16, 268–78), showing that they supported battle groups in the traditional manner, just as an unbiased reading of Plutarch and Pausanias would suggest. Indeed, as remarked already, one of them (Γ1: see Figure 268) supported a figure on its right-hand end that was poised like the Aix and Vatican Persians but positioned side-on to the spectator (see Figure 4); this fended off an opponent coming from exactly the direction Hölscher rejects – an ugly fact indeed! By identifying these pedestals Korres has produced the first new hard evidence for the Dedication since Brunn and Michaelis.

Yet some of Andreae's, Hölscher's, and Hoepfner's ideas have found adherents. The rift over chronology also continues among the archaeologists (the historians prefer the earlier date), but is now located along the Rhine, not at the English Channel.[103] The non-German opinions are best represented in tabular form (Table 1).

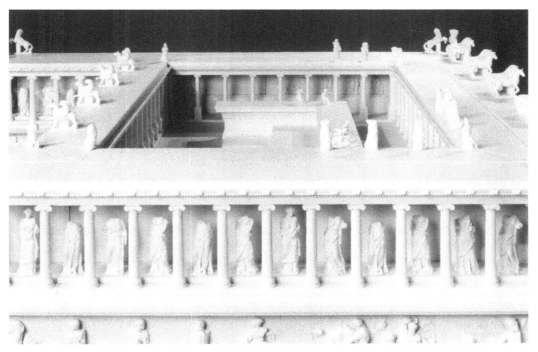

FIGURE 91. Model in corian of the Great Altar of Pergamon, ca. 180–160 BC. Berlin, Staatliche Museen. Photo: courtesy Staatliche Museen Preussischer Kulturbesitz, Dr. Wolf-Dieter Heilmeyer, and Prof. Wolfram Hoepfner. The Little Barbarians are conjecturally placed on the cornice of the sacrificial altar inside the court.

TABLE 1. The Attalid Dedication: Some Recent Opinions

Source	Date?	Victors?	Duplicate at Pergamon?
Pollitt 1986: 90	200	Probably not	No
Queyrel 1989, 1992	200	?	Yes
Ridgway 1990: 284	200	Probably not	No
Smith 1991: 101	200	Olympians only?	—
Hannestad 1993	200	Yes	—
Marszal 1998, 2000	Probably 200	Proved by the bases	No
Hurwit 1999: 269	200 or before[a]	Probably not	—
Beard and Henderson 2001: 162–64	Unspecified	Probably	—
Marvin 2002	Unspecified	Yes	—

[a] Citing AT1.

In addition, François Queyrel revives the link with the Athenian decree, AT2; speculates that the Persian and "core group" may be Hellenistic copies and perhaps even the very statues of the presumed duplicate at Pergamon (a kind of Brunn–Milchhöfer mélange); and endorses the notion of genre styles. R. R. R. Smith tersely remarks that the "use of varied formal styles here clearly has nothing to do with chronology; they simply express different things" (i.e., different races, ages, and sexes; the agony of dying versus the stasis of death). He also notes that freestanding bronzes were almost certainly more innovative than the architectural friezes with which the Little Barbarians have so often been compared, and that in any case the Great Altar may herald the end of the baroque rather than signal its apogee.

Brunilde Ridgway too stresses matters that others tend

to overlook. These include the clearly Roman and decorative character of most of the attributions; the "core group's" numerous restorations (see Figure 193); and the possibility of Roman contamination in its iconography. Indeed, she even doubts whether *any* of the figures, Big or Small, are bona fide copies. This pro-Roman agenda, already mentioned in connection with Coarelli and Palma, is one of the more interesting and controversial late twentieth-century developments in the field.

Although not new, it was catapulted to the status of an orthodoxy only in 1974 by Paul Zanker's pioneering book on classicizing statues and period taste in the Roman Empire. This superbly illustrated monograph reclaimed for imperial Rome a large series of winsome young males hitherto thought to be classical Greek (at least in origin); sought to establish a specifically Roman neoclassical aesthetic and set of functions for the genre; and organized it into a sequence of specifically Roman period styles. Zanker's and Ridgway's pupils and followers enthusiastically took up these ideas, promoting the originality of Roman-period work in various sculptural genres. Some even tried to contend that Romans *preferred* such contemporary, homegrown products to the Greek Old Masters.[104]

Critics, on the other hand, have responded that such proposals contradict what the ancient sources tell us about the Romans' overwhelming taste for Greek over contemporary art; inappropriately foist romantic/chauvinistic notions of originality and authenticity upon them; and last but not least now gainsay some of Zanker's own more recent conclusions about Roman visual culture. Zanker's own retreat from this early pro-Roman position was largely occasioned by Richard Neudecker's massive study of the sculptural programs of Roman villas, which showed that such collections were by and large thematically not stylistically based.[105]

Ridgway has approached the question from the opposite side, in a series of chronologically arranged handbooks on Greek sculptural styles.[106] Resolutely object-oriented and inductively reasoned, these studies at first sight look firmly neopositivist. Yet over the years their agenda has become somewhat different. In place of traditional, mainstream positivism's relentless quest for new facts, for new "bricks in the edifice of knowledge," they now manifest the trenchant, thoroughgoing skepticism of its more combative practitioners.

Ridgway staunchly (and refreshingly) refuses to take any observation or inference for granted. She has little truck with received wisdom and none with theory; emphasizes the limits of our knowledge rather than its horizons; and systematically uses perceived anachronisms in style and iconography to detach a wide range of works from their established contexts and to relegate them to later periods, preferably the Roman. Her targets include textbook pieces like the Praxitelean Apollo Sauroktonos, Pouring Satyr, and Aphrodite of Arles – and the Little Barbarians. But although "when all other contingencies fail, whatever remains, however improbable, must be the truth" (Holmes again, in "The Bruce-Partington Plans"), sometimes the upshot *is* improbable, and have all other contingencies really been ruled out?

So Ridgway's challenges have not gone undisputed. In the Barbarians' case she concentrates upon costumes, armor, and weapons, and finds them unhistorical – or at least, suspicious enough to impugn the statues' credibility as faithful copies. Where, for example, are the classical or Hellenistic parallels for a Persian wearing a sleeveless tunic (Figures 37–38, 77–78) or nothing at all except a hat (Figure 45)? Or for a Gaul wearing a possibly Italian helmet (Figures 43–44) or a Greek *exomis* (Figure 49)?[107]

Pursuing Ridgway's line of argument, her pupil John Marszal has questioned other aspects of the Barbarians' iconography. One or two of these objections concern parts of the figures that are restored, like the head placed on the Naples Dying Gaul (see Figures 24–25, 43–44, 193). Moreover, they all rest on a problematic combination of an argument *e silentio* (a lack of certified Greek parallels); an argument from verisimilitude (an expectation that Greek monuments of this kind would be historically and ethnographically accurate); and a hunch that the anomalies thus uncovered point to Rome. Yet though these revisions are unsustained by systematic testing – how well do these pieces fit into *Roman* art? – they must be taken seriously and are addressed in Chapter 4. Marszal, aware of Korres's pedestals, endorses the early-date-plus-victors scenario for the Akropolis Dedication.[108]

Finally, somewhat akin to Ridgway, Marvin and also Beard and Henderson finesse these problems by addressing the Attalid Dedication's afterlife in Rome. Both contributions, published after my Chapter 3 was written, anticipate some of its conclusions. Marvin too argues that the omission of the victors from both the Big and Little Barbarians was a Roman innovation, reminding contemporary spectators of the "triumphs of empire."[109] Beard and Henderson's postmodern agenda is more self-consciously radical. Although they agree that "in classical art, Greece is always mediated through Rome," they insist that "still more vitally, the works we shall be featuring *cannot* be seen outside their history since their modern rediscovery."[110] In the Little Barbarians' case they omit to follow up this second proposition, but concerning the first one they argue as follows:

[T]he business of selection, adaptation, and recombination opens up complications which must defy any attempt to treat such versions as straight replicas, no more no less. But the translation of Pergamum's defeated Gauls into the Roman landscape adds a particularly memorable twist to that general point. At no period in Roman history could you have imported any image of a defeated Galatian, kitted out in distinctively Celtic costume, without delivering a specifically Roman message, and in some sense turning Attalid conflicts into Roman struggles against their northern neighbors.... If we accept a Pergamene origin for these statues, we must focus all the more on the changes in orientation and interpretation brought about as the world 'went Roman'. For Roman conquests were necessarily mapped onto, and realized in, all the multifarious imperialist imagery they could mop up from the repertoire of earlier victors, now their victims. Such is the logic of artistic triumphalism within world domination.

These words echo the agenda of Chapter 3.

On the other side most German scholars remain adamant despite their increasing attachment to a new, lower date for the Pergamon Gigantomachy (Figures 68–69, 236). This new chronology was first suggested in the late nineteenth century and was revived by Peter Callaghan in 1981 on the basis of pottery fragments found in the Altar's foundation. It makes the monument a thank offering for the suppression of the great Gallic revolt in 166 and extends its construction beyond Eumenes' death in 158. So the full generation that on Lippold's revisionist chronology formerly separated the two monuments has now shrunk, allegedly, to a mere half dozen years. Yet Callaghan's proposal has its critics. Some doubt that the sherds in question can be dated so exactly, and reassert the monument's connection with Eumenes' earlier victories in 188 and 184/83, and the reorganization of the Pergamene festival of the Nikephoria in 182/81.[111]

Paolo Moreno has also declared for the later date for the Attalid Dedication, accepting all the major attributions to it and endorsing the results of della Seta's anatomical analyses. (Recognizing the chronological problem, however, he rejects Callaghan's lowered date for the Great Altar, arguing that the sherds were deposited – several meters down in its hard-packed foundation grid – after its completion.) He has also floated the intriguing idea that the Amazon could be Antiope/Hippolyte, who fought on the side of the Athenians and Theseus, and that the baby might therefore be Hippolytos. And lest the time-honored practice of inflating the catalog of copies should languish, G. Spinola now offers a riding "Commodus" in the Vatican, allegedly recut from yet another Amazon.[112]

8. RENAISSANCE ECHOES

What of the Barbarians' history after their sixteenth-century rediscovery? In the past three decades several newly published Renaissance inventories have solved some old problems of provenance and identification. In 1978, Marilyn Perry clarified the peregrinations of the three Venetian figures, and in 1989 Christina Riebesell did the same for the Neapolitan quartet, uncovering new information about their restoration and purchase by Alessandro Farnese (RT10), and examining their function within the didactically organized Farnese collection.

In the same year Queyrel traced the Aix Persian as far back as he could, but unfortunately the paper trail peters out in 1738. In 1980, Carlo Gasparri published the Torlonia inventories, which inter alia include the Persian acquired from the Giustiniani Collection in the early nineteenth century. And finally, in 1998 Angela Gallottini published the Giustiniani inventories themselves, which chronicle the Torlonia Persian's history from 1638 to as far as 1811 and also confirm Reinach's old doubts about the Vatican Persian being the victorious Horatius that was sent to the pope in 1514 (RT2).[113]

Meanwhile, others had found more Renaissance drawings of the Barbarians and their fellow travelers. Examples include Aspertini's studies of the Venice Dead and Falling Gauls and of the Naples Gaul (see Figures 104–05), and Peruzzi's and Dosio's of the Wilton Amazon (Figure 92). Some are significant works of art in their own right.[114]

Investigation of the core group's impact on later art, inaugurated by Duhn in 1885, was less far advanced. Alongside the occasional recognition of borrowings by Raphael and others, interest focused mainly upon the possible reappearance of the Aix and Vatican Persians on Etruscan urns and in late medieval and early Renaissance painting.[115] In 1955 Brendel examined Titian's use of the Venice Falling Gaul for his *Martydom of Saint Lawrence* and other canvases (see Figures 138–40), but later drew Perry's fire for not realizing that Titian knew it *before* Aspetti restored and completed it in 1587 (see Figure 111).

In 1972 John Shearman published a definitive monograph on Raphael's tapestry cartoons, discussing his use of the Paris and Naples Gauls for the *Death of Ananias* (Figure 114), and in 1977 Nicole Dacos – a classically trained art historian – noticed that the Paris and Venice Falling Gauls reappeared in his Vatican Logge, completed by his pupils after his untimely death in 1520 (see Figures 120–27). In 1987 Giuliana Calcani pointed to Caravaggio's similar use of a back view of the Naples Dying Gaul; in 1990 Stephen Fox reviewed all these Roman

borrowings through the early seventeenth century and added several more; and at the turn of the millennium a sumptuous exhibition in Rome extended the net to include Poussin and his pupils.

Phyllis Bober and Ruth Rubinstein's publication in 1986 of an indispensable handbook of Renaissance discoveries and borrowings from the antique, which underpins the Roman sections of the next chapter, has now greatly facilitated this kind of work. For example, their catalog, extensive but by no means complete, has served as the basis for Luba Freedman's reexamination in 1997 of the Venice Falling Gaul's impact in Rome and Venice. It makes a recent assertion that the discovery of the Little Barbarians caused virtually no stir in Renaissance art circles hard to understand.[116]

Like Duhn, Curtius, and Palma, several of these scholars pointed to apparent echoes of the Little Barbarians in Italian Renaissance art *before* the find of 1514 (RT1), suggesting that some of them had actually emerged from the ground some years before. But as Chapter 2 shows, these supposed echoes are better explained in other ways.

9. PROBLEMS AND PROSPECTS

So what does all this teach us? For convenience we may consider its lessons under two heads: scope and method.

The investigation's *scope* has been quite selective and partial. Interpretations of the original Akropolis Dedication have focused on its location, reconstruction, date, style, and relation to the Big Gauls (see Figures 27–28) and Great Altar (see Figures 68–69). Surprisingly little has been ventured on its relation to its context – physical, artistic, generic, cultural, social, and political – and its meaning. And until recently the Roman angle, when considered at all, had been addressed only as far as it intersects the Greek – that is, only as regards the fidelity or otherwise of the copies. No handbook of Roman art includes them. Finally, Renaissance scholars have concentrated almost exclusively upon documenting their peregrinations from one collection to another and upon tracing their exploitation as images of pathos (so-called *Pathosformeln*) by motif-hungry cinquecento artists.

Yet some nagging questions persist alongside the timeworn topographical, compositional, formal, typological, iconographic, and chronological ones. How should one interpret the choice of subjects, the strange scale, the extremist manner, the equivocal relation to the Big Gauls and Pergamene Gigantomachy, the lack of victors, and the lack of duplicate copies? How should one judge the statues both as reproductions and as Roman artifacts in their own right? And is their Renaissance afterlife merely due to their privileged status as ancient marbles (a mere ten among hundreds) and their obvious utility as readymade pathos formulae? Or did they offer something more?

Any assessment of previous assaults on these questions, let alone any attempt to formulate tentative new answers to them, immediately comes up against problems of *method*. Michael Baxandall has sketched three criteria for judging art-historical interpretations. Adopting and refining some thoughts of E. D. Hirsch, he labels them external decorum, internal decorum, and parsimony – or rather, "(historical) *legitimacy*, (pictorial and expositive) *order*, and (critical) *necessity* or *fertility*. They are not modes of proof but stances from which one may reflect upon the probability of one intentional account as against another."[117] He glosses them as follows:

The first, legitimacy, is a matter of external propriety. Much of this is straightforward, a normal avoidance of anachronism. We try not to suppose things in the [artist's] culture which are not there. [But after weighing the work against others by the artist and against the standards of its genre], delicacy is needed particularly at two points. One is not to drive a demand for legitimacy so hard and unidirectionally that originality or inadvertence or defiance are quite ruled out. Many great pictures are a bit illegitimate. The other is in distinguishing between levels of authority. I might produce a contemporary text to show a certain notion was available in fifteenth-century Italy; but against this I might also know that in a certain genre, such as the altarpiece, notions of this complexion did not occur. The more general, the second, would have tentative priority over the less, but might have to yield if the larger framework of explanation demanded.

The second, order, is a matter of adequately comprehending an internal organization, posited in the object one is addressing and reflected, in a different and informal guise, in the nature of one's explanation; both have an internal consistency. If the word did not have technical senses in both hermeneutics and the philosophy of truth I would have liked to call it coherence: "order" sounds bland. The area I have in mind is articulation, system, integrality, ensemble. [And since superior artworks are going to be the most organized or "coherent"], on the whole, the explanation positing the more complex and embracing order is preferable.

The third mood is critical necessity or fertility. One does not adduce explanatory matter of an inferential kind unless it contributes to the experience of the [artwork] as an object of visual perception.... [For example] there are many [contemporary] circumstances that one could adduce as consistent with [the artwork under discussion] which one does not adduce because they are not necessary to the purpose: which is inferential criticism. It is a pragmatic mood, a demand for a sort of actuality.

FIGURE 92. Wilton Amazon, Figure 66. Page from a sketchbook by Giovanni Dosio, ca. 1568. Pen and ink on paper; 13.5 × 19.2 cm. Staatliche Museen zu Berlin – Preussischer Kulturbesitz, Kupferstichkabinett 79D1, fol. 70v. Photo: Museum.

These may appear blunt tools but energetically applied together, trident-like, they can cut radically.

To these three "moods" I want to add one more, or rather, to split Baxandall's third one into two, gently teasing out his call for critical fertility and glossing it with *creativity, boldness,* and *novelty*. For these are not quite the same as critical necessity and parsimonious pragmatism. Thus, in 1865 to interpret the Little Barbarians as an Attalid victory dedication was parsimonious, bold, and fertile; to do so in the twenty-first century is still parsimonious – even Shylockian – but neither bold nor fertile. It ignores the main goal of all interpretation: to say something new.[118]

To stretch a point, these positions somewhat recall the four ancient cardinal virtues of Justice (*dikaiosyne*), Prudence (*sophia*), Temperance (*sophrosyne*), and Fortitude (*andreia*).[119] So we may call them for convenience the Four Cardinal Virtues of Archaeology. Starting with Brunn, the best of the accounts discussed above satisfy all of them to a greater or lesser degree. But what of the others?

Simple violations of these protocols and mundane mistakes aside (like failing to check facts or to gather all available evidence), it is all too easy to come up with a devil's list of transgressions. At the risk of sounding slogan-happy, one is tempted to press the metaphor and to label them the Seven Deadly Sins of Archaeology.

1. *Accepting survivals alone as significant or inferring negatives from silence.* The researcher succumbs to "the positivism of an object-oriented discipline: If it isn't in the artifactual record . . . it didn't exist" (or is unimportant or unknowable).[120] Yet absence of evidence is not evidence of absence, and arguments *e silentio* are often *weaker* than their targets. For negatives are unprovable, and new evidence may positively disprove them; but inferences/"abductions" may be supported by *comparanda*.

2. *Creating facts out of hypotheses or treating received hypotheses as facts.* The researcher so craves positive results, to "add another brick to the edifice of knowledge," that he or she uses theory or conjecture to invent a fact, twists the facts, or uncritically adopts another's theory as a fact. Yet in reality these concoctions are only pseudo-facts or (to resurrect Mailer's witty term) "factoids."

3. *Creating needlessly ingenious and complex solutions to problems.* Carried away by his or her own inductive arguments, the researcher piles hypothesis upon hypothesis (and often invents lost monuments) instead of finding a simpler and less conventional way out. The resulting edifice of conjecture both violates the Law of Parsimony and, like a card house, becomes more rickety the loftier it gets.[121]

4. *Arguing in circles.* Hypothesis A begets hypothesis B, which the researcher promptly uses to support hypothesis A – the classic vicious circle. (This is not to be confused with two *mutually sustaining* hypotheses or a "healthy circle," since in this case each one is conceived and supported independently. And it is emphatically not the same as following two separate arguments to their point of intersection.)[122]

5. *Special pleading.* Presenting a single item of evidence to create, support, or test a thesis while ignoring or dismissing everything to the contrary, or even blatantly resorting to argument by assertion (in print or orally), the researcher either reasons inductively from insufficient data or breezily subordinates *all* the evidence to his or her individual will.

6. *Obsolescence.* Clinging to once-authoritative ideas long after their utility has disappeared or the theories that sustained them have been discredited.[123]

7. *Parochialism.* Convinced of the superiority of his or her own school of thought (local or national), the researcher disparages or ignores work done elsewhere, in another language, or in a different tradition. Extreme parochialists refuse to acknowledge the validity of questions other than their own.

However, let the sinless throw the first stone. For since most ancient art is lost, what tends to drive our study of it is a kind of *horror vacui:* the desire to fill the void. And since the remains are often unprovenanced and undated, and we are historians rather than critics, we need to turn them into history in order to talk about them. We need to make connections, tell stories, build chronologies, and construct theories, and thus at times will inevitably join the ranks of the sinners.

Second and more seriously, since the 1920s and 1930s significant developments in this corner of the field have been few indeed. Positivism, formalism, and hellenocentrism may be crumbling, but most of the issues seem stale and the debate largely stymied. Maybe this particular topic has had little to offer for a while, but such stagnation also reflects a general crisis in the field.

The great project of classification that began around 1850 is now all but complete, and the methodologies that sustained it have less and less to offer. Much of the field has been mapped and its artifacts identified, sorted, and dated where possible. Excavation of most of the main sites (e.g., Delphi, Olympia, the Agora, the Akropolis [Figure 67], Pergamon, Ephesos) is largely complete, though much work remains to be done on architectural *disiecta membra* (like the blocks of the Attalid pedestals, see Figures 214–16, 268–78) and on artifacts in storerooms. Even so, future discoveries are likely to be incremental, and strict laws about cultural property combined with strangulating red tape will probably ensure that Italians, Greeks, Turks, and others will make most of them. All in all, significant new "bricks in the edifice of knowledge" will certainly be fewer.

Responding to this daunting, even unpromising situation and to what they see as the crippling positivism of the field in general, some have emphatically rejected traditional methodologies in favor of other, more experimental ones. Several of these projects – one thinks of the collaborative, poststructuralist *A City of Images* (1984/1989) – have borne copious fruit. Others, such as Beard and Henderson's outspokenly postmodern *Classical Art: From Greece to Rome* (2001) have yet to ripen into maturity.[124] And a few have produced a cankered crop. In place of positivism's passivity and pseudoscientism they substitute its opposite: solipsistic and often anachronistic readings of the material, frequently developed from photographs or plans alone in place of in situ autopsy. This kind of armchair speculation produces only a mirror image of its author's ego.

Historians of the discipline have connected this crisis with one in the humanities as a whole. To Ian Morris, for example, classical archaeology is essentially a modernist project, and its crisis is both a symptom and result of the collapse of modernism's faith in secure, stable centers. This crisis involves:

... the disappearance of depth models of the world, such as the dialectical distinction between the essential and the apparent, the Freudian between latent and manifest, the existential between authentic and inauthentic, and the semiotic between signifier and signified; and the loss of a genuine sense of the past as a place where alternative realities can be found.

The upshot, the "episteme" of postmodernism, involves:

... the decentring of the subject, an approach that rejects the primacy of the "panoptic" gaze; the piecemeal use of the past without regard for context; and the refusal to accept any totalising "metanarrative" which would provide a coherent meaning in history.[125]

An unsettling prospect. For almost two and a half centuries, ever since Winckelmann and Lessing fathered in the 1760s the decisive modernist break between the history and criticism of art, historians have dominated the field. (Suggestively, this is also precisely the period covered by T. J. Clark's recent "Farewell" to modernist painting).[126] So are the only available choices either simply to objectify the past in order to nail it down, and then to move on, or to collapse past and present completely – in short, to embrace either a problematic positivist historicism or a self-indulgent, ahistorical subjectivism?[127] At this point I must come clean with my own views, some of which surely have long been obvious.

First, as a historian I emphatically endorse the art of the periods I discuss as the historical "real." Indeed, it is hard to do otherwise when one is scrutinizing marble bodies for ancient tool marks or latter-day restorations, or standing in one's bare feet on a pockmarked statue base (see Figures 214–16) attempting to reconstruct the bronzes it once supported. I thus follow the lead of the artists I study, who (as we shall see) quote the products of the past as meaningful entities in themselves and thus proclaim the embeddedness of both object/source and its user in history. Yet such a stance by no means entitles me to suppose that this "real" can be objectified in a positivistic way.

Some reasons for rejecting historical positivism follow:

1. Our alienating and epistemologically frustrating distance, historically and culturally, from the past and its products.

2. Our role as latter-day readers of signs, which are continually inflected both by their tour through history and by our own active and evolving consciousness before, while, and after we encounter them.[128]

3. The ultimate undecidability of the visual, which consumes language and thus defies cut-and-dried objectification.

4. The refusal of artifacts/artworks to "speak for themselves." Instead, they issue challenges, and when confronted dare us to ventriloquize them.[129]

5. The impossibility of deducing an artist's intention from his or her work. For "the spectator will always understand more than the artist intended, and the artist will always have intended more than any single spectator understands."[130]

6. The slipperiness of contexts, which cannot be prepackaged and treated as finite, objectifiable historical units distinct from the artifacts/artworks under study; they are as much *effects* as they are causes.[131]

7. And finally, the codependence of (3)–(6), which continually deflects our judgments about each of them, opens them up to endless supplementation, and thus defers closure indefinitely.[132]

But to stop here – at a reductio ad absurdum of Wölfflin's "two roots of style" – is to risk paralysis. Moreover, it would be a needless capitulation to despair, confusing the impossible dream of closure with the quite practical goal of reaching some degree of understanding, however limited and provisional. For insofar as contemporary theory agrees on anything, it concedes that we *can* make meaningful historical statements about artifacts (among which, as mentioned at the outset, artworks constitute a special and particularly overcoded case), however imperfect and contingent they might be. Of course, such statements are not objective demonstrations or proofs but (as in the rest of the humanities) products of ongoing, intersubjective debate within a community of informed observers.

Even the context problem can be finessed. For since no work of art has a 1:1 relation to the material/cultural record, our understanding of the latter need not be perfect in every detail, merely serviceable enough for us to be able to assess that particular work against it and ultimately to integrate the two. The payoff is that since all explanation is underdetermined by fact, we are continually reinventing history. So, far from being ossified, it lives.

Second, "art" and "context" are not polar opposites nor even complementary to one another. Artworks do not "reflect" their contexts, "reproduce" ideas and feelings, or "represent" ideologies. Notions of this kind are merely more sophisticated versions of the ancient mirror theory of artistic *mimesis*, which reduces art to the redundant and frivolous business of reproducing the already known. On the contrary, artworks help to *create* environments; *produce* thoughts and feelings; and (as Louis Althusser argued years ago) help to *construct* ideologies. They are part of the stuff of social life.[133]

In this respect the socially and politically constitutive function of artworks parallels and complements the socially and politically constitutive work of language. To quote Terry Eagleton, "The hallmark of the linguistic revolution of the twentieth century, from Saussure to Wittgenstein to contemporary literary theory, is the recognition that meaning is not simply something 'expressed' in language: It is actually *produced* by it."[134] Linguistic production of signs *defines* human life: In Wittgenstein's famous definition, it is a "form of life." So are the other forms of human sign production, the visual arts included. To shift to an anthropological perspective, art, literature, music, sport, politics, philosophy, myth, religion, and so on are human *practices,* fields of cultural production, and can be analyzed codependently from this standpoint.[135]

So the goal is a historically and culturally informed attention to and analysis of the properties of a given artifact/artwork *in relation to others and to the field of production that generated it* – its functions, authorship, material, technique, genre, content, style, composition, iconography, and so on. A fragment of an ancient human practice, and culturally freighted in all sorts of ways, it thereby emerges as a socially, culturally, and politically formative entity, as as a form of Greek or Roman life. And reciprocally, it thereby offers mediated perspectives onto that life via its particular fields of cultural production – in the present case, the sculptural, religious, social, and political practices of mid-Hellenistic Athens and Pergamon.

This kind of close reading resembles the so-called New Historicism but differs from it by focusing upon the artifact/artwork per se rather than upon the culture that it "represents," and it also shies away from the 1:1 text(/artifact)–culture nexus tacitly assumed by many of the New Historicism's practitioners. But equally, to christen it a "New Formalism" is to overlook the latter term's checkered past, unwelcome associations, and limited scope.[136] With apologies to Peirce, James, and Dewey, "new pragmatism" might be better (though still not ideal), since it simultaneously addresses the method's renewed dedication to the object (*pragma*) in its totality, that object's own rootedness in and contribution to *praxis,* and the interpreter's employment of the discipline's traditional pragmatic tools. For the study of material culture, and thus of artworks, is not physics. Its methods are cumulative, not successive, and new ones do not necessarily drive out the old – positivist autopsy and analysis included. Even Newtonian physics is good enough for everyday use; no one needs Einstein in order to hit a baseball.

Yet our particular monument was made 2,200 years ago; lasted for many centuries; generated a cluster of texts (see Appendix 1) and a lopsided series of copies (see Appendix 2 and Figures 1–25, 29–64, 77–80); and has now disappeared but for a few dozen blocks from its pedestals (see Korres's Essay and Figures 214–16, 268–78, 286). Ten of these copies reemerged battered and broken in the Renaissance (see Foldout); promptly begat their own Roman and Venetian offspring (see Figures 93–149); were heavily restored (see Figure 193); and now stagger under the burden of a century and a half of accumulated scholarship. Moreover, the historical, epistemological, and personal factors listed above have both clouded the Dedication's original meaning(s) and indelibly colored our conceptions of it and its progeny.

So instead of heading directly for the Akropolis I want to feel my way toward it step by step, working backward from the Renaissance. In so doing, the meaning of these images may emerge as a product both of their own complicated genesis and of their continual appropriation and redescription, of the dynamic and ongoing interactions of facture, style, iconography, context, and interpretation through history.

Accordingly, the remaining three numbered chapters present a palimpsest of responses to the Little Barbarians – the results of a two-track engagement with the images and the cultures that created them. If one could graph each chapter, one would see that its concrete factuality (its absolute truth content), never 100 percent even at the start, declines markedly with each move away from the objects themselves into the murkier realms of interpretation and reception. And the deeper we dig, the more conditional our inferences become. "If Raphael indeed saw our Barbarians, then . . . ; if they were made under Trajan or Hadrian, then . . . ; if they are reasonably faithful copies of their bronze originals, then . . . ; if these originals were commissioned in 200 and not around 150, then . . . ; if Attalos and the Athenians really felt thus at that time, then"

But this does not mean that what follows is unhistorical; merely that it uses several different modes of inferential reasoning and thus (one hopes) explores several kinds of historical truth. It represents the results of one series of engagements with and responses to these ten statues within the parameters of what I, as a more-or-less informed student of these three cultures, can conjecture about them and the practices that produced them. It is not intended to be definitive or to preclude responses of quite other kinds in the future. This is the best we can get – with apologies to Paul Cézanne, it is the Truth in Sculpture. The alternatives are self-delusion or silence.

2. APPROPRIATION

Gladiators for Christ

෧෧ ෧෧ ෧෧

> "[W]hat is out of the common is usually a guide rather than a hindrance."
> SHERLOCK HOLMES, in *A Study in Scarlet*

IN 1527 OR 1528, the Scuola di San Pietro Martire in SS. Giovanni e Paolo in Venice held a competition for a new altarpiece. The entrants included Palma Vecchio, Titian, and Pordenone. Palma produced a saccharine, stodgy, and utterly conventional composition – nothing out of the common. But Titian and Pordenone hit upon exactly the same scenario – a completely unconventional, violence-filled drama that redefined the rules of the genre (Figures 93–94). A miracle? A case of innocent inspiration from the same source – the Venice Kneeling and Falling Gauls (see Figures 49, 53, 95)? Or something more sinister?[1]

Stalking the ten Little Barbarians through sixteenth-century Italy is hard work. Brunn uncovered parts of the trail in 1865, and Michaelis, Palma, Perry, Riebesell, and others have filled in many of the lacunae.[2] Still others have noticed that Renaissance artists eagerly sketched the statues and often used them for their own paintings and sculptures. Yet no one has pieced together the entire puzzle, and no one has systematically investigated the Barbarians' impact upon these High Renaissance artists. These are the aims of the present chapter.

The first section discusses the Barbarians' discovery in 1514 and the reasons for their immediate identification as the Horatii and Curiatii of Roman legend. The second charts their subsequent dispersal (see Figures 1–5) and considers their changing meanings after their installation in their new contexts and their refurbishment by two professional sculptor-restorers (cf. Figures 95, 111, and see Figure 193). The third, central section of the chapter turns to Renaissance responses to ancient statuary, theories of borrowing and quotation, and the ways in which some of the Little Barbarians satisfied the artistic needs and paradigms of the period and some did not. And sections 4–7 somewhat rashly examine the various uses that eight selected artists made of them and their types: Raphael, Peruzzi, and Michelangelo in Rome; and Sansovino, Titian, Pordenone, Veronese, and Tintoretto in Venice.

1. DISCOVERY

In the late summer of 1514, a group of Roman nuns or lay sisters were doing – more probably supervising – some construction work in their convent. While "walling up a cellar" (presumably part of an ancient Roman building) they made a startling discovery. They found at least five under-life-size figures, all of them dead or dying, which local pundits promptly identified as the Horatii and Curiatii of Roman legend (RT1). The nuns soon decided to sell them off; by this time they had recovered at least seven (RT2). The buyer was Alfonsina Orsini, the formidable widow of the hapless Piero de' Medici, who had moved to Rome only a couple of years previously. The nuns' decision to dispose of the statues was not unusual. Nunneries often were chronically short of funds, and when the sisters came across statues of naked men they usually sold them off as quickly as possible, deftly placating God and Mammon at a single stroke.

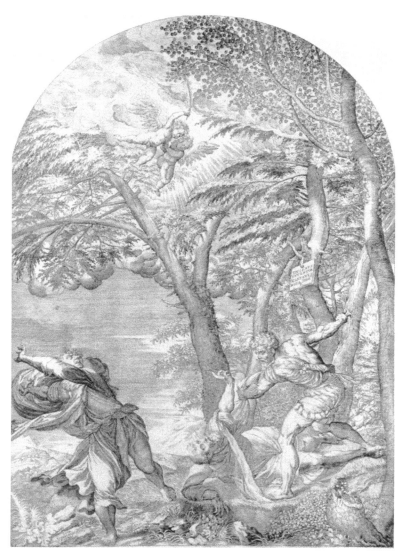

FIGURE 93. Woodcut by Martin Rota after Titian, *Martyrdom of Saint Peter Martyr*, 1526–30. Original, oil on canvas; 5.15 × 3.08 m. Photo: U.C. Berkeley Photo Archive.

FIGURE 94. *(below, left)* Study by Pordenone for *Martyrdom of Saint Peter Martyr*, 1526. Red chalk on paper; 24.4 × 20.7 cm. The J. Paul Getty Museum, Los Angeles, 87.GB.91. Photo: © J. Paul Getty Museum.

FIGURE 95. *(below, right)* Venice Falling Gaul. Photo: Osvaldo Böhm.

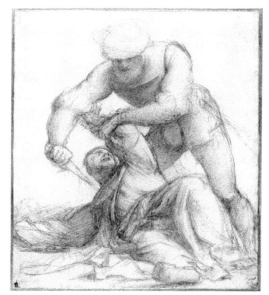

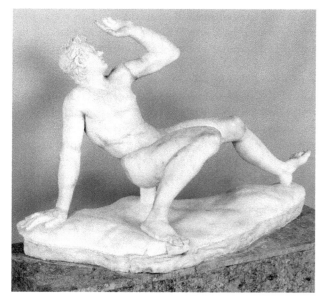

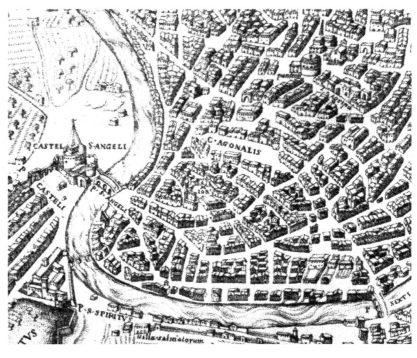

FIGURE 96. Detail of view of Rome by Francesco Paciotti, 1557. Vatican, Biblioteca. From Antonio Lafréry, *Speculum Romanae Magnificentiae* (Rome 1557): fol. 12v. Based on Bufalini's definitive plan of 1551; north is to the left. Toward the top, the Piazza Navona ("C. Agonalis") and Pantheon are easily distinguishable; the Palazzo Medici–Madama is the large, two-storied, freestanding building with prominent front door immediately above the former.

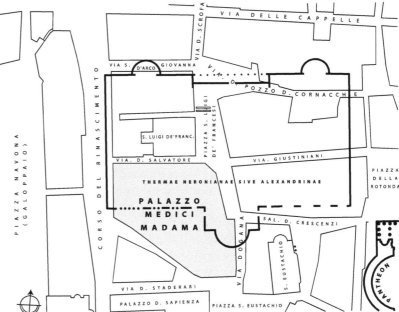

FIGURE 97. Plan of the modern streets of Rome and Palazzo Medici–Madama, superimposed upon the ancient topography (Nero's Baths and environs). Drawing by Erin Dintino.

Previous investigators, assuming that Alfonsina was the patroness of the convent in question, have occasionally tried to use this inference to locate it.[3] Yet Renaissance aristocrats did not control women's religious or semireligious communities in this way, and Filippo Strozzi's letter describing the discovery (RT1) shows that she was no exception. His point is to compliment her for renouncing the vulgar profits of usury and investing in art instead. If she had really controlled the convent, presumably she would not have needed to spend a single scudo on the statues. Yet though this particular trail seems to have petered out, all is not lost.

For the convent almost certainly stood in the Campo Marzio (Campus Martius; Figure 96). Women's establishments were concentrated there for safety's sake,[4] and Alfonsina's residence, the present-day Palazzo Medici–Madama, also stood there, amid the ruins of the Baths of Nero and Alexander Severus (Figures 96–97). Unfor-

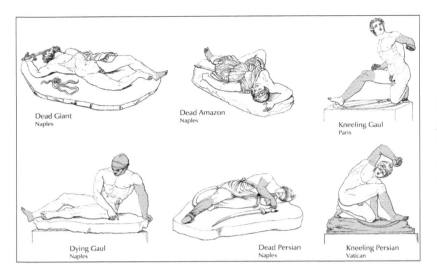

FIGURE 98. Alfonsina Orsini's six Little Barbarians, 1514. Adapted by Erin Dintino from Johannes Overbeck, *Geschichte der griechischen Plastik*, vol. 2 (3rd ed., Leipzig 1881): fig. 124. Later restorations are shaded; the Amazon had a baby at her breast (see Figure 72).

tunately, in the absence of further documentation the trail really does end here; but the statues themselves offer several clues as to their display context and thus to their location and function, as Chapter 4 shows.

A memoir by the French humanist Claude Bellièvre (RT2), who visited Alfonsina in the winter of 1514–15, lists the seven figures. Six can be securely identified (Figure 98). Numbered for convenience (see RT2) they are (1) the Naples Giant; (3) the Naples Amazon – who then had a baby at her breast; (4) the Paris Gaul; (5) the Naples Dying Gaul; (6) the Naples Persian; and (7) the Vatican Persian. The odd man out is no. 2, listed only in a marginal note that describes him as Marcus Horatius, "the sole survivor and victor." The note also says that Alfonsina had already given him to her brother-in-law, Pope Leo X. She put the remaining six (Figure 98) on display in her palace, the Palazzo Medici – later renamed the Palazzo Medici-Madama and now occupied by the Italian Senate (RT1–2).

Before continuing, however, we have a theory to test: that Bellièvre's fifth statue, the Naples Dying Gaul (see Figures 1, 41, 116), had been discovered well *before* 1514.[5] For a similar figure does duty as a cowering soldier in a Mantegna *Resurrection* of 1456–59 and in a Timoteo Viti cartoon of ca. 1505. Moreover, in 1512–14 Raphael recycled the type in his studies for his stillborn Chigi *Resurrection* (Figure 99) and in the Stanza d'Eliodoro, where it materializes as Heliodorus himself.

Unfortunately this theory violates two basic principles of iconographic source hunting. The artist must have *known* the source in question; and it must be *necessary* to explain the image that he created.[6] Yet Mantegna and Viti first visited Rome only in 1488 and 1511, respectively, and how they could have known about the Naples Dying Gaul earlier remains unexplained. Moreover, the proposal creates two very substantial problems.

First, if the Gaul was indeed known already, why was the new find – which we must now shrink to a mere *five* men and one woman – immediately identified as the *six* battling triplets and their sister (RT1)? Strozzi's story of the identification and his vague but suggestive mention of "at least five" statues (RT1) implies exactly the opposite. All seven surely were found together, prompting the pundits to pounce upon this identification. Second, if the Gaul was indeed already sitting in some other, now unidentified Roman collection, how did Alfonsina – a somewhat diffident collector – manage to find, recognize, and acquire him so fast, within a few months of the new discovery (RT2)? Both propositions entail that we suspend disbelief on a grand scale, leaving Occam's Razor to rust in the drawer and indulging in much special pleading en route.

Yet in reality this Mantegna soldier-type (if one may call him that) points to a quite different source of inspiration. For he begins by supporting his body on his *elbow*, not his hand, and is much more slumped over, only gradually raising himself from the ground by using his shield as a lever. Similar figures appear on the Etruscan urns, which (as mentioned in Chapter 1, §8) northern Italian quattrocento painters certainly knew and used, and on the reliefs of the Columns of Trajan and Marcus Aurelius (see Figures 198–202), which were widely disseminated in drawings.[7]

So (to return to our narrative) the sisters' discovery remains intact. And fortunately for their bank balance, it apparently caused quite a sensation. Strozzi's breathless account of the find (RT1) and the alacrity with which contemporary painters reacted to it (Figures 102, 114, 117–19, 121–31) make this crystal clear.

As we have seen, local connoisseurs had even been able to identify the group's subject, at least to their own satisfaction: the Horatii and Curiatii of Roman legend (RT1

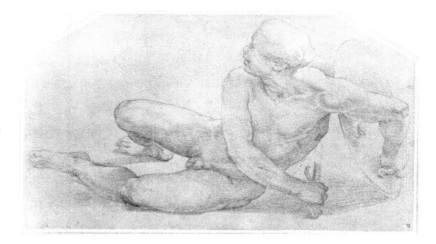

FIGURE 99. Raphael, recumbent guard, study for the Chigi *Resurrection*, ca. 1513. Black chalk on paper; 18.5 × 315 cm. Oxford, Ashmolean Museum P11560. Photo: courtesy of the Ashmolean Museum, Oxford.

and 2). The story, familiar to every educated person from Livy's great *History of Rome*, went as follows:[8]

Rome under King Tullius Hostilius was fighting for independence from its mother city, Alba Longa. Goaded by their dictator, Mettius Fufetius, the Albans had invaded, and the two armies were drawn up outside the gates of Rome, ready for battle. Yet with the Etruscans waiting to pounce, no one really wanted a fight. Fortunately, each side boasted a set of valiant triplets, the three Curiatii from Alba and the three Horatii from Rome. (But Livy has doubts as to which set actually belonged to which city.) The cream of Italian manhood, they were also cousins, and to complicate matters further, the sister of the Horatii (who is not named in the main ancient sources) was secretly betrothed to one of the Curiatii.

Selected as champions by ancient ritual, all six men resolved to subordinate kinship to country, and proceeded to fight each other between the armies. The Horatii triumphed only by a ruse. After a short time, though all three Curiatii were wounded, two of the Horatii lay dead on the ground. The surviving Horatius, being both unwounded and coolheaded, decided to feign flight. As his enemies followed one by one, slowed by their wounds, he turned on the nearest, killed him, and then fled again. Soon just one Curiatius was left; since he was also the most severely wounded and barely able to stand, let alone fight, the outcome was a foregone conclusion.

When the victorious Horatius returned to Rome, however, his sister met him at the city gate. Recognizing her fiancé's bloody cloak around her brother's shoulders, she fainted away. Enraged at this un-Roman display of emotion, Horatius at once ran her through with his sword. Put on trial, he was convicted of murder, but was allowed by King Tullius Hostilius to appeal to the people, who acquitted him. The Romans soon went on to destroy Alba and to incorporate the Albans into the Roman state. Horatius' appeal to the people (*provocatio*) established a venerable precedent in Roman law, and the conflict and its aftermath were associated with many ancient monuments and relics in and around Rome, which were revered as long as ancient Rome endured.

The Naples Amazon (see Figure 33) was at once identified as the Roman trio's murdered sister, even though she had a baby at the breast (RT2; see Figure 72) and the luckless Horatia must have been a virgin at the time.

Why the Battle of the Triplets? The label was not an obvious one. Not only did the figures not look like each other (one is bearded, and they are dressed quite differently), but what of the interloping infant? And the tale was by no means popular in medieval or early Renaissance Rome. When Petrarch toured the city in 1337 he was shown the place "where the triplets swore their allegiance over swords," but the description of Rome's historical geography in his *Africa* omits both this incident and the battle. And almost two centuries later, when Leo X revived the Palilia in September 1513 and commissioned Bramante to build an elaborate altarlike theater on the Campidoglio, its historical tableaux of archaic Rome omitted it too, stressing instead the themes of peace and cooperation between the city and neighboring Etruria. The poetry contest held within its walls did the same.[9]

This emphasis on peace was by no means gratuitous. For two years Rome and the Papacy had lived under the constant threat of destruction, and at last the thunderclouds seemed to be lifting. For in spring 1512 the French under Gaston de Foix had invaded Italy and on Easter Sunday had met the combined forces of Venice, Spain, and Leo's predecessor, Julius II, near Ravenna. In the bloodiest battle fought on Italian soil since the days of the Goths and Huns, ten thousand men died, two-thirds of them from the allied armies, and Ravenna was brutally sacked.[10]

Only Gaston's own death in the carnage and the resolve of the Swiss (who had not been involved in the battle) saved Rome from a similar fate. A month later a Swiss contingent eighteen thousand strong assembled in Verona, where Julius's envoy, Cardinal Schinner, addressed them. Calling them "loyal and chivalrous defenders and protectors of the Holy Church and the Pope," he presented them with Julius's gifts: a cap of honor and an ornamented sword. Thus fortified, the Swiss proceeded to sweep all before them; several major cities changed sides; and anti-French revolts broke out across the North. By July the invaders had retreated, and Julius was able to celebrate a glittering triumph and thanksgiving. In the Vatican, Raphael duly commemorated this miraculous deliverance with his frescoes of the expulsion of Heliodorus from the Temple and of Pope Leo I persuading Attila the Hun to leave Italy.

The storm had passed – for the moment. But in February 1513 Julius died and was succeeded by the young and inexperienced Leo X Medici, Alfonsina Orsini's brother-in-law. In fall, as the war wound down, he held his Palilia, choosing Italian unity as its theme, as we have seen. But peace proved elusive. The Venetians changed sides, and the French and Spanish soon joined forces. Faced with this formidable coalition, Leo temporized until July 1515, when the French finally made up his mind for him by invading. Outflanking the Swiss and papal detachments sent to guard the passes, they took Lombardy by storm and in September confronted Leo's demoralized coalition at Marignano, near Milan. A bloody two-day battle on the 13th and 14th decided the war, and with thousands more of his Swiss soldiers now dead on the battlefield Leo was forced to come to terms.

2. DISPERSAL

Despite or maybe because of its topicality, Alfonsina's group did not remain intact for long. According to Bellièvre (RT2, no. 2), in a gesture that was both timely and astute, she promptly selected the only statue among the seven that could be identified as the lone victor, Marcus Horatius, and presented it to her brother-in-law, Pope Leo. The gift, made before Bellièvre's visit in the winter of 1514–15, not only took up the main theme of the collection of Leo's predecessor Julius – the foundation of a New Rome under his own guidance – but was an obvious reference to the almost miraculous reversal of events after Ravenna.

Which statue did Alfonsina give him? Here we must pause for a moment to exorcise a stubborn incubus: the conviction that it was the Persian now displayed in the Vatican's Galleria dei Candelabri (see Figures 3, 45). For in 1889 Salomon Reinach realized that this statue must be the *final* one in Bellièvre's list (RT2, no. 7), "who has a fillet on his head and stands stooped to the earth as if killing someone beneath him."

Although Reinach's idea found no favor, publication of the Vatican and Giustiniani inventories now shows that he was right. The paper trail is clear and all but complete. Identified as a statue of "a Paris" because of its Phrygian cap and correctly measured at about 3 ½ *palmi* (78 cm) in height, it was in the Giustiniani collection from at least 1638 until sold to the Vatican in 1771. How long Alfonsina or her heirs kept it (it is missing from the palazzo's midcentury inventories and gazetteers, RT6–8), and when and where the Giustiniani brothers came across it (they began collecting soon after 1590), are still mysteries. As for Leo's statue, this too remains an enigma – for the present.[11]

The timeliness of this gift of Alfonsina's may have prompted Leo to install it where the indefatigable Aldrovandi saw it thirty years later: in the Swiss Guards' room (RT6 and 13), just outside the papal apartment (Figure 100, upper floor, room no. 1). This gesture on Leo's part neatly complimented the Guards' fellow countrymen for heroically saving Rome and the Papacy after Ravenna, turning the little statue into a morale booster and even perhaps a kind of talisman for them. A little later, in 1556–59, the traveler Jean Jacques Boissard noted that it was still there and "gets . . . the highest praises from sculptors" (RT13).

Yet oddly enough in these two accounts Leo's statue has mutated from a victorious Horatius into a defeated Curiatius. This could suggest that in isolation it looked less obviously triumphant than when first discovered. Alternatively, the disaster at Marignano (where thousands of Swiss were killed) and then the Sack of Rome in 1527 (when the entire Swiss Guard was massacred) might have sown doubts about its true identity and efficacy. Macchiavelli, no less, bears witness to this second option. In his *Discourses on the Ten Books of Titus Livy*, written in 1513–19 but published only in 1531, four years after his death, he discusses the Battle of the Triplets and its aftermath. In his view, the affair was folly from start to finish, amply verifying inter alia the maxim: "Don't put all of your fortune in danger with only part of your forces" (1.23). His contemporary example is precisely Marignano, which proved that trying to repel an enemy with part of your army merely risks the demoralization and defeat of the rest.[12]

Unfortunately for us, the Swiss Guards' quarters have moved; this whole wing of the Vatican has been remodeled; and the enigmatic "victor" has vanished. For its dis-

UPPER FLOOR, VATICAN PALACE

1 **Sala Vecchia degli Svizzeri**
2 Sala dei Palafrenieri
3 Sala di Costantino
4 Stanza d'Eliodoro
5 Stanza della Segnatura
6 Stanza dell'Incendio
7 Chapel of Nicholas V
8 Bathroom within tower
9 Papal bedroom
10 Papal antechamber
11 Logge
12 Site of tower
13 Tower

FIGURE 100. Plan of the Vatican in 1514. Drawing by Erin Dintino after Loren Partridge, *The Art of Renaissance Rome 1400–1600* (New York 1996): fig. 40, by permission. On the upper floor, the Swiss Guards' room, where the victorious Horatius sent to Pope Leo X in 1514 stood, is no. 1; the Papal bedroom is no. 9; and Raphael's Logge are no. 11.

appearance we can thank the Counter-Reformation. On February 7, 1566, less than a decade after Boissard saw Leo's statue (RT13), the newly elected, reformist Pope Pius V issued his famous decree banishing all pagan sculpture from the Vatican. For as a contemporary put it, "it was not fitting that Peter's successor keep idols in his house." In the end the Laokoon (Figure 109), the Torso (Figure 110), the Apollo, and a few other masterpieces stayed in the Belvedere (behind firmly locked doors), but all the rest went out. In the greatest giveaway of the Renaissance, many were handed over to the Conservatori on the Capitoline, but other collectors soon began to jostle for shares. Pius responded generously. Some of the remaining marbles went to his favorite cardinals and others to Francesco I of Tuscany, Albert V of Bavaria, and the Holy Roman Emperor, Maximilian.

Since Leo's statue stood just outside Pius's private apartment, it was surely among the first to go. Not surprisingly, the Vatican inventories show that the area was completely bare of sculpture on his death. Yet here the trail goes cold. Nothing like it appears in the inventory of his gifts to the Conservatori or in the letters to and from Francesco, Albert, and Maximilian.[13] We shall revisit this mystery shortly.

Alfonsina died in 1520, but her immediate heirs kept the rest of her collection largely intact. Between 1532 and 1536 Maarten van Heemskerck made two drawings of it, then displayed in the palazzo's loggia and garden, one of which shows two of her remaining six Barbarians (see Figure 71). On the extreme left, the (headless) Naples Dying Gaul (see Figures 1, 41, 116) is just discernible, sitting on the garden wall under the water basin. On the right, inside the loggia, the artist himself lounges, sketching, just in front of the (armless) Paris Gaul (see Figures 5, 61, 115), which leans against a marble table at the back of the loggia.[14] The other Barbarians must have been displayed elsewhere. Aldrovandi's account of twenty years later (RT6) suggests that the Amazon may have been on the garden wall to the left of the basin, and the rest out of sight behind it.

In 1537 Margaret ("Madama") of Austria, the sixteen-year-old widow of the appalling Alessandro de' Medici,

"The Moor," inherited the palazzo, which was soon universally known as the Palazzo Madama. Yet as Duchess of Parma, Regent of the Netherlands, and wife (from 1545) of Ottavio Farnese she was seldom in residence and in any case had little interest in antique sculpture.

By 1550, when the tireless Aldrovandi visited the collection to research his indispensable gazetteer of ancient statues in Rome (RT6), the Amazon was no longer recognized as Horatia, and the two most mutilated Barbarians, both armless, nude, and kneeling – the (Paris) Gaul and the (Vatican) Persian – had been disposed of, reducing the group to a mere four (see Figure 1). Both figures had presumably been sold, but to whom is still a mystery.

By 1619 the Gaul was owned by Scipione Borghese, who had begun collecting only in 1609. Extorted by Napoleon from the Borghese family in 1808 with numerous other antiquities, it now graces the Louvre's Hellenistic sculpture gallery. The Vatican Persian, as mentioned earlier, resurfaces in a 1638 inventory of the Giustiniani collection. In 1590 this family of merchant bankers had bought a palazzo near the Palazzo Madama and promptly went on a buying spree for sculpture to fill it; when and from whom they bought it, however, remains unknown. It stayed in the Palazzo Giustiniani for almost a century and half. When in the 1770s the family fell on hard times and started selling off its collection, the sculptor Bartolommeo Cavaceppi funneled it to the Vatican.[15]

Yet in other respects it is clear that in 1550 the garden and loggia had changed little if at all since Heemskerck's visit twenty years earlier. The Amazon still had her baby (see Figure 72) and the Dying Gaul, still headless, was still exactly where Heemskerck had drawn him, perched on the garden wall (see Figure 71).

Ten years later, however, Margaret suddenly displayed a quite uncharacteristic burst of interest in her collection. In a *motu proprio* of 1566 (RT8), Pius V – no friend to pagan statues, as has appeared – granted a petition from her to transfer selected pieces to Parma, the four remaining Barbarians (see Figure 1) included. The transfer never took place, and her reasons for making the request are opaque. Perhaps, as some have suggested, she was simply taking out an insurance policy. For she and the last direct Medici heir, Caterina, had been squabbling over the ownership of the palazzo and its contents for many years. This papal permission slip guaranteed that if she lost the battle she would at least have the satisfaction of depriving the implacable Caterina of some of her spoils.[16]

In this document (RT8), the Amazon has undergone drastic surgery. Aldrovandi had dutifully noted the baby at her breast fifteen years earlier (RT6), and some years before that Frans Floris had included a drawing of it in his Basel sketchbook, sprawled across her right side (see Figure 72). Yet Pius's *motu proprio* (RT8) omits it, noting only that the girl's right breast bore a wound. The baby is never mentioned or pictured again, and the reason for its sudden removal between ca. 1550 and 1566 remains a mystery.

When Margaret died in 1586 she left her entire Roman estate to her son, Cardinal Alessandro Farnese. Yet since the Medici still held title to the palazzo itself, Alessandro lost no time in removing the collection before they could lay their hands on it. It went directly to the Palazzo Farnese, where an inventory of February 1587 (RT10), records it in the studio of Alessandro's house sculptor, Giovanni Battista de' Bianchi, whom he had charged with refurbishing it for display.

Giambattista's restorations must have been minor. They certainly did not include the removal of the Amazon's baby, which had occurred two dozen years before, or the provision of a new head for the Dying Gaul. For he is still headless in the Farnese inventory of 1644 and in a drawing in the Cassiano dal Pozzo collection of 1657 (see Figure 76).[17] The later inventories are annoyingly unspecific,[18] but since the collection was moribund by then, it may be that the head presently on the Dying Gaul was added as late as the 1790s. At that time, many of the marbles were transferred to the sculptor Carlo Albacini's studio for restoration before shipment to Naples (see Figure 193). It seems to have had a head ten years later, when a Naples Museum inventory describes it as "deserving restoration because of its expression."[19]

In the 1587 Farnese inventory (RT10) the dead and now childless girl is at last identified, correctly, as an Amazon, and the three male statues are no longer called Curiatii. Instead, the Dying Gaul and Persian are anonymous and the Giant is a gladiator. The final curtain call for the old identification came a quarter of a century later, when the Cavaliere d'Arpino painted his monumental treatment of the Battle of the Triplets for the Palazzo dei Conservatori on the Capitoline. There, following cinquecento tradition (RT2, 6–8), he painstakingly modeled the dead Curiatius in the left foreground upon the Persian.[20]

Yet in the 1644 Farnese inventory all four are again anonymous; in that of 1697 all are gladiators (even the Amazon!); and in that of 1767 two are gladiators and two are Amazons. (But now, more understandably, given his costume, the Persian is the misidentified one.) In Naples in the 1790s these slips were corrected and the canon finally established: three gladiators and an Amazon (compare Figure 1). These identifications held until Brunn's lecture of 1865.[21]

After all this it comes as no surprise that when in 1586 Giambattista began his restoration work and needed a pendant for the fountain he was making out of the huge

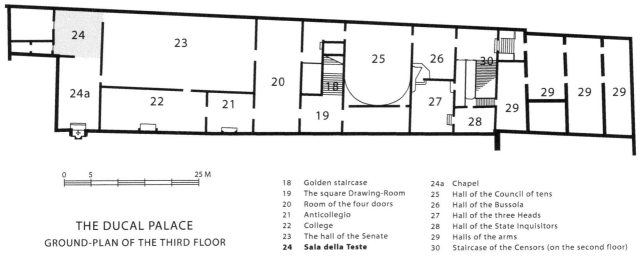

FIGURE 101. Plan of the upper floor of the Palazzo Ducale, Venice, in 1523. Drawing by Erin Dintino.

Farnese Bull, he chose six entirely different and much larger ancient marbles to play the battling triplets. For the pendant had to be both impressively large in order to balance the Bull's "meravigliosa monte di marmo" and had to feature a proper battle scene, with all or most of the participants still on their feet and fighting.

The Medici–Madama collection furnished four of the victims, three of which are identified today as a triumphant Perseus and the Tyrannicides Harmodios and Aristogeiton; the fourth is the still anonymous Farnese Gladiator. To complete the sextet Giambattista added two other warriors already in Alessandro's possession. Renaissance theory and practice sanctioned – indeed encouraged – such restorations that not merely resurrected the monuments of antiquity but creatively rivaled them in a spirit of *paragone*. But Alessandro's sudden death in 1589 spiked the project, and his *pugna*-fountain was never built.

The instigator of this exercise in rivalry with the antique is unknown, and now that Giambattista's restorations are gone and his group broken up, his capacity for *inventione* is equally obscure. His stylistic sense, however, was quite acute. For the six statues are quite similar in scale, and five of them are copies after early classical bronzes and stylistically quite homogeneous.

Yet Giambattista's work was not entirely in vain, for some years later Cardinal Odoardo Farnese set up his six fighters as a group in the palazzo's grand salon, where they are dutifully recorded as Horatii and Curiatii in the seventeenth-century inventories. In 1775–80 and 1784–85 Jacques-Louis David probably saw them in situ, was duly impressed, and used them as models for his celebrated and revolutionary *Oath of the Horatii*, now in the Louvre.[22]

To return to the Little Barbarians, what of the other four: the three Gauls now in Venice and the Persian in Aix (see Figures 2, 4)?

Even in 1865 Brunn already knew that two of the Venice Gauls, the Falling Gaul (the "Breakdancer") and the Kneeling Gaul, were to be found in the palace of Cardinal Domenico Grimani (1461–1523) on the Quirinal Hill in Rome by the early 1520s. Immediately after Domenico died they were inventoried among the huge collection that he had shipped from Rome to Venice toward the end of his life and stored in the convent of Santa Clara on the island of Murano (RT4, nos. 6.A and 9.F). Eleven days before his death he had willed many of these objects, including numerous paintings and all his bronzes and marbles, to the Venetian state (RT3 and 5).

The Signoria, however, accepted only a few of them, the two Gauls included. Domenico's favorite nephew, Marino, took charge of the rest, adding them to his uncle's own generous legacy to him. Two years later, on September 11, 1525 (RT5), the two Gauls went on display with the rest of the marbles in a special room in the Palazzo Ducale, the Sala delle Teste (Figure 101). In this fairly accessible spot (RT5), they could be seen by the Venetian elite and soon attracted the attention of artists such as Jacopo Sansovino, Titian, Pordenone, Veronese, and Tintoretto (see Figures 93–94, 137–49).[23]

In the 1523 inventory (RT4) and repeatedly thereafter (RT9 and 12), the Venice Gauls are called "gladiators," and from 1587 the Farnese statues often are identified as such too (RT10; see earlier in this section). This may seem unremarkable given the fact that the original find of 1514 had been broken up, and the Renaissance had little of our sophisticated iconographic and textual apparatus with which to work. Yet any educated individual

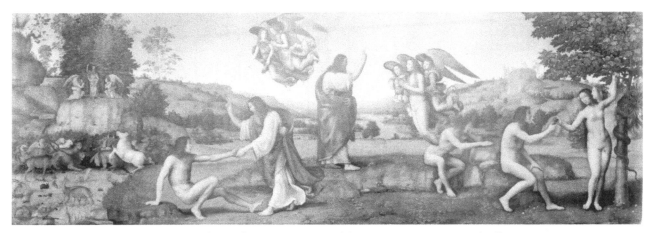

FIGURE 102. Mariotto Albertinelli, *cassone* painting of the *Creation, Temptation, and Fall,* ca. 1514–15. Oil on wood; 56.5 × 165.5 cm. London, Courtauld Gallery, Gambier-Parry Bequest. Photo: Courtauld B61/490, courtesy of the Samuel Courtauld Trust © Courtauld Gallery, Courtauld Institute, London. The Adam on the left quotes the Venice Falling Gaul.

who had read Ovid, Seneca, and Suetonius on the Roman games and Pliny and others on Greek and Roman statuary must have known perfectly well that gladiators were a problematic institution in ancient Rome and were never commemorated in mainstream Roman art. Alternately praised for their bravery and condemned for their crudity and servile status, they provided a necessary but potentially brutalizing service to the body politic.[24] So why identify these statues as gladiators?

The answer is threefold. First, most ancient authors took a positive view of gladiatorial bravery and lauded the beneficial social effects of the games. Second, the Renaissance was obsessed with ancient Roman triumphalism, with re-creating the great triumphal spectacles that the gladiatorial games had climaxed. Beginning in the quattrocento, Renaissance antiquarians painstakingly researched and documented the ancient Roman triumphs; Renaissance artists just as diligently pictured them; and Renaissance potentates enthusiastically re-created them in the flesh.[25] And third, these Little Barbarians had come to light completely without context and conspicuously lacked the helmets and armor of proper soldiers. (The Naples Dying Gaul was then headless; see Figures 71, 76, 193.) No wonder they were identified as gladiators so quickly.

Few have noticed that the 1523 Grimani inventory (RT4) hardly marks the Renaissance debut of these Venetian "gladiators." For from 1515, the Falling Gaul (Figures 95, 111) makes several appearances in the work of Albertinelli, Peruzzi, and the pupils of Raphael (Figures 102, 127, 130–01). These show that, just like Alfonsina's Barbarians, it too was discovered almost certainly in 1514 and caused a similar sensation.[26] Its debut is in Mariotto Albertinelli's sparkling *cassone* painting of the *Creation, Temptation, and Fall* now in the Courtauld Gallery (Figure 102), where the leftmost figure of Adam clearly quotes it. The Paris Gaul (see Figures 61, 115) may also have inspired the Abel of one of the *cassone*'s side panels, now in Bergamo. Fortunately, because of their idiosyncratic style and their pointed references to other antique statuary in Rome (the Dioscuri of Monte Cavallo and a sarcophagus in the Villa Medici), the date of these panels can be pinpointed with some confidence.[27]

From 1509 to 1512 Albertinelli worked in Florence with Fra Bartolommeo, deftly accommodating himself to his partner's graceful and visionary classicism. In 1512, however, he abruptly dissolved the partnership and abandoned painting to run a tavern. When he took up his brush again early in 1513, his style was much different: quirky, mannered, and full of archaisms. He first visited Rome in the summer of 1514, at about the time that Alfonsina's Barbarians were discovered, and he died in Florence in November 1515.[28]

Albertinelli therefore must have painted his *cassone* with its Roman citations in the last year of his life. Consequently the Venice Falling Gaul, his source of inspiration for Adam (Figures 95, 111), must have been found with or very soon after Alfonsina's figures, in the late summer or fall of 1514. Either Alfonsina was content with acquiring the first batch of statues to appear (Figure 98) or the nuns sold the others separately, or both. The Falling Gaul then begins to turn up regularly in the work of other painters, particularly Peruzzi (from 1516) and the pupils of Raphael (from 1517: Figure 127).

The 1523 inventory of Domenico's legacy also lists another "gladiator" (RT4, no. 27.L). Could this statue be the third Venetian Gaul, the one sprawled out dead on his shield? He is listed clearly in the final Grimani inven-

tory, seventy years later (RT11, no. 13). Yet a fuller description of Domenico's legacy in the 1587 inventory (RT9, no. 14) shows that "gladiator" no. 27.L cannot be the Dead Gaul. For "gladiator" no. 27.L was "on his feet, naked, with a piece of drapery gathered on his right shoulder ... [and] with a cuirass on the ground leaning up against his right leg." An under-life-size statue in the Museo Archeologico di Venezia of a furtive Ulysses wearing a *pilos* (Figures 2, 103) fits the bill perfectly.[29]

So where was this third, Dead Gaul (see Figure 57)? Although first documented only in 1593 (RT11, no. 13), he was definitely in circulation at least sixty years earlier and probably in the 1510s. For he appears along with the Venice Falling Gaul in the second London sketchbook of the eccentric Bolognese artist Amico Aspertini (1474/5–1552) (Figures 104–05). Its drawings are remarkably homogenous in style, and it is unanimously dated to ca. 1535–40; both figures are set against the fantastic architectural backgrounds that preoccupied the artist during these years.

Yet there is no evidence that Aspertini ever visited Venice, and the only other identifiable Venetian antiquity in his sketchbooks, a sarcophagus with a relief of a naval battle, was certainly in Rome around 1500. Furthermore, another drawing in the same sketchbook groups the Venice Falling Gaul with a naked man that might be a composite of the Naples Persian and Dying Gaul in mirror image, and a third shows the Naples Dying Gaul itself (Figures 104–05). Both of these statues were in Rome throughout the period in question.[30]

But Aspertini did visit Rome. He went there at least twice, first in 1500–03 and a second time probably around 1515–18. As has appeared, only during this latter period were the Naples and Venice Barbarians (see Figures 1–2) in Rome together, and a few years later they were separated forever. So Aspertini presumably first drew them during his second Roman visit and resurrected them to inhabit his architectural fantasies twenty years later.

All this means that, along with the Falling and Kneeling Gauls, the Venice Dead Gaul was probably part of the nuns' find of 1514. If Domenico Grimani had acquired it along with the other two figures, it must have been one of the marbles rejected by the Signoria in 1523 and taken in by his nephew Marino. If not – and such a rejection would be somewhat surprising given its quality and expressiveness – either Marino bought it shortly thereafter or his brother Giovanni, Bishop of Aquileia (of whom more below), did so after Marino died bankrupt in 1546. For Giovanni promptly acquired Marino's entire collection; handsomely augmented it with numerous purchases of his own; and thenceforth focused his energies on re-

FIGURE 103. Ulysses. Roman. Marble; height 97 cm. Venice, Museo Archeologico 98. Photo: Osvaldo Böhm.

uniting all the family treasures in the family palace at Santa Maria Formosa on the Ruga Giuffa. Wherever the Dead Gaul came from, it was definitely in this palazzo by the 1580s (RT11).[31]

The Falling and Kneeling Gauls remained in the Palazzo Ducale until 1586, when the Signoria decided to use the Sala delle Teste for other purposes. Since this meant dismantling Domenico's by now somewhat dilapidated legacy, Giovanni, the family patriarch, promptly intervened. He begged the Signoria to take his magnificent collection as a gift; to add it to Domenico's legacy from the Sala delle Teste; and to display everything properly in an adequately funded state museum. Persuaded by the old man's eloquence the senators caved in. Giovanni immediately had the marbles from the Sala delle Teste inventoried (RT9); taken to his palazzo at Santa Maria Formosa; and restored by his house sculptor, the energetic and talented Tiziano Aspetti (Figures 95, 111, 193)

Autopsy of these Barbarians (see Figures 2, 49–60, 95, 111, 193) and a glance at the 1587 inventory (RT9) shows that Aspetti's list of restorations (RT12) – compiled seven years after the event in order to further his plea for payment – is somewhat exaggerated and contains a number of mistakes. Not noticing this, one critic has even

FIGURE 104. Amico Aspertini, drawing of figures in a classical landscape, ca. 1535–40. Pen, ink, and watercolor on paper; 22.5 × 16.5 cm. London, British Museum 1862-7-12-394 to 435, fol. 17. Photo: BM PS 356445 © The Trustees of the British Museum. The two foreground figures quote the Venice Falling Gaul and the Naples Dying Gaul.

FIGURE 105. Amico Aspertini, drawing of figures in a classical landscape, ca. 1535–40. Pen, ink, and watercolor on paper; 22.5 × 16.5 cm. London, British Museum 1862-7-12-394 to 435, fol. 30. Photo: BM PS 356446 © The Trustees of the British Museum. The figure at center quotes the Venice Dead Gaul; the one to the right quotes the Venice Falling Gaul.

tried to credit him with the thoroughgoing agenda of restoring the collection in a "modernizing" way after contemporary paintings like Tintoretto's at the Scuola Grande di San Rocco. This theory takes Aspetti's petition (RT12) at face value; ignores the entire history of the Falling Gaul's reception; and entails that Aspetti's spiderlike reconstruction of it is wrong.[32]

Yet Aspetti certainly did complete the figures by repairing such items as broken noses and drapery folds and by adding new limbs and other items as necessary. Half of the Falling Gaul is his work (see Figures 95, 111, 193). Yet the stumps of the limbs and the complete lack of any traces of plinth attached to the buttocks suggest that he got the pose more or less right – like several of the painters who had quoted the statue since its discovery seventy years earlier (Figures 102, 127, 131, etc.). As Chapter 3 (§4) will show, however, he may have erred in making the Kneeling Gaul threaten an opponent with a sword. Instead, this Gaul was perhaps begging for mercy with outstretched hand, somewhat as Veronese rendered him around 1570 (see Figure 142).

Yet even though Aspetti completed his task with dispatch, the Venetian bureaucracy moved at its usual glacial pace. When Giovanni Grimani died on October 3, 1593, the new museum was still under construction. The massive inventory of his effects made shortly after his death includes Domenico's two Gauls; the Ulysses; and the Dead Gaul (see Figure 2; RT11). Four years later, in mid-1597, their installation in the new Statuario Pubblico at the entrance to Sansovino's library (the Biblioteca Marciana) at last brought an end to their peregrinations. They are still in the same building and retain most of Aspetti's restorations, though the Statuario has now become the Museo Archeologico di Venezia (see Figure 2).[33]

Finally, there is the Aix Persian (Figure 106). Tobias Dohrn and more recently François Queyrel have shown that presently it cannot be traced beyond 1738, when it appears as a "gladiator" in an inventory of the collection of Cardinal de Polignac. Then located in Paris, the collection had been formed in Rome between 1724 and 1732, when de Polignac was French ambassador to the Vatican. According to its publication by the sculptor and restorer

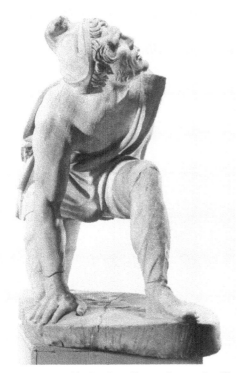

FIGURE 106. Aix Persian. Photo: Centre Camille Jullian.

FIGURE 107. Amico Aspertini, *Adoration of the Shepherds*, ca. 1530. Florence, Uffizi 3803. Oil on wood; 44.5 × 34 cm. Photo: U.C. Berkeley Photo Archive. The kneeling shepherd at right seems to quote the Aix Persian.

Lambert-Sigisbert Adam in 1755, the marbles had "been found at Rome in the ruins of the Palaces of Nero, and of Marius."[34]

In this 1755 publication the Persian is illustrated (in mirror image) and described as a Phrygian, but its exact provenance is not stated. The few individual provenances that are given, however, show that the "Palace of Nero" is Domitian's palace on the Palatine and the "Palace of Marius" refers to a sculpture find near Frascati in the 1720s. Since this was a sale catalog, however, Adam's statement was certainly self-promoting and cannot be trusted in the particular case. Although given the history of the other Little Barbarians one inevitably wonders whether the "Palace of Nero" might not also refer to the *Baths* of Nero, the catalog offers no comfort for such a leap of faith and a fair amount to discourage it. One can say only that the Persian certainly came from Italy and probably from Rome or nearby.

Could the Persian be "the sole survivor and victor... Marcus Horatius, whose statue was taken to the Pope," of the marginal note in Bellièvre's manuscript (RT2, no. 2)? If the cowering Persian presently in the Vatican could be described as "killing someone beneath him" (RT2, no. 7), this other one might (just) be taken for a victor too. If so, he must have been hidden away in some Roman collection between 1566, when Pius V expelled him from the Vatican, and the early 1700s. The fact that he wears shoes, contrary to Bellièvre's specific statement that the Naples Persian (RT2, no. 6) alone did so, is irrelevant, for Bellièvre was describing only the six statues that he actually saw in Alfonsina's collection. His marginal note about the seventh, the one sent to the pope, is an afterthought – a later clarification – and there is no evidence that he ever clapped eyes on it at all. In the papal apartments, the Persian's facial hair and dress (cap, jacket, trousers, and slippers) may have made him especially congenial to the similarly attired Swiss Guards. Did Alfonsina choose him for that very purpose?

A Renaissance painting and cartoon offer some support to this idea. Dohrn, Brendel, and Queyrel have correctly dismissed several supposed quotations of the Persian in the fifteenth-century *Très Riches Heures du duc de Berry* and in works by Mantegna, Dürer, and others. Yet they overlook another one, much closer in time and place to the Barbarians' discovery: a kneeling shepherd in Aspertini's *Adoration* of ca. 1530 (Figure 107).[35] As has appeared, Aspertini certainly saw and drew the Naples Dying Gaul, the Venice Falling and Dead Gauls, and perhaps the Naples Persian too when they were together in Rome between 1514 and 1521 (Figures 104–05). The shepherd, with his similar pose, right hand flat on the ground, telltale "drilled" cross folds, long sideburns but

93

no beard (the Persian's is restored and he is described as "beardless" in the 1738 de Polignac inventory),[36] cap, and wild hair, is basically the Aix Persian's double. Only the left arm curving across the body is different, and this is exactly what is missing in the statue.

The cartoon is Raphael's study for the tapestry of the *Sacrifice at Lystra* in the Vatican, executed for Leo X in 1515–early 1516 (Figure 108). Although scholars have rightly identified a pair of Roman sacrifice reliefs as its primary source, the kneeling attendant or *popa* in the foreground also somewhat recalls the Aix Persian.[37] The folds of the garment over the leg and the muscular arm and shoulder are not dissimilar, but what strikes the eye (my eye, at least) is the strong facial resemblance between the two. The open mouth, beaky nose, wavy brow, and distinctive hairline with forward-brushed hair are all identical. Was Raphael perhaps flattering his patron by quoting the most recent addition to his collection?

But with this conjecture we have entered the contested world of Renaissance appropriations.

3. APPROPRIATION

The discovery of the Little Barbarians in 1514 evidently caused something of a sensation. Most, perhaps all of them were on display in Rome for the next few years – critical ones for the High Renaissance. At least two became accessible for study in Venice after 1525 (see Figure 2). And artists as varied as Albertinelli, Aspertini, Raphael, Giulio Romano, Peruzzi, Michelangelo, Baccio Bandinelli, Jacopo Sansovino, Vasari, Stefano Maderno, Pordenone, Titian, Tintoretto, and Veronese apparently knew them and made repeated use of them in their work. Yet despite the foregoing conjectures as to the Aix Persian, it appears that of the ten figures only the Naples Dying Gaul, the Venice Falling Gaul and the Paris Gaul (Figures 95, 111, 115–16) made any major impact on Renaissance art. The others all but disappear into oblivion. Why?

In a seminal article of 1972 David Summers identified the *figura serpentinata* as a central trope of High Renaissance representational practice.[38] Invented by Leonardo at the end of the fifteenth century and perfected by him and Michelangelo in the first decade of the sixteenth, this compositional schema was an intensification of the simple two-dimensional *contrapposto* of the quattrocento. Both schemes were derived from the study of Greco-Roman sculpture and texts, particularly the writings of Cicero, Pliny, and Quintilian.

Yet quattrocento theory demanded only an antithetical arrangement of straight and flexed limbs and raised and

FIGURE 108. Raphael, detail of the cartoon for *Sacrifice at Lystra*, 1515–16. London, Victoria and Albert Museum. Black chalk and tempera on paper; 3.47 × 5.42 m. Photo: V&A F13219. The kneeling attendant (*popa*) may quote the Aix Persian.

lowered hips and shoulders in two dimensions. This was the scheme that Polykleitos had perfected almost two millennia earlier in his Doryphoros, known to the Renaissance only through Pliny's brief description (*Natural History* 34.55–56) and a few other scattered texts. The new cinquecento *figura serpentinata* required the artist to develop these antitheses in depth and to integrate them in a manner that suffused the body with life, movement, and grace. Accorded Christian authority by the spiritual musings of Dionysios the Areopagite (translated by Marsilio Ficino in 1499, widely disseminated, and highly esteemed), this upward, flamelike spiraling of the human body soon came to represent the symbolic externalization of the spirituality of the soul.[39]

The crucial text is a treatise by Giovanni Lomazzo, published only in 1584 but much indebted to Michelangelo's ideas and pictorial practice.

Thus Michelangelo gave this advice to his pupil, the painter Marco da Siena, that he should always make the figure pyramidal, serpentinate, and multiplied by one, two, and three. And this precept appears to me to contain the entire secret of painting, inasmuch as the greatest grace and beauty that a figure can have is when it reveals itself in movement, which is called by painters the *furia* of the figure. And to represent this movement there is no form better suited than that of the

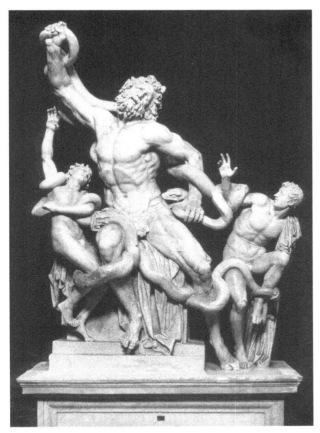

FIGURE 109. Laokoon, Figure 83, as restored by Giovanni Montorsoli in 1532–33. Marble; height 2.42 m. Vatican, Cortile del Belvedere, now dismantled. Photo: Vatican Museums VIII.5.23. The right arm is restored.

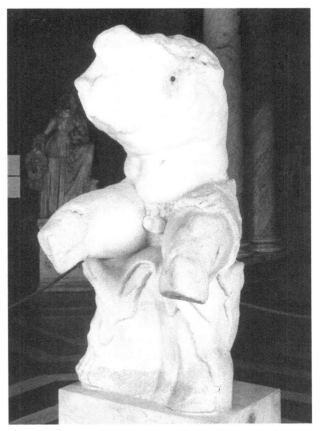

FIGURE 110. Belvedere Torso, signed by Apollonios son of Nestor of Athens, 1st century BC. Marble; height 1.59 m. Vatican, Atrio del Torso 1192. Photo: Vatican Museums Museums XXXIV.22.10.

flame of fire, which according to Aristotle and all the philosophers is the most active element of all, and the form of its flame is the most suited to movement of them all, because it has the cone and ths sharp point with which it seems to want to break through the air and ascend to its sphere. . . .

But because there are two forms of pyramids, the one straight like that which is near St. Peter's in Rome, which is called the pyramid of Julius Caesar, and the other in the form of a flame of fire – this is the one Michelangelo called serpentinate – the painter must add the geometric pyramid to the serpentinate. . . .

So all the aforesaid movements, with so many others that may be made, should be represented in such a way that the body is serpentinate, to which Nature is easily disposed. Also it has always been used by the ancients, and by the best moderns. In all the acts that the figure may do, the twistings of figures are always seen done in such a way that if the arm thrusts forward for the right part (or whatever attitude seems best to you) and the other part of the body is lost [to sight], the left arm obeys the right, and so the left leg comes forward, and the other is lost to sight. The same must be observed if you wish to make the left arm thrust forward, and so the right leg, because the right arm must obey the left, and the other side of the body must be drawn back. This should be followed in whatever action is done, lying as well as running, flying, fighting, standing still, kneeling, and in short in whatever purpose to which a body may be turned. It will never be graceful if it does not have this serpentine form, as Michelangelo wished to call it.[40]

This is what Vasari is talking about in his famous but notoriously vague account of the *terza maniera,* the High Renaissance style:

After [the quattrocento artists] their successors were enabled to attain [perfection of finish] through seeing excavated out of the earth certain antiquities cited by Pliny as amongst the most famous, such as the Laocoon [here Figure 109], the Hercules, the Great Torso of the Belvedere [here Figure 110], and likewise the Venus, the Cleopatra, the Apollo, and an endless number of others. These, with their sweetness and severity, their fleshy roundness copied from the greatest beauties of nature, and certain attitudes which involve no distortion of the whole figure but only a movement of certain parts, revealed with a most perfect grace, brought about

the disappearance of a certain dryness, hardness, and sharpness of manner, which had been left to our art by the excessive study of Piero della Francesca and [a dozen or so more quattrocento artists].[41]

Now our Little Barbarians certainly ranked high among this "endless number of others" that Vasari mentions. Yet among them only the Naples Dying Gaul, the Paris Gaul, and the Venice Falling Gaul (Figures 95, 111, 115–16) truly conform to the requirements of the *figura serpentinata*.

As their respective restorers later understood when completing them, they alone develop a *contrapposto* in depth, deploying head, shoulders, and hips in a series of counterpoised, recessive diagonals to create a truly "serpentine" and flamelike movement to the body. They alone meet Lomazzo's stipulation that this kind of movement should characterize *all* bodies, including kneeling and prostrate ones. And they alone stand comparison with those two Renaissance icons par excellence, the Laokoon and Belvedere Torso (Figures 109–10), and mutatis mutandis are formal counterparts to them.

Indeed, *formally* the Venice Falling Gaul, Paris Gaul (see Figures 95, 111, 115), and Laokoon (Figure 109) are cousins, as are the Venice Falling Gaul, Naples Dying Gaul (see Figures 95, 111, 116) and Torso (Figure 110). But by their very nature the Laokoon and Torso served best as models for lunging and seated figures, respectively. What made the Little Barbarians special (and no doubt particularly attractive at that time) was the virtuoso way in which they extended the range of options to a dazzling variety of falling, kneeling, slumped, and prostrate bodies.

To put it another way, Leonardo, Michelangelo, and their cohorts discovered, analyzed, and appropriated a fundamental compositional principle of the Hellenistic baroque, now presented to them in a compelling mixture of guises. We shall revisit the subject of their insight in Chapters 3 and 4. At present let us concentrate on what a selected group of them made of it.

Yet throughout it must be remembered that the identification of the Paris and Naples Dying Gauls as Horatii and/or Curiatii was never fully codified; was signally weakened by the removal of one of them to the Vatican soon after discovery (RT2); and was never extended to the three Venetian figures (see Figure 2). Though they were clearly warriors, a glance at Trajan's Column (see Figures 198–202) would immediately confirm that they were just as clearly *not* Roman soldiers. As a result they remained enticingly open to creative interpretation.

Moreover, all of them were left in an unrestored, fragmentary state until late in the sixteenth century (RT8 and

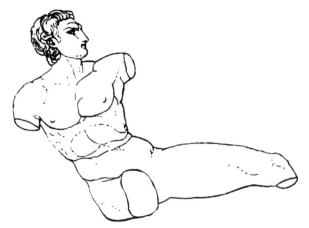

FIGURE 111. Venice Falling Gaul with restorations removed. Drawing by Erin Dintino.

12). The Paris Gaul was missing both arms below the shoulders and his right leg below the knee. The Naples Dying Gaul had lost his head, his right forearm, his left arm below the shoulder, and his right foot. And the Venice Falling Gaul had no left arm, right arm below the shoulder, left leg below the knee, or right leg (see Figure 193). Indeed, sans arms and legs, the Venice Falling Gaul (Figure 111) was surely displayed in the Sala delle Teste lying supine, like the devastated lover in Veronese's *Scorn* (Figure 143), or at best propped up a little, like Titian's *Saint Lawrence* (see Figure 140). Yet any alert observer – and Renaissance artists were exceedingly alert – would have realized that originally he must have appeared much as Aspetti later restored him, supporting himself on one hand like his pendant, the Venice Kneeling Gaul (see Figures 2, 49, 53). So while the remains offered strong clues as to how each figure should be completed, the numerous lacunae equally encouraged artistic invention and creativity.

Still, in all this uncertainty and flux the one constant and most emphatic feature of the Little Barbarians must not be forgotten. All of them display the most intense emotion and strong physical contortion. These features make them prime candidates for consideration under the sign of the "pathos formula" or *Pathosformel*.

Coined in 1905 by the brilliantly original art historian Aby Warburg (1866–1929) to account inter alia for the continuing spell of the Laokoon (Figure 109), the *Pathosformel* has been defined as "a formulaic representation of a pronounced psychological state of being." It is an instantiation of a mood or emotion that is so complete, powerful, and satisfying that it not only anchors itself in the individual observer's memory but also enters the collective imagination as such. Warburg himself went further, somewhat breathlessly labeling these formulae "dynamograms," "precipitations of those psychic energies

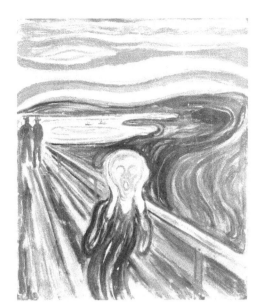

FIGURE 112. Edvard Munch, *The Scream*, 1893. Oil on canvas; height 91 cm. Oslo, Munch Museet. Photo: Museum. © 2002 The Munch Museum / The Munch Ellingsen Group / Artists Rights Society (ARS), NY.

which once shook the Greek tribal communities . . . and took hold of the Roman world in the exultations of a pagan warrior tribe. Whether by heritage or by contact, the artist who comes into touch with these symbols once more experiences the 'mnemic energies' with which they were charged."[42]

Warburg's insights gave a powerful shot in the arm to what many art historians were apt to regard as a relatively routine procedure. Nevertheless, his *Pathosformeln* and "dynamograms" still tend to boil down to a potent dose of the old concept of "influence," understood almost in its primary (medieval, astrological) sense of a kind of subliminal emanation that one cannot avoid even if one wants to. Yet to Warburg the expressive gesture, the remembered "engram," is essentially neutral with respect to content. Like a volatile metaphor it can easily reverse its meaning. A triumphant gesture can turn to one of magnanimity, an angry gesture to one of pain, and a brutal gesture to one of healing. Continually faced with converting pagan subjects to Christian ones, Renaissance artists found such "energetic inversions" most appealing.

Warburg never properly defined the *Pathosformel*. "Sometimes [it] seems to mean no more than an item of visual vocabulary, a way of representing a gesture or scene, sometimes it contains the sense of urgency controlled through ritual, but it could also be something which could be debased by facile use."[43] Unfortunately, at this point his own biases led him into further trouble, causing him to favor the early Renaissance and to brand most if not all mannerist and baroque artists as degenerates. In other words, he finessed the entire problem by imposing a scale of aesthetic value upon his material and judging its borrowings accordingly.

One of the paintings Warburg denounced most vehemently was Giulio Romano's *Battle of Constantine* of 1520–24 in the Vatican. Since this huge fresco features a possible reminiscence of the Venice Falling Gaul (the fallen warrior under Constantine's horse, though a different source of inspiration is perhaps more likely), we too have apparently stumbled onto hotly contested ground. For the Sala di Constantino was a papal hall of state – a sumptuous audience chamber for the first Christian emperor's latter-day successor, Pope Leo X. Commissioned under the threat of Hapsburg invasion, painted after Raphael's premature death in 1520, and completed only three years before the Sack of Rome in 1527, its four huge frescoes of Constantine's life expounded the basis of the pope's temporal authority and the church's supremacy over the empire. Raphael and Giulio Romano designed them to rival Roman antiquity and thematized their borrowings accordingly. Instead of disparaging their work, recent scholarship prefers to assess it in relation to this fraught, highly charged context. Many critics give it a high grade, and one even considers the battle scene to be "[un]surpassed in the whole of the Cinquecento."[44]

Yet one should not write off Warburg's *Pathosformeln* altogether, for certain emotionally and culturally charged icons do seem to persist in individual and collective (cultural) memories and often do "influence" artists by offering them a tempting treasury of unforgettable images to plunder. The Laokoon itself has all but vanished from the contemporary imagination, but in its place we now have modern icons like Edvard Munch's *The Scream* (Figure 112) and "Nick" Ut's harrowing 1972 snapshot of a naked and napalmed Vietnamese girl, *Terror of War* (Figure 113). We shall revisit the subject of cultural memory in Chapter 4, §5.

But even in these cases to speak of "influence" still distorts the picture. It still fails to address the "user's share" – what Warburg himself correctly recognized as the creative artist's contribution to the process. A paragraph from Michael Baxandall's *Patterns of Intention* (1985) clarifies the issues at stake:

"Influence" is a curse of art criticism primarily because of its wrong-headed grammatical prejudice about who is the agent and who is the patient. . . . It is very strange that a term with such an incongruous astral background has come to play such a role, because it is right against the real energy of the lexicon. If [instead of X "influencing" Y] we think of Y rather than X as the agent, the vocabulary is much richer and more attractively diversified: draw on, resort to, avail

oneself of, appropriate from, have recourse to, adapt, misunderstand, refer to, pick up, take on, engage with, react to, quote, differentiate oneself from, assimilate oneself to, align oneself with, copy, address, paraphrase, absorb, make a variation on, revive, continue, remodel, ape, emulate, travesty, parody, extract from, distort, attend to, resist, simplify, reconstitute, elaborate on, develop, face up to, master, subvert, perpetuate, reduce, promote, respond to, transform, tackle ... – everyone will be able to think of others. Most of these relations just cannot be stated the other way round – in terms of X acting on Y rather than Y acting on X. To think in terms of influence blunts thought by impoverishing the means of differentiation.[45]

So while keeping the power of the Little Barbarians' pathos firmly in mind, let us quit talking of their "influence" upon Renaissance artists and substitute words that describe the latter's creative engagement with them, such as quotation, borrowing, appropriation, and so on.

Other late twentieth-century art historians have taken the matter further. Whether or not they acknowledged it, their common ground was the increasing realization that quotations or borrowings never come content-free. Bakhtin himself believed that the word never forgets its origins; semioticians theorize this quite simply by noting that the sign, qua sign, must signify something. "The sign borrowed, because it is a sign, inevitably comes with a meaning."[46] Yet equally inevitably the borrower immediately reshapes this meaning. As the founder of semiotics, Charles Sanders Peirce, famously noted:

A sign, or *representamen,* is something which stands to somebody for something in some respect or capacity. It addresses somebody, that is, creates in the mind of that person an equivalent sign, or perhaps a more developed sign. That sign which it creates I call the *interpretant* of the first sign. The sign stands for something, its object. It stands for that object, not in all respects, but in reference to a sort of idea, which I have sometimes called the *ground* of the representamen.[47]

For the art historian, Richard Wollheim – though certainly not a card-carrying semiotician – clarified the attendant issues as follows in his book *Painting as an Art* (1987):

[A] borrowing enters the content of the painting only if, in putting to new use some motif or image from earlier art, the painting reveals what this borrowing means to the artist. . . . In any adequate account . . . the context [of the borrowing] must be recognized to have a certain flexibility: it cannot, for instance, be automatically equated with the actual source from which the borrowed motif or image is taken. . . . [W]ithin the framework provided by his beliefs, the artist can choose how much or what part of this background is to be taken into account in considering the motif or image. The crucial consideration here, which the artist can exploit, is that, as its background is allowed to expand or contract, so a given motif or image will vary in what it conveys. A schematic example: A borrowed image will convey different things if the source from which it comes, hence the background against which it is to be seen, is thought of as, successively, something classical, something Roman, a Roman sarcophagus, a Roman sarcophagus depicting the labors of Hercules. [I]n borrowing a motif or image from a certain source, the artist always does so under a certain description of that source.[48]

So to be pedantic, our Little Barbarians will convey different things to the Renaissance artist if he thinks of them as, successively, old statues; classical statues; Roman statues; anguished classical/Roman statues; anguished classical/Roman statues of fallen warriors; the anguished, fallen Horatii and Curiatii; or anguished, fallen gladiators. His view of their putative context and identity will inevitably color his view of them, guiding his decision as to what aspects of this package he will reference in his painting or not; whether he will reinterpret or transform it; challenge or negate it; and so on.

The same will be true of the Barbarians' status vis-à-vis the three eras of Renaissance Christian historiography: The world *ante legem,* before the Law of Moses; the world *sub lege* or under that law; and the world *sub gratia,* under Christ's Grace. As pagan statues they belonged by definition outside these eras, to a world that tried mightily to suppress Christianity and in turn was vanquished by Christ's Grace. Moreover, as gladiators they directly represented men who even murdered Christians. Yet as artifacts of Rome and its empire, as symbols of *antiqua Romanitas* and all it stood for, now housed in the collections of popes, princes, and others, they automatically elicited huge respect and even awe.[49] So they were deeply ambiguous; a certain tension – even conflict – was built into them from the start. The artist could do what he liked with all of this, but the one thing he could not do was to ignore it altogether.

To risk gilding the lily, it is worth turning finally to Mieke Bal's analysis of the entire problem in her book *Quoting Caravaggio* (1999). In her view, quotations function in four different ways:

First, according to classical narrative theory, direct discourse or . . . literal "quotation" . . . is a form that reinforces mimesis. As fragments of real speech, [quotations] authenticate the fiction. . . .

Second, these fragments of reality are the product of a manipulation. Rather than serving reality, they serve a reality *effect* (Barthes 1968),[50] which is, in fact, the opposite – a fiction of realism. Thus they function as shifters, allowing

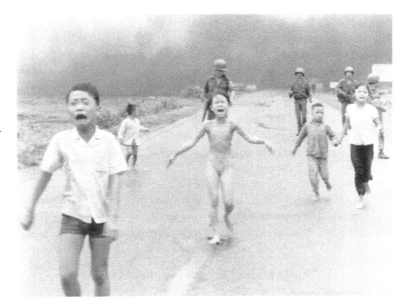

FIGURE 113. Nguyen Kong (Nick) Ut, *Terror of War*, 1972. Pulitzer Prize–winning photograph of the Vietnam War. Courtesy, Associated Press/Wide World Photos.

the presence of multiple realities within a single entity. . . .

Third, in Bakhtinian dialogism, quotations stand for the utter fragmentation of language itself. They point in the directions from which the words have come, thus thickening, rather than undermining, the work of mimesis. . . . This interdiscursivity accounts for pluralized meanings – typically, ambiguities – and stipulates that meaning cannot be reduced to the artist's intention. . . .

Finally, deconstructionism paradoxically harks back to what this same view might repress when it represents the polyphony of discursive mixtures a little too jubilantly. Stipulating the impossibility of reaching the alleged, underlying, earlier speech, this view emphasizes what the quoting subject does to its object. Whereas for Bakhtin the word never forgets where it has been before it was quoted, for Derrida it never returns there without the burden of the excursion through the quotation.[51]

This final stage in the process is what literary critics, following the Russian theorist Mikhail Bakhtin (1895–1975), call *intertextuality*. They define this as the discovery of conveniently prepackaged elements (in Bakhtin's case, linguistic signs) in earlier texts; one's incorporation of them as *quotations* (i.e., everything from direct quotes to passing allusions) into one's own; and the inevitable inflection of the source that results when one returns to it with all this in mind.

Bakhtin himself subsumed the resulting intertextual dialogue under the more generalized rubric of *heteroglossia*, the "clash of tongues" or mixture of discursive modes that sustains all fictions. For him, the novel represented the supreme example of this kind of creative interaction. The world of Roman copies has been characterized thus, and Renaissance art with its insistence on the equal importance of imitating nature and imitating other artists, particularly (where available) those of antiquity, is as rich if not richer in possibilities.[52]

But is it really appropriate to use purely textual terms to characterize an artist's engagement with and reinterpretation of the past? In conversation, some have suggested "interpictoriality" or "intervisuality," but the first is too painting-specific and the second vague and somewhat off-target; "intersemiosis" might work but is a linguistic hybrid (like "television"!) and smacks of jargon. Instead, terms like "visual interplay," "visual interaction," "visual exchange," "visual dialogue," "visual repartee," or even "visual codependency" may be preferable, according to the tenor of the relationship.

Finally, influenced (dare I use the word?) by Michel Foucault, some recent commentators on the Renaissance discourse with its ancient past have proposed to read its "archaeology of knowledge" as a knowledge–power nexus. In reaction, another has "hesitantly" called for a "new aestheticism" – a reconsideration of what its discoveries meant qua art to the artists who so eagerly drew, quoted, and discussed them.[53] Alongside these approaches a "new iconology" would treat such quotations not merely as rediscovered wonders that empower the artwork by lending it a kind of formal authority or cachet, but as bearers of meaning in their own right. As such, they both enrich and are enriched by the total configuration of the work considered in dynamic relation with its historical – i.e., political, social, religious, and physical – context.[54]

The rest of this chapter tries to keep at least some of these balls in the air simultaneously. Its purpose is not to produce a complete reinterpretation of every painting or

sculpture touched upon, still less to rewrite the history of Renaissance art. Instead, it offers a sketch of the Little Barbarians' reception by some selected sixteenth-century Italian artists and a modest contribution to understanding the artworks in which they appear.[55] Although some (probably most) of these artists had direct knowledge of the Little Barbarians themselves, for the most part we will be considering the history of their *types,* of the tradition that they inaugurated. We will see them, in other words, becoming *tokens* of a *type.*

But first, some principles and procedures. To gloss our earlier proviso that the artist must have *known* the source in question and it must be *necessary* to explain the image he created, an ideal scenario would look something like this:

1. The artist exhibits a strong interest in antiquity and a desire to use it in his work.

2. He sees the proposed ancient source in person, or has ready access to it or to drawing(s) of it.

3. He draws it himself; draws a living model in a pose reconstructed from it; and/or makes a wax model from it as a starting point for his own composition.[56]

4. He creates a new type from it; or thematizes his borrowing compositionally and/or iconographically; or at least drops a heavy hint that he is referencing it in the work under discussion.

5. After the initial borrowing he continues to utilize and develop its type, gradually assimilating it into his iconographic repertoire but occasionally perhaps returning to the source itself (or his drawings of it) for further inspiration.

Unfortunately the *testimonia* are never so obliging. Vasari, our main source for Renaissance artists and their doings, rarely specifies what they saw or what casts and statuettes they owned, and still less what they drew. For example, they must have visited and drawn the Laokoon in droves, and some of them certainly owned reproductions of it, but no anecdotes and a mere handful of sketches survive; and the same is true of our Barbarians (see Figures 71–72, 104–05).[57]

As a result, no proposal is likely to satisfy all of these conditions. Indeed, since few if any borrowings can be objectively proven anyway, detecting and verifying them usually boils down to a matter of individual judgment in the particular case. What follows rests firmly upon the consensus in the field but also explores new paths where the evidence seems to warrant it. It also makes no claim to exclusivity: Other sources may have been in the artist's mind alongside the Barbarians, and probably often were. If the results seem unduly maximalist, that is because much recent research seems to disregard or discount such borrowings from antiquity altogether.[58]

Throughout, I have also tried to move beyond the raw *fact* of the borrowing – i.e., beyond a purely formalist agenda – to its *meaning.* What might the artist in question have seen in his source? Under what description did he borrow it? And how did he register all of this in his work? How, in other words, does the borrowing *inform* his work and color our understanding of it?

Yet (to repeat some observations from the previous chapter) any such approach must acknowledge the ultimate undecidability of the visual and the slipperiness of the contexts themselves. Their codependence deflects all judgments about each, exposes them to endless supplementation, and thus defers closure indefinitely. As a result, all statements of visual meaning – including those that follow – must necessarily remain provisional.

4. ROME (I): RAPHAEL

The Naples and Paris Gauls make their debut in Renaissance painting in Raphael's tapestry cartoon for *Death of Ananias,* now in the Victoria and Albert Museum (Figure 114), and in the finished tapestry for the *Stoning of Stephen* (Figure 118), whose cartoon is lost. Moreover, Raphael perhaps used the Venice Falling Gaul for his *Conversion of Saul* (Figure 119) and (as conjectured in section 2) maybe even the Aix Persian for his *Sacrifice at Lystra* (Figure 108). Since our interest will focus on the finished products, not upon Raphael's personal style, for the most part I illustrate the tapestries themselves (Figures 117–19). As usual, these tapestries reverse the cartoons, which were never intended for exhibition. Yet Raphael clearly had the reversal in mind at every step, for he made only two minor mistakes in the main compositions and two in the monochrome "reliefs" below them.[59]

Leo X commissioned these cartoons in 1513–14; made a down payment on them on June 16, 1515; and paid the balance on December 20, 1516. So they were probably begun in the winter of 1514/15 and completed by the summer of 1516. The tapestries themselves were woven by Pieter van Aelst in Brussels; reached the Vatican between 1519 and 1521; and were proudly hung in the Sistine Chapel under Perugino's, Botticelli's, and Ghirlandaio's frescoes of 1480–82 and Michelangelo's great ceiling of 1508–12. But they stayed there only until 1527, when they were plundered and dispersed during the Sack of Rome. Although all had found their way back home by 1554, Leo's original display was irrecoverable by then. For in the interim, Michelangelo's *Last Judgment* (1534–

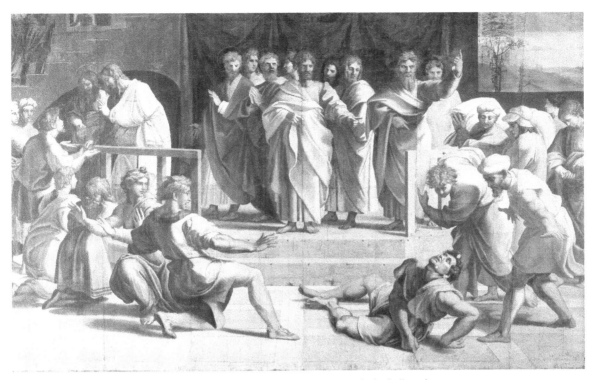

FIGURE 114. Raphael, cartoon for *Death of Ananias*, 1515–16. Black chalk and tempera on paper; 3.42 × 5.32 m. London, Victoria and Albert Museum. Photo: V&A FF1984. The dying Ananias quotes the Naples Dying Gaul, and his companion quotes the Paris Gaul.

FIGURE 115. Paris Gaul. Photo: Chuzeville.

FIGURE 116. Naples Dying Gaul. Photo: Luciano Pedicini. The statue was headless in 1515–16.

41; Figures 133–36) had usurped the altar wall where two of them had hung.

Michelangelo's ceiling depicts the Genesis story from the Creation through Noah, and the wall frescoes below it chronicle the lives of Moses and Christ. Together they represent the first two eras of Renaissance Christian historiography (the world *ante legem,* before the Mosaic Law, and *sub lege* or under it) and the beginning of the third era (*sub gratia,* under Christ's Grace). The tapestries completed the program, expanding it into a Christo-

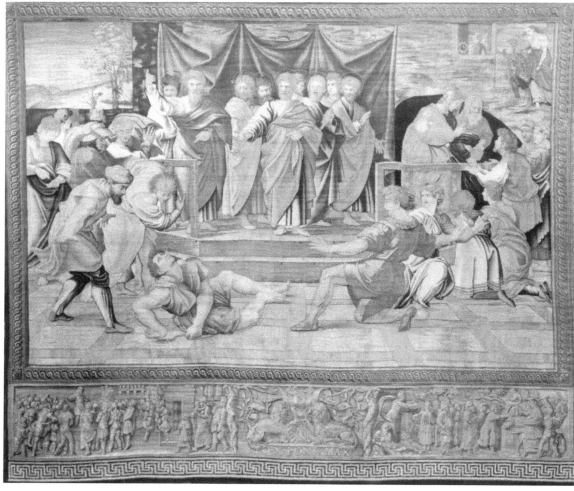

FIGURE 117. Pieter van Aelst after Raphael, *Death of Ananias*, 1519–21. Tapestry; 4.9×6.31 m. Vatican, Pinacoteca. Photo: Vatican Museums XXXIV.11.36. The dying Ananias quotes the Naples Dying Gaul, and his companion quotes the Paris Gaul.

centric summa of world history that included the first generation of his followers in the Era of Grace. Six scenes from the life of Saint Paul were to hang under the Life of Moses and four from Saint Peter's under the Life of Christ. Both saints supposedly had been martyred in Rome on the same day and thus shared the same feast, and Peter was the source of all papal authority and the popes' all-important link to Christ. Leo himself endowed the chapel with a sumptuous missal for their joint feast.

Beginning (1) either side of the altarpiece, at that time a frescoed *Assumption of the Virgin,* and proceeding (2–6) down the two sides of the chapel, the entire sequence read as shown in Table 2. Like the fresco cycles above

TABLE 2. The Sistine Chapel Tapestries

No.	Pauline Cycle	Petrine Cycle
1.	Stoning of Stephen (Fig. 118)	Miraculous Draft of Fishes
2.	Conversion of Saul (Fig. 119)	Christ's Charge to Peter
3.	Conversion of the Proconsul	Healing of the Lame Man
4.	Sacrifice at Lystra (detail, Fig. 108)	Death of Ananias (Fig. 117)
5.	Paul in Prison	
6.	Paul Preaching at Athens	

them, the two tapestry cycles were meant to be read from the high altar, and in the Gospels and *Acts of the Apostles* the Petrine cycle preceded the Pauline one chronologically. The viewer was intended to begin with Saint Peter's *Draft of Fishes* on his left, to scan the chapel's south

wall through the *Death of Ananias* (Figure 117), and then to switch to the *Stoning of Stephen* (Figure 118) on his right. As will appear, all this bears heavily on the matter of Raphael's quotations.

As remarked earlier, Raphael apparently used the Little Barbarians for one picture in each of these two cycles: the *Death of Ananias* (Figure 117) in the Petrine cycle and the *Stoning of Stephen* (Figure 118) in the Pauline one. The *Conversion of Saul* (Figure 119) and *Sacrifice at Lystra* (Figure 108) in the Pauline one are also contenders. In the *Death of Ananias,* his debt to the Naples Dying Gaul (Figure 116) for Ananias and the Paris Gaul (Figure 115) for Ananias' horrified friend, and perhaps also for the woman behind him, was noticed early in the twentieth century; recognition of the Venice Falling Gaul in the *Conversion of Saul* took somewhat longer.[60] But Raphael's clear reuse of the Paris Gaul in the *Stoning of Stephen* (Figure 118) has gone unnoticed, together with the Aix Persian's possible appearance in the *Sacrifice at Lystra* (Figure 108). At that time, of course, the Gaul's right lower leg and arms and the Persian's left arm were all missing (see Figures 71, 193).

The *Death of Ananias* (Figures 114, 117) is taken from Acts 5:1–5:

But a man named Ananias with his wife Sapphira sold a piece of property, and with his wife's knowledge he kept back some of the proceeds, and brought only a part, and laid it at the Apostles' feet. But Peter said, "Ananias, why has Satan filled your heart to lie to the Holy Spirit and to keep back part of the proceeds of the land? While it remained unsold, did it not remain your own? And after it was sold, was it not at your disposal? How is it that you have contrived this deed in your heart? You have not lied to men but to God." When Ananias heard these words, he fell down and died. And great fear came upon all who heard of it.

The finished tapestry (Figure 117) reverses the Naples Dying Gaul and switches the legs of the Paris one (see Figures 5, 115–16). To accommodate these reversals Raphael reproduced the Naples Dying Gaul and the lower body of the Paris one directly in his cartoon (Figure 114) so that they would appear in mirror image in the finished product (Figure 117). The more complicated Paris Gaul thus remains easily recognizable in the latter, since his head, arms, and torso are all direct transcriptions of the statue.

Raphael evidently engineered all this in order to place the dying Ananias to the left of the tapestry (Figure 117), below Peter's death-dealing right arm and hand, and to enable his recoiling friend at right to thrust his nearer arm and leg together across the picture plane toward him. The drama would then read from left to right in

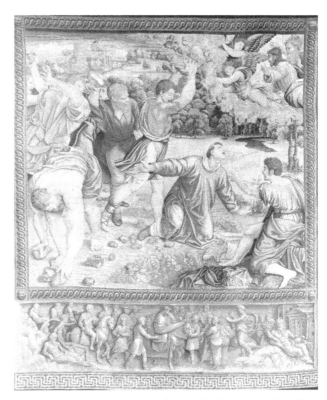

FIGURE 118. Pieter van Aelst after Raphael, *Stoning of Stephen*, 1519–21. Tapestry; 4.5 × 3.7 m. Vatican, Pinacoteca. Photo: Vatican Museums XXXV.17.85. The figure of Saul quotes the Paris Gaul.

normal Renaissance fashion. The narrative begins as it should with the writhing Ananias, then bifurcates into a kind of 'Z' as one follows the dying man's eyes up to the source of his agony, the implacable Peter, and the highlighted, arrowlike triangle of his legs across to his horrified friend at right.[61]

Historians of Renaissance art now seem to have jettisoned the old idea that the sensitive Raphael had a "problem" with violence and that this supposed problem is responsible for the *Death of Ananias*'s rather theatrical and supposedly forced appearance. In fact, not only do his earlier drawings for the Chigi *Resurrection* (Figure 99) and some of his other late works prove decisively otherwise, but several interrelated technical, thematic, contextual, and theological concerns evidently guided his approach.

First, he clearly wanted the starkest possible contrast between a physically violent foreground and a background replete with spiritual power and majesty. Second, the *Ananias* was no. 2 of a pair on the chapel's south wall that celebrated Peter's power to give and take life, demanding a strong contrast on yet another level. Third, Raphael was evidently concerned that in the translation from cartoon to tapestry much might be weakened or

lost. And fourth, his work had to stand comparison with Michelangelo's above it – the quintessence of Renaissance *furia* or "energy."

This is why Raphael not only paired the two foreground figures in a physically violent but statuesque *contrapposto* but also contrasted them with an equally statuesque but now classically dignified Peter (the pope's prototype and alter ego) and companions; contrasted the entire scene in turn with Peter's *Healing of the Lame Man;* and deliberately intensified the entire sequence's overall rhetoric to ensure that it both stood up in translation and balanced the *furia* of Michelangelo's great ceiling above.

Whereas the Paris Gaul marks a new addition to Raphael's rich repertoire of figure types, the painter was no stranger to figures like the Naples Dying Gaul. As noted earlier, he had already developed one quite like it for the cringing Heliodorus in the Vatican's Stanza d'Eliodoro, which he painted between early 1512 and late June 1514, just before the Little Barbarians came to light. In 1513 he had even begun to recycle this figure in a series of sketches for the awestruck guards of his never-completed Chigi *Resurrection* (Figure 99).[62] What is different about the Ananias?

Though Raphael himself has left no remarks on the matter, a comment attributed to Michelangelo may help. The context is an exchange that refers almost certainly to the classicizing sculptor Baccio Bandinelli:

Asked by a friend of his what he thought of someone who had replicated in marble the most famous antique artworks, the imitator all the while bragging that he had far exceeded the ancients, Michelangelo responded, "A person who runs behind others never manages to pass them; and someone who doesn't know how to work well on his own cannot make good use of other people's work."[63]

As Leonard Barkan has remarked:

Michelangelo . . . [by using an ancient metaphor for artistic imitation] put his finger directly on the essential problem, which is the relation between self and external inspiration. The footrace metaphor is appropriate precisely because Bandinelli has boasted that he can "win" or surpass his model; the very terms of the relation are thus dictated by the model, and the imitative artist is doomed to coming in second on a linear course. Michelangelo's alternative is, on the other hand, circular, consisting in a continuous exchange between *saper fare bene da sè* and *servirsi delle cose d'altri*, since each of these is needed to define the other.[64]

Substitute Raphael for Michelangelo here and the relation of invention to appropriation becomes immediately obvious. Raphael's own predecessor to the Naples Dying Gaul (Figure 99) proves the point. Its right leg is drawn up and its left extended in a sweeping curve so that it both elegantly echoes the right arm drooping across the torso and allows the body as a whole to curve continuously from head to toe. This graceful, dominating curve, rooted in quattrocento *contrapposto,* was sanctioned by Quintilian's authoritative description of the need for art to perfect nature, and in doing so to create a corporeal flexibility that "so to speak, gives an impression of action and animation" (*Institutio Oratoria* 2.13.8). Quintilian then holds up the sweeping curves of Myron's Diskobolos as the supreme example of this kind of composition.[65]

The injured, bleeding Naples Dying Gaul (Figure 116) challenged this paradigm, offering both a truly "serpentine" form and obvious rhetorical potential as an antique and thus certifiably non-Christian figure of violence. Borrow the poise of its legs so that the left foot almost rests against the heel of the right; force them further apart so they occupy two planes at more than a right angle to each other; flex them at a sharper angle at the knee so that they echo the arms; add deep blobs of shadow at the withdrawn left hip and right shoulder; and one creates a perfect Lomazzian *contrapposto* – but without the defining grace of the *figura serpentinata*.

So in contrast to the awestruck guards of the Chigi sketches (Figure 99) or (for example) the serpentine and entirely graceful Christ child of Michelangelo's Bruges *Madonna,* Ananias is deliberately grace*less*. With his model's open wounds now erased and his fate sealed purely by spiritual means, he is a perfect – and perfectly appalling – image of human agony and a perfect counterpart to the jagged, recoiling figures of his two horrified companions. While all of them epitomize the violence and primitiveness of the old order and its precipitate collapse before Christian Grace, Ananias specifically illustrates the hell into which the alleged sins of the Jews – disobedience, deceit, and avarice – can lead them.

Peter meanwhile represents the judgment of the sternly moral, newly formed church, here represented as Leo conceived it (or affected to conceive it): not as an autocratic organization but as an assembly of the apostles in which he is *primus inter pares*. Any suspicion of personal autocracy is gainsaid by the imposing apostle beside him, pointing to heaven and dressed in Saint Paul's trademark red and green. He cannot be Paul himself, however, since the latter's conversion still lay well in the future – in scene 2 of the other, opposite wall.

By quoting the imperial *oratio* on the Arch of Constantine, tribunal and all, for this group,[66] Raphael paralleled his own quotation of the Naples and Paris Gauls (whether in the guise of Horatii/Curiatii or of gladiators) for Ananias and his companions. Together they function both

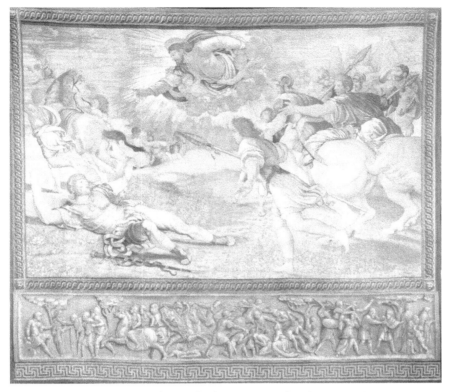

FIGURE 119. Pieter van Aelst after Raphael, *Conversion of Saul*, 1519–21. Tapestry; 4.65 × 5.3 m. Vatican, Pinacoteca. Photo: Vatican Museums XXXIV.16.46. The figure of Saul may quote the Venice Falling Gaul.

as authenticators of the narrative and as shifters that produce multiple realities within the composition. For although Constantine was the first Christian emperor, Peter and the apostles have now superseded the old imperial Roman order in the same way that the congregation of the faithful has replaced that of the Jews and pagans, and the Era of Grace has replaced the Era of the Law.

Raphael's two contrasted groups of figures offer a virtuoso display of the advent of this new era. Setting up a *paragone* with antique Roman sculpture and the paganism that sustained it, they channel Peter's new and awesome spiritual power through High Renaissance pictorial *varietà* and compositional *contrapposto* at its most sophisticated. Only Raphael's powerful, monumental classicism keeps the scene from fragmenting, though the present-day critics' evident unease suggests that it strains the limits of the genre.

As remarked above, the viewer at the altar was next supposed to switch to the first of the Pauline tapestries, the *Stoning of Stephen* (Figure 118). And here – lo and behold! – he would find that the first figure on the right recalled Ananias' shocked companion and onlooker, but now with *his* legs reversed – a switch that makes him a direct 1:1 transcription of the Paris Gaul (see Figure 5). This twisted individual is Saul/Paul himself, as yet unconverted to Christianity, guarding the executioners' clothes (Acts 7:58) and enthusiastically cheering Stephen's agony.

This second, direct quotation of the Paris Gaul (complete with open mouth and curly hair) extends the chain of borrowings and underscores their meaning. Like the greedy Ananias and his companions, the still unconverted Saul – a Roman citizen – is the "rapacious wolf" (*lupus rapax*) of Genesis 49:27 and of a sermon attributed to Leo X's revered role model, Saint Leo (Pope Leo I).[67] Represented via this combative antique/Roman warrior, these are Jews of the old Law, imprisoned by (and unconsciously struggling against?) its protocols and dictates. They know not Christ and his Grace.

Of the two other candidates, the possible dependence of the *popa* in the *Sacrifice at Lystra* (Figure 108) upon the Aix Persian (Figure 106) has already been mentioned in section 2. The second candidate is the fallen Saul in the *Conversion of Saul* (Figure 119). He looks suspiciously like the Venice Falling Gaul (Figures 95, 111), especially when one remembers that the latter, lacking its arms, probably rested flat on its back throughout most of the century. The borrowing, if accepted, both reinforced the pagan Saul's helplessness and vulnerability, and effectively insinuated a *figura serpentinata* into the type, which had been well established by the late quattrocento.

Raphael further emphasized Saul's defenselessness by decking him out in a useless suit of armor. A century later Poussin, who knew the cartoons well, copied his conceit in his splendid *Rinaldo and Armida*, when he furnished the naked, sleeping, and newly discovered Barberini Faun with armor and used it for the helpless, sleeping Rinaldo. Interestingly, Marcantonio Michiel, an eyewitness, tells us that Raphael's cartoon for this tapestry, now lost, was in the possession of Cardinal Domenico Grimani by 1521. Could he have bought it in part because he already owned the Falling Gaul?[68]

Raphael recycled the types of the three Gauls again and again in the four years of life that remained to him. In the extensive series of frescoes that he designed at Leo's behest for the Vatican Logge around 1516 (Figure 120), they reappear several times over in different guises (Figures 121–27). At about this time too he began to design the Villa Madama on Monte Mario for Giuliano de' Medici, which would have afforded him ample opportunity to visit the Palazzo Medici–Madama and to refresh his memory of Alfonsina's collection.[69]

Raphael used the type of the Paris Gaul for *God the Father Separating the Sun and the Moon* in the Creation cycle in the first bay (scene 1c; Figure 121); for Adam in the *Original Sin* (2b; Figure 122); perhaps for a doomed man in the *Flood* (3b; Figure 123); and for a kneeling servant in the *Abraham and Melchisedek* (4a; Figure 124). The Naples Dying Gaul became a semiprostrate man in the background of the *Flood* (3b; Figure 123); the recumbent Jacob in *Jacob's Dream* (6a; Figure 125); and perhaps a recumbent Israelite in *Joseph Interpreting His Brothers' Dreams* (7a; Figure 126). The Venice Falling Gaul makes a cameo appearance as one of the fallen Amorites in the scene of *Joshua Stopping the Sun and Moon* (10c; Figure 127).

The Logge (Figure 120) were Leo's private retreat, intended "al piacere solum del papa," and housed some of his most precious antiques. Raphael's workshop stuccoed and frescoed them in 1517–19 with a lavishness and flamboyance hitherto unknown in Renaissance Italy. The mythologies, grotesques, and other whimsies that decorated their walls and arches were inspired by Nero's recently discovered Domus Aurea, and their thirteen vaults were embellished with a pictorial cycle that complemented, in miniature, that of the Sistine Chapel. Although Raphael delegated executive control of the project to Giulio Romano, he obviously masterminded it and probably sketched out all or most of the biblical scenes personally. The individual panels were designed to be easily legible from below, but the overall program is highly complex both visually and theologically, and can be addressed only insofar as it bears upon our central theme.

The frescoes of the first nine vaults chronicled the world before and up to God's gift of the Mosaic Law (*ante legem*); the next three the world under it (*sub lege*); and the last one the world under Christ's Grace (*sub gratia*). With the exception of two bays devoted to Moses, the giver of that law and the greatest Old Testament predecessor to the Papacy, each one focused on a single major figure. The sequence runs as follows: (1) God the Father; (2) Adam; (3) Noah; (4) Abraham; (5) Isaac; (6) Jacob; (7) Joseph; (8–9) Moses; (10) Joshua; (11) David; (12) Solomon; and (13) Christ. Each narrative group occupied five panels, one on each side of the square vaults and one on the dado or *basamento* of the inner or west wall.

To begin with the Paris Gaul (see Figures 5, 61–64, 115). Perhaps because the ceiling panels are small and require considerable physical effort to read, the God the Father (1c), Adam (2b), and servant (4a) transcribe their model directly, and the first of them, painted by Giulio Romano, now begins to compress it radically for increased expressive effect (Figures 121–23). If the quotation holds, this is the only time that Raphael used one of the Barbarians for a figure outside the mortal and non-Christian realm. If so, it may have been the statue's obvious utility as an icon of elemental, even primitive force (Bellièvre's *impetus virilitatis*, RT2) that attracted him.

With its Venus-like Eve and Gaul-like Adam, the splendid *Original Sin* (2b; Figure 122) offers another obvious sculpture-painting *paragone*. The Adam makes much of the Gaul's extreme *contrapposto* and almost *écorché* anatomy as he stretches out to grasp the fatal fig (*not* an apple), and even copies the statue's thickly tousled coiffure. The stark contrast with the standing Eve's smooth, graceful body is clearly more than a matter of gender. It is one of volition. Stark naked, lithe, and completely in control of the situation, she offers Adam the fatal fruit with absolute self-assurance as the serpent looks on. Yet beneath his hypermasculine physicality he is a psychological wreck. Conflicted, tense, and struggling mightily with himself, he presents a classic study in mixed emotions in this primitive and still (just) prelapsarian world. As with the Ananias (see Figures 114, 117), critics have noticed that his antics all but tear the composition apart, though now Raphael himself was not on hand to ease the stress.[70]

So this Adam is a man who is about to be wounded by sin and thus to fall from grace *and to take us with him*: the Gaul captured a split-second before his wounds, so to speak. Any Renaissance observer would understand this as a clarion call for obedience to divine (i.e., papal) authority — a theme taken up in the final bay (13a,b), where the *Adoration of the Shepherds* and the *Adoration*

FIGURE 120. The Vatican Logge. Designed by Raphael in 1516 and frescoed and stuccoed by his workshop in 1517–19. Photo: Alinari/Art Resource 6457.

FIGURE 121. Giulio Romano after Raphael, *God the Father Separating the Sun and the Moon*, 1517–19. Fresco; ca. 1.4 × 1.4 m. Vatican, Logge. Photo: Alinari/Art Resource P.2.N. 7761. The figure of God may quote the Paris Gaul.

of the Kings occupy half of the vault. "The supporting themes of the history of salvation thread the interval of time and distance, making all history – Hebrew, pagan, and Christian – but one effort to recover in Christ the eternal Sabbath lost through Adam's fall."[71]

A version of this specimen of fallen humanity appears in the *Flood* (3b; Figure 123). Leading two other highly charged quotations from the antique, he dominates the foreground of the picture. Burdened with two children (Cain and Abel *redivivi*, as it were), he vainly struggles to escape from the rising waters sent by God to punish men for their disobedience. The couple that follows the little family echoes the famous Pasquino group (an older hero carrying the body of a younger one, perhaps Menelaos and Patroklos or more likely Ajax and Achilles). Displayed in the Piazza del Pasquino, it functioned as a billboard for libelous and subversive lampoons, and so was roundly hated by the popes. The rider behind these figures quotes some fleeing Dacians on Trajan's Column, overwhelmed through divine providence by a river in flood. Finally, in the background, a collapsed version of the Dying Gaul (blended with the Naples Persian?) underscores this unremitting litany of man's punishment for his disobedience to divinely ordained authority. For "only those admitted to the ark will survive the sea of death, just as those who pass through the ritual death of baptism will be delivered through the intercession of the Church."[72]

The servant in Giulio Romano's *Abraham and Melchisedek* (4a; Figure 124), an Old Testament prefiguration of the Eucharist, rounds off this particular sequence. By kneeling to offer the sacramental bread he now willingly accepts his status as an obedient minister to Abraham, the man of perfect faith, and Melchisedek, the perpetual priest-king and antetype of Christ. He thereby hints at the continuance of his subservient status *sub gratia*, in the coming Era of Grace, and calls us to follow his acceptance of it. Like the *Original Sin* (2b; Figure 122), this scene is situated on the inner (western) side of the vault, with the *Flood* (3b; Figure 123) above the right-hand arch of the intervening bay. The attentive visitor can thus take in man's fall, punishment, and promised redemption in a single glance.

What may be two more distant recensions of the type of the Naples Dying Gaul, also attributed to Giulio Romano (6a and 7a), can be seen together from below the

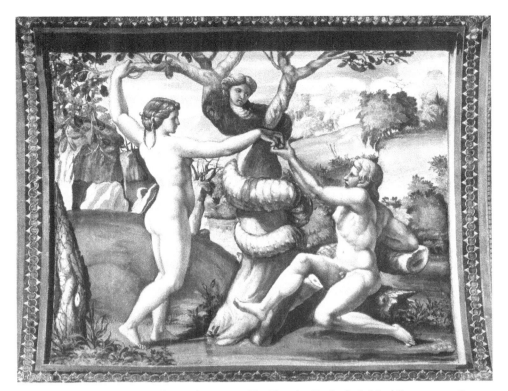

FIGURE 122. Pellegrino da Modena and Tommaso Vincidor after Raphael, *Original Sin*, 1517–19. Fresco; ca. 1.4 × 1.4 m. Vatican, Logge. Photo: Alinari/Art Resource P.2.N. 7767. The Adam quotes the Paris Gaul.

FIGURE 123. Giulio Romano after Raphael, *The Flood*, 1517–19. Fresco; ca. 1.4 × 1.4 m. Vatican, Logge. Photo: Alinari/Art Resource P.2.N. 7772. The refugee at right may quote the Paris Gaul; the reclining figure in the background may quote either the Naples Persian or the Naples Dying Gaul, or both.

FIGURE 124. Giulio Romano after Raphael, *Abraham and Melchisedek*, 1517–19. Fresco; ca. 1.4×1.4 m. Vatican, Logge. Photo: Alinari/Art Resource P.2.N. 7776. The servant at right quotes the Paris Gaul.

arch that separates the two scenes. The Jacob of *Jacob's Dream* (6a; Figure 125) reappears as a recumbent Israelite in *Joseph Interpreting His Brothers' Dreams* (7a; Figure 126). Both are again somewhat compressed, and both transform the type of the fallen Gaul into a paragon of peaceful relaxation, blending him with the well-known antique type of the reclining river god.

Yet whereas the Jacob reverses its model(s), the Israelite offers a straightforward back view of them, teasing our powers of recognition like a pair of musical variations. And whereas Jacob's dream materializes behind him, the servant's gaze leads the spectator's eye directly to Joseph and his brothers' dreams, rendered medieval-style in two circular vignettes that hover in the sky. Finally, whereas Jacob is a Christ-type, freed in sleep from his earthbound prison of the body and prefiguring Christ's ascension after his death, the servant is a mere signpost. Situated at the center of the entire loggia complex, he directs our attention to Joseph, who was both a Christ-type himself and Leo's own particular hero.[73]

Finally, as P. G. Huebner saw as early as 1909, the Venice Falling Gaul was surely enlisted, again in direct transcription, as one of the cowering Amorites in the scene of *Joshua Stopping the Sun and Moon* (10c; Figure 127). As a vanquished, pagan warrior or gladiator – not a fallen Curiatius, since he was never identified as such (cf. RT4) – he was perfect for the part. He is an anguished and terrified representative of the pagan world that oppressed the Jews and Christians – a world now superseded by the Era of Christ's Grace. The victorious Joshua towers over the scene, arms outflung in a premonition of the Crucifixion (when the sun and moon also appeared simultaneously at midday). His gesture mimics God the Father's in the first bay (1c; Figure 121) and brings the spectator, and us, around full circle.

By the time of Raphael's last painting, the huge Vatican *Transfiguration* (Figure 128), these sundry borrowings had been totally assimilated into his figural repertoire. Commissioned by Cardinal Giulio de Medici (later Pope Clement VII) in 1516 but begun only late in 1518, this altarpiece was originally intended for export to his archbishopric in France but was retained in Rome after being exhibited, not quite finished, next to Raphael's coffin in 1520. (The cardinal also commissioned a *Raising of Lazarus* from Sebastiano del Piombo at the same time, aiming to goad the two artists into productive rivalry, but that is outside our agenda.) Thematically complex and compositionally innovative, the *Transfiguration* revives an earlier practice of conflating two distinct scenes in one panel: in this case, the Transfiguration itself and the apostles' failure in Christ's absence to heal a boy possessed by the Devil (Matt. 17:2–6, 14–15).[74]

APPROPRIATION: GLADIATORS FOR CHRIST

FIGURE 125. Giulio Romano after Raphael, *Jacob's Dream*, 1517–19. Fresco; ca. 1.4 × 1.4 m. Vatican, Logge. Photo: Alinari/Art Resource P.2.N. 7786. Jacob may quote the Naples Dying Gaul.

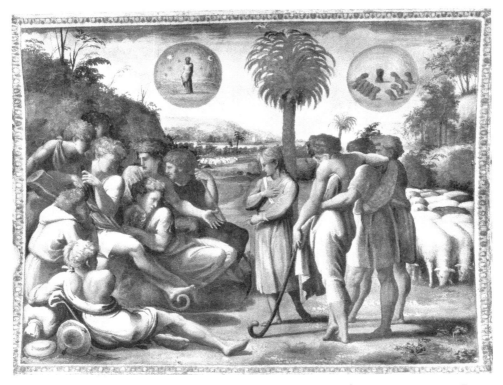

FIGURE 126. Giulio Romano after Raphael, *Joseph Interpreting His Brothers' Dreams*, 1517–19. Fresco; ca. 1.4 × 1.4 m. Vatican, Logge. Photo: Alinari/Art Resource P.2.N. 7791. Jacob may quote the Naples Dying Gaul.

III

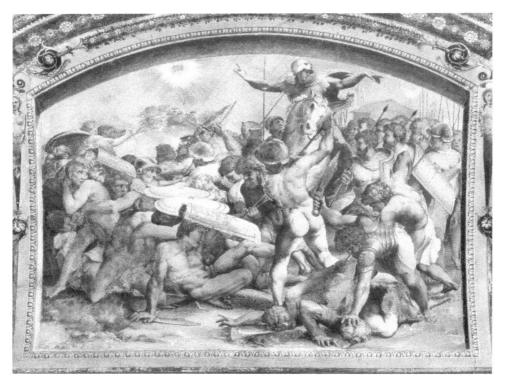

FIGURE 127. Perino del Vaga after Raphael, *Joshua Stopping the Sun and Moon*, 1517–19. Fresco; ca. 1.4 × 1.4 m. Vatican, Logge. Photo: Alinari/Art Resource P.2.N. 7808. The collapsing warrior at center left quotes the Venice Falling Gaul.

FIGURE 128. *(facing)* Raphael, *Transfiguration*, 1518–20. Oil on wood; 4.05 × 2.78 m. Vatican, Pinacoteca 333. Photo: Alinari/Art Resource 7710. Saint Peter, at center, may quote the Naples Dying Gaul and Dead Persian; Saint John, at right, quotes the Paris Gaul.

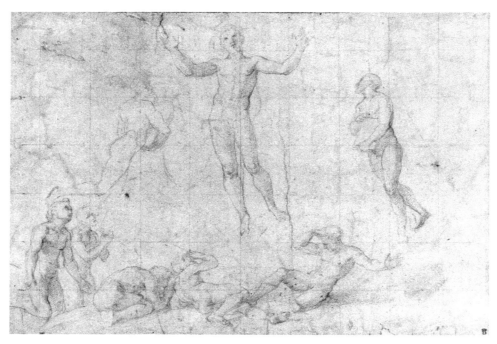

FIGURE 129. Raphael, layout design for the *Transfiguration*, 1518. Red chalk over stylus underdrawing on paper; 24.6 × 35 cm. Devonshire Collection, Chatsworth House (England) 904. Photo: Photographic Survey, Courtauld Institute of Art 308/17/5. Reproduced by permission of the Duke of Devonshire and the Chatsworth Settlement Trustees. Saint Peter, at center, may quote the Naples Dying Gaul and Dead Persian; Saint John, at right, quotes the Paris Gaul.

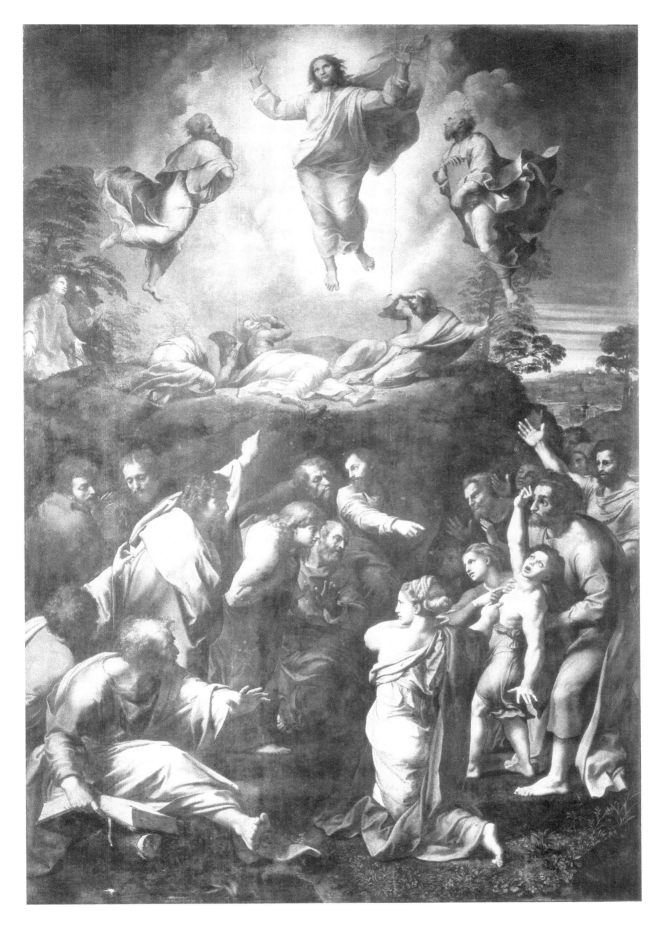

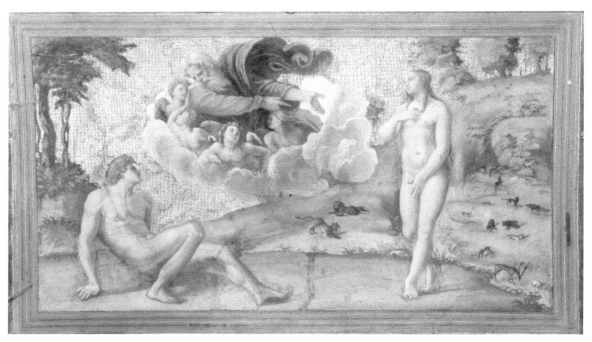

FIGURE 130. Baldassare Peruzzi, *Creation of Eve*, 1519. Fresco; 63 × 122 cm. Rome, Palazzo della Cancelleria. Photo: GFN E 37876. The Adam quotes the Venice Falling Gaul.

By making this juxtaposition, Raphael may have been paying homage to the untimely death of the young Lorenzo de' Medici in 1519 and perhaps also responding to a burst of apocalyptic prophecies urging the church to cure its own ills quickly before the Second Coming, then believed by some to be imminent. But in addition he was surely referencing the cliché that Leo X (also a Medici) was the new *medicus* specially predestined by God to doctor those ills. As God's earthly avatar, *alter deus in terris,* Leo had even been addressed upon his accession in 1513 as "our supreme Pontiff . . . raised to this dignity by the Holy Spirit, as if the latter had consigned the ailing Church of Christ *ad optimo medico.*" Yet nearly seven years had passed, the Reformation was in full swing, and the promised cure must have seemed more remote than ever.[75]

The upper register is the main focus of our interest. It illustrates Matthew's report that when the three disciples, James, Peter, and John, saw the Transfiguration and heard God's voice from the clouds acknowledging Jesus as his son, "they fell on their faces, and were sore afraid" (Matt. 17:2–6). Prostrated by the radiant epiphany of the weightless, floating Christ above, and pinned to the earth by the gravitational pull of the massive, somber mountain below, they thematize the genre's basic contrast between earth and heaven, mortality and divinity, sin and salvation, darkness and light, and matter and spirit. As such they epitomize our mortal helplessness and total dependence upon divine Grace for salvation. The woman at center foreground, a stunning female version of the type of the Paris Gaul purified of all wounds and blemishes, perhaps represents this Grace.

A nude layout design in Chatsworth (Figure 129) helps to clarify Raphael's design process, showing inter alia that here one can no longer speak of borrowings per se.[76] The types are virtually undetectable unless one knows their history. Of the three prostrate apostles, John, at right, is the one most obviously derived from the Little Barbarians. In him the Paris Gaul (Figure 115) has become so compressed – contrast the upright, commanding "Grace" below (Figure 128) – that he all but morphs into the Venice Falling Gaul (Figures 111). Since Raphael was completely alive to the expressive potential of both, did he intentionally conflate them for enhanced effect, capping his own earlier forays into the awesome workings of the divine in the *Death of Ananias* and *Conversion of Saul* (Figures 117, 119)?

The central apostle, surely Peter, is more enigmatic still. One would like to see him as a conflation of the types of the Naples Dying Gaul and Dead Persian, but echoes of the Chigi *Resurrection* drawings are equally strong (Figure 99). With this blended figure the exchange noted earlier between *saper fare bene da sè* and *servirsi delle cose d'altri,* each defining and enriching the other, has come full circle.

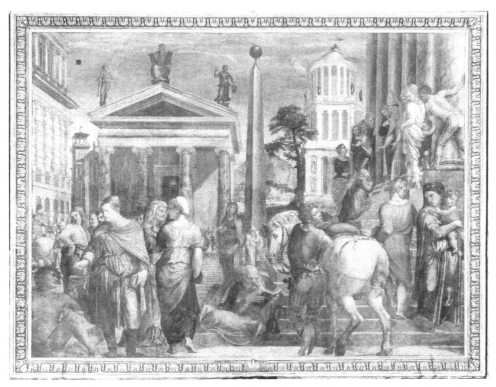

FIGURE 131. Baldassare Peruzzi, *Presentation of the Virgin*, 1523. Fresco; 3.51 × 4.6 m (originally ca. 5.5 m). Rome, Santa Maria della Pace. Photo: GFN Rome 91159. The beggar at far left, partially truncated by the later frame, quotes the Venice Falling Gaul.

5. ROME (II): PERUZZI, PARMIGIANINO, AND MICHELANGELO

Knowledge of the Little Barbarians was diffused well beyond Raphael and his school. The brilliant all-rounder Baldassare Peruzzi (1481–1536), whom Vasari describes as a devoted student of antique architecture and sculpture from the minute he arrived in Rome in 1503, is a good example.[77] Peruzzi began to use the Venice Falling Gaul (Figures 95, 111) as early as 1516. In that year it suddenly appears, a completely new figure type for him, as the plaintive, supplicating painter Apelles in a drawing in the Louvre for a rendition of Lucian's *ekphrasis* of Apelles' lost pictorial allegory, the *Calumny*.[78]

For the next decade the Falling Gaul becomes almost a leitmotif in Peruzzi's painting. The next year he adapted it for the reclining Pan in a Bacchic procession for the Farnesina, and in 1519 brilliantly recycled it twice on the Palazzo della Cancelleria's famous Volta Dorata. There it does duty as Adam in a scene of God the Father introducing the naked Eve (Figure 130) and as Abel murdered by Cain. Poised between stunned shock and expectation, Adam stares amazed at Eve, who, echoing the Capitoline Venus, coyly hides her nakedness in an eerie anticipation of the Fall. The scene is obviously indebted to Raphael's recently completed Vatican Logge (compare Figure 122) but also curiously recalls Albertinelli's Courtauld *cassone* (Figure 102). Albertinelli's borrowing is much more straightforward, however, eschewing such postural and emotional ambiguities.

The Falling Gaul's next appearance in Peruzzi's work comes in his huge fresco of the *Presentation of the Virgin* in Santa Maria della Pace, begun in 1523 (Figure 131). By this time the statue itself was in Venice, so Peruzzi must have been working from his sketches alone. Vasari pays special attention to the figure in question. Positioned at the extreme left, and now partially truncated by later restoration work on the building, he is "a beggar, quite naked and very wretched, who may be seen asking for alms with pitiful humility" from "a gentleman in antique dress just dismounted from his horse." This charity motif was a fixture of paintings of the *Presentation*, for beggars thronged the entrance of the temple (see, e.g., Acts 3:1–11), and to include it neatly referenced the need to match *amor Dei*, (Mary's) love of God, with *amor proximi*, love of one's neighbor. Here, it would have gained extra force from the close connections between (on the one side) Peruzzi, his patron the cleric Filippo Sergardi, and the church of Santa Maria della Pace itself, and (on the other) the great Chigi family of bankers.[79]

Indeed, a preliminary drawing in the Louvre shows that Peruzzi originally intended the type to appear *twice* in the picture, inserting a second, frontal version of it at stage center.[80] He then changed his mind, substituting for this figure a philosopher-like individual studiously reading the Bible. Together they stand for the entire span of history *ante gratiam,* and (since Peruzzi reduced Mary herself to a tiny figure in the background) bring the Christian's need to balance *amor proximi* and *amor Dei* right into the painting's foreground.

Peruzzi left Rome after the sack of 1527 and rarely returned to the city thereafter, devoting most of his energies to architecture. Yet a single late drawing, the *Allegory of Mercury* in the Louvre, shows that he never forgot the Falling Gaul. Apparently an attack on alchemy and a parody of the search for the philosophers' stone, the picture utilizes him right in the foreground again, directing the viewer's attention up through the crowd of squabbling scientists to the figure of the god.[81]

Peruzzi's engagement with the Falling Gaul is remarkably even and consistent, foreshadowing Titian's discussed in the next section. More typical of contemporary practice is the work of one of the alchemical devotees he was implicitly attacking, namely, Parmigianino (1503–40). Parmigianino, who lived in Rome only for three years (1524–27), seems to have quoted our Barbarians only once, but he did so in virtuoso fashion. He too immersed himself in the study of antiquity during his brief stay in the city, "devoting himself to examining all works of ancient sculpture and painting" within its walls.[82]

His lofty *Vision of Saint Jerome*, now in London (Figure 132), was commissioned on January 3, 1526, and was barely finished at the time of the Sack. Ordered by Maria Bufalini as an altarpiece for the Caccialupi Chapel in San Salvatore in Lauro, but in the hard times after 1527 stored for a long time in the sacristy of Santa Maria della Pace, it shows Saint Jerome asleep and dreaming. His vision – a radiant Virgin and Child – appears above, while Saint John the Baptist mediates between the two at lower left, lunging outward toward us and gesticulating upward towards the holy pair.

Some believe that Parmigianino perhaps based Jerome himself upon the famous sleeping Ariadne (then known as Cleopatra) in the Vatican, though other candidates are possible and perhaps even more likely. But his rugged, wilderness-dwelling John clearly quotes the Paris Gaul in mirror image. As in Raphael's *Death of Ananias,* this simple reversal – ensuring that the saint turns his body into the picture and gestures upward with his right arm – makes the scene develop from left to right in normal Renaissance fashion. Parmigianino's preliminary sketches show that he conceived the two saints quite differently to begin with, only later turning to the two antique statues for inspiration. They are, in other words, necessary to explain his final composition. Indeed, what seems to be the earliest sketch of Parmigianino's to make use of the Paris Gaul, now in the British Museum, even reproduces him from exactly the vantage point of a visitor to Alfonsina's loggia (see Figure 71). The artist has completed his then-missing arms (Figure 98) and has turned his head – most awkwardly – toward the spectator.[83]

In describing this painting, Vasari singled out this "figure of St. John, kneeling on one knee in an attitude of extraordinary beauty, turning his body and pointing to the infant Christ."[84] A brawny denizen of the world *ante gratiam* yet wounded in body (see Figures 61, 115), the Paris Gaul – or rather, the Roman hero that he was supposed to be – was the perfect model for the self-denying, self-tormented, yet hardy and decidedly physical prophet. (We shall encounter this kind of transfiguration again with Michelangelo.) Now – as it were – healed and made whole through faith, he has become the vital link between the Old Testament and the New, and between the holy pair and us. But there is more.

Parmigianino's painting is the first in the Renaissance to make open and direct use of what one might call the peculiarly *deictic* quality of the Little Barbarians. We look at them, and *they look back.* Indeed, they do more: Their flailing gestures, wild glances, open mouths, and puzzling lack of opponents arrest us with a force equivalent to a shout or command. To paraphrase some remarks of Mieke Bal's from another context, in the terminology of semiotics they are no longer merely *iconic* but *indexical*. They point to us and hail us like someone shouting, "Hey, you!" They mobilize a species of second-person address that in turn presupposes and requires our response.[85]

And among them the Paris Gaul – a mighty Roman hero, be it not forgotten – is perhaps the most indexical of all (see Figures 61, 115). Fortified by his *paragone* with the Gaul, and borrowing an emphatic pointing gesture from Leonardo's *Saint John the Baptist* (his last painting, now in the Louvre), Parmigianino's muscular, crusty, and outspoken saint is very much the voice of authority. To use Althusser's famous formulation, he too *interpellates* us, forcing us to attend to his command to believe and repent. In this respect he resembles "*the policeman* who shouts 'Hey, you!' – making the subject turn around because of being addressed, and thus constituting him as subject into subjection." If we can believe Vasari, the gambit paid swift and most unexpected dividends. When a band of German soldiers burst into Parmigianino's studio during the Sack of Rome and surprised him at work, reportedly they were "struck with amazement" at the

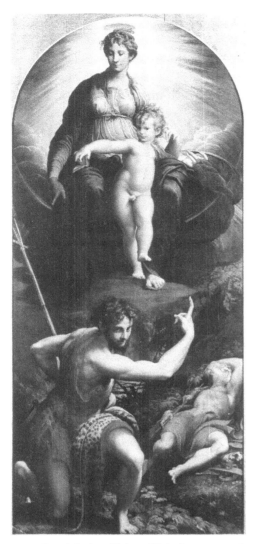

FIGURE 132. Parmigianino, *Vision of Saint Jerome*, 1526–27. Oil on wood; 3.4 × 1.5 m. London, National Gallery 33. Photo: courtesy National Gallery. The Saint John the Baptist in the foreground quotes the Paris Gaul.

painting and allowed him to continue instead of killing him.[86]

By deftly exploiting the Paris Gaul's serpentine *contrapposto* and his peculiarly deictic quality (which must have been obvious despite the damage to his arms), Parmigianino brilliantly crafted his Saint John as a mediator between Matter (Jerome) and Spirit (his vision) and as a means to draw the spectator into this nexus. He bridges, in other words, the genre's governing polarities of earth and heaven, mortality and divinity, sin and salvation, darkness and light, and matter and spirit. This is why he wears the leopard skin of Bacchus, the god of both sensuous experience and spiritual ecstasy, and shares the same serpentine *figura* as the two saints and the Christ child.

The baby Jesus, the summit of creation, is of course the least contorted and most graceful of the three. Glancing down at John to acknowledge his introduction, he stands with outflung arms in anticipation of the Crucifixion, while the rock at his feet symbolizes the church and the sunburst behind Mary the Apocalypse and Second Coming. Instructed by John, we understand Christ's ineffable majesty and believe, turning away from sin to repentance and from the travails of this world to the *imitatio Christi* that will ensure our salvation.

Finally, Michelangelo: truly a giant for a classicist to wrestle with. One feels both inadequate to the task and privately depressed that probably no ancient artist ever created work that even approached his – Renaissance inferiority complexes toward antiquity notwithstanding.

Although a highly serpentine model for a river god in the Accademia in Florence of about 1525 might owe something to the Venice Falling Gaul, Michelangelo's substantive engagement with the Little Barbarians is confined to the *Last Judgment* (Figures 133–36).[87] Now cleaned and fully visible in all its glory, this enormous fresco was commissioned by Clement VII around 1533, begun two years later, and unveiled on October 31, 1541. Three specific quotations from the antique – the Belvedere Apollo for Christ, the Crouching Venus for the Virgin, and the Farnese Hercules for John the Baptist – are well established and soon earned him much criticism.[88]

All of them are highly charged *paragoni* with ancient sculpture and the paganism it evoked. Cast as a latter-day Apollo (whose cult and temple once occupied Vatican Hill), the now massively muscled Christ is the *sol iustitiae*, the sun god, lord of wisdom, and divine castigator (*sophronistes*) extraordinary. As a latter-day Venus Urania and Venus Pudica, the Virgin reincarnates the goddess's perfect womanhood, her heavenly beauty and divine modesty combined. And as a latter-day Hercules, John is the tormented, laboring, indomitable champion of the faithful, the precursor of Christ and the first of the saints. His prominent camelhair shirt of penitence deftly reminds us of Hercules' lionskin, talisman of the hero's first labor and guarantor of his invulnerability.

These three transformations of the antique, signaling that in this Second Coming all human history, religion, and myth are embraced and fulfilled, set the scene for Michelangelo's use of the Little Barbarians. He makes three obvious quotations of them: The Naples Giant does duty for one of the ascending Elect; the Venice Falling Gaul for one of the Damned; and the Paris Gaul for Saint Sebastian.

The Naples Giant is quoted in the leftmost group of the ascending Elect, almost at the extreme left-hand side of the fresco (Figure 134). As massively muscled as his

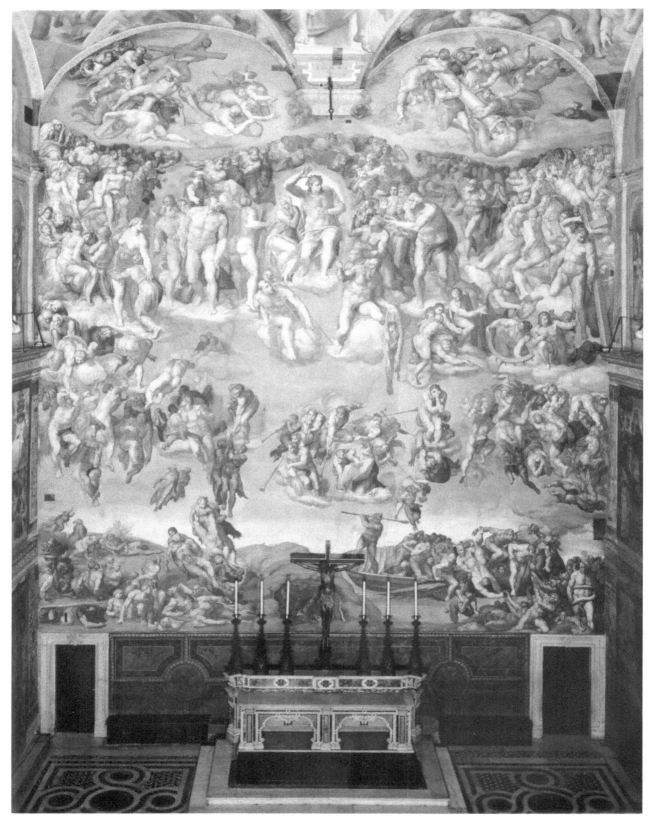

FIGURE 133. Michelangelo, *Last Judgment*, 1535–41. Fresco; 14 × 13.18 m. Vatican, Sistine Chapel. Photo: Vatican Museums XXVII.1.39.

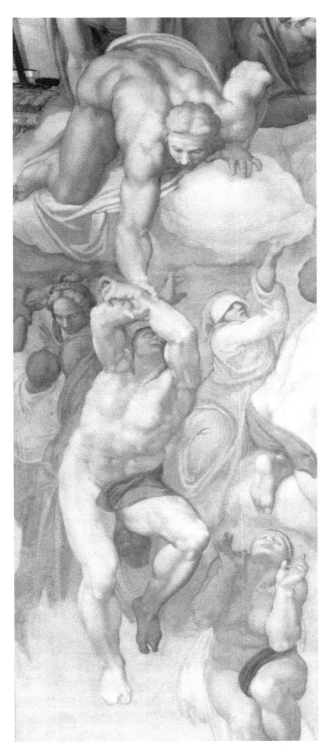

FIGURE 134. Michelangelo, ascending soul from *Last Judgment*, 1535–41. Fresco. Vatican, Sistine Chapel. Photo: Vatican Museums XXVII.1.54. The figure quotes the Naples Giant.

FIGURE 136. Michelangelo, Saint Sebastian from *Last Judgment*, 1535–41. Fresco. Vatican, Sistine Chapel. Photo: Vatican Museums XXXV.29.8. The saint quotes the Paris Gaul.

FIGURE 135. Michelangelo, damned soul from *The Last Judgment*, 1535–41. Fresco. Vatican, Sistine Chapel. Photo: Vatican Museums XXVII.1.97. The figure quotes the Venice Falling Gaul.

marble model, the man is beginning to twist in an ecstatic, flamelike, "serpentinate" *contrapposto*. Now beardless and ideally "youthened," he cocks his left leg instead of his right one, which now frames this entire group of figures and in turn mimics the fresco's framing pilaster. He also raises both his arms above his head in order to receive the grip of a powerfully muscled angel who doubles over in order to hoist him bodily up to heaven. His coy little swatch of drapery was added in the 1560s, destroying Michelangelo's *concetto* that total nudity signifies the soul's acceptance of the mortal body's death as a prelude to hypostatic union with the Godhead.

Together, the two figures echo the heavily articulated pilaster and cornice at their left, and by doing so "associate architectural with muscular uplift and simultaneously contrast material with spiritual support."[89] They thus neatly embody the genre's function, to create bridges between heaven and earth.

Yet since a dead, pagan hero/gladiator could not literally have been a candidate for divine redemption, the quotation's meaning must be sought elsewhere. Here one thinks of the antique body's paradigmatic status for the Renaissance and of this particular one's extraordinary muscular development. As one critic perceptively remarks, "What is resurrected in Michelangelo's fresco is the same race of ideal humanity based on antique models that in the Christian art of Rome had been baptized and had come to embody the *imago Dei*. . . . They are shown as unique persons with dignity and awesome strength, their motivation arising from within, not imposed by some external authority . . . each responding with his own emotions, no one assured of salvation."[90]

And to express this human individuality and its vast emotional range, Michelangelo's fresco mobilizes a hitherto undreamed-of range of *contrapposti*. As his biographer Condivi remarked, its enormously extended postural vocabulary "expresses all that art is able of the human body, omitting no act or gesture." Some of these *contrapposti* Michelangelo invented from scratch; but others he adapted, as here, from the most authoritative source available – ancient sculpture.[91]

Yet although man may propose, God disposes. In the final analysis human individualism and free will are absolutely dependent upon God and subject to divine predestination. This is why another of the Barbarians, the Venice Falling Gaul, is to be found among the Damned at the right-hand corner of the fresco, his pose and even the details of his musculature faithfully transcribed (Figure 135). With his mouth open and teeth bared like those of his marble model, but now sunken in a despairing swoon, he is hauled unceremoniously off Charon's boat by a hairy-legged devil that gnaws enthusiastically into his calf. Whereas the redeemed Naples Giant is shown as miraculously regaining life, this godforsaken individual is decisively further down the road to losing it.

The same principle, but even more boldly applied, characterizes the last of Michelangelo's three quotations from the Barbarians, of the Paris Gaul for Saint Sebastian (Figure 136). Unlike his quattrocento and early cinquecento predecessors, however, this Sebastian is no pincushion of arrows. Instead, like his fellow martyrs in the fresco he is now miraculously untouched and whole again. He vigorously reenacts his *own* martyrdom, brandishing in his outstretched left hand the darts that killed him.

Here, like Parmigianino (see Figure 132), Michelangelo was perhaps attracted by the fact that the Paris Gaul – or rather, the Horatius/Curiatius – is wounded and bleeding in thigh and flank (see Figures 61, 115), yet still remains upright and heroically defiant (as Bellièvre aptly remarked, RT2: "ostendit impetum virilitatis"). So he simply returned the statue's body to its original, unblemished state. A true hero of the church, Sebastian has imitated Christ's self-sacrifice. He has suffered and died for the faith and now gets his due reward in paradise. His wounds are now just a memory, nagging at the spectator's subconscious – a brilliant transformation. And like Christ, John the Baptist, and Mary he embraces, incorporates, and transcends the best of the pagan tradition.

This transformational process, which effectively integrates these three pagan quotations into a larger Christian whole, may explain why (unlike many others) they have hitherto escaped recognition. No longer functioning in any strong way as shifters that direct our attention to their sources, they do exactly the opposite. They keep it firmly riveted upon the here and now of Michelangelo's art. The transformation both deepens the painting's meaning(s) and helps it to avoid both the Bakhtinian "clash of tongues" and fragmenting mixture of discursive modes, and the derivative exhaustion that Michelangelo himself criticized in his acid response to Bandinelli, quoted earlier. Instead, the artist decisively caps his discourse with antiquity by translating and Christianizing it. *Saper fare bene da sè* overrules *servirsi delle cose d'altri*.[92]

6. VENICE (I): SANSOVINO, TITIAN, AND PORDENONE

Around 1530 many Venetians would probably have agreed that an ill wind always brings someone some good. For the Sack of Rome in 1527, although traumatic not only for the Eternal City but for Italy as a whole, had benefited the Serenissima to no small degree. Papal authority (ever a sore point in Venice) was much dimin-

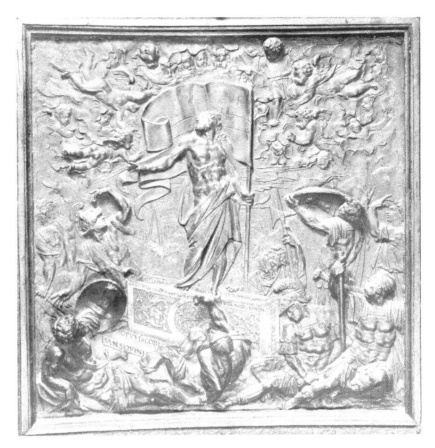

FIGURE 137. Jacopo Sansovino, *Resurrection*, 1546–53. Relief on the Sacristy doors of San Marco, Venice. Bronze; panel, 61.5 × 59.5 cm. Photo: Alinari/Art Resource 38712. The three guards quote the three Venice Gauls.

ished, and the republic was profiting handsomely from the ensuing influx of skilled refugees.[93]

One of these immigrants was the talented sculptor-architect Jacopo Sansovino (1486–1570). According to Vasari, Sansovino had already visited Venice five years previously and had met Doge Andrea Gritti through the good offices of a longstanding acquaintance of ours, the aged Cardinal Domenico Grimani (see section 2). Sansovino had known the cardinal for years, having provided him with a casting of his celebrated statuette of the Laokoon over a decade before. As a result, it comes as no surprise to find that when the sculptor fled Rome in 1527 one of the tombs he had to abandon unfinished was none other than that of the cardinal, who had died in August 1523 (cf. RT3).

Vasari's account and the contemporary documents are complicated and somewhat conflicting. But it is clear that this Grimani–Gritti connection proved decisive in getting Sansovino established in Venice, where he was appointed *protomagister* of the Procuratia di San Marco de Supra on April 1, 1529. This office, one of the republic's most ancient and prestigious, placed him and two colleagues in joint control of the finances, personnel, and fabric of the great cathedral. He held it continuously until his death forty-one years later.[94]

Sansovino's ties to the Grimani clan grew ever closer over the years. So it is not surprising to find him quoting at least two of the Venetian trio of Little Barbarians (see Figure 2), and furthermore doing so in the foreground of one of the two main panels of his most prestigious commission for San Marco, the Sacristy doors (Figure 137). Indeed, it is probably no coincidence that Sansovino designed these panels only weeks after Vettor Grimani had helped to rescue him from the greatest crisis of his long career. For in December 1545 part of the stone vault of the library that Sansovino had been constructing for San Marco collapsed. He was swiftly jailed, interrogated by the procurators, deprived of his salary for two years, and eventually made to finance the repairs out of his own pocket.

The procurators made their final judgment in the case on February 5, 1546. But in a stunning volte-face that was at once a striking tribute both to Sansovino's unique talent and to the power of his friends, they proceeded only a few days later to give him the contract for the Sacristy doors.[95] The panels, featuring the *Entombment* and the *Resurrection*, were finished and cast in 1553, but the doors themselves were not assembled until 1569 and not installed until 1572, two years after Sansovino's death. One monograph calls them "the great masterpiece of

Venetian bronze-relief casting of the High Renaissance" (Figure 137).⁹⁶

As was traditional in cinquecento resurrection scenes, stunned guards roused from their sleep by the miracle occupy the foreground, contrasting and decisively subordinating the pagan world to the world *sub gratia*. The Kneeling Gaul appears at right, the Falling Gaul in the center, and what looks suspiciously like a resurrected Dead Gaul (complete with shield) at left (see Figures 2, 49, 53, 57, 111).

It will be recalled that all three were Grimani pieces (RT4, 9, and 11). As noted in section 2, Cardinal Domenico had acquired the Kneeling Gaul and Falling Gaul in Rome. Transferred to Venice with the rest of his collection in 1523, they were among a select group of sixteen marbles (mostly busts) installed in the Sala delle Teste in 1525, where they were easily accessible to the Venetian elite (RT5; Figure 101). The Dead Gaul may have been Domenico's too, but makes its formal debut only in Aspertini's drawing of ca. 1535 (Figure 105), by which time it was probably in Marino Grimani's collection at the family's Venetian palace at Santa Maria Formosa. It is hard to dismiss their sudden appearance here – and nowhere else in Sansovino's work – as mere coincidence. As was the case with Parmigianino's *Vision of Saint Jerome* (Figure 132), they are necessary to explain the composition.

Since the Venetians identified all three Gauls as gladiators from the start (RT4, 9, 11, and 12), their conversion into Roman soldiers was easy. Sansovino furnished all of them with muscle cuirasses and clothing. He also completed the Kneeling Gaul's missing right arm and placed a staff in his right hand; reversed the Falling Gaul's upper body and arms to lead the spectator's eye more decisively to the focal point of the composition; and (perhaps) brilliantly made the Dead Gaul start up and hold his shield before his eyes at the awesome miracle transpiring before him. We have just witnessed Michelangelo charting exactly the same course.⁹⁷

Upon his arrival in Venice, Sansovino had swiftly struck up a friendship with a second recent immigrant, the Tuscan scholar-poet Pietro Aretino, and also with a third one of far longer standing: Titian (ca. 1485–1576). Titian had been firmly installed as Venice's leading painter for many years. His ongoing *paragone* with sculpture is well documented, and his close engagement with ancient art, oddly denied by Vasari, is amply confirmed by other sources. His studio contained casts and statuettes after the antique, including a fine little Laokoon. In particular, he evidently knew the Sala delle Teste and the Grimani collection at Santa Maria Formosa well. One of his drawings seems to quote the head of the Venice Kneeling Gaul, and his studies for the *Martyrdom of Saint Peter Martyr* of 1526–30 clearly rework the Falling Gaul. His numerous borrowings from ancient art – those from the Little Barbarians included – were first studied in detail by Otto Brendel in 1955.⁹⁸

Brendel thought that Titian first used the Venice Falling Gaul around 1550 for his *Tantalus* (ca. 1550; Figure 139; now lost but known from an engraving), *La Gloria* (1552–54); and *Martyrdom of Saint Lawrence* (1548–59; Figure 140). In fact it appeared much earlier in his *Martyrdom of Saint Peter Martyr* (1526–30; Figure 93), now lost, and then turned up a dozen years later in his *Cain and Abel* (1542–44; Figure 138) for Santo Spirito in Isola, later transferred to Santa Maria della Salute.⁹⁹

Marilyn Perry has justly criticized Brendel's reliance on the Little Barbarians as Aspetti restored them in the decade after Titian's death (see Figures 2, 95, 111, 193). Yet Brendel's basic argument is still valid. For – to repeat – just enough of the Falling Gaul survives that whether one envisages it as hovering Aspetti-like above the ground, sitting, or even totally supine, its limbs could be completed in the mind's eye only more or less as Aspetti later restored them.¹⁰⁰

The *Martyrdom of Saint Peter Martyr* (Figure 93), painted in 1526–30 as an altarpiece for the Scuola di San Pietro Martire in SS. Giovanni e Paolo, indicates that Titian saw and admired the Sala delle Teste soon after it opened in September 1525. Though the original picture was destroyed by fire in 1867, three of his sketches for it survive, plus an extensive series of copies and engravings. They show that Peter, a medieval inquisitor murdered for his inquisitorial zeal in 1252, on the road between Milan and Como, was based precisely upon the Venice Kneeling and Falling Gauls, which had only lately gone on show (RT5; see Figures 49, 53, 111). Two of the sketches even seem to show the saint clean-shaven just like the Falling Gaul.¹⁰¹

Critics have often noted the picture's Michelangelesque flavor, though attributing it to the time of the sculptor's brief visit to Venice in September–November 1529 (by which time the work was well under way) is problematic.¹⁰² Indeed, the composition's similarity to his rival Pordenone's drawings of the same theme (Figure 94) suggests otherwise. Furthermore, Pordenone's study in the Uffizi for Saint Peter's head closely replicates the Falling Gaul's face (but not his hair, which has mutated into the saint's). As remarked at the beginning of this chapter, how all this came about is a mystery given the security that surely surrounded each painter's studio and its competition entry. Yet it must be related, first, to Pordenone's recent arrival on the Venetian scene; second, to his reputation as an ambitious, aggressive, talented, and highly expressive

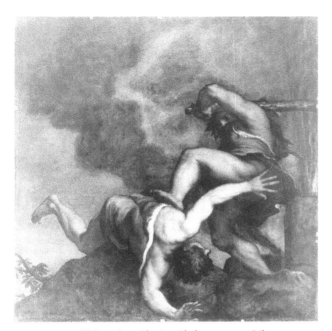

FIGURE 138. Titian, *Cain Slaying Abel*, 1542–44. Oil on canvas; 2.92 × 2.8 m. Venice, Santa Maria della Salute. Photo: Osvaldo Böhm Ve 14633. Abel quotes the Venice Falling Gaul.

painter; and third, to the bitter rivalry between the two that Vasari – suggestively – traces to these very years.[103]

The simplest explanation (but not necessarily the right one) is that the Gauls were indeed the fulcrum of the affair; that one of the painters got wind of the other's idea; and that the feud between them started precisely from there. Pordenone's use of a similar (and completely gratuitous) murder group in his *Christ Nailed to the Cross* of 1520–22 at Cremona and his almost certain visit to Rome around 1518 (when the Falling Gaul was on show in the Palazzo Grimani) perhaps hint at who "borrowed" what.[104] Yet Titian won, so we shall focus on him.

Unlike Pordenone, Titian cleverly combines the motif of the Falling Gaul with the supporting left arm and hand of the Kneeling Gaul. Moreover, the emphatically naturalistic setting of his scene, its diagonally thrusting composition, and its strong narrative tense break radically with the genre's traditional norms, substituting a clear, powerful, and arresting drama that seeks a vigorous emotional response from its audience. By replicating the Falling Gaul's principal viewpoint (Figures 95, 111) and making his knife-wielding assailant lunge leftward out of the woods at right, Titian creates a strong right–left thrust that breaks decisively with normal Renaissance compositional practice.

This compositional volte-face stresses the grotesque unnaturalness of the saint's murder. Its gross injustice and defiance of the Divine Will is literally a retrograde step in humankind's progress to Grace. Although in both compositions the downed saint hovers between terror and ecstasy, only in Titian's does his raised arm and gesturing hand acknowledge the heavenly messengers of his martyrdom.

In this prototypically Counter-Reformation image one may hazard that Titian was reacting to the Gauls not merely qua pathetic victims of violence but qua "gladiators." If so, deeply aware of their ambiguities, he quotes them ironically. For whereas the marbles (purportedly) represented *pagan* gladiators bested in the Roman arena, Saint Peter is a martyred *Christian* gladiator for the Catholic faith. This makes him the worthy successor to those early Christians martyred at the very hands of gladiators like (supposedly) the Grimani figures.

A dozen years would pass between the completion of Titian's picture and his return to the Little Barbarians and the *Saint Peter*'s particular kind of dramatic intensity. The Santa Maria della Salute canvases of 1542–44 (Figure 138) are sometimes described as inaugurating a "mannerist" phase – even a mannerist crisis – in his art.[105] Yet they are better thought of as both his final answer to Pordenone (who had died in mysterious circumstances – poisoned, some said – in 1540), and his definitive response to the demands of a genre – the illusionistic ceiling painting – that was still in its infancy at Venice. Furthermore, he was taking over the commission from Vasari, no less, who had withdrawn from it. So he shrewdly embraced those aspects of Pordenone's and Vasari's mannerism that would make his canvases speak most clearly and dramatically to the spectator far below. These included radical *dal sotto in su* perspectives, daring foreshortenings, bold *contrapposti*, quasi-sculptural modeling, and starkly contrasting chiaroscuro.[106]

Yet to borrow Marilyn Perry's phrase, even the *Cain and Abel* is a cautionary case. For if the radically foreshortened Abel really draws on the Venice Falling Gaul, he is not only reversed but seen in a back view that would have been unobtainable in the Sala delle Teste – and so had to be reconstructed by a live model in the studio. Moreover, not only does another painting from the same set, the *Abraham and Isaac*, at once push this schema further, but (like most of Brendel's other examples) Titian's next essay in the genre, the ecstatically "serpentinate" *Saint John on Patmos* of 1544–47, does so as well. Perhaps, then, Titian was using live studio models throughout, developing his types as he went.[107]

Brendel himself understood the phenomenon clearly:

In the incessant development of Titian's art, the classical element emerges as a constantly present and active factor. He

possessed an intuitive understanding of the ancient monuments with which he had contact, and a keen intelligence of the possibilities hidden in an ancient motif. These possibilities he realized by consciously reshaping – *not necessarily copying faithfully* – the classical models which he incorporated into his own work. The most conspicuous fact about his borrowings from ancient art is that the freedom with which Titian employed them increased throughout the years.[108]

Others agree. A more recent critic stresses Titian's "immense culture of images assembled piece by piece and uninterruptedly throughout his long career. . . . From this repertoire he drew at his own pleasure, recomposing its single elements" as it suited him. This is Michelangelo's *saper fare bene da sè* and *servirsi delle cose d'altri* once more.[109]

Brendel's other main conclusion, that Titian was interested in these sources almost exclusively for their "emotional and expressive content" – that is, although he avoids the term, as mere *Pathosformeln* – is less compelling. On the contrary, one can easily see how the painter appropriated the type of the Venice Falling Gaul as a "fallen gladiator" and eagerly exploited its ambiguities. Seen as an icon of pagan violence, and again combined as appropriate with the Kneeling Gaul, it becomes the figures of Abel (violence's primordial victim) and the sadistic infanticide, Tantalus (Figure 139). To these, incidentally, one can also add the rapist Tityus from the same cycle of pictures, which are ceiling paintings too.

The difference between them, of course, is that whereas Abel was an innocent victim of violence, the two pagan sinners are reaping their just reward for inflicting unprovoked violence on others: eternal punishment in hell. As Luba Freedman has noted, "By adopting the posture of the Fallen Gaul for the Tantalus, Titian converts the Gaul's emotional and physical helplessness into an eternal metaphysical predicament."[110] Consciously or not, this caps Michelangelo's use of the Falling Gaul for one of the Damned of the *Last Judgment* (Figure 135), which Titian had seen in Rome in 1545–46. His ongoing *paragone* with the great Florentine as well as with the art of sculpture is well documented.

The *Martyrdom of Saint Lawrence* is Titian's great religious masterpiece of the 1550s (Figure 140). An imposing sixteen feet (4.93 m) high, and often considered to be the first successful nocturne in Western art, it has prompted several perceptive iconographic readings that cannot be addressed in detail here. Saint Lawrence quotes the Falling Gaul verbatim, replicating him at almost exactly his proper size in order to dispel all doubt as to what the painter is trying to say. Moreover, one of Lawrence's tormentors even grasps his arms at exactly the

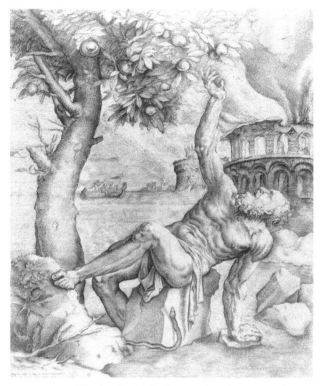

FIGURE 139. Woodcut by Giulio Sanuto after Titian, *Tantalus*, ca. 1550. Original, oil on canvas; ca. 2.5 × 2.16 m. London, British Museum. Photo: BM PS 148818. Tantalus quotes the Venice Falling Gaul.

point where the Gaul's are broken off, and the saint's legs are shadowed at exactly their point of breakage also.[111]

Though some details are still hotly disputed, it is clear that Titian conceived his picture as a double *paragone*, challenging on the one hand the two modern paragons of the art, Michelangelo and Raphael, and on the other the magisterial world of pagan sculpture and architecture.[112] His entire composition is structured in terms of the pagan–Christian struggle and the church's ultimate triumph that Lawrence's martyrdom allegedly secured,[113] and he programmatically arranged its main ingredients in cruciform fashion. His own signature in Roman letters on the front of Lawrence's grill, overlooking the church's high altar and the ritual elevation of the Host, shows his keen awareness of his own place in this divine scheme. It signals both his own mortality and his hope in turn to become immortal ("Divino") by his association with the saint and his good work in painting this great picture.

By quoting the Venice Falling Gaul so obviously, Titian characterizes Lawrence as a gladiator for the faith just like Saint Peter Martyr (Figure 93). By completing the marble's missing limbs to form a cross, he identifies the saint as a Christ-type, thereby enabling us to understand

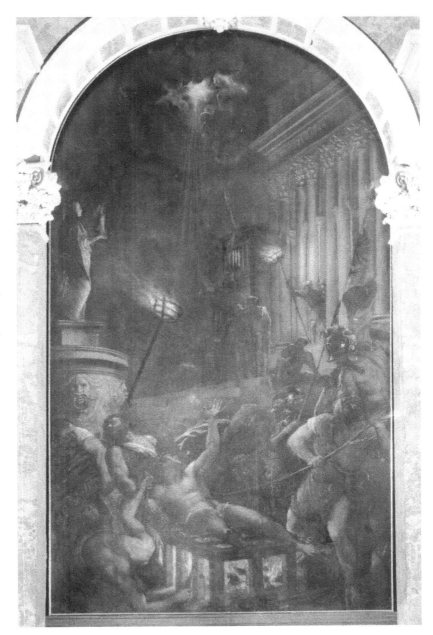

FIGURE 140. Titian, *Martyrdom of Saint Lawrence*, 1548–59. Oil on canvas; 5 ×2.8 m. Venice, Chiesa dei Gesuiti. Photo: Osvaldo Böhm Ve 9021. The saint quotes the Venice Falling Gaul.

the function of Lawrence's sacrifice and easing us into the complexities of the picture. And as in the *Saint Peter Martyr* the saint replicates the statue's principal viewpoint (Figures 93, 95, 111), to similar effect. Together, the saint and his flaming grill stab brutally and perversely backward into the canvas, spotlighting the grotesque unnaturalness of this unholy barbecue. They underscore its crass reversal of the proper order of things and its ugly defiance of the Divine Will.

But at the very moment that Lawrence glances diagonally across at the pagan prefect and priest who have ordered his torment, and gestures up the picture's vertical axis (compare the earlier *Saint Peter Martyr*, Figure 93),

across the black hole that so ominously blots out the center of the scene, the moon bursts through the thunderclouds above. The Virgin Mary, the new Diana Lucina, has come to succor him. In a flash we too understand how this very sculptural Lawrence can mediate for us between earth and heaven, mortality and divinity, sin and salvation, darkness and light, and matter and spirit. He personifies our mortal helplessness and total dependence upon Divine Grace for salvation.

The Corinthian capitals of the picture's framing pilasters establish the horizontal axis of this cruciform composition. At left a statue of Vesta, goddess of the hearth that stood at ancient Rome's center and of the domestic

fire that is now being misused so cruelly to torture Lawrence, stands stiff and still on its grotesquely carved base. A winged Victory (Titian's own invention) rests in its lifeless, outstretched hand, ironically celebrating paganism's hollow "victory" over the saint. It guides us across the picture to the magnificent pagan temple (also Corinthian) at right, complete with Roman priest and prefect standing on the steps before it. This is probably the Templum Divi Hadriani whose colonnade still frames the Piazza di Pietra in Rome.[114] Commentators upon Titian's picture have apparently yet to notice that in the 1550s this building had been Christianized. It housed the Pontificia Dogana di Terra, the latter-day heir to Lawrence's own position as financial administrator for the fledgling church.

Titian reworked his dazzling composition for King Philip II of Spain in 1564–67 and soon referenced the Venice Falling Gaul again in a problematically dated *Fall of Man*, echoing Raphael (see Figure 122) in resurrecting the Little Barbarians as relics of the pagan world.[115] But what just possibly might be his final citation of it appears in a most unexpected place: the *Rape of Europa* of 1559–62 (Figure 141). Painted for Philip II along with a *Perseus and Andromeda* and a *Death of Actaeon* it was the last of the *poesie* after Ovid's *Metamorphoses* that Titian would complete for that monarch. Unanimously thought to quote the Dirke from the famous marble group of the Farnese Bull, discovered in Rome in August 1545, it cannot in fact do so.[116]

For though Titian could easily have seen the Bull when he visited Rome a few months after its discovery, at that time it was merely a huge heap of fragments, and Dirke's entire upper body was missing. Identified as Hercules and the Marathonian Bull, it was not recognized as Dirke and the Theban one until 1565 at the earliest. Dirke herself was not restored in the crab-claw fashion that characterizes Titian's Europa until at least that date and probably not until 1579 – in any case far too late for the painter to have used her in his picture. The restorer was none other than our old acquaintance Giambattista de' Bianchi (see section 2). One wonders: Did he somehow get his inspiration from Titian?[117]

Since Europa looks like the Falling Gaul with its sex changed and upper body reversed, let us allow ourselves to be carried away for a moment and to speculate what such a citation might signal. Many observers have noticed how strongly the heroine emerges from the composition and how contorted and fleshy she is. To skim the surface of the huge literature on her, Erwin Panofsky deemed her an "obvious anomaly"; Leonard Barkan calls her "almost grotesque" and hazards that by translating Europa's fear and passion into so distorted a body, "the painter has transferred metamorphosis from the bull to the girl"; Philipp Fehl confesses himself "amazed" by "her wiggly form and the ample fullness of her beauty"; and Filippo Pedrocco more coyly notes her dominating presence and "sculpturally modeled contours."[118]

All this arouses the suspicion that Titian is virtually putting Europa in quotes for our benefit. Could he be gesturing in the direction of his source? Any interchange between them would certainly release a plurality of messages – in other words, ambiguities – to thicken the work of mimesis and to warn us afresh against trying to reduce the picture's meaning(s) to the artist's intention.[119]

Several thoughts come to mind:

First, there is Titian's emphatic, ongoing *paragone* with sculpture and with both ancient and contemporary painting, and his particular *paragone* in this instance with the weaver Arachne and the poet Ovid.[120] His lusciously tactile heroine eclipses the best of antiquity and the moderns. His apologist, Lodovico Dolce, said it all when the picture was finished:

Ne depinse gia mai Zeusi, od Apello
Rafael, ne Titian si raro oggetto
Ne degna d'agguagliare a questa parmi
Opra d'antichi, o di moderni marmi.

Ne'er once did Zeuxis or Apelles,
Raphael or Titian paint a thing so rare,
Nor do works fit to compare with her
Exist among marbles ancient or modern.[121]

Second, if the proposal holds, Titian achieves a private metamorphosis of his own that rivals and even surpasses Jupiter's outspokenly dramatic and public one. The god changed only into an animal – something that gods can do whenever they want – but Titian has metamorphosed *his* figure from marble into paint, from ancient into modern, and from man into woman. His fleshy, half-draped, and supremely sensuous Europa is to her sex what the muscular, naked, and homoerotically appealing "gladiator" is to his: a heroic archetype, a paragon of gendered sex appeal. At a certain (sadistic, Freudian) level, the fact that both are equally and conspicuously vulnerable and terrified only enhances their allure.

Yet (third) Europa's fate will be utterly different from the "gladiator's," especially if the critics are right that the picture is the climax of Titian's *poesie* and that her abduction is a veiled metaphor for death, resurrection, immortality, and eventual union with God.[122] The young "gladiator" about to die in agony now metamorphoses into the young woman who is promised life, union with the divine, and eternal fame; his barren life and death metamorphose into the fecund future of the mother-to-

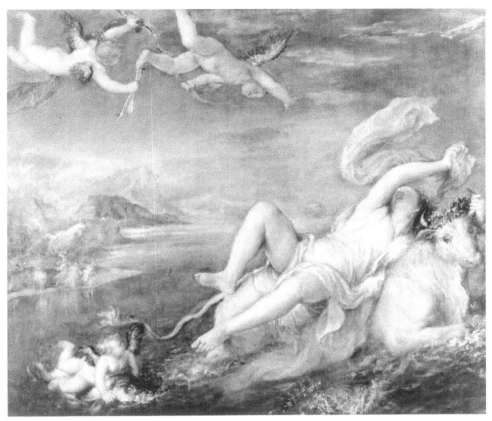

FIGURE 141. Titian, *Rape of Europa*, 1559–62. Oil on canvas; 1.78 × 2.05 m. Boston, Isabella Stewart Gardner Museum. Photo: Museum P26e1. Europa may quote the Venice Falling Gaul.

be and eponymous heroine of a continent. Of course Philip, far removed from Venice and unacquainted with Titian's sources (whatever they were) would at best have understood only the second half of each equation. But as heir apparent to a large part of that continent and as a king that (Dolce again) "in our century even outshines Augustus in his glory," he would have been well pleased.

7. VENICE (II): VERONESE AND TINTORETTO

By the time he painted the *Europa*, Titian had been ceding his Venetian clientele increasingly to his sometime pupils Paolo Veronese (1528–88) and Jacopo Tintoretto (1519–94). The classicizing Veronese also briefly collaborated with Sansovino in the late 1550s, and in this period apparently had access to the sculptor's studio and often drew upon his work for new ideas. He may have used the Venice Kneeling Gaul (see Figure 49) first in 1566, when he painted a *Saint Jerome in the Desert* that looks quite like it (drapery included) and a *Martyrdom of Saint George* that may be an adaptation of it.[123]

As a result, one is not surprised to find him taking up and developing Sansovino's particular usage of the Kneeling Gaul shortly thereafter, in his *Christ and the Centurion* now in Madrid (Figure 142; cf. Figure 49). It is undated, but it is usually put around 1570. Here, though, Veronese now reverses his figure in order to maintain the left–right flow of the narrative and poises him on the diagonal. This creates a deep 'V' in the composition and leads the eye to a pagan altar in the background, of which more anon. The picture was popular. Several workshop versions survive, and Veronese soon recycled it himself for two separate eucharistic narrative sequences.[124]

Philip Fehl has determined that of the two biblical accounts of the miracle (Matthew 8:5–13; Luke 7:1–10), Veronese followed Matthew's.[125] The centurion, whose servant was lying at home sick of the palsy, had come to Jesus and asked him for help. Jesus offered to come to his house, but the centurion demurred, saying that he was unworthy to have him under his roof; instead, Jesus should heal his servant by speaking the healing words alone, there and then.

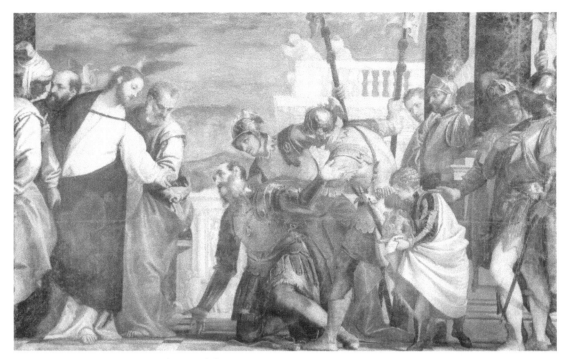

FIGURE 142. Veronese, *Christ and the Centurion*, ca. 1570. Oil on canvas; 1.92 × 2.97 m. Madrid, Prado 492. Photo: Prado 492. The centurion quotes the Venice Kneeling Gaul.

When Jesus heard it, he marveled, and said to them that followed, "Verily, I have not found so great faith, no, not in Israel. And I say unto you, That many shall come from the east and west, and shall sit down with Abraham and Isaac and Jacob, in the Kingdom of Heaven. But the children of the Kingdom shall be cast into outer darkness: There shall be weeping and gnashing of teeth." And Jesus said unto the centurion, "Go thy way; and as thou hast believed, so it shall be done to thee." And his servant was healed in the selfsame hour.

The miracle had long been understood as basic to the meaning of the Mass (where communicants receive Christ's own body on faith), but in these very years it became a cornerstone of Counter-Reformation theology. In 1570 the Council of Trent enshrined it in the new *Missale Romanum* as a paradigm of salvation through faith and grace, and thus as a decisive index of the world *sub gratia*.[126] (Could this move have motivated Veronese's commission?) Fehl has shown that the turbaned Turk at the extreme left and the two figures in contemporary Italian armor at the extreme right represent the east and west of Jesus' speech, and that in the redaction in Kansas City, Missouri, the rightmost of these men is probably the painter himself. They extend the unseen miracle and the act of faith that supports it through contemporary space and time. But that is not all.

In borrowing the Kneeling Gaul for his scene, Veronese opens a double *paragone,* Titian-fashion, with ancient *and* modern sculpture. Following Titian's lead in the *Saint Peter Martyr* and *Saint Lawrence* (Figures 93, 140), he turns the defeated pagan "gladiator" and Sansovino's stunned Roman guard (Figure 137) into a believer. (One notices that the centurion both gestures *away* from the pagan altar at center and has dropped his sword.) No longer groveling in terror, he voluntarily kneels at Christ's feet in steadfast faith and humble homage. Through his trust and humility he has gained a spiritual victory that both reverses the dire situation of his antique model and renders the work of his own bloody profession suddenly obsolete.

The meaning of the altar, embellished with a statuette of an Aphrodite or nymph then in the Grimani collection and donated to the Serenissima in 1586, now becomes clear.[127] For as always in Veronese's work, architecture signifies. Like the balustrade and massive columns that reinforce the entire right-hand side of the picture, the altar represents the mighty world of paganism now conquered by Christ's grace. (The Kansas City version replaces it by a triumphal arch opening onto a paradise garden, which skews the meaning somewhat by erasing the religious element from the pagan side of the equation and substituting a foretaste of the Christian triumph.)

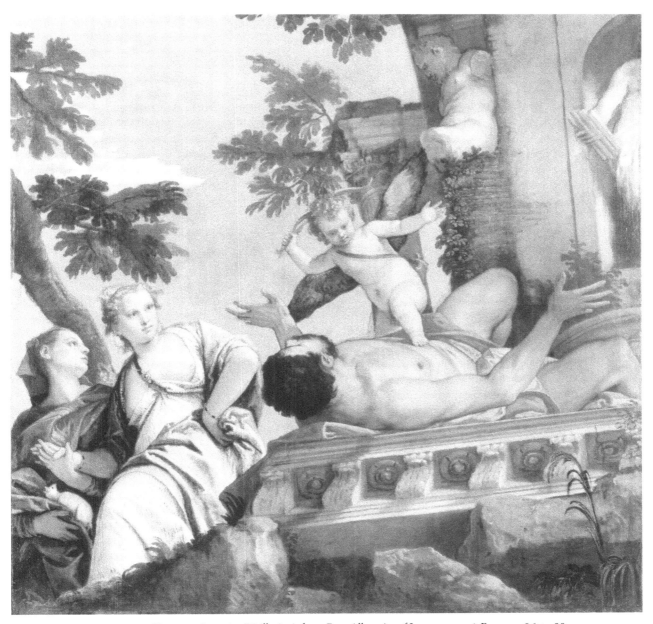

FIGURE 143. Veronese, *Scorn* (or *Disillusion*), from *Four Allegories of Love*, ca. 1576. Fresco; 1.86 × 1.88 m. London, National Gallery 1324. Photo: Photo: courtesy National Gallery. The devastated lover quotes the Venice Falling Gaul.

As to the Venice Falling Gaul, Veronese seems to have made use of him as early as 1553–54 for the Vices in his *Jupiter Smiting the Vices with Lightning* in the Palazzo Ducale. He recycled it the next year for a disciple at the foot of his *Transfiguration* in Montagnana and again in 1558 for his *Saint Sebastian Beaten and Martyred* in the church of San Sebastiano in Venice. Shortly thereafter his workshop used it for the beaten and pitiful traveler in a *Good Samaritan* now in Dresden. Its most interesting appearance, however, comes in one of his four splendid *Allegories of Love* now in London (Figure 143). Painted around 1576 perhaps for the Emperor Rudolf II's bedroom in Hradčany Castle, Prague, they still hold many secrets, though their general meaning is clear. Two, the so-called *Fidelity* (or *Happy Union*) and *Respect* (or *Continence of Scipio*), send a positive message; and two, the so-called *Infidelity* and *Scorn* (or *Disillusion*), deliver warnings.[128] It is the last of these that concerns us.

The devastated lover, a supine version of the Falling Gaul (Figures 95, 111) viewed – programmatically – from an abnormal angle, has collapsed upon a broken cornice that signals the demolition of his hopes (Figure 143). (Since Aspetti's restoration of the statue's limbs and plinth was still a decade away, this may offer a glimpse of how it was actually displayed in the Sala delle Teste.) In the background, a ruined building bearing a broken satyr and part of a Pan with his bawdy pipes reinforces the message. Consumed by a ruinous lust symbolized by the shattered architecture, the broken images of desire, and his own blood-red cloak, the lover is being beaten by a grim little Cupid, perhaps Anteros, god of spiritual love. A casualty of the war with sex and the war between the sexes, he is a ruined, fallen gladiator in the pitiless arena of love.[129]

Following this hapless wretch's gaze to the left – a retrograde move that, as in Titian's *Saint Lawrence* (Figure 140), underscores how far the proper order of things is now reversed – we come upon two female spectators. A compositional caesura sunders them from the prostrate lover. Holding hands, they witness his degradation and disdainfully spurn his plea for help. The nearer woman, her bared breasts radiating carnal love, cocks her left elbow and scornfully sizes him up; the further one, heavily swathed and holding an ermine – a classic symbol of chastity – looks across behind her at the flailing Cupid. Together, the pair urge upon us a quasi-philosophical golden mean or *aurea mediocritas*. Carnal love and chastity are inseparable; we should hold them in balance, eschewing both lustful excess on the one hand and frigidity on the other.[130]

Veronese's aristocratic clientele clearly enjoyed this kind of brilliantly witty play upon the antique and wanted as much of it as he could produce. His great contemporary Jacopo Tintoretto generally cultivated a lower-level public that had little such interest. Yet he had been acquainted with the Sala delle Teste since his twenties (three fine drawings of its splendid portrait of Vitellius survive) as well as with the Grimani collection at Santa Maria Formosa, and throughout his long career he still occasionally produced pictures *all'antica* for educated and/or aristocratic clients.

The trenchantly individual and arresting approach to his subject matter that Tintoretto developed in order to secure his middle-class public led him to create a highly expressive vocabulary of posture and gesture (inevitably criticized by Vasari as fantastical, extravagant, and bizarre) that reveled in superhumanly violent *contrapposti*. Overtly anticlassical when it suited him to be so, he advertised his dedication to Counter-Reformation spirituality through an appropriation of Michelangelesque *figure serpentinate* that took their ecstatic, flamelike striving to extremes. He thereby commits himself to the ultimate *paragone* with sculpture, which – he hints – now stands no chance at all.[131]

All this means that in his work quotations are most hard to spot, especially as his art develops. For he had little investment in flaunting his sources – indeed, perhaps often wanted to bury them – and his keyed-up figures, interwoven compositions, and flickering chiaroscuro in any case tend to drive them well into the background. Among the three Venetian "gladiators" only the Kneeling Gaul and "serpentinate" Falling Gaul in the Sala delle Teste seem to have caught his eye. Though apparently he used the former only once, the latter's writhing posture became a favorite of his, exploited in every possible variation, often with the figure's arms flailing like a windmill. Yet oddly it seldom turns up where one would expect it – never in his vast array of paintings for the Scuola di San Rocco, for example, or in the Gonzaga cycle.[132]

The Venice Kneeling Gaul may do duty for a cripple in the left foreground of the *Saint Augustine Healing the Forty Cripples* of 1549 for San Michele in Vicenza (Figure 144), and it has been argued that the Falling Gaul inspired the other unfortunate on the right; if so, he adapted both quite drastically. Yet the Gauls' utility in this regard is obvious. As Luba Freedman has remarked, "Tintoretto 'copies' the amputated Gaul[s] in order to emphasize the anxious appeal of the crippled and the paralyzed to be cured, that is, to return to their original state of health. These figures are logically parallel . . . because the statue can be metaphorically 'cured,' i.e., restored."[133]

Other canvases from the early and middle periods of Tintoretto's huge output do seem to reference the Fallen Gaul directly. They are the early *Apollo and Marsyas* (1543–44) in Padua; a *Cain and Abel* (1550–53) in the Accademia at Venice; *Theft of Saint Mark's Body* and *Saint Mark Saving a Saracen from Shipwreck* (1562–66; Figures 145–46) from the Scuola Grande di San Marco, now in the Accademia; the *Last Judgment* (1562–63; Figures 148–49) in the Church of Madonna del Orto; *Temptation of Saint Anthony* (1577) in San Trovaso; *Saint Michael and the Devil* (ca. 1582; Figure 147) in San Giuseppe di Castello; and two undated canvases of the *Martyrdom of Saint Lawrence* (1570s and 1580s), one in Christchurch College, Oxford, and the other privately owned.[134] Several give the body an extra half-twist in order to wind up the *contrapposto* even more.

The two Saint Lawrences rework Titian's essays on the same theme (Figure 140); they will not concern us further. Some of the others conform to the general pattern

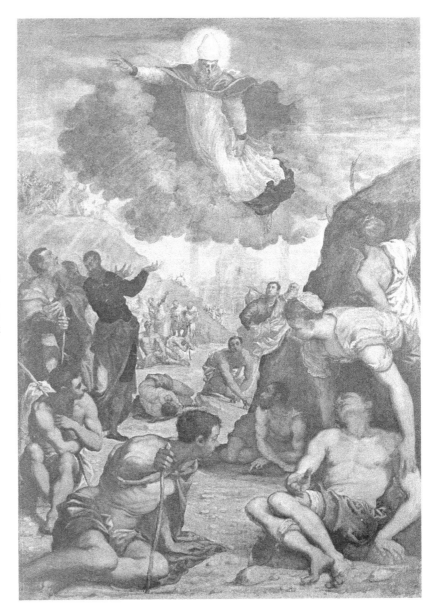

FIGURE 144. Tintoretto, *Saint Augustine Healing the Forty Cripples*, 1549. Oil on canvas; 2.55 × 1.75 m. Vicenza, Museo Civico. Photo: UCLA Photo Archive. The man in the left foreground quotes the Venice Kneeling Gaul.

that has emerged earlier in this study of using the Falling Gaul for figures of the world *ante legem* and often for characters that are in some way "beyond the pale." These include the doomed, cowering Marsyas in the *Apollo and Marsyas*; a cowering, terrified pagan in *Theft of Saint Mark's Body* (Figure 145); one of Saint Anthony's evil tempters; and the Devil himself in the *Saint Michael and the Devil* (Figure 147). Each borrowing is slightly disguised. Marsyas and the tempter are frontal but reversed, and the cowering pagan and the Devil rendered in back view. If the Venice Falling Gaul was indeed displayed supine, Tintoretto perhaps used a live model in order to recreate the latter.

In the two Saint Mark canvases, which were pendants, the quotations neatly frame the action to left and right; in the right-hand one, *Saint Mark Saving a Saracen from Shipwreck* (Figure 146), the figure has become a Christian, though as always Tintoretto carefully avoids mechanical symmetry. In the *Saint Michael and the Devil* (Figure 147) the painter both crams the cowering Devil (complete with horns) into the bottom left-hand corner of the picture and creates an abrupt vertical caesura between him and the majestic, pious figure of the donor, Michele Bon, to the right. Here Tintoretto is surely punning on the latter's name: Evil (*malo*) on the left versus Good (*buono*) on the right.

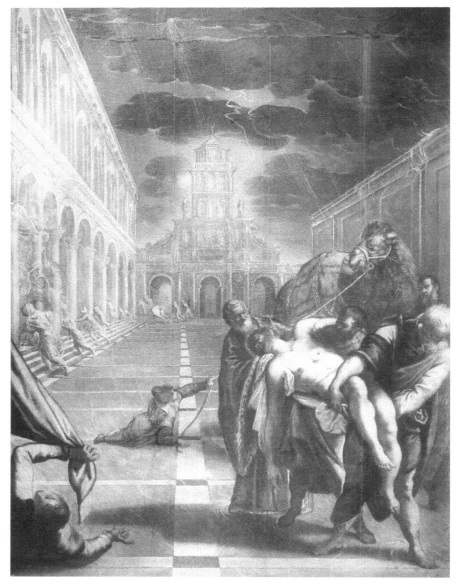

FIGURE 145. Tintoretto, *Theft of Saint Mark's Body*, 1562–66. Oil on canvas; 3.98 × 3.15 m. Venice, Galleria dell'Accademia 831. Photo: Collezioni fiorentini 3715, by permission of the Soprintendenza per il Patrimonio storico artistico demoetnoantropologico di Venezia. The man at lower left quotes the Venice Falling Gaul.

Almost fifty feet (14.5 m) tall, dark and swirling, and hung on the right wall of the sanctuary where it can be seen only at an angle, the *Last Judgment* (Figure 148) will serve to end this Venetian tour just as Michelangelo's great fresco of twenty years earlier ended our Roman one. Unlike the Michelangelo, though, it defies both proper firsthand scrutiny and adequate reproduction in photograph. Opposite it hangs an equally huge but somewhat more legible *Adoration of the Golden Calf,* with Moses receiving the tablets in its upper register. Together, the pair signals the opening of the Era of the Law and the closing of the Era of Grace, flanking the focus and fulcrum of all history, the crucified Christ, displayed on the high altar between them.[135]

A revolving vortex of bodies that was obviously intended to outdo Michelangelo's giant fresco (Figure 133), the *Last Judgment* (Figures 148–49) contains no fewer than three recensions of the type of the Falling Gaul, all among the Resurrected Souls at lower left and all seen in mirror reversal. This extravagance might be explained if a recent suggestion that the Grimani helped to finance the two pictures could be verified.[136] The type first appears

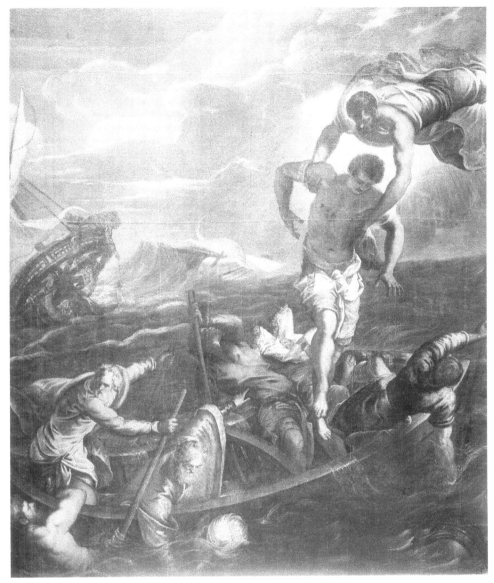

FIGURE 146. Tintoretto, *Saint Mark Saving a Saracen from Shipwreck*, 1562–66. Oil on canvas; 3.98 × 3.37 m. Venice, Galleria dell'Accademia 832. Photo: Collezioni fiorentini 3717, by permission of the Soprintndenza per il Patrimonio storico artistico demoetnoantropologico di Venezia. The sailor at right quotes the Venice Falling Gaul.

in back view in the extreme left-hand corner as a part of a male–female pair that is quite clearly intended to echo a pair of idolatrous Israelite women at the same spot in the *Adoration*. Next, in a nightmare capriccio derived from Michelangelo, he reappears two meters or so up to the right as a man whose head is still not enfleshed, and whose sightless skull stares out horrifically from atop his muscular torso. In a third epiphany further up the left-hand side of the picture, though, he changes sex into a woman who ascends to meet her fate upside down. Titian may have pioneered this kind of transgender adaptation shortly before (Figure 141), but here Tintoretto metamorphoses it into horror.[137]

8. ENVOI

When Tintoretto died in 1594, the Sale delle Teste had been closed and its contents stored for more than seven years. Giovanni Grimani was also dead; the rest of the family collection was now in the Serenissima's possession, and Aspetti had restored it to general satisfaction –

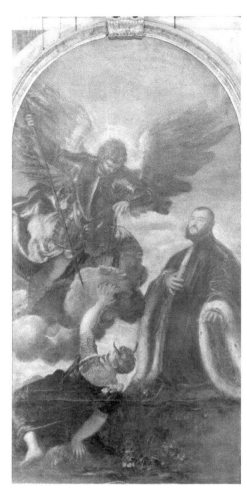

FIGURE 147. Tintoretto, *Saint Michael and the Devil*, ca. 1582. Oil on canvas; 3.8 × 1.8 m. Venice, San Giuseppe di Castello. Photo: Osvaldo Böhm Ve 14774. The Devil quotes the Venice Falling Gaul.

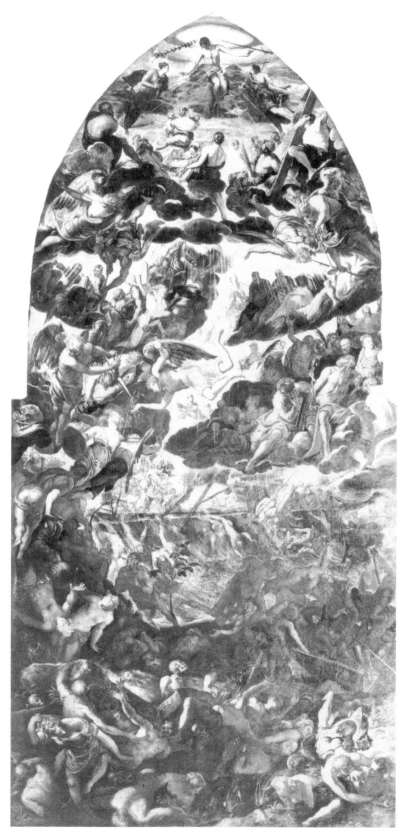

FIGURE 148. Tintoretto, *Last Judgment*, 1562–63. Oil on canvas; 14.5 × 5.9 m. Venice, Chiesa della Madonna dell'Orto. Photo: Osvaldo Böhm Ve 14046.

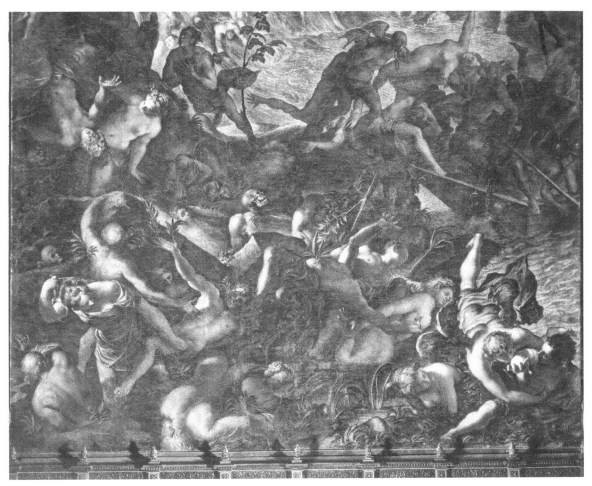

FIGURE 149. Tintoretto, *Last Judgment*, detail of the Resurrected Souls. Oil on canvas. Venice, Chiesa della Madonna dell'Orto. Photo: Alinari/Art Resource 13693. Three of the Resurrected (all left of center above) quote the Venice Falling Gaul.

if not to the improvement of his own bank balance (RT10–12). Henceforth our three "gladiators" would offer little to the creative imagination. So it is time to return to the copies themselves and the time and place of their manufacture. Yet it is hard to do so without recalling their Renaissance identities and these inspired and compelling transformations of them.[138]

Ironically, then, to stay classically pure and uncontaminated by such thoughts I should not have written this chapter and the reader should not have read it.

3. REPRODUCTION

Vae Victis!

೧೯ ೧೯ ೧೯

"Singularity is almost invariably a clue."
SHERLOCK HOLMES, in "The Boscombe Valley Mystery"

THE BIG AND LITTLE BARBARIANS are unique copies and, strangely, were displayed in Rome minus victors (see Figures 1–25, 29–64, 77–80; cf. 27–28, 81, 167). Made in the Roman period for Romans and set up in Rome, they are first and foremost works of Roman art, these singularities included. This chapter considers them as such.

Its first three sections offer some standard archaeological fare, exploring the Barbarians' place in the Roman visual landscape. Who made them and when? Where did they stand? And how might they have been displayed? The exercise is valuable because in addition to establishing probabilities and parameters, it alerts us to features of the works themselves that we might otherwise overlook and offers a framework (however tentative) for thinking about them as Roman sculptures as opposed to mere shadows of Greek ones.

Apart from assuming an imperial date for our marbles, the next four sections are logically independent of the first. Here I turn to the Roman spectator, focusing upon some of the Barbarians' more eye-catching features and situating them in the world of Roman cultural practice. For they would not have been made unless they were thought to be potentially appealing to a Roman audience. So what was their particular appeal? How did they strike a public that instinctively judged a man's character, personality, and status from his face, body, and behavior; was steeped in centuries of discourse about barbarians and barbarism; regularly thrilled to the gladiatorial fights and "fatal charades" (mythical and historical) of the Roman arena; and was well schooled in the awful damage that fighting with edged weapons could inflict upon the human body?

Finally, as in the previous chapter, I focus on reception of a different kind, within the Greco-Roman artistic community. In sections 8–9, attending to the high imperial sculpture of Rome and Greece, I consider a selection of monuments that may reference the Barbarians or at least grapple with their themes. As before, the basic question is not about artistic *influence* but about artistic *appropriation*. It is about borrowing for a purpose and under a description.[1] Given that these imperial-period sculptors were in the business of celebrating and advancing the Roman imperial cause, how far did they draw on our Barbarians, their originals, or (perhaps most important) their *types* in order to do so?

1. DATE AND WORKSHOP

Although there is an increasing tendency to date the Little Barbarians to the late Republican or Augustan period,[2] in my view they were probably carved in or around the first quarter of the second century AD. They date in or around the reigns of the emperors Trajan (98–117) and Hadrian (117–38). Technically uniform (with much use of the drill in hair and drapery, and to outline figures and attributes against their plinths), they are made of Asian marble from Marmara or (less likely) Denizli.[3] Their elder cousins, the Big Gauls (see Figures 27–28, 81, 167) may have been carved by the same workshop. For

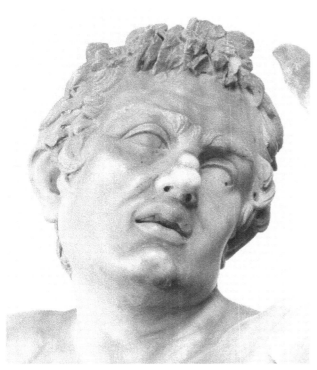

FIGURE 150. Head of the Venice Falling Gaul. Photo: DAI Rome 68.5021.

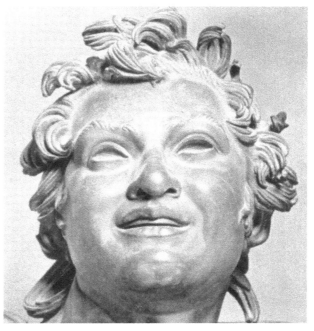

FIGURE 151. Head of the Fauno Rosso (Roman copy). From Hadrian's villa at Tivoli; original, 2nd–1st century BC. Red marble; height of statue, 1.67 m. Rome, Museo Capitolino 657. Photo: From Rudolph Horn, "Hellenistische Köpfe 1" *RM* 52 (1937): pl. 39, 2; source unknown.

the Dying Gallic Trumpeter's shield (see Figure 28) carries a wave design identical to the Venice Dead Gaul's (see Figures 12, 23, 59–60), and the Suicidal Gaul's molded plinth and his wife's drapery folds (see Figures 27, 81) are best paralleled in this period. Finally, the marble of these two figures is blue-gray, like that of the Little Barbarians, and supposedly has also tested out as Asian.[4]

Rudolf Horn laid the foundation for a Trajanic/Hadrianic date in 1937. Assigning the copies to the second century AD, but leaving their place within it undetermined, he realized that they formed a particularly cohesive ensemble. Only the Aix Persian (see Figures 77–80) stood a little apart by virtue of its livelier drapery, which perhaps put it closer to its Hellenistic original.[5] In fact, it is merely less repolished and reworked. In its scale and undrilled eyes and mouth it is identical to, for example, the Paris Gaul (see Figures 61–64) – and like him, it even has four teeth. The hair configuration at its temples and nape of the neck recurs on the Naples Giant and Persian, and the drapery folds between its legs echo those of the quasi-*exomis* of the Venice Kneeling Gaul (Figure 196). And like them, it is made of marble from Asia Minor. So although several men may have carved our Barbarians, apparently all of them worked in the same shop. But when and where?

Horn also realized that the head of the Venice Falling Gaul (the "Breakdancer," Figure 150) is strikingly close in style to a well-known Greco-Roman satyr-type, whose chief copy is the red marble so-called Fauno Rosso in the Capitoline Museum – the titular "Marble Faun" of Nathaniel Hawthorne's romantic novel (Figure 151). He rightly singled out their remarkably similar eyes with flangelike eyelids; prominent cheeks; mouths clearly framed by surrounding skin folds; and sharply defined, distinctively modulated lips.[6] Yet this is not all. When one factors in their similar proportions, facial topography, eyebrows, side hair, and overall rhetoric of poise and expression, they start to look uncannily like cousins. A coincidence of genre strengthens the relationship, for to Greek and Roman eyes the Gauls really did look like satyrs and Pans:

> The Gauls are . . . always washing [their hair] in limewater and they pull it back from the forehead . . . so that they look like satyrs and Pans; for this treatment makes the hair so heavy and coarse that it differs not at all from horses' manes. . . .[7]

Yet since Horn wanted to construct a chronology for *Hellenistic* male heads, his attention immediately slid to the ensemble's Greek originals. Comparing a Giant from the Pergamene Altar (see Figures 68–69) and forgetting his own earlier warning that the Roman carvers had likely sharpened and simplified the Barbarians' modeling, he unhesitatingly put the prototypes of the Venice Falling

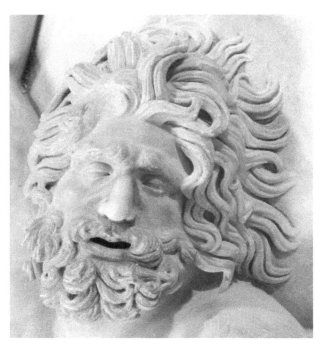

FIGURE 152. Head of the Naples Giant. Photo: DAI Rome 72.2799.

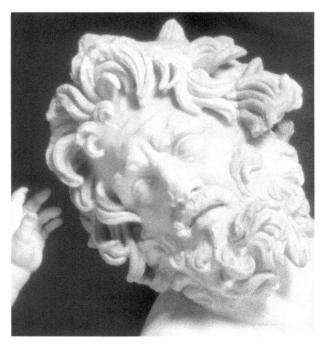

FIGURE 153. Head of an Old Centaur (Roman copy); original, 2nd–1st century BC. Marble; height of statue, 1.47 m. Paris, Louvre Ma 562. Photo: Giraudon 144.

Gaul and Fauno Rosso a little later than the Pergamene Giant, in the mid-second century BC.

The Fauno Rosso was found at Hadrian's Villa at Tivoli. The villa was built between AD 117 and 138 and has yielded a huge cache of sculptures, almost all of which are surely Hadrianic. Very few pieces are obviously later, and there is almost no evidence that Hadrian's successors were much interested in the site. The Fauno Rosso is universally ascribed to the workshop of Aristeas and Papias of Aphrodisias, who signed the two centaurs from Tivoli that are now exhibited beside it in the Museo Capitolino. The three share an almost masklike face; sharply contoured eyes and mouths; hard, faceted, knobby modeling; emphatic transitions that tend to isolate individual features and muscles; meticulously engraved details; heightened dramatic intensity; and an ultrahigh polish. This virtuoso combination is visually stunning and tailor-made to the dense, colored stones from which they are carved.[8]

The Fauno Rosso and the two centaurs are probably based on Hellenistic models, and the centaurs were certainly carved by Greeks. Yet their particular rhetoric of *facture*, of materials-plus-skill, is not Hellenistic but Roman through and through: precise, hard-edged, and strident. Roman, too, is the end it serves. The centaurs, for example, were set up in a belvedere as decorative, didactic, and heraldically displayed pendants. Overlooking the rolling Tiburtine hills and their lush vineyards, they somewhat sententiously articulated two contrasting aspects of the Dionysiac experience that were also thematized in much the same manner on Roman silver drinking cups: "The frenzied freedom and painful enslavement induced by the god's peculiar nature."[9] The Venice Falling Gaul, made of white marble and part of a (quasi-)narrative group, is less blatantly mannered and quite differently characterized, but still from the same milieu.

Yet this is a somewhat narrow foundation upon which to base the chronology of ten marble statues. What of the remaining ones? Although dating copies is a hazardous business at best, some broad trends can be traced and parallels for our figures found. Comparisons with imperial portraits and reliefs may help, though one should not assume either that the copies kept in step with these two very different genres or that developments were uniform throughout the Mediterranean. But if one selects sculpture from Rome and particularly marbles by Aphrodisian sculptors, the best *comparanda* cluster where the Venice Falling Gaul's similarities with the centaurs and Fauno Rosso would indicate, in the early second century AD.

First, the hair: As Horn also noticed, the Naples Giant is also related to the two centaur-types, but most particularly to the white marble replica of the Old Centaur in the Louvre (Figures 152–53).[10] This statue is universally dated to the Hadrianic–Antonine period. In both cases the hair flames around the head in long, serpentine locks that are grouped in bunches of two or three and are sep-

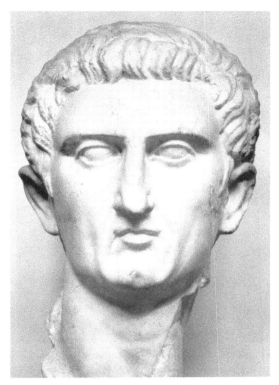

FIGURE 154. Posthumous portrait of the Emperor Nerva (r., AD 96–99). From Tivoli. Marble; height 46 cm. Rome, Museo Nazionale Romano 106 538. Photo: DAI Rome 70.233.

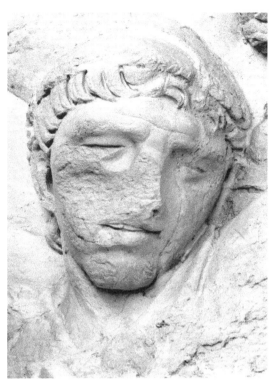

FIGURE 155. Head of a Dacian from the Great Trajanic Frieze; ca. AD 110. Marble; height of frieze, 3 m. Rome, Arch of Constantine. Photo: DAI Rome 82.1080, from a cast.

TABLE 3. The Little Barbarians: Roman *Comparanda*

Little Barbarians	Imperial Portraits and Reliefs
Naples Amazon (see Figures 35–36): hair	Victoria attributed to the Templum Gentis Flaviae (AD 90–96), Museo Nazionale Romano 310258
Naples Giant (Figures 31–32): hair	Great Trajanic frieze, Dacian head (no. 72)
Naples and Vatican Persians (see Figure 39, 48): fringes	Flamen attributed to the Templum Gentis Flaviae, Museo Nazionale Romano 310251; posthumous Nerva (r., 96–98), Museo Nazionale Romano 106538 (Figure 154)
Aix Persian (see Figure 79): fringe	Flamen attributed to the Templum Gentis Flaviae (AD 90–96), Museo Nazionale Romano 310251; Great Trajanic Frieze, Dacian head (no. 46; Figure 155); Villa Medici Dacian relief (Figure 156); posthumous Nerva, Museo Nazionale Romano 318 (Figure 157); Trajan, Selçuk

arated by deeply drilled chasms of curvilinear shape – lentoid, lunate, teardrop, paisley, and so on. Each lock is then chiseled graphically into four or five slightly twisting strands divided by V-shaped channels that often terminate midway along the lock only to reappear somewhat further on. To turn to the Venice Dead Gaul (see Figures 59–60), the drilling technique of his explosively sprouting hair resembles that of the Poseidon from Corinth signed by P. Licinius Priscus of Aphrodisias. Now in Madrid, it is also considered to be Hadrianic by Squarciapino and others.[11]

Comparisons with coiffures on Roman imperial portraiture and historical reliefs broadly support this Trajanic or Hadrianic date, though late Flavian (Domitianic) sculpture also offers some parallels. These are best laid out in tabular form (as in Table 3).[12]

Second, the eyes, which share the following characteristics: The upper and lower lids are strongly curved and

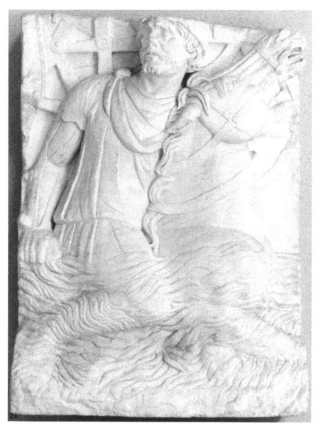

FIGURE 156. Relief of a Dacian; ca. AD 110–120. Marble; height, 1.58 m. Rome, immured in the walls of the Villa Medici. Photo: DAI Rome 71.2773, from a cast.

FIGURE 157. Posthumous portrait of the Emperor Nerva (r., AD 96–99). Marble; height 60 cm. Rome, Museo Nazionale Romano 318. Photo: Alinari-Anderson/Art Resource 2480.

rendered as broad, flat flanges that are sharply demarcated both from the flesh around them and from the eyeball. The upper lid always crosses the lower at the outer corner. In marked contrast to sculpture of the Antonine period and later, the canthus is discreetly drilled into an already-modeled tear duct, and the pupil and iris are not engraved. (The head place on the Naples Dying Gaul [Figure 43] has deeply drilled canthi but is clearly alien to the statue.) When the eyes are half closed in death, the upper lid drops down like a shutter, leaving visible a narrow, lentoid portion of the eyeball or merely a simple slit. Eyes of this kind recur in the following selection of Trajanic–early Hadrianic works:

Trajan's Column, scenes 24, 66, 108, etc.

The Great Trajanic Frieze, figures 31 and 46 (Figure 155)

The Villa Medici Dacian relief (Figure 156)

The Dacians from Trajan's Forum and elsewhere (Figure 158)

The Louvre Dacian relief

Portrait of Trajan, Selçuk

Third, the drapery. Since the Naples Giant wears an animal skin, the sample now shrinks to the four clothed figures: the Venice Kneeling Gaul, the Naples Persian and Amazon, and the Aix Persian (see, respectively, Figures 49–50; 37–38; 9, 33–34; 77–78, 106). The men's garments are the most diagnostic. They share the same long, sweeping, rounded folds with occasional nicks along their course as if they had been partially inflated, starched, and then bent (Figure 159). This revives a mannerism of Attic late fifth-century BC sculpture from the Parthenon frieze (ca. 440) to the Nike temple parapet (ca. 410) where, however, the valleys between the folds are contoured in all sorts of different ways. In the case of the Little Barbarians, however, they are U-shaped and uniformly deep; become shallower toward their ends; and often terminate in a tight semicircle when two folds converge, dartlike, into one. Compare the following:

support figure attributed to the Templum Gentis Flaviae, Museo Nazionale Romano

Roma, Trajanic relief in the Villa Albani (Figure 160)

captive Dacians from Trajan's Forum and elsewhere (Figure 161)

document-carriers, Trajanic relief in Chatsworth House[13]

All these motifs reappear in the sculptures from Hadrian's Villa at Tivoli, often in a more linear and drier form.

FIGURE 158. Head on the statue of the Dacian, Figure 161; ca. AD 110–120. Marble; height 45 cm. Rome, Palatine, pavilion of the Farnese Gardens. Photo: DAI Rome 80.4079. The head does not belong to the body.

FIGURE 159. Tunic of the Venice Kneeling Gaul. Photo: Osvaldo Böhm.

FIGURE 160. Relief of the goddess Roma, ca. AD 100–125. Marble; height 2.04 m. Rome, Villa Albani 9. Photo: Alinari/Art Resource 27712. Many details restored; the head, though ancient, does not belong.

FIGURE 161. Colossal statue of a Dacian, ca. AD 110–120. Marble; height 1.57 m. Rome, Palatine, pavilion of the Farnese Gardens. Photo: DAI Rome 80/4076. The head, though ancient, does not belong to the body.

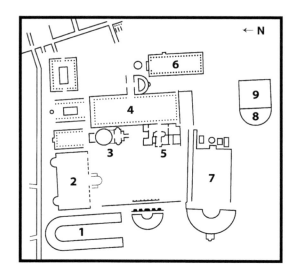

FIGURE 162. Plan of the Campus Martius, Rome. Drawn by Erin Dintino.

Compare, for example, the drapery of the caryatids and basket-bearing sileni from the Canopus, or the Villa Albani Antinous.[14] And as before, one could easily multiply the examples, but to no useful purpose.

So all the Little Barbarians were probably carved in the same Trajanic/Hadrianic workshop, perhaps by Aphrodisian sculptors, and presumably come from the same Roman monument. Since (as far as we know) they are unique copies, made of Asia Minor marble, and carved by sculptors almost certainly resident in Rome, presumably casts were specially ordered from Athens for the purpose.[15] At this point it is tempting to pursue standard archaeological practice to its limits: First determine the copies' latest technical and stylistic features and then use them to fix their date even more accurately. In our case, the analogies with the Tivoli centaurs and Fauno Rosso (Figure 151) could point to the 120s or even 130s. But this would be overprecise.

2. PROVENANCE

Unfortunately, the Little Barbarians' original location and function are harder to determine than their workshop and date. Yet one assumption can safely be made. Since senatorial and private patronage of monumental architecture and sculpture in the city center apparently was nonexistent in the Trajanic and Hadrianic periods, and since the Barbarians seem to be unique and thus would have required a special order of casts to produce, they were probably a special, imperial commission.

As described in Chapter 2, §1, the six statues now in Naples, the Vatican, and Paris were found in a nunnery in the summer of 1514 (RT1; see Figure 98), bought by Alfonsina Orsini, and installed in her home on the Campus Martius, later the Palazzo Medici–Madama (RT2). Although our sole informant about the discovery itself, Filippo Strozzi, says nothing about this nunnery's location, we have seen that it too may be placed with some confidence in the Campus Martius, where Alfonsina's palazzo also stood, over the Baths of Nero/Alexander Severus (see Figures 96–97, 162). Because ground levels in this area rose dramatically between AD 400 and 1500, Strozzi's comment that the nuns made their find while "walling up a cellar" (RT1) could point to a cryptoporticus; a ground-floor structure; or even a (collapsed?) upper room. Or the statues could have been cached and in storage, as often seems to have happened in late antiquity in response to impending barbarian attacks. Moreover, of the ten survivors only the Aix Persian bears any trace of weathering, in areas that suggest exposure to the elements *after* its discovery (see Figures 77–78, 106).

What of the trio in Venice and the Aix Persian (see Figures 2, 4)? Strozzi (RT1) knew of "about five" figures, but Claude Bellièvre, who saw them a few months later in Alfonsina's palazzo (RT2), lists seven: the six now in Naples, the Vatican, and Paris, and the mystery one sent off to Pope Leo. Now the three Venetian statues are obviously from the same workshop as the others. Moreover, as also established in Chapter 2, Albertinelli knew of the Venice Falling Gaul in 1515 (see Figure 102), Aspertini drew the Dead Gaul (see Figure 105) probably around that time, and the Falling and Kneeling Gauls were *alla casa* Grimani in Rome by 1520 (RT3). The logical conclusion is that all of them (including the Aix Persian?) were found as the nuns' subterranean renovations progressed and were sold off piecemeal as they emerged from the ground.

Since all the Barbarians except the Aix Persian are unweathered, and its weathering may be secondary, all of

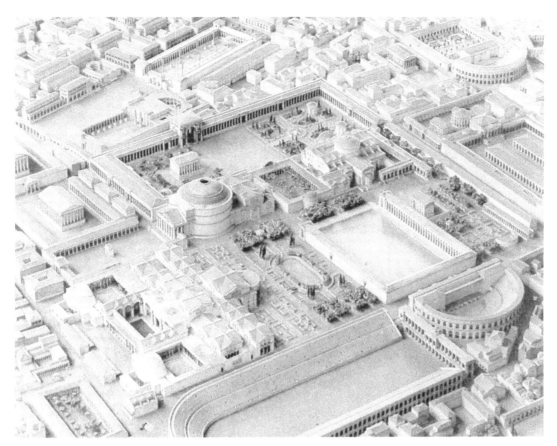

FIGURE 163. Model of the Campus Martius in the Constantinian period (AD 307–36). Rome, Museo della Civiltà romana. Photo: U.C. Berkeley Archive, reproduced by permission of Bruno Brizzi.

them must have stood indoors. Yet since they are carefully finished all round, and some are even wounded in the back, installation in niches or close up against a wall seems unlikely. This proviso, in turn, all but disqualifies one otherwise attractive candidate: the Crypta Balbi (Figure 162). Situated a few hundred meters to the south of the Pantheon and the only public cryptoporticus in Rome, its tunnels were punctuated at regular intervals with niches for the display of sculptures or other trophies.[16]

Trajanic architectural work on the Campus Martius that could account for this remarkable find is sparse, presumably because all the emperor's energies went into his great Forum, Markets, and Baths. Ancient writers mention only his completion of Domitian's Odeum and construction of a theater there that supposedly was later demolished by an envious Hadrian.[17] Yet Hadrian's biographer had little love for his subject, and this isolated remark looks suspiciously like one of his many attempts to smear the emperor's name.

Hadrian himself was much busier than Trajan. He concentrated upon repairing the lingering effects of the great fire of 80, which had consumed Agrippa's Pantheon and much around it – the district directly to the southeast of Alfonsina Orsini's later palazzo. This restoration project occupied a vast area measuring over 200 m from east to west and 400 m from north to south, with the Pantheon as its focus (Figures 162–63). As well as rebuilding the Pantheon itself, Hadrian built a Temple of the Deified Matidia and, northeast of it, a basilica dedicated to her and to Marciana; restored the great, colonnaded former voting precinct, the Saepta Iulia, which stood directly to the east of the Pantheon; added a monumental portal that connected the Saepta with the Temple of Isis and Serapis; restored the portico of the Divorum to the south of this temple; restored and extended the Baths of Agrippa, which stood south of the Pantheon; and interpolated yet another basilica, possibly the Basilica of Neptune, between these last two.[18]

The Pantheon still stands, but all the other buildings are destroyed and never have been properly excavated. The ruins of part of the supposed Basilica Neptuni and of the Saepta are still visible directly behind and to the east of the Pantheon, respectively, several meters below

FIGURE 164. Reconstruction of the *praetorium* or *kaisareion* at Side (Turkey). Photo: Norman Neuerberg Archive, U.C. Berkeley.

the present street level. The Baths were known – and partially dug – during the early sixteenth century, only to be built over soon after.[19] Both of them were veritable treasure houses of art and favorite recreational areas for the Roman populace. Panel paintings of the Argonauts and of the Hunters of the Kalydonian Boar embellished the colonnades of the Saepta, which also housed marble groups of Chiron and Achilles, and of Pan and Olympos. The Apoxyomenos of Lysippos graced the entrance to the Baths, whose rooms – even the hottest – were all adorned with paintings. Agrippa, we are told, gave all of this to the Roman People. They took the gift to heart and exploded in fury when anyone tried to remove any of it.[20]

When the Barbarians were discovered in 1514, two churches occupied the ruins of the Baths: Santa Chiara and Santa Caterina da Siena (see Figures 96–97). The Saepta were covered by two more: the Church of the Holy Stigmata of Saint Francis (SS. Stimmate di San Francesco) and Santa Maria sopra Minerva, which was perhaps named after the Temple of Minerva Chalcidica that in reality lay still further to the east, beyond the Serapaeum. The garden of a neighboring Dominican convent also overlaid one of the Serapaeum's porticoes.

Beatrice Palma and Carlo Gasparri have tentatively suggested that the Barbarians came from the Baths, noting that the first attested owner of two of the three Venice Gauls, Domenico Grimani (RT4), had a huge marble vase taken from there in his collection.[21] Yet the connection cannot be proved, and it should be emphasized that other candidates – particularly the Saepta and supposed Basilica of Neptune – definitely remain in the running. Gasparri has even attempted to connect the ensemble with Agrippa's *original* Baths of 25 BC. Unfortunately for this thesis, they burned to the ground in the great fire of AD 80, which presumably destroyed much if not all of the artwork inside them. The date proposed for the Barbarians in the previous section would, however, still allow them a place in Hadrian's restoration of the complex.

3. DISPLAY

As remarked earlier, since all the Little Barbarians except the Aix Persian are unweathered they were surely displayed indoors. And since all of them are modeled in the round, and some are even wounded in the back, they were probably not tucked away in niches or backed up close against a wall (cf. Figure 164). This leaves display either between columns, or within a colonnaded portico, or in some kind of long, basilica-like hall.[22]

FIGURE 165. Hypothetical reconstruction of the Little Barbarians displayed in the Saepta Iulia, Rome. Drawing by Erin Dintino.

Display between columns is the least likely of the three. For although such framed exhibits had been popular on Greek mausolea and altars, they are virtually unknown in Italy. The example most often cited is the array of Danaids that Ovid saw in Rome between the columns of Augustus' portico around the Temple of Apollo Palatinus. Yet these have now been identified with a series of under-life-size, caryatid-like hip herms from the site, which probably did not stand at ground level but alternated with the columns of the portico's attic story. This leaves only the Amazon and three naked warriors that still stand (in concrete cast) in the open, arcaded colonnade of the "Canopus" of Hadrian's Villa at Tivoli. Exposed to the elements at front and back and to rainwater dripping from the arches above, and thus badly weathered and eroded, they make bad *comparanda* to our pristinely preserved Barbarians.[23]

Displays of freestanding sculpture inside porticoes are far commoner. The loci classici are the Villa dei Papiri at Herculaneum, whose great garden peristyle housed a set of bronze "Dancers" (probably also Danaids); the Atrium Vestae in Rome, where statues of the Vestal Virgins were similarly exhibited; and the east portico of the forum at Pompeii, where the statue bases stood against the columns, so that the figures faced into the covered promenade. One might imagine the Little Barbarians similarly arrayed, on a row of bases backed up against one of the long colonnades of the Saepta, for example (Figure 165). Such colonnades were favorite Roman venues for strolling and socializing.[24]

Finally, sculpture could be found in huge quantities inside Roman palaces, villas, nymphaea, basilicas, baths, and temples. In this case an obvious candidate would be Hadrian's rebuilt Baths of Agrippa (*Historia Augusta: Hadrian* 19.10). Numerous texts and actual discoveries attest to a great variety of subjects on show in such locations. Among these the closest to our Barbarians are the "Dying Children of Niobe" that Pliny saw in the Temple of Apollo Sosianus (*Natural History* 36.28), and two other sets of fleeing and dying Niobids: three from a cache in the Gardens of Sallust and ten more, plus their mother (Figure 166) and (perhaps) their old teacher, found in 1583 outside the gate of San Giovanni in Laterano in what may have been the baths of another set of gardens, the Horti Lamiani. We shall return to them later.[25]

Often aggressively three-dimensional but still basically relieflike and completely comprehensible from their two cardinal viewpoints (front and back), the Little Barbarians make an immediate impact from afar. Sufficiently human to arouse our curiosity, they are still different

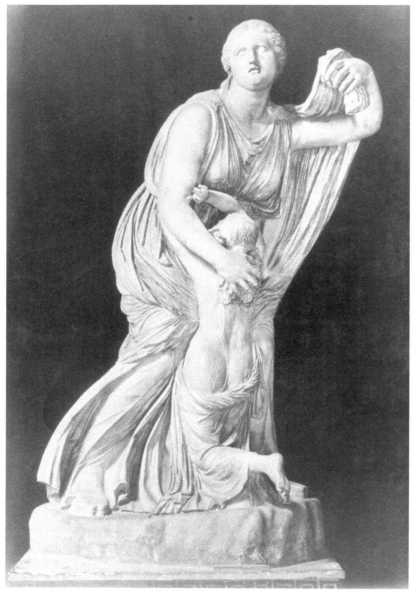

FIGURE 166. Niobe and her youngest daughter (Roman copy). From Rome; original, ca. 320–300 BC. Marble; height 2.28 m. Florence, Uffizi 294. From Brunn and Bruckmann, *Denkmäler* (B-B): pl. 311.

enough from us in scale, features, and deportment, sufficiently *other* (see Figure 6) for us to be able to maintain our distance. Yet at almost four (English) feet tall (1.15 m) they are too big to partake of the aesthetic of the miniature and the exquisite – of (for example) ancient and Renaissance small bronzes, or Chinese, Dresden, and Meissen porcelains. Neither statues nor statuettes, they badger us for a response but obstinately refuse us closure when we comply.

One notices immediately that they illustrate three declining states of consciousness. If the essence of war is injuring, they capture it precisely.[26] Some are about to be injured; others are already injured; and the rest are terminally injured. Five have fallen to their knees but still remain vigorously defiant; one is near death; and four lie dead on the ground. Repetitions and alliterations soon emerge. Two of them (the Vatican and Aix Persians) are mirror-image pendants; two more (the Naples Giant and Amazon) are near duplicates; yet another (the Venice Dead Gaul) is virtually a reversal of these; two more (the Venice Kneeling and Falling Gauls) neatly complement each other – and to judge by their faces and hair were carved by the same hand; and a final two (the Naples Dying Gaul and Naples Persian) look like successive stages in a textbook narrative of the process of dying.

Given the Roman love of pendants and other visual rhymes, all this cannot be coincidental. For as Carlin Barton has remarked, in this incompletely literate or *oligoliterate* culture, "the most common and effective way of unifying was not by synthesis or abstraction but through formulaic repetition, and the most common and effective way of expressing relation was through variations on a repeated story or theme." The imperial Roman artist's basic method, like the Roman rhetorician's, was comparative. To quote one particularly pedantic member of the latter profession, "comparison is a [device] that carries over an element of likeness from one thing to a different thing. This is used to embellish or prove or clarify or unify. Furthermore, corresponding to these four aims, it has four forms of presentation: Contrast, Negation, Analogy, and Abridgment."[27]

So these comparisons, iterations, and variations (*similitudines, imitationes, variationes*) were mnemonic and didactic in function – in other words, broadly *rhetorical*. Narratologically, in the Little Barbarians' case they function as shifters that produce multiple, congruent realities within the ensemble. Clearly the selection from the original Attalid Dedication, which probably numbered well over one hundred figures (see Chapter 4, §1), was made with some care.

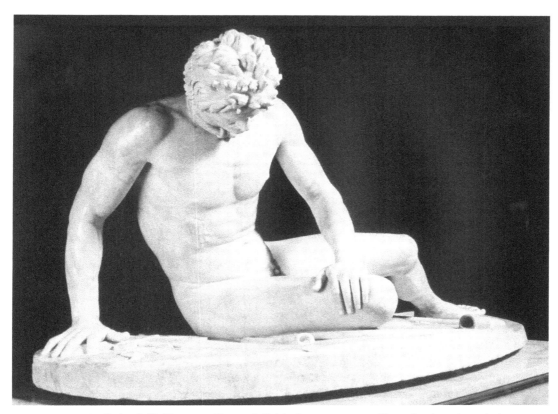

FIGURE 167. Dying Gallic Trumpeter, Figure 28. Original, ca. 230–200 BC. Photo: Soprintendenza Archeologica di Roma. The right arm, sword, and adjacent section of the plinth are restored.

The shrunken scale of the figures, however, their eye-catching (even bizarre) subject matter, and their insistent particularity beg for closer scrutiny. And the nearer one draws, the more one's stereoscopic vision kicks in and the statues' crisp, emphatic modeling comes into play. The sculptor's obsessive care over details of weapons, dress, muscles, physiognomy, hair, and especially wounds presses insistently upon the eye. Although the power of small-scale sculpture usually lies in its grand and minor forms, not in its middle ones, these examples of the genre outdo all comers.

Where their plinths survive, all of them are landscaped, mimicking the terrain of the battlefield. This particular touch is certainly Roman, for the cornice blocks of the original Attalid Dedication's newly discovered pedestals are uniformly flat and only discreetly textured (see Figures 214–16, 265, 268–78, 287). Yet whenever parallels can be checked (see Chapter 4, §2), the arms and armor of the figures betray no serious anachronisms, and so probably were copied faithfully.

The Little Barbarians were almost certainly found alone and foeless. For as noted in Chapter 2, the single alleged victor "sent to the Pope" in 1514 [RT2] was quite possibly not a victor at all. Later in the same text Bellièvre even misidentifies the cowering Vatican Persian (Figures 3, 45) as triumphant, and the papal statue soon switched roles to become one of the vanquished, a Curiatius (RT6 and 13). Yet Plutarch (AT5), Pausanias (AT6), and the Attalid Dedication's recently recovered pedestals (see Figures 214–16, 268–78) confirm that it certainly included the victors. So at the risk of violating Edmonson's Law (see Chapter 1, §9), what if the Romans intentionally omitted them?

Negatives cannot be proved, but the clues are unmistakable. First, it is most unlikely that ten vanquished Barbarians copied from all four of the Akropolis groups would survive the ravages of time, but no victors at all. Second, since the Big Gauls (see Figures 27–28, 167) were also found alone (probably in the Horti Sallustiani), the odds are astronomical that *both* ensembles included victors that later disappeared. Indeed, fragments of several other Big Barbarians (Gauls and Persians) have been found in Rome and at Tivoli (see Figures 243–47), and in no case were victors anywhere in evidence. Probably the Ludovisi (Suicidal) and Capitoline (Trumpeter) Gauls (see Figures 27–28, 167) formed a pyramidal composition with a third one, now lost, and embellished one of the numerous structures – a palace, loggias, baths, sanc-

FIGURE 168. Bronze plaque from Pergamon. Battle scene with Gauls. Date uncertain; formerly in Berlin, now lost. From Alexander Conze et al., *Stadt und Landschaft* (1912) (*Altertümer von Pergamon* 1.1): 250, fig. 1.

tuaries, nymphaea, cryptoportici, and so on – that dotted the vast Gardens of Sallust.[28]

The Big Barbarians' putative Pergamene originals are discussed in Chapter 4. Like the Akropolis Dedication (AT5 and 6) these originals almost certainly included the victors: the king, his staff, and his army. No other Greek victory dedication known to archaeology omitted them, for good reason: The whole point of the exercise was to identify and glorify them. The genre indeed took pains to probe barbarian psychopathology (see Figure 70), but since its purpose was explicitly to contrast barbarism and Hellenism and to justify and applaud the triumph of the latter, it would have staunchly resisted any move to jettison the victors.

A monument at Pergamon to which the Big Barbarians are often (wrongly) attributed was no exception, since a hoofprint is preserved on one capstone, and in 1938 was even found to fit a bronze hoof discovered nearby but now lost.[29] This single horse suffices to secure the presence of the victorious Pergamenes (see Figure 224). For not only was the cavalry the Attalids' main striking arm, led in person by the king, but a troupe of Gauls falling off horses with no adversaries in sight would be visually problematic at best. It would strike one first and foremost as an image of barbarian incompetence.

Some support for this thesis comes from Pergamon itself. Two Galatomachies are associated with the site, both of them in the minor arts. One was actually found there but is now lost; the other is unprovenanced but clearly of Pergamene manufacture. The first, a Hellenistic bronze plaque, survives only in a drawing (Figure 168) that shows a frenzied and complicated battle scene with a full complement of fighters on both sides. But the second, a relief kantharos of ca. AD 100 now in Mainz (Figure 169), is completely different. It features a Galatomachy on each side, though the one on the reverse was produced from a reworked version of the mold used for the obverse. In a rocky landscape populated on the left by a reclining personification and two barely visible female spectators, it shows a fight among six men. Only one of them (the man with the round shield at center) may be a Greek – though he hardly dominates the composition as one would expect and could well be one of the defeated. At least three of the latter are fighting, defeated, and dying Gauls. Imperial Roman in date and excerpted from one or more larger compositions, on a miniature scale these scenes complement the Big Gauls from Rome and environs.[30]

The Fallen Gaul from the Agora of the Italians on Delos (see Figure 70), carved around 100 BC, may be the first extant barbarian displayed alone in this way. Surely dedicated by or to a Roman, it was found in a niche that contained no signs of a victor and looks too small (4 × 3 m) to have accommodated one.[31] As to metropolitan Roman precedents, the Augustan poet Propertius tells us that Augustus' Temple of Apollo Palatinus boasted two such tableaux. Carved in ivory on its doors were "the Gauls hurled from the peak of Parnassus" and the slaughter of the Niobids. The two were obviously pendants: the most egregious examples of human *insolentia* and *impietas* against Apollo and his twin sister, Artemis. The Gallic panel depicted the events of 279 BC, when the barbarians marched against Apollo's sanctuary at Delphi but were miraculously routed by a snowstorm and avalanche before encountering any Greek forces at all. So this scene probably included no victors either, only (at

FIGURE 169. Pergamene relief kantharos with Galatomachy. From Asia Minor; ca. AD 100. Terra-cotta; height 12.5 cm, of relief, 5.2 cm. Mainz, Römisch-Germanisches Zentralmuseum. Photo: RGZM 69/2987.

best) the vengeance of Parnassus: ice, snow, and rocks. As for the Niobid relief, a contemporary Pompeian fresco shows a huge golden tripod with seven wounded and dying Niobids deployed around it but, again, no avenging Apollo and Artemis.[32]

The Uffizi Niobids (see Figure 166) and those from the Gardens of Sallust, also found without their two divine avengers, beg to be interpreted in the same way. True, the Uffizi Niobe looks pleadingly upward, naturalizing the omission of the two Olympians and stimulating much speculation about their possible absence from the original Hellenistic composition. Yet in a Roman villa on Crete a small replica of the Niobe was accompanied by a bow-shooting Artemis, and on the Roman Niobid sarcophagi the goddess and her brother either awkwardly flank the scene or appear in miniature on the corners of the lid above. So in the Uffizi group's Greek archetype they probably stood on a higher level, as (for example) in the Niobid Painter's famous calyx-krater of ca. 450 BC and the imperial-period Niobid disk in the British Museum (Figure 170).

Interestingly, Pausanias reports an "Apollo and Artemis Slaying the Children of Niobe" in or on the Choregic Monument of Thrasyllos on the South Slope of the Athenian Akropolis. Dedicated shortly after 320/19 BC, this ensemble has caused much controversy. Recently, though, it has been suggested that Pausanias' figures stood in the spacious cave behind it, on a series of steps sculpted from the living rock and offering a perfect setting for the two avenging Olympians. Independently, the most authoritative study of the Uffizi group (Figure 166) dates their originals to ca. 320–300. Could they have been copied from this very monument, but minus the Apollo and Artemis?[33]

As to the three Niobids from the Gardens of Sallust, in 1906 Rodolfo Lanciani connected the recently discovered Niobid now in the Terme Museum with the Big Gauls; floated the possibility of a pyramidal composition for both groups; noticed the parallel with the doors of the Temple of Apollo Palatinus; and suggested an Apolline connection for the marbles also. Since the Niobids are Greek pedimental sculptures probably plundered from the Temple of Apollo Daphnephoros at Eretria, Lanciani's thesis is most appealing. In keeping with the sacralidyllic spirit that suffused these Roman gardens, the two groups would have been exhibited as exempla of human transgression upon the divine realm and its punishment by the divine castigator par excellence, Apollo. The conversion of the Big Gauls from those defeated by the Attalids in Asia to those destroyed by Apollo's ice, snow, and rocks outside Delphi would not have bothered the Romans, especially if – as suggested in Chapter 4 – their originals actually stood at Delphi. In this case to omit the Pergamene victors would literally have scored a double kill with a single blow.[34]

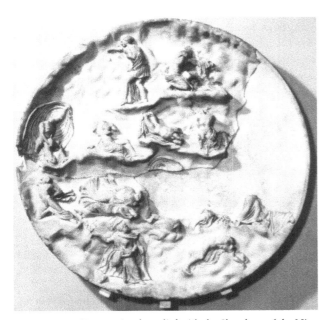

FIGURE 170. Roman circular relief with the Slaughter of the Niobids. Marble; diameter, 94 cm. London, British Museum. Photo: BM 159244.

This list of isolated victims could easily be expanded. One thinks of the Hanging Marsyas, where a Philostratean *ekphrasis*, a Trajanic inscription from Apameia, several Roman sarcophagi, a marble altar and oscillum, and an Alexandrian coin all show that the original Hellenistic composition consisted of Marsyas, the Scythian slave ordered to flay him, and his divine nemesis, Apollo.[35] Yet the roster of full-size copies is grotesquely unbalanced. No fewer than fifty-nine replicas of the Marsyas survive, but only one Scyth and no Apollos at all.

So apparently it was the Romans who wrote this particular gimmick into the display manuals. Yet one cannot say that it entirely lacked Greek precedent, at least in the mythological realm. The fifth-century-BC group of Amazons at Ephesos, isolated, wounded, and exhausted, commemorated their escape from the wrath of Herakles and Dionysos to asylum in the sanctuary of Artemis Ephesia but left their welcome still in doubt. The Hellenistic "Pasquino" (Menelaos–Patroklos or, more likely, Ajax–Achilles) and Achilles–Penthesileia groups also included no opponents to meet the isolated and threatened hero's anxious glance, insinuating that the unseen enemy either lurks in ambush or prowls the battlefield, ready to pounce. Here again the sculptor wants us to think that the issue still hangs in the balance. He wants to keep us in suspense, to make us fear for the living as well as to pity the dead. A wider trawl might include numerous other mythological figures that invite the spectator's participation, such as the sleeping Ariadne, Hermaphrodite, Eros, and Barberini Faun – though in these cases we cannot say for sure whether their teasing solitude was a Greek idea or a Roman one.[36]

But on present evidence victory monuments proper only began to toy with this idea in the context of a Roman enclave – Delos – on Greek soil (see Figure 70), then adopted it definitively during the Roman Empire, when the Hellenistic kingdoms were long extinct and eclectic replication of Greek models for architectural embellishment had become popular. In this environment the sculptures' new Roman contexts and functions smother their original Greek ones, and an appetite for discontinuous display within a rigidly gridded architectural environment overpowers the Greek taste for freestanding, interlocked, and complex sculptural groups (compare Figures 164, 168, 224).

Furthermore, Roman society was one that flocked in its thousands to see triumphal parades of huddled, shackled captives; applauded the death of barbarians, particularly by suicide; and thrilled to action replays of all of this in the arena. It reveled in triumphal displays of Roman might and rejoiced in the defeat, shame, and humiliation of its enemies. Isolated and alone under the withering, desouling gaze of the public eye, these wretched individuals were made to seem like naught. They were unpersons, "objects of sport" whose sole remaining function in life was to feed the voracious Roman ego and its consuming preoccupation with the *maiestas populi Romani*. In Roman sculpture, their correlates are the endless trophies of chained-up barbarians (Figure 171), and the Augustan Danaids and caryatids – Vitruvius' "exempla of eternal slavery." The Trajanic Dacians (Figure 161), however, are one step removed from this: Now technically provincials, docile and unbound, they patiently await the orders of their Roman masters.[37]

The reasons why the Romans dispensed so peremptorily with the Attalid Dedication's victors now become clearer. In essence, they *troped* it for their own purposes, converting it from a Greek victory monument to a didactic display of Roman power, to an imperialistic spectacle of barbarian punishment. Like the Gauls and Niobids discussed earlier (see Figures 27–28, 166, 167) it became an exemplum.

Exemplum is a powerful term in Latin, for Romans preferred to reify and dramatize rather than to philosophize and idealize, and they hit upon this technique as the best way to accomplish these goals. As the historian Livy advised his readers, "This is the most salutary and fruitful aspect of the study of history. You can gaze at exempla of every kind displayed on a conspicuous monument, some of which you should imitate for your own benefit and the state's, and others – bad through and through – you should avoid." The rhetorician Quintilian tells us that orators in particular must possess a rich store of them, both historical and poetical. "For while the former have the authority of evidence or even of legal decisions, the latter either have the warrant of antiquity or are regarded as having been invented by great men to serve as lessons to the world."[38]

So we can now situate our Barbarians within a genre, or more precisely can create one for and around them. For they, the Big Gauls (see Figures 27–28, 167), the Danaids, the various sets of Niobids (Figure 166), and the Marsyas all share one crucial thing in common: They are all transgressors undergoing punishment, many of them (the Gauls included) for impiety (*impietas*), insolence (*insolentia*), and arrogance (*superbia*). Confronting these exempla, one is supposed to feel (in varying proportions) a mixture of fear (*timor*), pity (*commiseratio*), and delight (*delectatio*), depending upon their identity, transgression, punishment, and castigator.[39]

This brings us to the spectator's share. The Akropolis Dedication had presented its Greek audience with a series of specific comparisons between barbarism and specific agents of civilization: the Olympians, Athenians, and

FIGURE 171. Frieze with procession and *ferculum* bearing barbarian captives and a trophy. From the Temple of Apollo Sosianus, Rome. Marble; height of relief, 85 cm. Rome, Palazzo dei Conservatori, Museo Nuovo 2776. Photo: DAI Rome 71.45.

Attalids (AT6: see Figures 227–28). True to its genre, it played out these comparisons as a contest (*agon*) whose outcome was determined by a combination of ethnic superiority on the one side and massive, unsustainable injury on the other.[40] In Rome, however, minus their victors (Figure 165), the Little Barbarians were effectively decontextualized, largely freed from any adherence to particular historical circumstance, to earlier times and places. They existed only vestigially in the past (evoked by their attributes and identities) but most concretely in the present, since Romans now confronted them in place of their erstwhile victors.

In such circumstances the Roman spectator could hardly refrain from invoking the triumphs of civilization's current champion against barbarism – the Roman Empire – in the assurance that it had now surpassed all its predecessors, the Attalids and Athenians certainly included. (Indeed, in another case of that intertextuality or visual interplay discussed in Chapter 2 this realization would immediately have colored the well-traveled Roman spectator's view of the Barbarians' originals on the Akropolis, putting the Attalids and others firmly in their place.) Moreover, the exclusive focus on the vanquished now promoted a fantasy of war as *one-directional* injury. This is no real contest involving hurt and death on both sides but a walk-over. Its place on war's sliding scale from multiplicity to (unstable and self-canceling) duality to unity has shifted decisively toward the last of these. The endless struggle with barbarism, it implies, has taken a mighty and irrevocable step forward.[41]

So what happens if we duly interpolate ourselves into this sanguinary scenario and stand in the Roman spectator's shoes? As J. J. Pollitt has remarked (though of the Akropolis Dedication itself):

Walking around or through the group must have been like walking through a battlefield when the battle is nearly over. Surrounding one were bleeding corpses, dying warriors, and a few pockets of final resistance. The work seems to have been designed to provoke in its viewers an imaginary experience, to inspire them to live through, in their imaginations, the events which the monument commemorated.[42]

Hellenistic and Roman rhetoricians called such mental exercises in interpolation *phantasiai* or *visiones*, and they expected both rhetoric and the visual arts to conjure them up. To quote Quintilian again: "We . . . call them mental pictures or *impressions* for they represent images of absent things to the mind in such a way that we seem to discern them with our eyes and to have them in front of us. Whoever best perceives these will be able to generate the most powerful emotions."[43] The Little Barbarians meet these criteria perfectly. To repeat an observation from the previous chapter (§5), their gestures, glances, grimaces, and lack of opponents arrest us like a shout or command. No longer merely *iconic* but *indexical*, they accost us like someone shouting, "Hey, you!"

They are *deictic*, presupposing and requiring our response.[44]

So, standing before them and imagining their proper Roman context (e.g., Figure 165), far away from the Athenian Akropolis (AT6; see Figure 227) and the memories, thoughts, and feelings it conjures up, we may sum up our mental impressions as follows:

Some unseen, cataclysmic, and anonymous force has struck down these contorted, grimacing little men. Terrorized by some avenging nemesis beyond mortal ken they gesticulate and stare wildly around us. A remark by the historian Tacitus comes to mind: "The unknown always seems bigger."[45] They've received the punishment they deserve. Justice, divine and human, is satisfied. But who's doing the punishing?

Not us. Any momentary fantasies that we might have on this score are immediately dispelled by the fact that the fight was decided before our arrival, and by the figures' goggling stares above, across, beside, and beyond us. Trying to meet their eyes takes effort and even some physical contortion. Their assertive tridimensionality is no help either, for it distracts our attention and deflects us from direct confrontation with them. The feeling that we are not alone refuses to go away. Someone (or something) – the true source of their terror – is standing behind us, looking over our shoulders.

Given who they are, there is only one possible candidate – the state – and in imperial Rome this meant the emperor and his army. Yet since neither is physically present, our sense of divine nemesis still lingers. The denarius drops: Of course, the *res Romana* and the *res divina* are one. And we instantly remember the countless occasions when the gods have shown up to aid the Roman side, from Apollo helping Augustus at Actium to Jupiter Tonans helping Trajan in Dacia (Figure 172). For Rome's mission is both divinely sanctioned and itself divine. As Pliny the Elder proudly remarked, Rome is "chosen by Divine Providence . . . to unite scattered empires and to soften their ways; to conjoin in converse by community of language the discordant and savage tongues of so many nations; to give humankind civilization; in short to become the single fatherland of all races worldwide."[46]

So in the end the "real" narrative of these little figures still bypasses us – or rather, reduces us to a distinctly subaltern, noncombatant position in the ongoing, Manichaean battle between civilization and chaos, good and evil, Roman and barbarian. Though it situates us (as Romans) firmly on the winning side, it just as firmly subordinates us (as bystanders) to a greater power: the *maiestas imperii Romani*. Though it flatters us by magnifying our status vis-à-vis these little folk, it reduces us to the passive role of civilian spectators of their destruction. For others did the real work before we arrived and will soon complete the job regardless of our presence. As with Parmigianino's London altarpiece (see Figure 132), the deictic mode of these figures again *interpellates* us, forcing our attention both to them *and to their unseen nemesis*. They point us to "the state's representative, the policeman who shouts 'Hey, you!', making the subject turn around because of being addressed, and thus constituting him as subject into subjection."[47]

Let us analyze these feelings more closely.

4. FEAR AND LOATHING IN BARBARY

In one of Cicero's dialogues, a character describes how an orator can squash a rival and raise a laugh at the same time. Caricature is an excellent weapon: Just skewer an opponent for his ugliness or a physical defect. So, wanting to put Helvius Mancia in his place, he "pointed out a Gaul painted on one of Marius's Cimbrian shields hung below the New Shops, all contorted with his protruding tongue and flabby cheeks. This got a laugh, for nothing seemed so like Mancia."[48]

Never mind that Cicero or his stand-in probably mistook a Gorgoneion (see Figure 257) for a Gaul. This close connection between an age-old folk tradition of racist (and sexist) put-downs and representational art was not new. Caricatures and grotesques appear in Greek vase painting in the seventh century BC, and small-scale work in bronze and terra-cotta soon follows suit; in the theater there is of course the comic mask. In monumental sculpture their closest relatives are centaurs and satyrs, the Hellenistic old derelicts, and of course barbarians.[49] But in the world of letters all these images of difference and alterity were the stock-in-trade of a single discipline: the parascience of physiognomics.

Though physiognomics is first heard of around 400 BC, its earliest major exponent was none other than Aristotle, a member of whose school wrote its first extant textbook, the *Physiognomonica*. It enjoyed enormous popularity in the second century AD under the relentlessly self-promoting sophist Polemon of Laodicea (88–144), a friend of Trajan, Hadrian, and Antoninus Pius, and thrived well into the twentieth century. Sherlock Holmes, needless to say, was an expert practitioner of it. And most important for us, like Greco-Roman medicine it was essentially the literate expression of Greco-Roman folklore, and the product of a thoroughly active sense of viewing.[50]

For in both cultures to look was to scrutinize. The Roman spectator had little or no use for cool, disinterested detachment. He was a scrutinizer, an "inspector, judge,

FIGURE 172. Jupiter Tonans (at top left) appears to aid the Romans against the Dacians. Scene 24 from the frieze of Trajan's Column; ca. AD 110. Marble; height of frieze ca. 1 m. Rome. Photo: DAI Rome 1931.465, from a cast.

and connoisseur.... Who failed the test of being seen was *improbus*, 'unsound,' not satisfying a standard, improper, incorrect, morally defective." And whether in litigation, politics, or battle the critical test, the moment of truth, was the contest or *discrimen*. Thus, we are told, one Gallic tribe, the Helvetii, had a reputation for great valor before their critical *discrimen* in AD 69; but after it, for nothing but cowardice.[51]

In these circumstances the concrete results of such scrutiny, the handful of extant physiognomic treatises, offer a potential gold mine of information as to how our Little Barbarians were conceived by their authors and viewed by their public. Fortunately for us they show little development over the centuries. Only a much greater focus on the subject's eyes, a greater reliance upon personal anecdote, and a haughtily judgmental tone ("I approve of X"; "I disapprove of Y") separates the second-century AD Polemon from his Aristotelian predecessor of four centuries before.

So physiognomics rested on the premise that one can indeed judge a book by its cover. From the start, it had two complementary agendas: to distinguish good Greeks from bad and to distinguish all Greeks from barbarians. As regards the latter its founding charter is a pronouncement allegedly made by Thales, the father of Greek philosophy: "I thank Fate for three things: That I was born a human being, not a beast; a man, not a woman; and a Greek, not a barbarian."[52]

This one pithy sentence both inaugurates the discipline's mapping of sexual and racial difference and hints at its methodology: the comparison of men (i.e., free Greek males and, later, Roman ones) with animals and "others." Soon physiognomers would begin to observe their subjects for telltale physical "signs," to find analogies for these signs in the animal kingdom (for animal characters are relatively straightforward), and to deduce human character therefrom. And since the discipline's first authoritative synthesis was Aristotelian, the ideal usually turned out to be the mean between two extremes.

This gives the game away. As scholars have repeatedly pointed out, the method is far less scientific – less objectively inductive – than it appears. "[Its] efficacy derives, not from an exhaustive amassing of empirical data, but rather from a classification oriented – and guaranteed – by ideological values."[53] Not only are its broad-brush psychological categories and simplistic polar oppositions radically overdetermined by the confusing and contradictory kaleidoscope of signs and their manifold interpretations, but its conclusions are strongly shaped by notions of "congruity," "appropriateness," or "overall impression" (*epiprepeia*). This ultimate reliance on hunch (i.e., on prejudice) neatly closes the circle.

FIGURE 173. Emperor Hadrian stomps a barbarian. Colossal statue from Hierapytna (Crete); ca. AD 120–35. Marble; height 2.68 m. Istanbul Archaeological Museum 585. Photo: Alinari/Art Resource 47609.

Furthermore, Roman inclusiveness (Trajan and Hadrian, for example, were both Spanish) and its consequent revaluation of the concepts of civilization and barbarism presented physiognomers (mostly Greeks) with an irresolvable dilemma. Barbarians did not change their faces or bodies when the empire's frontier expanded to embrace them: Appearance and character merely parted company. Born in the world of the late classical polis with its strict division between Greek and barbarian, wedded to an essentially racist Greek worldview, and promoted by Greek intellectuals who looked down on the upstart West, physiognomics could not adapt to this new state of affairs. Polemon's own ruthless, sneering, and slyly racist dissection of his rival Favorinus illustrates the point. Favorinus was fluent in Greek, a leading intellectual, a Roman *eques,* and a confidant of Hadrian, of his successor, Antoninus Pius, and of the fabulously wealthy aristocrat and aesthete Herodes Atticus – but a Romanized Gaul from Arles. Polemon used this fact to attack him mercilessly.[54]

A host of texts show that, during the empire, art was routinely interpreted in physiognomonical terms – but because painters could show subtleties of eye color, the critics considered their work superior to sculpture in this respect. So how would the physiognomers and their public have understood our Little Barbarians? Although they worked from the whole body, signs like "rounded flanks" and "thin thighs" provided a relatively feeble basis for character reading. The head was far more diagnostic. For though all Romans agreed that one's whole aspect or *facies* revealed who one was, it was one's face or *persona* that uniquely manifested one's spirit – one's *person.* "The persona guaranteed the existence of the will, the driving vitality at the core: the *animus.* . . . The *persona* and the role expressed by it were the very boundary and definition of one's being, the *sine qua non* of existence. For the Romans there was no depth without surface."[55]

So let us take a leaf from Polemon's book and see what personae our Little Barbarians project. Throughout, two images should be kept firmly in mind: the Roman ideal of the triumphant conqueror, posed full frontal with spear in hand, and Polemon's ideal Greco-Roman face. For our purposes the two may be conveniently united in the commanding persona of the Emperor Hadrian (Figures 173–74). Our gesturing, "deictic" barbarians implicitly point us to him, and he in turn confronts and thus interpellates us – and them.[56]

So, mining the treatises for all they are worth, let us construct a physiognomer's reading of the head of the Naples Giant (Figure 175):

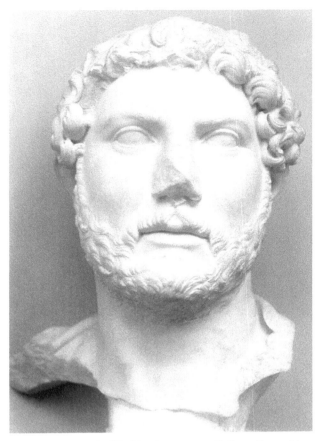

FIGURE 174. Head of Hadrian (r., AD 117–38). From Rome. Marble; height 42.5. Rome, Museo Nazionale Romano 124 491. Photo: DAI Rome 54.794. From a statue in armor like that of Figure 173.

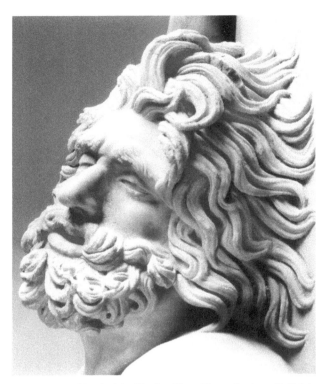

FIGURE 175. Head of the Naples Giant. Photo: Luciano Pedicini.

The hair and beard are thick and wild, signaling lustfulness and savagery: Witness the beasts. The hair overhangs the forehead, and at the temples it starts low down, signaling a spirited, passionate, and half-bestial man: Witness bears. Above the middle of the forehead it is swept back over the cranium, indicating a hot and unintelligent soul: Witness barbarians. The forehead is small, rather long, convex, and curved across the top, signaling ignorance, shamelessness, and insensitivity: Witness pigs and asses; also the panther; and women. The brow is clouded, signaling boldness and impudence: Witness the lion and bull. (For since the clouded brow signals impudence and the smooth brow flattery, the condition midway between these extremes is most fitting.) The heavy forehead, contracted brow, and bushy eyebrows signal boldness, anger, carelessness, and dishonesty: Witness serpents, apes, and wolves. (The nose is restored.) The thick lips with the upper one projecting a little signal stupidity and gluttony: Witness pigs, asses, and apes.[57]

Quite a litany! But to repeat, this reading simulates a professional physiognomer's response. The average spectator would probably catch only the basics: This man is savage, impudent, treacherous, and stupid, and for trying to storm heaven has received his just desserts. But what of the other Little Barbarians? Many of them share the same arsenal of negative signs – wild hair, rounded foreheads, projecting brows, thick lips, and so on. Yet the Persians and Gauls each have some special tales to tell.

The Persians signal their ignorance, impudence, anger, and treachery by their rounded foreheads, contracted brows, and small eyes, and their stupidity and gluttony by their thick lips. Their fleshy faces might also suggest laziness: Witness cattle.[58] But in addition they all share one particularly telling characteristic: a thick, soft fringe of hair that overhangs their foreheads. This fringe betrays the slave. To quote the Aristotelian physiognomer again, "men whose hair stands up above the brow at the hairline are free: Witness lions. But those whose hair droops over the forehead toward the nose are unfree; this is inferred from overall impression [*epiprepeia*] since it appears slavish."[59]

Moreover, soft hair like that of the Vatican and Naples Persians is effeminate and indicates the cowardice particular to southern barbarians – of which more later. These

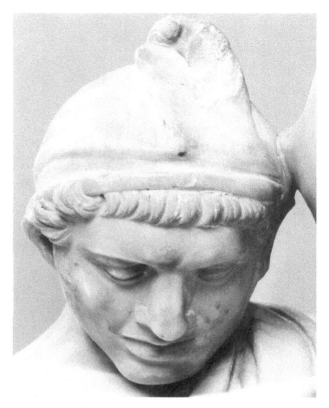

FIGURE 176. Head of the Naples Persian. Photo: Luciano Pedicini.

defects correlate well with, and indeed can even be inferred from, the general impression (*epiprepeia*) made by the hunched shoulders of all three Persians and the cringing stance of the ones in the Vatican and in Aix, which look slavish, timid, and probably also "low-spirited." For as every Greek and Roman knew, among Orientals "all are slaves but one" (Euripides, *Helen* 276).[60]

Yet these three Persians (see Figures 79, 176–77) are not entirely homogeneous. While the Naples and Vatican statues (Figures 176–77) have smooth, rounded faces that somewhat resemble the Naples Amazon's (see Figure 35; Orientals were notoriously womanish), the Naples Persian is relaxed in death but the Vatican one is clearly afraid. His mouth trembles at the corners and his eyebrows twitch uncontrollably, dipping over the middle of the eye then rising again at the root of the nose. In sculpture these had served as classic signs of fright for half a millennium. The series begins with the Priam on the early fourth-century Temple of Asklepios at Epidauros (Figure 178) and proceeds through several Giants on the Great Altar of Pergamon and the Laokoon to a cowering barbarian in the Athenian Agora – of which more anon (see Figures 68–69, 83, 206). The physiognomers describe similar symptoms induced by misery, distress, grief, and imminent disaster.[61]

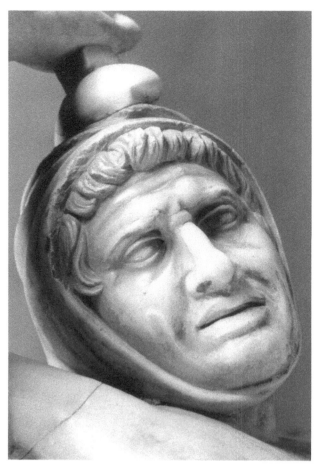

FIGURE 177. Head of the Vatican Persian. Photo: Vatican Museums XXXVI.27.25/9.

The Aix Persian, by contrast (see Figure 79), has a more vigorously corrugated and mobile forehead, bushy brows, furrowed cheeks, a thin, short, scruffy goatee, and small ears. These features make him particularly menacing. As Polemon remarks, "when in a savage man you espy a convulsion of the lips, the skin between the eyes, and the cheeks, consider him foolish, stupid, and mad." His corrugated brow radiates anger and deceit; his lined cheeks and fleshy mouth concur; his *mala barba* signals a bestial, simian, and satyric character; and his small ears are simian too. Moreover, he bares his teeth like a dog or Momos, the personification of Blame, and between his legs his tunic bulges under the pressure of his oversized genitalia (see Figure 4).[62] He's the epitome of the sneaky, vengeful, lascivious, and ever-dangerous Oriental. Never mind that he's cringing in defeat. Get too close to him and you'll regret it.

The Gauls (Figures 179–81, 183) are more diverse than the Persians, though they share some of their signs of impudence and anger, and all of them now bare their teeth. The Venice Kneeling Gaul (Figure 179) closely re-

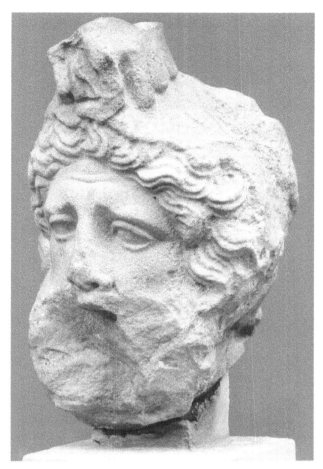

FIGURE 178. Head of Priam from the Temple of Asklepios at Epidauros. Ca. 380 BC. Marble; height 15 cm. Athens, National Museum 144. Photo DAI Athens, Epid. 165. The hand grasping his hair belongs to his killer, Neoptolemos.

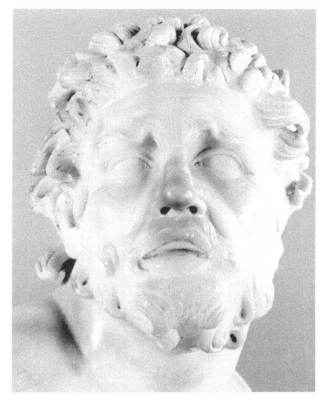

FIGURE 179. Head of the Venice Kneeling Gaul. Photo: Osvaldo Böhm.

sembles the Aix Persian (see Figure 79) except for two particularly telling details. First, his hair is wild and stiff like the Venice Falling Gaul's (Figure 180), and stands up in thick clumps from his forehead. This signals courage, but of a wild, impetuous, and unreasoning sort, like the god Pan's (who instills panic in men),[63] and reintroduces us to a famous passage from the historian Diodoros, partially quoted already in section 1:

The Gauls are tall in body with very moist, white skins, and their hair is blond, not only naturally so but they are also accustomed to use artificial means to enhance its natural color. For they are always washing it in limewater, and they pull it back from the forehead to the top of the head and the nape of the neck, so that they look like satyrs [see Figure 151] and Pans; for this treatment makes the hair look so heavy and coarse that it differs not at all from horses' manes. Some shave the beard while others let it grow; and the nobles shave the cheeks but let the moustache grow until it covers the mouth. So when they are eating, their moustaches get entangled in their food, and when they are drinking the drink passes as it were through a kind of strainer.[64]

This passage, probably borrowed from the eminent Hellenistic historian and ethnographer Poseidonios of Apameia (ca. 135–51 BC), is of great physiognomic interest. For it links up not only with our Gauls (was their hair perhaps gilded?) but also with the numerous writers that describe the proverbial bravery of the northern peoples. These sources are fascinated by the *furor Celticus*, the Gauls' headstrong impetuosity that was not, however, matched by any great staying power in battle. They exemplify the *thymodes* or *thymoeides* (Latin, *animosus*): the rabidly passionate and irascible man.[65]

Thus Adamantios asserts that "hair too blond and fair, like that of the Scyths and Celts, [shows] ignorance, stupidity, and savagery," and Clement of Alexandria bleats that "it's frightening ... and threatens war." A host of authors explicitly contrast this northern (particularly Gallic) recklessness and stupidity with southern (particularly Asiatic) cowardice and intelligence. The great quantity of the northerner's blood explains his courage, and his white skin – like women's – his lack of stamina. In this respect, if it is not a coincidence, we may note that among

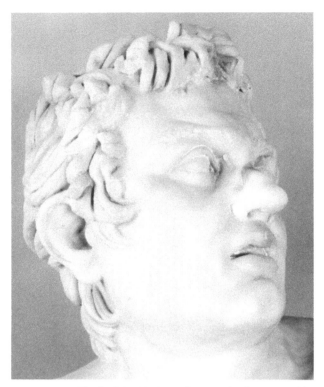

FIGURE 180. Head of the Venice Falling Gaul. Photo: Osvaldo Böhm.

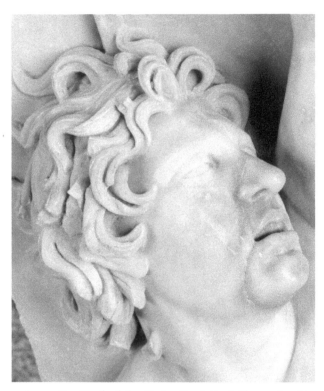

FIGURE 181. Head of the Venice Dead Gaul. Photo: Osvaldo Böhm.

our ten statues the three poorly blooded Persians (see Figures 37–38, 45–47, 77–78) are the only ones who are not bleeding. By contrast, three Gauls and the Giant – all well-blooded northerners – are bleeding copiously, as is the fit, young, and naturally emotional and well-blooded Amazon woman (see, respectively, Figures 11–12, 41–42, 57–58, 61–62, 187–89; 29, 191; 13, 33, 190). Eighteen hundred years later, Holmes used exactly the same "fact" to solve *A Study in Scarlet*.[66]

Yet the Venice Kneeling Gaul, though still unwounded, has more to offer (Figure 179). For other telltale signs seemingly contradict the courageous demeanor signaled by his stiff, thick hair. His eyebrows are even more roiled than the Vatican Persian's, and his mouth gapes. He is mortally afraid. These signs, fleeting and evanescent, speak to *pathos* rather than *ethos*, to momentary emotion rather than underlying character. They confirm the mercurial nature of the Gauls – a courageous race, but one that loses heart at any serious reverse. Governed solely by *animus*, they lack the Roman virtues of stamina and discipline, *patientia* and *disciplina*.[67] One recalls that the Naples Dying Gaul is wounded in the back – the classic mark of the deserter (see Figures 42, 188).

These telltale signs also suggest that Aspetti's restoration of the Kneeling Gaul's right arm (see Figures 2, 49) may have been wrong. Originally, perhaps, he was pleading for mercy rather than vigorously defending himself with upthrust sword – somewhat as Veronese, with fine intuition, had rendered him (as a centurion) around 1570 (see Figure 142).

The Venice Dead Gaul (Figure 181) manifests this mercurial character in exactly the opposite way to the Kneeling Gaul. His face is unlined and beautiful, and his hair rises from his forehead in a leonine double-cowlick or *anastole*, the classic sign of male courage and freedom. In short, he looks like a Gallic Alexander (cf. Figures 182, 184). But at second glance his *anastole* turns out to be excessive. It curls around almost full circle, and the locks above it are backcombed, all of which betrays a hot, unintelligent, and altogether barbarous soul. And as a result he is dead.[68]

As to the Paris Gaul (Figure 183), the bags under his eyes betray his race's notorious addiction to drink. But are his eyes themselves bulging or just big? The former would indicate slowness (witness oxen) and the latter stupidity (witness asses and sheep). They are certainly wide open and staring – a clear sign of overt hostility. Most of the Gauls, too, have bigger ears than the Persians – another sign of the former's asinine stupidity and the latter's simian deceitfulness. To sharpen the contrast, the Paris

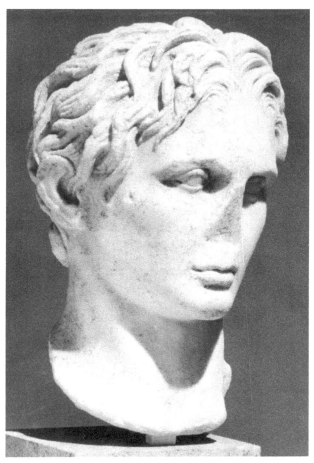

FIGURE 182. Head of Alexander the Great (Roman copy). From Tivoli; original, ca. 330 BC. Marble; height 35.5 cm. Photo: Author.

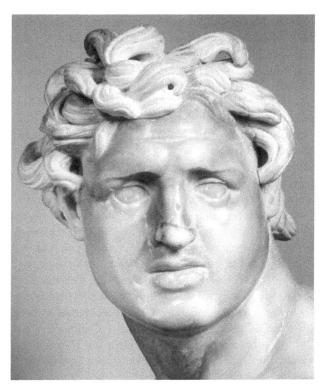

FIGURE 183. Head of the Paris Gaul. Photo: Chuzeville.

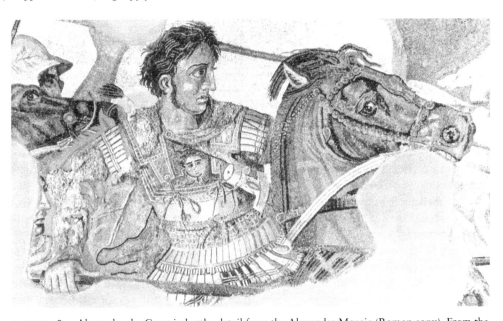

FIGURE 184. Alexander the Great in battle, detail from the Alexander Mosaic (Roman copy). From the House of the Faun at Pompeii; original painting, ca. 330–300 BC. Height of battle scene, 2.71 m. Naples, Museo Nazionale 10020. Photo: DAI Rome 58.1448.

and Venice Kneeling Gauls are not cowering cravenly like the Persians but hold themselves erect and ready for the death blow (thereby incidentally gainsaying their reputation for lack of stamina). They are passionate – even stupidly so – but not cowards. Jerky, muscular, and aggressive, they are still extremely dangerous – more like wounded beasts than men.[69]

What of the lay spectator? Once again, he would likely have understood only that he faced two distinct types of barbarian: treacherous, arrogant, slavish, and bellicose Persians and savage, arrogant, stupid, and brutal Gauls. He would certainly have found some of them funny, "objects of sport" for his ever-censorious eye. He might, however, have made one connection lost on the more genteel physiognomer, for the Gauls share some of the characteristics of the *stupidus*, the butt of the enormously popular Latin comic mime. Fascinating the crowd by his grotesque idiocy, the *stupidus* was a potent *probaskanion* or *fascinum*, a strong talisman against the evil eye – like the Gaul/Gorgoneion on Marius' Cimbrian shield that introduced this section (see Figure 257). And if the eyes of our Gauls were painted blue, as would befit their race, the coincidence would have been even stronger. For a host of authors tell us how fascinating, threatening, and ultimately unbearable these blue eyes were. And as Tacitus tells us, "in every battle, the eye is conquered first."[70]

5. BEYOND THE PALE

Towering over these perfectly realized yet tortured little bodies (see Figure 6), one cannot help but feel a shiver of excitement, a vicarious pleasure at their suffering. This sadistic response may make us most uncomfortable but is nevertheless authentically Roman. Roman victory monuments seek not to arouse sympathy for barbarians but to portray them as animals. Their very lack of proper *humanitas* has driven them to this pass. They have brought their fate upon themselves.[71]

Specifically, these "frozen images of humiliation" (to borrow an apt phrase of Carlin Barton's) define for us *per contrarium* what it is to be Roman. As *exempla superbiae et barbaritatis*, they offer us a series of thought-provoking contrasts with our own felicity as subjects of the empire and of its serene and visionary *princeps* (Figures 154, 157, 173–74). Made of shining marble, vividly present before us, and speaking clearly and emphatically through judicious repetition and variation, they eclipse the exempla of even the best orators. These (to quote our anonymous rhetorician again) "place their subjects before our eyes . . . by describing everything so vividly that I would say it can almost be touched with the hand."[72]

Now the Romans of the empire held specific views about barbarism and what defined it. The physiognomers to the contrary, the touchstone was not race or culture but – as in present-day real estate – location, location, location. Regardless of ethnicity those who lived within the frontiers were on the road to civilization, for (like the Dacian of Figure 161) they had accepted the inevitability of the divinely ordained world empire, of *Roma caput orbis terrarum*. Those outside them, the *gentes externae*, were literally beyond the pale: mere savages, subhumans living by choice in the land of the beasts.[73]

So Roman imperial ideology both took world domination as god-given *and* simultaneously acknowledged its fictionality. For despite all the rhetoric this supposedly universal, divinely ordained empire did have boundaries, and people did live outside them. Faced with this paradox, the Romans simply expelled such outsiders from humanity's ranks. Their very existence represented an ongoing threat to the *orbis Romanus* and the *pax Romana*, to world order, peace, and prosperity. Only endless punitive expeditions kept them at bay, backed up by an ever-lengthening Maginot Line of fortifications (*limes*) like Hadrian's Wall in Britain: "A wall to divide Romans and barbarians" (*Historia Augusta*, Hadrian 10.2).

In such a climate, any resistance automatically merited and *inevitably brought* extermination without mercy – just as one would put down a jackal or a mad dog – whereas submission brought pardon and promotion into the ranks of civilized humanity. This is why Roman imperial sculpture shows only total wars and offers the foe only two choices: annihilation or unconditional surrender. It is also why it pays great attention to Rome's allies – the auxiliaries – as former barbarians who have accepted civilization's dictates and now fight bravely on Rome's side. Here, Trajan's Column (Figures 172, 198–202), his Great Frieze subsequently built into the Arch of Constantine (Figure 155), the Column of Marcus Aurelius, the imperial battle sarcophagi (Figures 203–04), and imperial portraits furnish exempla aplenty.[74]

As these barbarians outside the imperium were essentially subhuman – beasts rather than men – the Romans developed a rich array of pejorative clichés to describe them. Although culturally and linguistically heterogeneous, they divide geographically into two types: northern and southern. The latter, in turn, were subdivided into Asiatics and Africans. As appeared in the previous section, in their different ways they differed from the civilized peoples of the empire in their *feritas* (bestiality), *vanitas* (self-delusion), *perfidia* (treachery), *discordia* (discord), *ferocia* (savagery), and *belli furor* (war frenzy); their women, if anything, were worse.

By contrast, Romans and their allies exemplified the virtues of *concordia* (unity), *disciplina* (discipline), *patientia* (stamina), *fortitudo* (resolution, courage), *continentia* (temperance, moderation), *constantia* (firmness, self-possession), and *gravitas* (dignity, seriousness, and depth of character). The emperor ideally personified these virtues and now monopolized power, propaganda, the right and means to make war, the triumph, and the fruits of victory. So as he became the perpetual and increasingly exclusive conqueror, barbarians emerged as his exemplary foes, becoming indispensable and inexhaustible raw material for Roman valor and glory in general, and for the emperor's in particular (Figure 173).[75]

Here, as so often in Western culture, high–low and in–out find themselves locked in mutual embrace:

Repugnance and fascination are the twin poles of the process in which a *political* imperative to reject and eliminate the debasing 'low' conflicts powerfully and unpredictably with a desire for this Other.... [The high] includes that low symbolically, as a primary eroticized constituent of its own fantasy life. The result is a mobile, conflictual [sic] fusion of power, fear, and desire in the construction of subjectivity: a psychological dependence upon precisely those Others which are being rigorously opposed and excluded at the social level. It is for this reason that what is *socially* peripheral is so frequently *symbolically* central.[76]

To Roman eyes our Little Barbarians would have been essentially didactic. Object lessons in intransigent barbarism, they define the essence of *Romanitas* by contrast. Their thoroughgoing ugliness and their painful prelanguage of cries and groans only verify their subhuman status. And to the level, dominating, and imperious Roman gaze they oppose the flickering, unstable, chaotic barbarian glance or the hooded blankness of eyes frozen in death. Compare Hadrian's face and eyes, the latter regarded as "perfect" by at least some second-century observers (Figures 173–74). As Polemon fawningly remarks, "They were full of lovely radiance, swift, and sharp of glance. No man was ever seen endowed with eyes so full of light." The Alexander of the Alexander Mosaic (Figure 184) offers a striking precedent.[77]

Imploding before this mercilessly imperialistic gaze, our barbarians not only vividly exemplify a pack of grossly negative and essentially bestial character traits, but also in their chaotic diversity more or less reduce to the two basic types (northern and southern) mentioned earlier. The Gauls of course were exemplary northerners, and the Persians had been exemplary Asiatics for so long that even though their empire was ancient history they dominated Roman thinking about their successors, the Parthians, deep into the imperial period.

Cicero and the poets Vergil, Horace, Tibullus, Ovid, and Statius all thought instinctively along these lines, and to Pliny the Elder "the Persian kingdom" is quite simply that "which we now understand as the Parthian." In Roman art the equation appears shortly after Actium, which Augustus celebrated in imperial reliefs and circus shows as a second Salamis. It was popularized by the striking figure of the young, beardless, oriental slave in Phrygian cap and trouser suit, meekly standing, sitting, or kneeling before his Roman masters. Nagging feelings about Roman belatedness in history may lurk behind all this strident triumphalism. For in both art and the arena, Roman historical *exempla* were never invoked to celebrate such victories, only Greek.[78]

Moreover, the Naples Giant (see Figures 29–32) could easily do duty as a northerner alongside the five Gauls, and the Naples Amazon (see Figures 33–36) as an Asiatic alongside the three Persians. Perhaps they were selected from the Akropolis Dedication for that very purpose. The Celtic Wars had been compared with the Gigantomachy since Marius' victories of 102–101 BC, and triumphant Roman emperors with the Giant-slaying Jupiter since the time of Augustus. In AD 103 Trajan had even erected an arch to Jupiter on the Capitoline that carried both Dacian spoils and a Gigantomachy. The Amazon, on the other hand, was conveniently ambiguous, for Amazons had lived both in the East (Thermodon) and the North (Sarmatia). Some scholars have even – wrongly – identified her as a Gallic woman, and the Romans' experience with the implacable Boudicca had accustomed them to the awful specter of enraged Celtic queens in battle.[79]

So the Little Barbarians register the civilized–barbarian or high–low/in–out opposition in all four of the symbolic domains known to the Romans (and us): mind, body, geography, and society.[80] Against the motley charivari of these *exempla discordiae feritatisque*, the omission of the victors would have had the immediate effect of erasing all distinctions on the winning side. As we have seen, with the victorious Olympians, Athenians, and Pergamenes left far behind on the Akropolis, the Roman spectator would inevitably conjure up the *imperium Romanum* in their stead: unified, monolithic, unimaginably powerful, and resolutely bent upon its god-given task.

In this context, the Barbarians' intransigent otherness, their all-consuming *ira* (rage), *ferocia barbarica*, and "animi saevaeque manus et barbarus horror" (Statius, *Silvae* 2.1.169), starkly isolated for all to look down on, would amply justify their extermination. Intransigent to the end, they have sought no pity or pardon and so deserve neither: "Tu regere imperio populos, Romane, memento/.../parcere subiectis et debellare superbos" (Vergil, *Aeneid* 6.851–53):

But Rome! 'tis thine alone, with awful sway,
To rule mankind, and make the world obey

. . .

To tame the proud, the humbled foe to free:[81]
These are imperial arts, and worthy thee.
 (tr. John Dryden, slightly adapted)

But could some viewers have read the message differently? Since in their tragic isolation the dying and the dead – especially the still-suckling Amazon (see Figure 72) – achieve a certain poignancy, might they have moved some spectators to pity? And what of the sheer, bloody-minded, animal courage of those Gauls still fighting (see Figures 2, 5, 49, 61)? Could it have recalled the compensating trope of barbarian *libertas*? Roman intellectuals had developed this theme under the first-century-AD despots Tiberius, Caligula, Nero, and Domitian, inserting their own frustrations and fantasies into the mouths of barbarian kings and chiefs. Barbarian *libertas* thus became, in other words, "a primary eroticized constituent of [their] own fantasy life." In impromptu remarks and set-piece speeches in high rhetorical style, the barbarian leaders ventriloquized by these imperial Roman writers repeatedly contrast the crushing burden of Roman *servitudo* with their own still unfettered freedom.[82]

Roman imperial art (e.g., Figures 171–73), however, was the official voice of the regime in a way that Roman letters were not. Unrelentingly imperialist and triumphalist, it invited no dissenting readings, no pity for the vanquished, no victory for the desperate barbarian glance over the hegemonic imperial gaze. Our Little Barbarians probably fall under this rubric, but until their exact context is ascertained, a sliver of doubt must remain. They may have embellished a bath, theater, or garden rather than an official, imperial monument – semiofficial or unofficial contexts that could well have opened a space for heterodox readings of this kind.[83]

At first sight, the Ludovisi and Capitoline Gauls (see Figures 27–28, 167) could certainly have been read in this way. Preferring suicide to slavery and expiring in heroic solitude on the battlefield, they have consistently personified the "noble savage" for over two centuries:

He leans upon his hand – his manly brow
Consents to death, but conquers agony,
And his drooped head sinks gradually low –
And through his side the last drops, ebbing slow
From the red gash fall heavy, one by one,
Like the first of a thunder-shower; . . .
 . . . his eyes
Were with his heart, and that was far away;
He recked not of the life he lost nor prize,
But where his rude hut by the Danube lay –

There were his young barbarians all at play,
There was their Dacian mother – he, their sire . . .
All this rushed with his blood – Shall he expire
And unavenged? – Arise! ye Goths, and glut your
 ire![84]

Yet since these statues almost certainly stood in a Roman park – the Gardens of Sallust – which had become imperial property early in the first century AD, whoever commissioned them cannot have *intended* them to be read in this anti-imperialist manner. The Apolline connection suggested in section 3 renders this idea doubly improbable. Nevertheless, individual Romans – even members of the elite – could covertly still have envisioned them thus. If the oft-repeated but in fact unverified provenance of two copies of the Tyrannicides Harmodios and Aristogeiton from Hadrian's Villa at Tivoli could be substantiated, they would offer a neat parallel. For Hadrian could never have intended them to be read subversively, but how did his guests react as his reign wore on and popular resentment against him increased?[85]

As to the Little Barbarians, their welter of unremittingly negative and denigrating physiognomical "signs" (Figures 179, 180, 183) is not encouraging for the proponents of such readings. Indeed, even those writers who dwell upon the theme of barbarian liberty tend to acknowledge that in the end Roman civilization is necessarily superior. In a speech written in 105, for example, the orator Dio Chrysostom confesses that he had visited Dacia to see "men contending on the one hand for empire (*arche*) and power, and on the other for freedom and fatherland" (12.20). At first sight this seems evenhanded enough. Yet elsewhere Dio defines *arche* as "a just government of men and care for them according to the law" (3.43), which prejudges the contest by openly loading the dice. And unlike the "bad emperors" of the first century, Trajan was officially an *optimus princeps*, the best of princes, and Hadrian officially a second Augustus.[86]

Still, although the gaze of the public eye always exceeds the individual glance it can never entirely suppress it. For the glance is long-distance touch, the reach of our individual desires. It always contains a libidinal supplement.[87] And try as they might, the Romans could never stop the *gentes externae* from glancing over their defenses and coveting and sometimes seizing the wealth that lay within them. The empire could never crush them entirely. It might kill some and subjugate others, but more always lurked beyond the horizon. Even the fleeing refugees shown in the final scene of Trajan's Column ended up somewhere, to live (and fight?) another day.[88] In this sense even the most implacably orthodox Roman imperial monuments are indeed silent witnesses to barbar-

ian freedom, or at least to barbarian resilience. For none of them was ever definitive, ever terminated the series. Instead, they required endless supplementation, for the barbarians *kept coming back*.

So could our Little Barbarians have celebrated an imperial victory? Since they seem to be unique copies and not part of the endlessly recycled catalog of Greek *opera nobilia*, they were surely made for some special purpose. Domitian's Dacian triumph of 89 and Sarmatian victory in 93; Trajan's Dacian Wars of 101–02 and 105–06; his Parthian Wars of 114–17; and Hadrian's suppression in 118 of the revolts that broke out upon Trajan's death – these successes provide some obvious contexts. Comparisons between them and the earlier Gallic and Persian Wars would have leapt to mind immediately. Statius and Epictetus certainly made the connection at the time. The latter may even have done so in Hadrian's presence, although not to the Romans' advantage.[89]

All this gives new force to the aforementioned Roman practice of dividing barbarians into two types: savage, arrogant, and brutal northerners and treacherous, arrogant, and bellicose southerners. For like the Gauls and Persians, the Dacians and Parthians too had coveted, attacked, and ravaged civilized territory; had clashed with the forces of civilization; had lost; and either had died (some bravely but insanely preferring suicide to civilization; Figures 200, 202–03) or sensibly had surrendered to their betters (Figure 161). But though the Dacians were ostensibly northerners they lived to the east and south of the Celts, and their iconography manifests many oriental traits as well.[90] On the ladder of civilization, of course, the Parthians stood many rungs above them. While northerners brought chaos, they imposed tyranny.

Yet Domitian's Dacian and Sarmatian victories were ephemeral; Trajan's Parthian successes had evaporated in 117; and Hadrian abandoned Mesopotamia and his predecessor's remoter Dacian conquests soon after. His biographer paints a grim picture of the situation that confronted him at his accession:

The nations Trajan had conquered were in revolt; the Moors went on the rampage; the Britons rejected Roman rule; Egypt was torn by insurrection; and finally, Libya and Palestine flaunted the spirit of rebellion.[91]

Hadrian's response was quick and efficient. He himself pacified Syria, Dacia, and the Danube by the end of the spring of 118 and dispatched his deputies to sort out the rest. So within a year of his accession he could claim to have imposed peace through strength throughout the world – for the present. By the time he entered Rome to popular acclaim on July 9, 118, shrewdly presenting himself as a mere private citizen, Vergil's ringing declaration of Rome's mission, quoted above, surely resounded in the minds of many.[92]

So much for means and motives. As to opportunities, Domitian apparently never visited Athens, and Trajan went there only once, on his way to Parthia in late 113. His stay was brief, and he never returned to Greece or Italy again. By January 114 he was already at Antioch, where he barely survived a great earthquake that killed several of his staff. Cassius Dio provides a long, wrenching description of the horrors, among which was the pitiful sight of an infant vainly suckling at its dead mother's breast (Dio 68.25.4; compare AT3b and Figure 72). Coincidence – or not?

Hadrian, on the other hand, made no fewer than four visits to Athens, of which the first, longest, and most important was in 111–13. He probably met Epictetus en route and may have grown his trademark beard there; the Athenians soon elected him archon and honored him with a statue in the Theater of Dionysos. He cannot have failed to visit the Akropolis during his stay, and there he surely saw the Attalid Dedication in all its splendor.[93] And it must have been then or soon after that the Athenians put up the colossal statue of an emperor – either him or Trajan – with a barbarian cowering at his feet, that was found in the Stoa of the Library of Pantainos in 1972 (Figures 205–06).[94] The even bigger and more brutal Hierapytna Hadrian (Figure 173) followed a decade or two later. We shall return to them shortly.

6. "FATAL CHARADES"

The Barbarians' shrunken scale and overt theatricality suggest yet another Roman frame of reference: the perspective of the arena. The connoisseurs who for three hundred years – from the mid-sixteenth century to the mid-nineteenth – identified them as gladiators (RT4, 9, 10, and 12, etc.) were no fools. For the Roman arena was the "world theater" where the empire came to watch myth, history, and current events bloodily restaged before its eyes. It was the world turned outside in, the Other viewed in microcosm, where the enemies of the state were corralled and turned into objects of sport for Roman eyes – in Byron's famous line on the Capitoline Gaul (see Figure 28), "butchered to make a Roman holiday."[95]

Seated in rigidly stratified array in the great amphitheaters of Rome and its provinces, mass audiences of tens of thousands could see foes destroyed, criminals punished, and order restored in this way. They could even participate in the action. Some emperors even "encouraged" senators and equestrians to "devote" themselves to the arena as gladiators, while others, outraged at such

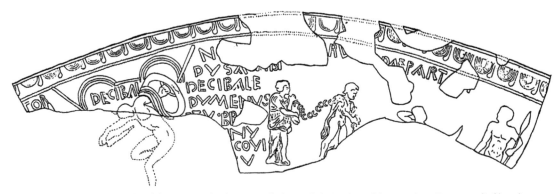

FIGURE 185. Suicide of the Dacian chieftain Decebalus and chained Parthian captives. Roman relief bowl from La Graufesenque (France); ca. AD 110–120. Drawing by Erin Dintino after M. Labrousse, "Les potiers de La Graufesenque et la gloire de Trajan," *Apulum* 19: 63, fig. 4. Compare Figures 186 and 200.

unseemly and degrading behavior, just as sternly forbade them to do so.

Writing to celebrate the opening of the Coliseum in AD 80, Martial boasts that *even barbarians* cannot resist the arena. Nobody – whether Thracian, Sarmatian, Arab, Ethiopian, African, or Gaul – is so remote and so barbarous as to be immune to its magnetism.[96] The mass audience for these bloody frolics – the Coliseum seated more than fifty thousand – took the form of a broad-based pyramid:

By the early empire, the games had evolved into vast, Hollywood-style extravaganzas where entire battles – terrestrial and naval; mythological, historical, and recent – were ritually reenacted for the baying crowd, using prisoners of war and ignoring the butcher's bill. Like today's war movies, their outcome was scripted and preordained. And like today's movie audiences, fewer and fewer among the tens of thousands of fans for what have aptly been called these "fatal charades" had themselves ever fought on the frontiers. Under the empire, professionals fought Rome's wars, and her *spectacula* were produced for civilians.

In Rome, the Giants were uniformly visualized as snake-legged, which considerably retarded their arena debut. Outgrossing even Hollywood, Commodus – ever the practical joker – introduced them only around AD 185, infamously utilizing legless unfortunates grotesquely fitted with snaky prostheses and armed with sponges instead of rocks.[97] But the Persians, Gauls, and Amazons all had become arena favorites long before our little figures were carved.

Spartacus' slave army of 73 BC had included many Gallic gladiators, and Julius Caesar had reenacted both ancient battles against easterners and his own victories against the Gauls and others as early as 46 BC; but the really huge pageants came under the empire. In 29 BC, Augustus staged battles against the Dacians and Suebi, and in 2 BC he put on the entire Battle of Salamis, mobilizing at least thirty beaked galleys and numerous smaller vessels for the event. This spectacle had a threefold purpose. Augustus aimed to revive memories of Actium upon the dedication of the Temple of Mars Ultor, which honored his divine protector in the war; to present his regime as Greece's champion against the Orient; and to give his nephew Gaius Caesar's new campaign of revenge against the Parthians an appropriate and rousing send-off. For some of these fights Augustus and his successors used the Saepta Iulia, noted above as one of the possible locales for the Little Barbarians.[98]

In AD 47, Claudius put on the victories of Aulus Plautius in Britain, including the storming of an entire British town – an extravaganza so big that he had to move it to the Campus Martius. He also famously presented an utterly fanciful sea battle between nineteen thousand "Sicilians" and "Rhodians" on the Fucine Lake, from which few participants escaped alive. Nero, on the other hand, preferred to follow Augustus. To promote a renewed attempt to wrest Armenia from the Parthians, in 57 or 58 he revived the now-hoary theme of Salamis, which he enlivened in typically sadistic fashion by infesting the water with "sea monsters," presumably sharks and other predators.[99]

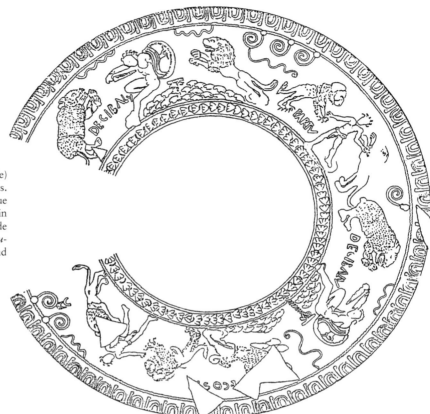

FIGURE 186. Decebalus (committing suicide) and Parthian captives savaged by wild beasts. Roman relief bowl from La Graufesenque (France); ca. AD 110–120. Drawing by Erin Dintino after M. Labrousse, "Les potiers de La Graufesenque et la gloire de Trajan," *Apulum* 19: 63, fig. 1. Compare Figures 185 and 200.

Titus reenacted his storming of Jerusalem in 70 and several sea fights from the Peloponnesian War. Yet Domitian outshone them all after his Dacian triumph in 89 by staging a huge Dacian battle in the Circus Maximus, which could accommodate a quarter of a million spectators. In 107, Trajan celebrated his own Dacian triumph with a 123-day festival in which eleven thousand beasts were killed and ten thousand gladiators fought, and in 116 commemorated his Parthian victories in absentia with a similar spectacle. The posthumous Parthian triumph that Hadrian staged for him in 118 was far less lavish, involving only one thousand beasts and an unknown number of gladiators.[100]

Some Roman *terra sigillata* bowls made at La Graufesenque in France, one of them signed by a Lucius Cosius, seem to reference these last three sets of games (Figures 185–86). In execrable Latin they list the peoples that Trajan conquered (the Germans, the Arsacids of Armenia, and the Parthians), and hail him as Dacicus and Parthicus. Between and below these semiliterate inscriptions appear a naked, triumphant warrior, presumably Trajan himself; a seated, mourning woman, presumably personifying the conquered; a procession of chained prisoners; the Dacian king Decebalus (DECIBAL[V]) knifing himself on a hilltop while a lion and a bear pounce on him; and two lions mauling a Parthian (PARTV) clad in only a loincloth. These last two scenes conflate a historical reenactment with a *damnatio ad bestias*. This way of spicing the entertainment by having wild beasts savage the losers reappears in some of the mythological "fatal charades" described in the literature.[101]

Nor were women spared from these sanguinary sports. Aside from the hapless female victims of Claudius' British extravaganza on the Campus Martius and perhaps too of Domitian's and Trajan's Dacian spectacles, women fought and hunted in the arena under Augustus, Nero, Titus, Domitian, and their successors, until Septimius Severus banned the practice. A marble relief celebrating two such women gladiators – suggestively named "Amazon" and "Achilia" – is known from Halikarnassos; predictably, they are fighting bare-breasted. And just like their male counterparts, highborn women sometimes even volunteered – or were coerced – to perform.

The texts linger salaciously on their nobility, their beauty, their race (Celtic, or black), or the exotic parts they played. Thus we hear of one "Maevia the barebreasted boar-hunter," emulating the heroine Atalanta; another woman lion killer "as fearless as Hercules"; a

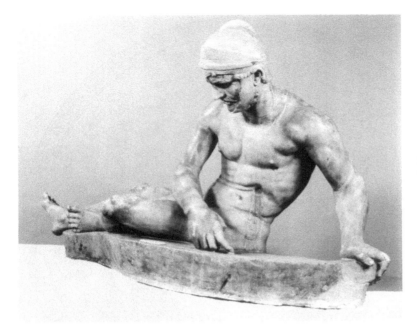

FIGURE 187. Naples Dying Gaul, three-quarter view. Photo: Luciano Pedicini.

"Venus" battling as fiercely as Mars; and the inevitable Amazons, fighting "as before on the Tanais, Phasis, and Thermodon." No doubt the latter wore standard Amazonian garb, just like the Naples Amazon (see Figures 9, 13, 33–34), with her filmy, finespun *chitoniskos* that salaciously bares a breast, and the Amazons on the later Roman sarcophagi (Figure 195).[102]

So nine out of ten of our Little Barbarians were familiar figures in the Roman arena when these copies were carved. Surveying them, the spectator would find himself surrounded by a veritable maelstrom of carnage. Schooled by the arena's clear-cut framing of Right and Wrong, its radical dilation of space and time, and its frequent mobilization of his peers to "act" in its events, he could simultaneously experience the real battles with the Giants, Amazons, Persians, and Celts of yore; the empire's ongoing struggles with their latter-day successors; and the recurrent, ritual restaging of these epochal conflicts in Rome's own "world theater." And when he got up close, the Barbarians' conspicuous wounds and spurting blood would have driven home the point with a vengeance. For no fewer than half of them are wounded, some twice or thrice and in both front and back (see Figures 11–13, 15, 29, 41–42, 58, 61, 187–91).

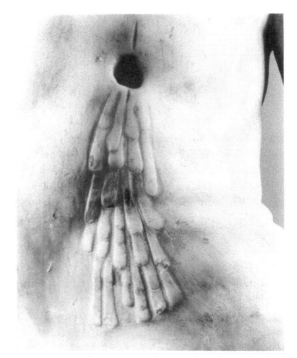

FIGURE 188. Naples Dying Gaul, wound under right shoulder blade. Photo: Luciano Pedicini.

7. OF WOUNDS

Wounds fascinate, repel – and signify. Brutally violating the body's integrity, opening up its interior to the probing eye, and allowing its vital essence to gush out over its surface, they speak to us with a unique, gut-wrenching immediacy. Savagely rupturing the fabric of being, they thrust the hapless victim into a state of – possibly terminal – transition and the startled spectator into one of voyeuristic fascination and unexpected anxiety. The yawning gashes and spurting blood immediately conjure up narra-

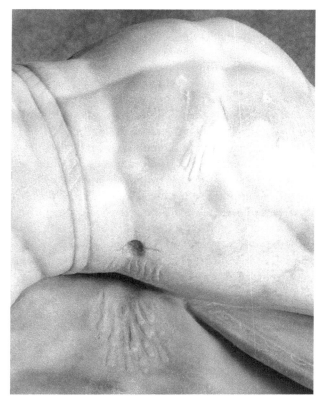

FIGURE 189. Venice Dead Gaul, wounds. Photo: Osvaldo Böhm.

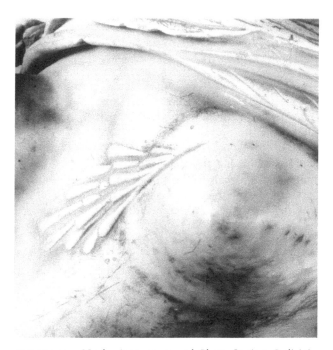

FIGURE 190. Naples Amazon, wound. Photo: Luciano Pedicini.

FIGURE 191. Naples Giant, wound. Photo: Luciano Pedicini.

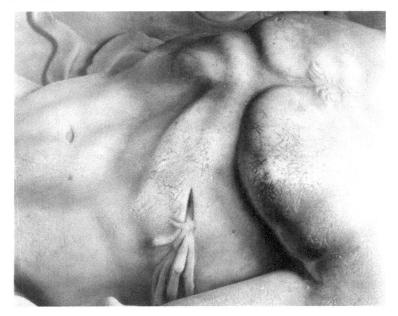

tives of conflict and suffering, of wholeness and dismemberment, of man (or woman) become meat. They shock us into asking, Why? When? How? And where? Placing the sufferer under the sign of death, they force us to consider the ultimate question: Will he or she live or die? And displayed for dissection by our probing eyes, they brutally remind us of our own mortality.

In warrior cultures, wounds are polysemic: They cut both ways. Greek and Roman veterans proudly displayed their battle scars – always on the front, never on the back – as proof of their own virile courage and toughness.[103] The healed wound does more than mark the survivor; it makes the man. He has met the ultimate test (*krisis; discrimen*), triumphed, and lived. For the losers, on the

other hand, wounds are an index of (an often fatal) inferiority. Compare these two accounts, written over six hundred years apart:

> And he who so falls among the champions and
> loses his sweet life
> So blessing with honor his city, his father, and all
> his people
> With wounds in his chest, where the spear that he
> was facing has transfixed
> The massive guard of his shield, and gone through
> his breastplate as well,
> Why such a man is lamented alike by the young
> and the elders
> And all his city goes into mourning, and grieves
> for his loss.
> ...
> His shining glory is never forgotten, his name is
> remembered
> And he becomes an immortal, though he lies under
> the ground.
>
> (Tyrtaios 12.23–32 [ca. 650 BC], tr. Lattimore)

And:

The morning after the battle [of Cannae, 217 BC], as soon as it was light, the Carthaginians pressed forward to collect the spoil and to gaze on a carnage that was a ghastly sight even to an enemy's eyes. All over the field Roman soldiers lay dead in their thousands, cavalry and infantry indiscriminately mingled, as chance had brought them together in the battle or the rout. Here and there amidst the slaughter men covered with blood, whose wounds had begun to throb in the morning chill, started up from the mass of corpses, and were immediately cut down by their enemies. Others were found lying there alive with thighs and knee-tendons slashed, baring their throats and necks and begging their conquerors to spill what little blood they had left.

 (Livy 22.51.5–7)

Both cultures habitually stripped the war dead of their armor and weapons and often of their clothes too – a signal humiliation. The captured equipment was either reused or dedicated in sanctuaries: Pausanias specially remarks upon the massive dedications of Gallic spoils at Pergamon, well illustrated by the balustrade reliefs of the stoa of Athena Nikephoros; at Rome, the practice was equally popular, as witness the Dacian spoils carved on the pedestal of Trajan's Column.[104] Among the Little Barbarians, the Venice Dead Gaul (Figures 2, 20, 23, 57–58), wounded in three places and all but naked, would immediately have recalled this practice.

When inflicted under the pretext of moral superiority, as here, wounds also function as an implicit moral justification of violence, turning us willy-nilly into eyewitnesses of the triumph of Justice, Law, Civilization, and so on. They anchor in the body and in nature these otherwise disembodied cultural fictions, because the damage that this violence has wrought on their behalf is palpable and unalterable – indeed in many cases terminal. For the essence of power is the ability to hurt, and the body's reality is both natural and incontestable.[105]

When translated into art, wounds take over the image like a kind of carbuncle or cancer, especially when the victim is removed from the naturalizing context of battle and offered up for scrutiny like meat on a tray. Visually offensive and psychologically distressing to contemplate, both painful to look *at* and painful to look away *from,* the Barbarians' wounds rivet our attention, paralyzing us before them. An affront to our eyes, they wound them too, turning the act of seeing into an excruciating experience. Yet simultaneously igniting our capacity for empathy, they hijack our responses and deflect them in directions we cannot control, regardless of the supposed moral status of the victim. And as we get closer and the part inexorably eclipses the whole, the figure becomes little more than a wound with a body attached to it. Our aesthetic experience thus curiously replicates what real live pain does to our own bodies, eventually blotting out all sensations except those of itself.[106] By substituting itself for all that is human, it dehumanizes.

Moreover, contradicting all our preconceptions about art's supposed permanence and stasis (and particularly about classicism and the "timeless" legacy of Greece and Rome), wounds subvert the painted or sculpted representation with an unnerving glimpse of the momentary, of the material object's own particular susceptibility to destruction and decay. They thus sadistically play upon "art history's unconscious cultural neurosis: a disavowal of history's work of transformation, of transfiguration."[107] Against all our instincts and desires, they violently reinsert the image, its subject, the discipline, and ourselves into the flux of change and therefore into history.

The Greco-Roman world was not insensitive toward much of this. In Greek art, bleeding wounds first make their appearance in vase painting during the seventh century BC, and in marble sculpture (indicated by paint) around 525, on the Gigantomachy of the Siphnian Treasury at Delphi. Thereafter, painted blood occurs quite regularly on sculptured battle scenes protected from the elements in tombs and elsewhere. So where none survives, as on the marble warrior of Figure 192, weathering or modern cleaning has presumably removed it. Preserved bronzes are, of course, far rarer, but a fifth-century bronze spearhead from Olympia is inlaid with rivulets of blood realized in copper, as is the famous Hellenist-

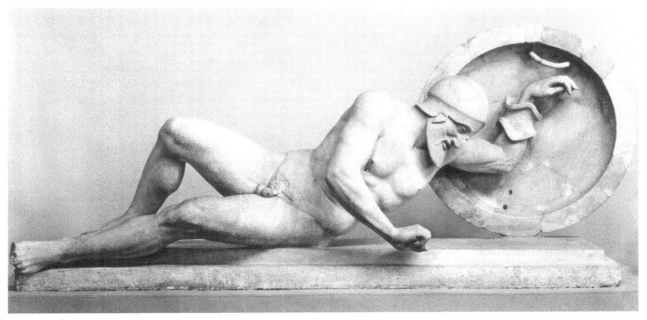

FIGURE 192. Wounded warrior from the east pediment of the Temple of Aphaia at Aigina; ca. 480 BC. Marble; length, 1.85 m. Munich, Glyptothek Aeg. O.XI. Photo: Glyptothek K 29. One of Herakles' arrows (now lost) has pierced him in the chest.

ic bronze boxer in Rome. As to three-dimensionally rendered blood, the marble copies indicate a mid-fifth-century origin. Thick gobs of it stream from the wounds of a copy in Naples of an early classical warrior (the so-called Farnese Gladiator encountered in Chapter 2, §2), and congeal on the thigh of one of the high-classical Ephesian Amazons, whose original was definitely in bronze (Pliny, *Natural History* 34.53).[108]

The first solo wounded warrior mentioned in the texts was made by the bronzeworker Kresilas (fl., ca. 430 BC). It invited one "to judge how little life remained" in him (Pliny, *Natural History* 34.74), and the sculptor's contribution to the Ephesian Amazons must have done the same.[109] As for reality, compare Livy's remarks on the Gauls:

The fact that they fight naked makes their wounds conspicuous, and their bodies are naturally fleshy and white since they are never naked except in battle; so that both more blood flowed from their abundant flesh and the wounds stood out more terribly and the whiteness of their skins was more stained by the dark blood. But they are little disturbed by open wounds....[110]

Yet as remarked in section 4, the Gauls had little stamina; this is why the Naples Gaul is wounded in the back – the classic mark of the deserter (see Figures 42, 188).

The Romans' horrified fascination with the grisly consequences of Gallic war frenzy was matched by an equal ambivalence toward the traumas of the arena. For like the warrior, the gladiator too was supposed to ignore his wounds, to carry them bravely like marks of honor, and to face death without flinching. Yet while free men could learn something from his stoical bravery, the spectacle itself was still brutalizing. Ovid put it best: "Whoever has seen these wounds sustains one himself."[111]

Thus, like a hyperviolent action-hero movie where the good guys always eventually come out on top, the arena's tension-release psychology would fully prime the Roman spectator to appreciate the Little Barbarians' audacity, intransigence, rage, and terror, and to contemplate their gory maelstrom of destruction with satisfied equanimity. For like their ugly, disfiguring grimaces, their bleeding gashes would amply confirm his superiority. Looking down on them, he would see them writhing under the sign of death, pinned like insects by the basilisk stare of the *populus Romanus,* up to and including the emperor himself – the representative and paragon of Roman male beauty, *gravitas, constantia,* and invulnerability (Figures 173–74).

So by testifying to the reality of the empire's eternal conflict with barbarism these injuries (fictitiously) certify the completeness of the winner–loser outcome and the universality of Roman power. In the same way that the Barbarians' inarticulate cries and groans – the concrete expressions of their pain – squelch their own real voices in favor of the victor's, substantiating his otherwise purely verbal assertion of the *imperium*'s overwhelming superiority, their broken bodies and cut flesh also confirm his

superior power. They anchor in the body and in nature this otherwise disembodied cultural fiction. For as remarked earlier, the body's reality is incontestable – or would be, if these particular bodies were flesh and not marble.[112]

And just as the arena's awful "spectacles of fascination" all but consumed the original mythological and historical tales they purported to reproduce, the Barbarians' fascinatingly repellent spectacle of death all but eclipses their own Athenian originals, already obscured by the copyists' wrenching changes of medium, composition, and locale. The Romans' careful selection from the roster of the vanquished and (surely intentional) omission of the victors strongly indicates that they had precisely this effect in mind.

In the final analysis, then, these ten little statues function in a way that at first sight looks quite different from the thousands of copies of Greek *nobilia opera* – the staples of our sculpture handbooks – that thronged the public spaces and buildings of the empire (Figure 164). Accustomed to the Romantic cults of the original and the great master, we think of the latter as intended to recuperate their models, as objects for connoisseurial appreciation. But if the foregoing has shown anything, it is that our Little Barbarians all but *obliterate* their Attalid–Athenian originals in favor of the imperial Roman present.

Yet by the second century AD did not most copies function in this way? In republican times, it is true, they substituted for authentically Greek masterpieces as these became increasingly scarce and unavailable, and thus reminded the Romans of their control over these works and the culture that created them. But as republic became empire, these original functions must have become increasingly passé.[113]

Almost never provided with labels identifying either their subjects or original authors, imperial-period copies were usually displayed thematically, without regard to the styles, dates, and authorship of their originals. Whether scattered about in Roman gardens and plazas, or arrayed in serried ranks in Roman palaces, basilicas, baths, nymphaea, theaters, and gymnasia (cf. Figure 164), their function was to create an ambience, a distinctly Roman mood and sense of place. Thus, for example, the multistoried scene building or scaenae frons of a theater might carry Dionysiac scenes, images of Apollo and the Muses, and statues of orators and other worthies past and present in order to emphasize the building's pedigree, character, functions, and pretensions. This kind of display subsumed and transcended any individual item even while gesturing vaguely toward its Hellenic origin and exemplary status.

Here (to paraphrase out of context a comment by Mieke Bal) we see the Romans turning their own sense of belatedness in history – a trigger of melancholy and a site of suture – into a potent source of support.[114] So in their particular context – whatever it was – our Little Barbarians probably performed a similar function.

8. ROMAN ECHOES?

Compared with the extraordinary record of response to the Little Barbarians during the Renaissance (for which see Chapter 2), echoes in the art of imperial Rome are strangely elusive. The problem is not confined to these statues, but it is exacerbated in their particular case by their condition upon discovery and their history after it.

Borrowings in Greco-Roman art are much harder to pin down than in the Renaissance because the power of convention is stronger; the geographical and temporal distribution of the material is far wider; provenances and chronology are often problematic; and so much is lost. Some qualifications to the principles advanced in Chapter 2, §3, are therefore in order. If one observes a similarity between earlier image *A* and later image *B,* any of the following scenarios is possible:

(1) *B* is borrowing directly from *A.*

(2) *B* is borrowing indirectly from *A* via one or more missing intermediaries.

(3) *B* is borrowing from a now-lost image like *A* but independent of it.

(4) Both *A* and *B* are borrowing from a now-lost common source, either directly or via now-lost intermediaries.

(5) Both *A* and *B* are independently descended from similar iconographic traditions.

The odds are clearly stacked against (1) from the beginning and multiply greatly when *A* and *B* have been found in widely different locations, and/or *A* is much earlier than *B.*

Fortunately, since the Little Barbarians were found in Rome, this final complication does not concern us. Nevertheless, what follows necessarily deals more with the Romans' reception of the *types* of the Little Barbarians than their engagement with our statues per se. As in the previous chapter each of them is treated largely as a *token* of a type. And again the discussion is selective rather than comprehensive. In particular, the vigorous afterlife of their types in the minor arts lies outside our scope – though a glimpse of it may be ascertained by comparing the Paris Gaul (see Figure 61) with a small Roman bronze

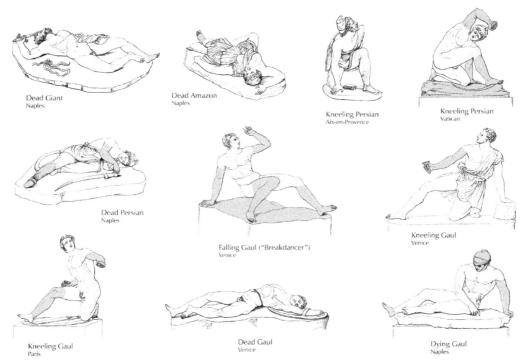

FIGURE 193. Little Barbarians: restorations. Adapted by Erin Dintino from Johannes Overbeck, *Geschichte der griechischen Plastik*, vol. 2 (3rd ed., Leipzig 1882): fig. 124.

of a Giant in Geneva (see Figure 234 and Chapter 4, §2).[115]

Unfortunately, although Giants and Amazons reappear often in second- and third-century Rome, they are the least well represented among our extant statues (see Figures 1, 29–36). And as to Persians and Gauls, in both art and reality the former had long given way to Parthians and the latter to Dacians (Figures 158, 161), Germans, and other troublesome northerners. So any borrowings in these departments would necessarily pass through an ethnic and iconographic filter that could alter clothes, weapons, physiognomies, and coiffures either partially or completely, leaving only poses intact –

or not. Here it may be illegitimate to speak of borrowings at all, for the thought processes of the ancient artist, always elusive, have become totally impenetrable.

Second, most key figures of the "core group" are either missing entire limbs and attributes or are extensively and perhaps misleadingly restored, as shown in Figure 193 and Table 4.

Some of these restorations may be fairly accurate – those on the Vatican and Naples Persians, for example. Others are highly questionable. The Venice Kneeling Gaul may have held a sword in his right hand, as Aspetti thought when he restored it in 1587, or (as his frightened expression suggests) he may have been begging for mercy

TABLE 4. The Little Barbarians: Major Restorations

No.[a]	Statue	Questionable and/or Misleading Restorations
2.	Naples Amazon (see Figures 1, 9, 13, 18, 33–34)	Baby removed
3.	Vatican Persian (see Figures 3, 6–8, 45–46)	Plinth and shield; both arms (correctly?), with sword hilt
6.	Paris Kneeling Gaul (see Figures 5, 61–62, 115)	Right forearm (with sword hilt) and entire left arm (with shield-grip)
7.	Venice Kneeling Gaul (see Figures 16, 49–50, 196)	Right arm with sword hilt
8.	Venice Falling Gaul (see Figures 17, 53–54, 95, 111)	Plinth; left lower leg; right leg; left arm; right arm below shoulder (all more or less correctly?)
9.	Naples Dying Gaul (see Figures 1, 24–25, 41–42, 116)	Head (ancient but alien)

[a]See Appendix 2.

FIGURE 194. Man falling off a mule. Scene 9 from the frieze of Trajan's Column; ca. AD 110. Marble; height of frieze ca. 1 m. Rome. Photo: DAI Rome 73.1800.

(compare Figure 142). For as Schober observed in 1939, he was definitely not committing suicide. His upper arm was withdrawn a little, whereas a suicide's would have been angled forward in order to wield the knife (see Figure 16; cf. Figures 201–02).[116] The Venice Falling Gaul may have been restored accurately, or just possibly could have been falling sideways from a horse, as on Trajan's column, on the sarcophagi (Figures 194, 203), and in the minor arts. He was probably not sitting tamely on the ground (cf. Figure 204), since there are no traces of a plinth attached to his buttocks, and had there been any, Aspetti surely would not have restored him as he did.[117]

To turn to concrete examples. *Gigantomachies* (I) are found on some sarcophagi and on many coins and other items, but as normal in Rome the Giants are anguiped and thus irrelevant to our inquiry. *Amazonomachies* (II) are more common. Several sarcophagi include an Amazon who at first sight looks like the Naples Dead Amazon with a *pelta* on her left arm and minus baby (Figure 195). Yet the pose is a stock one, invented in the fifth century BC, and could have been imitated from anywhere. Only the inclusion of the baby could certify the borrowing, and this is exactly what is missing.[118]

As to *Persians* (III) and *Gauls* (IV), the Columns of Trajan (erected in 107–13) and Marcus Aurelius (180–92) include numerous figures that look somewhat like the Naples Dead Persian and Dying Gaul, and the Venice Kneeling and Falling Gauls. Yet their Dacian/Sarmatian clothing and hair and their slightly different postures make certitude impossible in the particular case.[119]

Yet in this fog of uncertainty one recurring image does stand out, chiefly because of the way in which Trajan's master sculptor isolates and thematizes it: the kneeling Dacian (see Figures 198–201).[120] This individual appears no less than four times (in scenes 38, 112, 145, and 151). He is the Venice Kneeling Gaul reincarnated – or would be if we had the Gaul's right hand and knew whether it was open in entreaty or (as Aspetti restored it) closed around a sword hilt (Figure 196). Its motif apart, presumably the designer of the reliefs found the type useful for the very reason that Renaissance artists largely disdained it: its flatness. Moreover, all four figures appear on the same side of the column, the northwest, with the figure of Victory interpolated in scene 78 between the first two of them (Figure 197). This side faced the head of the Forum complex.

The sequence begins about a quarter of the way up the column with an exercise in *variatio* (scene 38; Figure 198).[121] Here the designer reverses the pose so that the Dacian can protect himself with his shield. This is the classic "fallen but still defiant warrior" type, one of the most popular in Greek art (see Figure 258). Next, about halfway up appears the figure of Victory, in the interlude between the two campaigns. Then three-quarters of the way up we encounter the kneeling Dacian again but now his defiance has turned – too late – into entreaty. About to die by the sword of a Roman auxiliary and begging for mercy, he epitomizes the inevitability of Roman victory, of Vergil's *debellare superbos* (scene 112; Figure 199).

FIGURE 195. Amazonomachy, from an Amazon sarcophagus. From Rome; ca. AD 150. Marble; height 93 cm. Rome, Museo Capitolino 726. Photo: DAI Rome 72.681.

The unfolding rhetoric of imperialism does not stop here. Almost at the top of the column the type reappears again, but now brilliantly transformed into the suicidal Decebalus (scene 145; Figure 200). By substituting a flexed arm, clenched fist, and wicked-looking knife for the suppliant's outflung arm and open hand the designer radically shifts the meaning of the whole motif, converting it from an icon of barbarian abjection into one of bitter recalcitrance. Decebalus, at least, will not grovel for Roman *clementia* or grace a Roman triumph. But after this brief and bracing interlude the Column returns to its imperialistic homily by mutating the figure back again into a suppliant in the battle scene immediately above – the Column's last (scene 151; Figure 201). This dramatic reversion to type all but guarantees that the designer began with the begging motif; added the "defiant" one from the standard repertoire of battle iconography; and developed the "suicidal" one as his own particular variation upon the first of these.[122]

This quintessentially Roman exercise in *interpretatio, variatio,* and *aemulatio* has some further consequences. First, we can now confidently conclude, with Schober, that our Gaul should not be reconstructed as a suicide (cf. Figures 202–03) as Reinach first suggested in the 1880s. To Schober's crucial observation about the figure's shoulder muscles we may now add the following: If the begging type is the norm and the suicidal Decebalus the Column designer's own invention, suicide becomes the *least* likely motif for the Venice statue.[123]

These observations about the Venice Gaul and the two begging Dacians of the Column reinforce each other. Looking at Aspetti's restorations, then (see Figures 49, 193), the Gaul's upper arm seems about right. His forearm could have been outstretched as Aspetti thought, or raised, and his clenched fist and sword probably should be replaced by an open hand.

So did the Column designer know of our Barbarians and imitate this Venetian figure or its Athenian original? Obviously, his begging Dacians' ethnically specific clothing and the Venice Gaul's missing arm preclude any definitive answer, but another scene elsewhere on the Column may offer some evidence in support. In the mass suicide that precedes Decebalus' (scene 140, also on the northwest side), a Dacian plunges his dagger into his chest in exactly the same manner as the Ludovisi Suicidal Gaul (compare Figures 27, 202).[124] This striking coincidence greatly strengthens the possibility that the Column designer really did know *both* groups of Gauls. But does it entitle us to argue that he knew *our particular copies* (see Figures 27, 49) and thus to date all of them, Big and Small alike, before 107, when he probably began to sketch his design?

The reservations expressed at the beginning of this section do not inspire confidence. For it matters not whether the Column's designer was actually the well-traveled Apollodoros of Damascus, the architect of the entire Forum complex and of Trajan's Danube bridge.[125] Whoever he was, he could easily have journeyed to the Aegean area

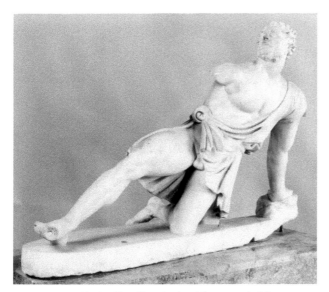

FIGURE 196. Venice Kneeling Gaul, with restored right arm removed. Photo: Osvaldo Böhm, digitally altered by Erin Dintino.

either as a part of his general education or to prepare for his work on the Column and could easily have seen, studied, and perhaps sketched both Attalid monuments in situ. And as remarked at the outset of this chapter, the Little Barbarians themselves cannot be dated exactly, and documented Trajanic projects on the Campus Martius that could account for their manufacture are all but nonexistent.

Whereas the ethnographic specificity of the two columns tends to obscure borrowings, the Roman battle sarcophagi (Figures 203–04) look more promising, at least at first sight. Although they must commemorate the Sarmatian and Marcommanic Wars they feature only generic northerners and, like their Attic cousins, are highly formulaic. Four Antonine ones dating to ca. AD 160–90 form a particularly tight group that was first studied in this context in 1956 by Bernard Andreae.[126]

Andreae first asked whether the Venice Kneeling Gaul (Figure 196) could have inspired the fallen barbarian who stabs himself with a knife (Figure 203). Furthermore, a dead man sprawled behind and to the left of the suicidal one in the more elaborate examples looks somewhat like the Venice Dead Gaul. And (to go beyond Andreae) the warrior falling off his horse could even echo the Venice Falling Gaul (see Figures 2, 53, 95). Finally, the Venice Kneeling Gaul might even find a distant echo in the kneeling Gaul second from right on the front. Yet this man wears a torque, and his right hand now grips his assailant's arm as the latter pulls his hair. So is he the carver's own adaptation of the Venice Gaul's supplication motif? Or is the Venice Gaul itself an adaptation of an original two-figure group from the Akropolis Dedication

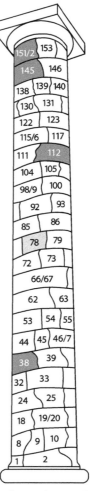

FIGURE 197. Scenes on the northwest side of Trajan's Column. Drawing by Erin Dintino after Werner Gauer, *Untersuchungen zur Trajanssäule* fig. 4. The scenes in Figures 198–201 are shown dark.

that was later echoed on the sarcophagus? One cannot tell.[127]

To return to the kneeling suicidal Gaul and the dead one (Figure 203): The suicide motif apart (see above), Andreae noted that their poses, drapery, and hair are somewhat different from those of the Little Barbarians. The Venice Kneeling Gaul (see Figures 2, 49, 196) kneels on his left knee; wears a thick, *exomis*-like garment gathered on the left shoulder and girdled and knotted at the right hip; and sports a beard, moustache, and shortish hair. The suicidal barbarian, on the other hand, sprawls with his weight on his left hip and tucks his left shin under his right; wears a thin *chitoniskos*-like garment with a cross strap, which was originally pinned on *both* shoulders but has slipped down over the left biceps, and is open at the right hip; and has no beard and longish hair. The Venice Dead Gaul (see Figures 20, 57–58) and dead barbarian are closer but not identical. The latter has lost

FIGURE 198. *(above)* Battle with (center right) defending Dacian. Scene 38 from the frieze of Trajan's Column; ca. AD 110. Marble; height of frieze ca. 1 m. Rome. Photo: DAI Rome 89.758.

FIGURE 199. *(right)* Battle with (bottom, left of center) supplicating Dacian. Scene 112 from the frieze of Trajan's Column; ca. AD 110. Marble; height of frieze ca. 1.1 m. Rome. Photo: DAI Rome 41.1632.

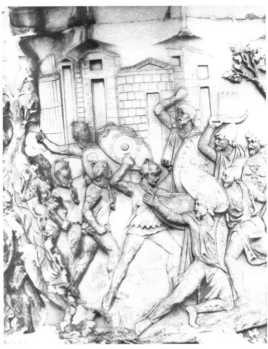

FIGURE 200. *(above)* The Romans surround the Dacian chieftain Decebalus, who commits suicide. Scene 145 from the frieze of Trajan's Column; ca. AD 110. Marble; height of frieze ca. 1.2 m. Rome. Photo: DAI Rome 41.1749. Compare Figures 185–86.

FIGURE 201. *(right)* Battle with (bottom right) supplicating Dacian. Scene 151 from the frieze of Trajan's Column; ca. AD 110. Marble; height of frieze ca. 1.2 m. Rome. Photo: DAI Rome 41.1220.

FIGURE 202. A Dacian commits suicide in scene 140 (Dacian refugees) from the frieze of Trajan's Column; ca. AD 110. Marble; height of frieze ca. 1.2 m. Rome. Photo: DAI Rome 1931.528.

his shield; has long, shaggy hair; and flexes his right leg, not his left.[128]

As remarked in Chapter 1 (§6), Andreae tried to explain these differences between the two sets of figures by their dependence upon a common source: a Hellenistic painting by Phyromachos allegedly exhibited at Pergamon. Others, on the other hand, either preferred to shift this hypothetical antecedent to Rome or rejected the whole idea. The skeptics, it seems, may be right. For careful analysis over the years of hundreds of other Roman sarcophagi suggests that their carvers seldom if ever used only one source but drew eclectically upon many and even invented much from scratch.[129]

So if we are right in suspecting that the "Ammendola" sarcophagus's designer did not base his suicidal barbarian (Figure 203) on the Venice Kneeling Gaul, from where (if anywhere) did he get him? And what of his Gaul toppling off his horse? He can hardly echo the Venice Falling Gaul per se, since the latter shows no evidence (e.g., telltale remains of breaks or dowels) that it was ever anything more than a single figure, just like its nine companions. So we have come full circle, back to where Andreae himself started half a century ago. If these eye-catching motifs were based on Hellenistic sources at all, they must have been now-lost figures either from the original Attalid bronzes on the Akropolis, or from some other monument. But which?

Since we shall almost certainly never be able to tell, it may be worthwhile to propose an alternative. What if

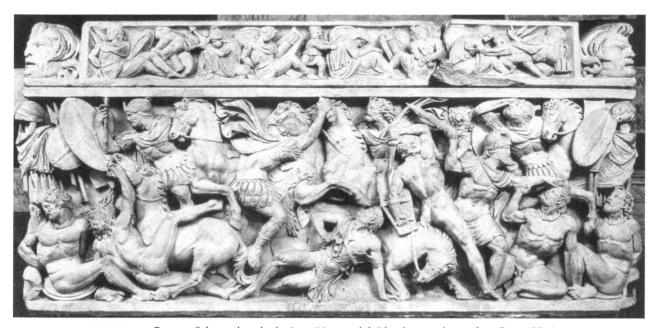

FIGURE 203. Romans fight northern barbarians. "Ammendola" battle sarcophagus, from Rome (Via Appia, Vigna Ammendola); ca. AD 170. Marble; height 1.25 m. Rome, Museo Capitolino 213. Photo: DAI Rome 55.427. In the center of the frieze, a barbarian commits suicide; at left, another falls off his horse.

both of them were worked up from Trajan's column? We have already met the suicidal Decebalus there (see Figure 200) and the falling Gaul's mirror image appears in scene 9, toppling off a mule (Figure 194).[130]

9. GREEK ECHOES?

It is time to return to the Athenian Agora and its emperor – probably Trajan – with a barbarian cowering at his feet (Figures 205–06). This statue and our Little Barbarians represent different sides of the same coin. While the Barbarians look as if some invisible, cataclysmic force has struck them down, the Agora statue magnifies the victor by literally turning his opponent into a pygmy, into a groveling attribute that merely confirms his power. This strategy too is quintessentially Roman, reducing the rich Attalid narrative of battle's ebb and flow to a simple statement of fact. Whereas the Little Barbarians highlight the process, the Agora statue shows us its terminus: *Roma triumphans et Dacia capta*.

Though the Agora barbarian is characterized as a Dacian by his cloak and brooch, his hair is shorter and beard sparser than usual. In fact, in physiognomy, beard, and pose he echoes the Aix Persian, only with legs reversed. And nor is he alone, for exactly twenty years before his discovery, the excavators of the Agora had found the head of another barbarian in a medieval wall built

FIGURE 205. Fragment of a statue of a Roman emperor (Trajan?) and captive barbarian. From the Athenian Agora; early 2nd century AD. Marble; height 90 cm. Athens, Agora Museum S 2518. Photo: Agora 87–305.

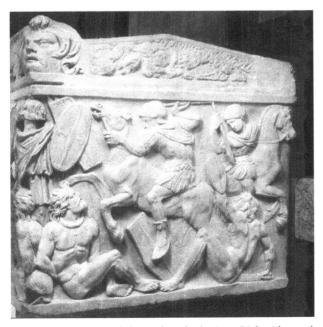

FIGURE 204. Romans fight northern barbarians. Right side panel of the sarcophagus, Figure 203; ca. AD 170. Photo: DAI Rome 35.1978.

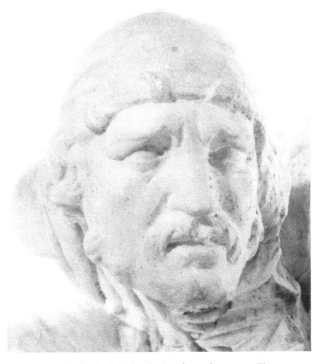

FIGURE 206. Head of the barbarian from the statue, Figure 205. Photo: Agora 87–307.

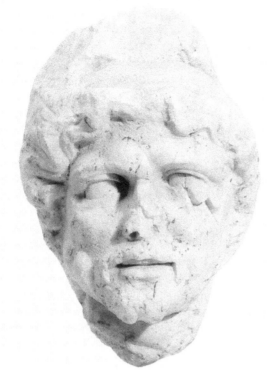

FIGURE 207. Head of a barbarian, probably from a statue like Figure 205. From the Athenian Agora; early 2nd century AD. Marble; height 17 cm. Athens, Agora Museum S 1596. Photo: Agora.

over the ruins of the South Stoa (Figure 207).[131] Homer Thompson's 1953 excavation report recognized his connection with the Aix Persian and the Small Dedication, and identified him as an Asiatic. About half the size of the cowering Dacian, he is more drily and precisely modeled, and his rasped finish is distinctively Hadrianic. He turns and looks up to the spectator's left; his proper right side is distinctly broader than his left; and there is a blank area in the hair at this point. So presumably he comes from another statue support mirroring that of Figures 205–06.

All this only goes to show how generic these barbarian figures often are – or rather, how these two imperial-period Attic sculptors, told to produce Dacians and Parthians but lacking a fixed *Athenian* iconography for them, simply consulted the best study of barbarians in the city: the Attalid Dedication on the Akropolis.

Another Athenian echo of the Attalid Dedication has been detected in a marble figure once in the Tower of the Winds but transferred to the National Museum between 1874 and 1880. An under-life-size dead warrior with long hair lies supine in a pose like that of the Venice Dead Gaul in mirror image, his face battered and his torso broken at waist level (Figure 208; NM 2251). Could he copy another statue from the group? Hope rises when one notices that the man just below him in the publication,

FIGURE 208. Fragments from a battle relief. From Athens; early 2nd century AD. Marble; about half life-size. Athens, National Museum 2179, 2250–53, 2262–63. From Joannes N. Svoronos, *Das Athener Nationalmuseum* (Athens 1913): pl. 166.

FIGURE 209. Fragments from a battle relief. From Athens; early 2nd century AD. Marble; about half life-size. Athens, National Museum 2248, 2256–60, 2264. From Joannes N. Svoronos, *Das Athener Nationalmuseum* (Athens 1913): pl. 167.

FIGURE 210. Fragments from a battle relief, with Athena and two standing women. From Athens; early 2nd century AD. Marble; about half life-size. Athens, National Museum 2249, 2254, 2261, 2265–68. From Joannes N. Svoronos, *Das Athener Nationalmuseum* (Athens 1913): pl. 168.

no. 2253, resembles the Venice Kneeling Gaul (see Figures 2, 49, 196).¹³²

The proponents of this idea have failed to notice that the supine figure is part of a high-relief frieze that (if all the pieces belong) contained at least two subjects, for along with another fifteen fighters three quietly standing female figures are also preserved, including an Athena (Figures 208–10). They all have the heavy rasping and classicizing manner that is typical of Hadrianic and Antonine work in the city. Indeed, some scholars have independently connected them with the Hadrianic reliefs in the Theater of Dionysos on the south side of the Akropolis, whose style they echo. Unfortunately, since no heads are preserved and no obvious Orientals or northerners are present, the identity of the combatants (Giants? the Pallantidai?) is quite uncertain. The figures' orientation, too, is problematic, since the edges of the slabs are missing. Placed upright and not flat, for example, the warrior NM 2251 finds a close precedent on the Telephos frieze from the Great Altar of Pergamon.¹³³

Yet the frieze cannot come from the theater since there is no place for it in the structure, and its only provenanced fragments were discovered on the opposite side of the Akropolis. One Hadrianic building in this area that could have accommodated such a frieze was the Panhellenion, apparently a huge basilica dedicated to Zeus Panhellenios and Hera; but until it is properly identified any attribution must remain completely hypothetical. Certainly it would have been a perfect setting for a Gigantomachy of this kind. Dedicated to Zeus, it was also closely linked with both the Olympieion and the quadrennial Eleutheria ("freedom") games at Plataia (celebrating the great victory of 479 BC) in an imperially sponsored promotion of Hellenism's achievements against the East. In the Olympieion, for example, stood a huge bronze tripod supported by Persian captives carved in Phrygian marble.¹³⁴

The Attic sarcophagi are less rewarding. Gigantomachies (I) and Galatomachies (IV) are totally absent from the repertoire, and the numerous Amazonomachies show the battle before Troy and contain no clear reminiscences of our figures. Unexpectedly, though, the Battle of Marathon (III) does turn up on two Attic caskets (one very fragmentary) found in Italy. Yet these show the fight at the ships, and although they differ substantially in composition both have been linked to the mid-fifth-century Marathon Painting in the Painted Stoa. On one of them, now in Brescia, a Persian counterpart in mirror image to the Naples Dying Gaul appears at far right.¹³⁵

Finally, the Hierapytna Hadrian (Figure 173): This statue bears the same head type as Figure 174, created upon the emperor's accession in 117.¹³⁶ Over-life-size and dressed as a conquering imperator, he stomps a barbarian under his left foot and holds his right hand aloft to grasp a spear. His breastplate is embellished with an archaistic, armed Athena crowned by two Victories; she, in turn, stands on the back of a she-wolf that suckles the twin babies Romulus and Remus. This symbolic representation of imperial triumph neatly complements and underscores the action of the emperor himself. While he interpellates us, confronting us with his success and demanding our attention, the suckling scene offers a "historical" explanation for the composition, returning us to Rome's origins and divinely ordained mission.

Clean-shaven and dressed in cloak, tunic, and trousers, the barbarian under his feet looks vaguely Asiatic. He could be one of the rebellious provincials of 117–18 (see section 5) or – perhaps less likely – a Jewish captive from the Bar-Kochba revolt of AD 132–35. But again, racial specificity was probably the last thing on the sculptor's mind: A composite and multivalent image would work far better. Typologically the figure is also a hybrid, melding the types of the Naples Dying Gaul and Dead Persian into a single, arresting image of brutal imperialism.

This portrait makes us, in the twenty-first century, most uneasy. Dramatizing the distance between Roman civilization and ours, it is a potent reminder that the past truly is another country. Indeed, when I first saw it in 1969 a chilling phrase from George Orwell's *1984* came immediately to mind: "A boot stamping on a human face, forever." Yet the similarities should not obscure the differences. Orwell's dreadful image is one of *internal* repression in the "perfect" totalitarian society. The Roman Empire never envisaged nor aspired to such control, and reserved its rhetoric of repression for *external* enemies, the barbarians beyond the pale and those individuals who, having tasted civilization's fruits, were then mad enough to reject them. A small difference, perhaps; but the devil is always in the details.

4. GENESIS

Barbarians at the Gates

ೞ ೞ ೞ

"Is there any other point to which you would wish to draw my attention?"
"To the curious incident of the dog in the night-time."
"The dog did nothing in the night-time."
"That was the curious incident."
SHERLOCK HOLMES and INSPECTOR GREGORY, in "Silver Blaze"

THE ULTIMATE *ARGUMENTUM E SILENTIO!*

Pausanias (AT6) tells us that a certain Attalos donated the Akropolis Dedication and that alongside the Gigantomachy (I), Athenian Amazonomachy (II), and Marathon (III), it celebrated "the destruction of the Galatians in Mysia" (IV). Since this event can only be King Attalos I Soter of Pergamon's great victory of ca. 237 at the sources of the River Kaïkos, the "Pergamene Marathon," he thereby becomes the monument's most likely donor. But Attalos (r., 241–197) did not visit Athens in 237 nor for years afterward; in fact, he had no direct relations with the city until 209 at the earliest, and perhaps not even then. But when in 200 the Macedonians suddenly began to hammer at its very gates, threatening its utter annihilation just like the barbarous Amazons and Persians had done, he came promptly and in person to its aid. The grateful Athenians at once showered him with honors, creating a new tribe in his name and paying him cult as its eponymous hero.

The city survived the onslaught, but only barely and at huge cost to life, property, and morale – and (despite all of Attalos' fine promises) with little further help from him. Yet many argue that although danger still threatened and the king even visited the city three times more before he died in 197, he proceeded to act as if nothing had happened. The dog did not bark in the night. Instead (we are asked to believe) it was his son and namesake Attalos II (r., 158–138) who donated not only the magnificent stoa in the Agora that bears his name, but also – in a prolonged period of peace, quite out of the blue, and almost a century after the Kaïkos victory – this ostentatious, programmatic, and clamorously bellicose series of bronzes. The dog now barked twice, but at nothing. This is hardly credible.

Once again, we begin our investigation of these curious incidents with three forays into standard archaeological sleuthing. Where exactly on the Akropolis did the Dedication stand? What did it look like and on what sources did it draw? And who made it? Sections 4 and 5 then turn to its date and its relation to the traumatic events of the year 200, investigating its genesis and seeking to embed it in Athenian–Attalid experience.

The final three sections turn to the spectator. What function(s) – religious, rhetorical, and political – did the Dedication serve? How did it negotiate and sharpen the expectations and sensibilities of its different audiences: Athenians; Greeks from other cities; the Attalids, their subjects, and their partisans; the other Hellenistic kings and their peoples; and the Romans? What messages did it send? What reactions could it have provoked? Where would these diverse viewers have situated it in the inner landscape of their own experience?

1. LOCATION AND DISPLAY

Pausanias describes the Attalid Dedication during his tour of the Akropolis (AT6; see Figures 26, 67). Though his exact route soon becomes quite controversial, up to this point it is relatively easy to follow. Noel Robertson,

an observer with no ax to grind apropos the Attalid Dedication, has succinctly described what he saw (cf. Figure 26):

> [Pausanias] goes east from the Propylaia along the south side of the Akropolis, past the shrine of Brauronian Artemis (1.23.7); then he skirts the north side of the Parthenon, and notes the monument of Ge, still marked for us by a rock-cut inscription (24.3); after reaching the precinct of Zeus Polieus at the northeast corner of the Parthenon, he turns to the east front of the temple (24.4–5); thereafter he comes to four statue groups dedicated by Attalos I of Pergamon, displayed in a row along the south wall of the Akropolis (25.2: AT6]). The groups depicted battles: three mythical ones and Attalos against the Gauls... (Plutarch, *Antony* 60.4 [AT5]).[1]

Pausanias apparently never saw the two colossi of Eumenes and Attalos that originally bounded the Attalid Dedication to the east. Converted into images of Mark Antony (AT5), or less plausibly into an Antony and Kleopatra (AT7), these had also pitched into the theater during the great storm before the Battle of Actium in 31 and apparently were never restored.[2] But he clearly describes the four Attalid battle groups from left to right (east to west) in their proper chronological order, beginning with the most ancient – the Giants (I) – and moving westward down the line via the Amazons (II) and Persians (III) to the Gauls (IV). This arrangement is confirmed by Plutarch's report (AT5) that the Dionysos from the Gigantomachy pitched into the theater in 31.

Pausanias then walks on to the portrait of the general Olympiodoros (1.25.2–26.3; Figure 211), honored for liberating the city from Demetrios Poliorketes in 287. He takes this moment to recall Olympiodoros' glorious victory over the Macedonian garrison on the Mouseion Hill to the southwest of the Akropolis, and then remarks on the Philopappos monument at its summit (1.25.8). So by this time he has all but circumnavigated the Parthenon and is standing near or at its southwest corner, ready to take off for the Erechtheion (1.26.5).[3]

Now Pausanias tells us that the Attalid Dedication stood "by" (πρός) [the parapet of] the Akropolis' South Wall (τῷ τείχει τῷ Νοτίῳ). His usage can sometimes be idiosyncratic, but here he employs standard Greek: *pros* with the dative case can only mean "hard by," "near," or "at," so the statues cannot have been mounted *directly* on the wall's parapet, as some have argued (see Figures 89–90).[4] Yet as Brunn and all subsequent commentators have recognized, the Dionysos was both sufficiently elevated and sufficiently close to the wall for it to tumble convincingly into the theater along with the colossi in 31 (AT5 and 7). We shall revisit their fate later; the immediate question is, Where in relation to the wall did the At-

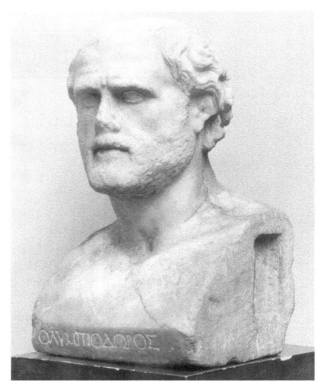

FIGURE 211. Inscribed portrait herm of Olympiodoros (Roman copy). From Caesarea Maritima in Israel; original, ca. 280 BC. Marble; height 51 cm. Oslo, National Gallery s.01292. Photo: Museum. Probably copied from the bronze portrait that stood by the South Wall of the Athenian Akropolis to the west of the Attalid Dedication.

talid Dedication stand? For all the foundations recorded in the nineteenth-century excavation reports and plans (Figures 212–13) are too far down to have supported it. Instead, it must have stood on the fabric of the wall *itself*.

About midway along the Parthenon's southern flank, the top courses of this ancient Kimonian–Periklean wall thicken dramatically to over six meters in width (Figures 212–13, 284). The reasons for this massive inward extension of the wall are still unclear, but its date is evidently Periklean (see the Essay by Manolis Korres in the present volume). In 1847, Penrose recorded two sections of the broad platform thus created, revealed by Ludwig Ross's soundings of 1835–36 (see Figure 26a), and even speculated that two marble blocks sitting on top of the southern part of it could have been the sole in situ remains of the Attalid Dedication.[5]

The massive excavations of 1888 uncovered the rest of this platform (Figure 212), and a deep triangular inspection pit left open behind the third buttress from the west (see Figure 67) shows exactly where the change occurs: opposite the middle of the Parthenon's south colonnade. This wide platform then continues around the eastern end of the citadel until it meets the rock rising toward the

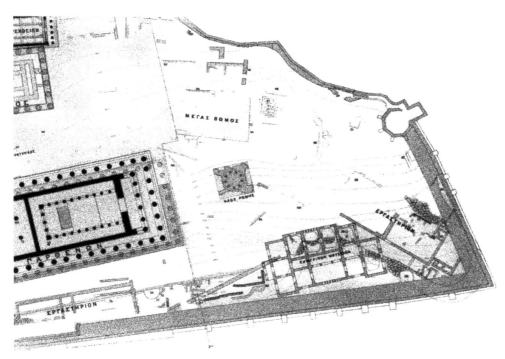

FIGURE 212. Plan of the Akropolis after the excavations of 1885–90. From Panagiotis Kavvadias and Georg Kawerau, *Die Ausgrabung der Akropolis vom Jahre 1885 bis zum Jahre 1890* (Athens 1906): pl. A. Note the inward extension of the southern retaining wall from opposite the center of the Parthenon to the Belvedere at the northeast, partially revealed first in 1835–36 (see Figure 26).

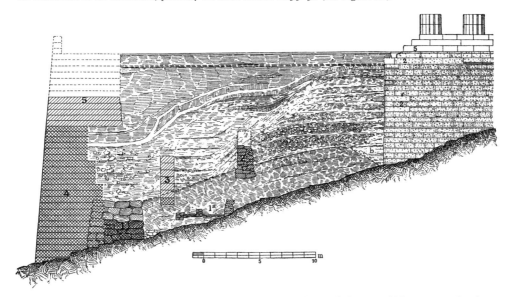

FIGURE 213. Section of the Akropolis excavations, 1885–90, after Wilhelm Dörpfeld, "Die Zeit des älteren Parthenon," *Athenische Mitteilungen* 27 (1902): 394, fig. 3. The section cuts across the east façade of the Parthenon.

medieval Belvedere at its northeast corner. It offered a tailor-made foundation for the Attalid Dedication: a ledge inside the wall's crowning parapet that was about 5 m wide and 143 m long. Indeed, this ledge's very existence raises the suspicion that it was intended for ded-

ications of this sort and prompts the speculation that, by placing his dedication here, Attalos was fulfilling an unexecuted Periklean project.

Unfortunately the top courses of this ledge are now covered by modern fill, and its face is obscured by Turk-

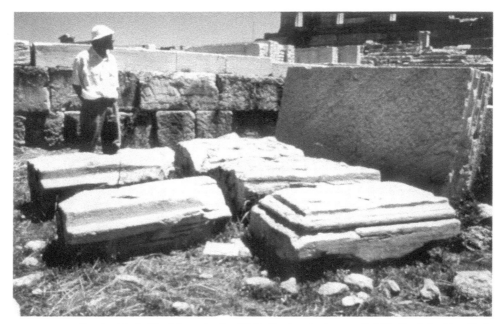

FIGURE 214. Cornice blocks Γ2–6 from the Attalid Dedication, in the so-called Chalkotheke (the plinth in the right foreground does not belong to the series). Ca. 200 BC. Marble; height of blocks, ca. 41 cm. Athens, Akropolis. Photo: Author.

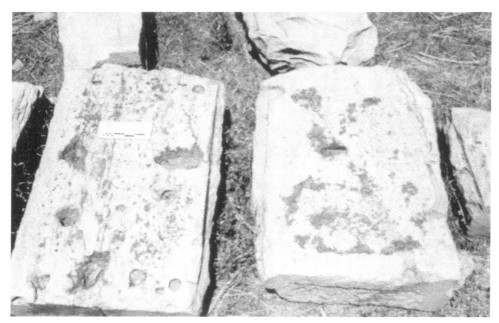

FIGURE 215. Cornice blocks Γ3 (on the right) and Γ4 (with scale) from the Attalid Dedication, in the so-called Chalkotheke. Ca. 200 BC. Marble; height of blocks, ca. 41 cm. Athens, Akropolis. Photo: Author.

ish and later repairs. As a result, its intended height and the classical landscaping within it are uncertain (see Korres's Essay). If its builders wanted to build it high enough to support a level terrace between it and the Parthenon (Figure 213), they certainly never finished the project. Its parapet is also problematic, since none of it survives. One of Lucian's comic dialogues, set on the Akropolis, suggests that it was relatively low, though probably higher than today's. For in one scene, a mob of fake philosophers, threatened with a test of their abilities, scatter and jump over the parapet onto the rocks below; and a little later, a fisherman sits on it to fish for more philosophers.

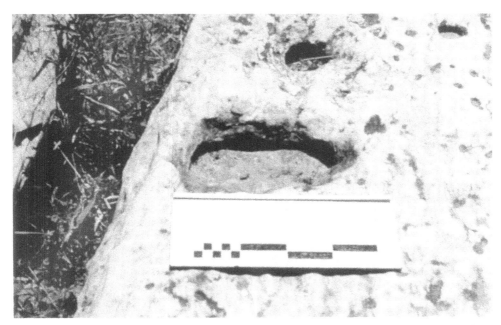

FIGURE 216. Cornice block Γ4 from the Attalid Dedication, in the so-called Chalkotheke: detail of footprint (i). Ca. 200 BC. Marble; height of blocks, ca. 41 cm. Athens, Akropolis. Photo: Author.

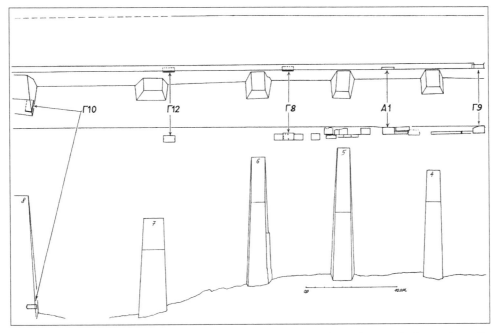

FIGURE 217. Cornice blocks Γ8–10, 12 and plinth Α1 from the Attalid Dedication, built into the medieval and Turkish revetments of the Akropolis South Wall. Drawing by Manolis Korres.

When he begins to catch them, one of the bystanders helps him to pull them up and land them. Nothing is said about either of them having to climb anywhere in order to do this and, indeed, the joke seems to demand that everyone – bystanders included – can see everything that is going on.[6]

As for the Dedication itself, the bases of the two colossi have vanished as completely as the statues themselves, but the same is not true of the battle groups. For in the early 1990s Manolis Korres noticed that a series of Pentelic marble cornice blocks located on and below the south side of the Akropolis (Figures 214–17) belonged

together and attributed them to these groups.[7] They are published below, in his Essay (Figures 268–78, 287), and the following discussion is based entirely on his work. The collection now comprises thirteen cornice blocks (including no fewer than three end blocks) and over forty orthostates and plinths, but unfortunately as yet no dedicatory inscription. Nine of the blocks are presently (2004) located in the so-called Chalkotheke and alongside the workshops to the south of the Parthenon. Four more are built into the medieval and eighteenth-century revetments of the Akropolis South Wall (Figure 217).[8] The structure is provisionally reconstructed in Figures 218–19, both freestanding and placed against the South Wall's parapet.

Many of these blocks have been cut down for use as building material, and several bear traces of cement. And as mentioned earlier, those orthostates that would have carried the dedicatory inscription are still missing. Nevertheless, these thirteen blocks surely belong to the Attalid Dedication. For they are clearly Hellenistic, and the provenanced ones among them have been found around, in, and below the South Wall. Since they include *three* end blocks (Γ1, 2, 5), they come from at least two identical complexes – halfway to Pausanias' total (AT6) – and they carry a riot of footprints and other cuttings on their upper surfaces. These cuttings anchored a series of interlocked – and thus fighting – bronze statues of the same unusual scale as our Little Barbarians. Their feet were two-thirds life-size, just like those of the copies.

The blocks are made of white Pentelic marble of somewhat mediocre quality, streaked with veins of white mica and often cut on the bias; some are badly weathered. The complete ones range from 1.22 to 1.53 m in length, and their undersides are 81 cm wide. They average 42 cm in height and carry an Ionic two-fascia architrave, *tainia*, cymation, and projecting cornice on both sides (see Figures 265–67, 287), proving that the Dedication could be seen from both front and back (Figures 218–19). The platforms for the statues rise 9 to 11 cm above the cornices and measure 79 to 84 cm across. They are stippled or rough-picked with the pointed chisel, not fully landscaped like the bases of some of the Roman copies (see Figures 1–6, 18–21, 29–30, 33–34, 37–38, 41–42, 57–58). One block (Γ11; see Figure 278) has a crudely cut B on the left-hand end of its upper surface. The others are weathered and/or battered at this point, or their top surfaces are inaccessible.

The blocks' different lengths, clamp and dowel arrangements, and molding sizes divide them into no fewer than four separate series – presumably carrying the four groups that Pausanias (AT6) describes and the copies (see Figures 1–25, 29–64, 77–80) confirm. The distribution, argued in detail in Korres's Essay, is as follows:

Pedestal 1: Γ2, 4, 7, 10, 12

Pedestal 2: Γ3, 6, 8, 13

Pedestal 3: Γ5, 9, 11

Pedestal 4: Γ1

Which of the four groups of bronzes noted by Pausanias stood on which pedestal is still a mystery, though some clues are investigated below. But first it is necessary to describe and discuss the cuttings on the blocks' top surfaces.

These cuttings divide into four main types: sausage-shaped footprints, round/oval holes, triangular ones with rounded corners, and square/rectangular ones. All of them are what the Greeks called *ektomai* or *embolai*, that is, sockets for dowels, tenons, and plugs rather than for the actual outlines of bronze feet, hands, hooves, and so on. They are often provided with pour channels for lead "mortar," showing that whatever they secured exceeded the dimensions of the socket in question.[9]

The *footprints* are 12–18 cm in length and up to 9 cm deep. The variation in length can be explained in two ways. Either some statues were anchored by plugs that were considerably shorter than their feet; or some of them – presumably the Amazons – actually had smaller feet. Γ4, with its two different foot sizes of 14 and 18 cm, may indeed belong to the latter group; another even smaller socket, only 12 cm long, occurs on Γ10 from the same series (Pedestal 1). As a crosscheck, the opponent of the mounted figure on Γ12 from the same series had large feet: an Athenian fighting a mounted Amazon?

The *round/oval sockets* are 5–7.5 cm in diameter and 4.5–6 cm deep. Some must have anchored the toes, knees, elbows, and hands of lunging, falling, and kneeling figures; others may have held horses' hooves; and still others may have secured items like fallen weapons.

The single *triangular socket with rounded corners*, on Γ2, is 8 × 7 × ca. 5 cm deep. It probably anchored a horse's hoof.

The *square/rectangular sockets* range from 2 × 3.5 cm to 5.5 × 7.5 cm in breadth and length and from 1.5 cm to 5–6 cm deep. They too could have secured fallen weapons, though three, on Γ3, 7, and 9, probably anchored belly supports for rearing horses. Among the numerous Hellenistic equestrian monuments of this type, the base for the two-thirds life-size equestrian statue of the Aitolian general Aristainos, erected at Delphi in 186/85, of-

FIGURE 218. The Attalid Dedication on the Athenian Akropolis. Reconstruction with the pedestals placed in the center of the top of the South Wall. The parapet is restored with four courses and a capping element. Reconstruction by Manolis Korres.

FIGURE 219. The Attalid Dedication on the Athenian Akropolis. Reconstruction with the pedestals placed against the parapet of the South Wall. The parapet is restored with two courses and a capping element. Reconstruction by Manolis Korres.

knelt on his left knee with his right hand flat on the ground behind his right heel; no doubt he was raising his free left arm to defend himself, probably with a shield. Yet the whole of the rest of the block, almost a meter long, has only a single pi-clamp cutting on it. Much of its other end is broken away, but an opponent on foot must have been closer than this and would certainly have left some trace on the surviving part of the platform.

The solution to the mystery is a rider whose rearing horse was supported either by attaching its forelegs to this fallen man (a favorite marble workers' gambit: see Figure 85), or by a belly support sunk into the missing part of the block. So this now-lost, cowering figure extends the catalog of internal cross-references by one, for it cannot have been the Vatican Persian or indeed a similarly poised Amazon. Since their Athenian conquerors would all have been on foot, it must have been a Giant (I) or a Gaul (IV). Its earliest recorded location at the citadel's extreme eastern end would argue for a Giant if indeed it were actually found there, as would its height – uniquely, 2 cm greater than its fellows. For as suggested in Korres's Essay, the pedestals' slightly differing heights may have been intended to compensate for the fact that the South Wall drops 10 cm toward its eastern corner. The composition is similar to that on another end block, Γ2 (see Figure 269c), where a warrior, now still on his feet, again parried a rider galloping out toward the end of the block.

To summarize: Five blocks (Γ1, 2, 3, 7, and 9) offer evidence for the presence of riders, two from Pedestal 1 and one each from Pedestals 2, 3, and 4. So not only did all four groups include them, but two of the five are end blocks (Γ1, 2) and three are interior ones, and the remains of Pedestal 1 include one of each kind (Γ2 and 7). So each group must have included at least *three* riders, one at each end and one or more in the interior of the composition. How does this square with the iconographical tradition?

The Gigantomachy (I). Traditionally, only Poseidon and the Dioskouroi fought the Giants mounted, though Dionysos (AT5 and 7) could have ridden a panther; the Giants themselves were always on foot. Chariots – the staple of the fifth-century Gigantomachies (Figure 221) and the Great Altar of Pergamon – can be ruled out. The narrow statue platform, only 84 cm wide at best, could not have accommodated them, and no wheel ruts survive. So the protagonists – Herakles, Zeus, and Athena – must have fought on foot. Whether they all stood together as on the Great Altar or apart as on the Parthenon's east metopes, Zeus must have taken center stage, ruling out an odd number of riders. This group, then, sets the standard for the three others. Each must have contained *four*

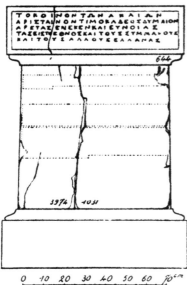

FIGURE 220. Base of the equestrian statue of Aristainos at Delphi. 186/85 BC. From G. Daux and A. Salac, *Fouilles de Delphes* III.3 (Paris 1932): 88–89, fig. 10.

fers a precise parallel (Figure 220).[10] The other sockets on these blocks belong to warriors lunging toward these horsemen.

In addition to this strong evidence for riders, an end block, Γ1, offers a further clue. Its terminal figure was cowering like the Vatican and Aix Persians (see Figures 3, 4, 45–47, 77–78, 268c). The cuttings show that he

FIGURE 221. Gigantomachy. Attic red-figure volute krater from Ruvo; ca. 400 BC. Height 31 cm. Naples, Museo Nazionale 2883. Photo: Hirmer Photoarchiv 571.0547. The left-hand Giant with the animal skin is labeled "Porphyrion"; the unique representation of the curve of the heavens suggests that the scene may echo the interior of the shield of Pheidias' Athena Parthenos (exterior, Figure 222).

riders, two galloping outward at the ends, and two more presumably galloping toward the center of the composition, thus: . ⇐ . . . ⇒ . . . ⇐ . . . ⇒.[11]

The Amazonomachy (II). Mounted Amazons had been a staple of the great fifth-century Athenian painted Amazonomachies, and Antiope (see section 2) was a renowned horsewoman; the Athenians always fought on foot. So in contrast to Pheidias' Amazonomachy on the shield of Athena Parthenos (Figure 222), ours probably did not represent specifically the storming of the Akropolis, where horses would have been decidedly de trop.[12]

The Persianomachy (III). Marathon (AT6) had been fought in part against Persian cavalry, and Attic iconographic tradition always respected that fact (Figure 223). When Pausanias visited the battlefield seven hundred years later, he found that "horses neighing and men fighting" could still be heard there every night.[13]

The Galatomachy (IV). The Kaïkos battle surely included riders, for in true Macedonian fashion the cavalry was the Pergamene army's main striking force (see Figures 168, 224–25). The king – in this case Attalos I himself – led it in person. The Gallic cavalry was formidable, too (see Figure 168), but since the other three groups included riders on one side only – for the Giants and Athenians always fought on foot – this group cannot have broken the mold.

So the Dedication's overall structure was chiastic, with the victorious, mounted gods (I) and Pergamenes (IV) bracketing the vanquished, mounted Amazons (II) and Persians (III) in an *A-B-B-A* chiasmus. We may schematize its composition as shown in Table 5.

As to correlations, we have seen that the Amazonomachy (II) may be represented among the extant remains by Pedestal 1 (Γ2, 4, 7, 10, 12), and the Gigantomachy (I) by Pedestal 4 (Γ1). The other two series of blocks could fit either of the remaining groups.

What else can the cornice blocks contribute? Looking more closely, one is immediately struck by the variation

TABLE 5. *The Attalid Dedication: A Hypothetical Reconstruction*

	Gigantomachy	Amazonomachy	Persianomachy	Galatomachy
Victors	4 mounted; others on foot	All on foot	All on foot	4 mounted; others on foot
Vanquished	All on foot	4 mounted; others on foot	4 mounted; others on foot	All on foot

FIGURE 222. The Amazons attack the Athenian Akropolis. Reconstruction by Evelyn Harrison of the exterior of the shield of Pheidias' Athena Parthenos. Original, 447–438 BC. Gold and ivory; diameter, ca. 4.9 m. From E. B. Harrison, "Motifs of the City-Siege on the Shield of Athena Parthenos," *AJA* 85 (1981): 297 fig. 4. Antiope is the dead Amazon at bottom right; Molpadia stabs at her from above; and Theseus, to Molpadia's left, comes too late to the rescue.

in the number of cuttings from block to block. Γ4, for example, is peppered with no fewer than ten of them, including two footprints that must belong to different figures; yet most of them might well belong to a dead or dying figure, which could take up to six tenons to secure (see Figures 271c, 280). On the other hand, Γ1, 5, 6, and 8 each bear definite traces of only a single figure – though, as noted above, riders probably loomed menacingly above them. So the composition was basically quite open, much closer to the Nike temple frieze and its Marathon battle (Figure 223) than to the densely packed Alexander Sarcophagus (Figure 225) and the Gigantomachy of the Great Altar (see Figures 68–69, 236).[14]

Many figures were clearly posed crosswise or on the diagonal, lunging into, out of, and across the battlefield. The riders galloping out toward the ends of the pedestals would have created a centrifugal effect that carried the action across from one battle to the next – the very opposite of the Alexander Sarcophagus's classically closed composition (Figure 225). The monument's restricted depth, around 81 cm, also explains why some of the copies are so flat (see Figure 16) and why those that look aggressively three-dimensional often are no less flat when seen side-on. The Venice Falling Gaul, for example, is a mere 40 cm deep (see Figure 17); though it is restored, Aspetti's additions cannot be far wrong. And the dead and injured must have been numerous, with the victors battling furiously over them, silhouetted against the intense blue of the Athenian sky. Expressive enough in marble, in their original polished and patinated bronze, with staring eyes, pursed lips, spurting blood, tousled hair, coarse clothing, and weapons inlaid in stone, glass, copper, silver, and perhaps even gold, they would have been quite stunning.[15]

Finally, the way in which the cuttings often cross two blocks and on one occasion (Γ7) intersect with a clamp

FIGURE 223. Persianomachy, probably the Battle of Marathon. Slab from the south frieze of the Temple of Athena Nike on the Akropolis, ca. 425 BC. Marble; height of frieze, 90 cm. London BM 424. Photo: BM LXXXV-(C)31.

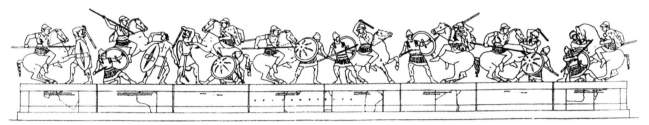

FIGURE 224. Pergamenes fighting Gauls and Seleukids. Reconstruction by John Marszal of a multiple-victory monument (the so-called Great Dedication or Long Base) dedicated by King Attalos I of Pergamon in the Sanctuary of Athena Nikephoros on the Pergamene Akropolis; signed by Epigonos of Pergamon; ca. 223 BC. Bronze; length of individual segments, ca. 2.3 m.; of monument as restored, ca. 18.4 m; the figures were life-size. The originals of the Ludovisi and Capitoline Gauls, Figures 27–28 and 237–42, were too large to fit on this monument.

FIGURE 225. Alexander Sarcophagus. From the royal necropolis at Sidon in Lebanon; ca. 320 BC. Marble; height of frieze, 69 cm. Istanbul Archaeological Museum 370. Probably the sarcophagus of King Abdalonymos of Sidon. From Osman Hamdy Bey and Salomon Reinach, *Une nécropole royale à Sidon* (Paris 1892): pl. 25.1.

cutting shows that the bronzes were designed independently of the pedestals, and presumably executed simultaneously with them. Along with the blocks' different lengths, clamp and dowel arrangements, and molding sizes – all indicating four separate teams at work – this suggests that speed was paramount and that the project might have been completed quite rapidly.

All these bronzes were plundered in antiquity or at the end of it. Whoever removed them did so carefully, with minimum damage to the cornice blocks. So perhaps they were among the many masterpieces taken to Constantinople during the early Byzantine period. In any case, the Dedication probably survived the Herulian attack of AD 267 just as it had survived the Sullan one 350 years earlier, for no Herulian destruction deposit has ever been found on the Akropolis. The anonymous geographer's account of AD 347 (AT8) would corroborate this conclusion if we could be sure that it refers to the Attalid Dedication. Whether it outlasted the Visigoths in 396 or was already gone by then is anyone's guess; the Byzantine sources make no mention of it. Many of the cornice blocks are severely weathered on one side, strongly suggesting that they, at least, stayed in place a long time. The pedestals' final demolition was perhaps prompted by the inward settlement of their foundation, most of which rests only upon fill (see Figures 213, 284[1–6]).[16]

Exact parallels for these pedestals are elusive. Fortunately, though, the memorial at Delos to Philetairos, the founder of the Pergamene state (dedicated after he died in 263 BC), the bases at Pergamon for the statues plundered from Oreos in 199, and two other second-century-BC bases also from Pergamon offer partial ones. The two-fascia architrave and its crown, in particular, seem characteristically Pergamene. And at around 81 cm wide, the statue platform compares favorably with the multiple dedication at Pergamon erected by Attalos I in the 220s to celebrate his Gallic and Syrian victories (see Figure 224), which was 1.02 m wide and held life-size combats. These fights, however, featured three or four figures only, separated by recessed strips 2.9 cm wide and 4 mm deep, cut into the fronts and tops of the bases.[17]

Korres's identification of the orthostates and plinths now shows, against a century and a half of scholarship, that at around 1.80 m high the pedestals slightly exceeded the average 1.72-m-tall Greek male in height (for details, see Korres's Essay).[18] This is startling, since it would have made the faces of the dead, their wounds, and the weapons, armor, and other bric-a-brac scattered around them (see Figures 5, 11–12, 18, 19, 21, 23, 29–30, 33–34, 37–38, 57–58, 61, 187–91) all but invisible from close up. Some special circumstance must have been responsible for this decision. If the pedestals indeed stood

TABLE 6. The Attalid Dedication: Elevation

	Attic Feet	= Predicted Ht. (m)	Actual Ht. (m)
Pedestals	6	ca. 1.77	1.82?
Infantry	4	ca. 1.18	1.16 (copies)
Cavalry	5/6	ca. 1.475/1.77	?

clear of the South Wall's parapet (see Figure 218), did its designer want to make the figures overtop it so they could be seen from outside the Akropolis, if only from a distance (Figure 226)? For the spectator standing inside the citadel, the sloping ground between the South Wall and the Parthenon would have mitigated this visibility problem by serving as a convenient grandstand.

Each pedestal was therefore around six Attic feet high (29.5 cm × 6 = 1.77 m). As to the bronzes, the three completely supine Barbarians (Figures 1, 29, 33, 57) show that the fighters on foot stood around 1.16 m or four Attic feet (1.18 m) high. This 2-cm discrepancy falls well within the ancient copyists' normal margin of error, especially since – as established in Chapter 3 – they would have been working from casts. For as casting molds dry out they shrink slightly. So Pausanias' "around two cubits" (AT6) is only a fraction short of correct. Raised in Asia Minor, he naturally used the Samian/Ionic system, in which two cubits of ca. 52.5 cm or three feet of ca. 35 cm equal 1.05 m. As to the riders, the *comparanda* (Figures 223, 225) show that these would have measured about five to six feet in height, according to whether their horses were rearing up and/or they were brandishing weapons above their heads.[19]

So we arrive at the results shown in Table 6. As in Attalos' multiple-battle dedication at Pergamon itself (Figure 224), this system would make the king, riding gloriously to victory on the Kaïkos (Galatomachy [IV]), the yardstick for the entire ensemble.[20]

Although the Dedication's total length is unknown, it can be determined with some degree of confidence. As will appear, each pedestal certainly exceeded the ca. 13.5-m minimum length that one can calculate for Pedestal 1 (Γ2, 4, 7, 10, 12: i.e., 1 extant end block of 1.375 m + 4 nonjoining extant interior blocks of ca. 1.34 m + 4 more interior blocks to fill the gaps between them + 1 more end block). Since each pedestal therefore used at least eight interior blocks of a standard length, but this standard varied from one pedestal to the next, the obvious recourse would be to multiply the interior block lengths by 8, 9, 10, and so on for each series and add two end-block lengths until the totals equalize for two or more pedestals.[21] Unfortunately, although three end

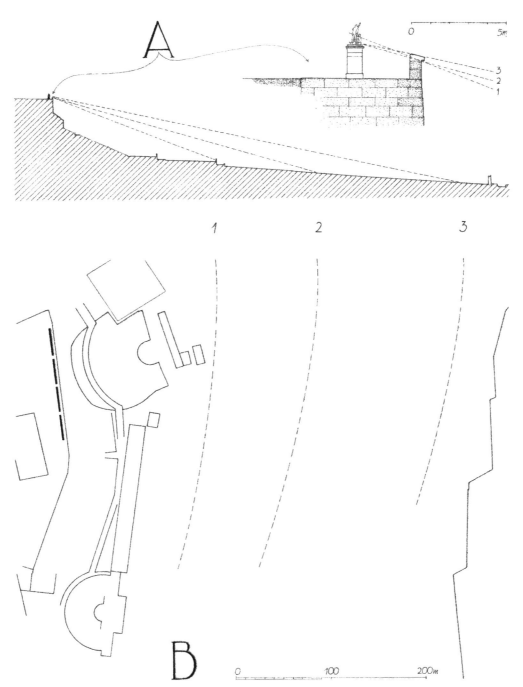

FIGURE 226. The Attalid Dedication on the Athenian Akropolis. Reconstruction of the Dedication's visibility from outside the Akropolis. The parapet is restored with two courses or two courses and a capping element. Reconstructions by Manolis Korres.

blocks survive, Γ1 is the sole representative of its series, and Γ5's original length is unknown, foreclosing this particular solution.

This leaves the sockets, which might indicate the number of figures per meter, and the iconography, which might potentially suggest a minimum number of participants in each battle.

The *sockets* total thirty-five in number and occupy about 11.5 m of extant statue platform. The ten Little Barbarians fit none of them exactly, though versions of them are detectable on Γ1, 4, 5, 8, and 11 (see Table 11 in Korres's Essay). Although half of the extant blocks (Pedestals 1 and 4) may have carried the two groups from which only a single dead figure survives in copy (the

193

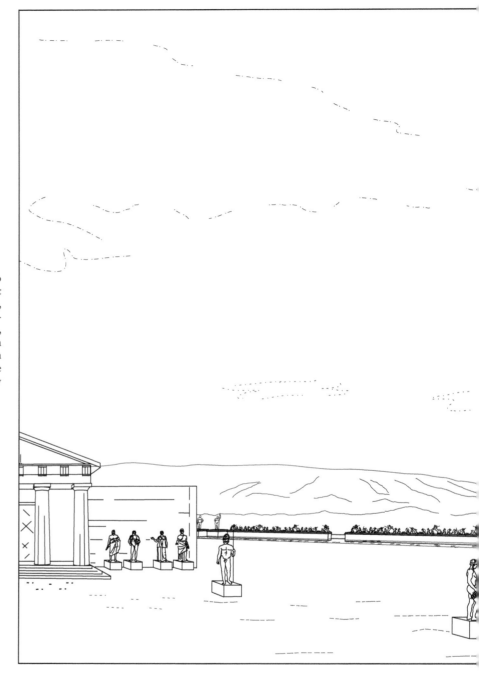

FIGURE 227. *(here and facing)* From left to right: the "Sanctuary of Pandion" and adjacent statues (Xanthippos, Anakreon, Io, Kallisto, and, in the foreground, Perikles and the Apollo Parnopios of Pheidias). In the background, the Attalid colossi and Attalid Dedication on the Athenian Akropolis, with the Parthenon and pillar monument (a gift to Attalos from the Athenian demos?) to the right. Panorama by Erin Dintino.

Gigantomachy [I] and Amazonomachy [II]), this disjunction suggests that we are dealing with a far bigger monument than the surviving blocks betray.

If each lunging figure used two sockets, each horse three, each kneeling/falling figure three or four, and each dead one five or more (see Figure 280), then one might conservatively posit about three sockets per figure on average. For all the victors and at least some of the vanquished would still have been on their feet, requiring two sockets only. So our thirty-five sockets could theoretically have secured around a dozen figures (riders included) – somewhat over one per meter. As a crosscheck, the compositions conjectured in the Catalog to Korres's Essay produce eight whole figures, seven half figures, and five half horses, that is, about fourteen figures in all. To this minimum density – one figure every 80 cm or so – the Nike temple frieze (Figure 223) offers a close parallel.

As to *iconography*, the Gigantomachy (I) properly demands all twelve Olympians plus Herakles (Figure 221), as on the Parthenon metopes diagonally opposite (see

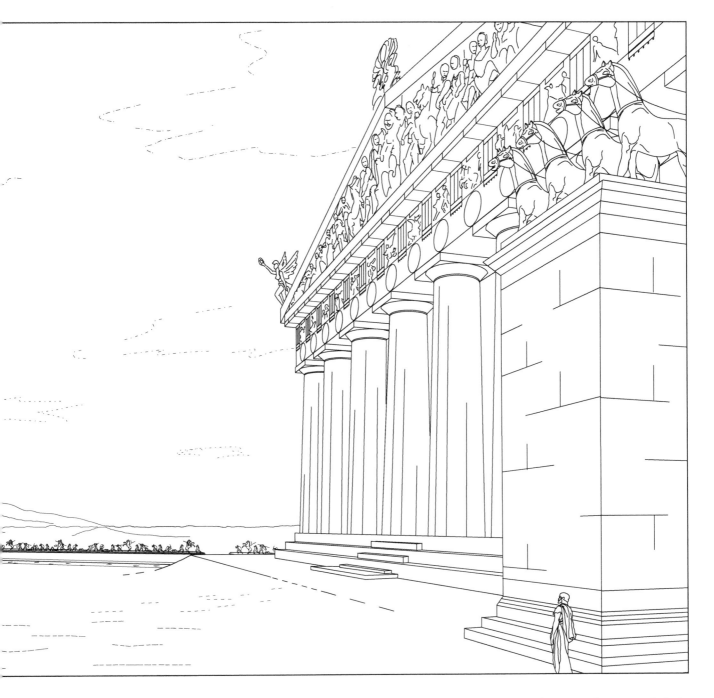

Figures 67, 227). The likely presence of the Dioskouroi (see above), two relatively minor participants in the struggle, would argue for this ensemble a fortiori.[22] These fifteen victors would each require an opponent – Zeus probably two (cf. Figure 68, where he has three) – and there was at least one dead Giant (the Naples Giant: see Figures 1, 29–32, etc.), bringing the minimum number of combatants to thirty-two.

The Amazonomachy (II), Persianomachy (III), and Galatomachy (IV) are completely flexible iconographically (see, e.g., Figures 222–24) but must have equaled the Gigantomachy (I) numerically. The Galatomachy also contained at least one dying figure (the Naples Dying Gaul; see Figures 1, 41–44, etc.). who would have had no direct opponent either. So we arrive at a minimum of thirty-three figures per group; a minimum length of about 90 Attic feet (0.8 m × 33 = 26.4 m ≅ 90 feet) for each group; and an impressive minimum count of 132 figures and minimum length of 360 feet (106 m) for all four groups put together. Indeed, given the obligatory gaps

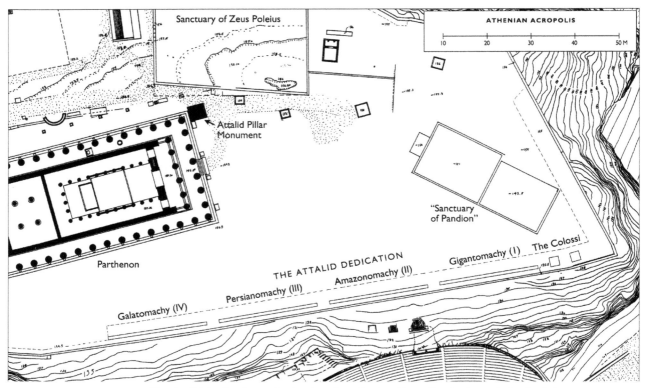

FIGURE 228. The Attalid Dedication and colossi on the Athenian Akropolis. Conjectural plan by Erin Dintino superimposed on a plan of the Akropolis by Manolis Korres.

between the pedestals, which hardly can have been much less than the monument's total height of around 12 feet (~3.54 m), its total theoretical minimum length now climbs to a whopping 396 feet (almost 117 m). Is this viable in practice?

It is. The wide ledge created by the inner extension of the South Wall (Figures 212–13, 284) is 485 Attic feet ≅ 143 m long, and so could have accommodated such a monument easily, leaving ample space for the two Attalid colossi – still (just) above the theater (AT5, 7) – at the far eastern end. As a result, it is tempting to gild the lily: to stretch each pedestal a little and to add a couple of figures. For pedestals 96 feet (28.32 m) long would produce a satisfying 8:1 length:height ratio for each group (Figure 228). Such a length is perfectly compatible with the permissible dimensions of the only pedestal whose end and interior cornice blocks are preserved intact (Pedestal 1; see Korres's Essay). For its two end blocks each bearing a statue platform 1.375 m long plus nineteen interior blocks each around 1.34 m long together would total 28.21 m. Since the interior blocks in fact vary by up to 2 cm in length, this total in essence matches the pedestal's predicted length of 28.32 m.

The resulting 420-foot-long (124 m) monument would still leave an ample 19 m for the colossi. It would equal almost exactly four times the span of the Parthenon's façade (105 feet ≅ 30.88 m) measured on the stylobate, and would bring the Attalid Gigantomachy (I) within striking distance of its 104-foot long (30.56 m) Periklean counterpart on the Parthenon's east metopes (see Figure 227).

Individual pedestals of this Parthenonian size or even 100 feet long, on the other hand, would be too large. For even though Pedestal 1's permissible dimensions match these two lengths exactly (2 end + 20 interior blocks = 29.55 m ≅ 100 feet; 2 + 21 = 30.89 m ≅ 105 feet), the resulting 436-foot-long (129 m) or 456-foot-long (133 m) monument would push the colossi decisively beyond the eastern limit of the theater, into which they fell in 31 (AT7). Moreover, the so-called Precinct of Pandion would have hidden them from view as one rounded the northeast corner of the Parthenon (Figures 227–28).

Despite its modern nickname, then, the Attalid Dedication apparently was huge: the longest Hellenistic freestanding sculptural monument yet known, lining almost the entire available space between the Parthenon and the eastern corner of the citadel, and even extending in the other direction almost 100 feet down the temple's southern flank. But its size was not completely unprecedented. For example, around 360 BC the Mausoleum at Halikarnassos had included around three hundred marble stat-

FIGURE 229. The Sanctuary of Athena Polias Nikephoros at Pergamon in the late third century BC. Plan by Erin Dintino.

ues from life-size to colossal; half of these were fighters and hunters arrayed on its two lower steps, which totaled 440 Attic feet (120 × 100 feet) and 360 feet in length (100 × 80 feet), respectively. And if one believes Diodoros, in 324 Hephaistion's multistepped funeral pyre at Babylon was a massive 600 feet square and displayed freestanding hunts and a golden Centauromachy on two of its steps.[23]

To return to the Akropolis, a spectator walking (like Pausanias) around the Parthenon's northeast corner would have found himself entering a vast triangular plaza, framed to the left by the Precinct of Pandion and the Attalid colossi, and to the right by the Parthenon and pillar monument with its (presumably) Attalid chariot group. Between them, filling the entire horizon and silhouetted against Mount Hymettos, stretched the Attalid battle groups: the Gigantomachy (I), Amazonomachy (II), Persianomachy (III), and perhaps a few feet of the Galatomachy (IV) (Figures 227–28). As he walked southward across this plaza, past the Parthenon's façade, the rest of the Galatomachy would gradually have emerged beyond its southeast corner as a climactic finale to the entire program.

On closer inspection, he would have noticed that two of the portrait statues standing between him and the colossi honored Perikles and his father, Xanthippos, succinctly characterizing the relationship between Periklean Athens and the Attalids.[24] Furthermore, the colossi and the pillar monument echoed the Parthenon's vertical columns and crowning sculpture, and the battle groups would have recalled the horizontal sequence of the temple's east metopes and their fourteen-panel Giganto-

machy. The pedestals and bronzes together would have declared themselves as an extended Pergamene/Ionic response to the Parthenon's stepped platform, Doric columns, and Doric frieze with its Gigantomachy and other battles for civilization – of which more in the next section. The composition's relative openness would have countered any sense of claustrophobia, and one could of course always walk between and around the pedestals, and look out over the parapet behind.

It may be no coincidence that this dramatic, even theatrical ensemble adapts and vastly amplifies a somewhat earlier display in the Sanctuary of Athena Nikephoros at Pergamon. Here, shortly after 223 BC, Attalos I had dedicated a great Gallic and Seleukid battle monument near the Athena temple on a long base six meters inside the old south wall, overlooking the city and the Pergamene plain (Figures 224, 229). The monument, which featured up to eight separate fights, was made by the local sculptor [Epi]gonos. Although it included no battles of myth, legend, or ancient history, and at 19.16 m long was far shorter than the Akropolis Dedication, it related to wall and temple in similar fashion, and was fronted by a round base that perhaps bore a colossus of Athena Promachos. This ensemble grew by accretion. The Athena temple was built first, possibly in the 270s; next came the round base, after Attalos' great victory over the Gauls on the River Kaïkos around 237; and finally the multiple dedication, shortly after 223.[25] Did its Athenian counterpart (Figure 227) grow step by step also, or – the Parthenon apart – was it planned as a unit?

The pillar monument (Figures 227–28) – a victory dedication par excellence – was probably an Athenian re-

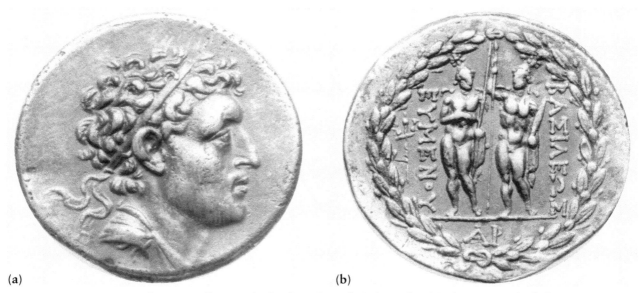

FIGURE 230. Pergamene silver tetradrachm formerly on the Swiss market. (a) Obverse: portrait of King Eumenes II of Pergamon. (b) Reverse: the Dioskouroi (Eumenes II and his brother Attalos – later Attalos II – of Pergamon?). Ca. 172 BC. Diameter 3.2 cm. Paris, Bibliothèque Nationale, Cabinet des Médailles 1983-248. Photo: courtesy Silvia Hurter; Auction Bank Leu 33, May 3, 1983, lot 364.

sponse to Attalos generosity and (to anticipate) the events of the Second Macedonian War (202–197). For it occupies a prime spot on the citadel, and the other three Pergamene monuments of this kind in the city (those fronting the Propylaia, Stoa of Eumenes, and Stoa of Attalos; later rededicated to Agrippa, Claudius, and Tiberius, respectively) all relate in one way or another to the later Attalids.[26]

The colossi of Eumenes and Attalos (so AT5, in that order) are more problematic since so little about them is known; although Eumenes must be Eumenes II (r., 197–158) it is by no means clear which Attalos (I, II, or even III) is meant. All one can say for sure is that Attalos I did not erect them. Hellenistic kings never seem to have put up portraits – still less colossi – of themselves in foreign sanctuaries, but only of their relatives and friends. So either Eumenes and his successors erected them, or the Athenians did so (see AT7, though Dio may have garbled the tradition).[27] Only new discoveries can help.

2. ICONOGRAPHY

It may seem far-fetched to scrutinize the iconography of a dedication one part of which (the colossi) is wholly lost and the remainder represented only by a motley collection of sockets and copies of ten of the vanquished. Yet something can still be said, and the process may help us to gauge the copies' general veracity as replicas – often doubted in the recent literature.

THE COLOSSI OF ATTALOS AND EUMENES

Nothing of these survives, and (as mentioned in section 1) just which Eumenes and Attalos they represented is uncertain. Yet fortunately Plutarch (AT5) does call them *kolossoi*, and Dio (AT7) adds that at least in their latter-day incarnation as Mark Antony (and, supposedly, Kleopatra!) they "had the *schema* (format) of the gods." Since Plutarch explicitly tells us that Antony merely reinscribed them with his own name, and Dio's account looks like a somewhat garbled version of this tradition, this godlike appearance – conveyed, no doubt, by divine attributes – was probably original to the composition.[28]

We may hazard something about the appearance of these theomorphic colossi from surviving Attalid portraits. The reverse of a rare wreathed tetradrachm of Eumenes II (Figure 230) from a hoard buried in 161/160 is particularly promising. He struck it probably either in 172/171 to celebrate his narrow escape from assassination at Delphi and his restored relations with his brother, the future Attalos II, or in the wake of his suppression of the great Gallic revolt of 166. For in 172 Attalos, believing that the king had succumbed to his wounds, had assumed the diadem and married Eumenes' queen, Stratonike. When the truth reached Pergamon he did a swift about-face, but Stratonike soon turned out to be pregnant with the future Attalos III! This embarrassing incident was soon buried under a very public display of homage and fraternal solidarity.[29]

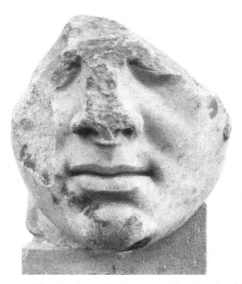
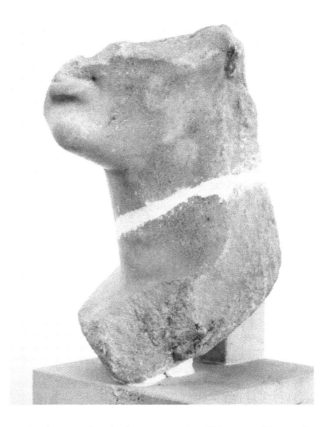

FIGURE 231. Head perhaps of a Pergamene king (Attalos I?). From the Akropolis; ca. 200 BC. Asian marble; height 17 cm. Athens, Akropolis Museum 2335. Photo: DAI Athens. From an acrolithic statue.

FIGURE 232. *(right)* Head perhaps of a Pergamene queen (Apollonis?). From the Akropolis; ca. 200 BC. Asian marble; height 26 cm. Athens, Akropolis Museum 3268. Photo: DAI Athens 68/291. From an acrolithic statue.

The tetradrachm's obverse carries a sharply characterized portrait of Eumenes, diademed and cloaked. The reverse bears his name and the heavily muscled images of two men who at first look like the Dioskouroi, for they carry spears and wear the twins' characteristic startopped, conical caps or *piloi*. Yet they are also diademed and cloaked, and the left-hand one both carries his spear in *doryphoros* or bodyguard fashion and points deferentially to his brother, who holds his spear assertively in his upraised right hand and cradles a sword in his left. So these, it is argued, are Attalos II and Eumenes II, respectively, presented in divine guise – a genre inaugurated by Apelles around 330 in his portrait of Alexander Thunderbolt-Bearer or *Keraunophoros* at Ephesos.[30] They hint at what the two colossi might have looked like – minus, presumably, the particular narrative element supposedly introduced by Attalos II's demonstration of subservience.

Yet the Dioskouroi would have been appropriate only if the colossi represented Eumenes II and his brother Attalos (II). What if they showed Eumenes II and his father, Attalos I? A Delphic oracle "predicting" the Gallic onslaught against Asia Minor and Attalos' victory on the Kaïkos hints at a solution, since it calls Attalos I "son of the bull" and "bull-horned." These taurine epithets could refer either to Poseidon or Dionysos, but since the Gauls were landlubbers and the Kaïkos battle took place on land, the conquering Dionysos Tauros is the obvious favorite. Not only was Dionysos the Attalid regime's divine patron, but precedents for invoking him in this way include Alexander (posthumously), Demetrios Poliorketes (d., 283), and Seleukos I Nikator (d., 281). Hence, perhaps, why these particular statues were chosen for reinscription, since Dionysos was Mark Antony's favorite Olympian also (AT5). Alternatively, if Attalos alone appeared in Dionysiac guise, Eumenes could have worn the lionskin of Dionysos' friend Herakles, the prototype par excellence of the triumphant ruler-savior, another Attalid idol, and Antony's supposed ancestor (AT5).[31]

Could our battle groups and colossi be the very "*anathemata* and *agalmata* dedicated by Attalos the king for the security of the [city]" mentioned in AT2, the decree of ca. 20 BC for the restoration of the Attic sanctuaries? For in Hellenistic Athens, *agalmata* are exclusively images of gods or of men in the guise of gods.[32] Yet, as mentioned earlier, Attalos I cannot have dedicated the colossi himself, and two other sets of candidates also obtrude themselves. These are the four aforementioned Attalid chariot groups that stood around the city on high pillar bases (see Figures 227–28) and two fragmentary heads in Asiatic marble (Figures 231–32) identified as Attalos II and his wife Stratonike by Georgios Dontas and as Attalos I and his wife Apollonis by Bernard Andreae.[33]

TABLE 7. The Attalid Dedication and Periklean Athens

	(1)	(2)	(3)	(4)
Stoa Poikile	Oenoe	Amazonomachy (ca. 450)	Troy Taken	Marathon
Parthenon (447–432)	Gigantomachy (E)	Amazonomachy (W)	Sack of Troy (N)	Centauromachy (S)
Attalid Dedication	Gigantomachy (I)	Amazonomachy (II)	Marathon (III)	Galatomachy (IV)

The chariot monuments can be dismissed at once, since as argued near the end of section 1, the Athenian demos probably erected them; it was certainly responsible for rededicating three of them later on, to Agrippa, Claudius, and Tiberius. Furthermore, these monuments would not have shown the Attalids in the guise of gods and could not have been described as dedicated "for the security of the [city]." The two marbles are a different matter. Unweathered and obviously broken from acroliths, they would certainly qualify as *agalmata;* perhaps like others of their kind they stood in the Parthenon or Erechtheion.

Yet the decree explicitly states that the Attalid *agalmata* it cites should be restored "so that the sacred things of the temples and precincts administered for the everlasting glory of the people should stay *immovable*" (AT2, italics supplied). Now the Dionysos from the Gigantomachy (I) had moved decisively and catastrophically along with the colossi only a decade or so before the decree was passed and inscribed, when they had all tumbled into the theater during the great storm of 31 (AT5, 7). So this statue emerges as the best candidate, and we shall revisit this text later (in section 5).

As to the height of the two colossi, Polybios tells us that in 197 BC the Sikyonians dedicated a *kolossos* of Attalos I ten cubits high (Attic standard, 4.42 m) in their agora, and an inscription records a five-cubit-high (Ionic standard, 2.64 m) *agalma* of Attalos III (138–133) in the temple of Asklepios at Pergamon.[34] Our colossi could have equaled the Sikyonian one in height, but until the Akropolis yields a likely base with a footprint on it, nothing can be proved.

THE BATTLE GROUPS

These selected one enemy of civilization and order (*dike*) from each of the four ages of the world. From protohistory they singled out the Giants (I); from ancient history, the Amazons (II); from more recent history, the Persians (III); and from the present, the Gauls (IV). The Dedication's location (see Figures 227–28) and the left–right sequence of the four battles beckoned the visitor (such as Pausanias, AT6) to traverse a historical timeline. Since the Kaïkos battle (IV) was placed at its far end, it naturally emerged as the climax of all history.

Geographically, too, the Dedication's coverage was universal, for these enemies came from north, south, east, and west. And it simultaneously gestured toward another hierarchy that cut across both history and geography, presenting the entire chain of being from subhumans, barbarians, and deviants through ideal representatives of Greek culture to the gods themselves. It therefore both anticipated the interests of Hellenistic universal history (as pioneered by Polybios in the mid-second century) and registered the high–low/in–out opposition in all four of the symbolic domains known to the Greeks and to us: psychology, the body, geography, and society.[35]

Finally, as Brunn first noted, it reached across the space of the city and back through the centuries to reference the Periklean-period frescoes of the Stoa Poikile and the Parthenon metopes (Table 7; see Figure 227).[36]

In the Parthenon's case, the Attalid Dedication's Ionic order, telling location, and small-scale figures strengthened the allusion, effectively appropriating the Periklean temple (Figures 67, 227–28) to the Attalid cause. Like the Parthenon's various Ionicisms, the Dedication's Ionic pedestals stressed Athens's links with eastern Greece, but this time emphatically promoted the case of the latter. Its Gigantomachy (I) stood diagonally across from the Parthenon's and its Amazonomachy (II) came next, pointing the spectator toward that temple's western façade. Directly above the Galatomachy (IV) stood the Parthenon's Centauromachy, completing and complementing the series in a kind of *Ringkomposition,* and above this, its huge Nikai akroteria (if a recent conjecture is correct) would have seemed to lunge out toward them (cf. Figures 90; 227).[37] The Dedication thus created a Pergamene–Periklean alliance across time and space to defeat the entire gamut of civilization's foes.

To focus on the Persianomachy (III) and Galatomachy (IV), the Greeks had linked these already in the 270s, during their first clashes with the invading Gauls. The decisive battle of 279 occurred at Thermopylai, the very site

of the heroic Spartan stand against Xerxes in 480, and the Gauls' subsequent repulse from Delphi was swiftly portrayed as a divinely orchestrated reprise both of the Persians' earlier discomfiture there and of the destruction of the Giants' equally hybristic predecessors, the Titans. In Egypt, where the Ptolemies hired Gallic mercenaries early in the century, a torn papyrus preserves part of an elegy apparently celebrating Ptolemy II's crushing of a mutinous army of them in 275. These mainland and Ptolemaic texts unanimously term the Gauls "mindless," and the papyrus explicitly compares their "mindless" courage and rough clothing with the "soft-skinned, purple-clad" Persians. No doubt the now-lost epics celebrating Antiochos I of Syria's Elephant Battle with the Gauls around 270 and Attalos' great victory over them by the Kaïkos around 237 did much the same.[38] On the Akropolis Dedication, as we have seen, the latter rounded off the entire sequence (see Figures 227–28), marking it as the climax of all history.

But what of the details?

THE GIGANTOMACHY (I)

A single supine figure (see Figures 1, 14, 19, 29–32, 175, 191, 255) is little enough to go on – unless the Naples Dying Gaul is in reality also a Giant (see the subsection on the Galatomachy below). But at least neither one is anguiped. This hybrid type appears in vase painting around 400 BC but apparently not in monumental sculpture until the Great Altar (see Figures 68–69), when it becomes all but de rigueur.[39] Yet the Naples Giant's wild coiffure, unkempt beard, grotesque features, chest hair, and feline cloak certainly mark him as a true savage. Yet he does brandish a sword: Greek anthropology was not consistent. The ribbon by his right side (see Figures 19, 29, 255) is too short and too elaborately knotted to be a baldric and lacks a scabbard; if a diadem, it would identify him as the king of the Giants, Porphyrion, whose normal garment was a leopard skin (Figure 221). His rocky plinth, presumably representing the mountains of Pallene (AT6), is a Roman addition.[40]

According to tradition Porphyrion became infatuated with Hera, tried to rape her during the battle, and was killed by Zeus' thunderbolt and an arrow shot by Herakles; Hera then finished him off with her spear. But if the Naples Giant really is he, it breaks with Athenian precedent. Although we have no firm idea what the Gigantomachy of the quadrennial Panathenaic peplos – possibly

FIGURE 233. Collapsing Giant (Roman copy). From Marino, Villa of Voconius Pollio; original, 2nd or 1st century BC. Marble; height 72 cm. Karlsruhe, Badisches Landesmuseum. Photo: Karlsruhe R 42027.

the most influential source of all – looked like, on the Parthenon metopes Porphyrion was still fighting, and perhaps also on the shield of Athena Parthenos (echoed in Figure 221?).[41] On the Great Altar a newly discovered inscription identifies Porphyrion as the rightmost of Zeus' three opponents, kneeling in back view and wearing a feline skin but no diadem (see Figure 68).[42] We shall explore the implications of all this later.

Among the various attributions to this group, the most interesting are a torso of a kneeling Giant in Copenhagen,[43] a collapsing Giant in Karlsruhe (Figure 233),[44] and a torso of a fighting Giant in Providence.[45] All three are roughly similar in scale to the Naples Giant, though the Copenhagen statue is a little larger. All are more classicizing, close to the Giants of the Great Altar (see Figures 68–69, 236).

201

As to their identities, the Karlsruhe figure (Figure 233) has the typically barbaric physiognomy of a Giant, rendered in a very sketchy, forceful manner; the Copenhagen torso has armpit hair; and the Providence torso a rosette of chest hair and a piece of what may be a snaky leg on his left buttock. The poses of all of them have precedents on the east metopes of the Parthenon and (perhaps) the Athena Parthenos' shield. But since their attribution to the Attalid Dedication is pure speculation, they add nothing concrete to our knowledge of it.

Finally, a bronze statuette in Geneva in the pose of the Paris Gaul and often wrongly identified as another Gaul hefts a rock in his right hand and has what may be a skin wrapped around his left (Figure 234; cf. Figure 61). The rock-throwing Giant was a staple of the Gigantomachy (see Figure 221), and the numerous cross-references among our Little Barbarians make him an attractive candidate for a miniature echo of one of the Attalid Dedication's lost Giants.[46]

As to the gods, the only one explicitly attested is Dionysos (AT5), but as noted in the previous section the winning side must have included at minimum also Zeus, Athena, and Herakles; indeed, the space available may have allowed the inclusion of all twelve Olympians, as on the Parthenon's east metopes. Since the narrow display surface precluded chariots, Zeus, Athena, and Herakles must have fought on foot, either at the center of the composition as on the Great Altar (see Figures 68–69), or evenly distributed throughout it as on the Parthenon. In addition, the almost certain involvement of riders in all four battles would entail the presence of Poseidon and the Dioskouroi; Dionysos could have ridden his panther.[47] Schematically and quite hypothetically, the composition might be restored as follows:

— (left)

Giant

Mounted God (Dioskouros) ↑

4 Olympians on foot, 4 Giants

Mounted Olympian (Dionysos) ↓

Giant

3 Olympians on foot (Herakles, ZEUS, Athena), 5 Giants

Giant

Mounted Olympian (Poseidon) ↑

4 Olympians on foot, 4 Giants

Mounted God (Dioskouros) ↓

Giant

— (right)

THE AMAZONOMACHY (II)

Again only one figure survives: the enigmatic Naples Amazon (see Figures 1, 9, 13, 18, 33–36, 190). She must be an Amazon and not a Gaul, despite occasional assertions to the contrary, for as Michaelis and Reinach noticed over a century ago her short dress – an undergirt *chitoniskos* – is not Gallic (contrast Figures 27, 81) but typically Amazonian. She also lies on two crisscrossed, broken spears – typically Amazonian weapons and her characteristic attributes just as the animal skin is the Giant's (cf. Figures 19, 29, 255). Her serene, beautiful face and the topknot in her hair have both attracted some attention over the years. Commentators have suggested assimilation to Aphrodite, but Artemis – also celebrated for her lovely face and hair and worshiped on the Akropolis in the form of Artemis Brauronia and Artemis Leukophryene – is equally likely.[48]

As mentioned several times during the preceding chapters, the Renaissance documents show that for much of the sixteenth century she had a baby at her breast (RT2 and 6; see Figure 72). Controversy has raged over this infant ever since Klügmann published the relevant texts in 1876 and then proceeded to dismiss it as a Renaissance addition.[49] He was surely wrong to do so, for the following reasons:

(a) The baby is concretely attested only a few months after the statue's discovery, in winter 1514–15 (RT2). Yet the ensemble's immediate identification as the Horatii and Curiatii (RT1) and thus of the girl as the Roman triplets' tragically bereaved sister (RT2), would have precluded any such tampering. For the Renaissance connoisseurs had read their Livy (RT2) and knew full well that "Horatia" was a virgin.[50] Alfonsina Orsini, an educated aristocrat and the statue's first owner, would have been no exception. Indeed, the temptation would have been to *remove* the child to make the statue conform to Livy's text. So as the *lectio difficilior,* the baby should be authentic.

(b) Heemskerck's drawing of the 1530s (see Figure 71) and the Palazzo Madama inventories (RT6, 8, and 10) clearly show that Alfonsina left the collection untouched by the restorer's hand, as did her immediate successors. They even failed to fix up statues like the headless Naples Dying Gaul (RT6 and 10) and the unstable Paris Gaul, who had to be propped up ignominiously against a table (see Figure 71). So why should Alfonsina have bothered with adding the baby?

(c) From at least the 1530s the baby had broken limbs and no head (see Figure 72; RT6). No Renaissance restorer ever added a figure in this deliberately incomplete fashion, as a fragment. And damage in the interim is unlikely since the surrounding areas of the statue are intact.

FIGURE 234. Fighting Giant. Roman. Bronze; height 7 cm. Geneva, Musée de l'Art et de l'Histoire. After Bienkowski 1928.

(d) The blood from the Amazon's wound, defying gravity, is spattered *above* her breast, toward her shoulder (see Figures 9, 13, 190) – the only part of it not covered by the baby's head. The breast itself has been recut as far as the hem of the *chitoniskos* (see Figures 13, 18). This hem, in turn, has been restored where the baby's arm would have crossed it, and clear signs of damage and repair continue on the folds under and past the left breast where its forearm and hand would have rested (see Figure 72).[51]

(e) Finally, as Michaelis noted in 1893, a group of this kind has good ancient support. Pliny tells us that the fourth-century painter Aristeides painted a "captured town with an infant creeping to the breast of its mother who is dying of a wound. One understands that the mother is aware of the child and fears that as her milk is exhausted by death it may suck blood. Alexander the Great removed this painting to his palace at Pella."[52] Even more suggestively, he remarks that the Pergamene bronzeworker Epigonos was famed for his Infant Pitiably Caressing Its Slain Mother (AT3b). We shall return to this text later.

So who are the two of them? All special pleading to the contrary, the woman cannot be a "normal" Amazon.[53] For the ancient tradition was clear: Amazons stopped fighting once they married and had children.

The obvious answer, proposed by Paolo Moreno in 1993 but either overlooked or spurned in the recent literature, is that they are Antiope and her son, Hippolytos.

Their story was popular already in the fifth century BC. Theseus abducted Antiope while raiding the Amazon kingdom of Themiskyra and brought her home to Athens; they fell in love and married. When her sisters invaded Attica in revenge and assaulted Athens, she fought loyally at his side at the great battle outside the walls but fell to the avenging Molpadia. A monument to her stood just inside the Itonian Gate of the city, and anyone looking over the shoulder of the original statue on the Akropolis could have spotted it easily. It stood just 500 m away to the southeast, to the right of the Olympieion (Figure 235). The statue's rocky plinth – a Roman addition – could thus represent the rocky outcrops just outside the gate or the Olympieion ridge.[54]

As to Hippolytos, he became an obsessive devotee of Artemis at Troizen (across the Saronic Gulf in the northern Peloponnese) and the tragic target of Phaidra's passion there. As Figure 235 also testifies, on a clear day a spectator standing at the Akropolis' South Wall could just see the site of his grave too, to the right of Antiope's and 60 km beyond it, below Athena's Troizenian citadel. But at both Troizen and Athens he was linked in cult also with his and Artemis' great adversary, Aphrodite. Her temple stood in the Troezenian Hippolyteion, and in Athens he was worshiped "at Hippolytos," his cenotaph on the Akropolis' South Slope. This cenotaph stood west of the Asklepieion and the temple of Themis, below and 100 m or so west of the Attalid Amazonomachy (II), looking out toward Troizen. So the Naples Amazon's knotted hair perhaps evoked *both* goddesses. Suggestively, brides-to-be customarily dedicated a lock of their hair to Hippolytos at his Troezenian shrine.[55]

Unfortunately, Attic artists had little time for Antiope beyond the juicy tale of her abduction. One vase only, a red-figured Polygnotan amphora in Jerusalem, definitely shows her in battle (on foot) against her sisters, though she has been suspected in several others; a metope of the Athenian Treasury at Delphi may show Molpadia killing her.[56] More intriguing and relevant in the present context, though, is the likelihood that the dead Amazon sprawled at bottom right of the shield of Athena Parthenos, whom she echoes, is Antiope herself (Figure 222). For it has recently emerged that the cuirassed figure looming above her is an Amazon too – Molpadia again. So the man wearing a *pilos* who attacks this armored Amazon must be Theseus.[57]

Like the Naples Amazon, the Antiope of the Parthenos shield lay on a rocky outcrop and had one breast bared, but she grasped a bow in her left hand; our Amazon's two spears could thus be intended to show that she now uses civilized weapons like the spear-carrying Athenians. So we have stumbled again upon the phenomenon of

intertextuality or visual interplay described in Chapter 2: what happens when one incorporates a conveniently prepackaged element from an earlier monument (here, the shield) into a later one (the Attalid Dedication). The Hellenistic artist not only glosses his source, enlisting it as an authority for his statements, but also bids us reread it through his own work. Making us read backward "up time," his work not only acknowledges as precedents the Pheidian colossus (whose shield is Figure 222) and the exemplary moment in history that it symbolizes but appropriates and partially *consumes* them. It turns them into a footnote to its own message. When like Pausanias one turned from the Parthenon to the Attalid Dedication (see Figures 67, 218, 227–28), one naturally reread the former through the prism of the latter's understanding.

To return to the Amazon battle's iconography, a number of mounted Amazons are likely, as has appeared (see section 1). Some may have resembled the numerous statues of this kind attributed to the Attalid Dedication over the years (see Figures 82, 85). But since these marbles are Roman, decorative, and quite different stylistically from the Naples Amazon (see Figures 33–36), they cannot be connected with it definitely or even plausibly.[58] Of those on foot, the kneeling Amazon in Wilton House (see Figure 92) is too big and stylistically wrong, and the rest are heavily restored. Ironically, then, not a single *attacking* Amazon can now be identified among the extant copies.[59]

The victors certainly would have included Theseus; the fifth-century Amazonomachies depicting the battle outside the gates also name his friend Peirithoos, together with Phorbas, Phaleros, and Rhoikos. All would have fought on foot.[60]

THE PERSIANOMACHY (III)

Three Persians are extant: the dead one in Naples (see Figures 1, 21, 37–40, 176) and the two cowering ones in the Vatican and Aix (see, respectively, Figures 3, 6, 8, 45–48, 177; 4, 22, 77–80, 106). The cringing pose of the Vatican and Aix figures is echoed on one of the extant cornice blocks (see Korres's Essay, Γ1; Figure 268c), strengthening their claim to be authentic copies of the Akropolis bronzes. Both the Naples and Aix Persians wear a Phrygian cap knotted at the nape of the neck like a kerchief; a folded tunic (*exomis*) bound by a tasseled belt and sleeved over the left arm only, leaving the right shoulder and arm bare; trousers (*anaxyrides*); and soft booties (*akatia*) knotted at the instep over a tongue. The Vatican figure wears a Persian headdress (*bashlik; tiara* in Greek) bound under his chin but is otherwise naked – a truly startling development. One detects a growing trend toward hyperbole: first the Giant's "diadem" (Figure 255), then the Amazon's baby (see Figure 72), and now a Persian male stripper!

As to equipment, the cutting for a metal sword in the Aix Persian's plinth and the sword hilt in the Vatican Persian's right hand are both modern. But the Naples Persian holds a scimitar or *kopis* with a pommel, handgrip, and lunate guard, and an oval shield that in combat was held horizontally before the body (see Figure 21). Although both are authentically Persian, the only preserved example of the scimitar has a hooked grip, not a pommel, and the shield should have two scallops cut out of its sides; perhaps an unscalloped version was in use by the fourth or third centuries BC.[61] The seventeenth-century Dal Pozzo drawing shows the shield's rim decorated with a battlement pattern and wave motif (see Figure 75), but these are now all but effaced (see Figures 21, 38). The Vatican statue's plinth is restored; the cornice blocks of the Akropolis pedestals (Figures 214–16, 268–78) show that the plinths of the other two, undulating gently perhaps to evoke the Marathonian plain, are Roman elaborations.

These three Persians are most improperly attired. Not one of them wears a Persian jacket, and only one wears the distinctive Persian *bashlik* – but nothing else! It is now fashionable to use these anachronisms to argue that they cannot be proper copies and consequently must be Roman in conception as well as execution.[62]

This skepticism is misplaced. For the Vatican Persian's nakedness is just as de trop in the Roman period as it is in the Hellenistic and so cannot tilt the balance one way or the other. Moreover, examination of the numerous Persians in fifth-century Attic art and the probable copy of the Marathon painting on the Roman sarcophagus in Brescia has shown that their riot of oriental and Scythian clothing is just as sartorially capricious as the dress of the Aix and Naples statues. So either these classical artists also knew little and cared less about proper Persian dress, or they were trying to stress the Persian army's awesome heterogeneity and "otherness," or both. Perhaps, in other words, they had an agenda to pursue.

In the next century the Alexander Mosaic and Alexander Sarcophagus (Figure 225) are more meticulous but still not entirely above reproach. But whereas the mosaic's original and the sarcophagus were crafted for audiences that were intimately familiar with the Persians and their costume, the Attalid Dedication addressed an Athenian one at a time when the Persian Empire and its army had faded into history.[63]

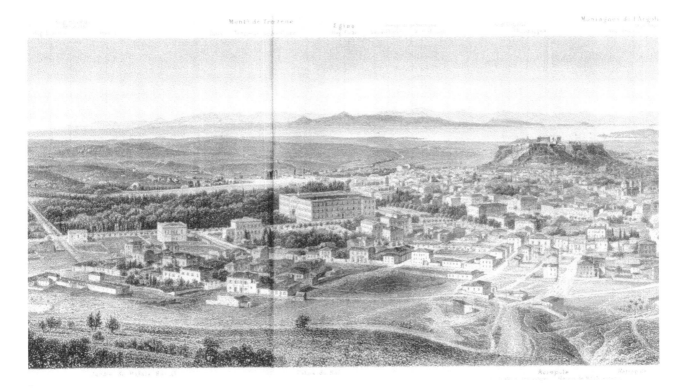

FIGURE 235. Panorama of Athens and the Saronic Gulf in the 1880s. The Olympieion is visible on the fold to left of center; the monument to Antiope stood just to the right of it, inside the Itonian Gate of the city. Troezen is in the distance, beyond and above the Olympieion. From Baedeker's *Griechenland* (Leipzig 1888), folding plate opposite p. 105.

So for all their emphatic realism of feature and body, are these three Persians – particularly the naked Vatican statue – just poorly researched? The answer must be yes if one accepts their otherwise strident realism as an index of historical truth. Yet this would not be the first time that a reality *effect* (to use Roland Barthes's famous phrase) promoting an underlying ideology has fooled unsuspecting art historians. In short, in this stridently realistic context, brimming with signs of Truth, our Persian's phony nakedness suggests ulterior motives at work.

Now despite the Vatican Persian's eye-popping muscularity he is cringing. Furthermore, as the physiognomic reading in Chapter 3, §4, has shown, his features betray his stupidity, cowardice, and treachery, and the soft fringe of hair he shares with the other two Persians marks all three as essentially slavish. So his nakedness begs to be read as slavish too. We see his true nature shattering the façade of his superbly well-trained body, brutally unmasking him despite his showy muscularity as the inverse of the proud, naked Greek and his thrusting *andreia*. The *exomides* of his two companions – garments worn exclusively by laborers and slaves – convey the same message in a different way. For as every Greek knew, among Orientals "all are slaves but one."[64]

As to predecessors, kneeling and even cowering Persians populate the Persianomachies of the Age of Alexander, and dead ones require no discussion. (The Palatine Persian [Figure 247] is another matter; it is discussed in the next subsection.) And of the attributions, the Palazzo Santacroce Persian (or Amazon) is lost and the Torlonia one inaccessible. The controversy about whether the latter is the "Paris" illustrated in the *Galleria Giustiniana* of 1631 (see Figure 65) has now been resolved affirmatively by the publication of the Giustiniani inventories; its previous history is unknown. The single published photograph of it shows that it resembles the Vatican Persian but is more classicizing and wears a Phrygian cap. It is also somewhat bigger.[65]

As to the victors, the Marathon painting in the Stoa Poikile featured Miltiades, Kallimachos (who died in the battle and who may be the naked Greek on the left of Figure 223), the hero Echetlos, and Kynegeiros (whose hand was cut off as he grasped an escaping Persian ship).[66] The Attalid Dedication surely included the first two, but beyond that we are in the dark.

THE GALATOMACHY (IV)

Five Gauls survive, equaling all the other barbarians put together (Figures 1–2, 5, 10–12, 15–17, 20, 23–25, 41–44, 49–64, 179–81, 187–89). Three of them are wounded by sword and spear. Their types also appear in the minor arts (see Figure 234), but in fact only two of them – the Venice Dead Gaul and the Paris Gaul – can be identified as Gauls with absolute certainty.[67] The first has a typically Gallic coffin-(lit.: door-)shaped shield or *thyreos* with a wave motif around its edge (see Figures 12, 20, 23), and the other an oval/lentoid one with a Gallic-type central ridge and boss (see Figures 5, 61–62). Both types appear on the early second-century-BC balustrade reliefs of the stoa surrounding the Sanctuary of Athena Nikephoros at Pergamon, and the *thyreos* on a contemporary Galatomachy from Ephesos (Figure 260). Hybrids appear on the Pergamene bronze plaque and relief kantharos (see Figures 168–69), but the pure forms turn up as late as the late second century AD (see Figure 203). The shields of the Capitoline and Ludovisi Gauls are also oval but add the wave motif of the Venice Dead Gaul's *thyreos* (see Figures 27–28).[68]

A broadsword lies on the Paris Gaul's shield (see Figure 61), and the Dead Gaul holds the hilt of another (broken?) one in his right hand (see Figure 20). The former has a sharp point, which normally would be unremarkable but for the Hellenistic historians' explicit testimony that Celtic swords were rounded at the end and so useful only for brute hacking, not for cut-and-thrust combat. In the Celtic graves of northern Europe, short, pointed swords give way to longer ones with rounded ends around 350, but in Italy the earlier, pointed type persists into the third century; the Gauls on the Pergamene bronze plaque and relief kantharos (see Figures 168–69) use the pointed kind, and so apparently does the Suicidal Gaul (see Figure 27).

Finally, the Dead Gaul also wears a metal torque encircling his waist (see Figure 20). Around 270, Kallimachos had used precisely these three items – broadsword, "cruel" belt, and "hateful" shield – to characterize the "mindless" Gauls in their hybristic assault upon Delphi.[69] As Malmberg showed in 1886, the Dead Gaul was run through from side to side with a spear – presumably (given the horizontal orientation of the holes for its shaft) wielded by an infantryman – whose head has left deep cuts to either side of these holes (see Figures 11, 189). He was then finished off with a sword thrust to the heart.

The Paris Gaul has sustained sword cuts on his left thigh and right side (see Figures 61, 115). His hands are restored, and with them his sword hilt and shield grip; neither makes sense, since these very items lie on the ground between his legs (see Figures 61–62). So what he was doing is a mystery. Perhaps Bellièvre (RT2) was right in thinking that he was stooping to pick up his sword. Maybe he was gesticulating with the other hand, shielding himself with a cloak, or even grasping at an opponent.[70] A similar figure may have appeared on cornice block Γ8, battling a rider.

To turn to the Venice Kneeling and Falling Gauls, their distinctive physiognomies certainly signal Gaul rather than Giant, as does the former's short tunic or *exomis* (see Figure 159) – another hint of boorishness? The Venice Kneeling Gaul's right arm and sword hilt are Renaissance additions (see Figure 196). As mentioned in Chapter 3, §8, his shoulder muscles show that he was certainly not committing suicide like the Gaul on the "Ammendola" sarcophagus (see Figure 203) – his upper arm angles back too far (see Figure 16).[71] Perhaps he was begging for mercy. Finally, the Naples Dying Gaul is a reversed replica of the Capitoline Trumpeter (see Figures 28, 167, 240) but now wounded in front *and* back (see Figures 41–42, 118, 187) and minus trumpet, shield, and torque – not to mention his original head, for which a substitute was added probably late in the eighteenth century (cf. RT6 and 8; see Figures 24–25, 71, 76).

The Dying Gaul might have been part of a group. For not only did cornice block Γ4 perhaps carry a figure like him between two fighting warriors (see Figure 271c), but his type is common on late classical reliefs, where one of his companions often supports him with a hand under the armpit and defends him with his shield. Yet in 1886, Malmberg saw that his two wounds were also caused by a spear, though in each case the spurting blood has obscured the lower part of the cut left by the spearhead. He was skewered from above and behind, presumably by a rider. So like the cowering figure on block Γ1 (see Figure 268c), could he have been positioned at the far right-hand end of the battle, with a victorious Pergamene rider towering above him, lunging out into the void?[72]

But given the extensive cross-referencing among the Little Barbarians, could this Naples statue rather be a dying Giant? Might Apollo's opponent on the Great Altar (Figure 236), also minus torque but now plus helmet, corroborate this thesis after the fact? Yet the two sides of the analogy (Trumpeter : Naples statue :: Naples statue : Altar Giant) cancel each other out, and the wound in the back fits perfectly with ancient accounts of the Gauls' tendency to break and run when the going got rough.[73] However, even if he is *not* a Gaul, this close-knit trio on the one hand and the Little Barbarians' ubiquitous self-referentiality on the other authorize us to speculate that the Attalid Dedication featured a Little Gaul just like him.

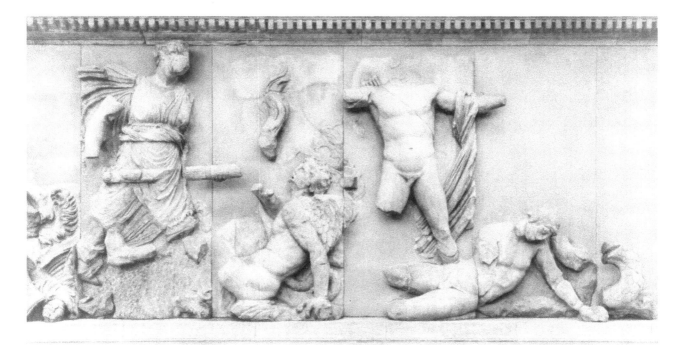

FIGURE 236. Artemis and Apollo fight the Giants. Relief from the Gigantomachy of the Great Altar of Pergamon, ca. 180–160 BC. Marble; height 2.3 m. Berlin, Pergamonmuseum. From Hermann Winnefeld, *Die Friese des groszen Altars* (Berlin 1910) (*Altertümer von Pergamon* 3.2): pl. 9.

Brunn was the first to notice the resemblance between the Capitoline Trumpeter and the Naples Gaul, and it has held center stage in discussions of the Little Barbarians ever since.[74] Since only diehard pro-Romanists doubt the Trumpeter's priority, the Dying Gaul's obvious dependence upon it has long become something of a cliché – though the Gaul's bogus, helmeted head (see Figures 24–25, 43–44) has often introduced needless complications.

The current orthodoxy is that the Trumpeter copies a bronze from one of the victory dedications in the Sanctuary of Athena Nikephoros at Pergamon (see section 1). Current scholarship usually attributes it and its fellows (see Figures 27, 237–47) to a long, low base by the south wall of the Pergamene sanctuary (Figure 229), commissioned in the late 220s to celebrate Attalos I's serial defeats of the Galatians and Seleukids, rather than to the tall, circular one in the center of it as was once thought. For the latter, erected in the mid-230s to celebrate the Kaïkos victory, could have held only four or five figures at best – and no victors. An impressive 2.48 m high, it would have dwarfed even the Big Barbarians and hidden much of the Capitoline one from sight, his shield and trumpet included. Instead, it perhaps supported a colossal Athena Promachos.

To close the circle, the Long Base is among several at Pergamon signed by [Epi]gonos, exactly the man whom Pliny singles out for his famous bronze Trumpeter (AT3b).

Following Michaelis's brilliant conjecture, his name is now regularly substituted for the otherwise unknown "Isigonus" in Pliny's list of those who "made the battles of Attalus and Eumenes against the Gauls" (AT3a): that is, ΕΠΙΓΟΝΟC for ΕΙCΙΓΟΝΟC.

Attributions to this so-called Great Dedication (the Big Barbarians) are distinguished by their over-life-size scale (just as telltale as the Little Barbarians' under-life-size one), their Asian marble, and their bluntly uncompromising realism. They include the Trumpeter himself, the famous Ludovisi or Suicidal Gaul, two heads in the Vatican and Palatine museums, and a torso in Dresden (see Figures 27–28, 81, 167, 237–43). Following a suggestion by Wilhelm Klein, a Persian from the Palatine is often added to the group and identified as a Seleukid mercenary (Figure 247).[75]

This splendid offering (it is argued) was widely influential, inspiring both the Galatomachy of the Akropolis Dedication (IV) and the Gigantomachy of the Great Altar. To use George Kubler's well-known phrase, it was a "prime object" – a flash of innovation within the tradition whose character is not explained by its antecedents and whose impact (its capacity to generate multiple replicas, derivations, and variations) is profound. For the classical period, Kubler selects the Parthenon and its colossal cult statue, Pheidias' Athena Parthenos.[76] For the Hellenistic, he might well have chosen the Big Barbarians.

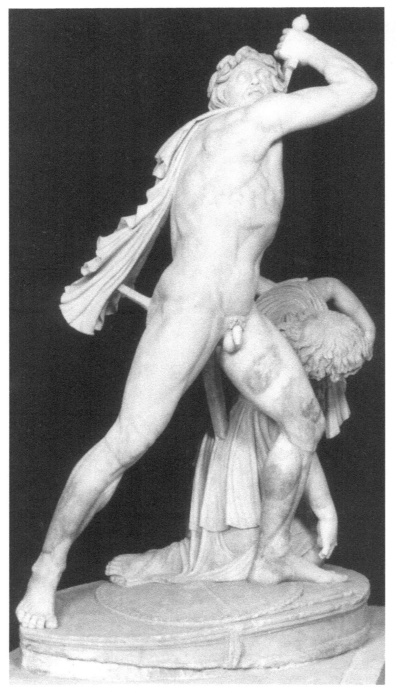

FIGURE 237. Suicidal Gaul, Figure 27. Original, ca. 230–200 BC. Photo: Soprintendenza Archeologica di Roma 188231. The Gaul's right arm and both of his wife's arms are restored.

FIGURE 238. Head of the Gaul, Figure 237. Photo: Soprintendenza Archeologica di Roma 188233.

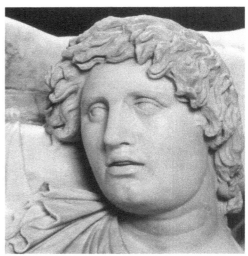

FIGURE 239. Head of the Gaul's dying wife, Figure 237. Photo: Soprintendenza Archeologica di Roma 188237.

For their inaugurative status is indeed clear, and there is no reason to follow those who think them Roman in origin as well as in execution. Gallic suicide is attested as early as 279 BC; since the Gauls were nomads, the inclusion of women in the carnage is unproblematic; and the Trumpeter's trumpet and torque are quite correct.[77] And as Chapter 3 has demonstrated, the victors surely were included in the original monument from which they were copied. Still, to return to Chapter 1 and its epigraph, it takes only a single ugly fact to slay a hypothesis, however beautiful. For John Marszal has demonstrated that the Long Base at Pergamon (Figure 229) supported *life-*

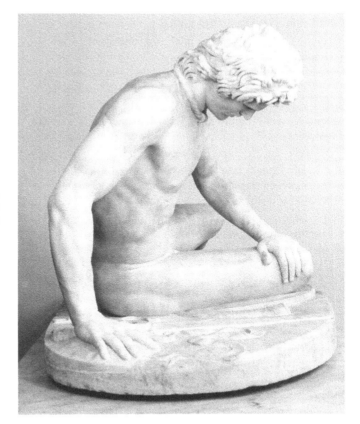

FIGURE 240. Capitoline (Dying Gallic) Trumpeter, Figure 28. Original, ca. 230–200 BC. Photo: Soprintendenza Archeologica di Roma. The right arm, sword, and adjacent section of the plinth are restored.

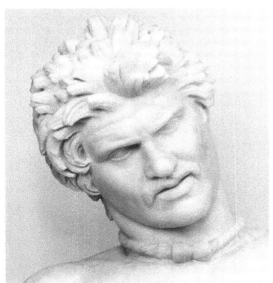

FIGURE 241. Head of the Trumpeter, Figure 240. Photo: Soprintendenza Archeologica di Roma.

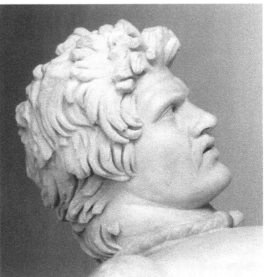

FIGURE 242. Head of the Trumpeter, Figure 240 (profile view). Photo: Soprintendenza Archeologica di Roma.

size statues, rendering these Big Barbarians suddenly homeless.[78]

Since there is no other place left for them in Pergamon's Athena sanctuary, where did they stand? Two alternative locations suggest themselves: the Pergamene Nikephorion and Delphi.

At first sight the Nikephorion's name and function make it an attractive candidate, but it lay outside the city walls and has not been discovered. It was also wide open to attack. Philip V of Macedon thoroughly destroyed it in 201, and Prousias II of Bithynia burned and looted it in 156.[79] These catastrophes augur ill for the survival of

a third-century group of this kind into the Roman period, when the extant copies – the Big Barbarians – were made.

Delphi has more to offer. In 1987 Georges Roux identified a huge foundation (which he called the *massif*) before the Stoa of Attalos I as a statue base and suggested that it supported the originals of the Big Barbarians or figures like them (Figure 248). Pausanias did not describe them (he argued) either because he had other priorities or because the Romans had already looted them. The stoa housed panel paintings perhaps of Attalos' Gallic victories, which the whole complex was probably intended to celebrate. It was definitely in use by 208, when a Delphic decree regulated access, protocols, and usage.

The foundations, which stand close in front of it, are an impressive 3.5 m (10 Samian/Pergamene feet) wide and might have been up to 27 m (almost 80 such feet) long; unfortunately, though, their entire southern and eastern sides have vanished. Nevertheless, given the structure's considerable width, any statue group that stood on it must have been composed somewhat differently from the basically linear monuments at Pergamon (Figures 224, 229) and Athens (Figures 218–19, 227–28).[80]

Recent work has clarified some details. Since an underground vaulted chamber trespasses upon the foundation's (lost) southern side, it probably carried not one pedestal but two: a wider western one and – starting at the subterranean chamber – a narrower eastern one (Figure 248). The former stood about 1.11 m (3 three Samian/Pergamene feet) high; carried vertical bronze spikes along its

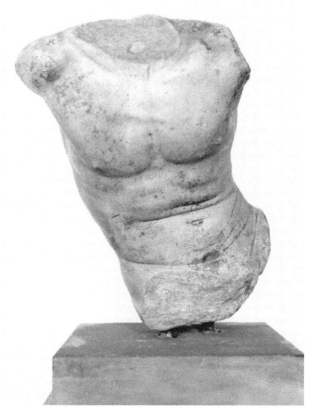

FIGURE 243. Torso of a falling Gaul (Roman copy). From Tivoli; original, ca. 230–200 BC. Marble; height 74 cm. Dresden, Antikensammlungen Hm 154. Photo: Dresden 76/12. A modern restorer may have removed the remains of a torque around his neck.

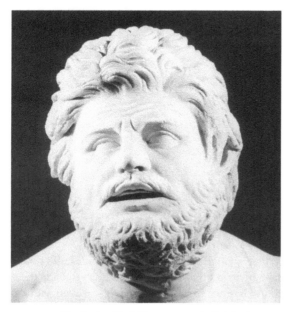

FIGURE 244. Head of a Gaul (Roman copy). Original, ca. 230–200 BC. Marble; height 35 cm. Vatican, Museo Chiaramonti 1271. Photo: Vatican Museums XXV.16.32. The bust is modern.

FIGURE 245. Profile view of the Gaul, Figure 244. Photo: Vatican Museums XXI.37.23.

FIGURE 246. Head of a dying barbarian (Gallic?) woman (Roman copy). From the Palatine, Rome; original, ca. 230–200 BC. Marble; height 23 cm. Rome, Antiquario Palatino 4283. Photo: Soprintendenza Archeologica di Roma.

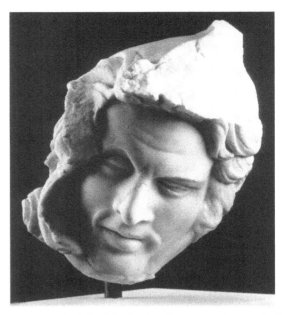

FIGURE 247. Head of a dying Persian (Roman copy). From the Palatine, Rome; original, ca. 230–200 BC. Marble; height 33.5 cm. Rome, Antiquario Palatino 603. Photo: Soprintendenza Archeologica di Roma.

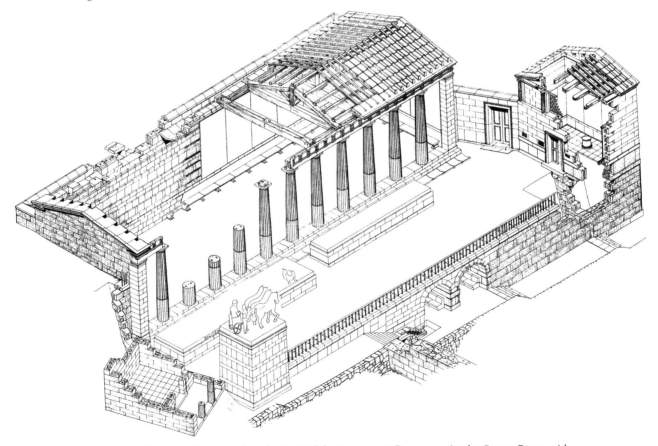

FIGURE 248. Stoa and terrace of Attalos I at Delphi. Ca. 210 BC. Reconstruction by George Roux, with additions by Wolfram Hoepfner. The *massif*, here split into two, is immediately in front of the stoa; a single Big Barbarian is restored on it *exempli gratia*. Used by kind permission of Wolfram Hoepfner.

TABLE 8. The Attalid Dedication and Its Predecessors: A Hypothetical Reconstruction

Date	Monument	Statues	Figure Nos.
Ca. 223–220	Multiple-battle (Great) Dedication (Long Base) at Pergamon	Predecessors of (models for?) Big and Little Gauls	224, 229 (plan)
Ca. 210	*Massif* at Delphi	Originals of Big Gauls? Persians??	27–28, 81, 167, 237–47; 248 (isometric)
200–197?	Akropolis Dedication	Originals of Little Gauls, with Giants, Amazons, and Persians	1–25, 29–64, 77–80; 227 (reconstruction), 228 (plan); Foldout

edges to deter loungers (*plus ça change!*); and supported a low, elevated platform.[81] A similar platform recurs on the Akropolis cornice blocks (Figures 214–19, 265–78, 287), further strengthening the *massif*'s claim to be a huge statue base. The Big Barbarians themselves, however, are of Asian marble and probably were made in Rome. So if their originals really did stand on the *massif*, either Sulla or Nero indeed confiscated them or the copyists worked once more from casts.

A Delphic location for the Big Barbarians would certainly add an extra frisson to the Little ones. For the Naples Dying Gaul quotes the Trumpeter, and the Venice Falling Gaul also imitates a second Big Barbarian: the Dresden torso (Figure 243). Although this figure is often thought to be another version of the Trumpeter,[82] his left arm was obviously raised, and his head was turned to its left, exactly like the Venice Falling Gaul's. His twisting body and the remnants of his other limbs also match the Falling Gaul's, cementing the relationship.

This second quotation, in turn, raises the suspicion that the Akropolis Dedication's Galatomachy (IV) echoed the one copied by the Big Barbarians (wherever it actually stood) either wholly or in part. This is "intertextuality" or visual interplay again, where a source is first appropriated and quoted, then reread "up time." Yet our ignorance of the earlier dedication's location and context prevents us from going much further. Could it or its copies, and not our statues, have produced the Roman echoes investigated in the previous chapter? Could it have included one or more of the other three battles? The Palatine Persian (Figure 247) might suggest so.

For although the Akropolis Dedication's Persianomachy (III) and Amazonomachy (II) were specifically Athenian, it is possible that it converted two originally Panhellenic versions of these themes into specifically local ones. And like the Gauls the Persians also had assaulted Delphi and had been routed by Apollo. Yet barbarians falling before a rain of hail, snow, and rocks were subjects not for freestanding sculpture but for painting or relief, as (later) on Augustus' Palatine temple.[83] So could the *massif* have carried the Kaïkos battle and either a generic Persianomachy or a specific but nevertheless Panhellenic one such as that at Plataia in 479?

A steady evolution from the purely contemporary battles of Attalos' multiple-victory dedication at Pergamon in the 220s (Figure 224), through a hybrid one at Delphi in the 210s, to the Akropolis Dedication's fully developed mythohistorical quartet (Figures 227–28) is certainly enticing – though the existence of paintings of the Gallic victories (certain at Pergamon; possible at Delphi) complicates the scenario somewhat.[84] Indeed, since the Akropolis Dedication's siting apparently alluded to the multiple one at Pergamon, it is tempting to propose that *pace* the reconstruction given in Figure 224, the latter's Galatomachies established the iconography for the whole series, which thus would have developed as is shown in Table 8.

Of course, gradually universalizing the Galatomachy in this way would have increasingly undermined its historical uniqueness, turning it into merely the latest assault upon civilization by sundry *hybristai*. Did sensitivity to the problem perhaps contribute to the Little Gauls' much heightened rhetoric? Yet as will appear, other factors may have been at work, and the Palatine Persian, though nearing the fate of the Naples one (see Figures 1, 37–40; 247), is otherwise quite unlike him. And one or both of the bases could even have carried a gift of a quite different kind, such as battle spoils – a Pergamene favorite. So theory all this remains.[85]

To return to the Akropolis Galatomachy (IV), of the various attributions to it most are not certainly Gauls; are too heavily restored to tell; and/or are inaccessible for study.[86] Only one, a fragmentary small-scale group in the Vatican of a now-headless warrior carrying the limp body of another, is of interest, for a citation on an Augustan frieze in Mantua makes it clear that these two men are indeed Gauls.[87] The exposition is brutal; the bodies display the same knotted muscularity as our Little Barbarians; and the dead warrior's head is intensely expressive. Yet the sketchy workmanship is completely different; the scale is too small (the standing Gaul stood less than 90 cm high); and the Mantua frieze features not Pergamenes

but Romans and has nothing directly in common with our Little Gauls.

So in descending order of probability, either (1) the Vatican group and Mantua frieze both quote a Roman victory monument of the second–first centuries BC in high Hellenistic style; or (2) they reference a different Pergamene work from the Attalid Dedication; or (3) against all odds, the group indeed echoes the Attalid Dedication and the frieze also cites it.

Finally, of the victors only Attalos himself is certain. He surely led the decisive charge on horseback in true Macedonian fashion, like Alexander in the Alexander Mosaic and Sarcophagus (see Figures 184, 225). One may imagine him – the yardstick for the whole ensemble – rearing up over a fallen enemy while battling another ahead of him, like the victorious commander of the Ephesos Galatomachy (Figures 259–60).

3. OF AUTHORS AND MAKERS

Pausanias (AT6), biased as usual against postclassical artists, omits to mention who made the Akropolis Dedication.[88] No other ancient source helps out, and whatever inscriptions it carried are still missing. This makes it necessary to attack the problem indirectly, on two fronts: via the Akropolis pedestals, and via the copies.

As mentioned earlier, the four pedestals' diverse employment (or not) of clamps and dowels, their four different cornice-block sizes, and the slightly different measurements of their moldings (see section 1; Korres's Essay; and Figure 265) strongly indicate that four separate but closely coordinated workshops were involved, one for each battle. This immediately brings to mind Pliny's well-known comment (AT3a) that "Several artists made the battles of Attalus and Eumenes against the Gauls: Isigonus, Pyromachus, Stratonicus, and Antigonus, who wrote books about his art." These two kings must be Attalos I (r., 241–197) and Eumenes II (r. 197–158), since Eumenes I (r., 263–241) paid off the Gauls instead of fighting them. Yet since their Gallic victories were spread over no fewer than seventy years (ca. 237–166), the obvious inference is that the four artists worked for them sequentially. Even if the careers of two or more of them overlapped, the chances that all of them were active precisely in the year 200 are slim.

Moreover, regardless of who actually made the pedestals and statues (whose radically different physiognomies, musculature, and drapery styles strongly indicate multiple executors at work), the pedestals' general uniformity and the copies' shared mannerisms could well indicate a single mastermind in control. Compare, for example, the identical postures of the dead (Figures 1, 18–21) and the way in which others, kneeling and reclining, support themselves on one arm extended with hand flat on the ground and fingers splayed (Figures 1, 2, 4, 41, 45, 49, 77); the latter pose even recurs on one of the extant cornice blocks (Γ1: Figure 268c). Perplexed by these mixed messages, scholars have debated the matter for almost one hundred and fifty years, some arguing for a single master, others for two, and still others for all four.[89]

Yet there is no particular reason to believe that style in this period (or any other) transparently and unproblematically points to "the man himself." Leaving aside the copy problem for the moment, four artists might easily have coordinated their designs to present a unified effect from afar, or a single one might have encouraged diversity in detail for expressive reasons. Moreover, several other individuals (Attalos for one) definitely had a hand in the Attalid Dedication's creation, and its genre surely guided its form to some extent. Since all this essentially sunders authorship (what critics call the *author effect* signaled by the work) from its actual fabrication (its design and execution), the path from signifier (the sculpture) to signified (its "author") to referent (its maker/s) now becomes rocky indeed.[90]

Even so, two prime candidates for the project's designer or at least overall coordinator suggest themselves: Epigonos and Phyromachos. In 1893, Michaelis first suggested substituting Epigonos for Pliny's "Isigonus" (AT3a), connecting Epigonos' Infant Pitiably Caressing Its Slain Mother (AT3b) with the Naples Amazon (see Figure 72) and proposing this artist as the author of the Attalid Dedication.[91] As for Phyromachos (presumably the "Pyromachus" of AT3a), the Little Barbarians share significant details with his recently identified Asklepios and Antisthenes (see Figures 87–88, 249–51).

Epigonos of Pergamon is known from seven signed statue bases and a battered dedication from the Pergamene Akropolis, and he is often identified as Attalos I's court sculptor. Yet on four of these blocks only the signature remains. A fifth carried a portrait of a certain Leontes, and the remaining two bore dedications by (confusingly) a certain general Epigenes and the army, and by Attalos I himself for the Kaïkos battle and several other victories (the multiple dedication, Figures 224, 229).

These last two monuments were erected shortly after 223, the date of the last victory named in the inscriptions, and their signatures use the same formula: The artist's name appears in the genitive followed by *erga*, "works" [of]. Yet in both cases only the end of the name survives, theoretically allowing one to restore [ANTI]GONOU (cf. AT3a) instead of [EPI]GONOU. Fortunately an old tran-

scription of the now-missing left half of the Epigenes inscription, reported at second hand, gives the first part of the artist's name as ESTI-. Since one might easily mistake EPI for ESTI (i.e., EΠI → EΣTI) but not ANTI for ESTI (i.e., ANTI ≠ EΣTI), and the formula is identical in both inscriptions, the artist in question in both cases was almost certainly Epigonos. Finally the dedication, made by a certain [. . .]gonos, son of Charios, if by Epigonos, may give us his patronymic, but this is obviously not to be relied on.[92]

In addition, in AT3b Pliny notes Epigonos' celebrated bronze Trumpeter and Infant Pitiably Caressing Its Slain Mother. The former was first associated with the Capitoline statue (see Figures 28, 167, 240–42) in the mid-nineteenth century, and in 1893 Michaelis saw that the latter precisely described the Naples Amazon-plus-baby (see Figure 72; RT2, 6). Yet the growing conviction that the infant was a Renaissance addition soon turned most scholars against him.[93] Is his proposal worth resurrecting?

The answer would be an unequivocal yes were it not for the Little Barbarians' evident fondness for quoting the Big Barbarians (Figures 240, 243) and their numerous internal cross-references. This leaves us with no fewer than four options, in ascending order of complexity. Epigonos' statue was either:

1. the original of the Naples Amazon;[94] or

2. a Gallic woman and child made for the Akropolis Dedication (but now lost) and quoted by the Naples Amazon's original; or

3. a Gallic woman and child made for the Big Barbarians (but now lost) and quoted by the Naples Amazon's original;[95] or

4. a Gallic woman and child made for the Big Barbarians (but now lost), copied at reduced scale on the Akropolis Dedication, and quoted by the Naples Amazon's original.

In normal circumstances Occam's Razor (the Law of Parsimony) would decisively favor (1), but should the special circumstances of the Big–Little Barbarians complex tip the balance to (3) or even (4)? Furthermore, one of the disembodied heads convincingly associated with the Big Barbarians (Figure 246) is surely of a dying or dead Gallic woman: a copy of Epigonos' statue? If so, his Trumpeter could be either the dying one in the Capitoline Museum (Figures 240–42) or – since Pliny says nothing about the man's ethnicity or state of health – a figure like the one lustily blowing the trumpet on some of the Roman battle sarcophagi. Perhaps it too was copied on the Akropolis Dedication – but this is speculation enough.[96]

FIGURE 249. Frontal view of the inscribed portrait herm of the philosopher Antisthenes, Figure 87. Original by Phyromachos of Athens, ca. 250–150 BC. Photo: DAI Rome 76.2096.

Finally, two footnotes: First, Pliny's description of a the fourth-century painter Aristeides' similar mother and child, quoted above (in the subsection on the Amazonomachy), clearly specifies that in this case the woman was still alive. So Aemilianus' epigram (AT4) probably refers not to it, as is generally believed, but to Epigonos' statue.[97] Second, Epigonos indeed remains the most likely conjecture for the "Isigonus" in Pliny's list of bronze-workers who "made the battles of Attalus and Eumenes against the Gauls" (AT3a). For "Isigonus" is certainly corrupt: The name occurs only once in the entire published corpus of Greek nomenclature, on a late Roman tombstone in Athens.[98] But the epigram unfortunately adds nothing to Pliny's note, and the Pergamene inscriptions already prove that Epigonos worked on Attalos I's Gallic victory dedications.

Phyromachos of Athens is much better attested. The sources list him among the four great *andriantopoioi* (makers of statues of mortals) alongside Myron, Lysip-

FIGURE 250. Portrait herm of the philosopher Antisthenes (Roman copy). From Hadrian's Villa at Tivoli. Original by Phyromachos of Athens, ca. 250–150 BC. Marble; height 37 cm. Vatican, Galleria Geografica 2888. Photo: DAI Rome 77.495.

pos, and Polykleitos, and credit him with a respectable oeuvre. On present evidence he spent most if not all of his career in Asia Minor, with one trip to Delos.[99] His two acknowledged masterpieces were an Asklepios in the Pergamene Asklepieion and a portrait of the fifth-century philosopher Antisthenes. Pliny, quoting an extreme neoclassicist source, dates him to the 121st Olympiad, or 296–293, after which allegedly "the art [of bronze casting] stopped," reviving only in the year 156 in the hands of "inferiors."[100]

By coincidence, 156 also furnishes a rock-solid *terminus ante quem* for him, since in that year Prousias II of Bithynia plundered his Asklepios from the Pergamene Asklepieion. It stood in the main, Ionic temple in the sanctuary, dedicated to Asklepios Soter. The building's few remaining fragments were found in a second-century BC fill; it could date as early as ca. 230 and was repaired at least once in its short history. So perhaps Attalos I built it and commissioned Phyromachos' statue; Philip V damaged it when he raided the city's extramural sanctuaries in 201; and Prousias destroyed it when he did the same and stole the statue in 156.[101]

Yet elsewhere Pliny seems to imply that Phyromachos' career extended almost to this very date. For one of his pupils was Herakleides of Macedon, who started out painting ships in Macedonia but relocated to Athens after the Romans defeated and captured the last Macedonian king, Perseus, in 168. So if Phyromachos taught Herakleides his trade, he must have been active after 200. Indeed, although Pliny calls Herakleides a "painter of note" he implies that he became one only after he moved to Athens and abandoned his ship painting.[102] So in 168 Herakleides could still have been quite young, placing his apprenticeship in the 170s or (at the earliest) the 180s.

Finally, Phyromachos occasionally collaborated as a junior partner with a fellow Athenian, Nikeratos son of Euktemon. Unfortunately only one of the latter's works, a group on Delos honoring Philetairos of Pergamon (d., 263), is even approximately datable. Its language suggests that the dedication was posthumous, and its tone, content, and orthography support a date before ca. 230. Nikeratos' other signatures, including the joint ones with Phyromachos, also seem to fit epigraphically around the latter date, and Pliny conspicuously fails to mention him among those who "made the battles of Attalus and Eumenes against the Gauls" (AT3a). Was he perhaps Phyromachos' father?[103]

All this suggests that Nikeratos was active around 260/250–210/200 and Phyromachos around 230/20–180/170. So why does Pliny date the latter to the 290s?

Two solutions suggest themselves. Either the Phyromachos of 296–293 was a different man or Pliny's classicizing source was wrong. For the name does occur elsewhere in Greek artistic circles. A Phyromachos of Kephisia worked on the Erechtheion frieze in 408, and another fathered a late third-century Rhodian bronze sculptor. Yet since Pliny's source evidently felt that Phyromachos was an important artist (otherwise he would not have included him), did he simply adjust his date in order to extract him from the abyss into which (he believed) bronze casting had then fallen? Whatever the truth, this chronological note has no direct bearing upon the present discussion.[104]

To begin with the Antisthenes: About a dozen copies of it survive (see Figures 87, 249–50), one of them inscribed with Antisthenes' name, together with a base from Ostia signed "Antisthenes the philosopher; Phyromachos made it." Two other bases found with it carried portraits of the comic poet Plato by Lysikles and of the Delphic prophetess Charite by Phradmon of Argos. All three were "signed" in the same script and so must be

renewals. The statues – surely the three sculptors' original bronzes – must have been looted from Greece without their heavy, cumbersome bases and furnished with new ones upon arrival.

A lively terra-cotta in Naples (Figure 251) gives a good idea of Phyromachos' statue. Seated on a backless throne, the tortured body of this "Sokrates gone mad," the hero of the austere, mordant Cynics, radiates mental agitation. Simply dressed, he sits with legs tightly crossed, one arm gripping the other, body tensed and twisting, and head vigorously turned toward an unseen interlocutor. Even before the Ostia inscription's discovery this portrait was often assigned to the high Hellenistic period, which now seems de rigueur.[105]

The Antisthenes and the Naples Giant (cf. Figures 29–32, 87–88, 249–50) belong to two quite different genres and at first sight diverge considerably in detail. Only a marked "baroque" expressiveness seems to unite them. Yet they do share one significant trait: a complex whirligig of hair that erupts above the center of the forehead, but on the Giant does so in mirror image and somewhat more wildly. One sickle-shaped lock curls sideways, another undulating one surges in the opposite direction, and a third snakes up behind them. This telltale motif has been recognized as a kind of artist's signature, but the reality is more complex. As Paul Zanker has argued:

The locks rising from above the forehead had been a popular symbol of strength and energy ever since the portraits of Alexander the Great; and centaurs, silens, and giants were all characterized as "wild" creatures by a similar treatment of the hair. It is tempting to see here a reference, again recalling the [*Lives of the Philosophers*] to Antisthenes' vigorous and abrasively contentious character or to his much-admired moral vigor. We may even remember how the chauvinistic Athenians never forgot Antisthenes' half-barbarian origins as the son of a Thracian mother.[106]

In other words the motif is a Hellenistic physiognomic sign. But is this version of it idiosyncratic enough to be a *particular artist's* rendition of that sign?

The Antisthenes has even more in common with the Aix Persian (see Figures 79–80). Their foreheads, noses, and cheeks are similarly modeled, though once again the Barbarian's are more exaggerated. So did Phyromachos himself make the Persian's original, or did someone strongly under his spell do so? Yet immediately the same problem arises. For a contracted forehead is also a physiognomic sign – of energy, ferocity, even anger. But again, is it sufficiently individualized here to qualify as a personal tic, a *particular artist's* version of that sign?

Finally, there is the head of a god on a Pergamene bronze coin, surely Phyromachos' great Asklepios (Figure

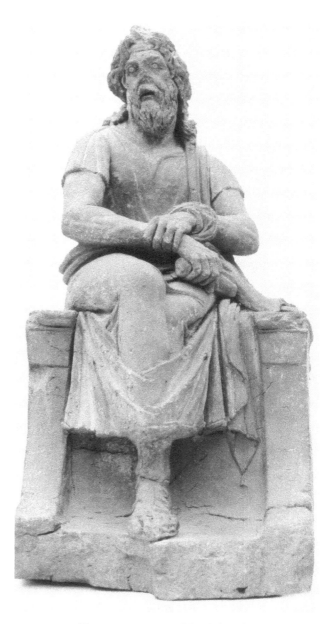

FIGURE 251. Terra-cotta statuette of the philosopher Antisthenes. Original by Phyromachos of Athens, ca. 250–150 BC. Height 70 cm. Naples, Museo Nazionale. Photo: DAI Rome 90.1.

252). Its reverse bears the legend "of Asklepios Soter" – the cult title of the god worshiped in the main, Ionic temple in the Pergamene Asklepieion and hence of Phyromachos' statue.[107] Despite its small scale this head is uncannily close to the profile of the Naples Giant (see Figures 32, 88), even though the latter's nose is restored. So are we dealing with yet another sign of physiognomically registered hyperactivity, or of a single author, or both?

Indeed, is a triple coincidence no coincidence at all? For in AT3a Pliny does name Phyromachos next to [Epi]-

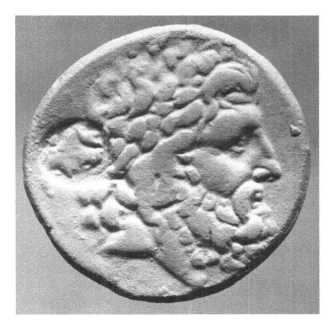

FIGURE 252. Head of Asklepios Soter. Pergamene bronze coin; 2nd century BC. Berlin, Staatliche Museen, Münzkabinett. Photo: Klaus Anger, by permission of Bernard Andreae. Probably copies the head of Phyromachos' cult statue for the Pergamene Asklepieion.

gonos as one of the four artists who "made the battles of Attalus and Eumenes against the Gauls," and given his probable date, his Athenian roots, and his Attalid connections, it would be strange if he missed out on this important commission. Of course, if he or Epigonos indeed designed and directed the Attalid Dedication, our observations hardly confirm the presence on it of an utterly pellucid personal style – "the well of inspiration undefiled." But maybe this is asking too much, given the chameleon versatility of Hellenistic sculptors (witness Pliny's comment about Epigonos in AT3b), the collaborative nature of ancient bronzework, and the four-part team clearly evidenced by the Attalid Dedication's pedestals.

So perhaps Epigonos and Phyromachos indeed produced two of the groups and Pliny's other two candidates, "Stratonicus and Antigonus," the other two. The former, however, remain obstinately in the shadows.

Antigonos, a distinguished art historian, was surely Pliny's source for this particular note (AT3a). It is the only secure record of him as a practicing sculptor, despite sporadic attempts to substitute his name for Epigonos' in the two half-preserved Pergamene signatures (reading -ONOU ERGA and -GONOU ERGA) discussed earlier.

Following a brilliant monograph by Ulrich von Wilamowitz-Moellendorff, this Antigonos is usually identified with the early Hellenistic polymath Antigonos of Karystos, but there are problems. According to Wilamowitz,

FIGURE 253. Portrait bust of the Stoic philosopher Chrysippos (d., 208–205 BC; Roman copy). Original, ca. 200 BC. Marble; height 34.5 cm. London, British Museum 1846. Photo: BM XCIX (B)51.

the Karystian was born before 300, possibly studied philosophy under Menedemos of Eretria in the 280s and sculpture at Athens in the 270s, and finally moved to Pergamon under Attalos I, writing his biographies there. Yet Pliny's inclusion in AT3a of *both* Eumenes II and the Antigonos "who wrote books about his art" severely undermines this glittering edifice. It shows that his source, presumably this very writer, certainly lived into the 180s, for Eumenes first defeated the Gauls only in 188, alongside Manlius Vulso and the Romans. Yet by then Wilamowitz's Antigonos would have been at least 120 years old! Clearly, something has to give.[108]

Stratonikos may be identical with a virtuoso metalworker (*toreutes/caelator*) and maker of "philosophers" mentioned by Pliny and Athenaios, but not otherwise recorded or dated. Finally, if the stylistic similarity between the Aix Persian and the Chrysippos holds (see Figures 84, 253), others may have been hired too. For this masterly study, presumably made soon after the philosopher's death in 208–205, is often attributed to the Athenian bronzecaster Euboulides.[109]

Yet our final inability to move from signifier to signified to referent, to use these signs of authorship to detect

the hand of a single, towering, creative genius – some ancient Bernini, Canova, or Rodin – pays some unexpected dividends. First, it has further certified the copies' veracity: They transmit physiognomic and other details that are, in several key respects, authentically Hellenistic. Second, it opens up a tempting domain famously scouted by the French critic Roland Barthes as long ago as 1968 under the provocative slogan "The Death of the Author." His conclusions are too diffuse to quote here, but as Terry Eagleton explains:

[In Barthes's view], all literary texts are woven out of other literary texts, not in the conventional sense that they bear the trace of "influence," but in the more radical sense that every word, phrase or segment is a reworking of other writings which precede or surround the individual work. There is no such thing as literary "originality," no such thing as the "first" literary work; all literature is "intertextual." A specific piece of writing thus has no clearly defined boundaries: it spills over constantly into the works clustered around it, generating a hundred different perspectives which dwindle to vanishing point. The work cannot be sprung shut, rendered determinate, by an appeal to the author, for the "death of the author" is a slogan that modern criticism is now confidently able to proclaim. The biography of the author is, after all, merely another text, which need not be ascribed any special privilege: this text too can be deconstructed. It is language which speaks in literature, in all its swarming "polysemic" plurality, not the author himself. If there is any place where this seething multiplicity of the text is momentarily focused, it is not the author but the *reader*.[110]

Not all of this needs to be taken at face value, and Barthes himself later disavowed some of it. Suggestively, though, American sociologists of art – especially theater, opera, and film – independently arrived at a similar position shortly thereafter. In 1976, Howard Becker argued that:

Works of art can be understood by viewing them as the result of the coordinated activities of all the people whose cooperation is necessary in order that the work should occur as it does . . . (including) the people who conceive the idea of the work . . . ; people who execute it . . . ; people who provide the necessary equipment and material . . . ; and people who make up the audience.[111]

Later, Becker extended his analysis to poetry and painting, and added artistic tradition, convention, and materials to the list, broadly anticipating the concept of a "field of cultural production" devised by Pierre Bourdieu and introduced in Chapter 1, §9.[112]

Barthes's and Becker's extension of the notion of authorship allows us to finger a number of putative "authors" for the Attalid Dedication – the populace of its various intersecting "fields of production." These include the several predecessors in those genres whose ideas and types it appropriated (see, e.g., Figures 240, 243); its own genre, which certainly helped to guide its form; the interplay with the Stoa Poikile, Parthenon, and Big Gauls that generated and enriched its meaning; King Attalos; the Athenian demos; and even (yes!) the goddess Athena herself. For like the other Olympians, some of whom had actually shown up in person to help defeat the Gauls in 279, she was no mere phantom: Her epiphany to aid Eumenes II during the great Gallic revolt of 167 is recorded in a Pergamene inscription. So all parties must have considered her preferences, which by no means necessarily matched the exact wishes of any single one of them.[113]

Finally, as noted in Chapter 1, an artwork's meaning is never reducible to an authorial intention anyway, of whatever complexity. Not only does its author always intend more than any one critic can understand, and critics always understand more than the author intends, but its meaning – its emancipation from authorial intention – evolves from the moment that it is first unveiled.

In default of any textual attribution or inscribed signature, to recast the Akropolis Dedication's authorship as a cumulative, collaborative process of appropriation and negotiation (i.e., as a discourse) is quite different from the Wölfflin–Carpenter thesis of an "art without artists." For as appeared in Chapter 1, §5, this was a purely formalist solution designed to finesse the supposed problem of the "two roots of style" (internal and external, formal and contextual) by isolating the artwork from any meaningful context whatsoever. Nor does it square with the current fashion for using the supposedly additive technique of ancient bronzes to proclaim the "death of the original" and thus of all chronology and authorship.[114] Barthes's and Becker's ideas – and the above reworking of them – could not be further from both.

4. DATE(S)

None of this, it will be noticed, helps us much with the long-disputed problem of the Akropolis Dedication's date. Here the responsibility lies squarely with Pausanias (AT6) for not specifying which Attalos dedicated it: Attalos I (r., 241–197) or Attalos II (r., 158–138). (Attalos III has never been a serious candidate.) So was it made around 200 or around 150? As explained in Chapter 1, in 1865 Heinrich Brunn argued for the former, but in 1914 Georg Lippold made a strong formalist case for the latter, which he later retracted.[115]

By the 1930s Lippold's later date had hardened into orthodoxy. Master formalists such as Gerhard Krahmer,

Alessandro della Seta, and Rudolf Horn pointed to the "one-sidedness" of several of the Barbarians; their extreme separation of surface from structure and of muscle from muscle; their formal elaboration, exaggeration, and dedication to emphatic axial divergences; their coordination of these traits into overarching patterns of movement across the frontal plane; and their abandonment of any unifying fluidity of line. All these features supposedly pointed to the generation after the Giants of the Great Altar (see Figures 68–69, 236), then dated to the 180s or 170s, but now often as low as 160. And recently, Andreae has sought to reinforce these stylistic arguments with a historical one. He points to Pausanias' use in AT6 of the word *phthora* ("destruction" or "annihilation" of the Gauls), which he believes can refer only to Eumenes II's suppression of the great Gallic revolt in 166.[116]

As also explained in Chapter 1, partisans of the earlier date have counterattacked this position vigorously but so far have failed to budge its defenders. The arguments include the following:

1. Pausanias (1.8.1) makes it clear that for him only Attalos I matters, because he defeated the Gauls (cf. AT6). He completely ignores all the other Attalid benefactions in Athens, including the Stoa of Attalos II — one of the largest buildings in the city. For in 8.52.1 he opines that just as Miltiades was "the first benefactor of Greece," the Achaian statesman Philopoemen (ca. 253–182) was the last, excluding these latter gifts from consideration de facto.

2. Attalos I's visit to Athens in 200 at the height of the Second Macedonian War offers a far stronger historical context than the reign of Attalos II, when no such danger threatened. The Kaïkos battle of ca. 237 was Attalos I's greatest triumph, and (*pace* Andreae) is the one that Pausanias means in AT6. For he explicitly says that the battle commemorated was in Mysia, and his earlier remarks on Attalos I (1.8.1) prove that he knew perfectly well that the war of 168–166 had taken place not there but in Galatia. Moreover, neither Attalos II nor III ever fought the Gauls during their reigns.[117]

3. Good late third-century stylistic *comparanda* for the Barbarians do exist. The surviving early Hellenistic battle reliefs show an increasing level of violence and turmoil that neatly sets the scene for them, and several assorted late third-century heads closely echo them in style. These include Chrysippos (see Figures 84, 253), who died between 208 and 205, and a terra-cotta head from a stratified deposit in the Athenian Agora — further evidence of the copies' overall faithfulness to mid-Hellenistic norms and thus, *a fortiori*, to their Attalid originals.[118]

4. The proposed stylistic development from Great Altar to Barbarians is a mirage. For the Altar's Gigantomachy (see Figures 68–69, 236) equally well could represent a retreat from the extremes of the baroque; the theory of style does not mandate linear progression (cf. Chapter 1, §5) and the available evidence strongly suggests that Hellenistic sculptural styles are usually nonlinear. Instead, they are genre- or subject-specific, or even a matter of choice in the particular case. So all such evolutionary theories are moot, and the burden of proving their validity rests firmly with their advocates.[119]

To these we may add three others:

5. Some arguments for downdating the Barbarians actually address their Roman-period "facture," which – in the absence of multiple replicas to provide a control – complicates the issue markedly.

6. Lippold originally posited a generation between the Great Altar and the Little Barbarians, but the Altar's new date around 160, if accepted, now brings it uncomfortably close to them.

7. If the Etruscan urns really do quote the Little Barbarians (see Figure 86),[120] a date around 150 for the latter unduly compresses the urns' chronology also.

Now objection no. 4 has led some to adopt the extreme position that dated monuments are purely *sui generis* and useless on the wider front. Yet this is equally untenable, for Greek art (to say nothing of Roman) clearly *did* develop after 323, and not all styles suddenly became available in mature form at this magic date.[121] To take just one example, the characteristically hard-boiled Delian portrait style appears in specific circumstances on the island after ca. 150 and apparently not before.[122] So let us reformulate the issues as follows:

1. Many of the fine distinctions in detail regularly used to argue for distinctions in date between one Hellenistic work and another are due to differences of genre, subject, mood, context, or artist, or to copyists' license. Unless all these factors can be discounted, the argument is moot.

2. If a "floating" work is generally similar to an externally dated one, this establishes only that the former *could* have been made at that time. It cannot settle which had priority.

3. Since Hellenistic art develops nonlinearly and style is therefore an unreliable predictor of date, indirect (historical or archaeological) evidence, however circumstantial, should normally prevail over stylistic.

4. The existence of a stable or developing genre style can be firmly established only by a chronologically well-distributed set of externally dated pieces in that genre. And conditions (1)–(3) entail that these schemes cannot be prescriptive.

Clearly, conditions (1) and (2) easily take care both of the supposed differences between the Chrysippos and the Aix Persian (Figures 79–80, 84, 253) and of the argument that the barbarian *must* postdate the philosopher.[123] But they do not confirm that the Persian's bronze original *must* have been made around 200, only that it *could* have been. Fortunately, here a newly discovered monument comes to the rescue.

This monument is a colonnaded rotunda in Limyra in Lykia (southern Turkey) discovered in the 1980s (Figure 254). Firmly dated on a number of grounds to the mid-third century, it has been identified as a *heroon* for Ptolemy II (r., 282–246) and Arsinoe II (d. 268).[124] Three of its metopes have been published, all from a Centauromachy, and offer clear precedents for the Little Barbarians. Their figures look like centerfolds from *Muscle & Fitness*. The flayed musculature of Figure 254 is far more extreme than that of the Naples Giant (Figure 255) and Paris Gaul (see Figures 5, 61–62); the Centaur's hair is more ornately flamelike than the Giant's; and the Lapith's pose compares well with the Gaul's. The 1930s formalist characterization of the Barbarians applies here too. We see a similar separation of surface from structure and of muscle from muscle; a similar formal elaboration, exaggeration, and dedication to emphatic axial divergence; a similar coordination of these traits into overarching patterns of movement; and a similar abandonment of any unifying fluidity of line.

Nevertheless, even though these similarities immediately urge a third-century date for the Little Barbarians, conditions (1) and (2) still obtain. So it is time to confront the copy problem (1) directly.

Although the Barbarians seem to be unique copies and their rocky plinths are clearly Roman, there is no reason to follow those who dismiss them as hopelessly compromised. The poses of four of them, the Vatican and Aix Persians and the Paris and Naples Dying Gauls, apparently turn up on the cornice blocks (Γ1, 4, and 8); their iconography manifests no inexplicable anachronisms (see section 2); and their style – understood in its broadest sense – is anticipated at sites as diverse as Bassai, Epidauros (see Figure 178), Sidon (Figure 225), and Limyra (Figure 254), and recurs in somewhat muted fashion on the Great Altar (see Figures 68–69, 236). Of course, any single detail could still be capricious, and the translation from bronze to marble surely had some effect, but the burden of proof now rests with the doubters. Unless some hard evidence turns up to the contrary, there is no reason to think them inaccurate either generally or in particular.

Yet they are still only replicas, and their bronze originals were made for a monument far from Limyra by completely different artists. So we cannot *necessarily* convert any distinctions in detail that we observe into a chronology for their Athenian originals. Indeed, under condition (2) the Barbarians theoretically could even predate the Limyra metopes. Yet on the other hand the reigns of the three Pergamene kings named Attalos – i.e., 241–197, 158–138, and 138–133 (AT6) – constitute the historical "windows" for the Attalid Dedication, and no one dates it or the Little Barbarians before the last decade of the third century. So the stylistic sequence is surely Limyra–Little Barbarians–Great Altar (i.e., Figures 254, 255, 236, respectively). On present evidence, to propose any other now seems eccentric.

But what of condition (3)? Our current sample of monuments spans about a century (ca. 260–160), but we can push it back another century and a half by factoring in, for example, the more "advanced" battle reliefs from the Bassai frieze (ca. 400) and the Mausoleum at Halikarnassos (ca. 360), the Alexander Sarcophagus (ca. 320: cf. Figure 225), the coffers of the Mausoleum at Belevi (ca. 300–280), and the Akropolis battle frieze (287?).[125] They show the "baroque" style's slow rise; Limyra and the Little Barbarians represent its apogee; and the Great Altar then retrenches somewhat. The Barbarians themselves might have inaugurated the retrenchment, but condition (1) forbids further speculation.

Moreover, the foregoing developmental scheme too is *de*scriptive of a particular set, not *pre*scriptive (condition [4]). As remarked in Chapter I, it cannot determine the particular case. Under conditions (1) and (2) it cannot be generalized into a teleological account of *all* Hellenistic battle monuments, let alone into a robust prediction about the dates of other, *as-yet-undiscovered* Hellenistic battle monuments. These must be considered on their own merits. Concerning the Akropolis Dedication, however, the remainder of this chapter treats it *exempli gratia* as a product of the year 200, and explores the consequences of this conclusion. En route, a certain amount of circumstantial evidence emerges that, in turn, helps to support it.

5. OF HISTORY AND MEMORY

Of the historians of the period, Polybios and Diodoros are fragmentary for the latter part of Attalos I's reign, and Livy is concerned first and foremost with Romans and their doings.[126] Yet these and other sources enable us to piece together the course of events in outline.

The First Macedonian War, uniting Rome, Aitolia, and Pergamon against Philip V of Macedon (Figure 256) ended inconclusively in 205 (see frontispiece Map). Yet the

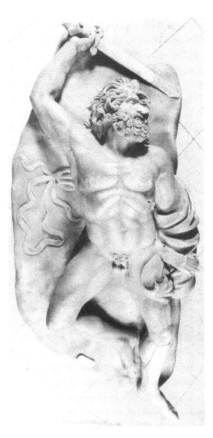

FIGURE 254. Centaur and Lapith. Metope from a *heroon* at Limyra (Lykia, southern Turkey); ca. 260 BC. Limestone; height 72 cm. Limyra. Photo by R. Schiele, Lykien-Archiv des Instituts für Klassischen Archäologie der Universität Wien, neg. Li 84/618; courtesy of Jürgen Borchhardt. The *heroon* may have been erected in honor of Ptolemy II Philadelphos of Egypt (r., 282–246 BC) and his queen, Arsinoe II (d., 270 BC).

FIGURE 255. *(right)* Naples Giant. Photo: Luciano Pedicini.

war, in which Athens had sensibly remained neutral, had achieved three things. It had drawn Rome and Pergamon together to fight on mainland Greek soil; it had gained Attalos the island of Aigina; and it had cemented Philip's already formidable reputation for recklessness and brutality. The Romans then refocused their energies on crushing Hannibal and the Carthaginians, and Philip turned to strengthening his forces, particularly his fleet.

In 202–201 Philip moved again. He advanced to the Sea of Marmora, expanded his holdings in Karia, and took the Ptolemaic dependency of Samos. Checked by the combined fleets of Pergamon, Kyzikos, Byzantion, and Rhodes off Chios, he ravaged Mysia up to the walls of Pergamon (the extramural sanctuaries included). Then he invaded Ionia and beat the Rhodian fleet at Lade. The Romans, badgered from all sides to intervene and fearing for the status quo, pondered war.

Meanwhile, in September 201 the Athenians had killed two citizens of Akarnania, a Macedonian ally, for unintentionally profaning the Eleusinian Mysteries. An Akarnanian and Macedonian force promptly raided Attica, and Philip's fleet captured four Athenian ships at sea.

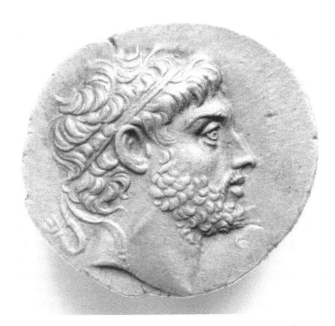

FIGURE 256. Portrait of King Philip V of Macedon. Macedonian silver tetradrachm, ca. 220 BC. Diameter, 3.2 cm. Berlin, Staatliche Museen, Münzkabinett. Photo: Hirmer Fotoarchiv 13.0577v.

That winter the Athenians appealed for aid from Egypt, Aitolia, Pergamon, and Rhodes. But the Ptolemies (their usual protectors) were facing a Seleukid invasion, and the other three were in no position to send quick and effective aid. Increasingly desperate, the Athenians too sent an embassy to Rome.

In spring 200, Attalos reached Aigina with his fleet. Crossing to Piraeus he met with envoys from Rhodes and Rome (the latter armed with the desired declaration of war) and was given a hero's welcome into the city. Invited to address the demos, he sent a letter of support instead, stressing his "previous benefactions" to the Athenians and asking them to declare war on Philip (AT1). The demos promptly obliged; abolished the tribes named after the Macedonian kings Antigonos and Demetrios; voted a new one, Attalis (an honor that included a cult, priest, and statue in the Agora); and created a new deme named after Attalos' queen, Apollonis. This decisive break with tradition – for Athens had been a Macedonian dependency from 263 to 229 and steadfastly neutral thereafter – was to cost the city much. Having gained a new ally, Attalos then prudently retired to Aigina to wait for the Romans.

The Athenians soon paid dearly for their temerity, for Attica now became the war's main battleground. That summer Philip's generals Nikanor and Philokles ravaged as far as the Academy but were halted by a Roman ultimatum. But more Macedonians soon marched in from Euboia and Corinth, and the Macedonian navy raided Attic shipping. Attalos, after tarrying in Aigina then sailing north to protect his Hellespontine interests, sent money but nothing else – later earning himself the historian Polybios' strong censure.[127] In fall, though, a small Roman force of twenty ships and a thousand troops arrived to garrison Piraeus and raided Chalkis.

In response Philip himself mounted a surprise attack on Athens. Alerted in the nick of time the Athenian army, a small Pergamene contingent, and a mercenary brigade met him in battle outside the Dipylon Gate but were forced back inside it; Philip then stormed the gate but was repulsed in turn. Enraged, he burned Kynosarges, the Academy, the Lykeion, and every other sanctuary and grove around the walls, and desecrated the local cemeteries. As Livy recalls, "not only buildings but also tombs were destroyed; nothing of human or divine use was saved in the face of his uncontrollable anger."[128] After vainly attacking Eleusis, Philip then marched off to raise allies in the Peloponnese. Philokles, temporarily alone, assaulted Eleusis again and upon Philip's return joined him in a two-pronged attack on Piraeus and Athens. Frustrated yet again, they both ravaged Attica a third time, then withdrew.

This time the devastation was total:

> Although Philip had previously done his pillaging by destroying the tombs around the city, now, in order to leave nothing unviolated, he ordered that the sanctuaries of the gods that the Athenians had consecrated around the countryside be destroyed and burned. And Attica, which was exceptionally well embellished with such works because of the abundance of its local marble and the talents of its craftsmen, provided much material for this madness. And Philip did not think it enough only to wreck the sanctuaries and overturn the statues. He ordered that even the individual blocks of stone be broken up so that they would not stay undamaged on the piles of ruins.[129]

So the year's end saw Athens battered and bruised, still ringed by foes, and her territory a smoking ruin – but still, miraculously, free. The Athenians retaliated in the only way they could. They cursed Philip's name and those of his family and kingdom; destroyed all monuments to them in the city; and expelled all Macedonians forever. Fortunately at this point a Roman army under Titus Quinctius Flamininus intervened, and the war moved northward. Attalos visited the city twice more in 199 and once again in 198,[130] but in spring 197 he was felled by a stroke and missed the decisive battle of Kynoskephalai in June; so, apparently, did the Athenians. Shortly thereafter Attalos died, leaving his son Eumenes to succeed him and the Romans to dictate the settlement that followed. Eumenes, preoccupied elsewhere, did not visit Athens himself until 192, at the beginning of the war with Antiochos.

In these circumstances to see the Akropolis Dedication as Attalos' response to the events of 200 makes perfect sense. For no one could have known that the Macedonians *would not come back*. Indeed, if the king's Athenian allies judged his feeble military response to their plight even half as severely as Polybios later did (see above), could it have been a hurried attempt at damage control? Not only does its removal to the years around 150 leave all this dangling in the air, but the Augustan restoration decree (AT2), which as we have seen almost certainly refers to the Attalid Dedication, explicitly and uniquely states that it was dedicated "for the security of the [city]." There was no such threat to Athenian security in 150 or indeed during the entire second century.

For after Kynoskephalai, apart from a short flirtation with Antiochos III in 192, the city resumed its traditional neutrality, remaining at peace and a haven of tranquillity. But by then the Akropolis Dedication was surely complete. Indeed Pausanias' report that "King Attalos" dedicated it could suggest that it was finished before he died in 197, since had the task fallen to Eumenes he would

probably have added his own name to the dedicatory inscription and so caught Pausanias' attention.

The historical-epigraphical case for 200–197, in other words, is circumstantial but sturdy and all but disallows the later date. It thus precisely mirrors the art-historical case made earlier; the two are independent, symmetrical, and mutually supporting. As Sherlock Holmes famously remarked, "when you follow two separate chains of thought . . . you will find some point of intersection which should approximate to the truth."[131] In our case, this crossroads is precisely the year 200.

But what of Attalos' letter to the demos (AT1) and its cryptic and intriguing reference about his "previous benefactions"? His remark has occasionally been taken to suggest an earlier date for the Attalid Dedication, perhaps 209–208, when he captured Aigina during the First Macedonian War and used it as his personal base of operations for a year.[132] Although the sources are fragmentary, this was clearly the only previous occasion upon which he visited the Athens area, and surely he would have taken the opportunity to sail across to see the city. Yet Athens was then neutral and at peace. In these circumstances such a lavish and pointed gift with its implication of a Pergamene protectorate over Athens would have been bombastic and meretricious. And Attalos was no blusterer but a canny and subtle politician.[133] So perhaps these mysterious "earlier benefactions" were those standard but ever-popular royal gifts, cash or grain.[134]

Concerning the pillar monument and the two colossi of Attalos and Eumenes (Figures 227–28), though, the situation is far less clear-cut. For they are totally lost and it is uncertain who erected them, who stood in the pillar monument's chariot, and which Attalos (I, II, or III) was represented in the colossi.

As noted in section 1, the pillar monument ought to be the earliest of the four known examples in the city, and it is best explained as an Athenian countergift to Attalos for his generosity in making the Akropolis Dedication in the first place. For the colossi, numerous scenarios are possible according to whether Eumenes and his successors or the Athenians erected them. All one can say for sure is that the two kings now joined such luminaries and city benefactors as Perikles (Pausanias 1.25.1; Figure 227) and gruff old Olympiodoros (Figure 211), the city's liberator from Philip's great-grandfather, Demetrios Poliorketes.

To return to the year 200 (if the battle groups truly belong there), it seems that its unusual circumstances called forth a most unusual response. For Hellenistic rulers often erected portraits and sculptural groups in their own capitals and sanctuaries and in international centers like Delos, Olympia, Delphi, even Helikon and Samothrace.

Attalos himself had embellished Delos with an ancestor (*progonoi*) group, a statue of his general, Epigenes, and a Gallic victory monument (probably, from the proportions of its base, another chariot group), and Delphi with the stoa and *massif* discussed in section 2 (Figure 248).[135] Yet the only earlier royal dedication of a multifigured *battle* group in a major sanctuary that is attested in the sources is Alexander's Granikos group at Dion, donated in 334. His successors routinely gave cities cash, grain, and walls, and sometimes temples, stoas, or gymnasia, but never anything like this.[136]

One reason for Attalos' unprecedented choice may have been that battle groups spoke to the current situation far more eloquently than any other kind of gift could ever have done. Indeed the first of them, the Gigantomachy (I), featured enemies from the very source of the city's current perils: Macedon. By letting slip that the Giants "once lived around Thrace and the Isthmus of Pallene" (AT6) Pausanias gives the game away. For this was the minority view; the main tradition located their home and the battle at Phlegra in Italy – Roman territory.[137] The regions named by Pausanias, on the other hand, lay squarely within Philip's kingdom. Pallene – the western spine of the three-pronged Chalkidike – was a strategically important part of it, guarded since 316 by the great city of Kassandreia, and by the year 200 significant parts of Thrace, too, lay inside the Macedonian border.

Furthermore, as early as the 260s the Athenians had openly compared the Macedonians to the despised Persians (III). Chremonides' fateful decree of 268 explicitly cites the "barbarian" – that is, Persian – invasions of old as a precedent for his new coalition of cities against Macedonian "enslavement," and the Macedonians' habit of using the hated Gauls (IV) as mercenaries in Greece and elsewhere soon blackened their image even more.[138]

The Macedonians' peaceful withdrawal from Athens in 229 did much to quiet the acrimony, but Philip's barbarous and brutal conduct soon rekindled it. By 197 the Greeks were calling him a second Xerxes, accusing him of trying to enslave them, and hailing the Romans and their proconsul Flamininus as their liberators:

Xerxes led a Persian host to the land of Hellas,
 And Titus led another from broad Italy;
But the one came to set a slave's yoke on Europe,
 The other to end Greece's slavery.[139]

"Wild, cruel, and a politically unpredictable adventurer," an implacable assailant and sacker of cities, and now a proven enemy of the gods themselves, Philip personified everything that had once doomed the Giants, Persians, and Gauls. He was a Porphyrion, Xerxes, or Brennos in a purple cloak and diadem (Figure 256).[140]

But the critical testimony is furnished by the Athenians themselves at a parley held in March 199, only a few months after that awful summer and fall. It is worth quoting at length:

The Athenians, who had suffered appalling things and were able more justly to attack Philip's cruelty and barbarity, were introduced. They deplored the lamentable devastation and despoiling of their land. They did not complain that they had suffered enemy actions at the hand of an enemy, for the laws of war stipulated that it was right to suffer what it was right to inflict. Burning of fields, destruction of buildings, and kidnapping of men and animals as booty were lamentable rather than undeserved for those who experienced them.

But they did complain that the man who called the Romans aliens and barbarians had so polluted divine and human law alike that on his first raid he had waged impious war with the gods of the world below, and on his second with the gods above. For all the tombs and monuments in their territory had been destroyed. The shades of all the dead had been left naked; no-one's bones were covered with earth. They had shrines which once their ancestors, dwelling in those small forts and villages, had consecrated and had not even abandoned when they joined together into one city. Philip had burned all these temples to the ground. The statues of the gods, half torched and mutilated, lay among the fallen doors of the temples.

What Philip had done to Attica, once so ornate and rich, he would, if permitted, do to Aitolia and all Greece. The city itself, if the Romans had not come to help, would have suffered the same mutilation. For in the same criminal fashion the gods that keep the city and Athena, guardian of its Akropolis, had been attacked, and the temple of Demeter at Eleusis too, and Zeus and Athena at Piraeus. But repulsed not only from their temples but also from the walls by force of arms, he had spent his wrath on those shrines that were protected by piety alone.[141]

So like the impious Giants (I), Persians (III), and Gauls (IV), Philip had revealed himself to be a monster of *hybris*, a barbarian, an enemy of both gods and men.[142] Yet since everyone accepted (however grudgingly) that he and his Macedonians were ethnically Greek, they could not be directly "barbarized" in bronze; so the only way in which the barbarity of their crimes could be exposed was by indirection. Who then could have resisted seeing the Naples Giant, with what might be a royal diadem conspicuous at his side (Figure 255), as a caricature of the bearded Macedonian savage (Figure 256)? And as one walked on (Figures 227–28), proceeding gradually down through time toward the present, the other groups would have strengthened this impression. Their numerous cross-references would have functioned as shifters, insinuating that all barbarians (Macedonians included) were basically one and the same, and merited the same ugly fate.

So the Athenian–Attalid dialogue that shaped the Akropolis Dedication surely occurred during Attalos' two subsequent visits to the city in 199, immediately after that wrenching summer and fall. This means in turn (to repeat the obvious) that our initial reading of it must be from the perspective of that very year *and no later*. For until midsummer 197 everyone knew that the implacable Philip and his merciless Macedonians might easily come back – another good reason for the monument's authors to insinuate its real target rather than represent it directly. But by then, if the observations made in section 1 are persuasive, it might have been already finished or nearly so.

Scanning the groups, then (Figure 227), the observer could read them either as a set of pejorative individual one-on-one (*paradigmatic*) comparisons or as an equally pejorative sequential (*syntagmatic*) array of interlocking similes. In the first instance, Philip (Figure 256) resembled the Giants (I) in his mad assault on the gods; the Amazons (II) in his ferocious attempts to sack Athena's citadel; the Persians (III) in his relentless desire to enslave Greece; and the Gauls (IV) in his mindless desecration of cemeteries and outrages against the dead.[143] In the second, he resembled the Giants (I), who resembled the Amazons (II), who resembled the Persians (III), who resembled the Gauls (IV), who resembled . . . Philip!

Pejorative one-on-one comparisons are the stuff of street, assembly, or law-court invective, but sequences of interlocking similes traditionally prefaced Athenian funeral speeches over the ashes of the war dead. The litany of villains is familiar: Amazons, Thebans, Eurystheus, Persians, and Peloponnesians. By invoking it the speakers constructed an ideal Athenian community by reaching "up time" from an originating present to an ideally recollected past populated by bellicose predators and signposted by examples of heroic, exemplary self-sacrifice.[144]

In the conservative atmosphere of Hellenistic Athens there is no reason to think that much had changed. The epitaph of a certain Leon who fell at Salamis in the 240s had compared him to the men who had fought the Persians, and the Athenian ambassadors to Sulla in 86 rehashed the same dog-eared catalog, to no effect. Perfectly understanding its purpose, he dismissed them with the remark that he had come to teach Athens a lesson, not to learn ancient history, and proceeded to storm the walls anyway.[145]

These themes echoed throughout the city. For as mentioned earlier, directly above the Attalid Dedication the metopes of the Parthenon (see Figures 67, 90, 227), by

then commonly accepted as a dedication from Persian spoils, told a similar story at a similar scale: "The Persians are like the Giants, who were like the Centaurs, who were like the Amazons, who were like the Trojans, who were like . . . the Persians!" Reprised on the Athena Parthenos' golden shield and shoes, this litany was already a commonplace down in the Agora, where the Stoa Poikile's four huge paintings juxtaposed Marathon directly with the Amazonomachy and the Sack of Troy. Its echoes reverberated as far away as Delphi, where the Athenian Treasury, Marathon Monument, Kydias monument, and perhaps even the Pergamene dedication on the *massif* (Figure 248) all told the same tale.[146] Like them, the Attalid Dedication offered yet another, updated recital of recorded history, enriched by frequent repetition of key motifs (see Figures 1–5 and Foldout) from group to group.

So on one level the Attalid Dedication was wholly "about" memory. It evoked a ghastly trauma, a desperate defense, and a miraculous escape, and secured their place in Athens' ancient and endless struggle against the forces of barbarism. Mobilizing all the resources of the city's representational landscape, it acculturated its memories of these traumatic events; enshrined them as an originating present; and inscribed them as a chapter in its ongoing story. It cemented them – suitably edited – into the city's cultural memory.

Now as it happens, cultural memory "has become an important topic in the field of cultural studies, where it has displaced and subsumed the discourses of individual (psychological) memory and of social memory. . . . Cultural memorization [is] an activity occurring in the present, in which the past is continuously modified and redescribed even as it continues to shape the future."[147]

Taking their cue from the French psychologist Maurice Halbwachs (1877–1945), researchers normally distinguish up to four different types of cultural memory: (1) unreflective folk wisdom of the "don't-step-in-the-puddle-or-you'll-catch-cold" variety; (2) local and/or ritual traditions ("This is the Hill of the Nymphs"; "Queen Elizabeth slept here"); (3) narrative memories of events made memorable by their emotional content; and (4) traumatic recall. We have already encountered Aby Warburg's speculations about one species of it, the *Pathosformel* (see Figures 109, 112–13), in Chapter 2, and we have met its intellectual expression – the parascience of physiognomics – in Chapter 3. Here our particular concern is with trauma. For the events of 200 appear to be a textbook case of how a trauma can outrage a society's collective memories, only to be relieved and reintegrated into common experience:

Traumatic memories . . . cannot become narratives, either because the traumatizing events are mechanically re-enacted as drama rather than synthetically narrated by the memorizing agent who "masters" them, or because they remain "outside" the subject. . . . Traumatic re-enactment is tragically solitary. While the subject to whom the event happened lacks the narrative mastery over it that turns her or him into a proper subject, the other crucial presence in the process, the addressee, is also missing.[148]

So the victim of such memories both needs to incorporate the past narratively into the present and requires a sympathetic third party to act as confirming witness to it:

This [third-party function] of witnessing and facilitating memory is an active choice, just as much as the act of memorizing that it facilitates. The acts of memory thus become an exchange between [the two parties] that sets in motion the emergence of narrative. The cultural nature of this process can be even more perspicuous when the [third party] who bears witness or facilitates self-witnessing is an artist or critical reader whose work functions as a role model. . . . Art . . . can mediate between the parties to a traumatizing scene and between these and the reader or viewer. The recipients of the account perform an act of memory that is potentially healing, as it calls for political and cultural solidarity in recognizing the traumatized party's predicament. This act is potentially healing because it generates narratives that "make sense." To enter memory, the traumatic event of the past needs to be made "narratable." Those memories that are most "normal" – narrative memories – thus provide a standard, however problematic, to measure what it means to speak of cultural memory.[149]

The relevance of all this to our topic is obvious. In 200 Philip had systematically destroyed the Athenians' hallowed "places of memory." Unlike twenty-first-century Western societies, ancient ones could absorb huge casualties – Syracuse and Cannae come immediately to mind – and (as the Athenians themselves pointed out) destruction and theft of one's property were accepted hazards of war. But graves and sanctuaries were different. Like the hated Persians, Philip had vented his wrath on the Athenians' very roots. By barbarously obliterating their links to their ancestors and to their gods he had destroyed the natural ties that defined them as a community.[150] The gravity of the historical trauma inflicted upon them is hard to overestimate.

The Athenians were of course strongly attached to their ancestors' graves, which proved their family and local roots, authenticated their genealogies, and validated their sense of community. Desecration of these graves both outraged the dead and deracinated the living. But

this was not all. According to one authoritative estimate, in 200 Attica "may have had as many as 2,200 deities (many sharing names and functions, of course, but worshiped separately) and 965 centers of cult.... The destruction may have affected most of them. [For] there is scarcely a dedication, decree, or any other piece of inscriptional evidence from any rural sanctuary after 200 BC."[151] So from that date the rich religious life of rural Attica essentially ceased to exist.

A people that believed it was literally autochthonous, sprung from the land and at one with it and its gods, would have seen this double rupture as an utterly incomprehensible disaster. So it retaliated by erasing Philip and the Macedonians from its own civic memory. This response paled by comparison with Philip's crimes but was the only recourse the Athenians had. They destroyed all memory of him and his ancestors just as he had destroyed theirs.

Fortunately the Athenians had acquitted themselves well in their own defense, and Attalos was on hand to offer himself as their confirming witness. After all, his own heartland had suffered almost as badly the year before, when Philip had systematically destroyed all Pergamon's extramural sanctuaries and ravaged its countryside.[152] So Attalos' gift, from Ionic-style pedestals below to battling bronzes above, was literally an exercise in *sympatheia*, in "suffering with." It showed his political and cultural solidarity with his traumatized allies by publicly recognizing their predicament – and his own. For neither party knew that the Macedonians would not come back. By contextualizing, narrativizing, and universalizing this trauma Attalos helped it lose "its essential incomprehensibility, the force of its affront to understanding."[153]

Attalos had done little of substance to avert the disaster and of course could not reverse it. But he could offer a concrete historical perspective upon it that mirrored and articulated the Athenians' own, placing Philip (Figure 256) in the company of world-class maniacs like the Giants (I), deviants like the Amazons (II), tyrants like the Persians (III), and sociopaths like the Gauls (IV) (see Figures 227–28). The gods had destroyed the first of these, the Athenians had crushed the second and third, and Attalos himself had beaten the fourth. So having failed to prevent their current trauma, he did what he could to help them cope with it. His gift, surely made in consultation with them, spoke directly to their urgent need to reassert themselves symbolically as a community now that their roots in the Attic landscape had been so savagely trashed.[154] It was potentially healing because in the circumstances it generated narratives that made sense.

6. "FOR THE SECURITY OF THE CITY"

So much for the past; what of the Attalid Dedication's address to the future? Ancient religion was always a *do ut des* affair, a series of transactional bargains with the gods. Janus-like, every dedication to them faced both ways, thanking them for "benefits received" (as Pergamene inscriptions put it) and hustling for more. At Pergamon, Attalos himself was accustomed to stress the first of these functions by explicitly labeling his dedications *charisteria*, "thank offerings."[155] At Athens, the Augustan decree for the restoration of sanctuaries (AT2) invokes the second of them by revealing that Attalos offered his *anathemata kai agalmata* "for the security of the [city]." Perhaps the phrase even echoes its dedicatory inscription, which would have been placed on the side of the base for the first of the groups, the Gigantomachy (I), as on his Long Base at Pergamon (see Figure 224):

ΒΑΣΙΛΕΥΣ ΑΤΤΑΛΟΣ ΑΘΗΝΑΙ
ΕΙΣ ΤΗΝ ΑΣΦΑΛΕΙΑΝ
ΤΗΣ ΠΟΛΕΩΣ

Now in addition to resurrecting the community of the Athenians and their ancestors – Theseus and friends (II) and the *Marathonomachoi* (III) – the Attalid Dedication created another between the Athenians and Attalos himself. Presided over by their joint patroness, Athena, it implied an Attalid protectorate over the city – one soon made explicit by the two colossi (see Figures 227–28). And it signaled to Philip and others Attalos' firm intention to behave in traditional Greek fashion, helping his friends and harming his enemies. A royal gift in a polis setting, it revealed the tensions between the two systems even as it sought to reconcile or elide them. But it also respected Athenian sensitivities about their subordinate position in the relationship.

For although the battle groups' unusually diminutive scale can be explained by the space available and the need to establish a clear relationship with the Parthenon metopes above, it had other advantages as well.

First, life-size bronzes would have reduced the number of figures by a third and huge ones like the Big Barbarians (see Figures 27–28, 81, 167, 237–47) by a half, yet each would have cost Attalos a lot more money.[156] But just as important, even with two-thirds life-size figures the Dedication already stood an imposing ten to twelve feet (3–3.6 m) high (Figure 227). Anything larger would have signaled a blatant Attalid colonization of the Akropolis, utterly dominating the plaza before the Parthenon, towering over the parapet, and dwarfing the temple's sculptures when seen from afar (cf., e.g., Figure 90). By contrast, Attalos' "cultural propaganda" was tactful,

considerate, and carefully tailored to its audience. Witness his preference in the spring of 200 for an epistolary response to the Athenian demos instead of appearing personally to make a speech (AT1).[157] And his actual military reaction to the Macedonian attacks had been less then vigorous.

So whereas figures that dwarfed everything around them might have backfired badly, these small-scale ones signaled a certain restraint as well as permitted numbers that did each theme ample justice. Indeed, if the reconstruction of Figures 227–28 is persuasive, Attalos' own moment of glory, the Galatomachy in Mysia (IV), was occluded by the Parthenon until one walked some distance into the plaza – an exercise in royal reticence that parallels, in its own way, his self-effacing refusal to address the Athenians in person in 200 (AT1). But nothing prevented him from making his presentation of the barbarian Other as eye-catching as possible, from heightening its antibarbarian rhetoric to fever pitch. The barbarians' diminutive scale and his own inglorious response to the Macedonian invasion might even have encouraged it.

As to Athena's role, in the decree for the restoration of the sanctuaries (AT2) the phrase "for the security of the [city]" is thought-provoking, especially since it pointedly avoids the standard vocabulary in such circumstances. Instead of *soteria*, "safety" or (better) "deliverance," it substitutes *asphaleia*, "security." Though the two are semantically close, *soteria* implies a specific threat: deliverance *from* something. In democratic Athens, it was also a legal and technical term, marking the issue as urgent and prioritizing it for debate.[158] *Asphaleia*, on the other hand, is more vaguely prospective (in modern Greek, it means "insurance") and emerges as an important Athenian political objective in the fourth century.[159]

Equally intriguing is the decree's inclusion of the Attalid *anathemata kai agalmata* in a list of what are apparently guardian shrines. Including Agathe Tyche on the Mouseion Hill, the Hyakintheion on the Hill of the Nymphs, and Eukleia and Eunomia on Kolonos Agoraios, these shrines were traditionally connected in various ways with the preservation of the city's independence and the well-being of its statehood.[160]

So could the Attalid Dedication have performed or come to perform a similar apotropaic function, however indirectly? For as remarked earlier, until mid-197 and perhaps even thereafter no one could have *known* that the Macedonians were not coming back. And what other threats might not burst from the shadows in the future? The one predictable thing about Hellenistic politics was their unpredictability.

Scholars generally distinguish *apotropaia* from talismans. Whereas the former were "displayed openly at the gate or along the periphery [of the defenses] to avert or frighten off human or superhuman evildoers," the latter were consecrated, numinous images that "protect[ed] by [their] mere presence, even if hidden away deep in the recesses of the citadel."[161] The Akropolis had more than its fair share of both. Some more efficacious or better attested than others, they include (in rough chronological order):

(1) the Athena Polias[162]

(2) the Mycenaean Akropolis wall, displayed through two portals in the Nike Bastion; ca. 430–420[163]

(3) the statue of Athena Nike (mid-sixth century?), popularly believed to be Apteros or "wingless" so that she could never fly away from Athens[164]

(4) Peisistratos' grasshopper or locust, allegedly dedicated to protect Athens from these insects; 547–527 BC; cf. Pheidias' Apollo Parnopios, no. 9, below[165]

(5) Athena Hygieia, ca. 500, or at least by ca. 470; bronze statue by Pyrrhos, ca. 425[166]

(6) the "Wooden Walls" of 480[167]

(7) the display of the entablature and cornice of the "Old Temple" of Athena, and of the drums of the Older Parthenon, both sacked by the Persians in 480, in the North Wall of the Akropolis, from ca. 465; erected to warn future would-be desecrators about the consequences of *asebeia* and Athena's capacity for revenge[168]

(8) the great bronze Athena of Pheidias, dedicated from Persian spoils; ca. 460[169]

(9) the bronze Apollo Parnopios ("Locust") by Pheidias, ca. 460–440[170] (see Figure 227)

(10) the Hermes Propylaios by Alkamenes, ca. 430–400[171]

(11) the Hekate Epipyrgidia by Alkamenes, ca. 430–400[172]

(12) Attalos' *agalmata* and *anathemata*? (see Figure 227)

(13) a gilded aegis and Gorgoneion, hung on the South Wall of the Akropolis over the theater of Dionysos; dedicated by "Antiochos," probably Antiochos IV (r., 175–164) rather than III (r., 223–187).[173]

An impressive array. In particular, one notices how the *apotropaia* cluster around the gate and on the North and South Walls, but also how the southern wall was essentially empty and unprotected until the mid-Hellenistic period. The Attalid battle groups' extra-high pedestals (Figures 217–19, 227) might suggest an intention to elevate them above its parapet and thus render them at least partially visible from outside the city (Figure 226). But could a *narrative* be apotropaic?

In general, narrative images seem to have been anticipatory and preemptive rather than intrinsically apotropaic like the Gorgoneion (Figure 257). Like concretized prayers or sacrifices they tried to forestall future unpleasantness. Thus, for example, a Rhodian religious prohibition forbade the removal of trophies dedicated to the gods. Left with an embarrassing one erected by the victorious Queen Artemisia in 350 that showed her branding a personification of their city, the Rhodians therefore walled it off in an *abaton*. This adroit move simultaneously respected the taboo, hid their shame, and preserved a handy talisman against similar threats in the future. This principle of "like repels like" is fundamental to ancient magic.[174] Even if Attalos did not intend his gift to be intrinsically apotropaic, this example shows how the Athenians could have come to see it as such after the fact – like, for instance, the Pheidian bronze Athena (no. 8).

A wider trawl would embrace the numerous images of the archers Apollo, Artemis, and Herakles at gates and entrances throughout the Greek world, ready to repel would-be attackers. As Christopher Faraone has argued, these were not merely *descriptive* but *prescriptive* or *rhetorical*, designed to entice or persuade the divinities in question to use their awesome powers to protect the city. They too functioned like petrified prayers, paralleling the latter's tripartite structure of invocation, narrative or argument, and request.[175]

On the Akropolis, then, the Attalid Dedication simultaneously invoked its recipient, Athena; argued its case; and requested her aid. For in 480 the Persians had sacked her citadel and temple; in 279 the Gauls would have done the same had they got the chance; and in 200 so would their latter-day emulators, the hated Macedonians, as the Athenians themselves pointed out in 199.[176] So the Dedication's authors surely would have wanted to demonize these foes as much as possible in order to make their case. Athena's approval was certain; indeed, she might even expect them to do this in order to warn off any future assailants.

These considerations make formalist notions of stylistic development less and less relevant to understanding our Little Barbarians' ugly, distorted features (see Figures 1–25, 29–64, 77–80). For ugliness is physically repellent, and the ancient world often used it as an apotropaic device.[177] So perhaps the Barbarians were intended to be admonitory and terri*fying* as well as terri*fied* – reminding the goddess of barbarism's ever-present threat and warning potential desecrators of the consequences of her wrath. En route, like the Gorgoneion (Figure 257), they mobilized every weapon in the Hellenistic rhetorical arsenal.

7. RHETORIC

Hellenistic "baroque" sculpture and the so-called Asian style of Hellenistic rhetoric were intimately related.[178] Both were native to western Asia Minor. Living in cities like Pergamon, Ephesos, or Magnesia, many sculptors would have been brought up on this kind of florid, highly rhetorical speech, and some key characteristics of their work can easily be described using its terminology. What the sculpture handbooks describe as theatricality, grandiloquence, emotionalism, energy, pictorialism, and floridity, and define as a penchant for extreme contrasts, novelty, and surprise – all this translates quite precisely into Asian rhetorical terms.

Specifically, one thinks of its favorite stylistic devices of *auxesis* (amplification), *makrologia* (extended treatment), *dilogia* (repetition), *palillogia* (recapitulation), *megaloprepeia* (grandeur), *deinosis* (intensity), *ekplexis* (shock), *enargeia* (vividness), antithesis, and pathos. All of these were gleefully exploited by Asian rhetoricians and (as convenient) more cautiously utilized or loudly derided by their critics. By adopting them, the sculptors presented a reprocessed image of the classical past that is filtered through the lens of the baroque and attuned to a visually and historically sensitized audience.

In the Attalid Dedication's case, its thematic prolixity certainly qualifies as *auxesis* and *makrologia*; its theatricality and sheer length (if not the scale of its individual fighters) as an exercise in *megaloprepeia*; and its numerous internal cross-references as examples of *dilogia* and *palillogia*. And *auxesis*, *deinosis*, *ekplexis*, *enargeia*, antithesis, and pathos also aptly describe the suckling Amazon, the naked Persian, and the Gauls with their manic movements and freakish features (see Figures 45, 49–64, 72). In reality, Attalos himself had used Gallic mercenaries against the Seleukids as early as 218, and Eumenes even had one or two Gallic chieftains as "friends." But the Akropolis Dedication was an exercise in rhetoric, not objective history. Its extremist style instantiates barbarian excess.[179]

Moreover the extreme pathos of the vanquished and especially of the suckling Amazon (Figure 72) recalls the methods of the so-called tragic historians, who aimed at the most vivid mimesis of great and terrible events. The most important exponent of this kind of writing was the late third-century Athenian historian Phylarchos, but even Pausanias occasionally employs the same tricks – including blood-crazed Gauls slaughtering geriatrics and babes at the breast. The aim was rhetorical, to "sway the soul" by inspiring pity and fear.[180]

How was all this received? All ancient rhetoricians assumed an attentive and critical audience and crafted their

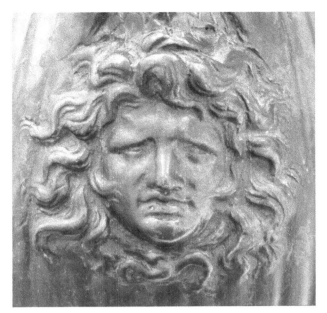

FIGURE 257. Gorgoneion from a Gnathia-style jug. From S. Italy; ca. 300 BC. Kassel, Staatliche Kunstsammlung Alg 19. Photo: Kassel A5 2127.

work accordingly. And modern critics also hold that the author–audience relationship is a reciprocal one that both antedates the work's creation and is incorporated within its utterances. As T. J. Clark has remarked in another context, "every word is directed towards an answer and cannot escape the profound influence of the answering word that it anticipates.... This relationship towards the concrete listener, taking him into account, is a relationship that enters into the very internal construction of rhetorical discourse. This orientation toward an answer is open, blatant, and concrete."[181]

Any Greek, of course, could enjoy a put-down of barbarians, especially the hated Gauls. Here some earlier remarks of mine about the Big Barbarians (see Figures 27–28, 81, 167, 237–47) apply equally to the Little ones:

The received wisdom was that the Celts were mad, the ultimate Other. In ancient terms, they were both devoid of *dike* (Justice, Right, Order) and were its mortal foes. We would call them sociopaths. Aristotle had remarked that their utter lack of fear was both excessive and insane, and Hellenistic writers added inter alia that Celtic men were incurably violent, addicted to unmixed wine, openly had sex with each other, and looked like Pans and satyrs. Their women too were just as reckless and shameless. This is familiar rhetoric. It demonizes Celtic society as a nonsociety, a militarized satyr kingdom in which all the norms of civilized (e.g., Greek) behavior had been overturned.[182]

So, we are told, the Celts raped and committed war crimes as a matter of course; they often fought naked, oblivious of wounds; they cared nothing about burying their dead; and when cornered their leaders never contemplated surrender but committed suicide instead [see Figure 27] – to Greeks, a coward's exit. As Pausanias remarked, the Greeks realized that "the struggle ... would not be one for freedom, as it had been when they fought the Persians [see Figures 37–40, 45–48, 77–80, 223]; ... every man and every city knew that they must either conquer or perish."[183] Against the ultimate in savagery, the only choices were victory or the abyss.

So in the statues, the Celts' heads are indeed satyrlike and their physiques are absolutely un-Greek, extremes of either defect or excess. For their skin is either so thick that it obscures the body's rational construction, or so thin that the muscles pop out like tumors all over the surface. Their nakedness too is insane, a nightmarish example of Greek artistic convention come to life, but now in the person of the barbarian berserker.... Even the Suicidal Celt's "heroically" poised head is a perversion and a parody, for unlike Alexander [see Figures 182, 184] he turns to look at approaching *victors*. His questing glance is not a sign of strength but an index of weakness and the ultimate, irremediable lack. Far from being generated by a heroically driven *pothos* [longing] for conquest, it is an admission of defeat and despair.[184]

Furthermore, whereas wounds and blood are never shown in classical Greek battle scenes, those of the Celts are even rendered in relief. The ancient historians remark with horrified fascination that because their skins were white, "the gashes were more appallingly visible and the dark bloodstains stood out more starkly."[185] In the original bronzes the blood must have been inlaid in copper, and perhaps the Celts' flesh was also whitewashed, making them look much like the present marble copies. Inverting the classical Greek heroic nude, these statues turned it into a corpselike specter, a death demon from hell. And like Hesiod's Bronze Men, these barbarians' fate is preordained.... [Their] dedication to excess, their crazed obsession with killing Greeks and raping their women, has propelled them into a dead end where they can only destroy their own women and kill themselves.[186]

The Little Gauls' twisting bodies, sprung rhythms, jerking limbs, and ugly, contorted faces would only have strengthened these feelings. Seizing our attention and making it skip from part to part and from figure to figure, they present a jumble of shapes and surfaces that would have been quite at variance with the groups' clearly configured, basically rectangular form when seen from a distance (Figure 227). They shunt our eyes back and forth in a radical fragmentation of viewing that is both thematized and intensified by their own convulsive crossfire of glances. Meanwhile, the raw ugliness of their puckered features clutches at us and disgusts us, gnawing at itself and all but consuming itself in the process.

Contrast the measured, twenty-year-old Dexileos and

his doomed but ever straight-backed opponent just half a mile away in the Kerameikos (Figure 258). A casualty of the Corinthian War of 394, where he distinguished himself with conspicuous bravery, Dexileos had received the signal honor of a memorial at the corner of the Street of Tombs. His imposing stele confronted everyone leaving the city with a classic statement of exemplary civic sacrifice. To quote Philip Fehl's brilliant account of a similar memorial:

> [T]he beauty of the victor is like Achilles. He looks like an avenging god; yet he seems conscious of the imminence of his own death. His triumph is not a source of pleasure or relief, but a moment of tragic climax. The scene is transfigured by the perfection of the action and by the appearance of a certain fatal necessity in it. The victim is represented in keeping with a sympathy often found on classical monuments but rarely, if ever again, bestowed in this measure upon the image of a foe. . . . A Greek enemy of a Greek is shown almost as if he were his brother: he is inferior to the victor but chiefly, perhaps, because he was unlucky . . . [T]he fate of the victor, of course, is also tragic, for it is in the memory of his death in battle that the image was erected; but it is so on a different level of sorrow. The pictured eulogy offers us the melancholy consolation that he was allowed to die in glory.[187]

Or, as the orator Lysias remarked in a speech possibly written for Dexileos' own public funeral, "there is no difference between victor and vanquished, except that one will die a little sooner." Yet the stele sidesteps even this distinction, for Dexileos' spear clearly stopped short of his opponent's body, leaving it whole and unpierced. A superbly realized fictionalization and idealization of war, it sanitizes battle, injury, blood, pain, and death, and redescribes them metaphorically as a chance encounter of two young men on the road to glory.[188]

By contrast, our mostly naked, kicking, screaming little men are as inglorious, irrational, dangerous, and self-destructive as wounded animals. For every Greek knew that "a man without a polis is either a beast or a god," and that "second only to the war which all mankind wages against the savagery of the beasts, the most necessary and righteous one is that which we and the Hellenes wage against the barbarians – our natural foes who eternally plot against us."[189] Three types of war result: (1) of Greeks against Greeks; (2) of Greeks against barbarians; and (3) of humans against beasts. In the fourth century, Greeks increasingly had condemned the first of these as fratricidal, and from the late third century the chorus of protest swelled again.[190] Since Philip, a Macedonian and at least nominally a Greek, had committed barbarous outrages against fellow Greeks (1), the Attalid Dedication could castigate him as an egregious example of (2) by using the charged vocabulary of (3) to articulate its message.

Bestial to the end, then, these manically anarchic little figures both epitomize barbarian excess and authenticate Greek superiority through their pierced flesh, grimacing features, and animal cries – for the body is always the ultimate index of the real (see Figures 1–2, 5, 10–12, 41–42, 49–64, 179–81, 183, 187–91). Their injuries and screams anchor and articulate the cultural fiction of Greek preeminence, and their bodies broken in death naturalize the victor's triumph.[191] His voice nullifies theirs, and his body literally tramples theirs. Beaten, brutalized, bloodied, and baying, they are forever denied his "beautiful death" (*kalos thanatos*) in the eternal contest (*agon*) of Greek against Greek.

Their open mouths, gaping wounds, and cupped, convulsive poses contrast with the Dexileos stele's two tight-lipped, straight-backed, and still-unwounded Greeks (Figure 258), and for all their ugliness of feature and eye-popping muscularity covertly feminize them by comparison. For every Greek knew that that Persians were effeminate and that Gauls openly had sex with each other. The Gauls' liaisons, it should be noted, were not the mature citizen's politically and socially sanctioned *erastes-eromenos* relationship with a teenager, evoked on the Dexileos stele by the supple flesh and youthful beauty of the two warriors, but (to Athenians) a perversion punishable by instant loss of citizenship. Older, muscle-bound, scruffy, and uncouth, these barbarians repel the glance of civilized desire. The only one of them that might attract it (see Figures 12, 57–60) is dead.[192]

Furthermore, whereas a Persian victory would have brought slavery, a Gallic one would bring both slavery *and* chaos.[193] Not for nothing was the Galatomachy (IV) placed last, at the climax of the fourfold sequence of battles (Figures 227–28). So whereas the Persians are marked as slaves (see Chapter 3, §4), the Gauls' features dissolve into a violent clash of emotions. And whereas the faces of Dexileos and his opponent share the tranquil beauty and composure proper to the ideal citizen-soldier – instantiating the classical Greek metaphysic of masculinity – those of the Gauls register only conflict, internal and external. Characterized by ancient writers essentially as manic-depressives, they are the ultimate bipolar personalities. Being *aphrones*, "mindless," they completely lack the calm deliberation of the Greek male and the rationality that underpins his bravery. So their decisions are instinctual, erratic, and self-contradictory, and they have no staying power. One of them, the Naples Dying Gaul, is even wounded in the back – the classic sign of the coward (see Figure 42).[194]

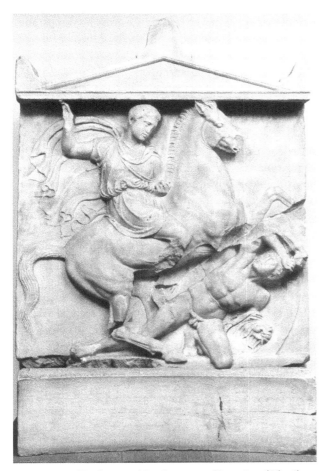

FIGURE 258. Tombstone of Dexileos, son of Lysanias of Thorikos. From the Kerameikos cemetery, Athens; 394/93 BC. Marble; height 1.4 m. Athens, Kerameikos Museum P 1130. Photo: DAI Athens KER 15534. The inscription says that he was one of five cavalrymen who died that year in battle at Corinth, and gives his age as twenty. He thrusts a bronze spear, now lost, toward the chest of his opponent.

What of their outspoken ugliness? Here, Greek attitudes differed markedly from our own. To them, the ugly (*to aischron*) was not only a sign of moral and social/racial inferiority but a species of the comic. As Plato shrewdly noted in the *Philebos,* one's reactions to it would vary depending upon whether the individual concerned could harm one or not. So while Greeks would have regarded most or all of the Attalid Dedication's Giants, Persians, and Gauls as basically disgusting (*bdelyroi*), those still fighting might have provoked a certain nervous apprehension, but the wounded and dead – that is, our Little Barbarians and their fellows – would probably have elicited nothing but derision. One could rejoice in their discomfiture with impunity.[195]

Yet at another level (beyond the Greeks' simple *need* for the Barbarians to validate their own self-description),

all four sets of them do kindle a kind of desire – the desire for the primitive, the repugnant, the barbaric, the violent, the forbidden. Like Gorgons (Figure 257), satyrs (see Figure 151) – with whom the Gauls were regularly compared – and grotesques, they fascinate.[196] Here, to quote Stallybrass and White again, we find high and low, in and out, locked once more in mutual embrace:

> Repugnance and fascination are the twin poles of the process in which a political imperative to reject and eliminate the debasing "low" conflicts powerfully and unpredictably with a desire for this Other. . . . [The high] includes that low symbolically, as a primary eroticized constituent of its own fantasy life. The result is a mobile, conflictual fusion of power, fear, and desire in the construction of subjectivity: a psychological dependence upon precisely those Others which are being rigorously opposed and excluded at the social level. It is for this reason that what is *socially* peripheral is so frequently *symbolically* central.[197]

So four more explanations for the Little Barbarians' physiognomic hyperbole now suggest themselves. Was it intended to counter the Dedication's obvious artificiality qua monument (to produce an intense *effect* of the real)? To deride the barbarian foe? To play on a sneaking fascination with him? And/or to parry criticism that some of his big cousins (see Figures 27–28) really did look a little too sympathetic to these madmen? Before this last suggestion is dismissed out of hand, one should recall that two and half centuries before, the Athenians had fined Mikon, the painter of the Battle of Marathon in the Stoa Poikile, the huge sum of thirty minae for the same offense.[198]

The Akropolis Dedication's clever manipulation of Greek negativity toward the barbarian Other thus had the merit of aligning its four battles with the three fundamental distinctions of Greek (and Western) life: good and evil in ethics; beauty and ugliness in aesthetics; and friend and enemy in politics.[199] By simultaneously collapsing these distinctions into each other and converting the last of them to an absolute polarity, it also played to the Greeks' and, a fortiori, the Athenians' sense of communal solidarity – now badly shaken by Philip's devastating raids. A strongly classicizing portrayal of the victors – like Dexileos (Figure 258) – would have reinforced the effect.

Beyond this, though, the Dedication's audience was totally fragmented. For instead of reducing Greek fractiousness, Alexander's conquests had massively increased it. One man's royal "savior" (*soter*) was another man's tyrant. So we must imagine the Attalid Dedication in dialogue with at least six (!) separate constituencies – what literary critics call "interpretive communities" or

"communities of response." These included Athenians; citizens of other Greek cities; Pergamenes; Macedonians; rulers of other kingdoms and their adherents; and Romans and Italians. How far its authors actually *considered* all of them individually is unknowable. But what did their sculptures have to *say* to each of them, and how might they have reacted to them?[200]

8. RESPONSES

Athenians, the Attalid Dedication's main constituency, would have thrilled to its every nuance – except for those who paused to reflect how far their city had sunk that it now *needed* a protector. The Dedication's emphatically Ionic pedestals registered their unique place in history as the ancestors of the Eastern Greeks. Its themes stoked their patriotism, for – their heroism against the Amazons (II) and Persians (III) apart – they had distinguished themselves against the Gauls in 279 and typically soon claimed that they had led the victorious alliance.[201] It boosted their pride at fighting off the brutal Macedonians almost unaided and eased their sense of loss at the ruined landscape beyond their walls – the loss of much of their very essence as a community. It demonized their enemies and reminded their city goddess of her ongoing need to watch out for them. And by echoing the Parthenon and Panathenaiac peplos, it reassured them that their own heroics truly merited a place in the Olympians' Hall of Fame.

All this provided fuel aplenty for the Athenians' fast-growing nostalgia – a feeling once aptly defined as "memory with the pain removed."[202] Indeed, did Philip's invasion and Attalos' response to it help to launch the second-century Athenian nostalgia industry that soon enthroned the city as the "education to Greece" of Perikles' dreams? For after Athens' liberation from the Macedonians in 229 and especially after the disaster of 200, it swiftly changed from what sociologists of memory have called (none too felicitously) a "memorial" society into a "historical" one. We might call it a museum culture, as with its ongoing, living traditions shattered, it now redescribed itself as *the* repository of the essence of Hellenism. Reasserting its cohesiveness, uniqueness, and distinctive boundaries as a community, it invested (to borrow a remark from the French memory researcher Pierre Nora) in "the systematic construction of a memory that [was] at the same time authoritarian, unitary, exclusivist, universalist, and intensely *passéiste.*"[203]

Athenian literature and art had been canonized as "classics" well before 200; but thereafter, the city promoted its past as never before. Courted by kings and commoners, smug and self-satisfied, the Athenians began to bask in the warm glow of their cultural preeminence and luxuriated in the lavish gifts – temples, stoas, gymnasia, and so on – of benefactors jostling for a place at culture's wellspring. The Panathenaic festival was now celebrated with special lavishness, and the display of Athena's great saillike peplos with its Gigantomachy at the celebrations of 198/197 (by which time the Attalid Dedication may have been complete or nearly so) must have been especially moving. And every year the ephebes paraded their drill and weapon skills at the ancient festivals of the Theseia and Epitaphia and solemnly made the rounds of the ancient "places of memory." Among these was Marathon, where they laid a wreath on the collective tomb of the fallen and held games in their honor, "for they considered showing proper respect to those who had given their all for freedom a noble part of their duties."[204]

Logically, these very years also saw the Hellenistic baroque – the Akropolis Dedication included – anathematized by some unknown but highly influential critic (perhaps the Athenian chronicler Apollodoros) as nonart. His hostility surfaces most dramatically in Pliny's statement that "the art (of bronze-casting) stopped" in the 121st Olympiad (296–293) and revived again only in the 156th (156–153) at the hands of (classicizing) "inferiors." Consigning Epigonos, Phyromachos, and their peers to oblivion, it accounts for much of our uncertainty about them and the Hellenistic baroque. Visiting the Akropolis, critics of this persuasion must have seen the Attalid Dedication as fundamentally alien to the Athenian visual landscape – as an Asiatic import and even imposition – while simultaneously acknowledging its importance to city, sanctuary, and goddess: an uncomfortably conflicted position in which to be.[205]

The city's alliance with Pergamon and Rome remained firm throughout; the Athenians knew a good thing when they saw one. Of course there were always dreamers to chase the mirage of freedom. Some agitated for Antiochos III in 192; Flamininus promptly sent Eumenes to quiet the city and when he failed to do so, the Roman came himself.[206] But if we are correct, Antiochos IV Epiphanes, that inveterate Athenophile and Romanizer, made good twenty years later by dedicating his colossal gilded aegis and Gorgoneion right under the four groups, reinforcing their apotropaic status. He probably donated them soon after 175, when he regained his throne with Attalid assistance, and we can perhaps visualize them hanging directly under the Athena of the Attalid Gigantomachy (I). No one, it seems, took Perseus of Macedon's side in 171–168; memories of 200 died hard.[207]

But in 133 the Attalids faded into history, and in 88 the freedom faction persuaded their fellows to join King Mithradates of Pontos in his ill-advised (although not unprovoked) crusade against Rome. Two years later they paid dearly for their decision, though the Akropolis held out and everything but the gold and silver survived. Three centuries later a Roman epigrammatist praised the bravery of the city's starving defenders by asserting that not one of them died with a wound in his back. So despite their defeat by Sulla's legions, the battered survivors could still count themselves worthy heirs of the *Marathonomachoi;* look up to their undamaged citadel; and glory in their implied superiority over men like the Naples Dying Gaul (see Figure 42).[208]

After Caesar's murder in 44 Athens again backed the wrong horse – the Tyrannicides (as they saw them) Brutus and Cassius – but for once miraculously escaped unscathed. In late 42, soon after the two republicans' demise, Mark Antony – the "New Dionysos" – visited the city and quickly made himself at home. The Athenians promptly converted the two Attalid colossi into portraits of him (AT5, 7) simply by reinscribing them – by then a common sleight of hand.

Yet this new protectorate was to last only a decade, collapsing at Actium in 31 soon after both the colossi themselves and the Dionysos from the Gigantomachy (I) nose-dived so spectacularly into the theater (AT5, 7). Reconfirming the Dedication's special status as one of those contributing to "the everlasting glory of the people," the Assembly's restoration decree (AT2) a decade or so later ordered repairs to it. If this decree really did include the colossi, their replacement(s) would certainly have honored Augustus. For soon after 31 the Athenians had scrambled to dedicate a life-size statue of him at Eleusis as their "Savior and Benefactor," but there is no indication that on the Akropolis this larger step was ever taken. Pausanias, at any rate, does not mention them (AT6), though this may or may not be significant. But all this brings us to the Roman Empire, already addressed in the previous chapter.[209]

Other Greeks' reactions no doubt depended upon how far they accepted Athens's new pretensions as Greece's cultural mecca and its role as a Roman and Attalid puppet. Unfortunately for us the Athenian cultural propaganda campaign's very success afforded dissenting opinions almost no chance of survival. And though Roman hegemony stirred some strong emotions – and Attalos' behavior in 200 won him little esteem from Polybios, at any rate[210] – the historians record only two specific outbreaks of resentment at this Rome–Pergamon–Athens axis, one of which is highly ambiguous.

First, chronicling the events of 195, Livy describes an ugly incident at an international conference involving the mainland Greek states and Pergamon, chaired by Flamininus. When the Athenian delegate trotted out the allies' stock pro-Roman line the Aitolian one exploded, excoriating the Athenians as "once the leaders and champions of liberty but now traitors to the common cause because they want to win a place for themselves by adulation." The backlash was immediate. The (also pro-Roman) Achaian delegate leapt to the Athenians' defense and attacked the Aitolians as robbers and thieves, "Greeks in tongue only and men in appearance only; more bestial in their practices and rites than any barbarian, no, more so even than monstrous beasts!" The matter rested there.[211]

Second, Polybios notes that in the 160s the more the Romans snubbed Eumenes, the more the other Greeks sympathized with him. Yet so far from signaling any prior Greek dissatisfaction with the Pergamene king (which would contradict a mountain of other evidence), the historian's remark merely implies that Roman actions further strengthened his already strong position in their eyes. And the Akropolis Dedication omitted the Romans anyway. Taken at face value it simply proclaimed Eumenes' father, Attalos, to be the foremost benefactor of the Greeks in general and of the Athenians in particular, and the second-century Attalid donations to the city underscored the fact.[212]

Visiting Asian Greeks would not have disagreed. For they still had much to fear from the Gauls, who raided Lampsakos in 196 and Herakleia and Pergamon itself in 190. A joint Roman–Attalid campaign in 189–188 led by Manlius Vulso dealt them a huge blow, but in 185 they allied with Prousias I of Bithynia and attacked again. Eumenes then defeated them twice more and annexed their territory in the subsequent peace treaty. Yet only after a major rebellion in 168 and a Pergamene invasion of the Gallic heartland – against Rome's wishes and without its help – were they crushed once and for all.

A Gallic battle frieze found at Ephesos may be connected with these events (Figures 259–62). Once thought to be imperial in date, it manifests many points of contact with the frieze of the Temple of Artemis Leukophryene at Magnesia, the Telephos frieze, and the Aemilius Paullus base at Delphi – all carved between 200 and 150. Since it features both Greeks and Romans (identifiable by their round and oval cavalry shields, respectively), one immediately thinks of Vulso's campaign of 189–88, when he returned booty-laden to Ephesos to enormous popular acclaim. One of the dead somewhat resembles the Venice Dead Gaul, but otherwise the hirsute, bearded, trou-

sered fighters, naked from the waist up, are nothing like either the Big or Little Barbarians. So are our copies unrepresentative of the two ensembles, or did Attalid dedications in Greece focus on the totally naked berserkers at the expense of the others? Lacking further enlightenment, it is time we returned to the Akropolis.[213]

Pergamenes, the Attalid Dedication's no. 2 constituency, would have gloried in it – especially since their kingdom had little history to speak of; was new to the international scene; was relatively weak compared with Macedon and Syria; and had played a less than stellar part in the Second Macedonian War and the events of 200. For it visibly certified their bravery, power, independence, wealth, taste, and beneficence; it paraded both their Hellenic roots and their East Greek distinctiveness; it consecrated their great victory over the Gauls (IV) as the climax of all history; and it demonstrated beyond doubt that they both respected and would protect the true fount of Hellenism. What followed – the colossi, stoas, and pillar monuments – would only have strengthened these feelings. By midcentury, Athens was studded with Attalids.

The Akropolis Dedication's eulogy of all things Pergamene precisely mirrored its implicit assault on all things Macedonian: "The Pergamenes are like the ancient Athenians, who are like the Olympians, who are like . . . the Pergamenes!" Indeed since it both celebrated Athens' defeat of the Amazon hordes (II) and enthroned the Kaïkos battle (IV) as the Pergamene Marathon (III), what a coincidence that the Amazon Queen Myrina had halted her invading hordes at the Kaïkos River too![214]

Yet a generation later, the Great Altar (see Figures 68–69, 91, 236) fingered the Gauls and other hostiles only indirectly.[215] The Gigantomachy introduced on the Akropolis (I) to supplement human victories had now all but consumed them. Myth's universalizing power was now in the ascendant, and among its vast corpus of stories only this one could elevate victory to truly cosmic significance. The wheel had turned full circle, back to the Panathenaic robe and Parthenon.

Macedonians, being unrepresented and (surely) unnamed on the Attalid Dedication, would have greeted all this with cynicism or even a certain annoyance – if any dared visit the city between the expulsion decree of 200 and the kingdom's extinction in 168. For regardless of the war's final outcome, the events of 200 had taught the meddlesome Athenians a stern lesson and forced them back into their traditional impotent neutrality. Moreover the Attalids were mere Roman lackeys; the Kaïkos battle (IV) was ancient history and had not exterminated the Gauls anyway; and the Pergamene army was puny compared with their own.

Furthermore, Mount Olympos and the halls of the gods lay squarely within Macedonian territory; their national sanctuary of Zeus at Dion sat at its foot; and it was their king who had finally smashed the Gallic threat to Greece in 277. So how could the Dedication's Giants (I), Gauls (IV), and others legitimately stand for themselves? Even during the war their archenemy Flamininus had publicly admitted that if Macedonia were destroyed, the Greeks "would very soon experience the lawless violence of the Thracians and Gauls, as so often in the past." Macedonia was Greece's bulwark against barbarism, not its source.[216]

Visitors from other Hellenistic kingdoms would have reacted more equivocally. The Bithynian kings were rabidly anti-Attalid and used Gallic help against them whenever possible, but there is no record of any contact at all between them and Athens. Pharnakes of Pontos (r., ca. 196–170) trod the same anti-Attalid path but befriended Athens from the start. Unfortunately only a single decree survives, from 195, and apparently he never came to visit. As for the Ptolemies, Athens's traditional protectors, in 200 their bitter struggle with the Seleukids had let them off the hook, but the erosion of their position must have become ever clearer with every new Pergamene donation to the city. They probably viewed the city's new partners with decidedly mixed feelings.[217]

To turn to the Seleukids, the war of 192–188 had interrupted Athens's longstanding friendship with them only briefly – indeed, many Athenians remained pro-Seleukid throughout. Pergamene–Seleukid relations were a different matter. For Attalos I had fought the Seleukids for much of his reign, and in 198 Antiochos III had taken advantage of his absence at the Macedonian War to stab him in the back by invading his kingdom. A Roman embassy stopped him in his tracks, but soon he was making deep inroads into Pergamon's sphere of influence in western Asia and even extending his domains to Europe.[218]

In 188, though, the Romans expelled Antiochos from Greece and Asia Minor altogether; fixed his western frontier at the Tauros Mountains; and ordered him to send his younger son Antiochos (the future Antiochos IV Epiphanes) to Rome as a hostage. Only then did Pergamon recoup its lost territory. Not surprisingly, Pergamene–Seleukid relations soon improved, peaking in the early 170s upon the young Antiochos' release from captivity. After lingering in Athens for several years, where he became hugely popular, in 175 he persuaded Eumenes to help him onto the Seleukid throne. The Athenians promptly sent off effusive congratulations.[219]

Once entrenched in Syria, Antiochos IV soon sent the city the great gilded aegis and Gorgoneion mentioned earlier and financed a completely new Temple of Olym-

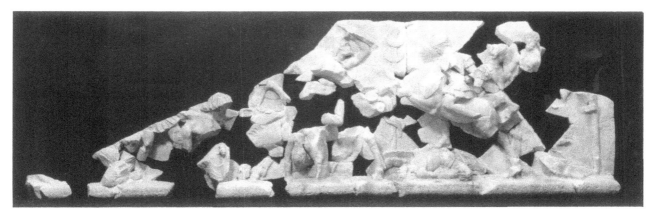

FIGURE 259. Greeks and Romans fight Gauls. Frieze from Ephesos; ca. 200–150 BC. Marble; height 99 cm. Formerly Vienna, Kunsthistorisches Museum I 814, now returned to the Selçuk Museum. Photo: Kunsthistorisches Museum, Wien II.27.335. Possibly carved to celebrate Manlius Vulso's Gallic campaign of 189–88, when he returned booty-laden to Ephesos.

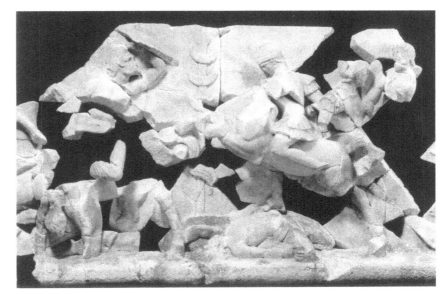

FIGURE 260. Right-center of the frieze, Figure 259. Ca. 200–150 BC. Photo: Kunsthistorisches Museum, Wien II.27.333.

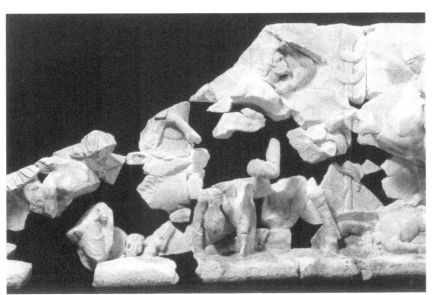

FIGURE 261. Left-hand side of the frieze, Figure 259. Ca. 200–150 BC. Photo: Kunsthistorisches Museum, Wien II.27.334.

FIGURE 262. Head of a Gaul from the frieze, Figure 259. Ca. 200–150 BC. Photo: Kunsthistorisches Museum, Wien.

pian Zeus (Figure 235) to replace the unfinished Peisistratid one. Fervently pro-Roman, pro-Pergamene, and pro-Athenian, as well as an ardent classicizer and an all-around philhellene, he died a decade later crusading against the Persians' successors, the Parthians. So ironically and unbeknownst to the Attalid Dedication's authors (who cannot have foreseen any of this or the radically changed world that brought it about), he becomes its latter-day model spectator. He must have known and admired it during his years in Athens, and obviously meant his aegis not to trump it but to complement it, to strengthen whatever apotropaic powers – by Athena's grace – it possessed.

Finally, *Italians and Romans:* Though the Attalid Dedication ignored the Romans, the Attalids' staunch fidelity to their cause both made Rome a kind of silent partner in it and anticipated a favorable response from them. Locked in their own ongoing struggles with the Gauls that were finally resolved only by Caesar's conquests of the 50s, the Romans – or rather, their northern Italian allies – had ample reason to imitate it in their own funerary art (see Figure 86).

Unfortunately, their other Gallic monuments are less illuminating. The Ephesos frieze (Figures 259–62) – regardless of who commissioned and carved it – makes no obvious reference to the Little Barbarians, nor does the contemporary terra-cotta Galatomachy from Civitalba. The Fallen Gaul from the Agora of the Italians on Delos (see Figure 70), perhaps connected with Marius' victories of 102–101 over the Germans in southern Gaul, resembles them only in that he too falls wounded. He was found alone in one of the niches of the Agora, whose restricted space (4 × 3 m) leaves very little room for a victor. He shows that by 100 BC the lords of the West were openly exploiting the favorite publicity tool of the now-defunct Attalid regime and may have been experimenting already with displaying the vanquished alone, for reasons discussed in Chapter 3, §3. Roman republican coins offer many images of fighting and defeated Gauls, but these follow the long-bearded type of the Ephesos frieze (Figure 262); a denarius minted by P. Fonteius Capito in 55, however, does show a Paris Kneeling Gaul–type battling a rider.[220]

Roman attitudes to Athens were much different. Consistently turning down the city's offers of military help and well aware of its political impotence, they viewed it merely as a convenient strategic base even while accepting its self-proclaimed status as Greece's cultural capital. Yet such recognition had its downside. Though Aemilius Paullus, for example, took in the Akropolis like a modern tourist after his great victory at Pydna in 168, his tastes were sternly classical; he even decamped with a Pheidian Athena to dedicate at Rome in the Temple of Today's Fortune.[221] And Sulla, besieging the city in 86, brutally put its Panhellenic and historicist pretensions into crystal-clear perspective. When an Athenian delegation tried to conciliate him by resurrecting the ghosts of the Epitaphia – Theseus, Eumolpos, and the Persians – he dismissed them with the jibe that that he had come to teach them a lesson, not to learn ancient history.[222]

By then, with the Athenians' Attalid protectors long defunct and their kingdom a Roman province, ancient history is exactly what the Akropolis Dedication had become. Briefly thrust once more into the limelight under Antony in the late 40s and 30s, after Actium and the loss of the Dionysos and the two colossi it soon became merely a historical curiosity (AT2, 5, and 7). By the high Roman Empire, when Pausanias saw it, he even had to explain to his audience who the Attalids were, "since no report of them still survives."[223]

CONCLUSION

"The Truth in Sculpture"

◎ ◎ ◎

1. LOOKING BACKWARD

In the 1920s, American archaeologists digging the huge occupation mound or *tell* at Megiddo in Palestine declared that they were going to "peel it like an onion," layer by layer, until all its strata had been revealed and removed and nothing was left. In the 1960s, Michel Foucault developed a superficially similar "archaeological" method in order to dig up the discursive "archive" – the discursive rule systems or *epistèmes* – underpinning the modern disciplines of psychology, medicine, and the social sciences.

Tell-peeling, however undesirable and unworkable in practice, was suggested by the very nature of the archaeological site to be dug. And although Foucault eventually replaced his "counterhistory" with a "genealogical" method, tracing the descent of practice as a series of discursive "events" sundered by historical ruptures or "jolts," this was a refinement of his previous technique, not a rejection of it. The present volume, in the early 2000s, is prompted by the conviction that:

1. an artwork lives only through its interpretations;
2. all interpretations color it to some extent; and
3. any thorough attempt at a historical interpretation must work backward through them.

To lay bare these successive interpretations and their intellectual/discursive roots not only provokes a sense of estrangement that upsets one's complacency,[1] but also alerts one to the polyphony of voices that the artwork itself has generated. It simultaneously defamiliarizes the object and reveals its polysemy.

2. LOOKING AGAIN

Having sifted and historicized these interpretations, we can begin to understand the object's steady accumulation of meaning – its semantic dynamism. One way to do this is to resurrect a paradigm partially explored in a previous volume and briefly touched on in Chapter 3, §§3, 5: the dichotomy of glance and gaze.[2] To summarize:

Current theory is derived from the writings of three twentieth-century French thinkers: the existentialist philosopher Jean-Paul Sartre (1905–80), the psychologist Jacques Lacan (1901–81), and the phenomenologist Maurice Merleau-Ponty (1908–61). It distinguishes two polarities in the scopic field: the *glance,* which emanates from the self, and the *gaze* (often capitalized), which issues from the Other – from "society." The two are not reciprocal but cross chiastically and are locked in perpetual conflict.[3]

The glance may be defined as the reach of my desire. Among the Greeks (the atomists and Epicureans in particular) it was conceptualized as long-distance touch.[4] But as I glance around, register the gaze of another, and become conscious of being looked at – of being *in society,* in the "public eye" – I not only tend to freeze and look away but also to adapt my behavior to it. This gaze is

preexistent but essentially unseen. It is the presence of others *as such,* and Lacan pointed out that it even manifests itself extravisually. Thus (in his classic illustration) the peeping Tom at the keyhole hears a footstep in the corridor and immediately feels ashamed at what he is doing.

So by turning me into another's object, the gaze constrains my freedom. Yet it can never win entirely – can never totally suppress my desiring glance – while I am still alive and functioning as a desiring subject. So to paraphrase Kaja Silverman, although the gaze indeed exceeds the glance, the glance also exceeds the gaze, for it alone contains a libidinal supplement. Yet (in a further refinement of the theory) since the gaze is unseen and I have to imagine it, it is actually a socialized projection of my desire too, of my yearning for specular plenitude, for a remedy to my lack.

In our case, the Little Barbarians' manic glances and grotesque facial expressions present an obvious starting place. Now that we have traced the statues' genesis and reception these features too begin to look different: not merely *fin-de-style* sculptural rhetoric but the product of a history. We can insert them into a discourse. In fact, the previous two chapters have suggested at least nine (!) more potential functions for them, as follows:

(2) *Compensatory*: to offset the Barbarians' small scale and thus their reduced impact;

(3) *Persuasive*: to create a powerful reality *effect* to counter the monument's evident artificiality;

(4) *Denigratory*: to mark their subjects as excessive, violent, wanton, wild, and subhuman;

(5) *Derisive*: to make them seem ridiculous and contemptible;

(6) *Fascinating*: to evoke the lure of the primitive, repugnant, barbaric, and forbidden;

(7) *Apologetic*: to meet criticism that some of the Big Barbarians were too soft on the barbarian foe;

(8) *Exculpatory*: to deflect criticism of Attalos' feeble response to Macedonian aggression;

(9) *Vengeful*: to register Athena's revenge on her foes; and

(10) *Apotropaic*: to deter future would-be desecrators of her citadel.

These functions are neither mutually exclusive nor of equal weight. Some of them were probably intended at the time, but others perhaps emerged either during the Attalid monument's manufacture, or when it was first unveiled, or over the following years. Still others may have remained completely unconscious and unarticulated. Their common denominator is an unremitting negativity shaped and reaffirmed by the monument's multiple "authors" – by its "field of production." This field includes the miscellaneous sources whose ideas it appropriated; its actual makers; its genre, which to some extent guided its form; its interdiscursive, interdependent, and interactive relationships with the Stoa Poikile, Parthenon, and Big Gauls; Attalos; the Athenian demos; the "Gorgon-eyed" (*gorgopis*) goddess Athena herself;[5] and its various intended and actual audiences, ourselves included.

This negativity, this gaping, hungry void at the core of these statues, reflects the Hellenistic public's-eye view of barbarism – the judgment of the Greek gaze about the year 200. These Barbarians are defined by what they are not: not articulate, not healthy, not wholesome, not rational, not civilized, and not Greek. They thereby implicitly construct their own antithesis: a single, ideal Hellenic spectator patched together Humpty-Dumpty fashion from the motley viewership enumerated in Chapter 4, §8. As against, say, the Dexileos monument (see Figure 258) the monument's four separate attempts to anchor this fictional Hellenic subject's supposedly unitary gaze in history betray its utter artificiality and its real fragmentation in the Hellenistic present – even on the subject of barbarism. For the Hellenistic kings – even the Attalids – were by no means implacably hostile to barbarians; and the Romans, though currently allied to the Attalids and Athenians and thus arrayed on the side of virtue, were not only technically barbarians but often behaved like them too – and sometimes even worse.[6]

Our Little Barbarians cringe and open up before this neurotically fixated gaze, which attacks and penetrates them mercilessly. They suffer cruelly at its touch. For all its macho muscularity, this is a sculpture of orifices – of cupped bodies, splayed crotches, distended armpits, gaping wounds, open mouths, and flaring nostrils. The gaze penetrates and tortures these individuals with its own fear of dismemberment and disintegration, of lurking animality, of the invasive uncivilized Other that threatens its already compromised unity and integrity. It translates the objectified attributes of their pain into insignia of power, converting them into factitious emblems of their victors' strength.[7]

This tormenting violence and resultant display of a fiction of power are the products of this society's own crisis of distinction; of its disordered loss of difference; of the unholy specter of Macedonians/Greeks themselves turned barbarians. In his classic study of a similarly tormented Germany after 1918, Klaus Theweleit analyzes some

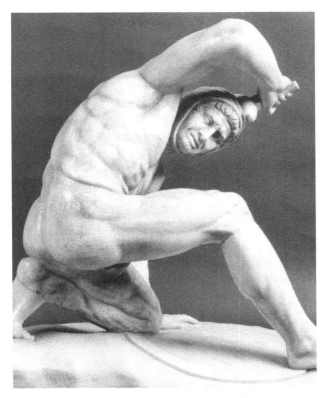

FIGURE 263. Vatican Persian. Photo: Vatican Museums XXXVI.-27.25/5.

FIGURE 264. Rider from the west frieze of the Parthenon. Ca. 440 BC. Marble; height of frieze 1.05 m. London British Museum. Photo: Alison Frantz Archive, American School of Classical Studies at Athens EV 190.

German army proverbs about category confusions that signal the onset of war. In our case too the crisis "accompanies the disappearance of the signifier" and threatens a state of "becoming animal."[8]

What of the glance, of the reach of individual desire? Cowering and glancing hysterically this way and that, the Barbarians are clearly men of *failed* desire (Figure 263). Inter alia this helps us to eliminate any desire for them other than the sadistic or furtive sort. (Among the extant ones, only the Amazon – if Antiope, a convert to civilization – and the Venice Dead Gaul could possibly ignite a "normal" eros [see Figures 12–13], and they are safely in Hades.) On the Hellenistic Akropolis all this would have deflected our pent-up eros to the victors: the Olympians, the Athenians of old (Figure 264), and Attalos and his Pergamenes.

Yet despite the Athenians' adulation of Attalos in 200, one could hardly "fall in love" with a middle-aged king and his hard-bitten mercenaries as one could with the "eternal springtime" of Dexileos and the beautiful young men of the Parthenon frieze (see Figures 258, 264).[9] This further lack leaves only the past and its ghosts. So not only are gaze and glance misaligned but the one is irrevocably fragmented and the other has no living object. Small wonder that Attalos' successor, Eumenes, soon resurrected a unity of sorts in the vast mythological machine of the Great Altar (see Figures 68–69, 236). For myth is the narrational equivalent of the gaze. It too exists outside historical time, space, and the human viewer's body. And the Gigantomachy is the *Ur*-myth of conflict.[10]

3. LOOKING FORWARD

In imperial Rome the elimination of the victors ostensibly removed the eros-laden glance entirely, leaving only sadism and the gaze – the withering, desouling, "basilisk stare"[11] of the Roman public eye. It also brought the condition of the Little Barbarians – bleeding, cringing, crying, collapsing, and alone (Figure 263) – closer to that of men under torture than of real adversaries in battle. But as every Greek and Roman knew, torture (especially of barbarians and slaves) produces Truth and thus validates its enforcer, the gaze. Indeed, even as I write these words, the Giants are still being tortured eternally in Hades.[12]

But eliminating the four sets of victors also effectively reunifies the gaze and decisively realigns the spectator with it. Scrutinizing these tortured little bodies, he channels the unseen majesty of the emperor and the *res Romana* that together gaze over his shoulder, preceding and outlasting his brief appearance on the scene. He is ephemeral but they are eternal. Standing before these barbarians he momentarily joins with, embodies, and enacts this imperial – and imperious – Roman gaze; he *performs* it. Pinned like insects by its basilisk stare they are displayed for him like objects of sport. And like Winston Smith in George Orwell's *1984* he is grateful and glad. Recoiling from them, his eros fixates upon Big Brother (see Figures 173–74); but should he step out of line. . . .

In the Renaissance the picture changes radically. Decontextualized, soon dispersed, and swiftly turning from a group of legendary Roman heroes (the Horatii and Curiatii; see Figure 98) to a collection of morally ambiguous killers (gladiators; see Figures 2, 104–05), the ensemble is now all but atomized. But because these statues are ancient Roman artifacts they radiate enormous cultural authority. Desiring its own specular plenitude and anxious to create a meaningful, unitary past from the shattered scraps beneath its feet, the "scopic regime" of the *terza maniera* had canonized them even before their discovery. This canonization, in turn, informs and has helped to shape all subsequent Western perspectives upon the antique, the discipline of classical archaeology included.

This scopic regime immediately overcame the statues' resistance as decontextualized, anonymous fragments by naming and framing them – by situating them within what it knew or conjectured about the ancient visual landscape – and later by "restoring" them to a semblance of integrity (see Figure 193). And its spokesmen and prophets, the artists, immediately used them to fuel their own desire to create new worlds. They represented the raw material for Renaissance world making.[13]

This is perhaps one reason why *drawing* quickly became so important. As Francesco da Sangallo noted in his famous letter on the discovery of the Laokoon (see Figure 109), "as soon as it was visible everyone started to draw. . . ."[14] Drawing bridges the gaze (the public eye that gives the discovered fragment of antiquity its preordained authority) and the glance (the individual's desire for it and to create new worlds from it).

So Frans Floris diligently records the raw objects, the fragmentary material traces of the largely vanished, enigmatic but massively authoritative past (see Figure 72). Heemskerck documents their domestication in the collections of the elite, which now literally *owns* them and this segment of the gaze, thereby feeding its lust for power and prestige (see Figure 71). Aspertini co-opts them in order to create his own new fantasy worlds (see Figures 104–05). And thence to Raphael, Michelangelo, Pordenone (see Figure 94), Titian, and the rest.[15]

To turn to the nineteenth century and the Barbarians' rediscovery, the gaze–glance dichotomy emerges as a useful tool for evaluating an object-based discipline. By 1900 the gaze of classical archaeology had emerged as panoptic, modernist, and classicizing.

It is *panoptic* in that it brings or seeks to bring the entire field of Greek and Roman material culture under surveillance. In theory, it sees and reviews everything within it objectively, "from a point where all contradictions are resolved, where the incompatible elements can be shown to relate to one another or to cohere around a fundamental and originating contradiction." Everything beyond its horizon and anything within it that it deems irrelevant or unimportant is consigned to oblivion.[16]

It is *modernist* in that under the guise of objective, quasi-scientific neutrality it diligently sorts and orders its material, turning modern society's desire into fact and its knowledge into power. It does this by creating and imposing upon this material an ostensibly disinterested classificatory grid like those of modern science, bureaucracy, architecture, serial music, and (on occasion) abstract painting – what Friedrich Nietzsche once contemptuously called the "columbarium."[17] It conscripts them into a positivist evolutionary framework.

Finally, it is *classicizing* in that it instinctively continues to judge this material according to a scale of values inherited from Aristotle via Pliny, Vasari, and Winckelmann. Essentially idealist, it privileges classical formalized naturalism as *the* style par excellence.[18] It enthrones this style as the Golden Mean between the archaic and the baroque, implicitly and sometimes explicitly judging the latter, respectively, as "primitive" and "degenerate." So both of this gaze's creations – grid and value scale alike – are normative and norm enforcing.

Heinrich Brunn brought the Little Barbarians within this modernist gaze's purview by noticing, collecting, classifying, dating, and attributing them, and by inaugurating the processes of evaluating, contextualizing, and supplementing them. But under its basilisk stare they soon found themselves in a most uncomfortable situation. For its classicist bias soon doubly devalued them: Not only were they Roman copies but also extreme manifestations of the Hellenistic baroque. And with the triumph of evolutionist formalism their date became an irritant too: 200 or 150? Each date disrupted the grid in its own way.[19] This is why from Brunn onward the individual scholar's questing glance, the reach of his or her desire to look afresh and to say something new, focused

on these issues above all. And it is why recent scholarship has largely opted either for revisiting the grid's center (rehashing dates and attributions) or probing its periphery (reexamining matters of location, iconography, historicity, and so on).

As to what a postmodern view of our Barbarians would look like, the present volume has offered the merest glimpse. Here is another, a conjecture that deliberately strains the limits of the historical.

The Little Barbarians' expressions (see Figures 79, 176–77, 179–80, 183) show that they understand the end that imminently awaits them. But perhaps they do something else. Whereas Dexileos' Spartan opponent (see Figure 258) barely registers his coming fate, the Barbarians' diverse reactions openly acknowledge it *and* the victors' power – for as Plato memorably put it, the power of anything is literally its power to hurt.[20] By taking all this on board, they show that at some level they have internalized the victorious Other – Hellenism's overwhelming moral and ethical superiority, its matchless *arete*. They have measured themselves against it and have found themselves fatally wanting.

So we find a paradox: By thinking themselves *through* the victors in this instant of terminal self-revelation, these "mindless" (*aphrones*) barbarians have come to a certain understanding (*sophia, sophrosyne, gnome*), albeit only at the moment of death. Once repulsed by Apollo from Delphi, they have finally arrived there in spirit and (to a degree) now "know themselves" – their station and fate in life. They know that measured against the Greek, they know nothing and are nothing.[21]

So we arrive, ex post facto, at a final function for their wild glances and facial contortions:

(11) *Revelatory:* to register their understanding that in knowing their enemies, they finally know themselves.

But what of the victors? Was their demeanor classically impassive like Dexileos' (see Figure 258) or generically intense like the victors of, for example, the Alexander Sarcophagus (see Figure 225) and the Great Altar (see Figures 68–69, 236)? No matter. In contrast to the Barbarians' belated arrival at a kind of Socratic wisdom, neither sort would signal any equivalent self-awareness on the victors' side. Long conventionalized by the year 200, they would betray no real acknowledgment of human weakness, of the Greeks' ongoing need for barbarians to validate their own self-description, or (Zeus forfend!) of the Pergamenes' periodic need for Gauls as allies and "friends."[22] Unless, of course, such ostentatious indifference might do so inadvertently.

ESSAY

The Pedestals and the Akropolis South Wall

❦ ❦ ❦

Manolis Korres*

THE PARTHENON RESTORATION PROJECT offers an ideal environment for more intensive study of Greek architecture; the improvement of stone-conservation techniques; and the investigation of countless *disiecta membra* scattered around the Akropolis. Among the fruits of this research are a series of cornice blocks, plinths, and orthostates that can be shown to belong to the famous monument dedicated by King Attalos of Pergamon and described by Pausanias (AT6).

1. IDENTIFICATION

The plinths and orthostates are discussed later (§6). Thirteen cornice blocks have been recognized to date (Γ1–13; see Figures 214–17, 268–78). They are carved in white Pentelic marble of somewhat mediocre quality and average 1.30 m long, 0.80 m wide, and 0.42 m high; the total length preserved is 15.8 m. Since the collection includes three end blocks, two or more separate pedestals must be represented.

These cornice blocks belong to a well-known type consisting of the following elements (Figures 265–67):

1. a plain, roughly tooled underside sometimes furnished with a dowel hole on one or both ends (Figure 265, #10);

2. two long sides embellished with an Ionic two-fascia architrave, cymation, and cornice that on the three surviving end blocks also continue around one short side (Figure 265, #1–6, 1′–6′);

3. two anathyrosed short sides or one anathyrosed and one molded short side (Figure 265, #8, 8′, 9); and

4. a crowning platform set back about 10 cm from the face of the cornice, rising about 11 cm above it, and bearing sockets for bronze statues (Figure 265, #12) and (on some blocks) one or two sets of clamp cuttings for attaching the next block(s) in the sequence (Figure 265, #11).

The numerous sockets for the statues are classifiable into three main types, roughly corresponding to the parts of the body or objects that they secured: sausage-shaped, round or oval, and squarish. Though as usual the cuttings are somewhat narrower and more simply configured than the elements they once secured, the sausage-shaped ones clearly anchored feet about two-thirds life-size. The number, density, and variety of these sockets, their scale, the number of preserved blocks, and the existence of three end ones all indicate two or more long, linear compositions of many different figures at two-thirds life-size, a condition that only the Attalos monument (AT6) can fulfill. The findspots of the blocks reinforce this conclusion. Eight (Γ1–7, 13) were found on the Akropolis near the South Wall; four (Γ8–10, 12) are built into the South Wall's medieval and eighteenth-century revetments (see Figure 217); and one (Γ11) fell into the Theater of Dionysos but has now been returned to the Akropolis.

Nine of these blocks are almost complete, two are half-

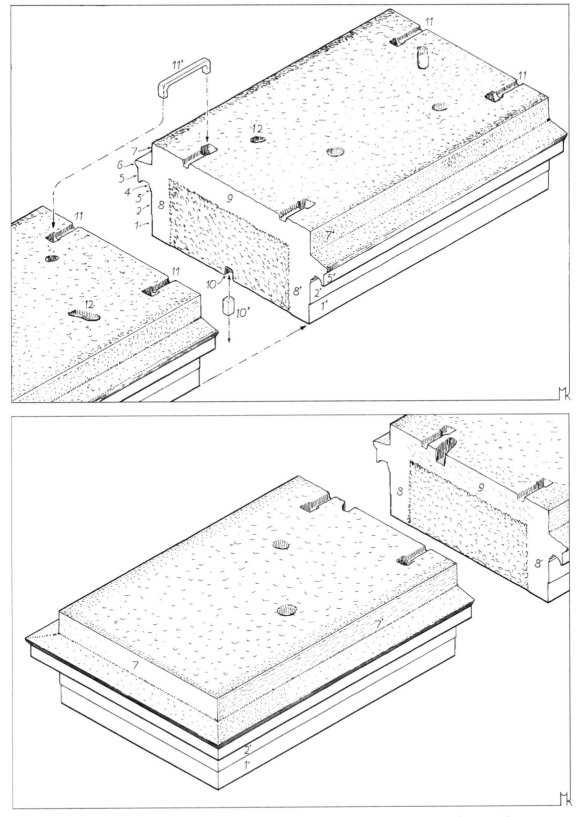

FIGURE 265. Cornice blocks from the Attalid Dedication. Reconstruction of jointing techniques *(above)* using both clamps and dowels; *(below)* using clamps only. Drawing by Manolis Korres.

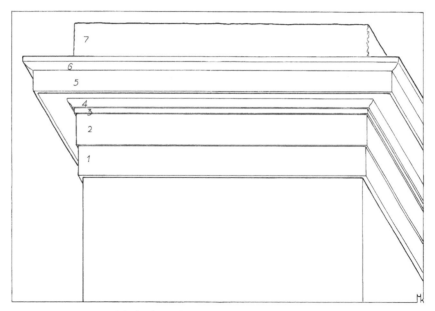

FIGURE 266. Cornice blocks from the Attalid Dedication. Perspective view of moldings. Drawing by Manolis Korres.

preserved, and two are mere fragments. The four reused in the South Wall, all of them almost complete, are partially visible only: Γ10, built upside-down into the base of the eighth medieval buttress from the east, has one long and one short side visible; Γ9, built into the parapet, has its top, one long side, and part of one short side visible; Γ8, built into the parapet midway between the fifth and sixth buttresses from the east, has its top visible; and Γ12, built into the Wall some 12 m farther to the west, has only its underside visible (see Figure 217).

First, some preliminary observations:

1. Γ1, 2, and 5 are end blocks; Γ7 was either an interior or an end block; the rest are interior blocks.

2. All blocks – with the exception of Γ5, whose underside is badly damaged – preserve both their top surface and underside, allowing their height to be measured with certainty in several places. The height of Γ5 is measurable only approximately and only at one point.

3. In most cases the cornices are broken away or sometimes chiseled off. Their complete profiles are preserved only in three cases (Γ1, 2, 6). The *cyma reversa* above the two fasciae, however, is preserved on almost every block. Consequently in almost all cases the width of the blocks is measurable either directly or indirectly.

4. Cuttings for clamps or dowels are present on most blocks but have been destroyed on some; Γ3, 6, and 8 never included any.

2. DOCUMENTATION

Owing to the blocks' limited accessibility, documentation cannot be as complete as desired. Nevertheless the drawings of the cornice blocks (Figures 268–78) contain as much information as possible. Measurements were taken with a precision appropriate to the relative regularity of the blocks (irregularities of 1–3 mm are common), and each block was drawn in situ at a scale of 1:10. The molding profiles were taken at actual size (Figure 267). The drafting distinguishes original and fractured surfaces; geological features (including some distinctive veins); original tool marks, clamp and dowel holes, sockets, and pour channels; later recutting, including the removal of the statues, clamps, dowels, and some of the cornices; and remnants of later mortar.

CATALOG OF THE CORNICE BLOCKS

General features and conventions:

1. The blocks are carved in white Pentelic marble of somewhat mediocre quality with distinct greenish and gray-black veins.

2. The possible 'B' mason's mark on Γ11 is an isolated case. Where the relevant parts of the top surfaces of the other blocks survive, they show no such marks.

3. Block length (L), width (W), and height (H) are in meters.

4. The terms "side 1," "side 2," and so on refer to the sides (1–4) and top surface (5) of each block as numbered in Figures 268–78.

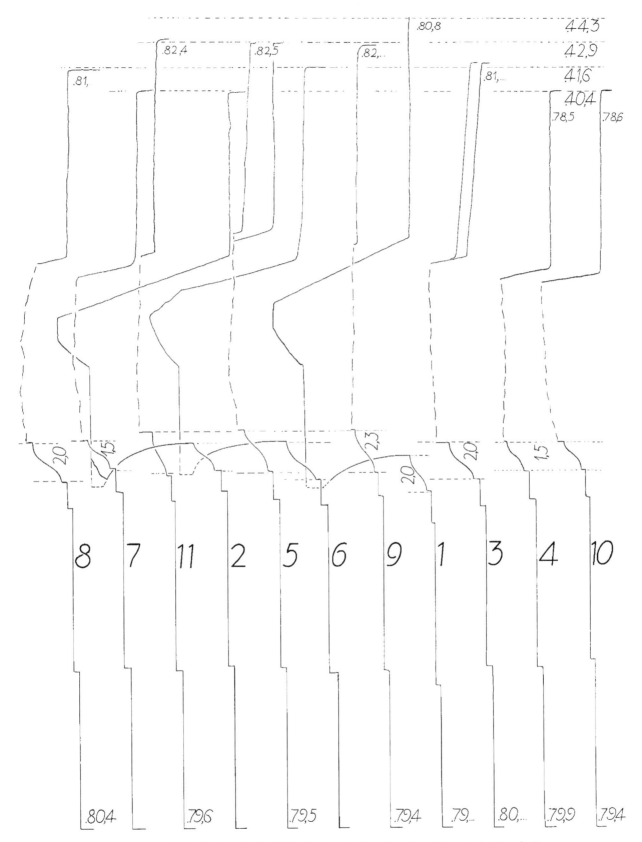

FIGURE 267. Cornice blocks from the Attalid Dedication. Profiles of moldings. Drawing by Manolis Korres.

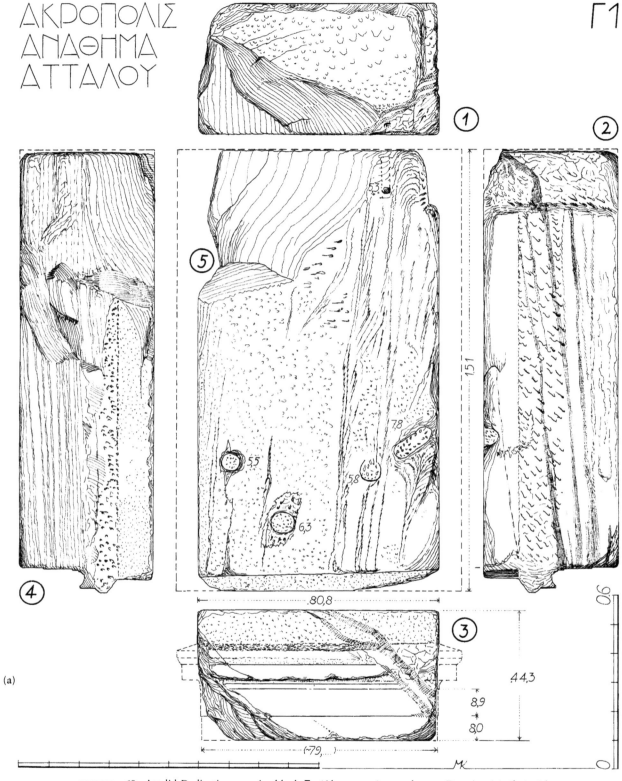

FIGURE 268. Attalid Dedication, cornice block Γ1 (Akr. 15473), actual state. Drawing (a) *(facing)* by Manolis Korres, with key (b) and reconstruction sketch (c) by Erin Dintino.

5. The symbols 1^2, 1^4, 3^2, etc., refer to the corresponding four *corners* of the top surface (5) of each block.

6. The symbols 1–5, 2–5, 3–5, etc., refer to the corresponding four *horizontal* edges of the top surface (5) of each block and adjacent anathyroses where present.

7. The symbols 1|2, 1|4, 2|3, etc., refer to the corresponding four *vertical* edges of each block and adjacent anathyroses where present.

8. All lengths, widths, and diameters of statue sockets are measured at the bottom of the hole, in order to exclude the incidental damage from the statues' removal.

9. All catalog entries are by Manolis Korres, with comments on the statue sockets by Andrew Stewart (AS).

10. For simplicity, all figures are described as male, even though some – the Amazons in group (II) – were certainly female.

Γ1. Akr. 15473. L 1.51; W 0.808; H 0.443. Statue platform, preserved L 1.32; W 0.808. Figures 267–68; Tables 9–10.

Location: South side of the Parthenon; from 1983 to 2002 on the South Akropolis Wall, 7 m from the SE corner; before 1983, 5 m further west (discernible in the aerial photograph, *Archaiologike Ephemeris* 1934–35: pl. 5). Probably built into the medieval crenellated parapet near this spot and removed in 1865 when that was demolished and the present parapet built.

End block, 90% preserved. Cornice on both long sides (2, 4) completely chiseled off, but is substantially preserved on the outer end (3). Recutting at (1^2) indicates secondary use in the medieval wall with side (2) uppermost.

Statue platform (5) ca. 85% preserved; inner end broken away in zigzag fashion; roughly dressed with the point; one pi-clamp cutting at inner end of platform (1–5) badly damaged, the other broken away with the missing part of the block.

Statue sockets (5): Three circular sockets (a–c) and one sausage-shaped one (d), all damaged by looters; others probably broken away with the missing part of the block. Measurements: (a) 5 cm diam × 5.5 cm deep; (b) 7 cm diam × 6.3 cm deep; (c) 7 cm diam × 5.8 cm deep; (d) 13 × 5 × 7.8 cm deep.

Comments (AS): Sockets (a)–(d) fit a two-thirds life-size figure posed like the Vatican and Aix Persians (Figure 268c; cf. Figures 45, 77; Foldout), cowering before an opponent advancing from side (1). He knelt on his left knee (a) with toes braced (b); his right hand (c) was flat on the ground behind his right foot (d), which also was flat on the ground. His body was twisted to his left, and his left arm was probably raised in defense, perhaps holding a shield. Since an opponent on foot would have left traces on the preserved part of the platform, his adversary was probably a rider on a rearing horse that was either joined to this cowering figure or braced by a belly support sunk into the missing part of the platform.

(b)

(c)

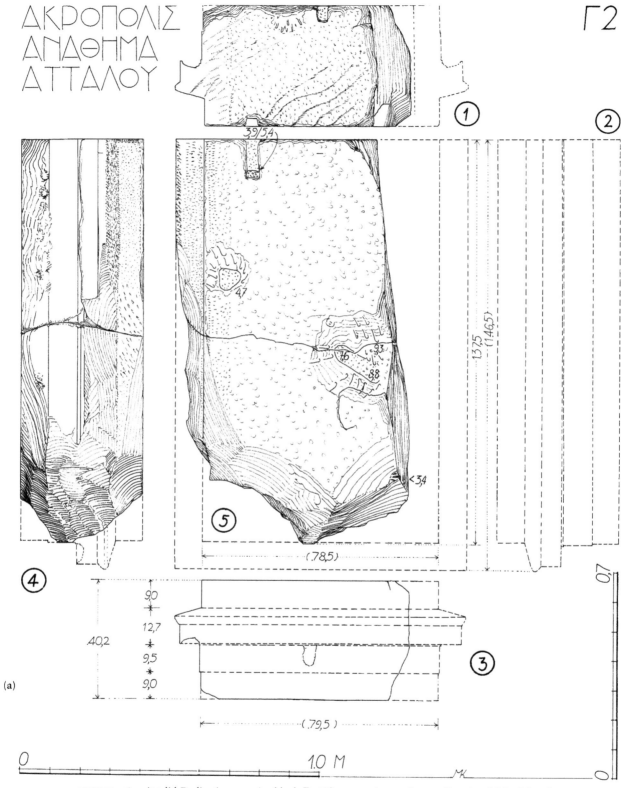

FIGURE 269. Attalid Dedication, cornice block Γ2 (Akr. 15451), actual state. Drawing (a) by Manolis Korres, with *(facing)* key (b) and reconstruction sketch (c) by Erin Dintino.

Γ2. Akr. 15451a + b. L 1.375; W 0.80; H 0.402. Statue platform, preserved L 1.34; W 0.65. Figures 214, 267, 269; Tables 9–10.

Location: In the Chalkotheke.

End block assembled from two large fragments; ca. 75% preserved. One long side (4) including the cornice largely preserved, with minute remnant of the outer end (3).

Statue platform 65% preserved, carefully dressed with a coarse point and slightly undulating; finer traces of point along edge (4–5); on side (4) very fine traces of point, interrupted at one place by heavier pointing. One pi-clamp cutting preserved on inner end of platform (1–5) (the other broken away with the missing part of the block), and one dowel hole at bottom center of side (1). Inner end of block (1) anathyrosed only at edge (1|4), using a fine claw chisel.

Statue sockets (5): One triangular socket (a) with rounded corners and one sausage-shaped one (b) preserved, but heavily damaged by looters. Near corner (2^3), later chiseling indicates a third socket (c); others perhaps broken away with the missing parts of the block. Measurements: (a) 8 × 7 × 4.7 cm deep; (b) 17 × 6 × 7.6–8.8 cm deep; (c) original socket not preserved, only later recutting around its edges.

Comments (AS): Sockets (b) + (c) fit a warrior lunging in from the pedestal's outer end (3), with his right foot (b) and the ball of his left (c) flat on the ground and his left heel raised (Figure 269c). He was attacking an opponent on a horse, whose right hoof (a) rested on the ground and whose left hoof was raised (Figure 269c).

(b)

(c)

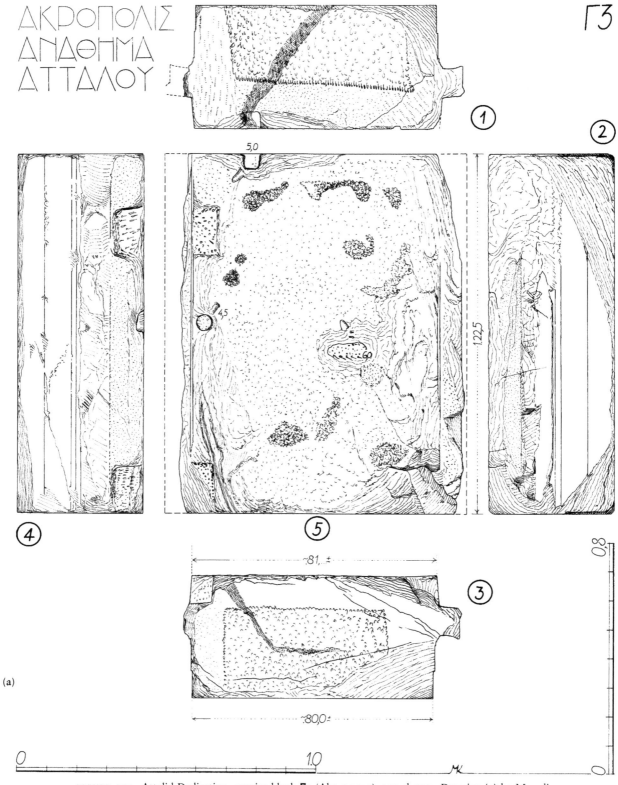

FIGURE 270. Attalid Dedication, cornice block Γ3 (Akr. 15455), actual state. Drawing (a) by Manolis Korres, with *(facing)* key (b) and reconstruction sketch (c) by Erin Dintino.

Γ3. Akr. 15455. L 1.225; W 0.91; H 0.418. Statue platform, L 1.225; W 0.81. Figures 214–15, 267, 270; Tables 9–10.

Location: In the Chalkotheke.

Interior block; ca. 90% preserved; cornice of side (2) mostly preserved, of side (4) broken away.

Statue platform (5) 90% preserved, roughly dressed with the point; its long edges (2–5) and (4–5) broken. Two large rectangular cuttings on one long side of statue platform (4–5) are secondary, presumably to hold wooden beams or rafters (with the block in its original position, built into the medieval additions to the South Wall, or elsewhere?). Remnants of mortar on the platform (5); on both its sides, fine point work. No dowel holes or pi-clamp cuttings. Both ends of block (1, 3) anathyrosed; each right-hand band (1|4, 2|3) wider than the left; horizontal bands carelessly dressed. Erosion at the joint on anathyrosis band (1|4) indicates that the block remained in situ for a long time.

Statue sockets (5): One square socket (a) (continued on the next block?), one round one (b), and one sausage-shaped socket (c). Lead pour channels in all three. Measurements: (a) 4.5 × 4.5 × 5 cm deep; (b) 3.5 cm diam × 4.5 cm deep; (c) 12 × 5 × 6 cm deep.

Comments (AS): Socket (b) and footprint (c) fit a warrior lunging across the pedestal, with his right foot (c) and the ball of his left (b) flat on the ground and his left heel raised (Figure 270c). He was probably challenging an opponent on a rearing horse, braced by a belly support sunk into socket (a) (Figure 270c): cf. the Aristainos base (Figure 220), also supporting a two-thirds life-size equestrian statue. The distance between the support (a) and this lunging warrior (b) + (c), around 55 cm, tallies with the dimensions of the horse that once stood on the Aristainos base (Figure 220).

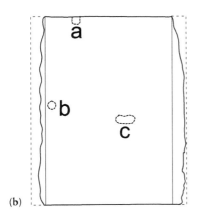

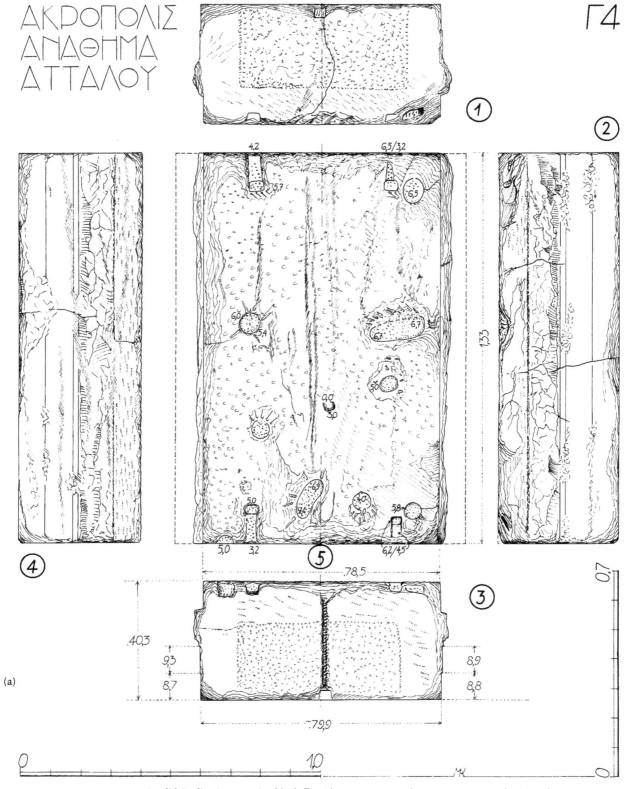

FIGURE 271. Attalid Dedication, cornice block Γ4 (Akr. 15461), actual state. Drawing (a) by Manolis Korres, with *(facing)* key (b) and reconstruction sketch (c) by Erin Dintino.

Γ4. Akr. 15461. L 1.33; W 0.88; H 0.403. Statue platform, L 1.33; W 0.785. Figures 214–16, 267, 271; Tables 9–10.

Location: In the Chalkotheke.

Interior block; ca. 98% preserved; cornice along both sides (2, 4) largely broken away.

Statue platform (5) 98% preserved, roughly dressed with the point; its long edges (2–5, 4–5) battered; both its sides dressed with claw chisel; drafting margin with a flat chisel. Two pi-clamp cuttings at each end of platform (1–5, 3–5); dowel hole at bottom center of each end of block (1, 3), the latter with vertical pour-channel. Both ends (1, 3) anathyrosed with traces of claw chisel.

Statue sockets (5): Two sausage-shaped sockets (d), (i); six round or oval ones (a), (b), (e), (f), (h), (j); part of another (c) near (3^4), definitely continued on the next block; a very shallow, square cutting (g) near the middle. Measurements: (a) 7.5 × 6 × 5.4–6 cm deep; (b) 6 × 5.5 × 6 cm deep; (c) 5.5 cm diam × 5 cm deep; (d) 14 × 6 × 6.9–7.4 cm deep; (e) 5 cm diam × 4–5 cm deep; (f) 5 cm diam × 5.8 cm deep; (g) 3.5 × 2 × 3 cm deep; (h) 6 × 5.2 × 5 cm deep; (i) 18 × 7.5 × 6.7 cm deep; (j) 8 × 7 × 6.5 cm deep.

Comments (AS): The composition, complicated and interlocked, is hard to restore. The two footprints (d), (i), both left feet but one considerably smaller than the other (an Amazon?), show that it consisted of at least three figures. One (i) + (j) lunged from the back of the block and another (d) + (?) from the next block in the sequence; they were probably fighting over one or more fallen figures (Figure 271c). Socket (g) is suspiciously shallow and small, with no trace of looting; it could be a mistake. So one might restore either a figure like the Naples Amazon or a mirror-image version of the Naples Dying Gaul in (a), (b), (e), (f), and (h); cf. Figure 280, nos. 4, 7, and the Capitoline Trumpeter, Figure 28. Socket (c) crossed two blocks, indicating that all were cut after the pedestal was assembled.

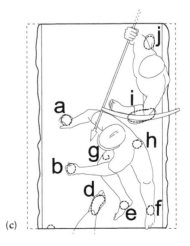

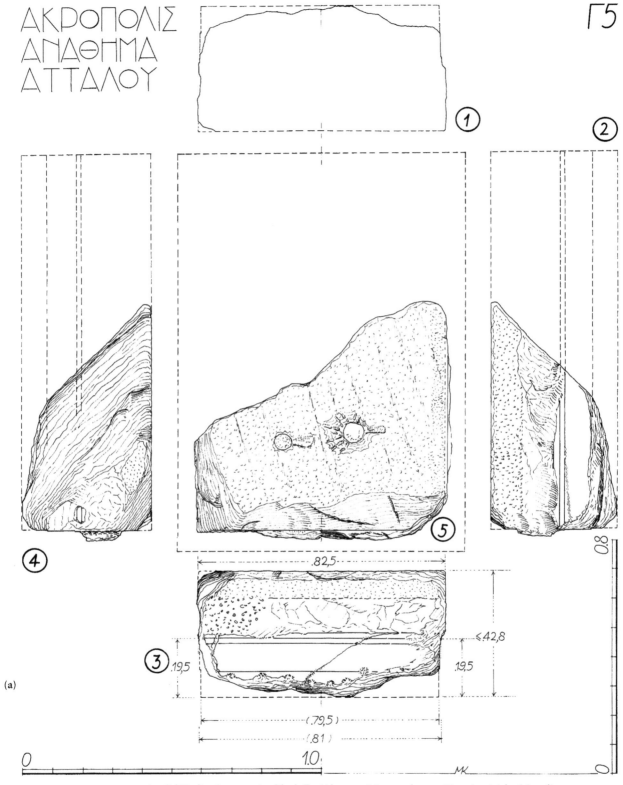

FIGURE 272. Attalid Dedication, cornice block Γ5 (Akr. 15465), actual state. Drawing (a) by Manolis Korres, with *(facing)* key (b) by Erin Dintino.

Γ5. Akr. 15465. L 0.83; W 0.84; H 0.428. Statue platform, preserved L 0.73; W 0.825. Figures 214, 267, 272; Tables 9–10.

Location: In the Chalkotheke.

End block; ca. 20% preserved; cornices broken off on all three sides (2, 3, 4); width measured from a tiny remnant of side (4). The equally tiny remnant of the underside is heavily worn, so measurements taken from it are approximate.

Statue platform (5) 30% preserved, carefully dressed with the point; finer pointing on the long edge (4–5); its sides roughly pointed.

Statue sockets (5): Two round sockets (a), (b), one (b) heavily damaged by looters; others probably broken away with the missing part of the block. Measurements: (a) 5 cm diam × 5 cm deep; (b) 7 cm diam × 5.5 cm deep.

Comments (AS): The two sockets could (just) be reconciled with the knee and toes of a kneeling figure like the Paris Gaul, a cowering one like the Aix and Vatican Persians (as on the end block Γ1), or even the toes and supporting hand of a figure like the Venice Kneeling Gaul; but plenty of other options are available – for example, the elbow and hand of a crawling figure.

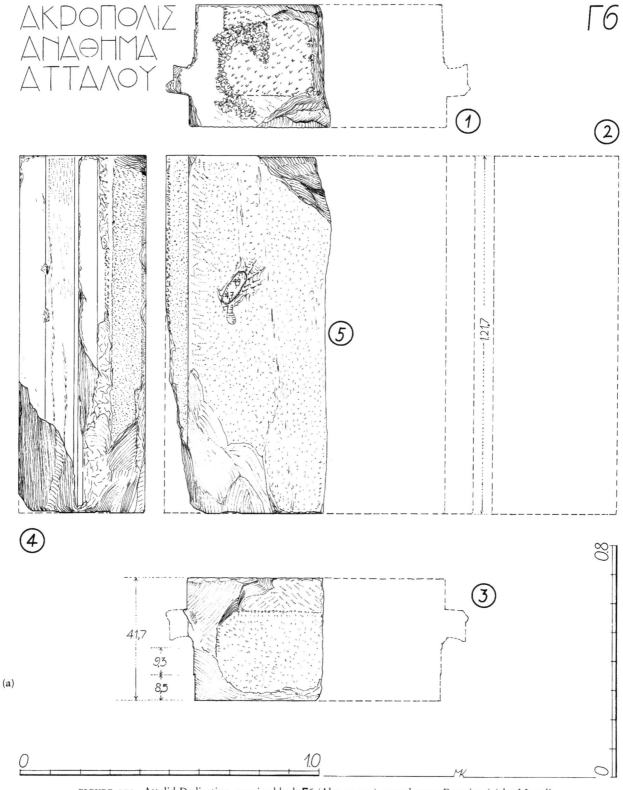

FIGURE 273. Attalid Dedication, cornice block Γ6 (Akr. 15471), actual state. Drawing (a) by Manolis Korres, with *(facing)* key (b) by Erin Dintino.

Γ6. Akr. 15471. L 1.217; W 0.54; H 0.417. Statue platform, L 1.217; preserved W 0.47. Figures 214, 267, 273; Tables 9–10.

Location: In the Chalkotheke.

Interior block; ca. 50% of the mass preserved; cornice along side (4) mostly preserved.

Statue platform (5) 40% preserved, dressed with a fine point and with a claw chisel along the edge; its side (4) dressed with a fine point and drafted along the edge with a flat chisel. No preserved dowel holes or pi-clamp cuttings. On the top of the cornice (4), the usual finish with a fine point is interrupted along the edge of the drip molding by coarser primary chiseling that was normally removed in the final stages of carving. This indicates either that the block was inaccurately roughed out in the quarry, or that the cornice was originally designed at a slightly lower level. Second fascia (4) dressed with a very fine claw chisel and a very narrow flat chisel along the margins. Sides (1) and (3) anathyrosed. Remains of mortar from secondary use on side (1).

Statue sockets (5): One sausage-shaped socket (a) with pour channel, damaged by looters; others probably broken away with the missing part of the block. Measurements: (a) 14.5 × 6 × 4.7–4.9 cm deep.

Comments (AS): Socket (a) held the right foot of a figure lunging diagonally across the block.

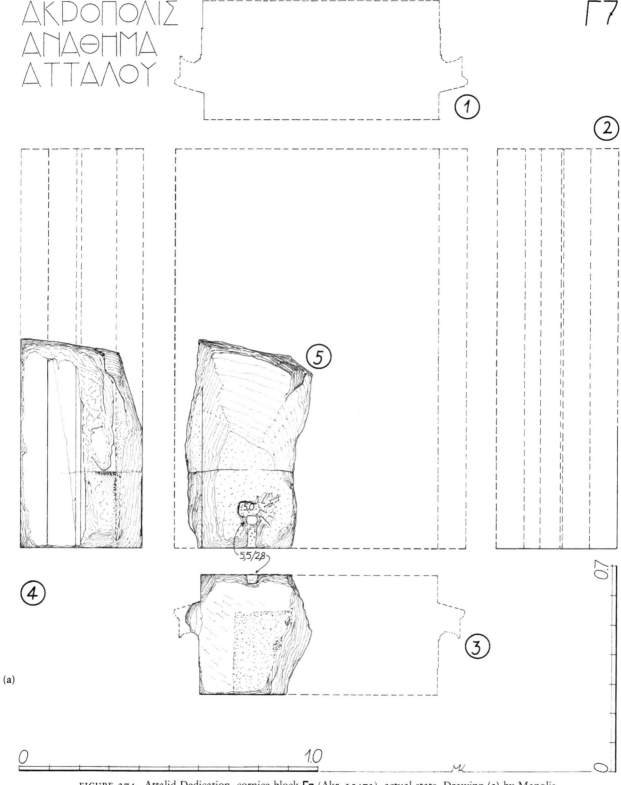

FIGURE 274. Attalid Dedication, cornice block Γ7 (Akr. 15472), actual state. Drawing (a) by Manolis Korres, with *(facing)* key (b) by Erin Dintino.

Γ7. Akr. 15472. L 0.70; W 0.37; H 0.405. Statue platform, preserved L 0.40; W 0.35. Figures 267, 274; Tables 9–10.

Location: In the Chalkotheke.

Interior block; ca. 17% preserved; cornice along side (4) mostly broken off.

Statue platform (5) 10% preserved, stippled with a fine point; its side dressed with fine point; its edge (4–5) is broken. One pi-clamp cutting preserved (3–5).

Statue sockets (5): One rectangular socket (a), damaged by looters, intersecting the pi-clamp hole. Measurements: (a) 7.5 × 5.5 × 5 cm deep.

Comments (AS): The positioning of socket (a), which probably held a belly support for a horse, again shows that the composition was designed independently of its pedestal.

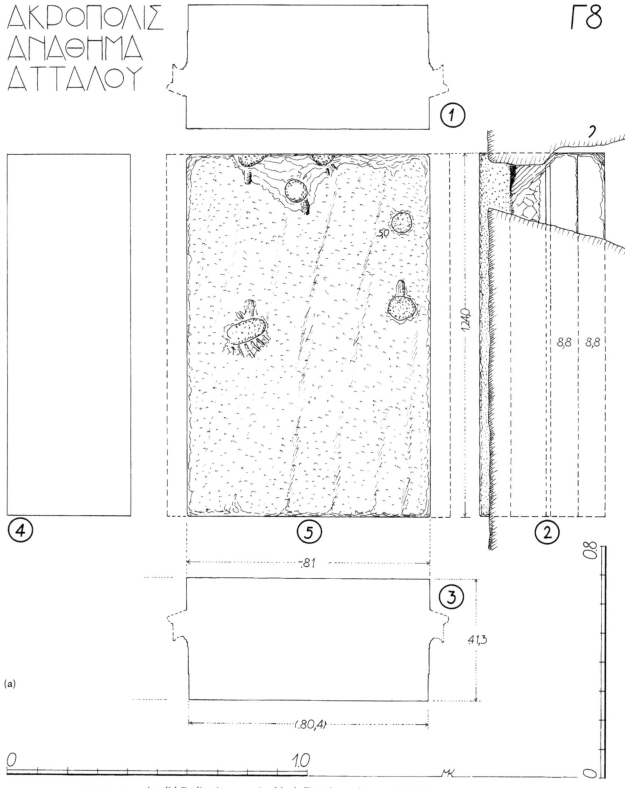

FIGURE 275. Attalid Dedication, cornice block Γ8 (Akropolis, South Wall, unnumbered), actual state. Drawing (a) by Manolis Korres, with *(facing)* key (b) and reconstruction sketch (c) by Erin Dintino.

Γ8. Akropolis, unnumbered. L 1.24; W 0.81; H 0.403. Statue platform, L 1.24; W 0.81. Figures 217, 267, 275; Tables 9–10.

Location: Built into the parapet of the South Wall, midway between fifth and sixth buttresses from the east, with its top (5) facing out and side (4) as resting surface.

Interior block; probably complete except for its cornices. (A section of the parapet was removed in order to investigate side [2].)

Statue platform (5) 98% preserved, dressed with the point; on side (2) traces of pointing. No pi-clamp cuttings.

Statue sockets (5): One sausage-shaped socket (c), three round ones (b), (d), (e); parts of another sausage-shaped one (a) and another round one (?) (f) along (1–5) (definitely continued on the next block). Sockets (c), (d), (e), (f) damaged by looters; pour channels are traceable along the sockets (a), (b), (c), (d). Measurements: (e), depth 5 cm.

Comments (AS): Sockets (c), (d), and (e) fit a figure like the Paris Gaul (see Figures 61 and 280, no. 1; Foldout), kneeling on his left knee with his right leg extended but now with his right foot turned out and flat on the ground (Figure 275c): Compare the Geneva Fighting Giant (Figure 234). Such a figure also explains the blank remainder of the platform, for like the cowering figure of Γ1 he could have been defending himself against a rider advancing from side (3). Sockets (a), (b), and (f) might fit either the hands and buttocks of the Naples Dying Gaul or the right knee and hand of a figure like the Aix Persian (see Figures 41, 77, and 280, nos. 3, 4; Foldout), though (a) seems oriented the wrong way for the latter.

(b)

(c)

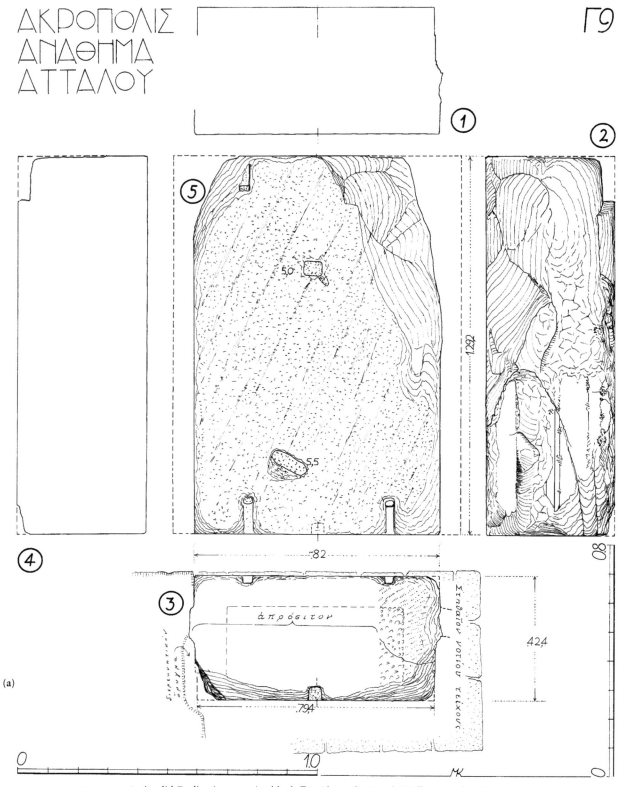

FIGURE 276. Attalid Dedication, cornice block Γ9 (Akropolis, South Wall, unnumbered), actual state. Drawing (a) by Manolis Korres, with *(facing)* key (b) and reconstruction sketch (c) by Erin Dintino.

Γ9. Akropolis, unnumbered. L 1.292; W 0.85; H 0.424. Statue platform, L 1.292; W 0.82. Figures 217, 267, 276; Tables 9–10.

Location: Built into the parapet of the South Wall, midway between third and fourth buttresses from the east, with its top (5) facing out and side (4) as resting surface.

Interior block; ca. 90% preserved. Both long sides (2, 4) and cornices badly damaged; remnants of upper tainia and cyma on both long sides enables measurement of the width. (A piece of rubble masonry was removed in order to investigate side [4].)

Statue platform (5) ca. 80% preserved, dressed with the point; two pi-clamp cuttings on (3–5) and one on (1–5) (the other broken away with the missing part of the block); one dowel hole at bottom center of side (3) (the other broken away with the missing part of side [1]). Side (3) anathyrosed using a fine claw chisel; side (1) inaccessible.

Statue sockets (5): One square socket (a) and one sausage-shaped one (b), slightly damaged by looters. Measurements: (a) 5 cm square × 5 cm deep; (b) 14 × 6 × 5.5 cm deep.

Comments (AS): A warrior lunges in from side (3), his right foot (b) flat on the ground and his left (on the adjacent block) raised, battling a rider whose rearing horse is braced by a belly support (a) (Figure 276c): cf. the Aristainos base (Figure 220), supporting a two-thirds life-size equestrian statue). The distance between belly support (a) and warrior (b), around 60 cm, tallies with the dimensions of the horse that once stood on the Aristainos base.

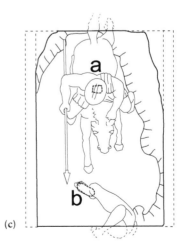

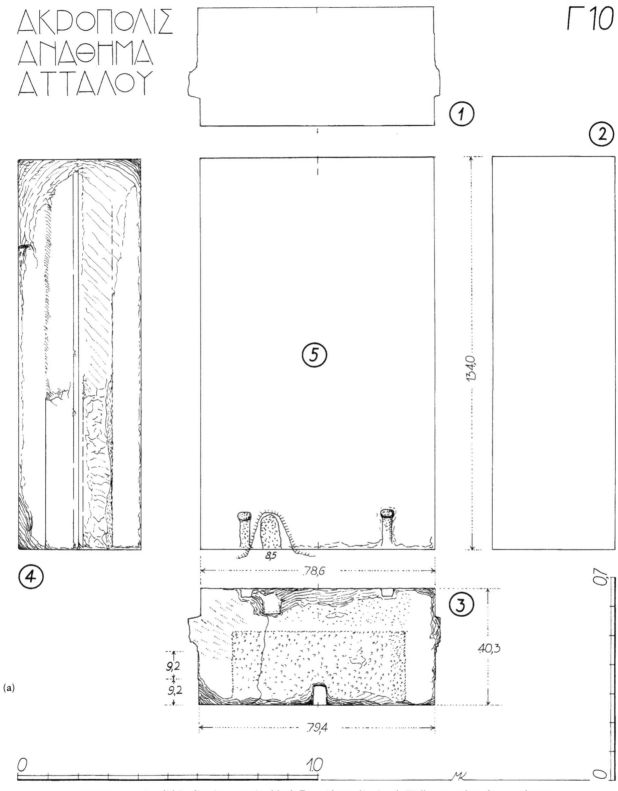

FIGURE 277. Attalid Dedication, cornice block Γ10 (Akropolis, South Wall, unnumbered), actual state. Drawing (a) by Manolis Korres, with *(facing)* key (b) by Erin Dintino.

Γ10. Akropolis, unnumbered. L 1.34; W 0.83; H 0.403. Statue platform, L 1.34; W 0.786. Figures 217, 267, 277; Tables 9–10.

Location: Built upside down into the base of the eighth (medieval) buttress of the South Wall.

Interior block; cornice along side (4) and apparently also side (2) broken away; otherwise relatively intact.

Statue platform (5) mostly invisible. Two pi-clamp cuttings on (3–5). One dowel hole at bottom center of side (3); side (1) inaccessible. Side (3) anathyrosed, the horizontal band (3–5) with a pointed chisel, the vertical (3|4) with a claw chisel.

Statue sockets (5): Removal of a section of masonry revealed one partial, very deep sausage-shaped socket (a). Measurements: (a) 12 × 7 × 8.5 cm deep.

Comments (AS): The remainder of socket (a) was cut into the adjacent block, again showing that the composition was designed independently of its pedestal.

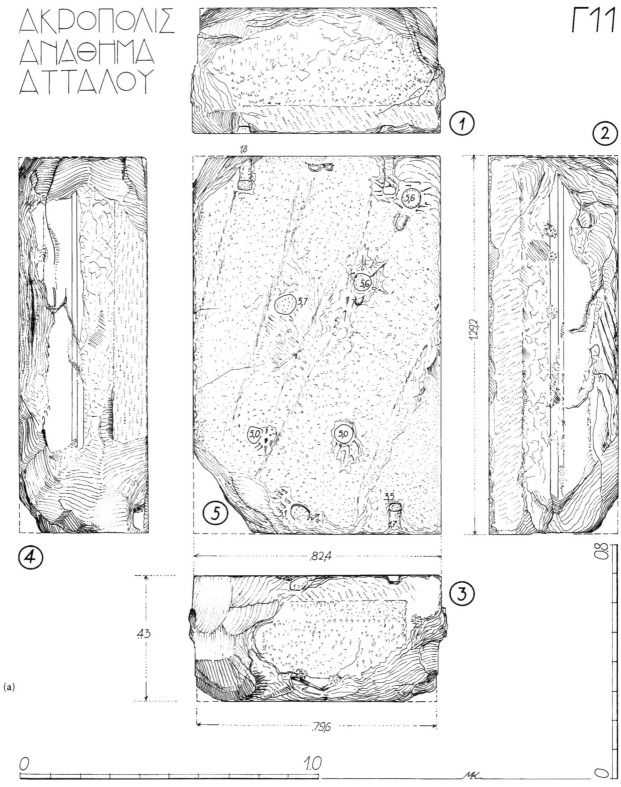

FIGURE 278. Attalid Dedication, cornice block Γ11 (Theater of Dionysos, unnumbered), actual state. Drawing (a) by Manolis Korres, with key (b) by Erin Dintino.

Γ11. Akropolis, unnumbered. L 1.292; W 0.85; H 0.43. Statue platform, L 1.292; W 0.824. Figures 267, 278; Tables 9–10.

Location: Formerly in western diazoma of theater of Dionysos near Asklepieion; moved in 2003 to the south of the Parthenon.

Interior block; ca. 95% preserved. Cornice along both long sides (2, 4) badly damaged; corners (3|4) and (1|4) broken away.

Statue platform (5) 95% preserved, stippled with the punch, much finer along the edges; close to (1–5) a letter B is incised (H 7.5 cm); sides dressed with a medium claw chisel; traces of drafting margins. Two pi-clamp cuttings on (1–5) and one on (3–5) (the other vanished with the missing corner). No dowel holes visible; despite the damage to side (1), traces would have survived had there been one, but side (3) is too badly battered to tell. Yet (to anticipate) this block belongs to a series where dowels were de rigueur. If it alone was not doweled, it should have been the penultimate one to be installed (the final one being the end block) – a role normally indicated by the use of a mason's mark.[1] This could explain the presence of the letter B.

Statue sockets (5): Six round/oval sockets (a)–(f), damaged by looters; (e) and (f) furnished with pour channels. Measurements: (a) 7 × 6 × 5.7 cm deep; (b) 5 cm diam. × 5 cm deep; (c) 8 × 6 × 5.1 cm deep; (d) 6 cm diam × 5 cm deep; (e) 6 × 5.5 × 5.6 cm deep; (f) 7.3 × 6.5 × 5.6 cm deep.

Comments (AS): The composition seems impossible to restore, but must have been complicated and interlocked. Unless everyone stood on tiptoe, the plethora of circular/ovoid sockets and complete absence of footprints could suggest that one or more of these holes are for horse's hoofs. The four central ones (a), (b), (d), (e) might have secured a figure like the Venice Falling Gaul, or a dead one: Figure 280, nos. 5–7.

Γ12. Akropolis, unnumbered. L ca. 1.34; W ca. 79.5. Figure 217; Tables 9–10.

Location: Built into the South Wall 15 m west of Γ8, resting on one long side with its underside facing out.

Interior block; cornice broken away on both sides but otherwise probably complete.

Statue platform (5) facing into wall; a dowel hole at bottom center of each end as on Γ4.

Comments (AS): None.

Γ13. Akropolis, unnumbered. L 1.22; H ca. 42.2. Tables 9–10.

Location: In a marble pile to the north of the Akropolis Museum.

Interior block; ca. 50% preserved. Cornice along side (4) mostly broken away. No observable dowel sockets or clamp cuttings; on sides (1) and (3) the middle of the lower edge is well preserved and contains no dowel socket.

Statue platform (5) presently inaccessible.

Comments (AS): None.

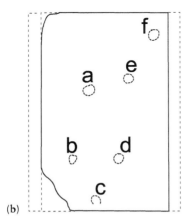

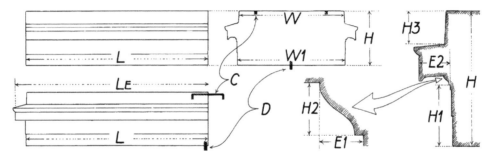

FIGURE 279. Cornice blocks from the Attalid Dedication. Key to Tables 9–10, columns 8–12: clamps, dowels, and measurements. Drawing by Manolis Korres.

TABLE 9. The Attalid Dedication: Cornice Blocks – Dimensions and Main Characteristics

(1)	(2)	(3)	(4)	(5)	(6)	(7)	(8)	(9)	(10)	(11)	(12)	(13)	(14)
	End or Interior Block	Length	Length Incl. Cornice	Width, Bottom	Width, Top	Height	H_1	H_2	E_1	E_2	H_3	Clamps	Dowels
Γ1	End	145	151	—	~80	~44.3	~18.4	~1.8	~1.1	~6	~12	(2)	0
Γ2	End	137.5	146.5	—	—	~40.2	~19.6	~1.4	~1.4	6.8	~8.9	(2)	1+0
Γ3	Interior	122.5		~80	~81	~41.8	~19.2	~2.0	~1.5	—	10.5	0+0	0+0
Γ4	Interior	~133		79.9	78.5	~40.3	~19.6	—	—	—	~9.5	2+2	1+1
Γ5	End	—	—	~79.5	~82.5	~42.8	~19.5	~2.3	~1.5	—	~10.1	?	?
Γ6	Interior	121.7		—	—	~41.7	~19.2	~2.0	~1.5	~7.5	10.4	(0)+(0)	0+?
Γ7	?	—	—	—	—	40.5	~19.7	~15	~1.3	—	~9.5	(2)+?	?
Γ8	Interior	124		(80.4)	~81	~41.3	~19.0	~1.8	~1.6	—	10.3	0+0	?+?
Γ9	Interior	129.2		~79.4	~82	~42.4	~19.5	~2.3	~1.5	—	10.8	2+(2)	1+?
Γ10	Interior	~134		79.4	78.6	40.3	~19.7	~1.4	~1.2	—	~9.8	2+(2)	1+?
Γ11	Interior	129.2		~79.6	~82.4	~43	~19.4	~2.4	~1.2	—	11.5	2+(2)	0+?
Γ12	Interior	~134		~79.5	?	?	?	?	?	?	?	?	1+1
Γ13	Interior	122.3		—	—	~42.2	~19.2	~2.0	~1.5	—	10.4	0+0	0+0

Note: All tolerances ±1mm. Unobtainable data (lost or inaccessible) are expressed by (—) or (?), respectively. For columns 8–12, Fig. 279 refers. In column 13 the number of clamps is given as (2) when only one is preserved but ipso facto proves that a second one was certainly employed; on blocks whose end face is half preserved and no clamp exists, the quantity is given as (0).

3. CLASSIFICATION

Cursory observation of Figure 267 and the data collected in each column on Table 9 reveals obvious differences among the blocks, both in size and in the presence or absence of clamps and dowels. More precise comparison proves that these differences are systematic.

Blocks Γ2, 4, 7 and 10 are ~40.4 cm high, ~78.5 cm and 79.6 cm wide at bottom and top, respectively, and include a cymation 1.5 cm high, situated ~19.6 cm above the block's lower edge. These constitute one series (Series 1). Blocks Γ3, 6, 8, and 13 are ~41.7 cm high, ~81 cm and 80 cm wide at bottom and top, respectively, and include a cymation 2 cm high, situated ~19.2 cm above the block's lower edge. These constitute a second series (Series 2). Blocks Γ5, 9, and 11 are ~42.8 cm high, ~82.5 cm and 79.6 cm wide at bottom and top, respectively, and include a cymation 2.3 cm high, situated ~19.5 cm above the block's lower edge. These constitute a third series (Series 3). Finally, block Γ1 is ~44.3 cm high, ~80 cm wide at the top, and includes a cymation 1.8 cm high, situated 18.4 cm from the block's lower edge. This is the sole ex-

TABLE 10. The Attalid Dedication: Classification of Cornice Blocks

(1)	(2) End or Interior Block	(3) Length	(4) Length Incl. Cornice	(5) Width on Underside	(6) Width on Upper Surface	(7) Height	(8) H1	(9) H2	(10) E1	(11) E2	(12) H3	(13) Clamps	(14) Dowels
Γ2	End	137.5	146.5	—	—	~40.2	~19.6	~1.4	~1.4	6.8	~8.9	(2)	1+0
Γ4	Interior	~133		79.9	78.5	~40.3	~19.6	—	—	—	~9.5	2+2	1+1
Γ7	?	—	—	—	—	40.5	~19.7	~15	~1.3	—	~9.5	(2)+?	?
Γ10	Interior	~134		79.4	78.6	40.3	~19.7	~1.4	~1.2	—	~9.8	2+(2)	1+?
Γ12	Interior	~134		~79.5	?	?	?	?	?	?	?	?	1+1
Γ3	Interior	122.5		~80	~81	~41.8	~19.2	~2.0	~1.5	—	10.5	0+0	0+0
Γ6	Interior	121.7		—	—	~41.7	~19.2	~2.0	~1.5	~7.5	10.4	(0)+(0)	0+?
Γ8	Interior	124		(80.4)	~81	~41.3	~19.0	~1.8	~1.6	—	10.3	0+0	?+?
Γ13	Interior	122.3		—	—	~42.2	~19.2	~2.0	~1.5	—	10.4	0+0	0+0
Γ5	End	—	—	~79.5	~82.5	~42.8	~19.5	~2.3	~1.5	—	~10.1	?	?
Γ9	Interior	129.2		~79.4	~82	~42.4	~19.5	~2.3	~1.5	—	10.8	2+(2)	1+?
Γ11	Interior	129.2		~79.6	~82.4	~43	~19.4	~2.4	~1.2	—	11.5	2+(2)	0+?
Γ1	End	145	151	—	~80	~44.3	~18.4	~1.8	~1.1	~6	~12	(2)	0

Note: All tolerances ±1mm. Unobtainable data (lost or inaccessible) are expressed by (—) or (?), respectively. For columns 8–12, Fig. 279 refers. In column 13 the number of clamps is given as (2) when only one is preserved but ipso facto proves that a second one was certainly employed; on blocks whose end face is half preserved and no clamp exists, the quantity is given as (0).

tant member of a fourth series (Series 4). So the old, generally accepted theory that the Attalid Dedication stood on four separate pedestals (cf. Figure 26b) is proven.

The differences in length among the blocks seem equally systematic. To begin with the interior ones whose full length is preserved, the measurements are as follows: 121.7 (Γ6), 122.3 (Γ13), 122.5 (Γ3), 124.0 (Γ8), 129.2 (Γ9), 129.2 (Γ11), 133.0 (Γ4), and 134.0 cm (Γ10). This time, three clusters are discernible: short blocks averaging 122.9±1.1 cm in length (Γ3, 6, 8, 13); medium blocks averaging 129.2±0 cm in length (Γ9, 11); and long blocks averaging 133.5±0.5 cm in length (Γ4, 10). These three clusters coincide – though not in the above order – with the first three series isolated in the previous paragraph. Blocks of Series 1 (Γ2, 4, 7, 10) are "long"; those of Series 2 (Γ3, 6, 8, 13) are "short"; and those of Series 3 (Γ5, 9, 11) are of medium length. Measuring 137.5 cm along its underside, Γ2, already classified in Series 1, is 4 cm longer than its fellows but is an end block. As for the isolated end block Γ1, this measures 145 cm along its underside – greater by far than any of the others. So the interior blocks of this final series (Series 4) would have been an impressive 141 cm or so in length.

No less important as evidence of the systematic character of these differences is the fact that only Series 2 has no clamps and no dowels. From its two measurable dimensions and its double set of dowels, Γ12, although the least accessible of the blocks, should be classified with Series 1. For convenience, these results are summarized in Table 10 (a rearrangement of Table 9); Figure 267 (a comparative drawing of all measured profiles) supports this proposed classification.

To summarize: The extant thirteen blocks belong to a large base of Hellenistic date that supported numerous two-thirds life-size bronze statues and stood on the south side of the Akropolis. But the existence of no fewer than three end blocks (Γ1, 2, 5) proves that this monument was at least bipartite. And the differences among the preserved blocks (a) preclude their attribution to *only* two pedestals; (b) indicate that they belong to four very similar (but not completely identical) ones; and (c) are insufficient to exclude any single block altogether from this four-part ensemble. What can the latter be but the four-part Attalid Dedication described by Pausanias (AT6)?

The distribution of the blocks is as follows:

Pedestal 1: Γ2, 4, 7, 10, 12
Pedestal 2: Γ3, 6, 8, 13
Pedestal 3: Γ5, 9, 11
Pedestal 4: Γ1

Each pedestal, however, clearly comprised more blocks than even Pedestal 1, whose statue platform as preserved totals 6.05 m in length.

Reconstructing the length and exact location of these pedestals would have been easier if many more blocks or Roman copies had survived, or a complete system of masons' marks (the B incised on Γ11 is of limited use), or relevant traces along or near the top of the Akropolis' South Wall. Yet the area has never been investigated archaeologically with this goal in mind, and at present cannot be so – even though the task is now urgent and would be relatively easy and cheap. For what remains of the south terrace must be kept open for tourist traffic now that the temporary workshops and offices of the Parthenon Restoration Project occupy its entire northern half. So the following observations concerning the disposition of particular blocks and the general setting of the pedestals are preliminary only.

4. ARRANGEMENT OF THE BLOCKS

First, two general structural criteria:

1. In any given wall, dowel holes alone can reveal the order in which a course of blocks was laid if each block is doweled only at one end (Figure 265). This is the case with Pedestal 3. If dowels were used on both ends of the blocks (as in Pedestal 1) or absent altogether (as in Pedestal 2), their order is impossible to determine.

2. The distance of the clamps from the wall face usually varies, as does the depth of their cuttings. These fluctuations, though apparently trivial, can furnish vital clues about the original sequence of an ancient wall's *disiecta membra*, for adjacent blocks must bear clamp cuttings whose position and depth match closely. Yet sometimes the original number of blocks far exceeds the number preserved, or the position and depth of the cuttings varies only slightly, or they were crudely carved, or are broken or damaged. So the following conclusions are provisional only.

Pedestal 1 (Γ2, 4, 7, 10, 12). The end block Γ2 has a dowel socket on its anathyrosed end, but the doweling of both ends witnessed on blocks Γ4 and 12 seems to be the rule for this pedestal; block Γ10 with one visible socket should therefore have another one at the other end. So the direction in which the course was laid cannot be determined, and the possible permutations must be examined one by one.

The only visible clamp cuttings on block Γ10 (side [3]) do not fit those on either side ([1] or [3]) of block Γ4. The preserved clamp cuttings on block Γ7 fit the relevant one on side (3) of block Γ10 tolerably well, but not the one on block Γ2 or those on block Γ4 (their positions and depths, respectively, differ). Finally side (1) of block Γ2 does not feature a half socket to complement the half socket on side (3) of block Γ4, and it cannot fit the other end of Γ4 either. For though a dowel hole is present on each end, neither has the obligatory pour channel like the one on Γ4, side (3). (For an explanation, see the catalog entry to Γ4.) So the preserved blocks do not fit each other, and thus at least three others (and probably far more), including Γ12, must have been positioned between them.

Pedestal 2 (Γ3, 6, 8, 13). On the best-preserved block, Γ3, no dowel holes exist at either end; ditto Γ13 and almost certainly Γ6 (the underside of Γ8, built into the South Wall, is inaccessible). So this pedestal lacked not only clamps but also dowels, and as a result the direction in which its cornice blocks were laid again cannot be determined. As to possible joins, side (1) of Γ8, with its partial statue sockets, cannot fit Γ3 because their continuations are absent. Yet its other end (3) cannot plausibly adjoin Γ3 because this would create an improbably large gap in the sequence of the statues. Because of its weathering, lichen holes, and linear erosion on contact band (1|4), side (4) of Γ3 surely faced north; likewise the preserved side (4) of Γ6. The orientation of Γ8, still built into the Wall, is unknown.

Pedestal 3 (Γ5, 9, 11). The clamp cutting on side (3) of block Γ9 could fit those on side (1) of Γ11. This arrangement also satisfies the condition that the doweled sides of each block share the same orientation (identical with the order of construction), for on both blocks side (3) is the doweled one (for Γ11, see Catalog). So the two blocks could theoretically belong together, but cannot be proven to have done so. For not only is an accidental coincidence more probable, but the absence of a letter incised on Γ9 to correspond with the B on Γ11 might argue against this – unless the B simply indicates that Γ11 was the penultimate block of the pedestal (see Catalog).

Concerning the pedestal's orientation, the side that faced north (i.e., inward toward the Parthenon: cf. Figures 218–19, 228) should be the more severely weathered. So side (4) of Γ11 ought to have faced north; as a crosscheck, the letter B also faces this side, as one would expect. This, in turn, shows that the sequence of construction was from east to west (left to right), again as one would expect. The relative position of the end block Γ5 in respect to Γ11 and Γ9 cannot be determined. They were probably some distance apart, for the sides of the statue platform on Γ5 and Γ11 are treated quite differently (see Catalog).

Pedestal 4 (Γ1). One block alone preserved; no comment.

TABLE 11. The Attalid Dedication: Attempt to Fit the Little Barbarians to the Cornice Blocks

	Little Barbarian No. (see Fig. 280) and Tenons				
	3	4	6	7	8
	a, b, c, d	a, b, c, d, x	a, b, c, d, x	a, b, c, d?, x	a, (b), c, d, f, g, x
Γ4				a, b, e, f, h?	
Γ5			a, b?		a, b?
Γ8	a,b, f?	a, b, e, f?			
Γ11				b, c, d?	

Note: Only those cases involving two or more correspondences between a given statue and cornice block are included. Blocks where no figure fits, and vice versa, are omitted, as are sockets in which the figure in question cannot fit. Sockets marked ? indicate cases where a fit is not absolutely precluded.

Can the statue sockets help? Thirty-five of them remain on the preserved upper sides (5) of the blocks available for study; an additional dozen or so have been broken away, and another dozen probably exist on the inaccessible faces of the blocks built into the South Wall. The preserved ones might help us to estimate the monument's size, using eight of the copies attributed to it (see Foldout) in place of the original bronzes.

Having deduced the likely positions of their tenons, one can check them against the cuttings on the cornice blocks in order to determine the odds statistically. The statues selected are sketched in Figure 280. They were secured at three points (or more) arranged in triangular fashion: feet, a hand, a knee, and so on.[2] More tenons must have secured their fallen weapons, shields, and other accouterments. For fallen figures, extra tenons securing the parts resting on the ground are likely, but these could have been positioned anywhere within the areas of contact (x). The latter are indicated in the drawings with a thick broken contour line. All tenons are designated with Roman letters. All possible positions were checked using transparent 1 : 10 scale drawings of the figures superimposed on those of the cornice blocks, and the possibility that each block might have supported only part of each figure was also considered throughout.

The results are summed up in Table 11.

So with some reservations,[3] the data do not allow us to fit *any* of the eight selected copies to any of the blocks examined. They merely indicate some possibilities and show that figures *like* those in Figure 280 and the Foldout perhaps stood on some of the blocks. On the other hand, the original quantity of both figures and blocks was clearly much greater. Positing six times more of each,

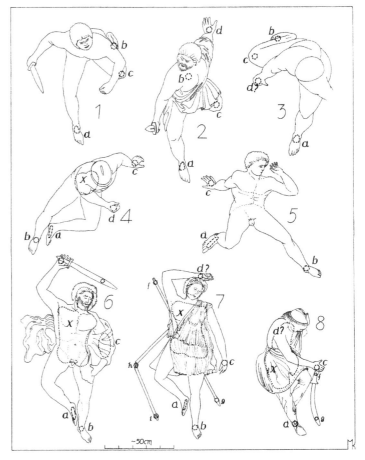

FIGURE 280. Attalid Dedication. Hypothetical reconstruction of doweling arrangements for eight of the figures preserved in copy. Drawing by Manolis Korres.

for example (a somewhat modest assessment since many scholars estimate a total of at least one hundred figures – see Chapter 4, §1), and assuming a purely random process of loss in both cases, the probability that any given figure *and* its sockets survive is only 16%!

But since we cannot know what circumstances are responsible for the data available (for history is not always logical), these arguments remain inconclusive. The only acceptable estimates for the total number of figures are iconographically based (see Chapter 4, §1).

All this brings us to the Dedication's setting: the area to the south and east of the Parthenon and the adjoining sections of the Akropolis wall.

5. THE AREA TO THE SOUTH AND EAST OF THE PARTHENON

In contrast to its predecessor, the classical Parthenon was conceived as a building standing on a perfectly level terrace. The evidence has been studied by such scholars as Francis Penrose, Karl Bötticher, Auguste Choisy, Friedrich Thiersch, Marcel Lambert, Wilhelm Dörpfeld, Gorham Phillips Stevens, and William B. Dinsmoor.

The results can be summarized as follows:

1. In fashioning the Older Parthenon's euthynteria (the level foundation course that carries its three-step krepis), much of the native rock on its northern side was trimmed down almost four feet, while on the precipitously sloping southern part an enormous stereobate (a solid ashlar foundation) was added.

2. Along the temple's south and west sides, this stereobate's four uppermost courses were finely rusticated in a way definitely and exclusively appropriate for public display. Along its east and north sides, owing to the rock's northward and eastward rise, the built faces of the stereobate occupied only a part of the temple's width and length, diminishing to nothing toward its northeast corner. The surrounding ground was deliberately left uneven (Figure 281a).

3. This euthynteria was enlarged along the north for the classical Parthenon by an additional substructure without any change in height. For the new temple did not cover the older stereobate completely, leaving a narrow strip of it unused along the southern side and a wider one along the eastern side.[4]

4. In contrast to the Older Parthenon's stereobate, its successor's additional substructure (visible around the temple's northwest corner and over a stretch of ca. 35 m along the north side) is built in a manner definitely and exclusively appropriate for concealment by an earth fill. Similarly along the south and east the portion of the old stereobate left uncovered by the new temple was trimmed down along its exposed top to a depth of ca. 15–20 cm. This rough, uneven trimming replaced an originally perfect surface and transformed its hair-fine anathyrosed joints into yawning chasms (the formerly invisible hollows of the anathyroses). Obviously this is not a finish per se but preparation for a now-vanished or never-completed terrace (Figure 281b).[5] This terrace was also meant to hide the so-called wall S4 to the southwest of the temple (see below) whose uppermost course (evidenced by pry holes on its present top surface) was level with the trimmed part of the stereobate.

5. The western limit of the terrace is the best known: a very broad flight of steps, partly hewn out the native rock and partly in masonry, beginning ca. 10 m in front of the temple.[6]

6. Its northern limit, a modest retaining wall along the Panathenaic Way some 8 m from the temple, is less discussed, but its rock-cut traces allow a fairly accurate restoration.[7]

7. The terrace extends far to the east, where it peters out. The trimmed part of the rock extends to a distance of ca. 80 m from the temple, where it became level with the fill inside the North Wall.

8. To the south and southeast the situation is unfortunately obscure. In 1877 the French architect Marcel Lambert, after participating intensively in the Akropolis excavations, presented a theoretical reconstruction of the area.[8] He restored a continuous terrace extending from the Parthenon's euthynteria to a South Wall that was considerably higher than the one preserved today. Dörpfeld agreed, restoring a South Wall seven courses higher than now (see Figure 213).[9] A generation later, Stevens proposed the currently accepted restoration, arguing that the area was divided into two terraces, the lower of which was approximately level with the bottom of the steps of the western terrace.[10] To support his hypothetical upper terrace, he restored a retaining wall that used the older, well-known wall S2 as its foundation, accepting Dörpfeld's dating of the Older Parthenon's stereobate and of S2 to the time of Kleisthenes (ca. 507 BC).[11] Stevens's two-terrace scheme became a fixture of later twentieth-century Akropolis plans, his friend John Travlos's included.[12] Yet in reality wall S2, quite differently oriented from the Parthenon, is one of the provisional structures that supported the steadily accumulating fill along the south side of the Older Parthenon's stereobate during its construction. In 1976 J. A. Bundgaard, after a meticulous study of all records kept from the Akropolis excavations, was able to state that this wall had never stood taller than when discovered in 1888.[13] And since it was found under a thick earth fill contemporary with the Older Parthenon, Stevens's hypothetical terrace wall cannot have been supported by it or in any way related to it.[14]

Making no reference to Stevens's terrace wall, Bundgaard also seems to restore a two-terrace arrangement,

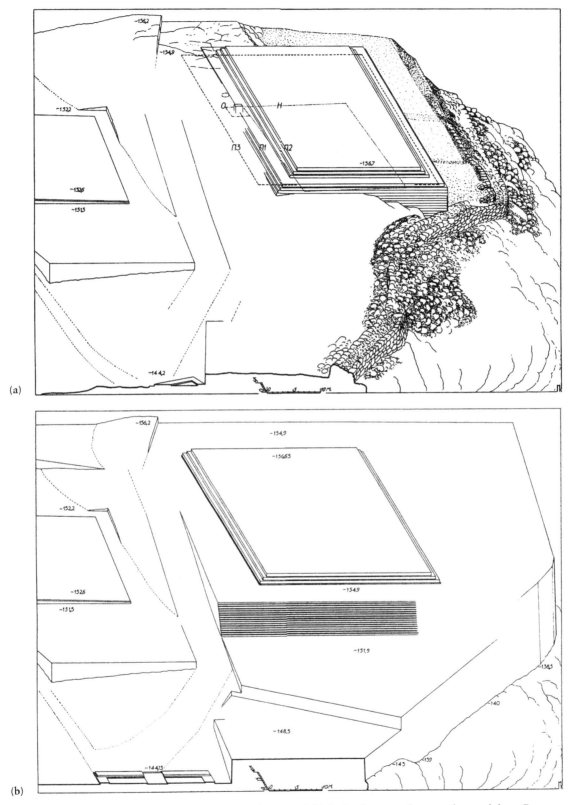

FIGURE 281. Relation of (a) the Older Parthenon and (b) the Parthenon to the ground around them. Reconstructions by Manolis Korres.

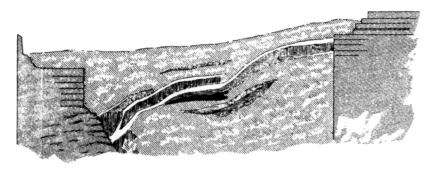

FIGURE 282. Ludwig Ross's stratigraphic section to the south of the Parthenon viewed from the east, as drawn by E. Schaubert (1846). From Ludwig Ross, *Archäologische Aufsätze* (Leipzig 1855): pl. 5.4.

but his terrace wall runs parallel to the temple.[15] As a base for it he used a discovery he had made some years earlier. In the official publication of the Akropolis excavation – a compilation of remains summarily sketched and measured some nineteen years earlier – the ground plan of the so-called Ergasterion or Building VI (a temporary structure inside the South Wall) is erroneously drawn.[16] Of its northern foundation, depicted as the thickest of all, only the 10-m-long easternmost section (henceforth named the "triglyph foundation" because of the material reused in it) is to be trusted; the rest is a farrago of fragmentary evidence and assumptions.[17] This triglyph foundation was not parallel to the Akropolis' South Wall and thus not a part of the Ergasterion (as in the official publication, see Figure 212) but – as Kawerau's in situ drawing shows – it paralleled the Parthenon. Moreover, excavation photographs clearly show that this "triglyph foundation" is superimposed upon (and therefore postdates) the Ergasterion's foundations.[18]

9. Unfortunately the "triglyph foundation" as discovered is not easily imagined as part of a terrace wall that was once ten times longer. A massive destruction of its supposedly missing remainder is possible only just to the west, where a Turkish building eliminated everything to a considerable depth, and perhaps a little further on where a medieval house stood at a remarkably low level with five courses of the Parthenon's stereobate exposed inside its court. But toward the east the stratigraphy of the construction of both stereobate and temple as recorded by Ross and Schaubert (Figure 282) renders such a terrace wall impossible.[19] Beginning at the top of the Parthenon's stereobate – a level much higher than that of Stevens's lower terrace or of the "triglyph foundation" – a series of continuous, undisturbed strata sloped gently downward to the top of the South Wall with no interruption at all. This situation eliminates all possibility of a two-terrace arrangement even in theory. We return to it below.

6. THE SOUTH WALL

Built after Kimon's successful Eurymedon campaign of 466 BC, the South Wall has a 165-m eastern leg and a 130-m western one that meet at an obtuse angle of 152.5 degrees. Looking at its only visible part – the exterior – the beholder can hardly discern the original monumental masonry, because strong buttresses, thick revetments, and later repairs displeasingly hide it from view.[20] This alien masonry can be classified as follows (Figure 283):

a. *Eight narrow buttresses,* spaced with near regularity over a distance of 87 m; the first stands 15 m from the Wall's southeast corner, while the eighth stands opposite the Parthenon's southeast corner. Their lower parts are built of large, reused, ancient stones; their upper ones (which have a strong inward slope, or *batter*) of rubble.

b. *Three wide buttresses,* spaced with near regularity over a stretch of 65 m almost exactly opposite the Parthenon's south side. They are built of rubble and marble fragments. Parts of its lower courses excepted, the Wall between them is also the result of extensive rebuilding with rubble masonry.

c. *A continuous revetment* some 110 m long, extending from a point opposite the Parthenon's southwest corner to the west end of the South Wall. This too is built of rubble and marble fragments.

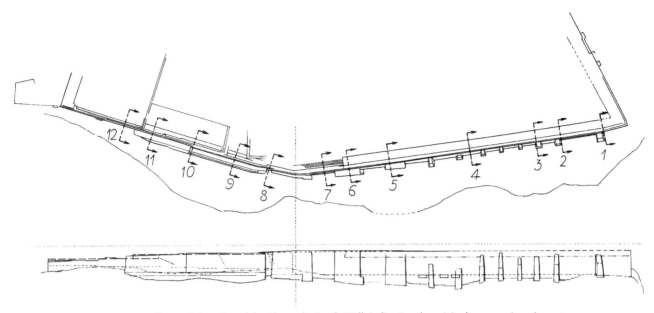

FIGURE 283. Plan and elevation of the Akropolis South Wall, indicating the original structure's main parts and later additions. The broken lines numbered 1–12 indicate the locations of the sectional drawings of Figure 284. Drawing by Manolis Korres.

d. *Replacements* of defective parts of the Wall's facing with new rubble masonry. This masonry is to be found almost everywhere between and above the buttresses (where the ancient facing is still traceable in places), but also occurs extensively on the much newer masonry of (b) and (c), which itself was often damaged during its turbulent life.

e. *A new mortar facing* imitating ashlar masonry. Added between 1936 and 1944, and therefore the most recent of all, it occurs chiefly from the Wall's southeast corner to the first buttress, and to a lesser degree from that point to the second buttress. It is mainly applied on masonry of type (d).

These additions not only hide the original Wall from view but also obscure its ground plan and structure. Even so, closer investigation yields the following observations:

1. The facing of the Wall between the narrow buttresses (a), of types (d) and (e), is new, but overall the Wall still maintains its original thickness.

2. By the wide buttresses the new facing (of types [c] and [d]) has thickened the Wall.

3. The continuous revetment is very thick with a very strong batter. For its first 40 m from the east, its top almost exactly replaced the destroyed outer row of the penultimate course of the South Wall. Yet many inner, transversally laid (header) blocks of that course are still preserved; together, a cutting on their upper surfaces and many pry holes indicate that the next course consisted of a single row of headers.

4. Along its remaining length the continuous revetment does not always replace the destroyed outer mass of the ancient South Wall. Although its lower part thickens the Wall considerably, above this – owing to its stronger batter – its outer surface sits ca. 50 cm inside that of the ancient one.

5. In addition to all these constructional deformities, the Wall has been severely distorted by the enormous pressure of the earth fill behind it, tilting and cracking along its length. The accumulated effect is impressive. The area to the south of the Parthenon has grown by almost half a meter, and the modern parapet has buckled badly.

Even so, the Wall's original layout, construction, and height can still be reconstructed if all relevant evidence is studied with care. It consists of two long sections set at an obtuse angle of 152.5 degrees, with a short 15-m transitional section inserted between them that slightly bevels the join; at the east end, another shorter bevel (ca. 13 m long) marks the transition to the East Wall. For further information, however, one must turn to the South Wall's inner face.

This face was unearthed and made accessible for study at different times. In 1836, at the southern extremity of Ludwig Ross's excavation (whose location roughly coincides with the entrance court of the present museum), a 6–7-m stretch of it was revealed. There, what seemed to be the top of the Wall was ca. 6.5 m wide. Yet the excavation was deep enough (as Schaubert's drawing shows; Figure 282) to reveal that this wide summit consisted of

just six courses (see §8). Below them there was only fill, so the underlying masonry must have been much narrower, and to reach its face would have meant undermining this wide, six-course inward extension. Seeing it a decade later, Penrose interpreted it as a platform for the Attalid groups (see Figure 26a).[21]

In 1864 the 70 m of this wide platform from Ross's trench to the southeast corner of the Akropolis were uncovered when the area was excavated in order to build the museum, but no drawing was ever published.[22] In 1888 the remaining 160 m from the museum to the Brauroneion were dug down to bedrock. The wide platform was followed to a point opposite the middle of the Parthenon's south side, where it was found to stop (see §8). The inner face of the Wall proper (the part beneath the wide platform) could not be investigated and remains unknown.[23] Moreover, the platform's northern face, though completely exposed, merited only one drawing – a stratigraphic section of a 17-m segment from the museum to the west, seen from the north – and minimal photographic coverage.[24] A 20-m segment immediately west of the museum's sunken courtyard was exposed for a second time in 1950 when the new museum storerooms were built, but again, no photographs or drawings were published.

For reasons already explained, the South Wall's inner face could be studied properly only from the wide platform's western terminus to the Brauroneion. For the first 45 m, conditions were highly unfavorable for photography. Kawerau recorded it in three rather sketchy 1:100 drawings, giving few measured dimensions.[25] The next 52 m, ending at the Brauroneion, were photographed but drawn only selectively and approximately.[26] The remaining 45 m alongside the Brauroneion, already extensively excavated, were investigated no further, and no photographs or drawings were made. Nevertheless, using those segments still available for study and the photographs and drawings of the 1888 excavation, the Wall's form and structure can be shown in section at several points along its length (Figure 284). Its main structural characteristics are as follows:

1. It rests directly on its own horizontal cuttings in the bedrock.

2. Its courses are perfectly horizontal and consist of orthogonal blocks averaging 0.50 m high × 0.65 m × 1.3 m, laid isodomically (i.e., with regularly alternating joints). Its westernmost 50 m employ larger blocks laid in single rows of stretchers.

3. The courses are not completely continuous over its whole length. At some points, now mostly obscured, they slightly change level, height, width, or structure. Most of these changes are of limited significance, but some define constructional stages (see below).

4. Each course was given a slight (ca. 2 cm) setback, yielding a (1 in 24?) inward inclination of the Wall's face.

5. Its lower part is always the thickest and strongest. It also includes numerous architectural members of the first peripteral Parthenon (the so-called Building H or H-Architecture), facing outward: stylobate blocks, orthostates, wall blocks, column drums, and architraves.[27]

6. Above the irregularly constructed lower parts, the Wall is almost exclusively built using standard poros ashlars, two Attic feet (one unit) wide, four feet (two units) long, and 1.5–1.75 feet high, laid in courses of either headers or stretchers or of both headers and stretchers. Consequently, its thickness can be rated in ancient terms as *diplinthon* (two units = two parallel stretchers or one header), *triplinthon* (three units = three parallel stretchers or one stretcher + one header), and so on up to *dekaplinthon* (ten units = any combination of the above) for the thickest part.[28] Its thinnest possible part, the parapet (see §7) is *monoplinthon,* that is, it consists of single courses of stretchers only.

7. Its thickness diminishes gradually via a series of major setbacks on its inner face. Its lowest course must exceed 5 m in thickness, but (its westernmost 50 m and wide eastern summit excepted) immediately under the parapet it is only two or three units thick – though its full width is preserved only in a few places. The architect could thus use a bonding system based on alternating stretchers and headers up to the highest course.[29] Whatever stood above this course functioned merely as a parapet and thus could be thinner with both faces perpendicular and well smoothed.

8. Its top course (the one immediately beneath the parapet) alongside the Brauroneion is ca. 10 cm higher than the leveled rock surface inside this sanctuary, which was covered with a ca. 10-cm-thick layer of earth.

9. Its top (as indicated by its partially preserved penultimate course) from the Brauroneion to the angle south of the Parthenon was level with the fill in front of the rock-cut steps of the temple's western terrace. This fill consisted of a thin layer of earth covering the leveled rock surface. A roughly dressed strip along the bottom of the steps' lowest riser exactly defines its depth.

10. Its top from the angle to the southeast corner is almost completely lost. Nevertheless, the extant remains (the corner, some blocks 15 m from it, and possible traces at two other points) indicate an original height of only one course more, as to the west.

Most scholars date the South Wall (its wide eastern platform excepted; see below) to Kimon and the 460s.[30] As

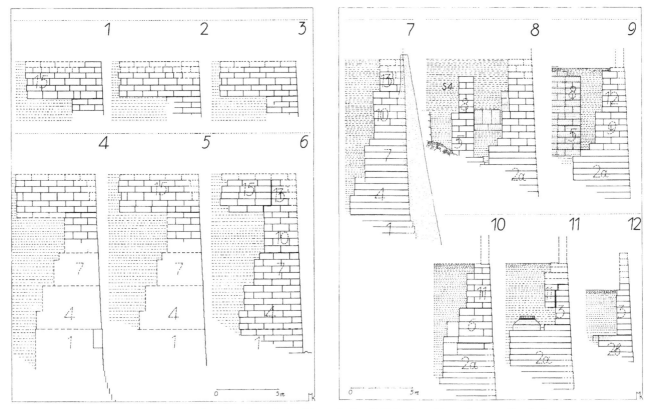

FIGURE 284. Theoretical sections through the Akropolis South Wall, viewed from the west. For the locations of the sections, see Figure 283. Reconstructions by Manolis Korres.

for its constructional phases (Figure 285), the following tentative observations may be of interest:

1. Because of the Akropolis' steep, rugged slope, the South Wall's first constructional phase, beginning at the rock's lowest ledges, sought to bring it up to the level of the higher crags, using the strongest ashlar masonry in order to create both a firm foundation for the remainder and for lanes to transport the stone. The first stage built in this way (Figure 285, no. 1) stood on the lowest part of the south side's eastern ledge. It is ca. 130 m long and 6 m high where the ledge dips most strongly (ca. 6 m below the top of the large reused architraves from the first peripteral Parthenon). Although its inner face was nowhere reached during the Great Excavation, it must be at least 5 m thick, given the exceptionally strong outward batter of its lower courses. Since the rock rises toward each end, the mean height of this phase of construction is ca. 2.5 m and its volume just over 2,000 m³. The precipitous, isolated site could not be served by the stone-transport lanes converging on the Akropolis from outside, but fortunately this was unnecessary. For it is almost completely built of material of the first peripteral Parthenon that had become available when this temple was replaced by a newer (and never-completed) one, and of hard limestone perhaps from the Mycenean wall or from the Akropolis' own rocky summit.[31] This stage is the only part of the South Wall that could predate its main phase of construction, perhaps by up to thirty years.

2. The second stage built in this way (Figure 285, nos. 2a, 2b) stood on the lowest part of the western ledge. Section 2a is ca. 110 m long, 6 m high at minimum, and *hektaplinthon* – nearly 5 m thick.[32] The topmost four courses of section 2a are incomplete, forming a sequence of four steps (at a distance of 11–13 m) descending toward the east. Since the rock rises toward each end (and particularly to the west) and also on its inner side, its mean height is ca. 3 m and its volume ca. 3,000 m³. When it was built its site, also precipitous and isolated, was accessed via a temporary ramp located in the western half of the later Chalkotheke, so that its Piraic stone could be transported via the Propylaia and the Panathenaic Way.[33]

3. The next stage (Figure 285, no. 3), partly superimposed upon sections 2a and 2b, extends from the southwest corner of the Akropolis through the Brauroneion to a point 18 m along the Chalkotheke's south side. It is 55 m long and ca. 3.4 m high; its lowest course is 2.2 m thick; the next is 1.7 m thick; and the remaining five

courses only 1.1 m thick. Exceptionally, these last five courses consist of extra large stretchers, measuring 5 × 3+ Attic feet. The volume of stone is around 280 m³, transported in the same way as for sections 2a and 2b. Presumably it was built at such an early stage in order to facilitate the transport of the heavy stones from the area inside the Propylaia to the South Wall building site. At its east end, then, the earth fill for a time took the form of a ramp descending to the level of section 2a (see arrows inside section 3 on Figure 285).

4. The next stage (Figure 285, no. 4) was built above section 1 to the height of section 2a. Section 4 (ca. 180 m long; *heptaplinthon*; ca. 2,500 m³ of stone) was subdivided into a number of constructional subsections, each one with its own transport lane (see arrows in Figure 285 and item 5, below). It is most likely that the earliest of these subsections was built simultaneously with section 3 and that the remaining ones were built in stages with many minor overlaps and adjustments both horizontally and course by course.[34]

5. The next stage – actually separate from the South Wall proper – is represented by the aforementioned auxiliary retaining wall S4 (around 200 m³ in volume). Wall S4 is usually linked directly with the Periklean Parthenon's construction, with severe consequences for the chronology of the main part of the South Wall.[35] It is more likely, however, that S4, though itself built in sections (Figure 285, nos. 5, 8), originally provided the necessary additional transport lane for the thousands of blocks destined for the center section of the South Wall (see arrows inside Figure 285, nos. 5, 9). Similarly, the Wall's builders needed two or three additional lanes leading from the northeast corner of the Parthenon to the south, southeast, and east in order to deliver the enormous number of blocks destined for the easternmost 100 m of the South Wall (see arrows inside Figure 285, nos. 1, 4) – not to mention the East Wall, which was being constructed simultaneously.[36] Only with five or six evenly distributed transport lanes could this huge project have been completed in the brief window allowed by its historical and archaeological context.

6. The next stage (Figure 285, no. 6) consists of two lower courses abutting the stepped top of section 2a, as well as four more partially superimposed to the west upon the sloping eastern end of section 3 and to the east terminating at the Chalkotheke's eastern end. This stage, much thicker than section 3, is *tetraplinthon* for most of its length; its volume is around 250 m³.

7. The next stage (Figure 285, no. 7), superimposed upon section 4, comprises five *pentaplinthon* courses; its volume is around 1300 m³. For transporting the stone the following lanes were used: the stepped top of section 2a (whose gradient had progressively to be reversed as section 6's construction reached its higher courses), the fill inside section 5 (= the lower part of wall S4), and the aforementioned lanes to the east of the Parthenon.

8. The next stage (Figure 285, no. 9) was built almost simultaneously with section 8 (the upper part of wall S4); it fills the interval between sections 6 and 7.

9. The next stage (Figure 285, no. 10), superimposed on section 7, comprises seven *tetraplinthon* courses; its volume is around 1,500 m³.

10. The next stages (Figure 285, nos. 11, 12), superimposed on sections 6 and 9, are *triplinthon* for the most part.

11. The next stage (Figure 285, no. 13), superimposed on section 7's westernmost stretch, is ca. 40 m long and had five *triplinthon* courses (whose top two are lost).

12. The final stage (Figure 285, no. 15), possibly built under Perikles (almost simultaneously with section 14, the topmost part of wall S4) is very sizable – ca. 3,000 m³ – and definitely the most distinctive because it is much thicker (*dekaplinthon* at most) than the rest of the Wall beneath it; hence the name used in this study, the "wide summit" or "wide platform." This stage is treated separately below (see §8) because it served as the foundation for the Attalid Dedication.

13. Along the 180-m length of sections 4, 7, 10, and 15, anomalies in the bond system indicate further internal subdivisions that are difficult to disentangle. Since these anomalies are present in the wide platform, section 15 (see Figure 284, nos. 1–6), which must belong to a single constructional phase, it is clear that they are not significant enough to merit further attention here.

14. As each course of blocks was laid, layers of rubble, gravel, stone chips (mostly from the final dressing of the wall blocks themselves), clay, and debris from the Persian Sack were packed down behind it and used for transport lanes and to create an outdoor building site. Its total volume was around 60,000 m³, not including the material from the Parthenon's predecessors). The last of these fill layers, supplemented with finer material, served as the final ground level for each particular precinct and terrace.

To evaluate the project's overall achievement, one may compare the stereobate of the Parthenon (Table 12).

7. THE PARAPET

The remains of parapets 3 m or more high at three points along the North Wall raise questions about the South Wall's parapet. How much of it had a high parapet, a low one, or even none at all? Some even argue for a high par-

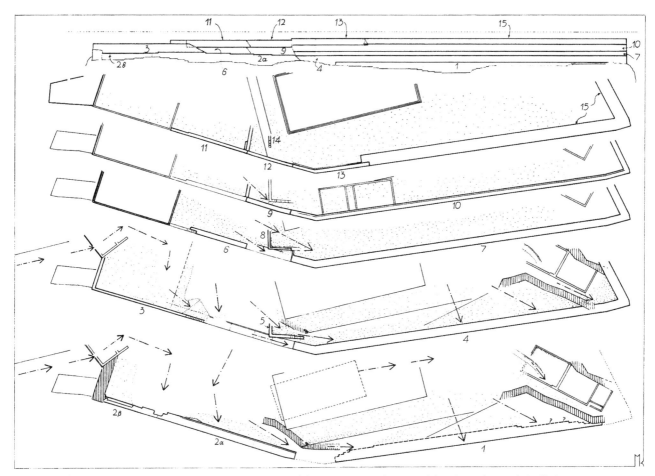

FIGURE 285. Restored elevation and plans of the constructional stages of the Akropolis South Wall. Arrows indicate the probable transport lanes for the stones. Reconstruction by Manolis Korres.

apet around the entire citadel.[37] Since the North Wall concerns us only indirectly, it is enough to note that even the well-preserved two-course parapet along its easternmost stretch was originally higher. For pry holes evenly distributed on its top indicate a capping element or a third course (which in turn could have been topped by a capping element or by a fourth course; and so on).

Along the South Wall, while mostly there is no evidence for or against either type of parapet, there is at least one stretch where a high one/precinct wall can be

TABLE 12. The South and East Akropolis Walls and Parthenon Compared

	South and East Walls	Parthenon
Rock-cut bedding	2,500 m²	2,400 m²
Stone volume	20,000 m³	10,000 m³
Dressed facing	4,500 m² (excl. parapet)	250 m²

Note: All figures are approximate only.

proven. The well-known cutting at the rear of the Propylaia's southwest wing shows that the Wall superimposed at that point on the existing Mycenean wall reached the highest tiles of the roof of that wing – at least 3.1 m above the floor of the Brauroneion.[38]

The continuation of this peribolos along the South Wall is witnessed by four blocks averaging ca 1.50 m in length that are still preserved in situ on the Wall's edge, at a distance of ca. 30 m from its western end (Figure 284, section 12). They are 75 cm thick: 10–15 cm thicker than the high parapets of the North Wall! The different characters of the North and South Walls can explain this difference. Because of the North Wall's strong angles and reentrant corners, it was conceived as a sequence of individual, visually self-sufficient segments. As a result, the different levels of the various precincts and sanctuaries inside it were reflected by parapets at different levels and with no batter.

On the south side of the Akropolis, the opposite was the case. Because the South Wall was continuous, para-

pets rising to different levels had to be flush with the battered parts of the Wall standing next to them. So the outer face of the high parapet along the Brauroneion had to incorporate a batter up to the level of the higher segment of the Wall proper rising to the east of it. This batter, a sequence of 2-cm setbacks per course, would have made the high parapet's top course around 63–65 cm (ca. 2 Attic feet) thick – the same as the North Wall's parapet.

Some 50 m to the east of the four blocks just discussed, the aforementioned inner blocks of the Wall's penultimate course provide the next piece of evidence. Only a part of their upper surface is dressed, showing that they supported a much narrower course consisting of a single row of headers (indicated by a series of pry holes for levering them outward). This course was level with the made ground in front of the large rock-cut steps of the Parthenon's west terrace and therefore, as its (presumed) header system also suggests, it can be considered as the foundation for the parapet.

These traces peter out at this point. Rubble, earth, and later repairs and additions hide the rest of the Wall's capping from view, but judging from the way Kawerau drew its penultimate course (surmounted by a modern rubble wall) it must have been the same until the Wall angled.[39] Thereafter any parapet must have stood one course higher, on the highest header course extending from that point to the Akropolis' southeast corner. This missing parapet's height is still conjectural (see Figures 218–19, 226, and further comments early in Chapter 4, §1).

8. THE WIDE SUMMIT OF THE WALL AND THE UNFINISHED TERRACING

As stated above (§6), the South Wall gradually thins toward its top; however, from a point opposite the Parthenon's ninth column from the west, an anomaly suddenly occurs. Along a stretch of 145 m ending at the eastern corner of the Akropolis, its uppermost courses widen to almost 6.5 m![40] The extra stone rests on earth fill and therefore is liable to subside.[41] The west end of this wide summit is still visible opposite the Parthenon's ninth column from the west in one of the Akropolis' several display pits, intentionally left open to show the results of the excavations (see Figure 67). Unfortunately, in the late 1880s its joints were sealed against the rain with mortar, obscuring the structural relationship between these courses and the rest of the Wall. In Dörpfeld's and Kawerau's restored sections this wide summit seems built uniformly as a thicker upper part of the Wall (see Figure 213), whereas in Kawerau's state drawing and Bundgaard's restored sections it seems to be a separate addition along the Wall's inner side. Judging from the DAI excavation photographs and the visible remains (see Figure 284, sectional drawings 1–6), a separate addition is probable only for the westernmost stretch located within the Ergasterion.[42]

Most of this wide summit is now hidden from view. The part to the west of the museum was never cleaned of its coating of earth; the outer half of the part to the south of the museum has been covered since 1889 by architecture dumps and the rest since 1983 by the Akropolis Restoration Project's crane and its railroad tracks. Nevertheless, the visible remains and those recorded prior to the crane's installation make it certain that most of the top course is gone, together with the easternmost 45 m of the one below it. A well-preserved upper surface may exist to the south of the sunken museum entrance court at the point recorded by Penrose (see Figure 26a). A row of blocks can actually be traced there along the wide summit's northern edge, along with structural evidence for a superimposed course, most probably of marble, but seems to be not in situ. Kawerau's drawing, mentioned earlier, shows seventeen headers of the uppermost course's inner row in place.[43]

Because the accessible parts of this wide summit are few, scattered, damaged, and displaced,[44] a leveling instrument was used to establish the form of its courses and their relationship to each other. Although we cannot know the exact arrangements of the blocks within this mass of masonry, its form can be sketched as follows (Figure 284):

Its *lowest course* consists of headers in regular arrangement (laid flat) excepting its easternmost 20 m, where the blocks are laid on their sides in order to increase the course's height (ca. 65 cm instead of ca. 50 cm). Its westernmost part is narrower, consisting of two rows of headers instead of two and a half.

The *second course* consists of headers in regular arrangement.

For most of its length the *third course* consists of blocks laid on their sides in order to increase the course's height. The innermost row consists of stretchers, the rest of headers. This arrangement seems to persist all the way from the southeast corner to the east side of the Ergasterion (visible in a DAI photograph).[45] Further to the west the third course consists of blocks laid flat (again visible in DAI photographs).[46]

The *fourth course* consists of headers in regular arrangement.

The easternmost 40 m of the *fifth course* consists of stretchers in regular arrangement, while the rest of it visible to the south of the museum and at the west end of the Wall consists of headers (also in regular arrange-

ment). Strangely enough, in Kawerau's drawing it seems to consist of stretchers.

The *sixth course,* also shown in Kawerau's drawing, as preserved consists of headers.

The purpose of the wide platform thus created is unclear. Was it intended to stabilize the South Wall by acting as a kind of counterweight or by diverting the fill's thrust toward its lower, stronger parts?[47] Was it meant to support terracing to the south and east of the Parthenon? Was it planned as a foundation for votive monuments to come, such as the Attalid Dedication?[48] Or was it intended to satisfy some combination of the above?

Although the relevant stratigraphic evidence was never properly recorded, it is generally believed that this wide platform is distinctively different from the rest of the South Wall – a Periklean not a Kimonian phase.[49] The stratigraphic sections composed by Dörpfeld on the base of all records available (Ross's observations, Schaubert's drawing, Kawerau's sketches, DAI photos, his own notes) show the southern tip of the upper marble chip stratum extending under it (see Figure 213).[50] If this is true, since this stratum must be construction debris from the Periklean Parthenon, the platform must be Periklean also.[51]

As to the East Wall, this seems to be a thoroughgoing continuation of the South Wall, its own wide summit included.[52] Part of it, which collapsed in an earthquake in 1705, was rebuilt fifty years later.[53] On the topmost block of its southeast corner important evidence is still preserved. Despite extensive erosion it seems that its upper surface was never properly smoothed down – a necessity once a course has been laid if another one is to follow. Indeed, along the entire East Wall no classical construction is to be found above the level of this corner block. The one apparent exception, where the rock rises above this course toward the north and the medieval Belvedere, was actually built in late antiquity with large, reused marble blocks. So against all expectation the East Wall never rose higher than this corner block, and the northeast corner of the citadel, rising 3.5 m above it, was left totally unwalled.[54] To close this gap and to reach the level of the Parthenon terrace would have required the addition of seven more courses of stone. Some possible explanations for this puzzling situation are as follows:

1. The original plan was to add these seven courses, but it was canceled or postponed for one or more of the following reasons: (a) the Peloponnesian War; (b) a fear of increasing the pressure exerted by the earth fill; (c) a reluctance to reduce the visibility of the Parthenon from below; (d) a reluctance to interfere with the preexisting Southeast Building (Buildings IV–V). This structure would have posed a serious problem if it were indeed a sanctuary (of Pandion?) and not a mere workshop, as stated in the Great Excavation's official publication (see Figure 212).[55]

2. For one or more of the above reasons the original plan was to terminate the East Wall at its present height. Yet this theory fails to explain how the northeastern part of the rock could have been fortified and how the area to the south of the Parthenon could have been completed. In the latter case, short of supposing that its massive fill was a simple error of judgment, the only logical solution would be a flight of steps like the one to the west of the temple, situated between it and the Wall but closer to the latter.

In any event, the landscaping needed to complete the terracing to the south and east of the Parthenon was put on hold for centuries. The northeast part of the Akropolis was in all probability not walled before the third century AD,[56] while not far from the Parthenon's east façade, on conspicuously high but (surprisingly) still unimproved ground, a dozen unused and randomly scattered column drums dominated the scene until the area was covered by medieval houses. Poorly constructed largely of mud brick and rubble, they had to be rebuilt or replaced many times over the centuries, a process that gradually raised the ground level in the area by several meters. Finally the site was excavated by the nineteenth-century archaeologists who tried theoretically to reconstruct not only what had once existed but also its builders' plans for those parts that they had to leave unfinished.

9. POSITION AND FORM OF THE PEDESTALS

As stated in section 3, no one has ever conducted a systematic search for traces of the Attalid Dedication on the top of the South Wall. Here Penrose's observations are of particular importance: "[U]pon the edge of the Cimonium, is a platform of Piraic stone, which contains two plain marble slabs, perhaps connected with the sculptures relating to the story of Attalus and the Gauls, evidently the broad summit of the Wall (see Leake, p. 349). A small portion of a similar platform is discovered close to the eastern wall of the Acropolis."[57] The position of the first "platform" (some 90 m from the southeast corner) is given on his Acropolis plan of 1847,[58] captioned as "Marble bases on Piraean stone Platform" (see Figure 26a).

The first of Penrose's platforms was the South Wall's wide summit, uncovered at the southernmost extremity of Ludwig Ross's excavation of 1835–36. Penrose's observations elicited a response three years later in Volume II of E. Beulé's *L'Acropole d'Athènes*: "they do not rest at all on the wall itself ... but [are] probably large ped-

TABLE 13. The Attalid Dedication: Plinths – Dimensions and Main Characteristics

(1)	(2) End or Interior Block	(3) Length	(4) Width	(5) Height	(6) Dowels on Underside at Edge	(7) Dowels on Underside near Edge	(8) Clamps	(9) Axial Pry Holes	(10) Lateral Dowels w/ Pour Channel	(11) Pry Holes	(12) Center Dowels w/ Pour Channel	(13) Pry Holes	(14) Lateral Dowels w/ no Pour Channel
A1	?	133.5	~88	~24	o	o	?	?	?	?	?	?	?
A2	Interior	123.5	~88	~24	?	?	2+2	1+1	2	2	2	2	2
A3	—	122.5	~88	~24	—	—	?	?	?	?	?	?	?
A4	—	~135	~88	~24	2	2	2+2	?	?	?	?	?	?
A5	Interior	~125	~88	~24.5	2	2	2+2	—	2	2	2	2	2
A6	?	?	—	~24	?	?	?	?	?	?	?	?	?
A7	?	?	—	~24	?	?	?	?	?	?	?	?	?
A8	?	?	—	~24	?	?	?	?	?	?	?	?	?

Note: All tolerances ±1 mm. Unobtainable data (lost or inaccessible) are expressed by (—) or (?), respectively.

estals," and "these pedestals abutted the citadel wall and perhaps overtopped it." On Beulé's surprisingly inaccurate Akropolis plan, four pedestals are shown in a line along the south side at exactly the stretch defined by Penrose's two platforms and designated – but from west to east! – as "Gigantomachie, Amazons, Marathon, Attale et les Gaulois."[59]

In 1855 Gottfried Semper used the same plan for a different purpose, making some changes to its western part.[60] Eight years later Karl Bötticher repeated the same statements: "this pedestal [Penrose's first 'platform'] could be the first that began the series, extending to the east, [of] closely spaced bronze groups."[61] In his fig. 1 the "Bathron" is indicated in the position defined by Penrose. The theory was vaguely criticized much later by A. Bötticher: "Karl B[ö]tticher believed that in them he had discovered the foundation of the westernmost pedestal. In the present situation, to draw conclusions about the figures' original order would be premature."[62] Even so, the location of the pedestals derived from Penrose's observation (see Figure 26b) remained acceptable.[63]

From the beginning of the twentieth century the site of the slabs indicated on Penrose's plan (see Figure 26a) was covered by earth and an architecture dump,[64] prohibiting any answer to the following questions: Do these slabs still exist? Were they in situ when Penrose saw them? Did they really belong to the Attalid monument and not to another one nearby? Even so, a number of slabs of Hymettan marble, unfortunately not in situ, meet the required conditions. One complete block is reused in the South Wall's parapet (block A1 in Figure 217, q.v.); another lies in a pile of stones immediately inside the parapet at a point some 20 m further east (one of the blocks observed by Penrose, Figure 26a?); further east yet, another sits exactly where it was in 1887;[65] two more complete blocks lie in stone piles nearby; and large fragments of others are scattered to the north of the museum. All are ca. 24 cm thick and ca. 88 cm wide. Their length varies in stages from 122.5 to 133.5 cm (Table 13).

Pry holes, dowel sockets, pour channels, and weathering lines (Figure 286, nos. 2–5; on A1, A3, and A4 the upper side is inaccessible) show the structure of the next course. It was a wall ca. 79 cm thick with a lower course composed of two parallel rows of orthostates ca. 35 cm thick (with a void left between them) alternating with transversally placed slabs ca. 25 cm thick. This wall thickness exactly fits the width of the

TABLE 14. The Attalid Dedication, Orthostates: Headers – Dimensions and Main Characteristics

(1) End or Interior Block	(2) Height	(3) Width	(4) Thickness	(5) Dowels on Underside	(6)	(7) Clamps
B1	?	~97	~79	~25	?	?
B2	?	~97	~79	?	?	?
B3	?	~97	~79	?	?	?

Note: All tolerances ±1 mm. Unobtainable data (lost or inaccessible) are expressed by (—) or (?), respectively.

TABLE 15. *The Attalid Dedication, Orthostates: Stretchers – Dimensions and Main Characteristics*

(1)	(2)	(3)	(4)	(5)	(6)	(7)	(8)	(9)	(10)	(11)
	End or Interior Block	Height	Length	Thickness	Dowels on Underside		Clamps	Pry Holes	Dowels near Center with	
					at Edge	near Edge			Channel	Channel
B4	Interior	~97	>95	?	?	?	?	?	?	?
B5	Interior	~97	108	32	1	1	1 + 1	2	1	1
B6	Interior	~97	?		?	1	1 + ?	?	?	?
B7	Interior	~97	~100		1	?	1 + 1	2	?	?
B8	Interior	~97	~101		1	1	1 + 1	—	1	1
B9	Interior	~97	>99	42	1	1	1 + 1	2	1	1
B10	Interior	~99	124.5		1	1	1 + 1	2	1	1
B11	Interior	~99	124.5		1	1	1 + 1	2	1	1
B12	Interior	~99	110		1	1	1 + 1	2	1	1
B13	Interior	~99	92				1(+ 1)			
B14	Interior	~97	>55				1(+ 1)			

Note: All tolerances ±1 mm. Unobtainable data (lost or inaccessible) are expressed by (—) or (?), respectively.

cornice blocks,[66] while the new blocks exactly correspond in length (122.5, 123.5, and 125 cm for A3, A2, and A5; and 133.5 and 135 cm for A1 and A4, respectively) to the cornice blocks of Pedestal 2 (ca. 123 cm) and Pedestal 1 (ca. 134 cm). So these new blocks belong to the pedestals' toichobates or plinths.

The dowel holes on their upper faces (Figure 286, no. 3) – a central pair and two pairs on either side – are of some interest. The central pair with pour channels is appropriate for doweling a header orthostate with inner dowels; the two lateral pairs are for stretcher orthostates but differ in one respect. The holes on one side (not included on the block illustrated in Figure 286) have pour channels and thus are intended for inner dowels too, whereas the others with no such channels (Figure 286, no. 3) are made for edge dowels. So each stretcher was doweled with one edge dowel and one inner dowel.

Many other blocks of the same marble and structural characteristics are lying around in the vicinity, but since most of them are fragmentary and all but inaccessible their study cannot be completed now. For the present, the following observations must suffice:

Three blocks built into the South Wall (B1, B2, and B3) can be identified as transverse (header) orthostates. They are 79 cm wide, ca. 25 cm thick, and ca. 97 cm tall, and their two faces have contact bands along their long edges (Table 14).

A block built into the South Wall (B4) and four others (B5–8) lying in stone piles to the north of the museum can be identified as stretcher orthostates (Table 15). They are

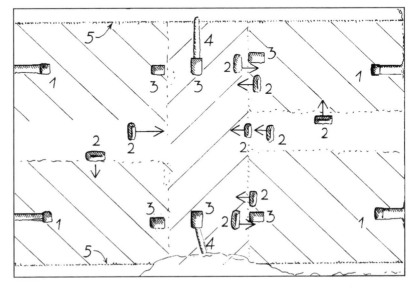

FIGURE 286. Attalid Dedication, plinth block (A2). Plan of the upper side (owing to its limited accessibility, some cuttings are drawn with a tolerance of ±1 cm). Drawing by Manolis Korres.

97 cm tall (like the headers B1–3), and ca. 35 cm thick. Their lengths plus the thickness of one stretcher correspond to the lengths of the plinths (Table 15). Furthermore they possess sockets for both kinds of dowels (edge dowels and inner dowels) in places exactly corresponding to the complicated system found on top of the plinths.

Four more blocks (B9–12),[67] collected in 1984 south of the Temple of Roma and Augustus, show all the characteristics described above but are ca. 1.5 cm higher. These blocks too should belong to one of the pedestals. Their slightly greater height is explicable in the context of a similar variation in the cornice blocks. Either a pedestal with lower cornice blocks (Pedestal 1 or 2) could have had slightly higher orthostates; or, since the top of the South Wall drops slightly toward the east at a gradient of ca. 10 cm in 130 m,[68] the easternmost pedestal could have been some 10 cm higher. This difference could have been split between two or more courses of the pedestals.

To turn to the pedestals' elevation: On the one hand, according to the rules of proportion and decorum the inclusion of an architrave and cornice indicates a structure of considerable height. On the other, the consensus is that it should not have exceeded an average Athenian in height (ca. 1.72 m) so that the fallen figures would have been visible.[69] But is this what Attalos and the Athenians really wanted? The facts are surprising.

Midway along the top of the stretcher orthostates (B4–12), dowel sockets and pry holes define the positions of the joints and dowels of the next course, whose blocks had the standard length proper to each pedestal. But since they also had a set of two dowels at one end, the cornice blocks must be ruled out as candidates. For these were doweled (if at all) with center dowels (see Figures 265, 269, 271, 276–77; block Γ12 also had center dowels) and therefore – since the dowels could not have doweled the 9-cm void between the orthostates! – had to sit on a still-missing course that occupied the pedestal's entire width. Though a search for blocks of such a course has not been productive, their height can be estimated at around 16–24 cm.[70]

To sum up (Figure 287): The pedestals consisted of a Hymettan marble plinth 88 cm or three Attic feet wide and 24 cm high (blocks A1–8); Hymettan marble orthostates 97 cm high (B1–14); a still-missing horizontal course around 16–24 cm high; and a Pentelic marble entablature around 40 cm high (Γ1–13). Their total height was ca. 1.77–1.85 m, or around six Attic feet.[71]

Surprisingly, the orthostates' height is equal to two courses of the South Wall and could also have equaled the missing courses of its parapet. Assuming a low, two-course parapet with capstones half a course high (the height of the pedestals' plinths), a correspondence between parapet and pedestals seems quite feasible, with the pedestals' orthostates reaching the top of the parapet's cap.

As for the pedestals' position vis-à-vis the parapet, as long as the area mentioned by Penrose (see Figure 26a) cannot be investigated two possibilities remain: pedestals either attached to the parapet or freestanding within it (see Figures 218–19).[72] If the parapet was relatively low, the first solution would have made the bronzes more visible from the city but would also have made them seem "one-sided" to visitors inside the Akropolis.[73] The second alternative would have allowed such visitors to see them from both sides but at the cost of making them all but invisible from the city below (see Figure 226). Moreover, it would cast further doubt on the story of the Dionysos' plunge into the theater in the storm before Actium (AT5).[74]

In fact, the pedestals' structure (slabs placed lengthwise and transversally) essentially rules out the first alternative, even with a parapet of moderate height. It would have been feasible only with the pedestals replacing the parapet, either wholly or partially, rather than touching it.[75] As a result, and given Penrose's high reliability, the second solution is far more probable, even though it has severe consequences for the visibility of the statues from outside the Akropolis, especially if the parapet stood more than two courses high (see Figures 218, 226).

But even with a minimal parapet consisting only of two courses and a capstone (as sketched in Figure 219), a spectator down in the city would have had to be at least 400 m away to catch sight of the groups. By this point they would have appeared vanishingly small, and from the Theater of Dionysos nothing – not even the heads of the riders – would have been visible. Yet from inside the Akropolis the reverse would have been true. Visitors standing near the parapet would have noticed the Dedication's visual dialogue with the Parthenon metopes, while those wanting to see the fallen figures could have taken advantage of the ground's northward rise, whatever its exact configuration. With an initial gradient of around 1:6 starting just one meter from the pedestals, adults standing only ten to fourteen feet from the monument could have seen the dead and injured in full detail.

In fine, since it is impossible to decide between these two alternatives before the now-invisible top of the South Wall is cleared and examined afresh, Figures 217–18 present both of them for the reader to consider.[76]

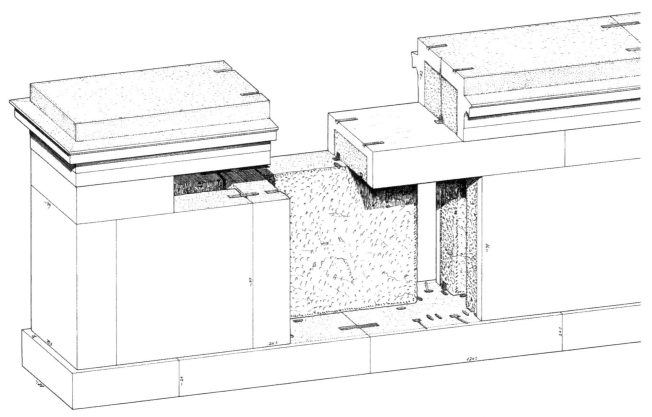

FIGURE 287. Attalid Dedication, restored cut-away isometric view of one of the pedestals. Reconstruction by Manolis Korres.

APPENDIX ONE

THE SOURCES

❦ ❦ ❦

1. ANCIENT SOURCES

AT1. Polybios 16.26.1–5 (ca. 140 BC, describing the events of spring, 200 in Athens):

Μετὰ δὲ ταῦτα συναγαγόντες ἐκκλησίαν ἐκάλουν τὸν προειρημένον. παραιτουμένου δὲ καὶ φάσκοντος εἶναι φορτικὸν τὸ κατὰ πρόσωπον εἰσελθόντα διαπορεύεσθαι τὰς εὐεργεσίας τὰς αὑτοῦ τοῖς εὖ πεπονθόσι, τῆς εἰσόδου παρῆκαν, γράψαντα δ' αὐτὸν ἠξίουν ἐκδοῦναι περὶ ὧν ὑπολαμβάνει συμφέρειν πρὸς τοὺς ἐνεστῶτας καιρούς. τοῦ δὲ πεισθέντος καὶ γράψαντος εἰσήνεγκαν τὴν ἐπιστολὴν οἱ προεστῶτες. ἦν δὲ τὰ κεφάλαια τῶν γεγραμμένων ἀνάμνησις τῶν πρότερον ἐξ αὐτοῦ γεγονότων εὐεργετημάτων ἐς τὸν δῆμον. . . .

After this they summoned an assembly and invited the king [sc. Attalos I] to attend. But when he begged to be excused, saying that it would be bad taste on his part to appear in person and to recite to the recipients all the benefactions he had made, they did not insist on his presence, but begged him to write a public statement of what he thought advisable under present circumstances. He agreed to do this, and when he had written the letter the presidents laid it before the assembly. The chief points in the letter were as follows. He first reminded them of the benefactions he had formerly made to the demos. . . .

AT2. *IG* ii². 1035, lines 25–27; Culley 1975, whence *SEG* 26: 121 (ca. 20 BC):

[— — — — — ἐπισκευ]άσ[αι τὰ ἀναθή]ματα κα[ὶ ἀγ]ά[λ]ματα τὰ ἀνατεθέντα ὑπ' Ἀτ[τάλου β]ασιλέως εἰς τὴν ἀσφάλειαν τῆς

[πόλεως — — — — — — ὅπως τὰ ἱερὰ τῶν ἱερῶν καὶ] τεμ[ενῶν τὰ π]επολιτευμ[ένα πρ]ὸς ἀείμνηστον δό[ξ]αν τοῦ δ[ημοῦ ἀμετα]κίνητα διαμένηι, ὀμνύειν τὸν ἀεὶ λ[α]-

[χόντα στρατηγὸν ἐπὶ τοὺς ὁπλείτας· — — — — — διατ]ηρῆσαι [τὰ ἀπ]οκατασταθέν[τα ἱ]ερὰ καὶ τεμένη·

[— — — — — to r]es[tore the ded]ications an[d div]ini[t]ies dedicated by At[talos the k]ing for the security of the

[city — — — — so that the sacred things of the temples and] prec[incts a]dminister[ed fo]r the everlasting glory of the pe[ople should stay [im]movable; whichever [general] has been assig[ned

[to the hoplites] should swear:[— — — — — — to main]tain [the re]store[d sac]red objects and precincts;

AT3a. Pliny, *Natural History* 34.84 (ed. Mayhoff) (ca. AD 70):

Plures artifices fecere Attali et Eumenis adversus Gallos proelia, Isigonus, Pyromachus, Stratonicus, Antigonus, qui volumina condidit de sua arte.

Several artists made the battles of Attalus and Eumenes against the Gauls: Isigonus [Epigonos?], Pyromachus [Phyromachos], Stratonicus, and Antigonus, who wrote books about his art.

AT3b. Pliny, *Natural History* 34.88 (ed. Mayhoff) (ca. AD 70):

Epigonus omnia fere praedicta imitatus praecessit in tubicine et matri interfectae infante miserabiliter blandiente.

Epigonus portrayed almost all of these subjects too [philosophers, athletes, etc.], but excelled in his Trumpeter and his Infant Pitiably Caressing Its Slain Mother.

AT4. Aemilianus of Nicaea, in the *Palatine Anthology* 7.623 (ed. Gow and Page) (1st century AD?):

Ἕλκε, τάλαν, παρὰ μητρὸς ὃν οὐκέτι μαστὸν ἀμέλξεις,
ἕλκυσον ὑστάτιον νᾶμα καταφθιμένης·
ἤδη γὰρ ξιφέεσι λιπόπνοος· ἀλλὰ τὰ μητρὸς
φίλτρα καὶ εἰν ἀίδῃ παιδοκομεῖν ἔμαθεν.

Suck from your mother, poor child, the breast you'll never milk again,
Suck the last stream from the slaughtered;
Already by the sword she lies breathless; yet a mother's
Love knows how to nurse her child even in death.

AT5. Plutarch, *Antony* 60.2–3 (ed. Ziegler) (ca. AD 100):

καὶ τῆς Ἀθήνησι γιγαντομαχίας ὑπὸ πνευμάτων ὁ Διόνυσος ἐκσεισθεὶς εἰς τὸ θέατρον κατηνέχθη· προσῳκέου δὲ ἑαυτὸν Ἀντώνιος Ἡρακλεῖ κατὰ γένος καὶ Διονύσῳ κατὰ τὸν τοῦ βίου ζῆλον, ὥσπερ εἴρηται, Διόνυσος νέος προσαγορευόμενος. ἡ δὲ αὐτὴ θύελλα καὶ τοὺς Εὐμενοῦς καὶ Ἀττάλου κολοσσοὺς ἐπιγεγραμμένους Ἀντωνείους Ἀθήνησιν ἐμπεσοῦσα μόνους ἐκ πολλῶν ἀνέτρεψε. ἡ δὲ Κλεοπάτρας ναυαρχὶς ἐκαλεῖτο μὲν Ἀντωνιάς, σημεῖον δὲ περὶ αὐτὴν δεινὸν ἐφάνη·

[Before the battle of Actium in 31 BC] at Athens, winds dislodged the Dionysos in the Gigantomachy and tossed it into the theater; for Antony assimilated himself to Herakles by descent and to Dionysos by his lifestyle, so that, it is said, he was called New Dionysos. And the same storm struck the colossi of Eumenes and Attalos at Athens, reinscribed as Mark Antony, and toppled them – alone among many. Kleopatra's flagship was called "Antonias," and a bad omen happened in regard to it as well:

AT6. Pausanias 1.25.2 (ca. AD 170):

Πρὸς δὲ τῷ τείχει τῷ Νοτίῳ γιγάντων, οἱ περὶ Θρᾴκην ποτὲ καὶ τὸν ἰσθμὸν τῆς Παλλήνης ᾤκησαν, τούτων τὸν λεγόμενον πόλεμον καὶ μάχην πρὸς Ἀμαζόνας Ἀθηναίων καὶ τὸ Μαραθῶνι πρὸς Μήδους ἔργον καὶ Γαλατῶν τὴν ἐν Μυσίᾳ φθορὰν ἀνέθηκεν Ἄτταλος, ὅσον τε δύο πηχῶν ἕκαστον. ἕστηκε δὲ καὶ Ὀλυμπιόδωρος. . . .

By the South Wall [of the Akropolis at Athens] Attalos dedicated [I] the legendary battle of the Giants, who once lived around Thrace and the Isthmus of Pallene, [II] the battle of the Athenians against the Amazons, [III] the affair against the Persians at Marathon, and [IV] the destruction of the Galatians in Mysia – each figure being about two cubits [three feet] high. And there too stands Olympiodoros. . . .

AT7. Cassius Dio 50.15.2 (ca. AD 200):

τάς τε εἰκόνας αὐτῶν [sc. Antony and Kleopatra], ἃς οἱ Ἀθηναῖοι ἐν τῇ ἀκροπόλει τὸ τῶν θεῶν σχῆμα ἐχούσας ἔστησαν, κεραυνοὶ ἐς τὸ θέατρον κατήραξαν.

And lightning hurled the portraits of them [sc. Antony and Kleopatra], which the Athenians had set up on the Akropolis in the form of the gods, down into the theater.

AT8. Anonymus Alexandrinus, *Expositio totius mundi et gentium* 52; A. Riese, *Geographi Latini Minores* (Frankfurt am Main 1878; repr. Hildesheim 1964): 118 (AD 347):

Athenas vero et historias antiquas et aliquid dignum nominatum Arcem, ubi multis statuis stantibus mirabile est videre dicendum antiquorum bellum.

At Athens, indeed, there are ancient tales and something worthy of mention, the Acropolis, where among the many statues standing there it's wonderful to see the celebrated war of the ancients.

2. RENAISSANCE SOURCES

RT1. Archivio mediceo, famiglia privata, Lettere filza 108 (Giovanni Gaye, *Carteggio inedito d'artisti di secoli XIV. XV. XVI* [Florence 1840; repr. Turin 1968]: II: 139, no. 84): Letter of Filippo Strozzi to Giovanni di Poppi (September 1514):

Direte ancora al Magnifico che sua madre è la piú fortunata donna mai fuisse, che li danari che le dà per dio li fruttono piú perchè se li prestassi a usura; et questo perchè murando a certe monache una cantina vi hanno trovate sino a questo di circa 5 figure sì belle quanto ne sian altre in Roma. Sono in marmo, di statura mancho che naturale, e sono tutti chi morti e chi feriti, pure separati. Evi che tiene che sian la historia delli Horatii et Curiatii; no ne scrivo piú particolari, perché in breve spero el Magnifico li abbia a vedere, a li piaceranno.

Also tell [Lorenzo] the Magnificent that his mother is the most lucky woman who ever lived, because the money that

288

God has given her benefits her more than if she had lent it out at interest; and this because when some nuns were walling up a cellar they found there about five figures up to now, as beautiful as any others in Rome. They are in marble, at a scale short of life-size, and they are all dead or wounded, and all single figures. The opinion is that they represent the story of the Horatii and Curiatii; I won't write you any more particulars about them, because I hope that [Lorenzo] the Magnificent will soon see them, and I'm sure he will like them.

RT2. Claude Bellièvre, *Noctes Romanae*. Paris, Bib. Nat. MS lat. 13,123, fol. 187 (Klügmann 1876: 35) (winter 1514–15):

Hoc eodem et hodierno die vidimus apud edem divi Eustachii in una domo mulieris cujusdam de Ursinorum familia has sequentes statuas, qui si rem intellegere voles et historiam de pugna, scilicet trigeminorum trium Horatiorum romanorum videlicet et trium Curiatiorum Albanorum, vide Livium decade. Horum unus barbatus et comatus est nudus et prostratus humi, mortuus, suum tamen ensem adhuc manu retinens, hic vulnus habet in sinistra mamilla. [*In marg.*: Horum omnium tantum superstes et victor fuit Marcus Horatius cujus statua ad papam vecta erat]. Est etiam Horatiorum soror, forma decora, confossa super mamillam dextram quam prostratam infantulus suus arida sugens ubera amplectitur. Est et alius modica coma imberbis, cujus facies ostendit impetum virilitatis. Hic vulnus habet in femore sinistro et alterum in latere dextro, hic etiam uno genu terram attingit, videturque velle levare lapsum ensem. Alius qui in actu cadendi est, confossum habet corpus a mamilla sinistra trans humeros. Inter istos est etiam unus qui fingitur animam exalasse; hic solus calceos habet, et hujus ensis curvus et clipeus in terra sunt. Postremus est qui vittam in capite gerit et stat curvus in terram ac si alium sub se jugularet.

Today we saw by the same S. Eustachius in the home of a certain lady of the Orsini family the following statues, which if you want to understand the matter and the story of the battle, that's to say of the Horatii triplets of Rome and the Curiatii triplets of Alba, see the ten books of Livy. Of these statues, (1) one is bearded, hairy, naked, and lying on the ground, dead, but still grasps his sword in his hand; he is wounded in his left breast. [*Marginal note*: Among all of them (2) the sole survivor and victor was Marcus Horatius, whose statue was taken to the Pope]. (3) There's also the sister of the Horatii, a beautiful woman, wounded above her right breast; her infant son embraces her as she lies there, sucking her dried-up teats. (4) There's another with medium-length hair, clean-shaven, whose face shows a masculine impulsiveness. He has a wound in his left thigh and another in his right side, but kneels down on one knee and seems to want to pick up his fallen sword. (5) Another is in the process of collapsing, and his body is pierced from the left nipple through the shoulder blade. (6) Among them is also one who is represented as dying; he alone has shoes, and his curved sword and shield are on the ground. (7) Finally there is one who has a fillet on his head and stands stooped to the earth as if killing someone beneath him.

RT3. Marino Sanuto, *Diarii 1496–1533* (Venice 1879–1903): vol. 34: cols. 386–87 (August 30, 1523):

Di Roma, vene lettere a Consejo di Foscari orator nostro, di 27. Come il reverendissimo Grimani a di dito hore . . . era morto. . . . Item, lassa a la Signoria tutti li soi bronzi et marmi, da esser adornado una sal per sua memoria.

From Rome arrived a letter to the Council from our orator Foscari, of the 27th. How on said day at the hour of . . . the most reverend Grimani died. . . . Item, he left all his bronzes and marbles to the Signoria, for a room to be embellished in his memory.

RT4. Archivio di Stato di Venezia, *Libri commemoriali* 20, no. 178 (Perry 1978: 241–42: Inventory of Cardinal Domenico Grimani's legacy to Venice, September 15, 1523):

MDXXIII Die xv Septembris In Monasterio Sanctae Clarae di Murano

Inventarium imaginum, et aliorum Infrascriptorum bonorum q. R.mi cardinalis Grimani . . .

6.A In una cassa ut supra [sc. di legname] due corpi rotti, uno ha Testa, e l'altro é senza, disse esser luno gladiator.

9.F In una cassa una figura di marmoro, dice esser laltro gladiator.

27.L In una cassa un gladiator de marmo.

1523, September 15, In the Monastery of Santa Clara di Murano

Inventory of the statues and following other goods of the Cardinal Prince Grimani . . .

6.A In one box as above [sc. of wood] two broken figures, one with a head, the other headless, the former said to be a gladiator.

9.F In a box a figure of marble, said to be the other gladiator.

27.L In a box a gladiator of marble.

RT5. Marino Sanuto, *Diarii 1496–1533* (Venice 1879–1903): vol. 39: cols. 427–28 (September 12, 1525):

Eri fo compito di meter li marmori antichi, teste et corpi di piera viva trovati a Roma che 'l reverendissimo cardinal Grimani lassò a la Signoria nostra, unde questo Principe li

ha fatti meter in la camera davanti la camera di la chiesiola drio la sala d'oro che si fa Pregadi de inverno; I qual sono tutti numero.... Et sarà uno epitafio in comemoration dil Cardinale che li lassoè, qual ancora non è stà posto suso. Stanno per excellentia, e adorno quel saloto per il qual il Serenissimo volendo di palazo venir in Collegio, passa de lì via.

Yesterday was completed the installation of the ancient marbles, heads, and statues of living rock found at Rome that the most reverend Cardinal Grimani left to our Signoria, so that the Doge had them placed in the room before the room of the chapel behind the golden room where the Senate meets in winter; all together they total [lacuna]. And there will be an epitaph in commemoration of the Cardinal's bequest, which has not been put up yet. They make an excellent display, and decorate the room through which the Doge has to pass when he wants to leave the palace for the Collegium.

RT6. M. Ulisse Aldrovandi, *Delle statue antiche che per tutta Roma, in diverse luoghi, et case si veggono* (MS, 1550): 121–22; Aldrovandi (1556/1558): 121, 182–83.

Nella guardia di sua Santità è la statua di un Curiato bellissima.

. . .

In casa Madama: presso Agona.

Nel giardinetto giù del palagio si vede un Bacco ignudo . . .

. . .

Vi è una donna con veste fino a ginocchi di mezzo rilievo: ha seco un putto, che è senza testa e braccia.

. . .

Vi è un Curiato ignudo, e steso in terra, et con la ferita nel lato manco: ma non ha la testa.

. . .

Dentro un'altro giardinetto poi si veggono attaccati al marmo [muro] gli altri due Curiatij morti, posti di mezzo rilievo; e sono nel luogo, dove già furono le Terme di Alessandro, come vi si veggono i vestigi; et è presso S. Luigi. I tre Curiatij furono tre fratelli Albani, che combatterono con li tre Oratij Romani per l'imp. delle patrie loro, e furono vinti e morti, et lasciarono soggetta la loro patria a' Romani.

In the guardhouse of His Holiness is a most beautiful statue of one of the Curiatii.

. . .

In the Casa Madama; near the Agona.

In the little garden behind the palace one can see a nude Bacchus . . .

. . .

There is also a woman in high relief wearing a garment that reaches her knees; she has with her a little boy, who is headless and armless.

. . .

There is one of the Curiatii, naked and reclining on the ground, with a wound in his left side; but he has no head.

. . .

Behind another little garden there, fastened to the marble [wall], are the other two dead Curiatii, in high relief; and they are in the place where the Baths of Alexander [Severus] once stood, as the remains there show; it is near S. Luigi. The three Curiatii were three brothers of Alba, who fought the three Horatii from Rome for the rule of their respective cities, and they [the C.] were defeated and killed, and left their city subject to the Romans.

RT7. *Documenti inediti per servire alla storia dei Musei d'Italia* II: 337 (Inventory of Palazzo Medici–Madama: mid-sixteenth century):

I.

Statue antiche che stanno nel pal. della Ser. Madama d'Austria.

. . .

Le infrascritte stanno nella casa dove habitava Msr. Gio. Lippi.
Una medaglia di Lorenzo vecchio di Medici in marmo.
Tre Curiatij.

. . .

Ancient statues that stand in the palace of Ser. Madama of Austria

. . .

The following stand in the house where Msr. Gio. Lippi lived:
A tondo of Lorenzo di Medici the Elder in marble.
Three Curiatii.

. . .

RT8. *Documenti inediti per servire alla storia dei Musei d'Italia* I: V n. 4 (Letter of Pius V authorizing transfer of statues from Rome to Parma, 1566):

Motu proprio etc. Dilectam filiam Margaritam ab Austria ducissimam Parmae et Placentiae Civitatu' gravissime favore prosequi volentes infra.tas antiquas statuas ad dictam margaritam spectantes et pertinentes ver' = Un Curiato in marmo col scudo et con la spada, un' altro simile in forma d'Hercule con la spada sopra la testa. Un' altro simile nudo siede senza testa, Una donna morta ferita in la zinna dritta,

Motu proprio, etc. Wishing to confer a most important favor upon our dearest Margaret of Austria, Duchess of Parma and Placentia [we allow the transfer of] the following ancient statues belonging to the said Margaret: (1) a Curiatius in marble with shield and sword; (2) another in the form of Hercules with a sword above his head. (3) Another like

it sitting nude and without his head; (4) a dead woman wounded in the right nipple;

RT9. Archivio di Stato di Venezia, *Proc. de supra*, B. 68, Prc. 151, fasc. 3, I, cc. 5r–6r (Perry 1978: 242–43: Inventory of sculpture taken from the Sala delle Teste in 1586, then [1587] in the Palazzo Ducale's Old Chapel):

1586, 20 Febraro [m.v.]
Nella Chiesiola veschia in Palazzo
. . .

XII. Un Torso d'un giovane nudo con la testa, et con la coscia sinistra, senza brazzi, et senza la gamba destra long tre quarte fino al sentar, tutto tondo, et bello.

XIII. Una figura d'un Gladiator caduto in terra con un genocchio, posa con la man sinistra in terra senza il brazzo destro longa sette quarte tutto nudo con un pezzo di panno groppiato su 'l fianco destro, che copre parte del corpo fino alla spada.

XIV. Un' altro Gladiator in piedi nudo, con un pezzo di panno groppato su 'la spalla destra, che copre il petto fino all spalla sinistra senza il brazzo destro, et senza la man sinistra, et senza la gamba sinistra del genochio in giuso con una corazza in terra appoggiata alla gamba destra.

1587, 20 February (1586, Venetian style)
In the Old Chapel in the Palace:
. . .

12. A torso of a naked youth with its head, and with its left thigh, armless, and without its right leg, three-quarters long to the buttocks, in the round, and handsome.

13. A figure of a Gladiator fallen with one knee on the ground, posed with its left hand on the ground, missing his right arm, seven quarters long, completely naked with a piece of drapery gathered on his right side, that covers part of the body as far as the shoulder.

14. Another Gladiator on his feet, naked, with a piece of drapery gathered on his right shoulder, that covers the chest up to the left shoulder, lacking the right arm, the left arm, and the left leg from the knee, with a cuirass on the ground leaning up against his right leg.

RT10. Archivio di Stato di Napoli 1853 (iii) 3, fols. 18–18v (Riebesell 1989: 197–98, no. 29: Inventory of statues taken in 1587 from the Palazzo Medici–Madama to the sculptor Giovanni Battista de' Bianchi's workshop behind the Palazzo Farnese):

Adì 10 Febbraio 1587. Nota delle statue della felice memoria di Madama Ser.^ma, che sono state consignate a messer Giovanni Battista scultore di casa nella stantia, dove egli habita dietro al Palazzo nuovo, et cominciando da quelle che stavano incascate in 20 cascie.

7. Un'Amazzone ferita nella zinna, che giace in terra morta di 5 palmi con una camiscia in dosso, con la testa, senza mezza mano, col posamento di sotto.

8. Una figura d'huomo ferito et morto, coricato in terra, vestito in parte, di palmi 5 con la sua testa, senza braccia et una gamba, col posamento di sotto.

9. Una figura d'huomo pur ferito di cinque palmi, sta a seder con due ferite, senza un piede et testa, ignudo, col posamento di sotto.

. . .

15. Un torso di Gladiator ferito et morto, di 5 palmi ignudo, senza una gamba, coricato in terra, con la testa barbata.

February 10, 1587. List of the statues belonging to the Most Serene Madama of happy memory, that have been consigned to Sig. Giovanni Battista, currently the house sculptor, where he lives behind the Palazzo Nuovo, and beginning with those that are boxed up in 20 boxes.

7. An Amazon wounded in the breast, who lies dead on the ground, 5 palms long wearing a tunic, with head, without half of her hand, with a plinth under.

8. A figure of a man wounded and dead, lying on the ground, partly draped, 5 palms long with the head, armless and missing one leg, with a plinth under.

9. A figure of a man also wounded, 5 palms long, sitting up with two wounds, missing one foot and the head, nude, with a plinth under.

. . .

15. A torso of a gladiator wounded and dead, 5 palms long, nude, missing one leg, lying on the ground, with the head bearded.

RT11. Archivio di Stato di Venezia, *Proc. de supra*, B. 68, Prc. 151, fasc. 3, I, cc. 33–65v (G[iuseppe?] Valentinelli, *Catalogo dei marmi scolpiti del Museo Archeologico della Marciana di Venezia* [1861–62; repr. Prato 1866]: 342–43; Levi 1900: II: 9–14: Inventory of combined Grimani collections in the Palazzo Grimani at Santa Maria Formosa in Venice, 1593):

Dalla parte destro nel entrar dentro

5. Una statua di huomo nudo distesa over cussa di lunghezza di piedi 3 in circa tiene la mano destra in terra, et la sinistra elevata in altro.

13. Una statua di huomo nudo disteso con un scudo nel braccio sinistro di piedi 3⅔ in circa.

15. Un huomo nudo con barba, et elmo in testa di piedi 3 in circa che sta sul fuggire con un pano ai piedi sopra un tronco.

18. Una statua di un huomo con barba ingenocchiato con la gamba sinistra, la mano sinistra in terra, e nella destra con manico di pugnale, di piedi 3 2/1 in circa.

From the right inside the entrance:

5. A statue of a naked man stretched out or thrust down about 3 feet long with his right hand on the ground and the left raised on high.

13. A statue of a man stretched out with a shield on his left arm, about 3½ feet long.

15. A bearded man with a helmet on his head, about 3 feet high, who stands about to flee, with drapery at his feet on top of a tree trunk.

18. A statue of a bearded man kneeling on his left leg, his left hand on the ground, with a sword hilt in his right hand, about 3½ feet long.

RT12. Archivio di Stato di Venezia, Senato terra, Filza 137, decreto 12 Settembre 1595 (Perry 1978: 243: contains Tiziano Aspetti's list of his 1587 restorations to Domenico Grimani's sculptures as he reported them to the Venetian Senate in 1594):

...

un Grediatore fatoli un gamba et la cosia et latra gamba sino al zegnochio et tuti dua li barci

un altro fatoli un barzio et li due piedi et il nazo ala testa

un altro fatoli le due gambe et la base et li barci tuti dua la spada et alcuni peci di pani

One gladiator I made for it a leg and thigh and the other leg up to the knee and both arms entire

Another I made for it an arm and both feet and the nose on the head

Another I made for it both legs and the base and all of both arms the shoulder and some pieces of drapery

RT13. Jean Jacques Boissard, *Romanae Urbis Topographiae & antiquitatum,* vol. 1 (Frankfurt 1597): 14.

Ad stationem Heluetiorum, qui excubant ante cubiculum Pontificis, marmorea videtur statua unius Curiacii: cuius perfectio plurimis extollitur laudibus a sculptoribus.

In the station of the Swiss Guards, who keep watch before the Pope's chamber, is to be seen a marble statue of one of the Curiatii: Its perfection gets it the highest praises from sculptors.

APPENDIX TWO

THE STATUES

1. SELECT GENERAL BIBLIOGRAPHY

1870–1900: Brunn 1870; *Monumenti inediti pubblicati dall'Instituto di Corrispondenza Archeologica* 9 (Rome 1869–73): pls. 19–21; Benndorf 1876; Klügmann 1876; Overbeck 1882: 202–17; Milchhöfer 1882: 26–29; Eugen Müntz, "Le Musée du Capitole et les autres collections romaines à la fin du XVe siècle et au commencement du XVIe siècle avec un choix du documents inédits," *RA* 43 (1882): 24–36, at p. 35 n. 1; Lucy Mitchell, *A History of Ancient Sculpture* (London 1883): 570–73; Duhn 1885; Malmberg 1886; Mayer 1887; Reinach 1889; Farnell 1890: 182, 205–07; Michaelis 1893; Petersen 1893; Reinach 1894; Sauer 1894; Habich 1896; B–B: nos. 481–82.

1901–30: Michaelis 1901: 20–21, 62; Lanciani 1902/1989–2000: vol. 1: 213; Bienkowski 1908: 37–78; Ferguson 1911: 209–10; Georg Lippold, *Göttinger gelehrte Anzeiger* 1914: 352–53 (book review); Dinsmoor 1920; Lippold 1923: 111–13; Krahmer 1927: 71 n. 1; Lawrence 1929: 295; della Seta 1930: 523–29.

1931–60: Schober 1933; Otto Brendel, text to *EA* 3965; Bernard Schweitzer, "Späthellenistische Reitergruppen," *JdI* 51 (1936): 158–74; Horn 1937: 150–62; Schober 1939; Arnold Schober, "Zur Geschichte pergamenischer Künstler," *ÖJh* 31 (1939): 142–49; Esther V. Hansen, *The Attalids of Pergamon* (1st ed., Ithaca, N.Y., 1947): 282–88; Lippold 1950: 353–54; Pietrangeli 1951–52: 92 n. 29; Schober 1951: 123–34; Curtius 1954; Brendel 1955; Andreae 1956/1973: 74–83; Pietrangeli 1956; Bieber 1961: 109–10; Carpenter 1960: 195.

1961–80: Dohrn 1961; Brendel 1967; Luigi Beschi, *Sculture greche e romane di Cirene* (Padua 1959): 264, 289; Andreae 1968–69: 153; Hansen 1971: 306–14; Shearman 1972: 121–22; Dacos 1977/1986: 157, 192–93; Perry 1978; Stewart 1979: 7–23; Andreae 1980; Perry 1980.

1981–2000: Palma 1981, 1984; Bober and Rubinstein 1986: nos. 143, 148–52; Hölscher 1985; Pollitt 1986: 90–97; Lanciani 1902/1989–2000: vol. 1: 213; Queyrel 1989; Riebesell 1989: 41–47, 50; Fox 1990; Paul Joannides, "On Some Borrowings and Non-Borrowings from Central Italian and Antique Art in the Work of Titian, ca. 1510–ca. 1550," *Paragone* 487 (1990): 21–45, at p. 45; Ridgway 1990: 287–304; Stewart 1990: 210; Smith 1991: 101; Andreae 1993: 97–98, pl. 16; Hannestad 1993: 15–38; Wolfram Hoepfner, "Siegestempel und Siegesaltäre: Der Pergamonaltar als Siegesmonument," in Wolfram Hoepfner and Gerhard Zimmer (eds.), *Die griechische Polis: Architektur und Politik* (Tübingen 1993): 111–25, at pp. 116–17; Korres 1994: 10; Moreno 1994: 586–93; Bringmann and von Steuben 1995: 66–68; Wolfram Hoepfner, "Der vollendete Pergamonaltar," *AA* 1996: 125–31; Spinola 1996: 65–91; Freedman 1997; Hoepfner, "Model of the Pergamon Altar (1 : 20)," in Dreyfus and Schraudolph 1997: 65–67; Hoepfner 1997b: 143–45; Andreae 1998: 184–93; Marszal 1998: 121–22; Hurwit 1999: 269–71; Kaminski 1999; Bringmann 2000: 75–76; Marszal 2000: 193–97, 205, 211–12; Schmidt-Dounas 2000: 128–30, 231–44; Steingräber 2000: 242–43, 246–48, 250; Stewart 2000: 46–49.

2001–03: Andreae 2001: 168–71; Beard and Henderson 2001: 160–64; Marvin 2002: 215–23; "Census of Antique

Works of Art and Architecture Known to the Renaissance" (http://www.dyabola.de): s.vv. "Gauls," "Gladiatore," "Venice," etc.

2. CATALOG

1. Dead Giant, Naples Mus. Naz. 6013 (Farnese Coll., FAR 184)

Figures 1 (complete), 14 (lionskin), 19, 29 (complete), 30 (side), 31, 32 (head), 73 (Pozzo drawing), 88 (head), 98 (Overbeck drawing), 152, 175 (head), 191 (wound), 193 (drawing, restorations marked), 255 (complete); 280 (Korres drawing, with tenons supplied); Foldout (Overbeck drawing).

Select bibliography: Clarac 1851: 136, no. 2216, pl. 871; Brunn 1870: 309, pl. 21, 8; B–B 482a; Ruesch 1911: no. 301; Horn 1937: 158, pl. 42, 1; Schober 1951: 127 (D1), 130, figs. 108–09; Stewart 1979: 15–19, pl. 7e; Andreae 1980; Palma 1981: no. 1, fig. 1; Palma 1984: 774–75, pl. 108, 3; Ajello, Haskell, and Gasparri 1988: 55–56; Pozzi et al. 1989: 54, 146, no. 15, col. pl. on p. 48 and fig. on p. 157; Fox 1990: 107, fig. 3; Bringmann and von Steuben 1995: 66–68, no. 1, fig. 18; Schmidt-Dounas 2000: 243, figs. 78, 81; Andreae 2001: 168–71, pl. 146; Marvin 2002: 208–23, fig. 9.5.

L 139.0; of figure, 116.0. For other measurements, see Table 16.

History: Found in Rome in 1514; Rome, Pal. Medici-Madama, 1514; Rome, Pal. Farnese, 1587; Rome, Farnesina alla Lungara by 1767; Rome, Albacini studio, 1790; Naples, Mus. Nuovo, 1796.

Documentation: Strozzi 1514 (RT1)?; Bellièvre 1514–15 (RT2, no. 1); Aldrovandi 1556/1558: 121 (RT6); mid-16th-cent. Pal. Medici–Madama inventory (RT7); *motu proprio* of Pius V authorizing transfer to Parma 1566 (RT8, no. 2; "Curiatius"; never carried out). Pal. Farnese inventory 1587 (RT10, no. 15: "Gladiator"); Pal. Farnese inventory 1644 (Jestaz 1994: no. 4563: "man"); drawing in collection of Cassiano dal Pozzo 1657 (Figure 73: *Windsor Sketchbook*, vol. 8, fol. 31: Vermeule 1966: 50, no. 8732, fig. 213; Palma 1981: 46, text fig. 1); Pal. Farnese inventory 1697 (*Doc-In* 2: 387; Palma 1984: 781–82, app. 5: "dead gladiator"). Pal. Farnesina alla Lungara inventory, 1767 (Palma 1984: 782, app. 6: "Gladiator lying dead"). Naples, Nuovo Museo inventory 1796, no. 184 (Palma 1984: 782, app. 7: "dead Gladiator"); Naples, Nuovo Museo inventory 1800 (de Franciscis 1946: 102: "Gladiator, or Hercules lying wounded"). Clarac 1851: 136, no. 2216, pl. 871.

Condition: Lightly weathered; surface then reworked with abrasives and repolished. Restorations (by Giambattista de' Bianchi 1587 – see Pozzo's 1657 drawing, Figure 73; then by Carlo Albacini, Naples 1790–96; see Figure 193) include the nose; fingers of r. hand; exterior of l. thigh; l. shin and foot; big toe of r. foot; upper paw of lionskin (now missing); sword hilt and most of blade.

Plinth, clothing, attributes, etc.: Rocky. Wears lionskin wrapped around l. arm and under body. Brandishes sword in r. hand. Deep stab wound on left side of chest, dripping blood. Fillet tied in a bow carved on plinth beside r. side of torso with 5-mm.-diam. drill hole at center of knot.

Notes: Features of face converge to proper left, following the movement of the head. On the physiognomy, see Chapter 3, §4; on the iconography, Chapter 4, §2.

2. Dead Amazon, Naples Mus. Naz. 6012 (Farnese coll., FAR 188)

Figures 1 (complete), 9 (drapery), 13 (head and torso), 18, 33 (complete), 34 (side), 35, 36 (head), 72 (Floris drawing), 74 (Pozzo drawing), 98 (Overbeck drawing), 190 (wound), 193 (drawing, restorations marked); 280 (Korres drawing, with tenons supplied); Foldout (Overbeck drawing).

Select bibliography: Clarac 1851: 46, no. 2035, pl. 810A; Brunn 1870: 306 and pl. 20, 5; Klügmann 1876; Michaelis 1893; Petersen 1893; Reinach 1894; Sauer 1894; Habich 1896: 15–16; B–B 482b; Ruesch 1911: no. 303; Horn 1937: 160, fig. 5; Schober 1951: 127 (C1), 131, figs. 110–11; C. Van de Velde, "A Roman Sketchbook of Frans Floris," *Master Drawings* 7 (1969): 255–86, at pp. 271–72, pl. 11a; Palma 1981: no. 2, fig. 2; Palma 1984: 774–75, pl. 108, 4–5; Bober and Rubinstein 1986: no. 143; Ajello et al. 1988: 55–56; Lanciani 1902/1989–2000: vol. 1: 213; Pozzi et al. 1989: 54, 146, no. 14, with fig. on p. 157; Riebesell 1989: 41–48, fig. 43; Fox 1990: 107, fig. 4; Ridgway 1990: 292–96, pl. 145; Moreno 1994: 590; Bringmann and von Steuben 1995: 66–68, no. 2, fig. 19; Kaminski 1999; Marszal 2000: 203–4; Schmidt-Dounas 2000: 243, fig. 84; Andreae 2001: 168–71, pl. 157; Marvin 2002: 208–23, fig. 9.6.

L 127.0; of figure, 116.0. For other measurements, see Table 16.

History: Found in Rome in 1514; Rome, Pal. Medici-Madama, 1514; Rome, Pal. Farnese, 1587; Rome, Farnesina alla Lungara by 1767; Rome, Albacini studio, 1790; Naples, Mus. Nuovo 1796.

Documentation: Strozzi 1514? (RT1); Bellièvre 1514–15 (RT2, no. 3: with baby boy); sketch by Frans Floris, 1540–47 (Figure 72: *Basel Sketchbook*, fol. 23v, inv. U.IV.19: Van de Velde, "Roman Sketchbook," 271–72, pl. 11a; Palma 1984:

TABLE 16. The Little Barbarians: Measurements (cm)

	Naples				Vatican	Venice			Paris	Aix
	Giant	Amazon	Persian	Gaul	Persian	Kneeling Gaul	Falling Gaul	Dead Gaul	Gaul	Persian
H TOTAL	38	27.5	35	59	(73)	76	(69)	28.5	87.5	(64)
H figure	—	—	—	51	(63)	69.5	(57)	17.3	80	(59)
L TOTAL	139	127	96	—	—	—	—	136	—	—
L figure	(116)	116.5	96	—	—	—	—	114	—	—
Plinth	133 × 53	124 × 61	96 × 62	97 × 36	(77 × 42)	111 × 27	(107 × 43)	136 × 53	70 × 39	67 × 36
H plinth	7–23	4–11	7–12	9	(5–13)	7	(5–10)	8–14.5	7.5	4–7
H head	21	15.5	14	20.4	15.8	16	16	17.5	17	15
H face	13	10.9	10	10.2	11	11.5	11.5	12.6	12.4	11
Chin–eyes	8.5	7	7	7.5	7.5	7.5	7.2	(8.3)	8	8.5
Mouth–eyes	4.5	4.2	4.2	4	4.3	4.3	4.2	5	4.4	4.5
W eyes (outer corners)	6.5	5.7	(7)	6	5.6	6.1	5.5	7.1	6.5	(7)
L left eye	2.5	2	—	2	2.1	2.1	2	2.5	2.2	—
L right eye	2.3	2	1.7	2	1.9	2	2	2.5	2	2.2
L mouth	2.8	2.6	3.5	3	3.5	3	2.9	3.5	3.5	3.6
Pit of neck–girdle	—	—	17	—	—	23.5	—	20.6	—	—
P. of n.–navel	22	—	—	22	(16.5)	—	17.5	23.6	23	—
P. of n.–pubic hair	29	—	—	28	(23)	—	25	33.1	32.5	—
W shoulders	29	(27)	27	36	(24)	(35.3)	(27)	(35)	(36.5)	—
W nipples	17.5	14	—	15.7	16	(16)	15.8	16.5	19.5	—
W waist	20	24.9	—	22	19.5	—	17	18.5	22.5	25
W iliacs	20.6	—	—	24.5	21.7	(22)	18.3	19.5	23.4	—
Pubic hair–heel	54.5	—	—	50	—	55	Restored	58	—	—
Back of knee–heel	25	26	26; 29	26.5	28	31	Restored	27.5	28	23
L right foot	16.5	(17)	15.5	Restored	Restored	(14+)	Restored	(15+)	(17)	17
L left foot	Restored	(16)	(15.5)	(16)	Restored	Restored	Restored	(15+)	(17)	17
W foot (toes)	7.5	6.5	6	7.5	Restored	7	Restored	6.8	6.6–8	7
W foot (heel)	—	4	4.5	4	Restored	5	Restored	5.1	4.5	5.5
Weapons:										
Shield	—	—	42.5 × 26	—	Restored	—	—	Obscured	64.5 × 37	—
Sword	(42)	—	52	—	—	—	—	15 (hilt)	(49)	Restored
Spear	—	(170)	—	—	—	—	—	—	—	—

Note: () = statue restored, broken, or measurement otherwise unreliable.

text fig. 5; Bober and Rubinstein 1986: no. 143); Aldrovandi 1556/1558: 121 (RT6: with baby boy); omitted from mid-16th-cent. Pal. Medici–Madama inventory (RT7: taken for restoration and removal of baby?); *motu proprio* of Pius V authorizing transfer to Parma 1566 (RT8, no. 4; no mention of baby; transfer never carried out). Pal. Farnese inventory 1587 (RT10, no. 7: "Amazon," no baby); Pal. Farnese inventory 1644 (Jestaz 1994: no. 4556: "woman"); drawing in collection of Cassiano dal Pozzo 1657 (Figure 74: *Windsor Sketchbook*, vol. 1, fol. 68: Vermeule 1966: 12, no. 8227, fig. 14; Palma 1981: 47, text fig. 2: no baby); Pal. Farnese inventory 1697? (*DocIn* 2: 387; Palma 1984: 781–2, app. 5: lists a dying gladiator and three gladiators lying dead, but no dead woman, so presumably mistaken for a man). Pal. Farnesina alla Lungara inventory, 1767 (Palma 1984: 782, app. 6: one of two "wounded Amazons lying on the ground"). Naples, Nuovo Museo inventory 1796, no. 188 (Palma 1984: 782, app. 7: "Amazon"); Naples, Nuovo Museo inventory 1800 (de Franciscis 1946: 102: "Amazon lying wounded"). Clarac 1851: 46, no. 2035, pl. 810A.

Condition: Lightly weathered; surface then reworked with abrasives and repolished. Restorations (by an unknown restorer, ca. 1560; then by Giambattista de' Bianchi, 1587 – see Pozzo's 1657 drawing, Figure 74; then by Carlo Albacini, Naples 1790–96: see Figure 192) include locks between left ear and shoulder; nose; ridges of some drapery folds; thumb and fingers of both hands (now mostly missing); lower l. leg w. foot; big toe and next two toes of r. foot. Baby removed in mid-16th cent., r. breast and adjacent drapery folds reworked and repolished.

Plinth, clothing, attributes, etc.: Rocky. Wears undergirt *chitoniskos* buttoned on l. shoulder with two visible buttons, leaving r. breast and side bare; weights at corners of skirt. Lies on two crisscrossed broken spears. Sword-cut above r. breast, dripping blood upward toward shoulder (i.e., away from the head of the now-lost baby).

Notes: Features of face converge to proper left, following the movement of the head. Baby boy certainly original, removed in the 1550s. Inscription chiseled on plinth by r. side of body: *I direto Abiit 1787*. On the physiognomy, see Chapter 3, §4; on the iconography, Chapter 4, §2.

3. Kneeling Persian, Vatican Galleria dei Candelabri 2794

Figures 3 (complete), 6 (complete, with technician), 7 (head and torso), 8 (thigh), 45 (front), 46, 47 (back), 48 (head), 98 (Overbeck drawing), 177 (head), 193 (drawing, restorations marked), 263 (front); 280 (Korres drawing, with tenons supplied); Foldout (Overbeck drawing).

Select bibliography: Clarac 1851: 103, no. 2153, pl. 859; Brunn 1870: 307, pl. 21, 6; Reinach 1889: 18; B–B 481a; Michaelis 1893: 120 n. 6; Horn 1937: 156, pl. 43, 2; Pietrangeli 1951–52: 92 n. 29; Schober 1951: 127 (B3), 129, fig. 113; Curtius 1954: 378, pls. 85–86; Dohrn 1961; W. Amelung and G. Lippold, *Die Skulpturen des vatikanischen Museums*, vol. 3.2 (Berlin 1956): 436, no. 32, 556, no. 32 (= Pietrangeli 1956), pl. 184; Hans von Steuben in Helbig[4], no. 574; Brendel 1967: fig. 2; Palma 1981: no. 4, fig. 4; Palma 1984: 774–75, 778, pl. 119, 3; Bober and Rubinstein 1986: no. 148 and fig.; Ridgway 1990: 292–96; Bringmann and von Steuben 1995: 66–68, no. 4, fig. 20; Gallottini 1998: 84, 137, 188, 224; Marszal 2000: 204; Andreae 2001: 168–71, pl. 150–51.

H 73.0; of figure, 63.0 (restored). For other measurements, see Table 16.

History: Found in Rome in 1514; Rome, Pal. Medici–Madama, 1514; Rome, Pal. Giustiniani by 1638; Vatican, 1771; restored by the sculptor Gasparre Sibilla, 1781–82.

Documentation: Strozzi 1514? (RT1); Bellièvre 1514–15 (RT2, no. 7); Italian drawing ca. 1514–20 (Dresden, Kupferstichkabinett, C34: *Dialoge: Kopie, Variation, und Metamorphose alter Kunst in Graphik und Zeichnung vom 15. Jahrhundert bis zur Gegenwart* [Dresden 1970]: cat. 30 and fig., there dated to "ca. 1510"; Bober and Rubinstein 1986: 184: "drawn from a model in reconstructed pose"). Listed in the Giustiniani inventories (Gallottini 1998: 84, 137, 188, and 224) as "una statuetta nuda di un Paris antica ristaurata alta pal. 3 ½" (1638, no. 123; 1667, no. 118; 1684 and 1757, no. 110; three and half *palmi* equal 78.19 cm). Listed in a Vatican acquisition notice of 1771 (Pietrangeli 1956) as "Gladiatore caduto di grandezza la metà del naturale... sebbene mancante delle braccia e d'una gamba è peraltro un monumento di antichità di stile così sublime che puo ammirarsi come un esemplare dell'arte di prima sfera. Sc[udi] 400." Clarac 1851: 103, no. 2153, pl. 859.

Condition: Some abrasion on body; entirely repolished. Restorations (by Gasparre Sibilla, 1781–82: see Figure 193) include top of cap and flap hanging over nape of neck; nose; both arms; part of l. knee; l. foot; lower r. leg and foot; plinth.

Plinth, clothing, attributes, etc.: Restored, including shield. Wears Phrygian cap. No wounds.

Notes: Features of face converge to proper right, following the movement of the head. On the physiognomy, see Chapter 3, §4; on the iconography, Chapter 4, §2.

4. Kneeling Persian, Aix-en-Provence, Musée Granet

Figures 4 (front), 22 (head), 77 (side), 78 (back), 79, 80, 84 (head), 106 (front), 193 (drawing, restorations marked); 280 (Korres drawing, with tenons supplied); Foldout (Overbeck drawing).

Select bibliography and illustrations: Benndorf 1876; Duhn 1885; Horn 1937: 151–53, pl. 35, 2; Schober 1951: 127 (B2), 129, figs. 117–18; Stewart 1979: 21–23, pl. 8b; Palma 1981: 77–78, no. 23, fig. 23; Palma 1984: 773, 778, pl. 118, 1; Queyrel 1989; Ridgway 1990: 292–96; Bringmann and von Steuben 1995: 66–68, no. 10; Marszal 2000: 204; Schmidt-Dounas 2000: 242–43, fig. 79; Andreae 2001: 168–71, pls. 148–49.

H 64.0; of figure, 59.0. For other measurements, see Table 16.

History: Supposedly "found at Rome in the ruins of the Palaces of Nero, and of Marius"; Paris, de Polignac collection by 1738; Paris, Lambert-Sigisbert Adam collection by 1755; given to Aix-en-Provence by Jean-Baptiste Giraud, 1808.

Documentation: De Polignac inventory 1738 ("gladiator"); Lambert-Sigisbert Adam inventory 1755 ("found at Rome in the ruins of the Palaces of Nero, and of Marius"); municipal archives, Aix-en-Provence, 1808; see Queyrel 1989: 255–56, 261–70.

Condition: Weathered, especially on back of cap, neck, shoulders, and legs; drapery folds battered and chipped. Statue broken from base at ankles and r. wrist and reattached. Restorations (see Figure 193) include top of cap, l. eyebrow, tip of nose, and l. shoulder (all lost); point of chin; sword hilt and metal sword (lost) cut into plinth. A 1755 engraving (reversed: see Queyrel 1989: fig. 12) shows l. arm restored with a shield, raised to ward off an enemy.

Plinth, clothing, attributes, etc.: Flat, but reworked and sword hilt and sword added (see "Condition," above). Wears *mitra* (Phrygian cap); folded, belted tunic that leaves r. shoulder and arm bare (see Queyrel 1989: fig. 11); *anaxyrides* (trousers); and *akatia* (slippers). No wounds.

Notes: Statue has obviously been exposed to the elements since its discovery. Features of face converge to proper left, following the movement of the head. On the physiognomy, see Chapter 3, §4; on the iconography, Chapter 4, §2.

5. Dead Persian, Naples Mus. Naz. 6014 (Farnese Coll., FAR 183)

Figures 1 (complete), 21, 37 (front), 38 (back), 39, 40 (head), 75 (Pozzo drawing), 98 (Overbeck drawing), 176 (head), 193 (drawing, restorations marked); 280 (Korres drawing, with tenons supplied); Foldout (Overbeck drawing).

Select bibliography and illustrations: Clarac 1851: 136, no. 2217, pl. 871; Brunn 1870: 307 and pl. 21, 7; B–B 482c; Ruesch 1911: no. 300; Horn 1937: 157, pl. 43, 1; Schober 1951: 127 (B1), figs. 114–15; Palma 1981: no. 3, fig. 3; Palma 1984: 774–75; Ajello et al. 1988: 55–56; Pozzi et al. 1989: 54, 146, no. 16, fig. on p. 157; Riebesell 1989: 41–48, fig. 44; Fox 1990: 106, fig. 2; Ridgway 1990: 292–96, pl. 146; Bringmann and von Steuben 1995: 66–68, no. 3; Marszal 2000: 204; Andreae 2001: 168–71, pl. 147; Marvin 2002: 208–23, fig. 9.4.

L 96.0; of figure, 96.0. For other measurements, see Table 16.

History: Found in Rome in 1514; Rome, Pal. Medici–Madama, 1514; Rome, Pal. Farnese, 1587; Rome, Pal. Farnesina alla Lungara by 1767; Rome, Albacini studio, 1790; Naples, Mus. Nuovo, 1796.

Documentation: Strozzi 1514? (RT1); Bellièvre 1514–15 (RT2, no. 6); sketch by Aspertini 1535–40? (Figure 104: London, BM 1862-7-12-394 to 435, fol. 17: Bober 1957: 82, fig. 117: conflated with Naples Dying Gaul?); Aldrovandi 1556/1558: 121 (RT6); mid-16th-cent. Pal. Medici–Madama inventory (RT7); *motu proprio* of Pius V authorizing transfer to Parma 1566 (RT8, no. 1: never carried out); Pal. Farnese inventory 1587 (RT10, no. 8: "man"); Pal. Farnese inventory 1644 (Jestaz 1994: no. 4552: "youth"); drawing in collection of Cassiano dal Pozzo 1657 (Figure 75: *Windsor Sketchbook*, vol. 1, fol. 66: Vermeule 1966: 12, no. 8225, fig. 12; Palma 1981: 48, text fig. 3: minus arms, r. leg from knee, part of shield); Pal. Farnese inventory 1697 (*DocIn* 2: 387; Palma 1984: 781–82, app. 5: "dead gladiator"). Pal. Farnesina alla Lungara inventory, 1767 (Palma 1984: 782, app. 6: lists two wounded gladiators and two wounded Amazons lying on the ground, so presumably mistaken for an Amazon). Naples, Nuovo Museo inventory 1796, no. 183 (Palma 1984: 782, app. 7: "Gladiator"). Clarac 1851: 136, no. 2217, pl. 871.

Condition: Lightly weathered; surface then reworked with abrasives and repolished. Restorations (by Giambattista de' Bianchi 1587 – see Pozzo's 1657 drawing, Figure 75; then by Carlo Albacini, Naples 1790–96: see Figure 193) include top of cap (missing), l. and r. arms, part of l. foot, r. leg below knee, part of plinth and shield behind r. shoulder.

Plinth, clothing, attributes, etc.: Undulating (rocky?). Wears *mitra* (Phrygian cap) knotted at nape of neck like a kerchief; *exomis* sleeved over l. arm only leaving r. shoulder bare, and bound by a tasseled belt; *anaxyrides* (trousers); *akatia* (soft booties knotted at instep over a tongue). Long scimitar lying by l. knee with lunate guard, handgrip, and pommel; lies on inside of round shield decorated with a battlement motif and inside it a running wave, gripping it with l. hand. No visible wounds.

Notes: Features of face converge to proper right, following the movement of the head. On the physiognomy, see Chapter 3, §4; on the iconography, Chapter 4, §2.

6. Kneeling Gaul, Paris Louvre Ma 324

Figures 5 (front), 61 (front), 62 (back), 63, 64 (head), 71 (Heemskerck drawing), 98 (Overbeck drawing), 115 (side), 183 (head), 193 (drawing, restorations marked); 280 (Korres drawing, with tenons supplied); Foldout (Overbeck drawing).

Select bibliography and illustrations: Clarac 1851: 103, no. 2151, pl. 280; Brunn 1870: 311; Reinach 1889; Bienkowski 1908: 51–53, figs. 63–65; Horn 1937: 154, pl. 41, 1; Schober 1951: 127 (A5), 129, fig. 112; Palma 1981: no. 8, fig. 8; Palma 1984: 774–75, 778; Bober and Rubinstein 1986: no. 150 and fig.; Fox 1990: 108, fig. 5; Ridgway 1990: 292–96; Bringmann and von Steuben 1995: 66–68, no. 7, fig. 21; Kalveram 1995: no. 117; Marszal 2000: 203–4, 211; Andreae 2001: 168–71, pl. 152.

H 87.5; of figure, 80.0. For other measurements, see Table 16.

History: Found in Rome in 1514; Rome, Pal. Medici-Madama, 1514; Rome, Villa Borghese on Pincio, 1619; Rome, Pal. Borghese, 1796; Paris, Louvre, 1808.

Documentation: Strozzi 1514? (RT1); Bellièvre 1514–15 (RT2, no. 4); drawing by Heemskerck 1532–36 (Figure 71: *Sketchbook* I, fol. 5r.: Hülsen and Egger 1913–16: vol. I: 4–5, figure (l), pl. 6; Palma 1984: pl. 108, 6; Lanciani 1902/1989–2000: vol. I: 190, fig. 112 (in the niche at the back of the loggia of the courtyard, leaning against the table). Missing from mid-16th-cent. inventories of Pal. Medici–Madama (RT7–8, 10). Kalveram 1995: 222 (Borghese inventories); Emilio Q. Visconti, *Monumenti gabini della Villa Pinciana* (Rome 1797): II, stanza VII, no. 11, p. 60 (Villa Borghese). Clarac 1851: 103, no. 2151, pl. 280.

Condition: Lightly weathered; surface then reworked with abrasives and repolished. Restorations (by David Larique, 1619; compare Heemskerck's drawing, Figure 71, and see Figure 193) include all protruding, freestanding locks of hair; tip of nose; patches on shoulders, back, and buttocks; l. arm; r. arm below shoulder; pudenda; patches on l. thigh and knee; l. foot except for toes; patches on r. knee; r. leg from knee to ankle; toes of r. foot; section of plinth behind l. knee, including sword hilt.

Plinth, clothing, attributes, etc.: Rocky. Two stab wounds in r. ribs and on l. thigh, spurting blood. Lentoid shield with two borderlines and *umbo* lies on plinth; short stabbing sword rests on shield. (Sword hilt in r. hand and shield grip in l. hand are restored.)

Notes: Features of face converge to proper left, following the movement of the head. Action of arms unclear, since his shield and sword lie at his feet. On the physiognomy, see Chapter 3, §4; on the iconography, Chapter 4, §2.

7. Kneeling Gaul, Venice Mus. Arch. inv. 57

Figures 2 (front), 10 (head), 16 (side), 49 (front), 50 (back), 51, 52 (head), 159 (tunic), 179 (head), 193 (drawing, restorations marked), 196 (front, restored right arm digitally removed); 280 (Korres drawing, with tenons supplied); Foldout (Overbeck drawing).

Select bibliography: Clarac 1851: 133, no. 2211, pl. 868; Brunn 1870: 302 and pl. 19, 2; Reinach 1889: 11, fig. 3; Bienkowski 1908: 41–44, figs. 53–55; Anti 1930: 97, no. 2; Horn 1937: 150, 153, pl. 37; Schober 1939: 83; Schober 1951: 126 (A2), 129–30, figs. 101–2; Brendel 1955; Perry 1978: 239, no. 13, 241, no. 27.L, pl. 25b; Stewart 1979: 19–21, 38, 40, pl. 8c; Palma 1981: no. 10, fig. 10; Palma 1984: 773–74, 778; Bober and Rubinstein 1986: 183; Traversari 1986: no. 26; Ridgway 1990: 292–96; Bringmann and von Steuben 1995: 66–68, no. 9; Marszal 2000: 204; Schmidt-Dounas 2000: 243; Andreae 2001: 168–71, pl. 153.

H 76.0; of figure, 69.5. For other measurements, see Table 16.

History: Rome, Pal. Grimani on Quirinal before ca. 1520; Venice, Santa Chiara on Murano, ca. 1520; Venice, Pal. Ducale, 1525; Venice, Pal. Grimani at Santa Maria Formosa, 1587; Venice, Statuario Pubblico, 1596.

Documentation: Grimani inventory, Venice 1523 (RT4, no. 27.L); Grimani inventory, Venice 1587 (RT9, no. 13); Grimani inventory, Venice 1593 (RT11, no. 18); Aspetti inventory, Venice 1594 (RT12). Clarac 1851: 133, no. 2211, pl. 868.

Condition: Lightly weathered; surface then reworked with abrasives and repolished. Some locks of hair damaged, some drapery folds chipped. Restorations (Aspetti, 1587: RT12; see Figures 193, 196) include tip of nose, little finger of l. hand, r. arm with sword hilt, l. foot, toes of r. foot; entire plinth probably cut flat with exception of rocky part under l. hand.

Plinth, clothing, attributes, etc.: Formerly rocky, like section under l. hand? Wears belted tunic (*exomis*) knotted at r. hip and leaving r. side of chest bare. No weapons preserved (sword hilt in r. hand is restored). No wounds.

Notes: Face apparently symmetrical. Restoration of r. arm possibly erroneous: supplicating? Not about to commit suicide like, e.g., the barbarian on Ammendola sarcophagus, Figure 203 (so Reinach 1889: 11; Bienkowski 1908: 43–44; *contra*, Schober 1939). On the physiognomy, see Chapter 3, §4; on the iconography, Chapter 4, §2.

8. Falling Gaul ("Breakdancer"), Venice Mus. Arch. inv. 55

Figures 2 (front), 17 (side), 53 (front), 54 (back), 55 (head and torso), 56 (head), 95 (front), 104, 105 (Aspertini drawings), 111 (drawing, restorations removed), 150 (head), 180 (head), 193 (drawing, restorations marked); 280 (Korres drawing, with tenons supplied); Foldout (Overbeck drawing).

Select bibliography: Clarac 1851: 117, no. 2177, pl. 858; Brunn 1870: 301, pl. 19, 1; Bienkowski 1908: 44–46, figs. 57–59; Anti 1930: 97, no. 3; Horn 1937: 150, 153, pl. 39, 1; Schober 1951: 126 (A3), 128, 130, fig. 99; Brendel 1955; Bober 1957: 72; Perry 1978: 233, 238–39, no. 12, 241, no. 6.A, pl. 25a; Perry 1980; Palma 1981: no. 9, fig. 9; Palma 1984: 773–74, 778; Bober and Rubinstein 1986: no. 149 and fig.; Ridgway 1990: 292–96; Bringmann and von Steuben 1995: 66–68, no. 8; Freedman 1997; Schmidt-Dounas 2000: 243; Andreae 2001: 168–71, pl. 154.

H 69.0; of figure, 57.0 (restored). For other measurements, see Table 16.

History: Rome, Pal. Grimani on Quirinal before ca. 1520; Venice, Santa Chiara on Murano, ca. 1520; Venice, Pal. Ducale, 1525; Venice, Pal. Grimani at Santa Maria Formosa, 1587; Venice, Statuario Pubblico, 1596.

Documentation: Grimani inventory, Venice 1523 (RT4, no. 6.A); two sketches by Aspertini 1535–40 (Figures 104–05: London, BM 1862-7-12-394 to 435, fols. 17 and 30: Bober 1957: 81–82 and 85–86, figs. 117–18); Grimani inventory, Venice 1587 (RT9, no. 12); Grimani inventory, Venice 1593 (RT11 no. 5); Aspetti inventory, Venice 1594 (RT12). Clarac 1851: 117, no. 2177, pl. 858.

Condition: Lightly weathered; surface then reworked with abrasives and repolished. Some locks of hair damaged, l. shoulder chipped. Restorations (Aspetti, 1587: RT12: see Figures 111, 193) include nose, both arms below shoulder, l. leg below knee, r. leg, plinth, support.

Plinth, clothing, attributes, etc.: Restored. No wounds.

Notes: Version of the Dresden Gaul, Figure 243. Features of face converge to proper left, following the movement of the head. On the physiognomy, see Chapter 3, §4; on the iconography, Chapter 4, §2.

9. Dying Gaul, Naples Mus. Naz. 6015 (Farnese Coll., FAR 182)

Figures 1 (front), 15 (back), 24, 25 (head), 41 (front), 42 (back), 43, 44 (head), 71 (Heemskerck drawing), 76 (Pozzo drawing), 98 (Overbeck drawing), 104 (Aspertini drawing), 116 (side), 187 (side), 188 (wound), 193 (drawing, restorations marked); 280 (Korres drawing, with tenons supplied); Foldout (Overbeck drawing).

Select bibliography: Clarac 1851: 107, no. 2158, pl. 858B; Brunn 1870: 304, pl. 20, 4; Malmberg 1886; Michaelis 1893: 122; B–B 481b; Bienkowski 1908: 47–49, figs. 60–62; Ruesch 1911: no. 302; Horn 1937: 160, pl. 33; Schober 1951: 126 (A4), 130, figs. 106–7; Palma 1981: no. 7, fig. 7; Palma 1984: 774–75; Bober and Rubinstein 1986: no. 151 and fig.; Petros Dintsis, *Hellenistische Helme* (Rome 1986): 109–10, 272, no. 204, pl. 47, 3 and Beil. 8,309; Ajello et al. 1988: 55–56, pls. 77–79; Pozzi et al. 1989: 54, 146, no. 17, w. col. pl. on p. 46 and fig. on p. 157; Riebesell 1989: 41–49, fig. 45; Fox 1990: 106, fig. 1; Ridgway 1990: 292–96, pl. 147; Bringmann and von Steuben 1995: 66–68, no. 6; Andreae 2001: 168–71, pl. 155; Marvin 2002: 208–23, fig. 9.3.

H 59.0; of figure, 51.0. For other measurements, see Table 16.

History: Found in Rome in 1514; Rome, Pal. Medici-Madama, 1514; Rome, Pal. Farnese, 1587; Rome, Farnesina alla Lungara by 1767; Rome, Albacini studio, 1790; Naples, Mus. Nuovo, 1796.

Documentation: Strozzi 1514? (RT1); Bellièvre 1514–15 (RT2, no. 5: "collapsing, with a wound in his r. breast"); drawing by Heemskerck 1532–36 (Figure 71: *Sketchbook I*, fol. 5r.: Hülsen and Egger 1913–16: vol. I: 4–5, figure (o), pl. 6 – but not recognized as such, even though already identified by Michaelis 1893: 122; cf. Palma 1984: pl. 108, 6: in background below r.h. side of fountain basin on the low garden wall; headless); sketch by Aspertini 1535–40 (Figure 104: London, BM 1862-7-12-394 to 435, fol. 17: Bober 1957: 82, fig. 117: adaptation, perhaps conflated with Naples Persian; doubted by Riebesell 1989: 89 n. 236); anonymous sketch (Giovanni Bologna?) 1550–53 (Cambridge, Trinity College MS R 17, 3, fol. 46: see Elisabeth Dhanens, "De Romeinse ervaring van Giovanni Bologna," *Bulletin de l'Institut Historique Belge de Rome* 35 (1963): 159–90, at p. 183, cat. 42, pl. 11, fig. 29; Fox 1990: 111, fig. 7: headless and minus right foot); Aldrovandi 1556/1558: 121 (RT6: in courtyard of Pal. Medici–Madama; "Curiatius wounded in l. breast and headless"); mid-16th-cent. Pal. Medici-Madama inventory (RT7: one of three Curiatii); *motu proprio* of Pius V authorizing transfer to Parma 1566 (RT9, no. 3: never carried out; "headless Curiatius"). Pal. Farnese inventory 1587 (RT10, no. 9; "man with two wounds, missing head and r. foot"); Pal. Farnese inventory 1644 (Jestaz 1994: no. 4544: "man wounded in l. breast; missing head, r. foot, arm"); drawing in collection of Cassiano dal Pozzo 1657 (Figure 76: *Windsor Sketchbook*, vol. 9, fol. 31: Vermeule 1966: 57, no. 8814, fig. 25; Palma 1981: 49, text fig. 4: still headless but otherwise complete); Pal. Farnese inven-

tory 1697 (*DocIn* 2: 387; Palma 1984: 781–82, app. 5: "dying gladiator"). Pal. Farnesina alla Lungara inventory, 1767 (Palma 1984: 782, app. 6: "dying gladiator"). Naples, Nuovo Museo inventory 1796, no. 182 (Palma 1984: 782, app. 7: "dying gladiator, copy of Campidoglio dying gladiator"). Clarac 1851: 107, no. 2158, pl. 858B.

Condition: Lightly weathered; surface then reworked with abrasives and repolished. Restorations (by Giambattista de' Bianchi, 1587 – see Pozzo's 1657 drawing, Figure 76 – then by Carlo Albacini, Naples 1790–96, see Figure 193) include the head (and numerous patches on the head), neck, l. arm below shoulder including hand and adjacent part of plinth, r. thumb, index, and second finger, patch on the back (missing), toes of l. foot, r. foot. The head does not join the body and is crudely secured by a pi clamp at the back (see Figure 25). The drilled eyes are unique among the Little Barbarians, and the Adam's apple does not line up with the pit of the neck. The statue's head is described as "missing" in RT6, RT8, and the 1644 Farnese inventory, and is omitted from all Renaissance and later drawings through Pozzo's (Figure 76: published 1657).

Plinth, clothing, attributes, etc.: Flat. Wounds dripping blood at l. side of waist and below r. shoulder blade; both pierced by holes 1.5 cm in diam., 1.5 cm deep, each with a 3-cm-long vertical cut above it (below, obscured by the blood); so probably run through from back to front by a spear (Malmberg 1886). Restored head wears pseudo-Attic helmet.

Notes: Reversed version of the Capitoline Trumpeter (see Figures 28, 240). The loose skin at the waist perhaps indicates middle age (Palma 1981: 60–61). On the iconography, see Chapter 4, §2.

10. **Dead Gaul**, Venice Mus. Arch. inv. 56

Figures 2 (complete), 11 (wound), 12 (head and torso), 20, 23, 57, 58 (complete), 59, 60 (head), 105 (Aspertini drawing), 181 (head), 189 (wound), 193 (drawing, restorations marked); Foldout (Overbeck drawing).

Select bibliography: Clarac 1851: 136, no. 2215, pl. 872; Brunn 1870: 302 and pl. 20, 3; Malmberg 1886; Bienkowski 1908: 37–39, figs. 50–52; Anti 1930: 97, no. 4; Horn 1937: 150–51; Schober 1951: 126 (A1), fig. 100; Bober 1957: 72; Perry 1978: 233 n. 94; Palma 1981: no. 6, fig. 6; Palma 1984: 773–74, 778, pl. 118, 2; Bober and Rubinstein 1986: 183; Ridgway 1990: 292–96; Bringmann and von Steuben 1995: 66–68, no. 5; Andreae 2001: 168–71, pl. 156.

L 136.0; of figure, 114.0. For other measurements, see Table 16.

History: Venice, Pal. Grimani on Ruga Giuffa at Santa Maria Formosa, 1593; Venice, Statuario Pubblico, 1596.

Documentation: Sketch by Aspertini 1535–40 (Figure 105: London, BM 1862-7-12-394-435, fol. 30: Bober 1957: 85–86, fig. 118); Grimani inventory, Venice 1593 (RT11, no. 13); Aspetti inventory, 1595 (RT12). Clarac 1851: 136 no. 2215, pl. 872.

Condition: Lightly weathered; some locks damaged; surface reworked with abrasives and repolished. Restorations (Aspetti, 1587: RT12: see Figure 193): tip of nose, mouth, chin, edges of shield (missing), l. hand, toes of l. foot, heel and toes of r. foot.

Plinth, clothing, attributes, etc.: Rocky and undulating. Wears a metal torque around his waist with 3-mm-diam., 1.8-cm-deep hole in r. side (see Figure 11); cross-hatching stops short of it. Stab wound under l. pectoral, dripping blood; two wounds in l. and r. sides also dripping blood, both pierced by holes with horizontal cuts on either side; holes 1.5 cm in diam., 1–1.3 cm deep; cuts 3.2 (left) and 3.8 (right) cm from end to end; so likely run through from right to left by a spear (Malmberg 1886). Holds a coffin- (lit.: door-)shaped hexagonal shield or *thyreos* in l. hand, whose rim is decorated with wave motif like Capitoline and Ludovisi Gauls; holds hilt of sword with broken blade in r. hand.

Notes: Features of face converge to proper left, following the movement of the head. Principal viewpoint, Figure 57, perhaps indicated by absence of cross-hatching on proper right side of girdle, Figure 11. Aspertini sketch, Figure 105, suggests presence in Venice by 1540; not listed in Aldrovandi's description of Pal. San Marco in Rome (1556/1558: 260–62). On the physiognomy, see Chapter 3, §4; on the iconography, Chapter 4, §2.

3. RESIDUE

(i) Unidentified Warrior, now lost

Figures: None.

Select bibliography: Klügmann 1876; Reinach 1889: 18; Michaelis 1893: 120 n. 6; Pietrangeli 1951–52: 92 n. 29; W. Amelung and G. Lippold, *Die Skulpturen des vatikanischen Museums*, vol. 3.2 (Berlin 1956): 436, no. 32, 556, no. 32 (= Pietrangeli 1956); Palma 1984: 774–75.

History: Found in Rome in 1514; sent to Pope Leo X 1514; presumably deaccessioned from the Vatican collections by Pius V in 1566 with all the other pagan statues except the masterpieces in the Belvedere. Now lost.

Documentation: Strozzi 1514? (RT1); Bellièvre 1514–15 (RT2, no. 2: "the sole survivor and victor was Marcus Horatius whose statue was taken to the Pope"); Boissard 1597 (RT13).

Notes: Boissard (RT13) does not contradict this history since, despite his book's date of publication, he resided in

Rome only between 1556 and 1559. Identified with the Giustiniani–Torlonia Persian (item [iv] in this section) by Palma. Although Bellièvre (RT2) says that only one figure of the group (no. 6, the Naples Persian) has shoes, he clearly did not see this statue. Possibly the Aix Persian, cat. no. 4.

(ii) Kneeling Amazon or Persian, formerly Rome, Pal. Santacroce

Figure 71 (?).

Bibliography: Michaelis 1893: 127; Palma 1984: 776, pl. 119, 5; Lanciani 1902/1989–2000: vol. 1: 157–60, fig. 86.

H unknown.

History: Rome, Pal. Santacroce by 1536; lost after 1556.

Documentation: Drawing by Heemskerck 1532–36 (Figure 71: *Sketchbook* I, fol. 29v.: Hülsen and Egger 1913–16: vol. I: 17–18, figure (l), pl. 30, below; Michaelis 1893: 127, fig. 7; Palma 1984: pl. 119, 5; Lanciani 1902/1989–2000: vol. 1: 156, fig. 86; Aldrovandi 1556/1558: 236 (one of two "little torsos" next to a Mithras).

Notes: Very like the kneeling figure on garden wall of Pal. Medici–Madama, Heemskerck 1532–36 (see Figure 71: *Sketchbook* I, fol. 5r.).

(iii) Fallen Amazon, Wilton House M170 (MAZ 42)

Figures 66, 92 (Dosio drawing).

Select bibliography: Clarac 1851: 117, no. 2031C, pl. 810A; Brunn 1870: 313; Michaelis 1882: 667–68 and 708–9, no. 170; Palma 1981: no. 17, fig. 17.

H 92.0; W 86.0; D 58.0 (plinth). Thickness of plinth (max.), 11.0; height of figure, 81.0; of ancient part to shoulder, 65.0; length of r. foot, 20.0.

History: Rome, unknown location, ca. 1525–27; Rome, unknown location, probably Villa Madama at Montemario, 1532–36; Rome, Pal. Savelli (Theater of Marcellus), 1589; Paris, Collection of Cardinal Mazzarino by 1653; upper body hammered by the mad Duke Mazarin in 1670; England, Wilton House by ca. 1710.

Documentation: Drawing by Baldassare Peruzzi ca. 1525–27 (Florence, Uffizi 149F: Frommel 1967–68: cat. 114, pl. 95b); drawing by Heemskerck 1532–36 (*Sketchbook* I, fol. 47r.: Hülsen and Egger 1913–16: vol. I: 25–27, figure (a), pl. 48, above; Palma 1984: pl. 109, 4); drawing in *Sienna Sketchbook* S, IV, 7, fol. 5, after Peruzzi (Frommel 1967–68: cat. 110, pl. 95c); possibly among the *molti torsi, & altre figuretti* noted in the Pal. Savelli by Aldrovandi 1556/1558: 234; drawing by Dosio ca. 1568 (Figure 92: *Sketchbook*, fol. 70v.: Christian Hülsen, *Das Skizzenbuch des Giovann-antonio Dosio im Staatlichen Kupferstichkabinett zu Berlin* (Berlin 1933): 33, no. 161, pl. 91; Palma 1984: 51, text fig. 6); drawing in G. Franzini, *Icones statuarum antiquarum urbis Romae* (Rome 1589): Bl. d, fol. 15; Mazzarino inventory 1653 no. 47 (Michaelis 1882: 709). Clarac 1851: 117, no. 2031C, pl. 810A.

Condition: Unweathered; some drapery folds battered; r. breast and thigh hammered by the mad Duke Mazarin in 1670. Abrasion marks overlaid by (modern) polish over entire surface. Restorations include head and neck; l. shoulder; l. breast; r. arm; upper part of l. forearm; l. leg and foot from midthigh; both volutes and most of the right (rear) edge of the *pelta*. A section of plinth below the l. foot reattached with pi clamps. Behind the *pelta* the hoof and fetlock of a fallen horse are carved on the extreme proper left of the plinth, lying flat; *pace* Michaelis 1882: 709, they are not restorations. The fetlock is broken at the edge of the plinth; it lacks a dowel hole; and the edge of the plinth is tooled in a uniform manner. So the ensemble must have been drastically cut down and its plinth trimmed by a Renaissance restorer.

Plinth, clothing, attributes, etc.: Flat. She wears an overgirdled *chitoniskos* that leaves her right breast bare, and ankle boots; she holds a *pelta* in her left hand. No wounds.

Notes: Once part of a group with a fallen horse (and opponent?). As in the present restorations, her right arm was once raised and her head turned to her left and also raised. The right leg is incoherent: In front view the shin lies flat on the plinth, but in side view it is raised well above it by the supporting right foot. About 10–12 percent larger than the core group (nos. 1–10), and technically quite different, with thick marble screens supporting her body; the marble is either Carrara (65 percent probability) or Paros–Chorodaki (85 percent probability).

(iv) Kneeling Persian, Rome, Museo Torlonia

Figure 65.

Select bibliography: Giustiniani 1631: pl. 118; Clarac 1851: 117, no. 2178, pl. 857 (records numerous breaks and possible restorations); Ernst Curtius, "Der kniende Jüngling aus der giustinianischen Galerie," *AZ* 26 (1868): 42–45, pl. 6, 1; Brunn 1870: 312; Carlo Ludovico Visconti, *Les Monuments de sculpture antique du Musée Torlonia reproduits par la phototypie* (Rome 1884; Italian tr., 1885): no. 309, pl. 77; Reinach 1889: 14 and 18; Pietrangeli 1951–52: 92 n. 29; Gasparri 1980: 141, 192, no. 309; Palma 1981: 50, fig. 5 and 60–61, no. 5; Palma 1984: 776, pl. 119, 2; Giuliana Algeri, "Le incisioni della 'Galleria Giustiniana,'" *Xenia* 9 (1985): 71–99, figs. 12, 13; Bober and Rubinstein 1986: 184.

H ca. 90 cm (inventories, see below); 1 m (Palma).

History: Rome, Palazzo Giustiniani by 1631; sold to the Torlonia family between 1825 and 1868; Rome, Castellani estate of the Torlonia family by 1868; restored and reworked; Rome, Museo Torlonia by 1884.

Documentation: Giustiniani 1631: pl. 118 (engraving by Giovanni Luigi Valesio). Listed in all the Giustiniani inventories of 1638–1793 (*DocIn* 4: 433, no. 319; Gasparri 1980: 98, no. 319; Gallottini 1998: 97, no. 616, 148, no. 475, 198, no. 462, 236, no. 462, and 252, no. 319) as "una statua antica ristaurata con un ginochio in terra e l'altro alzato, col braccio manco abbassato con la mano in terra e l'altro alzato in atto di ripararsi, col berrettino in capo (si crede di Paris). Alta pal. 4 inc.a." (Four *palmi* equal 89.36 cm.) Giustiniani sale catalog of 1808 (Gasparri 1980: 107, no. 200): "Figure d'un jeune Guerier combattant en genoux à terre, et le Bonnet phrygien sur la tete. Fr. 3.600"; Italian version of 1811 (Gasparri 1980: 118, no. 200; Gallottini 1998: 270, no. 200) reads: "Figura giovanile di un guerriero con ginocchio a terra in alto di ripararsi un colpo, con testa coperta di pileo Frigio. Figura piena di espressione e lavorata con somma maestria. Tom. I Tav. 118. Fr. 3000." Visconti, *Musée Torlonia*, no. 309, pl. 77 (Gasparri 1980: 192, no. 309). Clarac 1851: 117, no. 2178, pl. 857.

Condition: Non vidi. Clarac 1851 notes many breaks (including across the neck and waist) but restorations only on the nose, upper lip, l. ear, r. armpit, chest (reworked), part of the drapery, and part of the r. foot. Brunn 1870: 312 thought the entire head was restored. The sash around the waist, illustrated in Giustiniani 1631: pl. 118 and Clarac 1851: pl. 857; noted in the inventories; and noted by Curtius, "Der knieende Jüngling," 42, was removed when the statue was taken to the Museo Torlonia shortly thereafter, for it is absent in Visconti's 1884 photograph.

Notes: The 1631 engraving, Giustiniani 1631: pl. 118 (here Figure 65), does not show the figure's Persian or Phrygian cap, presumably because its hair obscured it from the angle the engraver selected. This and its vanished sash have caused much confusion. Yet the Giustiniani inventories from 1638 would not have identified the statue as a Paris without the cap; it is mentioned in the 1793, 1808, and 1811 inventories and in Clarac's description; and it is shown in Visconti's 1884 photograph. The 1811 entry references Giustiniani 1631: pl. 118, clinching the identification. Brunn 1870: 312, comparing casts, thought it larger in scale than the Vatican Persian (see no. 3).

NOTES

PREFACE

1. Alert readers will have noted that the date I give for the beginning of Attalos II's reign, 158, is one year later than usual. A recent discovery has now extended the reign of his brother Eumenes II into a fortieth year, thus into early 158: *ZPE* 30 (1978): 263, no. 12.
2. Korres 1994: 10.

LITTLE BARBARIANS: AN ENCOUNTER

1. For my viewing sequence see James Elkins, *Pictures of the Body: Pain and Metamorphosis* (Stanford 1999): 16–17; and for sculpture specifically, from both ends of the modernist critical spectrum, Adolf Hildebrand, *The Problem of Form in Painting and Sculpture* (1893; tr. Max Meyer and Robert Ogden, New York 1907): 21–35; Alex Potts, *The Sculptural Imagination: Figurative, Modernist, Minimalist* (New Haven 2000): 8–13. For the battlefield metaphor, Pollitt 1986: 92; and for "seeing as" and "seeing in," Wollheim 1980: 205–06.

1. REDISCOVERY: SCHOLARS, SLEUTHS, AND STONES

1. Robert M. Cook, *Greek Painted Pottery* (3rd ed., London 1997): 311.
2. Croce, *Teoria e storia della storiografia* (5th ed., Bari 1943): 4: "Ogni vera storia è storia contemporanea"; cf. Hodder et al. 1995: 10–11; Jonathan Hall, *Ethnic Identity in Greek Antiquity* (Cambridge 1997): 15; and Shanks 1999: 28–29 on underdetermination and knowledge claims.
3. Baxandall 1985: 107; for a hypertheorized development of this point in the context of the discipline of classical archaeology, see esp. Shanks 1999: 24–36.
4. Leake 1821/1841: 240, pl. 8.
5. Penrose 1851/1888: 3, pl. 2 (see the discussion by Manolis Korres in his Essay in the present volume); Leake 1821/1841 (repr. 1854 only): 348–49, pl. 3.
6. Brunn 1870; the copy in the American School of Classical Studies at Athens has been perceptively annotated by its donor, the vase-painting scholar J. C. Hoppin. For the next few paragraphs, see Brunn's biographies in Reinhard Lullies and Wolfgang Schiering (eds.), *Archäologenbildnisse* (Mainz 1988); Sichtermann 1996: 234–37; Nancy T. de Grummond, *An Encyclopedia of the History of Classical Archaeology* (London and Chicago 1996); and Marchand 1996: 60, 102, 110–12, 143–44.
7. Heinrich Brunn, *A History of Ancient Sculpture* (London 1883): viii.
8. On Welcker, see esp. W. M. Calder III, A. Köhnken, W. Kullmann, and G. Pflug (eds.), *Friedrich Gottlieb Welcker: Werk und Wirkung* (Hermes Einzelschrift 49, Stuttgart 1986); de Grummond, *Encyclopedia*, 1189; Sichtermann 1996: 211–15.
9. Heinrich Brunn, *Artificum liberae Graeciae tempora* (Bonn 1843); id., *Geschichte der griechischen Künstler*, 2 vols. (Stuttgart 1857): v and 2; for the translations, see his obituary by his pupil Alfred Emerson, *AJA* 9 (1894): 366–71, at p. 367.
10. Richard H. Popkin (ed.), *The Columbia History of Western Philosophy* (New York 1999): 668. On nineteenth-century positivist historiography, archaeology, and anthropology and their modern successors see, e.g., Collingwood 1946: 127–33; Harris 1968: 59–66, 149–50, 250–89, 675–76; Maurice Mandelbaum, *History, Man, and Reason: A Study in Nineteenth-Century Thought* (Baltimore 1971): 10–20, 289–310; Georg Henrik von Wright, *Explanation and Understanding* (Ithaca, N.Y., 1971): 3–33; Jauss 1982: 46–48; John Moreland, "What Is Archaeology?" *History and Theory* 30 (1991): 246–61; Christopher Lloyd, *The Structures of History* (Oxford 1993):

13, 16, 52–53, 70–77, 189–90; Sichtermann 1996: 200–39; and Raymond Martin, "The Essential Difference between History and Science," *History and Theory* 36 (1997): 1–14.

11. On the early history and reception of these statues see Francis Haskell and Nicholas Penny, *Taste and the Antique* (New Haven 1981): 224–27, 282–84; and on their identification, etc., Brunn, *Geschichte der griechischen Künstler* I: 442–44.

12. Diodoros 5.28; Livy 38.14; Pausanias 10.20.7.

13. Scyth and Marsyas: Bieber 1961: figs. 438–44; Pollitt 1986: figs. 120–21; Stewart 1990: figs. 748–50; Smith 1991: figs. 135–36.

14. *Monumenti inediti pubblicati dall'Istituto di Corrispondenza Archeologica* 9 (Rome 1869–73): pls. 19–21.

15. See Palma 1981: nos. 28–29 and figs. 28–29 for the pair; no. 5 and fig. for the Persian, with reproduction of Giustiniani 1631: pl. 118 on p. 50, fig. 5; and no. 18a and fig. for the toppling Amazon.

16. Nereid Monument and Mausoleum: Stewart 1990: figs. 478–73, 524–38.

17. As remarked in the Preface, alert readers will have noted that the date given here for the beginning of Attalos II's reign, 158, is one year later than usual. A recently discovered inscription has now extended the reign of his brother Eumenes II into a fortieth year, thus into early 158: *ZPE* 30 (1978): 263, no. 12.

18. Pliny, *Natural History* 34.51.

19. Donald Preziosi, *Rethinking Art History: Meditations on a Coy Science* (New Haven and London 1989): 82–83.

20. Gerhard 1850.

21. Hall, *Ethnic Identity*, 5, referencing Collingwood 1946: 147. *The Cambridge Ancient History* first appeared in 1923. To pick another example closer to home, the firmly object-based *Oxford History of Classical Art* was structured in exactly the same manner (even laying out its wares in catalog fashion) but was published in the 1990s.

22. See Maurice Merleau-Ponty, *The Phenomenology of Perception* (1945; tr. Colin Smith, London 1962): 26–51, esp. 28; Jauss 1982: 47; Pierre Bourdieu, *The Logic of Practice* (1980; tr. Richard Nice, Stanford 1990): 30–41, 45–46, 52–53; Jay 1993: 137, 146–47, 307–8. The principle that all artifacts could be explained by their origins still dominated classical archaeology at Cambridge in the 1960s: See the published examination papers of Group D of the Cambridge Tripos.

23. See most recently Neer 2002: 28–30; and in general, Olga Hazan, *Le mythe du progrès artistique* (Montréal 1999).

24. On Pausanias see Ulrich von Wilamowitz-Moellendorff, "Die Thukydideslegende," *Hermes* 12 (1877): 236–67, at pp. 344–47; August Kalkmann, *Pausanias der Perieget* (Berlin 1886) with comments by Christian Habicht, *Pausanias' Guide to Ancient Greece* (Berkeley and Los Angeles 1985): 186–87; cf. Stewart, "Nuggets: Mining the Texts Again," *AJA* 102 (1998): 271–82, at pp. 278–79. On the "positivist fallacy" see Anthony M. Snodgrass, "Archaeology," in Michael Crawford (ed.), *Sources for Ancient History* (Cambridge 1983): 141–43, 163. This is one reason why object-oriented anthropology began to go out of favor early in the twentieth century: See Ira Jacknis, "Franz Boas and Exhibits," in George W. Stocking Jr. (ed.), *Objects and Others: Essays on Museums and Material Culture* (Madison 1985): 75–111, cf. 114–15. Yet Boas himself remained a positivist at root: see Harris 1968: 250–89, esp. 287–89. For critiques of positivism's archaeological sucessor, processualism, see, e.g., Hodder et al. 1995: 3–29; Shanks 1999: 9–36.

25. On survival rates for marbles, bronzes, and pottery, see Stewart 1997: 63, 243.

26. Since this well-known aphorism was a favorite of the late Colin Edmonson, Mellon Professor at the American School of Classical Studies in the 1980s, I shall call it Edmonson's Law. See also Andrew Sherratt, "*Fata morgana*: Illusion and Reality in 'Greek–Barbarian Relations,'" *Cambridge Archaeological Journal* 5 (1995): 139–48, at pp. 143–44, where he points out that because archaeologists often find exported luxury goods but almost never find imported raw materials, in assessing trade relations, "archaeological positivism . . . is always going to produce economic nonsense" (144). Of course Holmes, the ultimate positivist (but with many more clues to guide him) often found negative evidence highly significant: See Eco and Sebeok 1983: 62.

27. To the ultraskeptic one can retort that we can be sure that these never existed in the ancient world, since (1) the Greeks and Romans had numerous opportunities to mention and picture them had they done so; (2) they lacked the required technology to support the first of them; and (3) they didn't discover America.

28. Antonio Corso draws my attention to another discussion of the issue, by Manolis Andronikos: "*Argumentum e silentio*," *AAA* 13 (1980): 354–65; cf. now Corso, "Small Nuggets about Late-Classical Sculpture," *Quaderni ticinesi di numismatica e antichità classiche* 29 (2000): 125–51, at pp. 121–22, and passim for a series of test cases. Yet of Andronikos's two targets, Janer Belson's Hellenistic date for the Rondanini Medusa is ill chosen, since her argument is not *e silentio* but based upon her discovery of an apparently universal preference for different (fat) Gorgoneion types before ca. 300. Later research has substantiated this: *LIMC* 4 (1988) s.v. "Gorgo, Gorgones," 326, 329; s.v. "Gorgones Romanae" no. 25 (Rondanini Medusa) (Ingrid Krauskopf). To draw a parallel, since in the genre of the standing nude male a host of dated examples show that there is an apparently universal preference for kouroi before ca. 480 and thereafter for figures that throw their weight onto one leg, it is (1) not an argument *e silentio* to date new examples of the latter type to after 480, and (2) eccentric, in the absence of positive, corroborating testimony, to date them before 480.

29. Georges Didi-Huberman, "Critical Reflections," *Artforum* 33.5 (January 1995), 64–65.

30. As quoted in Harris 1968: 288; on the limits of induction see Eco and Sebeok 1983: 8–9, 22–24, 141–42, etc.

31. Cf. Eco and Sebeok 1983: 25, 131; compare Collingwood 1946: 253–56.

32. Reliefs: For the extensive bibliography and a demolition of the thesis, see Michaelis 1877: 5–15; cf. Overbeck 1882: 202–17; Lucy Mitchell, *A History of Ancient Sculpture* (London 1883): 570–73.

33. Milchhöfer 1882: 26–29; for the group see now Bieber 1961: figs. 485–87; Smith 1991: fig. 188; Dreyfus and Schraudolph 1996: no. 21.

34. Bieber 1961: figs. 40–22, 441–44, 686–89; Pollitt 1986: fig. 121; Stewart 1990: figs. 121, 810–11, 838: Smith 1991: figs. 54, 136.

35. Klügmann 1876.
36. F. Buecheler, "Coniectanea," *Rheinisches Museum* 27 (1872): 474–78, at p. 476, no. 12.
37. E. Müntz, "Le Musée du Capitole et les autres collections romaines à la fin du XVe siècle et au commencement du XVIe siècle avec un choix du documents inédits," *RA* 43 (1882): 24–36, p. 35 n. 1.
38. Reinach 1889: 18.
39. Malmberg 1886; cf. Carlo Ginzburg, "Clues: Morelli, Freud, and Sherlock Holmes," in Eco and Sebeok 1983: 81–118.
40. Michaelis 1893; for thumbnail biographies, see Lullies and Schiering (eds.), *Archäologenbildnisse,* and de Grummond, *Encyclopedia,* s.vv.
41. Michaelis 1877: 5–15; Michaelis 1882: 708.
42. Mayer 1887: 85 n. 34; independently refuted also by Reinach 1894.
43. E.g., Petersen 1893 (against); Sauer 1894 (for); Reinach 1894 (for; imitates a Gallic mother and child).
44. Fränkel 1890 (*AvP* 8.1): nos. 12, 22, 29, 31, 32, two of them fragmentary and restored as Epigonos by Fränkel after an early traveler's transcription.
45. Pliny, *Natural History* 35.98: "oppido capto ad matris morientis ex uolnere mammam adrepens infans, intellegiturque sentire mater et timere ne e mortuo lacte sanguinem lambat."
46. Michaelis 1901: 20–21, 62. In his pioneering book *Hellenistic Athens,* the historian William S. Ferguson added yet another inscription, *IG* ii^2. 833, restoring the name of the honoree, one King A[. . .], as "Attalos" and using it to date his gift of the monument precisely to May–June, 228; Ferguson 1911: 209–10. Christian Habicht, *Studien zur Geschichte Athens in hellenistischer Zeit* (Göttingen 1982): 104 n. 114, shows that the king in question should be Antigonos Gonatas.
47. Benndorf 1876; Duhn 1885; cf. Queyrel 1989: 264, 270–73. For the Athens torso, NM 2251, see U. Koehler, "Torso aus Athen," *AM* 5 (1880): 368–69, pls. 8–9; Bienkowski 1908: 58–60, no. 30, figs. 72–73; Joannes N. Svoronos, *Das Athener Nationalmuseum* (Athens 1908–11): 649–50, pls. 166–68; Palma 1981: no. 24 (from Bienkowski, overlooking Svoronos); see Chapter 3, §9.
48. See the one-sentence report of Robert's lecture in *AZ* 41 (1883): 102, with further references in Michaelis 1893: 126 n. 35. Suicide: Reinach 1889: 11; *contra,* Michaelis 1893: 132 n. 69.
49. Mayer 1887.
50. See Farnell 1890: 182 for the judgment on the Naples statues and pp. 205–07, figs. 3–4 (the latter a surprisingly good photograph); the Karlsruhe Giant is Palma 1981: no. 11 and figs.; see Chapter 4, §2. On Farnell see now John Henderson, "Farnell's Cults: The Making and Breaking of Pausanias in Victorian Archaeology and Anthropology," in Susan Alcock, John Cherry, and Jas Elsner (eds.), *Pausanias: Travel and Memory in Roman Greece* (Oxford 2001): 207–23, at pp. 210–11, quoting from his memoir, *An Oxonian Looks Back* (London 1934): 199.
51. Habich 1896; Bienkowski 1908, 1928.
52. Gian Paolo Caprietti, "Peirce, Holmes, Popper," in Eco and Sebeok 1983: 135–53, at p. 141.
53. Gerhard 1850: no. 3; on Boas's fact-gathering, see Harris 1968: 250–89; and on data and the archaeologist's "panoptic gaze," see Michel Foucault, *The Archaeology of Knowledge* (1969; tr. Alan Sheridan, New York 1972): 195–228; Preziosi, *Rethinking Art History,* 31–36, 54–79; Morris 1994: 27. For the texts and signatures see Johannes Overbeck, *Die antiken Schriftquellen zur Geschichte der bildenden Künste bei den Griechen* (Leipzig 1868); Emmanuel Loewy, *Inschriften griechischer Bildhauer* (Leipzig 1885).
54. For this observation see esp. Anthony M. Snodgrass, *An Archaeology of Greece: The Present State and Future Scope of a Discipline* (Berkeley and Los Angeles 1987): 9–11. On corpora, see also Collingwood 1946: 131–32; Morris 1994: 27–28; Michael Shanks, *Classical Archaeology of Greece: Experiences of the Discipline* (London 1996): 93–97.
55. Bienkowski 1908: 37–78, at pp. 38, 43, 50 for wounds and suicide.
56. Georg Lippold, *Göttinger gelehrte Anzeiger* 1914: 352–53 (book review); Lippold 1923: 111–13, with the dating of the Ludovisi group on p. 102; cf. Milchhöfer 1882: 26–29.
57. Heinrich Brunn, "Archäologische Miszellen," *Sitzungsberichte der Königlichen Bayerischen Akademie der Wissenschaften, Phil.-Hist. Klasse* 2 (1872): 519–37, at pp. 529–35.
58. For Bayard's print, see Beaumont Newhall, *A History of Photography* (3rd ed., Boston 1982): 24–5. For Fox Talbot's see Joel Snyder, "Nineteenth-Century Photography of Sculpture and the Rhetoric of Substitution," in Geraldine A. Johnson (ed.), *Sculpture and Photography: Envisioning the Third Dimension* (Cambridge 1998): 21–34, at p. 24, fig. 1.1; and Larry J. Schaaf, *The Photographic Art of William Henry Fox Talbot* (Princeton 2000): 148, pl. 58 (with a garbled account of the head's relation to the Sperlonga sculptures). The head, BM 1860, was republished as a Gaul by Bienkowski 1908: 19–20, figs. 25a,b.
59. See esp. Anthony Hamber, "The Use of Photography by Nineteenth-Century Art Historians," *Visual Resources* 7.2–3 (1990): 135–61; Geraldine A. Johnson, *The Very Impress of the Object: Photographing Sculpture from Fox Talbot to the Present Day* (London and Leeds 1995); Marchand 1996: 106–7; Jerome J. Pollitt, "Masters and Masterworks in the Study of Classical Sculpture," in Olga Palagia and Jerome J. Pollitt (eds.), *Personal Styles in Greek Sculpture* (Yale Classical Studies 30, Cambridge 1996): 1–15, at pp. 12–13; Snyder, "Nineteenth-Century Photography of Sculpture"; Mary Bergstein, "The Mystification of Antiquity under Pius IX: The Photography of Sculpture in Rome, 1846–78," in Geraldine A. Johnson (ed.), *Sculpture and Photography: Envisioning the Third Dimension* (Cambridge 1998): 35–50; and Jane Shoaf Turner (ed.), *The Dictionary of Art* (New York and London 1996), 34 vols., s.v. "Alinari, Leopoldo and Giuseppe," "Anderson, James," and "Macpherson, Robert."
60. On cast collecting see esp. H. Ladendorf, *Antikenstudium und Antikenkopie* (Abhandlung der sächsischen Akademie der Wissensacchaften zu Leipzig, Phil.-Hist. Klasse 46.2, Berlin 1958): 69–74; Haskell and Penny, *Taste and the Antique,* 1–124; M. Berchtold, *Gipsabgüsse und Original: Ein Beitrag zur Geschichte von Werturteilung* (Berlin 1987); Peter Connor, "Cast-Collecting in the Nineteenth Century," in G. W. Clarke (ed.), *Rediscovering Hellenism* (Cambridge 1989): 187–235; Nikolaus Himmelmann, "Ein Plädoyer für Gipsabgüsse," in

Himmelmann (ed.), *Herrscher und Athlet: Die Bronzen von Quirinal* (Milan 1989): 185–98; the Edinburgh symposium published in the *Journal of the History of Collections* 3.2 (1991); Marchand 1996: 66–70, 112; and the symposium published in *Actes des Rencontres internationales sur les moulages, 14–17 February 1997* (Montpellier, 1999); Johannes Bauer and Wilfred Geominy, *Gips nicht mehr: Abgüsse als lezte Zeugen antiker Kunst* (Bonn 2000); Donna Kurtz, *The Reception of Classical Art in Britain: An Oxford Story of Plaster Casts from the Antique* (Oxford 2000); Édouard Papet et al., *À fleur de peau: Le Moulage sur nature au XIXème* (Paris 2001); Stephen G. Miller (ed.), *Plaster Casts at Berkeley* (Berkeley 2003). See also Gerhard 1850: no. 14; Brunn, "Archäologische Miszellen," 529–35.

61. For the Olympia sculptures see Stewart 1990: pls. 262–84.

62. Adolf Furtwängler, *Meisterwerke der griechischen Plastik* (Leipzig 1893): vii–viii; Adolf Michaelis, *A Century of Archaeological Discoveries* (London 1908): 301–7; cf. Marchand 1996: 144–46.

63. For Brunn's pictures see *Monumenti inediti pubblicati dall'Istituto di Corrispondenza Archeologica* 9 (Rome 1869–73): pls. 19–21; cf. B-B: nos. 481–82; Bienkowski 1908: figs. 50–88.

64. Lippold 1923: 111–13; cf. Milchhöfer 1882: 28–29. On the history of the study of copying see Margarete Bieber, *Ancient Copies* (New York 1977): 1–9; cf. Brunilde S. Ridgway, *Roman Copies of Greek Sculpture: The Problem of the Originals* (Ann Arbor 1984).

65. Dinsmoor 1920; cf. Milchhöfer 1882: 26–29.

66. Lippold 1923: 16, 43, 45, 52, 66–68. A large cache of casts from Baiae, found in 1954, has now clinched the matter: Christa Hees-Landwehr, *Die antiken Gipsabgüsse aus Baiai* (Berlin 1985). They include monuments that are demonstrably Athenian, such as the Tyrannicides: See Stewart 1990: figs. 227–31.

67. Pliny, *Natural History* 34.52.

68. Lippold 1950: 353–54; cf. Michaelis, *Century of Archaeological Discoveries*, 305. On Hildebrand, Riegl, and Wölfflin see esp. Michael Podro, *The Critical Historians of Art* (New Haven and London 1982): 61–151; also Udo Kultermann, *The History of Art History* (New York 1993): 162–64, 176–80; and Vernon Hyde Minor, *Art History's History* (Englewood Cliffs, N.J., and New York 1994): 106–28.

69. Krahmer, "Stilphasen der hellenistischen Plastik," *RM* 38–39 (1923–24): 138–84; Krahmer 1927: 71 n. 1.

70. Wollheim 1980: 145.

71. Whitney Davis, "Style and History in Art History," in Margaret W. Conkey and Christine A. Hastorf, *The Uses of Style in Archaeology* (Cambridge 1990): 18–31, at pp. 19 and 23–24.

72. Cf. Hodder et al. 1995: 9–10.

73. Holmes: Eco and Sebeok 1983: 24. Peirce: see Charles Hartshorne, Paul Weiss, and Arthur W. Burks (eds.), *Collected Works of Charles Sanders Peirce* (8 vols., Cambridge, Mass., 1935–66), vols. 8: 227 and 7: 202–07 (part of a long paper on the logic of source criticism in ancient history), respectively; cf. K. T. Fann, *Peirce's Theory of Abduction* (The Hague 1970); Shanks, *Classical Archaeology of Greece*, 39–41.

74. Hartshorne et al. (eds.), *Collected Works*, vol. 2: 623 (an early exploration of the topic); cf. Eco and Sebeok 1983: 8–9, with 181–83 for clarifications and modifications.

75. On all of this see esp. Eco and Sebeok 1983: 8–9, 22–23, 61, 73, 132, 143, 146–47, 181–83, 206–07, 213–14; Krahmer's disclaimer at the end of "Die einansichtige Gruppe" (1927: 91 n. 1) is revealing.

76. See esp. Carpenter 1960 – though oddly (since surely he knew Wölfflin's and Krahmer's work) Carpenter never seems to refer to them in his published writing.

77. Compare Carl Hempel's notorious "covering law" theory of history, now generally abandoned for the same reasons: "The Function of General Laws in History," *Journal of Philosophy* 39 (1942): 35–48; *contra*, e.g., William H. Dray, *Explanation and Laws in History* (London 1957); cf. von Wright, *Explanation and Understanding*, 10–18, 24–25.

78. See Stewart 1990: 82, 254–57.

79. Korres 1994: 10.

80. Cf. Didi-Huberman, "Critical Reflections."

81. On the ostensivity of description, see Baxandall 1985: 8–10.

82. Della Seta 1930: 523–29.

83. Horn 1937, after Krahmer 1927: 71 n. 1.

84. Ibid.: 145 ("mirror"), 150–62 (analysis).

85. Schober 1933 (for Magnesia see Bieber 1961: figs. 702–03; and Smith 1991: fig. 205; and for the updating, Wolfram Hoepfner and Ernst-Ludwig Schwandner [eds.], *Hermogenes und die hochhellenistische Architektur* [Mainz 1990]).

86. Bernard Schweitzer, "Späthellenistische Reitergruppen," *JdI* 51 (1936): 158–74.

87. Schober 1939, with Fränkel 1890 (*AvP* 8.1): no. 214–15, 453–55 for the bases; Schober, "Zur Geschichte pergamenischer Künstler," *ÖJh* 31 (1939): 142–49.

88. Schober 1951: 123–34.

89. Andreae 1956/1973: 74–83; Andreae 1968–69: 153; cf. Brunn 1870: 320; Milchhöfer 1882: 28–29; Lippold 1923: 112; and Chapter 1, §4.

90. Doubts: Koeppel 1972: 200–01. Roman republican painting: Filippo Coarelli, "Arte ellenistica e arte romana: La cultura figurativa in Roma tra 2. e 1. secolo a. C.," in Marina Martelli and Mauro Cristofani (eds.), *Caratteri dell'ellenismo nelle urne etrusche: Atti dell'incontro di studi, Università di Siena 28–30 aprile, 1976* (Prospettiva, 10 Supplemento, 1977): 35–40, at pp. 38–39. For the un-Hellenistic look of the painting and hypothetical Trajanic relief see Gilbert-Charles Picard, *Gnomon* 33 (1961): 406–08 (review of Andreae 1956); and for an incisive critique of Andreae's entire project, Marszal 2000: 210–11.

91. See Bienkowski 1908: 79–85; Ursula Höckmann, "Gallierdarstellungen in der etruskischen Grabkunst des 2. Jhs. v. Chr.," *JdI* 106 (1991): 199–230; Marszal 2000: 214–15; Nancy de Grummond, "Gauls and Giants, Skylla and the Palladion: Some Responses," in de Grummond and Ridgway 2000: 255–77, at pp. 257–58; Steingräber 2000: 239–40, 244–47.

92. Andreae, *Römische Kunst* (Freiburg 1973): 249; Andreae 1990: 97; and esp. Andreae 1998: 109–229; see also Andreae 2001: 124, 151, 155, 162, 168–71 (Akropolis Dedication), 193; for a radically different date and context for, e.g., the Farnese Bull see Stewart, *Gnomon* 73 (2001): 468–70 (review of Kunze).

93. Otto Brendel, text to *EA* 3965; Luigi Beschi, *Sculture greche e romane di Cirene* (Padua 1959): 264, 289; the two are Palma 1981: nos. 15 and 16, figs. 15–16. Persian: Pietrangeli 1951–52: 92 n. 29; Pietrangeli 1956: 556, no. 32; Curtius 1954.

94. Dohrn 1961 (cf. Duhn 1885); Brendel 1955 and 1967; Moreno 1994: 569; with comments and update by Steingräber 2000: 242–43, 246–48, 250.

95. Lawrence 1929: 295; Esther V. Hansen, *The Attalids of Pergamon* (Cornell Studies in Classical Philology 29, Ithaca 1947): 282–88, at p. 288; Bieber 1961: 110 (reprinted verbatim from the 1955 edition); Carpenter 1960: 195; Hansen 1971: 306–14, usefully summarizing the evidence, problems, and scholarship.

96. Gisela M. A. Richter, "New Signatures of Greek Sculptors," *AJA* 75 (1971): 434–35; Stewart 1979: 7–23; Andreae 1980.

97. Andreas Linfert, *Gnomon* 53 (1981): 498–99 (review of Stewart 1979); Schalles 1985: 136 n. 785, with 48 n. 310 on Phyromachos; cf. Hodder et al. 1995: 8 on "black-boxing." Andreae – who was far more generous – and I both repeated our views in Andreae 1990: 57, 91; Andreae 2001: 132–36 (nos. 103–05); Stewart 1990: 210, 302–03. For the division of opinion among others, see, e.g., Habicht 1990: 563 n. 9 – who remained noncommittal both there and in Habicht 1995/1997: 224.

98. Palma 1981, 1984; on the attributions, see, e.g., Ridgway 1990: 301. Although Roman neoclassicism had been recognized and studied for years, the real catalyst for change was Paul Zanker's *Klassizistische Statuen: Studien zur Veranderung des Kunstgeschmacks in der römischen Kaiserzeit* (Mainz 1974): See the middle of this section.

99. Hölscher 1985: 123–28; repeated in condensed fashion in Tonio Hölscher, *Il Linguaggio dell'arte romana* (Turin 1993): 22–37. See now Pirson 2002 (*non vidi*).

100. Andreae 1990; Andreae 1993: 97–98, pl. 16; repeated, with superb photographs, in Andreae 2001: 132–36, figs. 97–99 (nos. 103–05), 168–71, figs. 130–31. Wolfram Hoepfner, "Siegestempel und Siegesaltäre: Der Pergamonaltar als Siegesmonument," in Wolfram Hoepfner and Gerhard Zimmer (eds.), *Die griechische Polis: Architektur und Politik* (Tübingen 1993): 111–25, at pp. 116–17; repeated, with drawings of the blocks, in Hoepfner, "Der vollendete Pergamonaltar," *AA* 1996: 125–31, figs. 4, 11–14; in "Model of the Pergamon Altar (1 : 20)," in Dreyfus and Schraudolph 1997: 65–67 and (with the observation on the Akropolis monument) in Hoepfner 1997b: 143–45. Hoepfner correctly cites me as endorsing his views concerning the Great Altar, but at that time (1991) I had seen only the single cornice block earmarked for the American Telephos exhibition in 1996, which bears an oval cutting and no dowel holes on its top surface, and so theoretically could have held a marble plinth. Unfortunately, as Hoepfner's own drawings now show, it is completely atypical.

101. No victors: See Dinsmoor 1920, whence Lippold 1923: 112 n. 37; and Schweitzer, "Späthellenistische Reitergruppen," 166; attacked by Schober 1939: 85–86. Elevated position: suggested and refuted soon after Brunn's 1865 lecture; see Michaelis 1877: 12 n. 9. On the pedestals see Korres 1994: 10. Altar: Heinz Kähler, *Der grosse Fries von Pergamon* (Berlin 1948) 146 had already suggested a location for the groups within its outer colonnade. Rebuttals: Stewart 2000: 46–49; Marszal 2000: 203–4, 211.

102. Spoils: Stewart 2000: 46–49, figs. 9–16, using Fränkel 1890 (*AvP* 8.1): no. 38 (Attalos I, dedicating "choice items from the capture of [. . .]") and Pausanias 1.4.6. Also, if the gods stood up on the Altar roof, where did the other victors stand?

103. E.g., Hansen 1971: 314; Green 1990: 339; Gruen 2000: 18; Habicht 1995/1997: 224 is ambivalent; Bringmann 2000: 75–76 acknowledges the force of this case, only to reject it once more.

104. Zanker, *Klassizistische Statuen*; cf. Ridgway, *Roman Copies of Greek Sculpture*, 3: "My task became as much a question of establishing Roman originality as that of determining its relationship to Greek art." Roman preferences: See, e.g., Linda J. Roccos, "Apollo Palatinus, the Augustan Apollo of the Sorrento Base," *AJA* 93 (1989): 571–88; Gazda 1995, 2002, the latter programmatically subtitled *Studies in Artistic Originality and Tradition from the Present to Classical Antiquity*.

105. Neudecker 1988, with review by R. R. R. Smith, *Journal of Roman Studies* 82 (1992): 270–73, at p. 271; Zanker 1988, 2000.

106. Brunilde S. Ridgway, *The Severe Style in Greek Sculpture* (Princeton 1970); *The Archaic Style in Greek Sculpture* (Princeton 1977; 2nd ed., Chicago 1993); *Fifth-Century Styles in Greek Sculpture* (Princeton 1981); *Fourth-Century Styles in Greek Sculpture* (Madison 1997); and Ridgway 1990, 2000, 2002.

107. Ridgway 1990: 287–304; cf., more moderately, Gazda 1995: 146; Corso, "Small Nuggets," refutes Ridgway's views on the Praxitelean pieces.

108. Marszal 1998: 121–22; Marszal 2000.

109. Marvin 2002: 222.

110. Beard and Henderson 2001: 6, 8; cf. Stewart 1990: 237: "In sum, our perspective upon the creators of what was arguably the world's most vital sculptural tradition is essentially a Roman one."

111. German orthodoxy is now enshrined in a three-part magnum opus, edited by Bringmann and von Steuben, on Hellenistic royal dedications: Bringmann and von Steuben 1995: 66–68, K30; Bringmann 2000: 75–76 (admitting some doubts); Schmidt-Dounas 2000: 127–31, 232–44. On the late date for the Altar see Adolf Brückner, "Wann ist der Altar von Pergamon errichtet worden?" *AA* 1904: 218–25; Peter J. Callaghan, "On the Date of the Great Altar at Pergamon," *BICS* 28 (1981): 115–21; Andreae 1990: 99 recognizes the problem, though most others (e.g., Bringmann and von Steuben 1995; Schmidt-Dounas 2000) ignore it. For critics of this late date, see Stewart 2000: 33, and cf. Peter Green, "Pergamon and Sperlonga: A Historian's Reactions," in de Grummond and Ridgway 2000: 166–90, at pp. 170, 177–79.

112. Moreno 1994: 586–93, with p. 590 for the Amazon; Spinola 1996.

113. Perry 1978; Gasparri 1980; Queyrel 1989; Riebesell 1989; Gallottini 1998.

114. Bober 1957: 81–82, 85–86, figs. 117–18; Frommel 1967–68: cat. no. 114, pl. 95b; Christian Hülsen, *Das Skizzen-*

buch des Giovannantonio Dosio im Staatlichen Kupferstichkabinett zu Berlin (Berlin 1933): 33, no. 161, pl. 91.

115. Duhn 1885; P. G. Huebner, "Raffael und die Sammlung Grimani: Studien über die Benützung der Antike in der Renaissance 2," *Monatshefte für Kunstwissenschaft* 2 (1909): 273–80, at p. 277. On the two Persians see Curtius 1954; Dohrn 1961; Brendel 1967.

116. Brendel 1955 (*contra*, Perry 1980); Freedman 1997; Shearman 1972: 121–22; Dacos 1977/1986: 157, 192–93; Bober and Rubinstein 1986: nos. 143, 148–52; Giuliana Calcani, "Galati Modello," *RIA* 10 (1987): 153–74, at p. 162; Fox 1990; Anna Gramiccia and Federica Piantoni (eds.), *L'Idea del Bello: Viaggio per Roma nel Seicento con Giovanni Pietro Bellori* (Rome 2000): cat. no. IV.28–29; "virtually no stir": Barkan 1999: 1. The information currently available (in 2004) in the online version of Bober and Rubinstein's work, the "Census of Antique Works of Art and Architecture Known to the Renaissance" (http://www.dyabola.de) is incomplete and therefore seriously misleading. Perusing it, for example, one would not guess that the Venice Kneeling Gaul came to Venice from Rome in the early 1520s and was on public display there for over sixty years, or that the Aix Persian certainly came from Italy and probably from Rome.

117. Baxandall 1985: 120; cf. E. D. Hirsch, *Validity in Interpretation* (New Haven 1967): 180–98, 235–44.

118. See, e.g., Stanley Fish, *Doing What Comes Naturally* (Durham, N.C., 1989): 98; cf. Shanks 1999: 26–28.

119. Xenophon, *Agesilaos* 6; Plato, *Symposion* 194e–197e; etc.: cf. Dover 1974: 66–67.

120. Sherratt, "Fata morgana," 143–44.

121. The Law of Parsimony (Occam's Razor): *Entia non sunt multiplicanda praeter necessitatem*: "entities must not be multiplied beyond necessity."

122. Thus Holmes, in "The Disappearance of Lady Frances Carfax": "when you follow two separate chains of thought . . . you will find some point of intersection which should approximate the truth."

123. As William A. P. Childs has cynically observed, the best index of one's scholarly importance is the longevity of one's mistakes: "Herodotos, Archaic Chronology, and the Temple of Apollo at Delphi," *JdI* 108 (1993): 399–441, at p. 401 n. 11; cf. apropos this and Deadly Sin no. 7, Hodder et al. 1995: 8 on "black-boxing."

124. Claude Bérard et al., *A City of Images: Iconography and Society in Ancient Greece* (1984; tr. Deborah Lyons, Princeton 1989); originally written to accompany a photographic exhibition in the Paris Metro.

125. Morris 1994: 40–41.

126. Timothy J. Clark, *Farewell to an Idea: Episodes from a History of Modernism* (New Haven 1999).

127. Cf. Bal 1999: 6; Neer 2002: 25.

128. As George Kubler observed some forty years ago, T. S. Eliot was perhaps the first to understand this "when he observed that every major work of art forces upon us a reassessment of all previous works. Thus the advent of Rodin alters the transmitted identity of Michelangelo by enlarging our understanding of sculpture and permitting us a new . . . vision of his work" (Kubler 1962: 35, referencing Eliot's "Tradition and the Individual Talent," *Selected Essays 1917–32* [New York 1932]: 5).

129. See, e.g., Jonathan Culler, *The Pursuit of Signs: Semiotics, Literature, Deconstruction* (Ithaca, N.Y., 1981): 54; Hans-Georg Gadamer, *The Relevance of the Beautiful and Other Essays* (Cambridge 1986): 23 and 26; W. J. T. Mitchell, *Picture Theory: Essays on Verbal and Visual Interpretation* (Chicago 1994): 18, 28; cf. Stewart 1997: 3.

130. Wollheim 1980: 119.

131. See esp. Neer 2002: 23–24.

132. See in general Bal 1999, with, e.g., Bourdieu, *Logic of Practice*; Jay 1993.

133. Mirror theory of *mimesis*: Plato, *Republic* 10,596d–e; cf. most recently Stephen Halliwell, *The Aesthetics of Mimesis: Ancient Texts, Modern Problems* (Princeton 2001): 133–47. Art and ideology: Louis Althusser, "Lenin and Philosophy" and Other Essays (London 1971): 127–86. Compare the different perspectives offered by Bourdieu, *The Field of Cultural Production* (ed. Randal Johnson, New York 1993): 13, 56–57, 180–81; Catherine Gallagher and Stephen Greenblatt, *Practicing New Historicism* (Chicago 2000); cf. Joseph Margolis, "Hermeneutics" and "Interpretation," in David Cooper (ed.), *A Companion to Aesthetics* (Oxford 1992): 192–97, 232–38. See also Stewart 1993: xxxiv; Morris 1994: 15 (citing the archaeological/anthropological literature); Stewart 1997: 12–13; Shanks 1999: 17–18; Neer 2002: 7–8, 23–26.

134. Terry Eagleton, *Literary Theory: An Introduction* (2nd ed., Minneapolis 1996): 52.

135. On language as a form of life see Ludwig Wittgenstein, *Philosophical Investigations* (2nd ed., Oxford 1958): sections 19, 23; cf. Wollheim 1980: 104–12, 117–20, 131–40 (limitations of the language–art analogy). On practice and fields of cultural production see Bourdieu, *Outline of a Theory of Practice* (1972; tr. Richard Nice, Cambridge 1977) and *Field of Cultural Production*.

136. Cf. Gallagher and Greenblatt, *Practicing New Historicism*; Barkan 1999: xxxii ("new aestheticism"); Neer 2002: 7 ("new formalism").

2. APPROPRIATION: GLADIATORS FOR CHRIST

1. But not, surely, a mere "coincidence of aesthetic aims" (Cohen 1996: 261).

2. Brunn 1870; Klügmann 1876; Michaelis 1893; Pietrangeli 1951–52; Perry 1978; Palma 1981, 1984; Riebesell 1989; Kalveram 1995.

3. Thus, e.g., Palma 1981: 52; repeated verbatim in Palma 1984: 774.

4. My thanks to Professors Carolyn Valone, Katherine Gill, and Joan Barclay-Lloyd for this information and for their kind help on Renaissance nunneries in general.

5. See most recently Fox 1990: 109–10, figs. 6–11. On the Persian see Curtius 1954; refuted by Dohrn 1961; cf. Brendel 1967.

6. See Giovanni Agosti and Vincenzo Farinella, "Pratica e tipologia delle deduzioni iconografiche," in Settis 1984–86: vol. 1: 375–444, at p. 382.

7. Urns: Bienkowski 1908: figs. 90, 94; cf. Dohrn 1961; Brendel 1967. Trajan's Column: See most conveniently *EAA, Atlante dei complessi figurati e degli ordini architettonici* (Rome 1973: roman numeration as in Conrad Cichorius, *Die Reliefs der Traianssäule* [Berlin 1896–1900]; repr. Frank Lepper and Sheppard Frere, *Trajan's Column: A New Edition of the Cichorius Plates* [Gloucester 1988]): pls. 84, xxxii; 86, xli; 92, lxxii; Settis 1988: pls. 40, 63, 122; Coarelli 2000: pls. 31, 45, 83. Column of M. Aurelius: *EAA, Atlante*, pl. 133, cix; C. Caprino et al., *La Colonna di Marco Aurelio* (Rome 1955): pl. 129.

8. Livy 1.24–28; Dionysius of Halicarnassus, *Roman Antiquities* 3.12–22.

9. Petrarch, *Epistolae de Rebus Familiaribus et Variae* VI.2, 14 (*hic tergeminorum acies*); ed. Giuseppe Fracassetti (Florence 1862), vol. 2: 160; Fabrizio Cruciani, *Il teatro del Campidoglio e le feste romane del 1513* (Milan 1968); see, in general, Davidson 1985: 22–24; Philip Jacks, *The Antiquarian and the Myth of Antiquity: The Origins of Rome in Renaissance Thought* (Cambridge 1993): 36, 175–76.

10. For this and what follows see Ludwig Pastor, *The History of the Popes* (tr. R. F. Kerr, St. Louis 1908): vols. 6: 395–420; 7: 45–73, 93–127.

11. Reinach 1889: 18, with Pietrangeli 1951–52: 92 n. 29 and 1956: 556, no. 32, for the 1771 sale to the Vatican. Angela Gallottini's publication of the Giustiniani inventories (Gallottini 1998) shows that Pietrangeli's discovery, accepted by Palma 1981: 59–60 (no. 4) but dismissed by Bober and Rubinstein 1986: 184, is correct. The Persian is item no. 123 in the 1638 inventory, no. 118 in that of 1667, and no. 110 in those of 1684 and 1757: "una statuetta nuda di un Paris antica ristaurata alta pal. 3½." He is clearly distinguished from the kneeling "Paris" published in the *Galleria Giustiniana* of 1631 pl. 118 (see Figure 65) and recorded as no. 616 in the 1638 inventory (with a height of four *palmi* or 89.36 cm.) and later. This statue was sold to the Torlonia family in the early or mid-nineteenth century and is still in their private museum in Rome. On the beginnings of the Giustiniani collection, see Jane Shoaf Turner (ed.), *The Dictionary of Art* (New York and London 1996), 34 vols., s.vv. "Giustiniani, Benedetto"; "Giustiniani, Giuseppe"; and "Giustiniani, Vincenzo."

12. Macchiavelli, *Discourses* 1.22–24.

13. On the decree and accompanying documentation, see Adolf Michaelis, "Geschichte des Statuenhofes im vaticanischen Belvedere," *JdI* 5 (1890): 5–72, at pp. 60–72; Lanciani 1902/1989–2000: vols. 2: 86–87; 4: 44–45; Pastor, *History of the Popes*, vol. 17: 110–16; Henry Stuart Jones (ed.), *The Sculptures of the Museo Capitolino* (Oxford 1912): 4, 363–76 (inventories). Georg Daltrop's account of the formation of the Vatican collections overlooks the Persian completely: "Nascita e significato della raccolta delle statue antiche in Vaticano," in Marcello Fagiolo (ed.), *Roma e l'antico nell'arte e nella cultura del Cinquecento* (Rome 1985): 111–29; Daltrop discusses Pius's decree on p. 128.

14. *Sketchbook* I, fol. 5r.: Hülsen and Egger 1913–16: I: 4–5, figures (o) and (l), pl. 6. They do not recognize the first figure as the Dying Gaul, even though Michaelis 1893: 122 had already identified it as such. On the Palazzo Madama see Giovanni Barracco, *Il Palazzo Madama* (Rome 1904); Renato Lefevre, *Palazzo Madama* (Rome 1973); cf. Christoph Luitpold Frommel, *Der Römische Palastbau der Hochrenaissance*, 3 vols. (Tübingen 1973): vol. 2, 227–28.

15. See n. 11, above.

16. Riebesell 1989: 42.

17. Jestaz 1994: 188–89, nos. 4544 (Gaul), 4552 (Persian), 4556 (Amazon), and 4563 (Giant). The inventory is Naples, Archivio di Stato, Archivio Farnesiano 1853 (II), fasc. IX.

18. E.g., those of 1697 and 1767: *DocIn* 2: 387 and 3: 192; Palma 1984: 781–82, nos. V, VI.

19. *DocIn* 1: 188, no. 182; Palma 1984: 781–82, no. VII: "Statuetta di gladiatore giacendo . . . è copia del gladiatore moribondo del Campidoglio, e merita ristauro per la sua espressione, con rifarsi porzione della mano destra, e le punte de' piedi."

20. See, e.g., Fox 1990: fig. 14; Margherita Albertoni et al., *Musei Capitolini* (Milano 2000): color pl. on p. 97; Herwarth Röttgen, *Il Cavalier Giuseppe Cesare d'Arpino* (Rome 2002): 147, fig. 74, and cat. no. 153 (but giving the source as Stefano Maderno's famous Santa Cecilia [in Santa Cecilia in Trastevere], which itself is based on the Naples Persian: See Niels von Holst, "Die Cäcilienstatue des Maderna," *Zeitschrift für Kunstgeschichte* [1935]: 35–46). In the same room, the Cavaliere d'Arpino also used the Paris Gaul as a model in his *Numa Pompilius Instituting the Cult of the Vestals* and the Naples Dying Gaul in his *Battle of Tullius Hostilius against the Veiians and Fidenates* (ibid.).

21. See nn. 17–19, above.

22. See the documentation and discussion in Riebesell 1989: 59–62 (suggesting Fulvio Orsini as the project's instigator), 203, figs. 40, 46, 47; Jestaz (ed.), *Le Palais Farnèse*, iii. 3: no. 4487 (1644 inventory); *DocIn* 2: 380 (1697 inventory); Christian Kunze, *Der farnesische Stier und die Dirkegruppe des Apollonios und Taurikos* (*JdI* Ergänzungsheft 30, Berlin 1998): 10–13, though in n. 50 he mistakenly identifies the candidates for the pendant fountain as the Tyrannicides *and* the four Little Barbarians; and Stewart, "David's *Oath of the Horatii* and the Tyrannicides," *BurlMag* 143 (April 2001): 212–19.

23. On the Grimani statues and the Sala delle Teste see esp. Brunn 1870: 297, 300; Perry 1978; Wolfgang Wolters, *Der Bilderschmuck des Dogenpalastes: Untersuchungen zur Selbstdarstellung der Republik Venedig im 16. Jahrhundert* (Wiesbaden 1983): 79–70; and Favaretto 1990: 84–93, with full bibliography.

24. Bravery, etc.: Cicero, *Philippic* 3.14.3–5; id., *Tusculan Disputations* 2.17.41; Seneca, *de Constantia Sapientis* 16.2; id., *Epistle* 30.8; Pliny, *Panegyricus* 33.1; *Historia Augusta: Maximinus et Balbinus* 8. Degradation: Ovid, *Ars Amatoria* 1.166; Seneca, *Epistle* 7.3–5; [Plutarch], *De usu Carnium* 997C–E; Lucian, *Anacharsis* 37, 918 Reitz; cf. Ville 1981: 455–64.

25. Renaissance scholarship on triumphs: Roberto Valturio, *De re militari libri XIII* (Verona 1483); Flavio Biondo, *Roma triumphans* (Venice 1511); Onofrio Panvinio, *Fasti et triumphi romani* (Venice 1557); id., *De triumpho commentarius* (Venice 1571); id., *De ludis circensibus libri II: De triumphis liber unus* (Venice 1600). The modern literature is vast: See esp. Roy Strong, *Art and Power: Renaissance Festivals, 1450–1650*

(Berkeley and Los Angeles 1973; repr. 1984); Charles L. Stinger, "*Roma Triumphans:* Triumphs in the Thought and Ceremonies of Renaissance Rome," in Paul Maurice Clogan (ed.), *Medievalia et Humanistica: Studies in Medieval and Renaissance Culture* n.s. 10 (1981): 189–202; Antonio Pinelli, "Feste e trionfi: Continuità e metamorfosi di un tema," in Settis 1984–86: vol. 2: 281–350; and Randolph Starn and Loren Partridge, *Arts of Power: Three Halls of State in Italy, 1300–1600* (Berkeley and Los Angeles 1992): 149–212, esp. 157–162.

26. Bober and Rubinstein 1986: 184.

27. Anthony Blunt et al., *The Gambier-Parry Collection: Provisional Catalogue* (London 1967): 8–11, no. 23, dating it to 1500–06 (reference kindly supplied by Julian Gardner); Ludovico Borgo, *The Life of Mariotto Albertinelli* (New York and London 1976): 17–21, 169–70, 348–56, cat. no. I.28 (dating it to ca. 1513), figs. 38–40. Bober and Rubinstein 1986: 184 were apparently the first to recognize the borrowings; Freedman 1997: 122 disagrees, preferring Michelangelo's Adam on the Sistine Chapel ceiling, but that pose is quite different.

28. On this part of Albertinelli's life, see Vasari, *Vite* 2: 44–45 (4: 108–11, ed. Barocchi; tr. DeVere).

29. Traversari 1986: no. 2 (inv. 98).

30. Bober 1957: 81–86, figs. 117–18, 121 (London II, fol. 17, 20, 30), with p. 53 and fig. 23 (London I, fol. 5v–6) for the naval sarcophagus, and p. 15 for the suggestion that in London II, "the scattered antiquities may be reminiscences of earlier studies." On the date of Aspertini's second trip to Rome see Marzia Faietti and Daniela Scaglietti Kelesian, *Amico Aspertini* (Modena 1995): 73.

31. For what little is known about Marino's collection see Pio Paschini, "Le collezioni archeologiche dei Grimani," *Atti della Pontificia Accademia Romana di Archeologia* 5 (1926–27): 149–90, at pp. 170–89; Roberto Gallo, "Le donazioni alla Serenissima di Domenico e Giovanni Grimani," *Archivio Veneto* 50–51 (1952): 34–77, at pp. 38–40; Marino Zorzi, "La famiglia Grimani e il Pubblico Statuario," in Zorzi (ed.), *Collezioni di antichità a Venezia nei secoli della repubblica* (Rome 1988): 25–40, at pp. 27–29; Lanciani 1902/1989–2000: vol. 2: 157–59; Favaretto 1990: 86, 88. On Giovanni's collection see the foregoing, with Zorzi, "La famiglia Grimani," 30–31; and Favaretto 1990: 87–91; and on the palazzo see Annalisa Bristot and Mario Piana, "Il Palazzo dei Grimani a Santa Maria Formosa," in Irene Favaretto and Maria Luisa Ravagnan, *Lo Statuario Pubblico della Serenissima: Due secoli di collezionismo di antichità 1596–1797* (Cittadella 1997): 45–52.

32. Orietta Rossi Pinelli, "Chirurgia della memoria: scultura antica e restauri storici," in Settis 1984–86: vol. 3: 183–252, at p. 217. She contrasts him with the supposedly more tentative Tullio Lombardo, yet the latter's restoration of the Muse for the Palazzo Ducale and other sculptures are *more* radical than his: See Traversari 1986: no. 18; Favaretto 1990: 69–70; Patricia Fortini Brown, *Venice and Antiquity* (New Haven 1996): 247, fig. 277.

33. On the Statuario Pubblico see esp. Marilyn Perry, "The Statuario Pubblico of the Venetian Republic," *Saggi e memorie di storia dell'arte* 8 (1972): 77–253; Favaretto 1990: 84–93; Anna Maria Massinelli, "Lo studiolo 'nobilissimo' del patriarca Giovanni Grimani," in Irene Favaretto and Gustavo Traversari (eds.), *Venezia e l'archeologia* (*Rivista di archeologia*, Supplement 7, Rome 1990): 41–49; and Favaretto and Ravagnan, *Lo Statuario Pubblico*.

34. Dohrn 1961, against Duhn 1885; Queyrel 1989: 262–68; cf. also Brendel 1967.

35. Dohrn 1961; Brendel 1967, with sensitive remarks on method; Queyrel 1989: 270–73, figs. 14–15. For Aspertini's *Adoration* (Florence, Uffizi 3803) see Faietti and Kelesian, *Amico Aspertini*, 177, no. 40, and color plate on p. 178.

36. Queyrel 1989: 264.

37. On the reliefs see Giovanni Becatti, "Rafaello e l'antico," in L. Becherucci and A. Marabottini (eds.), *Rafaello: L'Opera, le fonti, la fortuna* (Novara 1968): 493–569, at pp. 539–40; Shearman 1972: 122, figs. 78–79.

38. Summers 1972; cf. id., *Michelangelo and the Language of Art* (Princeton 1981): 71–96, 406–17; critique, Charles Dempsey, *BurlMag* 125 (1983): 624–27; cf. most recently Andreas Bühler, *Kontrapost und Kanon: Studien zur Entwicklung der Skulptur in Antike und Renaissance* (Munich and Berlin 2002): 225–70, 358–93. I thank Professor Evelyn Lincoln and Dr. Mary Alice Lee for sharing their opinions and the latter's unpublished paper on the issue.

39. Joanne Snow-Smith, "Michelangelo's Christian Neoplatonic Aesthetic of Beauty in His Early *Oeuvre*: The *Nuditas Virtualis* Image," in Francis Ames-Lewis and Mary Rogers (eds.), *Concepts of Beauty in Renaissance Art* (Aldershot, U.K., and Brookfield, Vt., 1998): 147–57, at pp. 150–52.

40. Giovanni Paolo Lomazzo, *Trattato dell'arte della pittura* (Milan 1584): bk. I, chap. 1 and VI, chap. 4; tr. Mary Alice Lee and Summers 1972: 272–73, respectively; cf. Snow-Smith, "Michelangelo's . . . Aesthetic of Beauty," 150–51; Bühler, *Kontrapost und Kanon*, 227–29, 374–79.

41. Vasari, *Vite* 2: ii–iii (4: 6–7, ed. Barocchi; tr. DeVere).

42. Aby Warburg, *Die Erneuerung der heidnischen Antike: Gesammelte Schriften*, vol. 2 (Leipzig and Berlin 1932): 443–49; id., *The Renewal of Pagan Antiquity* (ed. Kurt Forster, tr. David Britt, Los Angeles 1999): 553–58; cf. Ernst Gombrich, *Aby Warburg: An Intellectual Biography* (London 1970; Chicago 1986): 181–83, 231–33, 244–45 (whence the second quotation), 263, 309; Moshe Barasch, "Pathos Formulae: Some Reflections on the Structure of a Concept," in *Imago Hominis: Studies in the Language of Art* (Vienna 1991): 119–27; Margaret Iversen, "Retrieving Warburg's Tradition," *Art History* 16 (1993): 541–53, at pp. 542–43; Richard Brilliant, *My Laokoon* (Berkeley 2000): 35 (whence the first quotation). Warburg's methods have attracted much attention recently: See esp. Horst Bredekamp, Michael Diers, and Charlotte Schoell-Glass (eds.), *Aby Warburg: Akten des Internationalen Symposiums Hamburg 1990* (Weinheim 1991), and the useful critical remarks and extensive bibliography in Robert W. Gaston, "Erwin Panofsky and the Classical Tradition," *International Journal of the Classical Tradition* 4.4 (Spring 1998): 613–23, at 614–16.

43. Michael Podro, *The Critical Historians of Art* (New Haven and London 1982): 175.

44. Warburg, *Erneuerung*, 1: 173–76; id., *Renewal of Pagan Antiquity*, 271–73; full text in id., *La rinascita del paganesimo antico* (Florence 1966): 285–307; cf. Gombrich, *Aby Warburg*, 181–83, pl. 30a; Frederick Hartt, *Giulio Romano* (New Haven 1958): 42–51, figs. 58, 63; Dussler 1971: 88 (whence the quotation); Rolf Quednau, *Die Sala di Constantino im Vatikanischer*

Palast (Hildesheim and New York 1979); Pietrangeli 1996: 269, pl. 360; Loren Partridge, *The Art of Renaissance Rome 1400–1600* (New York 1996): 152–54, fig. 104; Oberhuber 1999: 191–92, figs. 171–73.

45. Baxandall 1985: 58–59.

46. Bal 1999: 9.

47. Charles Sanders Peirce, "Logic as Semiotic: The Theory of Signs," in Robert E. Innis (ed.), *Semiotics: An Introductory Anthology* (Bloomington 1984): 4–23, at p. 13 (emphases added).

48. Richard Wollheim, *Painting as an Art* (Princeton 1987): 187–89; in the same vein and directly relevant to the discussion that follows, see, e.g., Norman Canedy's thoughtful remarks on Nicole Dacos's *Le logge di Raffaello* in ArtB 63 (1981): 154–57, and compare the wholly or chiefly formalist accounts of Renaissance art's engagement with the antique in H. Ladendorf, *Antikenstudium und Antikenkopie* (Abhandlung der sächsischen Akademie der Wissensacchaften zu Leipzig, Phil.-Hist. Klasse 46.2, Berlin 1958): 69–74 (with comprehensive bibliography); Freedman 1997; and Barkan 1999.

49. On the concept of *antiqua Romanitas* see Stewart, "David's *Oath* . . . and the Tyrannicides," 217–18.

50. Roland Barthes, "L'Effet du réel," *Communications* 4 (1968): 84–89; "The Reality Effect," in Barthes, *The Rustle of Language* (tr. R. Howard, New York 1986): 141–54.

51. Jacques Derrida, *Speech and Phenomena, and Other Essays on Husserl's Theory of Signs* (tr. David B. Allison, Evanston, Ill., 1973): 130; cf. Bal 1999: 10–11; as she remarks on p. 7, here the classic case is Cézanne, whose work we can "see" only through cubism.

52. Mikhail Bakhtin, *Rabelais and His World* (Cambridge, Mass., 1968); id., *The Dialogic Imagination* (ed. and tr. C. Emerson and M. Holquist, Austin 1981); cf. Bal 1999: 8–10. On Roman copies, see Mark Fullerton, "Imitation and Intertextuality in Roman Art," *Journal of Roman Archaeology* 10 (1997): 427–40; and for applications in other visual disciplines such as film theory, see Graham Allen, *Intertextuality* (London and New York 2000): 174–88.

53. Barkan 1999: xxxii.

54. I.e., applying Baxandall's criteria, set forth and glossed in Chapter 1, §9.

55. On this distinction, see Kubler 1962: 45.

56. For a very early drawing of a live model in the pose of the Vatican Persian, see Dresden, Kupferstichkabinett, C34, *Dialoge: Kopie, Variation, und Metamorphose alter Kunst in Graphik und Zeichnung vom 15. Jahrhundert bis zum Gegenwart* (Dresden 1970): 38, no. 30, fig. 30; Bober and Rubinstein 1986: 184. On Renaissance dedication to such drawing see Barkan 1999: xxxii, 8–10, 17–42, etc.; on Tintoretto's use of wax models, see the contemporary documents quoted by Lucy Whitaker, "Tintoretto's Drawings after Sculpture and His Workshop Practice," in Stuart Currie (ed.), *The Sculpted Object, 1400–1700* (Brookfield 1997): 177–200, at p. 187.

57. For the impact of the Laokoon in the sixteenth century see Salvatore Settis (ed.), *Laocoonte: Fama e stile* (Rome 1999).

58. E.g., Boucher 1991: vol. 1: 67 (Sansovino); Robert Echols, "Titian's Venetian *Soffitti*: Sources and Transformations," in Joseph Manca (ed.), *Titian 500* (Studies in the History of Art 45, Washington, D.C., 1993): 29–50.

59. See Shearman 1972: 110.

60. P. G. Huebner, "Raffael und die Sammlung Grimani: Studien über die Benützung der Antike in der Renaissance 2," *Monatshefte für Kunstwissenschaft* 2 (1909): 273–80, at p. 277 (*Death of Ananias*); R. W. Kennedy, *Novelty and Tradition in Titian's Art* (Northampton, Mass., 1963): 15 (*Conversion of Saul*); *contra*, Perry 1980: 189 n. 22.

61. The only survey of Raphael's use of ancient sculpture is Becatti, "Rafaello e l'antico," which unfortunately overlooks the Barbarians and much else. On the cartoons see Shearman 1972, esp. pp. 121–22 on the use of the Gauls, perhaps completed by reference to other antique figures. In general, see Dussler 1971: 101–08, figs. 171–87; and Oberhuber 1999: 157–67, a superbly illustrated survey.

62. Freedman 1997: 121 thinks that Heliodorus actually quotes the Falling Gaul, but this is chronologically impossible if it was indeed part of the 1514 find. *Resurrection*: Ames-Lewis 1986: 104, figs. 123–24; Oberhuber 1999: 141, fig. 121.

63. Vasari, *Vite* 2: 779 (6: 118, ed. Barocchi; tr. DeVere).

64. Barkan 1999: 288–89.

65. The entire passage reads: "Expedit saepe mutare ex illo constituto traditoque ordine aliqua et interim decet, ut in statuis atque picturis videmus variari habitus, voltus, status. nam recti quidem corporis vel minima gratia est; nempe enim adversa sit facies et demissa brachia et iuncti pedes et a summis ad ima rigens opus. flexus ille et, ut sic dixerim, motus dat actum quendam et affectum. ideo nec ad unum modum formatae manus et in voltu mille species. cursum habent quaedam at impetum, sedent alia vel incumbunt; nuda haec illa velata sunt, quaedam mixta ex utroque. quid tam distortum et elaboratum, quam est ille discobolus Myronis? si quis tamen, ut parum rectum, improbet opus, nonne ab intellectu artis abfuerit in qua vel praecipue laudabilis est ipsa illa novitas ac difficultas?"

66. Shearman 1972: 120, fig. 62; Kleiner 1992: fig. 412.

67. References in Shearman 1972: 63; the connection is that Paul/Saul came from the tribe of Benjamin, which was excoriated in the Genesis passage.

68. Poussin: Christopher Wright, *Poussin Paintings: A Catalogue Raisonné* (New York 1985): no. 64, pl. 25. Grimani: Theodor von Frimmel, *Der Anonimo Morelliano* (Vienna 1888): 104: "1521: . . . in casa del cardinal Grimano . . . El cartone grande de la conversione di S. Paolo fo de mano de Rafaelo, fatto per un dei razzi della Capella"; see Paschini, "Le collezioni archeologiche dei Grimani," 182, and Shearman 1972: 139 for its later history.

69. Dussler 1971: 88–92, pls. 145–52; for photographs and commentary, noting most of these quotations, see Dacos 1977/1986; cf. Huebner, "Raffael und die Sammlung Grimani," 277; Freedman 1997: 120–21. On the program see esp. Davidson 1985, whose coding of the scenes I use; cf. Oberhuber 1999: 179–82, figs. 155–62; and for more superb photos, including a montage of the entire ceiling, Pietrangeli 1996: pls. 336–59.

70. Dacos 1977/1986: 157, with references.

71. Davidson 1985: 48.

72. Ibid.: 67; it is possible that here the Gaul is blended with the Aix Persian, who may have been displayed in the Swiss Guards' Room next door. For the Pasquino see Stewart 1990: figs. 745–47, and for its afterlife in the Renaissance see Barkan 1999: 210–31.

311

73. Davidson 1985: 72–75.

74. Dussler 1971: 52–55, pl. 111; Fabricio Mancinelli and Konrad Oberhuber, *A Masterpiece Close-up: The "Transfiguration" by Raphael* (Cambridge, Mass., 1981); Pietrangeli 1996: pl. 236; Oberhuber 1999: 223–29, figs. 199–203.

75. See Shearman 1972: 77–78, with references; Linda Caron, "Raphael's *Transfiguration* and Failure to Heal: A Medici Interpretation," *Storia dell'arte* 64 (1988): 205–13; Josephine Jungic, "Joachimist Prophecies in Sebastiano del Piombo's *Borgherini Chapel* and Raphael's *Transfiguration*," in Marjorie Reeves (ed.), *Prophetic Rome in the High Renaissance Period* (Oxford 1992): 323–43, at pp. 338–43.

76. Ames-Lewis 1986: pl. 28.

77. Vasari, *Vite* 2: 139 (4: 317, ed. Barocchi; tr. DeVere); on what follows see esp. Frommel 1967–68: cat. nos. 49, 51–53a, pls. 34a, 36, 41, who notes all these borrowings; *contra*, Freedman 1997: 122. One of the antique figures Peruzzi drew was the Wilton Amazon (see Figure 66): Frommel 1967–68: cat. no. 114, pl. 95b.

78. Lucian, *Calumny of Apelles* 4.

79. Vasari, *Vite* 2: 139–40 (4: 319, ed. Barocchi; tr. DeVere); Frommel 1967–68: cat. no. 89, pl. 60b; Maria Brugnoli, "Baldassare Peruzzi nella Chiesa di S. Maria della Pace e nella uccelleria di Giulio II," *Bd'A* 58 (1973): 113–22; for remarks on the charity motif see David Rosand, *Painting in Sixteenth-Century Venice: Titian, Veronese, Tintoretto* (rev. ed., Cambridge 1997): 91–92, who identifies the almsgiver as Joachim.

80. Frommel 1967–68: cat. no. 90, pls. 62, 63a.

81. Ibid.: cat. no. 125, pl. 76.

82. Vasari, *Vite* 2: 233 (4: 436, ed. Barocchi; tr. DeVere).

83. See Paola Rossi, *L'Opera completa di Parmigianino* (Milan 1980): cat. no. 35, pls. 31–32; Regina Stefaniak, "Amazing Grace: Parmigianino's *Vision of St. Jerome*," *Zeitschrift für Kunstgeschichte* 58 (1995): 105–15; Partridge, *Art of Renaissance Rome*, 92–94; A. Popham, *Catalogue of the Drawings of Parmigianino* (New Haven 1971): pl. 95, no. 181r; Mary Vaccaro, "Documents for Parmigianino's *Vison of St. Jerome*," *BurlMag* 135 (1993): 22–27, fig. 18; cf. Sandro Corradini, "Parmigianino's Contract for the Caccialupi Chapel of S. Salvatore in Lauro," *BurlMag* 135 (1993): 27–29.

84. Vasari, *Vite* 2: 233 (4: 537–38, ed. Barocchi; tr. DeVere).

85. On deixis see, e.g., Karl Bühler, *Theory of Language: The Representational Function of Language* (1934; tr. D. F. Goodwin, Foundations of Semiotics 25, Amsterdam 1990): 91–166; J. F. Duchan, G. A. Bruder, and L. E. Hewitt (eds.), *Deixis in Narrative: A Cognitive Perspective* (Hillsdale, N.J., 1995); and Nancy Felson, "Vicarious Transport: Fictive Deixis in Pindar's *Pythian* Four," *Harvard Studies in Classical Philology* 99 (1999): 1–31. Cf. Bal 1999: 98 n. 21: "Expressions are deictic, not referential, only when they have meaning in relation to the utterance. Deictic words are *I, you*, but not *she; yesterday, today*, but not *some day; here, there*, but not *in Rome*. Deixis presupposes and emphasizes the presence of the speaking subject and her addressee, her 'second person.' First person and second person exchange roles and presuppose each other." Cf. Bal 1999: 87, and on the work of art looking back see David Carrier, "Art and Its Spectators," *Journal of Aesthetics and Art Criticism* 45 (1986): 5–18, at p. 6. In Western painting, the classic case of this kind of address is Velázquez's *Las Meninas*, famously analyzed by Michel Foucault in *The Order of Things: An Archaeology of the Human Sciences* (1966; tr. Alan Sheridan, New York 1973): 3–16.

86. For Leonardo's *Saint John the Baptist*, see Pietro C. Marani, *Leonardo da Vinci: The Complete Paintings* (New York 2000): 308–19; a problematic *Saint John* supposedly by Raphael and also in the Louvre (Dussler 1971: 63) bridges the gap. Yet Parmigianino probably never saw this picture; commissioned by Cardinal Adrien Gouffier de Boissy, it went straight to France. On interpellation see Louis Althusser, "*Lenin and Philosophy*" *and Other Essays* (London 1971): 170–83; whence W. J. T. Mitchell, *Picture Theory: Essays on Verbal and Visual Interpretation* (Chicago 1994): 75; Bal 1999: 87–88 (italics supplied); and on its relevance to Greek art, see esp. Françoise Frontisi-Ducroux, "Eros, Desire, and the Gaze," in Natalie B. Kampen (ed.), *Sexuality in Ancient Art* (Cambridge 1996): 81–100, at pp. 85–89. Sack of Rome: Vasari, *Vite* 2: 233 (4: 537–38, ed. Barocchi; tr. DeVere); often thought to derive from Pliny, *Natural History* 35.104–05 (Protogenes), but the circumstances and results are different.

87. See Charles de Tolnay, *Michelangelo*, vol. 3: *The Medici Chapel* (Princeton 1948): 47, pls. 61–64; John Pope-Hennessy, *Italian Renaissance Sculpture*, vol. 3.1 (New York 1985): 22–23, fig. 25; Barkan 1999: 197, fig. 3.87; cf. Summers 1972: 284: the period when he "most deeply explored the ritualizing visual energies of the *figura serpentinata*." On the *Last Judgment*, see esp. de Tolnay, *Michelangelo*, vol. 4: *The Final Period* (Princeton 1960): 19–50, pls. 1–56, 132–57; Pietrangeli 1996: 271–73, pls. 366–68; Loren Partridge, *Michelangelo: "The Last Judgment": A Glorious Restoration* (New York 1997); Bernadine Barnes, *Michelangelo's "Last Judgment": The Renaissance Response* (Berkeley 1998); Francisco Buranelli (ed.), "*The Last Judgment*"*: The Restoration* (New York 1999).

88. Partridge, *Michelangelo: "The Last Judgment*," 142–44, pls. 122–25; Barnes, *Michelangelo's "Last Judgment*," 59–69, figs. 37–38, and pp. 81–88 on the criticisms; cf. Valerie Shrimplin-Evangelidis, "Sun-Symbolism and Cosmology in Michelangelo's *Last Judgment*," *Sixteenth-Century Journal* 21 (1990): 607–44.

89. Snow-Smith, "Michelangelo's ... Aesthetic of Beauty," 153; on the architectural metonymy, see Partridge, *Michelangelo: "The Last Judgment*," 70.

90. Marcia Hall, "Michelangelo's *Last Judgment*: Resurrection of the Body and Predestination," *ArtB* 58 (1976): 85–92, at p. 91; cf. also Barnes, *Michelangelo's "Last Judgment*," 89–93.

91. Condivi, *Vita* 83 (ed. and tr. Wohl).

92. Barkan 1999: 288–89, after Vasari, *Vite* 2: 779 (6: 118, ed. Barocchi; tr. DeVere); cf. Bal 1999: 10–11.

93. See the convenient summary by Wethey 1969: vol. 1: 19–21.

94. Vasari, *Vite* 2: 823–24, 829 (6: 178 and 185, ed. Barocchi; tr. DeVere); cf. Perry 1978: 221–22, 242; Boucher 1991: vol. 1: 9, 32, 37–44 (from a letter of Lorenzo Lotto).

95. Boucher: vol. 1: 1991: 42–44, 199–201, documents 106–07, 112.

96. Pope-Hennessy, *Italian Renaissance Sculpture*, vol. 3.1: 78, 83, pl. 110; Boucher 1991: vol. 1: 66–67, 331, cat. no. 23, color pl. VII, figs. 151–56, 159–60.

97. Boucher 1991: vol. 1: 67 argues that Sansovino adapted these figures from Giulio Romano's *Resurrection* at Mantua, painted in the 1530s but now known only from secondary sources (Boucher 1991: vol. 2: fig. 161). There is no evidence, however, that he ever saw this work. Yet both artists may well have seen and responded to Raphael's drawings for his stillborn Chigi altarpiece of ca. 1514 (see Figure 99: cf. Ames-Lewis 1986: 104, figs. 123–24; Oberhuber 1999: 141, fig. 121).

Does the fourth soldier (second from right) adapt the pose of the Naples Dying Gaul? The coincidence would be extraordinary if so, but it is hard to deny the resemblance; Sansovino was close to the Medici (Boucher 1991: vol. 1: 25) and could well have seen the figure at Alfonsina Orsini's palazzo during his years in Rome.

98. Vasari, *Vite* 2: 807 (6: 157 ed., Barocchi; tr. DeVere); on Titian's collection and knowledge of antiquities cf. Wethey 1969: vol. 1: 18; Favaretto 1990: 36, 68–69. On his use of them see esp. Brendel 1955; *contra*, Perry 1980; defended by Freedman 1997. On his knowledge of the Grimani collections see Wethey 1969: vol. 1: 24. Cf. Brendel 1955 and Hans Tietze, *Titian: Paintings and Drawings* (2nd ed., New York 1950): pl. 85; Luigi Beschi, "Collezioni di antichità a Venezia al tempo di Tiziano," *Aquileia nostra* 48 (1976): 2–43; Ugo Ruggieri, "Due nuove disegni di Tiziano," in Joseph Manca (ed.), *Titian 500* (*Studies in the History of Art* 45, Washington, D.C., 1993): 85–99, fig. 10.

99. Brendel 1955: 121–22, followed by Freedman 1997: 123–27; cf. Panofsky 1969: 31–36, figs. 35–40 (*Cain and Abel*, etc.); 53–57, figs. 60–64 (*Saint Lawrence*); 147–49, figs. 155–57 (*Tityus–Tantalus* cycle); Wethey 1969: vol. 1: cat. nos. 82–84, pls. 157–59 (*Cain and Abel*, etc.); 114, pls. 178–80 (*Saint Lawrence*); 133, pls. 153–54 (*Saint Peter*); 149, pls. 105–09 (*Gloria*); vol. 3: cat. no. 19, pls. 99–104 (*Tityus–Tantalus* cycle); Pedrocco 2001: 48 and cat. nos. 128–30 (*Cain and Abel*, etc.); 162–63 (*Tityus–Tantalus* cycle: preserved paintings only); 184 (*Gloria*); 200 (*Saint Lawrence*) – all in color. Echols, "Titian's Venetian *Soffitti*," omits Brendel and the marbles completely, focusing on Pordenone, Correggio, and Giulio Romano; unfortunately, Freedman 1997 is unaware that the Venetians identified the Gauls as gladiators and displayed them in the Sala delle Teste, not in the privacy of the Palazzo Grimani at Santa Maria Formosa.

100. Perry 1980: 187–9; *contra*, Paul Joannides, "On Some Borrowings and Non-Borrowings from Central Italian and Antique Art in the Work of Titian, ca. 1510–ca. 1550," *Paragone* 487 (1990): 21–45, at p. 45 n. 49; Freedman 1997: 119.

101. See Tietze, *Titian*, pls. 297–99; Titian's debt to the Kneeling Gaul (but not the Falling one) was first noticed by Joannides, "On Some Borrowings," 34, figs. 36–37.

102. See Wethey 1969: vol. 1: 20.

103. Uffizi study: Charles E. Cohen, *The Drawings of Giovanni Antonio da Pordenone* (Florence 1980): fig. 39; Caterina Furlan, *Il Pordenone* (Milan 1988): 258, D17, with D16 and D18 for the others. Rivalry: Vasari, *Vite* 2: 187 (4: 432, ed. Barocchi; tr. DeVere); on the competition see most recently Cohen 1996: 260–65.

104. Cremona: Furlan, *Il Pordenone*, color pl. on p. 103, detail on p. 105; Cohen 1996: pl. 225. Although Titian had already produced a prototype of sorts for his *Miracle of the Jealous Husband* of 1511, this is too unsophisticated and remote in time to be their real source of inspiration.

105. So, e.g., Panofsky 1969: 22.

106. Cf. Juergen Schulz, *Venetian Painted Ceilings of the Renaissance* (Berkeley and Los Angeles 1968): 5–18; Cohen 1996: 340. On Titian's sparing use of the *figura serpentinata*, see Summers 1972: 294.

107. For the *Saint John* see Wethey 1969: vol. 1: cat. no. 111, pl. 156; Pedrocco 2001: cat. no. 146.

108. Brendel 1955: 125.

109. Augusto Gentili, *Da Tiziano a Tiziano: Mito e allegoria nella cultura veneziana del Cinquecento* (2nd ed., Rome 1988): 191–92.

110. Freedman 1997: 124.

111. Ibid.

112. I thank Loren Partridge once more for alerting me to much in this picture that I would otherwise have missed.

113. Panofsky 1969: 55 aptly quotes Prudentius' *Passio Sancti Laurentii* (*Patrologia Latina* 60: cols. 294ff), lines 509–14: "Mors illa sancti martyris/mors vera templorum fuit./Tunc Vesta palladios lares/impune sensit deseri . . ./Aedemque Laurentem, tuam/Vestalis intrat Claudia."

For developments of Panofsky's ideas, see Robert W. Gaston, "Vesta and the Martyrdom of St. Lawrence in the Sixteenth Century," *JWCI* 37 (1974): 358–62; Sandro Sponza, "Martyrdom of St. Lawrence," in Susanna Biadene (ed.), *Titian: Prince of Painters* (Munich 1990): 208–13.

114. See Ernest Nash, *Pictorial Dictionary of Ancient Rome* (rev. ed., London 1968): 457, fig. 558; Steinby 1993–2000: vol. 3: 7–8, figs. 1–5.

115. *Saint Lawrence*: Wethey 1969: vol. 1: cat. no. 115, pl. 181; Pedrocco 2001: cat. no. 248. *Fall of Man*: Panofsky 1969: 27–30, figs. 29–31; Wethey 1969: vol. 1: cat. no. 1, pl. 162; Harold E. Wethey, "Titian's *Adam and Eve* and Philip II," *España entre el Mediterraneo y el Atlantico* (*Actas del XXIII Congresso Internacional de Historia del Arte*, Granada 1973): vol. 2: 437–42; Pedrocco 2001: cat. no. 224; all proposing widely differing dates.

116. *Europa*: Panofsky 1969: 164–68, fig. 175; Wethey 1969: vol. 3: cat. no. 32, pls. 138–41; Pedrocco 2001: cat. no. 212; cf. Alastair Smart, "Titian and the *Toro Farnese*," *Apollo* 85 (1967): 420–31; Jane C. Nash, *Veiled Images: Titian's Mythological Paintings for Philip II* (Philadelphia 1985); and Rona Goffen, *Titian's Women* (New Haven 1997): 267–73; Freedman 1997: 126.

117. See Riebesell 1989: 11, 59; and even more persuasively Kunze, *Der farnesische Stier und die Dirkegruppe*, 8–13.

118. Panofsky 1969: 166; Leonard Barkan, *The Gods Made Flesh: Metamorphosis and the Pursuit of Paganism* (New Haven 1986): 199; Fehl 1992: 90; Pedrocco 2001: 256.

119. Cf. Bal 1999: 10.

120. Ovid, *Metamorphoses* 6.103–7; his *paragone* with Arachne is differently explored by Fehl 1992: 91–94 and Goffen, *Titian's Women*, 270–72. On Europa and Raphael's *Galatea* see Fehl 1992: 94–101.

121. Lodovico Dolce, *Trasformationi* (Venice 1561): Canto 5: 60; quoted by Fehl 1992: 93.

122. Nash, *Veiled Images*, 37, 61.

123. Remiglio Marini, *L'Opera completa del Veronese* (Milan 1988): cat. nos. 118, 123; Terisio Pignatti, *Veronese* (Venice 1976): cat. nos. 159, 161, figs. 419–20, 422; Terisio Pignatti and Filippo Pedrocco, *Veronese* (Milan 1995): 163, cat. nos. 153, 168; for a color illustration of the Saint George see Filippo Pedrocco, *Veronese* (Florence 1998): pl. 56.

124. For all the versions see esp. Marini, *L'Opera completa del Veronese*, no. 154a–e, pl. 40; Pignatti, *Veronese*, cat. no. 165, figs. 433–39; cf. Pignatti and Pedrocco, *Veronese*, 167–69, cat. nos. 186, A17, A33. For Veronese's later reworkings of the theme see Stefania Mason Rinaldi, "Il tabernacolo della Chiesa dei 'Gesuiti' alla Dogana di Mare," *Arte Veneta* 36 (1982): 211–16; Friderike Klauner, "Zu Veroneses Buckingham-Serie," *Wiener Jahrbuch für Kunstgeschichte* 44 (1991): 107–19, 257–61 (figs.).

125. Fehl 1992: 218–22.

126. Klauner, "Veroneses Buckingham-Serie," 111.

127. For the statuette see Traversari 1986: no. 17 (inv. 61).

128. Marini, *L'Opera completa del Veronese*, nos. 21A, 28, 50G, 109C, 327, with color pl. 32; Pignatti, *Veronese*, cat. nos. 25, 45, 75, 233, 327, figs. 35, 91, 151–52, pl. VI, 548, 697; cf. Pignatti and Pedrocco, *Veronese*, 92, 101, 317, cat. nos. 53, 84, 249, 385; Pedrocco, *Veronese*, pls. 22, 68.

129. The interpretation advanced here is developed by way of Loren Partridge from Allan Braham, "Veronese's Allegories of Love," *BurlMag* 112 (1970): 105–12, at p. 206. Cf. also Elise Goodman-Soellner, "The Poetic Iconography of Veronese's Cycle of Love," *Artibus et Historiae* 7.4 (1983): 19–28; B. Krüger and G. Lepper-Mainzer, "Die 'Londoner Allegorien der Liebe' von Paolo Veronese," *Giessener Beiträge zur Kunstgeschichte* 6 (1983): 23–32; Laurent Palet, "'Che . . . possede': Une Nouvelle Lecture des Allégories de l'Amour de Paul Veronèse," *Histoire de l'Art* 23 (1988): 27–40.

130. *Nihil novum est sub sole*. Amazingly, Pheidias had arrived at exactly the same conclusion two thousand years previously. A recently discovered fragment from the east frieze of the Parthenon shows Artemis and Aphrodite, seated in precisely the same order as Veronese's women, holding hands in an identical way: See Ian Jenkins, *The Parthenon Frieze* (Austin 1994): 80, nos. VI.40–41; Jenifer Neils, *The Parthenon Frieze* (Cambridge 2001): 107, fig. 76 (cast).

131. Vitellius: Paola Rossi, *I disegni di Jacopo Tintoretto* (Florence 1975): 2–3, figs. 1–3; Lucy Whitaker, "Tintoretto's Drawings after Sculpture and His Workshop Practice," in Stuart Currie (ed.), *The Sculpted Object, 1400–1700* (Brookfield 1997): 177–200, at p. 182, figs. 10.3–4. Grimani: Nichols 1999: 30. Contrapposti: Summers 1972: 295; on his tactics see Nichols 1999: 13–27 and passim.

132. See most recently Giandomenico Romanelli, *Tintoretto: La Scuola grande di San Rocco* (Milan 1994); Cornelia Syre (ed.), *Tintoretto: The Gonzaga Cycle* (Munich 2000).

133. Freedman 1997: 128, fig. 11; Ulrich Middeldorff, "Reinterpretation of a Tintoretto," *ArtB* 26 (1944): 195–96 (the subject); Bernari 1970: cat. no. 74, pl. II; Pallucchini and Rossi 1982: cat. no. 136, figs. 182–83 (with eighteenth-century additions removed).

134. Bernari 1970: cat. nos. 82E, pl. IX, 156B, 162A and C, 224, 252, 279, pl. L; Pallucchini and Rossi 1982: cat. nos. 72, 152, 237, 243, 245, 417, 453, figs. 90, 201, 308, 323, 328, 531, 578; Nichols 1999: 136–37, 139–44, figs. 63, 111 (new *Martyrdom of Saint Lawrence*), 121, 123.

135. On the program see Lino Moretti, *La chiesa di Tintoretto: Madonna dell'Orto* (Venice 1994); and esp. Ruggiero Rugolo, "Il simbolismo dei grandi teleri custoditi nel presbiterio della Madonna dell'Orto," *Jacopo Tintoretto nel quarto centenario dela morte: Atti del vonvegno internazionale dei studi, Venezia 24–26 Novembre 1994* (Padua 1996): 213–223, 351–52; for good color pictures see Roland Krischel, *Jacopo Tintoretto, 1519–1594* (Köln 2000): figs. 53–54.

136. Dagmar Knöpfel, "Sui dipinti di Tintoretto per il coro della Madonna dell'Orto," *Arte Veneta* 38 (1984): 149–54; accepted, e.g., by Krischel, *Jacopo Tintoretto*, 70.

137. For Tintoretto's other possible transgender metamorphoses of the Falling Gaul, see, e.g., the Venus in his *Venus, Vulcan, and Mars* in Munich; Juno in his *Origin of the Milky Way* in London; and Lucretia in his doublet of *Tarquin and Lucretia* in Chicago and Köln: Bernari 1970: cat. nos. 89, 131, 255; Pallucchini and Rossi 1982: cat. nos. 155, 390, 450–51, figs. 204, 502, 594–95; Nichols 1999: 88–90, fig. 74, 135–37, fig. 120. It may be relevant that the first of these pictures burlesques courtly classicism, while the second and third embrace it.

138. Cf. Derrida, *Speech and Phenomena*, 130; Bal 1999: 10–11.

3. REPRODUCTION: *VAE VICTIS!*

1. See Baxandall 1985: 58–62; Richard Wollheim, *Painting as an Art* (Princeton 1987): 187–89.

2. E.g., Palma 1981: 52; Carlo Gasparri, "I marmi Farnese," in Ajello, Haskell, and Gasparri 1988: 41–57, at p. 56; Queyrel 1989: 275–76; Andreae 1998: 188–89. In Gasparri's case this idea seems largely prompted by his belief that the copies come from the Baths of Agrippa, which were built between 25 and 12 BC (but restored by Hadrian); in Andreae's, by the suggestion that they are made of alabaster and so ought to be products of a "late Etruscan" workshop.

3. A test on the underside of the plinth of the Paris Gaul determined that it was made of alabaster, but (1) the material of the statue itself looks like that of the other nine, and (2) the restored patches on the body look like alabaster. Unfortunately, no records of the process are available, and the statue has now been reset into its stone base; so perhaps the sample was taken from the restored section of the plinth.

4. On the provenance of the Big Gauls and 1623 inventory see: Beatrice Palma, *Museo Nazionale Romano: Le sculture* 1, 4. *I marmi Ludovisi: Storia della collezione* (Rome 1983): 31–39, 70, nos. 15, 27; Mattei 1987: 2, 17–22; Polito 1999: 11–14, with an excellent map. Date of the copies: Künzl 1971: 1–5; for their drapery, see esp. the so-called Thusnelda in the Loggia dei Lanzi in Florence, independently deemed Trajanic by Hans-Joachim Kruse, *Römische weibliche Gewandstatuen des zweiten Jhs. v. Chr.* (Göttingen 1968): 324, 332, no. D17f; and Carlo Gasparri, "Die Gruppe der 'Sabinerinnen' in der Loggia dei Lanzi, Florenz," *AA* 94 (1979): 524–43, at p. 530, figs. 17, 20; *LIMC* 4 (1988) s.v. "Germania," no. 11 (Ernst Künzl). Filippo Coarelli has proposed a Caesarian date in a number of publications, of which the most recent is *Da Pergamo a Roma:*

I Galati nella città degli Attalidi (Rome 1995); yet he produces no hard evidence in support. Asian marble: Marina Mattei, "The Dying Gaul," in Moscati 1991: 70–71; Polito 1999: 59, 73.

5. Horn 1937: 150–51.

6. Ibid.: 154, pl. 39.

7. Diodoros 5.28.2: Οἱ δὲ Γαλάται . . . τιτάνου γὰρ ἀποπλύματι σμῶντες τὰς τρίχας συνεχῶς ἀπὸ τῶν μετώπων ἐπὶ τὴν κορυφὴν καὶ τοὺς τένοντας ἀνασπῶσιν, ὥστε τὴν πρόσοψιν αὐτῶν φαίνεσθαι Σατύροις καὶ Πᾶσιν ἐοικυῖαν· παχύνονται γὰρ αἱ τρίχες ἀπὸ τῆς κατεργασίας, ὥστε μηδὲν τῆς τῶν Ἵππων χαίτης διαφέρειν.

8. See Maria F. Squarciapino, *La scuola di Afrodisia* (Rome 1943): 32–34, pl. F, with, e.g., Joachim Raeder, *Die statuarische Ausstattung der Villa Adriana bei Tivoli* (Frankfurt-am-Main 1983): 237–38; MacDonald and Pinto 1995: 94–95, 292–93, figs. 111–12, 171–72, 381–83.

9. John Van de Grift, "Tears and Revel: The Allegory of the Berthouville Centaur Scyphi," *AJA* 88 (1984): 377–88, at p. 385.

10. Horn 1937: 159, pl. 42.

11. Squarciapino, *La scuola di Afrodisia*, 12, 34–35, pl. 8; *EA* 1517–20.

12. For illustrations of the works cited in the following paragraphs, see esp. Max Wegner, *Das römische Herrscherbildnis* ii.1: *Die Flavier* (Berlin 1966); Walter Hatto Gross, *Bildnisse Traians* (Berlin 1940); Gerhard M. Koeppel, "Die historischen Reliefs der römischen Kaiserzeit II: Stadtrömische Denkmäler unbekannter Bauzuhörigkeit aus flavischer Zeit," *BJb* 184 (1984): 1–65, esp. figs. 30–31 (flamen), 33–34 (Victoria); id., "Die historischen Reliefs der römischen Kaiserzeit III: Stadtrömische Denkmäler unbekannter Bauzuhörigkeit aus trajanischer Zeit," *BJb* 185 (1985): 143–214, esp. figs. 6 (Albani relief), 10 (Chatsworth relief), 20–21 (Medici relief), 25 (Louvre Dacian relief); Anne-Marie Leander Touati, "The Great Trajanic Frieze," *Acta Instituti Romani Regni Sueciae*, ser. in 4°, vol. 45 (Stockholm 1987): pls. 32–35 (heads from the frieze), 50.3 (Louvre Dacian relief); Krierer 1995: pls. 63, 71, 79 (Trajan's Column), 130–33 (Great Frieze), 134 (Medici relief), 145–48 (Dacians from Trajan's Forum); Elaine K. Gazda and Anne E. Haeckl, *Images of Empire: Flavian Fragments in Rome and Ann Arbor Rejoined* (Rome and Ann Arbor 1996): 46, no. 3 (support figure), 48, no. 5 (flamen), 51, no. 8 (Victoria). The Great Trajanic Frieze is assigned to the north attic of the Basilica Ulpia, facing Trajan's Column, by James E. Packer, *The Forum of Trajan in Rome* (Berkeley and Los Angeles 1997): 113, 445; on the Dacians from Trajan's forum and elsewhere, see Jutta Pinkerneil, *Studien zu den trajanischen Dakerdarstellungen* (Freiburg 1983), esp. cat. nos. 55 and 69 for the Dacian figs. 158 and 161.

13. Probably commemorating Hadrian's public bonfire of tax documents in late 118 or early 119: Birley 1997: 97–98.

14. Raeder, *Die statuarische Ausstattung der Villa Adriana*, pls. 22–24; Kleiner 1992: figs. 214–15; MacDonald and Pinto 1995: figs. 174, 179.

15. See, e.g., Lucian, *Iuppiter Tragoedus* 33; cf. Christa Hees-Landwehr, *Die antiken Gipsabgüsse aus Baiae* (Berlin 1985). They include monuments that are demonstrably Athenian, such as the Tyrannicides.

16. The Crypta have given their name to the present-day Via de' Botteghe Oscure; L. Cornelius Balbus built them between 19 and 13 BC as a vestibule for his theater. In 19 he had become the last Roman outside the imperial family to celebrate a triumph, which was loaded with images of the Mauretanian towns and tribes that he had conquered (Pliny, *Natural History* 5.36–7). The niches are 1.9 m wide by 0.89 m deep and are spaced at approximately 5-m intervals; perhaps they housed these triumphal images, which were presumably of perishable and/or expensive materials. Steinby 1993–2000, q.v., with Daniele Manacorda, *Archeologia urbana a Roma: Il progetto della Crypta Balbi* (5 vols., Rome 1982–90).

17. Suetonius, *Domitian* 5; Dio Cassius 69.4.1; *Historia Augusta: Hadrian* 9; cf. Mary T. Boatwright, *Hadrian and the City of Rome* (Princeton 1987): 211 n. 95; see Steinby 1993–2000.

18. *Historia Augusta: Hadrian* 19.10; cf. Boatwright, *Hadrian and the City of Rome* 33–62; see Steinby 1993–2000.

19. Lanciani 1902/1989–2000: vol. 1: 183, 276, 288; cf. esp. Christian Hülsen, *Die Thermen des Agrippa* (Rome 1910).

20. Saepta: Martial 2.14.5–6 and the Severan Marble Plan; Pliny, *Natural History* 36.29. Baths: ibid. 34.62 (the riot when Tiberius attempted to remove the Apoxyomenos); 35.26 (donations of artworks to the People); on the entire complex see Zanker 1988: 139–43.

21. Palma 1981: 52; Palma 1984: 778; Gasparri, "I marmi Farnese," 56; cf. Marvin 2002: 216.

22. On Roman sculptural display, see most conveniently Vermeule 1977: 45–81.

23. For precedents see, e.g., the Nereid Monument at Xanthos, the Mausoleum at Halikarnassos, and the Great Altar of Pergamon: Stewart 1990: figs. 468, 524; Dreyfus and Schraudolph 1997: 58, foldout 3. Apollo Palatinus: Propertius 2.31.3–4; Ovid, *Tristia* 3.1.61 (intercolumnar statues); id., *Amores* 2.11.64 (an *agmen*); id., *Ars Amatoria* 1.73–4 (statue of their father with drawn sword nearby); cf. Steinby 1993–2000: s.v. "Apollo Palatinus, aedes"; Vermeule 1977: 49; Paul Zanker, "Der Apollontempel auf den Palatin," in *Città e architettura nella Roma imperiale* (Atti Seminario Roma, 1983): 21–40, at pp. 27–31; and esp. L. Balansiefen, "Überlegungen zu Aufbau und Lage der Danaidhalle auf dem Palatin," *RM* 102 (1995): 189–209, pls. 48–53 (herms; also showing that the scholiast to Persius 2.56, reporting equestrian statues of the fifty sons of Aegyptus in front of them, is mistaken); Michael Koortbojian, "Forms of Attention: Four Notes on Replication and Variation," in Gazda 2002: 173–204, at pp. 200–03. Hadrian's Villa: Vermeule 1977: fig. 63; Kleiner 1992: fig. 212; MacDonald and Pinto 1995: figs. 165–70. Against a reconstruction of some of the statues of the Villa dei Papiri at Herculaneum in this position, see Neudecker 1988: 106.

24. For the Herculaneum girls, see Neudecker 1988: 106–7, Beil. 1–2; for the Atrium Vestae, see Ernest Nash, *Pictorial Dictionary of Ancient Rome* (rev. ed., London 1968): figs. 167, 170; for Pompeii, see Paul Zanker, *Pompeii* (Cambridge, Mass., and London 1998): figs. 37, 53 (reconstruction).

25. On the Sallustian (Rome–Copenhagen) Niobids see Lanciani 1906; Boardman 1985: 175, fig. 133.1–3; Eugenio La Rocca, *Amazzonomachia: Le sculture frontonali del tempio di Apollo Sosiano* (Rome 1985): 71–72, pls. 39–42; Emilia Talamo, "Gli Horti di Sallustio a Porta Collina" and Mette Molte-

315

sen, "The Sculptures from the Horti Sallustiani in the Ny Carlsberg Glyptotek," in Cima and La Rocca 1998: 113–69, at pp. 145–48, and 175–88; Rolley 1999: 176–80, figs. 161–63. On the Florentine Niobids see Guido A. Mansuelli, *Galleria degli Uffizi: Le sculture*, 2 vols. (Rome 1958–61): vol. 1: 101–4, nos. 70–80, 84; Vermeule 1977: 47–48; Wilfred Geominy, *Die Florentiner Niobiden* (Bonn 1984); Hölscher 1985: 131–33; Ridgway 1990: 82–84, pls. 44–7; Ruth Christine Häuber, *Die Horti Maecenatis und die Horti Lamiani auf dem Esquilin: Geschichte, Topographie, Statuenfunde* (Köln 1991): 227–33, nos. 28–38 (suggesting that they originally embellished the nearby Diaeta Apollinis of the Gardens of Maecenas); Smith 1991: 107–08, figs. 140–41; *LIMC* 6 (1992) s.v. "Niobe," no. 7 (Margot Schmidt), and "Niobidai," no. 23 (Wilfred Geominy); for older reconstructions of the group and for the Cretan copies see Bieber 1961: 74–76, figs. 253–65; *LIMC* 2 (1984) s.v. "Artemis," no. 1359 (Lily Kahil), and s.v. "Niobe," no. 23a (Margot Schmidt); cf. Hubertus Manderscheid, *Die Skulpturenausstattung der kaiserzeitlichen Thermenanlagen* (Berlin 1981).

26. Scarry 1985: 62.

27. Barton 2001: 71; Auctor ad Herennium 4.45,59: "similiudo est oratio traducens ad rem quampiam aliquid ex re dispari simile. ea sumitur ad ornandi causa aut probandi aut apertius dicendi aut ante oculos ponendi. et quomodo quattuor de causis sumitur, item quattuor modis dicitur: per contrarium, per negativum, per conlationem, per brevitatem." Cf., e.g., Koortbojian 1995.

28. On the Big Gauls see esp. Bienkowski 1908; Schober 1938, 1951; Künzl 1971; Wenning 1978; Ridgway 1990: 284–90; Polito 1999; Marszal 2000; Andreae 2001: 92–93, pls. 46–48; Marvin 2002 (published after this chapter was written but anticipating its conclusions concerning the omission of the victors); Pirson 2002 (*non vidi*). The two main ones are (1) the Dying Trumpeter, Museo Capitolino inv. 747 (see Figures 28, 239–41); and (2) the Suicidal Gaul, Museo Nazionale Romano inv. 8608 (see Figures 27, 81, 236–38); both are of Dokimeion marble and probably from the Horti Sallustiani. See Helbig[4], nos. 1436 and 2337; Palma, *Museo Nazionale Romano: Le sculture* 1, 4: 31–39, 70, nos. 15, 27; Mattei 1987; Talamo, "Gli Horti di Sallustio," 141; Polito 1999. On the Horti Sallustiani and their contents see Gino Cipriani, *Horti Sallustiani* (2nd ed., Rome 1982); Steinby 1993–2000, q.v.; Talamo, "Gli Horti di Sallustio"; on the Gauls and the Horti see Lanciani 1906: 181–83. The other major pieces (with additional bibliography) are: (3) a torso of a wounded Gaul perhaps from Tivoli, Dresden Antikensammlung Hm 154 (see Figure 242); (4) a head of a Gaul (his torque has been chiseled off) perhaps from Tivoli, Vatican inv. 1271 (see Figures 243–44): Walther Amelung, *Die Sculpturen des vaticanischen Museums*, vol. 1 (Berlin 1903): no. 535, pl. 70; Helbig[4], no. 302; (5) a dying barbarian (Gallic?) woman in Dokimeion marble from the Palatine Stadium, Antiquario Palatino inv. 4283 (see Figure 245): Tomei 1997: no. 126; (6) head of a Gaul (fragment only), Museo Nazionale Romano inv. 4281; (7) a dying Persian in Dokimeion marble from the Domus Tiberiana, Antiquario Palatino inv. 603 (see Figure 246): Tomei 1997: no. 127; Helbig[4], no. 2240; A. Giuliano (ed.), *Museo Nazionale Romano: Le sculture* 1, 1 (Rome 1981): no. 86.

29. Schober 1938: 133, fig. 4 – though he did not measure the hoofprint or draw the obvious conclusion from it. The hoof is Franz Winter, *Die Skulpturen* (1908) (*AvP* 7): no. 468, and cannot now be located in the Pergamonmuseum; perhaps it was taken to Russia in 1945 with the Great Altar and (like much else) has not been returned.

30. Alexander Conze et al., *Stadt und Landschaft* (1912) (*AvP* 1.1): 250, fig. 1; Koeppel 1972; Ursula Mandel, *Kleinasiatische Reliefkeramik der mittleren Kaiserzeit* (*Pergamenische Forschungen* 5, Berlin 1988): 39–40 (correcting Koeppel's date of ca. AD 200), 90, 226, no. P149; Marszal 2000: 209–10.

31. Found in niche 41 on the north side of the Agora: See esp. E. Lapalus, *Exploration archéologique de Délos* (Paris 1939): 52, figs. 2, 6; Marcadé 1969: 119–27, cf. Stewart 1990: 227; Marszal 2000: 216; Ridgway 2000: 319; Andreae 2001: 204–06, pl. 195.

32. Propertius 2.31.12–13: "et valvae, Libyci nobile dentis opus/altera deiectos Parnassi vertice Gallos/altera maerebat funera Tantalidos"; cf. Zanker 1988: 85–87, fig. 70.

33. See Geominy, *Die Florentiner Niobiden*. Oddly, he overlooks the best *comparandum* for his late fourth-century date – the splendid head from the Akropolis South Slope, Athens NM 182 (a Dionysos?), attributed to the same workshop as the Niobids sixty-five years previously: Franz Studniczka, "Der Frauenkopf vom Sudabhang der Burg in Athen," *JdI* 34 (1919): 107–44; cf. Andrew Stewart, *Skopas of Paros* (Park Ridge 1977): 118–20, pl. 50, for further comments and documentation. Sarcophagi: Robert 1890–1939: vol. 3.3: pls. 99–102; Koch and Sichtermann 1982: 169, figs. 189–91; *LIMC* 6 (1992) s.v. "Niobidai," no. 32 (Wilfred Geominy); Krierer 1995: pls. 1–4. For the entire iconographic tradition (vases and disk included), see *LIMC* 6 (1992) s.vv. "Niobe" (Margot Schmidt) and "Niobidai" (Wilfred Geominy). On the Thrasyllos Monument see Pausanias 1.21.3; Gabriel Welter, "Das choregische Denkmal des Thrasyllos," *AA* 1938: cols. 33–68; Paul Amandry, "Monuments chorégiques d'Athènes," *BCH* 121 (1997): 445–87, at pp. 459–63; and esp. Rhys Townsend, "Aspects of Athenian Architectural Activity in the Second Half of the Fourth Century B.C." (unpublished Ph.D. dissertation, University of North Carolina at Chapel Hill 1982): 194–98, on the stepped interior of the cave.

34. Lanciani 1906: 181–83; for Niobe as an *exemplum superbiae* see Propertius 2.20.7.

35. See most recently Stewart 1990: 216, figs. 748–52; Smith 1991: 106–07, fig. 135; Harriet Ann Weis, *The Hanging Marsyas and Its Copies* (Rome 1992); *LIMC* 6 (1992) s.v. "Marsyas," nos. 61–64 (Harriet A. Weis); Ridgway 2000: 283–84; Andreae 2001: pls. 88–91.

36. Amazons: Stewart 1990: 162–63, figs. 388–96; cf. Pausanias 7.2.7. "Pasquino" and Achilles–Penthesileia groups: Ridgway 1990: 275–81, pls. 137–38; Stewart 1990: 215, figs. 745–47 (Pasquino only); Smith 1991: 104–05, figs. 133–34; Dagmar Grassinger, "Die Achill–Penthesilea-Gruppe sowie die Pasquino-Gruppe und ihre Rezeption in der Kaiserzeit," in Bol (ed.) 1999: 323–30; Andreae 2001: pls. 127–29. Peter Green, "Pergamon and Sperlonga: A Historian's Reactions," in de Grummond and Ridgway 2000: 166–90, at pp. 183–85, offers new arguments that the Pasquino's subject is probably Ajax carrying the body of Achilles from a Trojan ambush. On these

groups, see Stewart, "Baroque Classics and Classical Tragedy," in James I. Porter (ed.), *Classical Pasts: The Classical Traditions of Greco-Roman Antiquity* (Princeton, in press). Ariadne, Faun, Eros, and Hermaphrodite: Stewart 1990: figs. 696–97, 819–21; Smith 1991: figs. 84, 168–69; Andreae 2001: pls. 65, 67–71, 172–73.

37. On the complexities of the Pergamene treatment of barbarians, see Stewart 1997: 219–21, quoted below in Chapter 4, §7. Barbarian suicide, etc.: La Rocca 1994: 27–28, fig. 27; Conrad Cichorius, *Die Reliefs der Traianssäule* (Berlin 1896–1900): pls. 91–92, cxxi; 102, cxl; 106, cxlv; repr., Frank Lepper and Sheppard Frere, *Trajan's Column: A New Edition of the Cichorius Plates* (Gloucester 1988); Settis 1988: pls. 230–32, 258, 267–69; Pirson 2002 (*non vidi*); cf. Tacitus, *Agricola* 15.3, 30.2; *Germania* 8.1. On the Roman public eye, the "desouling Gaze," and "objects of sport" see Barton 2001: 246–53. Roman trophies, Danaids, caryatids, Dacians, etc.: see n. 23, above, with Gilbert-Charles Picard, *Les trophées romaines* (Paris 1957); Schneider 1986; Desnier 1991: fig. 1; Kleiner 1992: figs. 47, 64, 83, 214, 251–52; Vitruvius 1.1.4. On the civilizing process see Gros 1998, and on Roman sculpture as the repetition of exempla, Gazda 1995: 144–48.

38. Barton 2001: 70–71; cf. Koortbojian 1995: 34–38 and passim. Livy, *Praefatio* 10: "hoc illud est praecipue in cognitione rerum salubre et frugiferum, omnis te exempli documenta in inlustri posita monumento intueri; inde tibi tuaeque reipublicae quod imitere capias, inde foedum inceptu foedum exitu quod vites"; cf. also Auctor ad Herennium 3.5, 9; 4.45, 59; Quintilian 5.11.1–21; 12.4.1: "nam illa quidem priora aut testimoniorum aut etiam iudicatorum obtinent locum, sed haec quoque aut vetustatis fide tuta sunt aut ab hominibus magnis praeceptorum loco ficta creduntur."

39. For Niobe as an *exemplum superbiae* see, e.g., Propertius 2.20.7; for the Gallic chieftain Brennus as an *exemplum impietatis et avaritiae*, id. 3.13.51–54.

40. See Scarry 1985: 62–78.

41. On the structure of war see ibid.: 87. This process of selection and extrapolation fits with the general simplification of Roman imperial art under the Flavians, Trajan, and Hadrian in order to speak to a wider public, and to some extent anticipates the narrative techniques of the third-century sarcophagi: See Tonio Hölscher, "Staatsdenkmal und Publikum," *Konstanzer althistorische Vorträge und Forschungen* 9 (1984): 34–36; Paul Zanker, "Phädras Trauer und Hippolytos' Bildung: Zu einem Sarcophag im Thermenmuseum," in Francesco de Angelis and Susanne Muth (eds.), *Im Spiegel des Mythos: Bilderwelt und Lebenswelt* (Wiesbaden 1999): 131–42; id., *Die mythologischen Sarkophagreliefs und ihre Betrachter* (Bayerische Akademie der Wissenschaften, Phil.-Hist. Klasse, Heft 2, Munich 2000); and in Paul Zanker and Bjorn Ewald, *Mit Mythen leben: Die Bilderwelt der römischen Sarkophage* (Munich 2004).

42. Pollitt 1986: 92.

43. Quintilian 6.2.29: "quas φαντασίας Graeci vocant nos sane visiones appellemus, per quas imagines rerum absentium ita repraesentantur animo ut eas cernere oculis ac presentes habere videamur. has quisquis bene conceperit, is erit in affectibus potentissimus"; cf. Philostratos the Younger, *Imagines* Praefatio 6. The classic study of this visual topos is by Peter H. von Blanckenhagen, "Der ergänzende Betrachter: Bemerkungen zu einem Aspekt hellenistischer Kunst," in *Wandlungen: Studien zur antiken und neueren Kunst: Ernst Homann-Wedeking gewidmet* (Waldsassen 1975): 193–201, though it will be obvious that I explain the phenomenon differently; cf. also Murray W. Bundy, *The Theory of Imagination in Classical and Mediaeval Thought* (Urbana, Ill., 1927); Jerome J. Pollitt, *The Ancient View of Greek Art* (New Haven and London 1974): 52–55, 293–97; M. Fattori and M. Bianchi, *Phantasia-Imaginatio: V° Colloquio Internazionale, Roma 9–11 gennaio 1986* (Rome 1988); Gerard Watson, *Phantasia in Classical Thought* (Galway 1988); Jas Elsner, *Art and the Roman Viewer* (Cambridge 1995): 26–28. (I thank Kristen Seaman for some of these references.) The translation of *phantasiai* or *visiones* as "impressions" is taken from Anthony A. Long and David N. Sedley, *The Hellenistic Philosophers*, vol. 1 (Cambridge 1987): 72–86, 236–53, 460–67.

44. Cf. Bal 1999: 98.

45. Tacitus, *Agricola* 30.3: "omne ignotum pro magnifico est."

46. Vergil, *Aeneid* 8.704–6; *EAA, Atlante dei complessi figurati e degli ordini architettonici* (Rome 1973: roman numeration as in Cichorius, *Die Reliefs der Traianssäule*; repr. Lepper and Frere, *Trajan's Column*), pl. 82, xxiv; Settis 1988: pl. 30; Coarelli 2000: pl. 24. Pliny, *Natural History* 3.39: "[Italia] numine deum electa quae caelum ipsum clarius faceret, sparsa congregaret imperia ritusque molliret et tot populorum discordes ferasque linguas sermonis commercio contrahet a colloquia et humanitatem homini daret, breviterque una cunctarum gentium in toto orbe patria fieret." Cf., e.g., Tacitus, *Agricola* 12; *Germania* 33.

47. Bal 1999: 87, after Althusser.

48. Cicero, *De Oratore* 2.266: "demonstravi digito pictum Gallum in Mariano scuto Cimbrico sub Novis, distortum, eiecta lingua, buccis fluentibus; risus est commotus: nihil tam Manciae simile visum est." See the comments by G. Perl, "Der Redner Helvius Mancia und der *pictus Gallus*: Cic. de Orat. 2.266," *Philologus* 126 (1982): 59–67; Anthony Corbeil, *Controlling Laughter: Political Humor in the Late Roman Republic* (Princeton 1996): 40–41.

49. See esp. Stewart 1990: passim and index s.v. "physiognomics"; Stewart 1997: 186–95, 224–48, with references; Smith 1991: chap. 8. On theater masks see J. Richard Green and Eric Handley, *Images of the Greek Theatre* (Austin 1995); T. B. L. Webster, *Monuments Illustrating New Comedy*, 3rd ed. by J. Richard Green and Ann Seeberg (*BICS* Supplement 50, London 1995).

50. The literature on physiognomics is vast. The main surviving treatises are by pseudo-Aristotle (3rd century BC); Polemon (2nd century AD, surviving in Arabic translation only); and Adamantios (4th century AD). These and most of the other texts are collected in Richard Foerster, *Scriptores Physiognomonici Graeci et Latini* (2 vols., Leipzig 1893), hereafter cited in parentheses by volume and page followed by the letter 'F'. Two essential modern studies are Elizabeth C. Evans, "Physiognomics in the Ancient World," *Transactions of the American Philosophical Society*, n.s. 59.5 (1969); and Sassi 1988/2001; for its second-century AD efflorescence see esp. Gleason 1995. For its later history see, e.g., Jurgis Baltrusaitis, *Aberrations: An Essay on the Legend of Forms* (Cambridge, Mass., 1989); Stephen

J. Gould, *The Mismeasure of Man* (2nd ed., New York 1996); and James Elkins, *Pictures of the Body: Pain and Metamorphosis* (Stanford 1999): chaps. 2, 4. On physiognomics and sculpture, see Hans Peter Laubscher, *Fischer und Landleute* (Mainz 1982): 49–59; and Mechthild Amberger-Lahrmann, *Anatomie und Physiognomie in der hellenistischen Plastik: Dargestellt am Pergamonaltar* (Mainz 1996); despite his book's title, Krierer 1995 ignores the ancient texts.

51. On Greek viewing see Stewart 1997: 19; for the spectator and the *discrimen* see Barton 2001: 60–66 (whence the quotation). The Helvetii: Tacitus, *Histories* 1.68: "illi ante discrimen feroces, in periculo pavidi."

52. Diogenes Laertius 1.33.

53. Sassi 1988/2001: 75–76.

54. Polemon, *Physiognomonica* 1 (1: 160–62F); cf. Anonymous, *de Physiognomonica* 40 (2: 57–58F) for the identification, with Gleason 1995: 46–47. Sassi 1988/2001: 136 recognizes the problem but does not pursue it.

55. Roman-period *ekphrases* are full of physiognomonical observations, and the prefaces of the two Philostrati explicitly instruct the critic to analyze paintings in this way: Philostratos, *Imagines* 1.1.2 (painting's superiority over sculpture); Philostratos the Younger, *Imagines* Praefatio 3. On the importance of the head see [Aristotle], *Physiognomonica* 73,814b4 (1: 90F); Polemon, *Physiognomonica* 1 (1: 166–68F); Adamantios 2.1 (1: 348F); cf. Barton 2001: 56–58 (whence the quotation).

56. Polemon, *Physiognomonica* 1 (1: 148F); cf. Gleason 1995: 45–46.

57. Aristotle, *Problems* 10.24,893b10–17 (thick hair is symptomatic of an excess of blood and therefore of sperm; it signals a hot lustful man); [Aristotle], *Physiognomonica* 23,808a23; 42,810a2; 60,811a24; 64,811b29–812a1 (the mean in brows) (1: 34, 52, 64, 70, 72F); Polemon, *Physiognomonica* 1, 25, 27, 40 (1: 112, 136, 152, 226, 230, 248F); Adamantios 1.6, 18 (1: 309, 341F); 2.24, 37, 47 (1: 374, 392, 412F); Anonymous, *Physiognomonica* 14 (2: 224F, with remarks on barbarian hair).

58. [Aristotle], *Physiognomonica* 62,811b5 (1: 66F).

59. Ibid., 69,812b35 (1: 80F): οἱ τοῦ μετώπου τὸ πρὸς τῇ κεφαλῇ ἀναστεῖλον ἔχοντες ἐλευθέροι· ἀναφέρεται ἐπὶ τοὺς λέοντας. οἱ ἐπὶ τῆς κεφαλῆς προσπεφυκυίας ἔχοντες τὰς τρίχας ἐπὶ τοῦ μετώπου κατὰ τὴν ῥῖνα ἀνελεύθεροι· ἀναφέρεται ἐπὶ τὴν ἐπιπρέπειαν, ὅτι δουλοπρεπὲς τὸ φαινόμενον.

60. Hair: [Aristotle], *Physiognomonica* 9,806b7; 13,807b5 (1: 18, 28F); Polemon, *Physiognomonica* 40 (1: 248F); Adamantios 2.37 (1: 392–93F); and southerners: [Aristotle], *Physiognomonica* 9,806b16 (1: 20F); and slavish stance, [Aristotle], *Physiognomonica* 14,807b10; 57,811a4 (1: 28, 62F); Adamantios 2.16, 60 (1: 363–64, 425F). Low-spirited man (*athymos*): [Aristotle], *Physiognomonica* 20,808a8–13 (1: 32F). Persians are slavish: See esp. Aristotle, *Politics* 7.6.1,1327b27, with Sassi 1988/2001: 104, 108, 114–16.

61. Womanish Orientals: For references and discussion see Stewart 1993: 143–44, with Sassi 1988/2001: 110–12. For signs of fear see, e.g., Stewart 1990: figs. 459, 589, 696; cf. [Aristotle], *Physiognomonica* 14,807b11 (1: 28F); Polemon, *Physiognomonica* 60, 68 (1: 276F, 284F); Adamantios 2.51 (1: 415F); Anonymous, *Physiognomonica* 18, 91, 97 (2: 29–30, 120, 122–23F).

62. "Savage face": Polemon, *Physiognomonica* 28 (1: 232F); in the nineteenth-century translation of the Arabic this reads: "cum labiorum et eius quod inter oculos est et genarum spasmum in facie truci conspicis, eius stultitiam et stupiditatem et insaniam tribues"; also Adamantios 2.28 (1: 380F). Forehead and brow: Polemon, *Physiognomonica* 1 (1: 152F); Adamantios 1.18 (1: 341F). Beard: Anonymous, *Physiognomonica* 124 (2: 139F); Anonymous, *Physiognomonica* 8 (2: 228F); cf. Polemon, *Physiognomonica* 2 (1: 174F). Small ears: [Aristotle], *Physiognomonica* 66,812a10 (1: 72F); Adamantios 2.29 (1: 380F). Teeth: Polemon, *Physiognomonica* 25 (1: 226F); Adamantios 2.60 (1: 425F); *Palatine Anthology* 16.265–66 (Momos); cf. A. Otto, *Die Sprichworter und sprichwortlichen Redensarten der Romer* (Leipzig 1890): 69, 107. On large genitalia see Kenneth J. Dover, *Greek Homosexuality* (2nd ed., Cambridge, Mass., 1989): 124–35; J. N. Adams, *The Latin Sexual Vocabulary* (Baltimore 1982): 77–78. On the image of the Oriental see esp. Edward Said, *Orientalism* (London 1978): 57; Edith Hall, *Inventing the Barbarian: Greek Self-Definition through Tragedy* (Oxford 1989): 83–86.

63. [Aristotle], *Physiognomonica* 13,807a32 (1: 26F); Polemon, *Physiognomonica* 40 (1: 248F); Adamantios 2.37 (1: 392F).

64. Diodoros 5.28.1–3: Οἱ δὲ Γαλάται τοῖς μὲν σώμασίν εἰσιν εὐμήκεις, ταῖς δὲ σαρξὶ κάθυγροι καὶ λευκοί, ταῖς δὲ κόμαις οὐ μόνον ἐκ φύσεως ξανθοί, ἀλλὰ καὶ διὰ τῆς κατασκευῆς ἐπιτηδεύουσιν αὔξειν τὴν φυσικὴν τῆς χρόας ἰδιότητα. Τιτάνου γὰρ ἀποπλύματι σμῶντες τὰς τρίχας συνεχῶς ἀπὸ τῶν μετώπων ἐπὶ τὴν κορυφὴν καὶ τοὺς τένοντας ἀνασπῶσιν, ὥστε τὴν πρόσοψιν αὐτῶν φαίνεσθαι Σατύροις καὶ Πᾶσιν ἐοικυῖαν· παχύνονται γὰρ αἱ τρίχες ἀπὸ τῆς κατεργασίας, ὥστε μηδὲν τῆς τῶν Ἵππων χαίτης διαφέρειν. τὰ δὲ γένεια τινὲς μὲν ξυρῶνται, τινὲς δὲ μετρίως ὑποστρέφουσιν· οἱ δ' εὐγενεῖς τὰς μὲν παρειὰς ἀπολειαίνουσι, τὰς δ' ὑπήνας ἀνειμένας ἐῶσιν, ὥστε τὰ στόματα αὐτῶν ἐπικαλύπτεσθαι. διόπερ ἐσθιόντων μὲν αὐτῶν ἐμπλέκονται ταῖς τροφαῖς, πινόντων δὲ καθαπερεὶ διά τινος ἠθμοῦ φέρεται τὸ πόμα.

65. Poseidonios fr. 169 Theiler; cf. Kremer 1994; Sassi 1988/2001: 134–35. On the *furor Celticus/Gallicus* see Aristotle, *Nicomachean Ethics* 3.7.7–13,1115b25–29; Lloyd-Jones and Parsons 1983: no. 958 (where like Ares the Gaul is *thouros*, impetuous); Polybios 2.28–30; Diodoros 5.24–31; Livy 38.17–21; Strabo 7.3.8; Silius Italicus 4.190; Pausanias 10.21.3; Dio Cassius 12.50.3. For Gallic *thymos* see, e.g., Polybios 2.30.4, 35.3; and the *thymoeides*, [Aristotle], *Physiognomonica* 23,808a20; 39,809a34; 59,811a14; 61,811b3 (1: 34, 46, 64, 66F); cf., e.g., Seneca, *de Ira* 2.19 (Poseidonios fr. 440 Theiler); Sassi 1988/2001: 129–30.

66. Ultrablond hair: Polemon, *Physiognomonica* 41 (1: 250F); Adamantios 2. 37 (1: 392–93F): ἡ δὲ ἄγαν ξανθὴ καὶ ὑπόλευκος, ὁποία Σκυθῶν καὶ Κελτῶν, ἀμαθίαν καὶ σκαιότητα καὶ ἀγριότητα ...; Anonymous, *Physiognomonica* 14 (1: 23F); Clement of Alexandria, *Paedagogus* 3.3.24 (2: 306F): οἱ Κελτοὶ καὶ οἱ Σκύθαι κομῶσιν, ἀλλὰ οὐ κοσμοῦνται· ἔχει τι φοβερὸν τὸ εὔτριχον τοῦ βαρβαροῦ καὶ τὸ ξανθὸν αὐτοῦ πόλεμον ἀπειλεῖ. North vs. south: e.g., Aristotle, *Politics* 7.6.1,1327b20; id. *Problems* 14.8,909b9–24; [id.], *Physiognomonica* 9,806b15 (1: 18–20F); Vitruvius 6.1.3, 9; Tacitus, *Germania* 4; Polemon, *Physiognomonica* 31–34 (1: 236–40F); Adamantios 2.31 (1: 384–

85F); Galen, *de Temperamentis* 2.6 (1: 627 Kühn; 2: 288–89F); etc.; Sassi 1988/2001: 19–26, 111–39. On young women's ample blood see Hippokrates, *On the Nature of Women* 1 (7: 312 Littré); id., *Concerning Women* 1.1 (8: 12 Littré); Aristotle, *Generation of Animals* 1.19, 727a22–25; Plutarch, *Quaestiones Conviviales* 650F; etc.; Leslie Dean-Jones, *Women's Bodies in Classical Greek Science* (Oxford 1994): 47–65, 87. The Amazon bleeds from the breast, where ancient medical science believed that excess blood accumulated: Hippokrates, *Epidemics* 2.6.19 (5: 136 Littré).

67. Polybios 2.30.4, 32.8, 35.3; 3.43.12. This becomes a topos with Roman authors: See, e.g., Caesar, *Gallic War* 2.13; 3.8.3, 10.3, 19.6; Livy 7.12.11, 26.9; 10.28.2; 38.17.7, 21.14, 23.1, 25.15, 27.1; Tacitus, *Germania* 4; Dio Cassius 12.50.3; etc.; cf. Chr. Peyre, "Tite-Live et la 'férocité' gauloise," *Revue des Études latines* 48 (1970): 277–97; Kremer 1994: 31–39.

68. The *anastole*: [Aristotle], *Physiognomonica* 41,809b23; 69,812b35 (1: 50, 80F); cf. Stewart 1993: 76–78 on its significance; Anonymous, *Physiognomonica* 14 (2: 23–24F, with remarks on barbarian hair); and n. 65 above.

69. Bags: [Aristotle], *Physiognomonica* 63,811b14 (1: 68F); Polemon, *Physiognomonica* 1 (1: 164–66F); Adamantios 1.22 (1: 345F); and Gallic alcoholism: Diodoros 5.26.3. Big and/or bulging eyes: [Aristotle], *Physiognomonica* 63,811b20 (1: 68–70F); Polemon, *Physiognomonica* 1 (1: 108–10F), with remarks on hostility; Adamantios 1.4 (1: 306F). Ears: [Aristotle], *Physiognomonica* 66,812a10 (1: 72F); Polemon, *Physiognomonica* 29 (1: 234F); Adamantios 2.29, 60 (1: 380, 424F). Bravery and passion = an erect posture: [Aristotle], *Physiognomonica* 13,807a33; 23,808a20 (1: 26, 34F).

70. On ugliness, stupidity, etc. as comic see, e.g., Cicero, *De Oratore* 2.236, 239, 266; Martial 14.182, with Plato, *Philebos* 48c–d, 49b–c; *Laws* 7,816d–e; Aristotle, *Poetics* 5, 1449a32–36; "objects of sport": Barton 2001: 246–53. On the *stupidus* see esp. Barton, *The Sorrows of the Ancient Romans* (Princeton 1993): 167–72; and on the evil eye, ibid. 91–95, with Stewart 1997: 227–28. Northerners' blue eyes: cf., e.g., Vitruvius 6.1.3; Tacitus, *Germania* 4, 43.4 ("nam primi in omnibus proeliis oculi vincuntur"); Caesar, *Gallic War* 1.39; Horace, *Epodes* 16.7; Juvenal 13.164; etc.; Sassi 1988/2001: 134, 136; cf. the physiognomers: [Aristotle], *Physiognomonica* 13,807b1; 41,809b19; 68,812b6 (1: 26, 48, 76F); Polemon, *Physiognomonica* 1 (1: 112, 116–18, 120F); Adamantios 1.7–8, 11; 2.2 (1: 312–13, 317–18, 321, 350F).

71. See esp. La Rocca 1994; Zanker 1998.

72. Barton 2001: 88. Auctor ad Herennium 4.49,62: "exemplum . . . ante oculos ponit, cum exprimit omnia perspicue ut res prope dicam manu temptare possit."

73. On Roman attitudes to barbarians, see esp. Gerold Walser, *Rom, das Reich und die fremden Völker in der Geschichtsschreibung der frühen Kaiserzeit* (Baden-Baden 1951); Yves A. Dauge, *Le Barbare: Recherches sur la conception romaine de la barbarie et de la civilisation* (Collection Latomus 176, Brussels 1981); Schneider 1986; Desnier 1991; Wolfgang Speyer and Rolf Michael Schneider, *Reallexikon für Antike und Christentum*, Suppl. 1. 5–6, s.v. "Barbaren I, II" (1992); Kremer 1994; La Rocca 1994; Gros 1998; Zanker 1998; Pirson 2002 (*non vidi*).

74. See Kleiner 1992: passim, with La Rocca 1994; Zanker 1998.

75. For these terms and their contexts see esp. Dauge, *Le Barbare*, 428–34, and cf. Zanker 1998: 70–76; for the ideal emperor's virtues, see esp. Pliny's *Panegyricus on Trajan*. Raw material: Livy 6.7.3: "hostis est quid aliud quam perpetua materia virtutis gloriaeque vestrae?"

76. Stallybrass and White 1986: 4–5.

77. Polemon, *Physiognomonica* 1 (1: 148F); in the nineteenth-century translation of the Arabic this reads: "sunt certe oculi Hadriani imperatoris huius generis nisi quod luminis pulchri pleni sunt atque charopi acres obtutu, cum inter homines visus non sit quisquam luminosiore praeditus oculo"; paraphrased in Anonymous, *de Physiognomonica* 34 (2: 51–52F). Cf. Gleason 1995: 45–46; Stewart 1997: 13–14 on the gaze and glance, with Barton 2001: 246–53; and Stewart 1993: 140–44 on the Alexander Mosaic; for a development of these ideas, see the "Conclusion," below.

78. Cf., e.g., Cicero, *De domo sua* 60; Vergil, *Georgics* 5.211; Horace, *Odes* 1.2.22, 15.21–24, 21.13–16; 2.2.17; Ovid, *Fasti* 1.385; Tibullus 5.137–46; Statius, *Silvae* 5.3.185–87; Pliny, *Natural History* 6.41: "Persarum regna, quae nunc Parthorum intellegimus." Cf. Tonio Hölscher, "Actium und Salamis," *JdI* 99 (1984): 187–214; Schneider 1986; Holger Sonnabend, *Fremdenbild und Politik: Vorstellungen der Römer von Ägypten und dem Partherreich in dem späten Republik und frühen Kaiserzeit* (Frankfurt 1986): 235–46; Spawforth 1994; Schneider 1998: 103, 110–13, 114–15, pls. 11–17.

79. Giants: For Marius see Diodoros 37.1.5; Plutarch, *Marius* 23 (both clearly using the same source); cf. Horace, *Odes* 2.4.40–80, 3.1.6–8; Ovid, *Fasti* 3.430–48; id., *Tristia* 2.69–74, 331–40 (Augustus); Lucan, *Civil War* 1.33–50 (Nero); Statius, *Silvae* 1.1.74–83, 4.2.52–56, 5.3.195–202; Martial 8.49(50).1–6, 78.1–6; 11.52.17 (Domitian); cf. *LIMC* 4 (1988) s.v. "Giganten," 193 (Francis Vian and Mary B. Moore); Fred S. Kleiner, "The Trajanic Gateway to the Capitoline Sanctuary of Jupiter," *JdI* 107 (1992): 149–74, pls. 53–60; Maderna-Lauter 2000: 436–37, 440–41. The Romans expected Giants to be snake-legged (cf. pseudo-Vergil, *Aetna* 41–47) and Roman Gigantomachies invariably oblige: For implications, see Chapter 4, §2. For the Amazon see Mayer 1887: 85 n. 34 (Gallic); *contra*, Michaelis 1893: 125; Reinach 1894; Kaminski 1999: 99 (Amazonian); Andreae 1998: 189–90; Andreae 2001: 168 (Gallic). Boudicca: Tacitus, *Annals* 14.29–39; *Agricola* 16.1.

80. Cf. Sassi 1988/2001: 19–33 with Stallybrass and White 1986: 3: "The high/low opposition in each one of our four symbolic domains – psychic forms, the human body, geographical space, and social order – is a fundamental basis to mechanisms of ordering and sense-making in European cultures."

81. Dryden's translation reads "the fettered slave to free." Since this is inaccurate, I have taken the liberty of correcting it.

82. On barbarian *libertas*, see Walser, *Rom*, 103–09; the *locus classicus* is Tacitus, *Agricola* 30–32 (by then a hoary cliché: Caesar, *Gallic War* 3.8.3), but cf. also *Germania* 37, contrasting German *libertas* and Parthian monarchy. The quotation: Stallybrass and White 1986: 5.

83. In recent years some have argued that Roman imperial art nevertheless remained open to dissenting views: e.g., Andrew Wallace-Hadrill, reviewing Zanker 1988 in *JRS* 79 (1989): 162–

64; John Elsner, "Cult and Sculpture: Sacrifice in the Ara Pacis Augustae," *JRS* 81 (1991): 50–61; id., *Art and the Roman Viewer* (Cambridge 1995); others have stressed that the imagery of Roman public monuments can invite several different interpretative readings, and that this openness or polyvalence should be regarded as intentional: e.g., Krierer 1995; Karl Galinsky, *Augustan Culture: An Interpretive Introduction* (Princeton 1996). See, however, R. R. R. Smith's review of Mario Torelli, *Typology and Structure of Roman Historical Reliefs* (Ann Arbor 1982), in *JRS* 73 (1983): 225–28, at pp. 225–26, for a succinct refutation of this view; also Zanker 1998; Anne-Marie Leander Touati, *Gnomon* 71 [1999]: 696–99 (review of Krierer 1995); Hölscher, "Staatsdenkmal und Publikum," argues that the messages of high imperial art were intentionally routine and obvious, so as to be accepted by viewers without question – or even conscious thought. On the civilizing process and the "tamed barbarian" as a possible third term in the discussion, see Gros 1998.

84. Byron, *Childe Harold* IV, stanzas 140–41, identifying him as a Dacian gladiator; for a modern reaction in this vein see Philipp Fehl, *The Classical Monument* (New York 1972): 32–33, 46–47.

85. See Sture Brunnsåker, *The Tyrant-Slayers of Kritios and Nesiotes* (Stockholm 1971): 47 (skeptical); *Historia Augusta: Hadrian* 23–25, 27; Dio Cassius 69.2.5–6, 23.2–3.

86. Dio Chrysostom 12.20: ... ἐπιθύμων ἰδεῖν ἄνδρας ἀγωνιζομένους ὑπὲρ ἀρχῆς καὶ δυνάμεως, τοὺς δὲ ὑπὲρ ἐλευθερίας τε καὶ πατρίδος ... ; id., 3.43: λέγεται γὰρ ἡ μὲν ἀρχὴ νόμιμος ἀνθρώπων διοίκησις καὶ πρόνοια ἀνθρώπων κατὰ νόμον.... On Trajan as *optimus princeps* and Hadrian as a second Augustus, see Julian Bennett, *Trajan: Optimus Princeps* (Bloomington and Indianapolis 1997): 104–17; Birley 1997: 142–50. For a Trajanic critique of Domitian and his portraits, see Pliny, *Panegyricus* 52; but for hatred of Hadrian see *Historia Augusta: Hadrian* 25.6–7; Dio Cassius 69.23.2.

87. See "Conclusion," below.

88. For Trajan's Column, see most conveniently *EAA, Atlante*, pl. 107, cliv–clv; Settis 1988: pls. 284–88; Coarelli 2000: pls. 178–79.

89. Statius, *Silvae* 5.3.183–87; Epictetus 2.22.21–22: ... μηδὲν εἶναι τὸ καλὸν ἢ εἰ ἄρα τὸ ἔνδοξον. Διὰ ταύτην τὴν ἄγνοιαν καὶ Ἀθηναῖοι καὶ Λακεδαιμόνιοι διαφέροντο καὶ Θηβαῖοι πρὸς ἀμφοτέρους καὶ μέγας βασιλεὺς πρὸς τὴν Ἑλλάδα καὶ Μακεδόνες πρὸς ἀμφοτέρους καὶ νῦν Ῥωμαῖοι πρὸς Γέτας καὶ ἔτι πρότερον τὰ ἐν Ἰλίῳ διὰ ταῦτα ἐγένετο ("The Good is nothing but what is generally approved. Through this sort of ignorance the Athenians and the Spartans quarreled and the Thebans quarreled with both of them and the Great King with Greece and the Macedonians with both of them and now the Romans with the Getae, and even in former times the Trojan War came about this way."). Cf. Birley 1997: 61 and passim for much of what follows; also Bennett, *Trajan*.

90. Cf. Schneider 1998: 105; against Marvin 2002: 211–15, figs. 9.7 and 10, the appearance of a couple of "Gallic"-type heads on Trajan's Column do not warrant homogenizing the two across the board. Although some cross-contamination is to be expected, Roman emperors fought specific barbarian tribes; triumphed over specific barbarian tribes; erected monuments to their victories over specific barbarian tribes; and adopted *cognomina* celebrating their conquests of specific barbarian tribes ("Dacicus"; "Parthicus"; etc.). Why then should they want to homogenize them in their commemorative sculpture?

91. *Historia Augusta: Hadrian* 5.2: "nam deficientibus iis nationibus quas Traianus subegerat, Mauri lacessabant, Sarmatae bellum inferebant, Britanni teneri sub Romana dicione non poterant, Aegyptus seditionibus urgebatur, Libya denique ac Palaestina rebelles animos efferebant."

92. Amanda Claridge, "Hadrian's Column of Trajan," *JRA* 6 (1993): 5–22, argues that at this time Hadrian even commissioned the reliefs of Trajan's Column, presumably to neutralize his own abandonment of some of his predecessor's conquests. Yet the marble would have hardened by then, making it difficult to carve; the gradually narrowing composition with its sophisticated vertical analogies and correlations (see §7, below) would have been a latter-day designer's nightmare; and the Trajanic coins clearly show the frieze's helical spiral.

93. On the visit see the thorough account by Birley 1997: 58–65, with *IG* ii^2.4099 for the archonship and statue.

94. Agora S 2518: T. Leslie Shear Jr., "The Athenian Agora: Excavations of 1972," *Hesperia* 42 (1973): 359–407, at pp. 404–5, pl. 75c; Krierer 1995: figs. 463–64.

95. For most of the evidence up to AD 96, see Ville 1981. From the vast bibliography on the arena, I select the following, though not necessarily agreeing with their opinions: J. Maurin, "Les barbares aux arènes," *Ktema* (1984): 103–11; Catherine M. Coleman, "Fatal Charades," *JRS* 80 (1990): 44–73; Paul Veyne, *Bread and Circuses* (1976; tr. B. Pearce, London 1990); Magnus Wistrand, *Entertainment and Violence in Ancient Rome* (Göteborg 1992); Barton, *Sorrows*; Donald G. Kyle, *Spectacles of Death in Ancient Rome* (New York 1998); Zanker 1998: 77–85; Eckhart Köhne and Cornelia Ewigleben, *Gladiators and Caesars* (Berkeley 2000). For "objects of sport" see Barton 2001: 248–53; the quotation is from Byron's *Childe Harold* IV, stanza 141.

96. Martial, *de Spectaculis* 3: "quae tam seposita est, quae gens tam barbara, Caesar,/ex qua spectator non sit in urbe tua?"

97. On Roman Giants see *LIMC* 4 (1988) s.v. "Gigantes," 193–96, nos. 479–80, 484, 491–96, 601–3, 542–45, etc. (Francis Vian and Mary B. Moore), with Gerhard Kleiner, *Das Nachleben des pergamenischen Gigantenkampfes* (Berliner Winckelmannsprogramm 105, Berlin 1949); Maderna-Lauter 2000. Commodus: *Historia Augusta: Commodus* 9.6; Dio Cassius 73.20.3.

98. Spartacus: Caesar, *Gallic War* 1.40.5; Livy, *Epitome* 97; Plutarch, *Crassus* 8.1, 9.5; Orosius 5.24. Caesar: Pliny, *Natural History* 8.22; Suetonius, *Caesar* 39; Dio Cassius 43.23.3; Appian, *Civil Wars* 2.102. Augustus: Dio Cassius 51.22.4–9, 55.10.7; Ovid, *Ars Amatoria* 1.171–72 (revenge); Augustus, *Res Gestae* 23; Suetonius, *Augustus* 23.1, 43.1 (Saepta); Velleius 2.100. 2; Tacitus, *Annals* 14.15.3; on Actium, Salamis, etc. see Hölscher, "Actium und Salamis"; Spawforth 1994: 238, 242; and Schneider 1998: 110–13.

99. Caligula: Suetonius, *Caligula* 18.1 (Saepta). Claudius: Dio Cassius 60 [61].30.3; Suetonius, *Claudius* 21.4 (Saepta), 6; Tacitus, *Annals* 12.56.2. Nero: Dio Cassius 61.9.5; Suetonius, *Nero* 12.

100. Titus: Josephus, *Jewish Wars* 6.9.418; Dio Cassius 66.25.3–4. Domitian: Dio Cassius 67.8.1–2. Trajan: Dio Cassius 68.15.1; 69.1.3; *Fasti Ostienses* for 116, 11–12 (Smallwood, *Documents* no. 23). Hadrian: *Historia Augusta: Hadrian* 6.3; 7.12.

101. Bowl: M. Labrousse, "Les potiers de La Graufesenque et la gloire de Trajan," *Apulum* 19 (1981): 57–63; Settis 1988: 226–28, figs. 62–63; Zanker 1998: 78, fig. 25. For a parallel, see Martial, *de Spectaculis* 7 (Laureolus), with Coleman, "Fatal Charades," 64–65. On barbarians in the arena in general see Maurin, "Les barbares aux arènes."

102. Women gladiators: Athenaios 4,154a (Augustus); Petronius, *Satyricon* 45.7 (charioteer: a huntress?); Tacitus, *Annals* 15.32.3; Dio Cassius 61.17.3, 62[63].3.1; Juvenal, *Satires* 1 22–23, 6.246–67 (Nero: blacks, nobles, Maevia: "Maevia Tuscum/figat aprum et nuda tenebat venabula mamma"); Martial, *de Spectaculis* 6; Dio Cassius 66.25.1 (Titus: fighting "Venus," lion killer, huntresses); Juvenal, *Satires* 2.53; Dio Cassius 67.8.4; Suetonius, *Domitian* 4.1; Statius, *Silvae* 1.6.51–56 (Domitian: wrestlers, Amazons: "stat sexus rudis insciusque ferri,/ ut pugnas capit improbus viriles!/credas ad Tanaim ferumque Phasim/Thermodontiacas calere turmas"; etc.); Dio Cassius 76.16.1 (Severus' ban). Relief, BM GR 1847.4-24.19: Köhne and Ewigleben, *Gladiators and Caesars*, 127, no. 137; Kathleen Coleman, "*Missio* at Halicarnassus," *Harvard Studies in Classical Philology* 100 (2000): 487–500. Ville 1981: 263–64 gives a partial and somewhat inaccurate summary of the evidence; for an update, still omitting some texts, see Dominique Briquel, "Les femmes gladiateurs: examen du dossier," *Ktema* 17 (1992): 47–53.

103. Greece: See, e.g., Xenophon, *Memorabilia* 3.4.1; *Agesilaos* 6.1; Demosthenes 18.67 (Philip II); Plutarch, *Moralia* 327A–B, 341A–C (Alexander); Philostratos, *Epistles* 5. Rome: Plutarch, *Coriolanus* 14.1–15.1; Livy 45.39.17; Cato ap. Plutarch, *Moralia* 276C–D; Cicero, *In Verrem* 2.5.3, 25.32; *de Oratore* 2.194–95; Seneca, *Dialogue* 1 (*de Providentia*) 1.4.4; Pliny, *Natural History* 7.101–06 (the bravest of the brave).

104. Spoliation (Greece): *Iliad* 6.70–71, 11.91–121, 16.498–500, etc.; Herodotos 5.95; Thucydides 3.112.8–114; Xenophon, *Hellenica* 2.4.19; Diodoros 12.70.5; Pausanias 1.13; (Rome) Livy 1.10.4–6, 4.20.2, 7.26.6; 23.12.14, 46.14; 38.23.10, etc.; Suetonius, *Claudius* 1.4; Tacitus, *Agricola* 15.3; Pliny, *Panegyricus* 17.3. Gallic spoils in Pergamon: Pausanias 1.4.6, 10.21.6; cf. Bohn 1885 (*AvP* 2): pls. 43–50; Stewart 2000: 48–49, figs. 14–16; Polito 1998.

105. Scarry 1985: 45–53, 127–33; see also Michael Fried, *Realism, Writing, Disfiguration: On Thomas Eakins and Stephen Crane* (Chicago 1989): 61–66; Dennis P. Slattery, *The Wounded Body: Remembering the Markings of Flesh* (Albany, N.Y., 2000): 6–12, 13–15; on the power to hurt, see Plato, *Philebos* 49b–d.

106. Scarry 1985: 33–35, 52–56. The parallel goes further, since sensitive viewers of the Barbarians will also experience other aspects of pain: its adversiveness (we feel it acting *against* our consciousness), its brutal conflation of private and public (we feel it creating isolation *and* exposure), and its peculiar "double agency" (we feel the *weapon* that hurt and the *body/wound* that hurts).

107. Bal 1999: 31.

108. Vases: E.g., John Boardman, *Early Greek Vasepainting* (London and New York 1998): fig. 178.3, 216, 475.1. Marble sculpture: Vinzenz Brinkmann, *Beobachtungen zum formalen Aufbau und zum Sinngehalt der Friese des Siphnierschatzhauses* (Ennepetal 1994): 165 (N29); Nurten Sevinç et al., "A New Painted Graeco-Persian Sarcophagus from Çan," *Studia Troica* 11 (2001): 383–420, at p. 398 and figs. 11, 15; Franz Winter, *Der Alexandersarkophag aus Sidon* (Strasbourg 1912): pls. 3–5, 10–11, 16. Bronze spearhead: Peter C. Bol, *Grossplastik aus Bronze in Olympia* (Olympische Forschungen 9, Berlin 1978): no. 416, pl. 66; Christopher H. Hallett, "Kopienkritik and the Works of Polykleitos," in Warren G. Moon (ed.), *Polykleitos, The Doryphoros, and Tradition* (Madison 1995): 121–60, at p. 141, fig. 8.27. Boxer: Stewart 1990: fig. 814; Smith 1991: cover and fig. 62; Nikolaus Himmelmann, *Herrscher und Athlet: Die Bronzen vom Quirinal* (Milan 1989): figs. 170–71 (details). Farnese Gladiator (head supplied by Giambattista de' Bianchi: Stewart, "David's *Oath of the Horatii* and the Tyrannicides," *BurlMag* 143 [April 2001]: 212–19, fig. 29): B–B: no. 332; Pozzi et al. 1989: no. 177. Tivoli Amazon: John Boardman et al., *The Art and Architecture of Ancient Greece* (London 1967): fig. 221; Rolley 1999: fig. 28; *Bd'A* 40 (1955): 70, fig. 10 (detail).

109. Pliny, *Natural History* 34.53; on these see Stewart 1990: 138, 162–63, 262; figs. 245–46, 388–96.

110. 38.21.9–10: "detegebat vulnera eorum, quod nudi pugnant, et sunt fusa et candida corpora, ut quas numquam nisi in pugna nudentur; ita et plus sanguinis ex multa carne fundebatur et foediores patebant plagae et candor corporum magis sanguine atro maculabatur. sed non tam patientibus plagis moventur. . . ."

111. *Ars Amatoria* 1.166: "et qui spectavit vulnera, vulnus habet." On their wounds see esp. Cicero, *Tusculan Disputations* 2.17.41; Seneca, *De Constantia Sapientis* 16.2; Pliny, *Panegyricus* 33.1; *Historia Augusta: Maximinus et Balbinus* 8; and on the brutalizing effects of the arena see also Seneca, *Epistles* 7.3–5; Ville 1981: 455–56.

112. Scarry 1985: 45–53, 127–33; Slattery, *Wounded Body*, 6.

113. Cf. Gazda 1995.

114. Bal 1999: 15.

115. See, e.g., Bienkowski 1928: figs. 44, 117, 125–27, 146, etc.

116. Schober 1939: 83, against Reinach 1889: 11 and Bienkowski 1908: 43–44; Traversari 1986: 84 is noncommittal.

117. Bienkowski 1908: 18, figs. 14–15, 17.

118. Gigantomachies: *LIMC* 4 (1988) s.v. "Gigantes," nos. 479–80, 484, 491–96, 601–3, 542–45, etc. (Francis Vian and Mary B. Moore); Kleiner, *Das Nachleben des pergamenischen Gigantenkampfes*; Maderna-Lauter 2000. Amazonomachies: Robert 1890–1939: vol. 2: pls. 31–32, 42, 44, 47; Koch and Sichtermann 1982: fig. 147; *LIMC* 1 (1981) s.v. "Amazones," nos. 198, 206, 501, 520, 523 (Pierre Devambez and Aliki Kauffmann-Samaras); Krierer 1995: pls. 5, 19; 6, 20. Andreae 1968–69: 153 identifies two sarcophagi (his figs. 4–5) as Persianomachies, arguing that they echo the Pergamene battle painting that also inspired the Lesser Attalid Dedication (see

Chapter 1, §6); *contra*, Koch and Sichtermann 1982: 91, fig. 73; but see Schneider 1998: 101, fig. 5.2: a mélange of northerners and easterners – the forces of chaos combined.

119. *EAA, Atlante*, pls. 86, xli (Naples Persian); 83, xxxii; 92, lxxii (Naples Dying Gaul); 85, xxxviii; 100, cxii; 105, cxlv; 106, cli (Venice Kneeling Gaul); 79, ix; 83, xxxi; 79, xciv (Venice Falling Gaul); Settis 1988: pls. 13, 39, 40, 53, 63, 122, 170, 206, 268, 279; Coarelli 2000: pls. 9, 30, 31, 39–40, 45, 83, 113, 135–36, 171, 176. Column of M. Aurelius: *EAA, Atlante*, pls. 133, cix (Naples Dying Gaul); 125, lxviii (Venice Kneeling Gaul); 121, xlviii; 130, xcii (Venice Falling Gaul); C. Caprino et al., *La Colonna di Marco Aurelio* (Rome 1955): pls. 30, fig. 60; 43, fig. 85; 55, fig. 110; 65, fig. 129.

120. On this figure see Settis 1988: 115–17, proposing a different derivation.

121. For the procedure (*imitatio, variatio, interpretatio, aemulatio*) see esp. Raimund Wünsche, "Der Jüngling von Magdalensberg: Studie zur römischen Idealplastik," in *Festschrift L. Düssler* (Munich 1972): 45–80.

122. Thus Settis 1988: 115, 224–29, noting that the other two images of Decebalus' suicide, the La Graufesenque bowl (see Figures 185–86) and the tombstone of Tiberius Claudius Maximus, are quite different.

123. Schober 1939: 83.

124. *EAA, Atlante*, pl. 105, cxl; Settis 1988: pl. 258; Coarelli 2000: pl. 166.

125. Dio Cassius 69.4.1; see esp. William A. MacDonald, *The Architecture of the Roman Empire* (rev. ed., New Haven 1982): 129–37; cf. Settis 1988: 101.

126. Andreae 1956/1973, with an exhaustive discussion of the possible sources for each figure and group; a revised version, Andreae 1968–69, discards one of the four.

127. Andreae 1956/1973: pls. 1–3; Andreae 1968–69; Koch and Sichtermann 1982: 90–92, figs. 74–75; Krierer 1995: pls. 24, figs. 83, 85; 28, fig. 99; 29, figs. 100, 102; 30, fig. 107; 32, fig. 114; 33, fig. 119.

128. Andreae 1956/1973: 40–47.

129. Koeppel 1972: 200–01; Filippo Coarelli, "Arte ellenistica e arte romana: La cultura figurativa in Roma tra 2. e 1. secolo a. C.," in Marina Martelli and Mauro Cristofani (eds.), *Caratteri dell'ellenismo nelle urne etrusche: Atti dell'incontro di studi, Università di Siena 28–30 aprile 1976* (Prospettiva, 10 Supplemento, 1977): 35–40, at pp. 38–39; Gilbert-Charles Picard, *Gnomon* 33 (1961): 406–08. On the sarcophagi and their sources see Koch and Sichtermann 1982: 250–52 with, e.g., 454–55; Koortbojian 1995: 12; Schneider 1998: 101.

130. Cichorius, *Traianssäule*, pl. 10; repr. Lepper and Frere, *Trajan's Column*; *EAA, Atlante*, pl. 79, ix; Settis 1988: pl. 13; Coarelli 2000: pl. 9.

131. Agora S 1596: Homer A. Thompson, "Excavations in the Athenian Agora: 1952," *Hesperia* 22 (1953): 25–56, at p. 55, pl. 20d. Thompson identifies the marble as Pentelic and suggests the head came from a relief; only 17 cm high (measuring 7 cm from the underside of the chin to the tear duct of the right eye; and 5.6 cm between the outer corners of the eyes), it is about 20 percent smaller than the Aix Persian.

132. H. Heydemann, *Die antiken Marmor-Bildwerke in … dem Windturm des Andronikus … zu Athen* (Berlin 1874): 157, no. 407; U. Koehler, "Torso aus Athen," *AM* 5 (1880): 368–69, pls. 8–9; Bienkowski 1908: 58–60, no. 30, figs. 72–73 (a Gaul); Joannes N. Svoronos, *Das Athener Nationalmuseum* (Athens 1908–11): pl. 166; Palma 1981: no. 24, fig. 24 (follows Bienkowski; is unaware of museum number or Svoronos's publication).

133. Svoronos, *Das Athener Nationalmuseum*, 649–50, pls. 166–68 (whence Figures 208–10) publishes a total of twenty fragments and suggests that the males are the *originals* of the Small Dedication. The connection with the theater frieze was first proposed by Reinhard Herbig for the female torso NM 2265 only, in Karl Fiechter, *Antike griechische Theaterbauten 6: Das Dionysos-Theater in Athen*, ii: *Die Skulpturen vom Bühnenhaus* (Stuttgart 1935): 39, pl. 16. 1; it is suggested for the entire frieze by Ludwig Budde and Richard V. Nicholls, *A Catalogue of the Greek and Roman Sculpture in the Fitzwilliam Museum at Cambridge* (Cambridge 1964): 75, who publish yet another fragment of it (their no. 122, from the entrance to the Akropolis); Mary Sturgeon, "The Reliefs on the Theater of Dionysos in Athens," *AJA* 81 (1977): 31–53, at p. 45 n. 64, is skeptical; all of them are apparently unaware of the bibliography cited above. The frieze fragments in Athens are NM 2179, 2248–54, 2256–67; an unpublished torso in the Agora, S 2375+2380+2391, discovered in 1970 alongside the Athens-Piraeus railway, goes with them. For a third Roman frieze from Athens, perhaps also Hadrianic in date, see Barbara Schlörb, "Beiträge zur Schildamazonomachie der Athena Parthenos," *AM* 78 (1963): 156–72, Beil. 78–82, with additions from the Agora by Evelyn Harrison, "The Composition of the Amazonomachy on the Shield of Athena Parthenos," *Hesperia* 35 (1966): 107–33, at 132–33, pls. 40–41. Again, it carried at least two subjects, or an expansion of the theme, for some fragments show men carrying bodies. Harrison alerts me to yet another related torso, allegedly found near the "Theseion" and once thought to be from its metopes, now in Paris (Louvre inv. 3526): A. Linfert, "Der Torso von Milet," *Antike Plastik* 12 (1973): 81–90, at figs. 15–16 to p. 88; Georgios Despinis, *Hochrelieffriese des 2. Jahrhunderts nach Chr. aus Athen* (Munich 2004) (*non vidi*). For the Telephos frieze see Dreyfus and Schraudolph 1996: 66–67, cat. no. 8 and ill.

134. Pausanias 1.18.8–9; on the Panhellenion see Susan Walker and Anthony Spawforth, "The World of the Panhellenion I: Athens and Eleusis," *JRS* 75 (1985): 78–104, at pp. 94–98 (reidentifying the so-called Pantheon, Travlos 1971: 439–43); on the tripod see Spawforth 1994: 239, rejecting the Augustan date proposed by Schneider 1986: 82–90.

135. Amazon sarcophagi: Robert 1890–1939: vol. 2: nos. 60, 70, 72–74, 110, 116–24, 126–27 (whose dead Amazons do bear some resemblance to the Naples Amazon, but the pose is a stock one), 129–31; Koch and Sichtermann 1982: 390–92, figs. 420–21; illustrations, *LIMC* I (1981) s.v. "Amazones," nos. 194, 524, 530, 540 (Pierre Devambez and Aliki Kauffmann-Samaras). Marathon sarcophagi: Vanderpool 1966: pl. 35; Koch and Sichtermann 1982: 412, 414, nos. 22–23, fig. 446; and the Marathon painting, Harrison 1972: 359, pl. 77.16.

136. Kleiner 1992: 241; Zanker 1998: 53.

4. BARBARIANS AT THE GATES

1. Noel Robertson, "Athena's Shrines and Festivals," in Jenifer Neils (ed.), *Worshipping Athena: Panathenaia and Parthenon* (Madison 1996): 27–77, at pp. 39–40; the route was first worked out by Leake 1821/1841.

2. Not in 42 BC (Andreae 1998: 187 and 2001: 168). For the strange idea that the colossi stood not above the theater but on the Agrippa base in front of the Propylaia see W. B. Dinsmoor 1920; followed, e.g., by Hansen 1971: 105; C. B. R. Pelling, *Plutarch, Life of Antony* (Cambridge 1988): 265–66; its ghost even reappears in Habicht 1995/1997: 364, though on p. 226 and in Habicht 1990: 572 he puts them where they belong, above the theater. Dio is explicit on this point, and the successive chariot groups that stood on the Agrippa base were life-size, not colossal: Korres 2000: 314–19, figs. 26–28.

3. As opposed to the orthodox view (Leake 1821/1841: 243, 352; reconstruction, Nikolaos D. Papachatzis, *Pausaniou Hellados periegesis*, vol. 1: *Attika* [Athens 1974]: 370, fig. 221), which has him double back to the east after reaching the Galatomachy (IV); Schäfer 2000: 333–34 now endorses the route proposed here.

4. Thus (tentatively) Brunn 1870: 316; Schober 1933; Andreae 1993: 97–98, and pl. 16.

5. Penrose 1851/1888: 3 (quoted in Chapter 1, §1), plan 2, after Leake 1821/1841: 240.

6. Lucian, *Piscator* 44, 47–51, misinterpreted by, e.g., Schober 1933: 110; Judeich 1931: 211.

7. Korres 1994: 10.

8. Three of them into a belated Turkish repair of the late 1750s after an earthquake destroyed part of the wall on October 21, 1705. (I thank Judith Binder for this information.) It was still in ruins when Stuart and Revett visited Athens in 1751–53. One of their engravings shows its top broken down exactly where the three blocks are now built into it: See James Stuart and Nicholas Revett, *The Antiquities of Athens*, 4 vols. (London 1762–1816): vol. 2 (1787), chap. 4, pl. 2 (opposite p. 32); Travlos 1971: fig. 707.

9. For the various types of tenon see the useful collection in Korres 2000: 307, fig. 18.

10. G. Daux and A. Salac, *Fouilles de Delphes*, III.3.1: *Inscriptions depuis le Trésor des Athéniens jusqu'aux bases Gélon* (Paris 1932): 88–89, fig. 10, whence Heinrich Siedentopf, *Das hellenistische Reiterdenkmal* (Waldsassen 1968): 58–59, fig. 15, 65–68, cat. no. III.76.

11. See, in general, *LIMC* 4 (1988) s.v. "Gigantes," 260, 262, 263, with nos. 18, 19, 72, 322, 396–98 (mounted Poseidon; cf. Pausanias 1.2.4); 322, 489 (mounted Dioskouroi); and 47 (Megarian bowl with Dionysos on a panther fighting a Giant) (Francis Vian and Mary B. Moore). On the Parthenon (*LIMC* 4 [1988] s.v. "Gigantes," no. 18 and fig. on p. 201 [Francis Vian and Mary B. Moore]), Dionysos was accompanied by a panther, Poseidon was on foot hurling a rock (Nisyros), and the Dioskouroi were absent; the lineup was apparently (1) Hermes, (2) Dionysos, (3) Ares, (4) Athena and Nike, (5) Amphitrite(?), (6) Poseidon, (7) Hera, (8) Zeus, (9) Apollo, (10) Artemis, (11) Eros and Herakles, (12) Aphrodite, (13) Hephaistos, (14) Helios. On the importance of these divinities in Pergamon, see Hansen 1971: 434–53.

12. *LIMC* 1 (1981) s.v. "Amazones," nos. 230–44 (vases), 417 (the Parthenon metopes) (Pierre Devambez and Aliki Kauffmann-Samaras); cf. Aristophanes, *Lysistrata* 677–78 (Amazon cavalry in Mikon's painting in the Stoa Poikile); Euripides, *Hippolytos* 307 (Antiope is "hippia").

13. Pausanias 1.32.4; cf. Vanderpool 1966: 105, pl. 35; Harrison 1972: 365, pls. 75, 77; Koch and Sichtermann 1982: 412, 414, nos. 22–23, fig. 446.

14. See also the third-century Akropolis battle frieze: Schäfer 2000.

15. For the visual effects that could be achieved in bronze see Stewart 1997: 52–54.

16. Heruli and Visigoths: See Hurwit 1999: 283–87.

17. *AvP* 6: 48, pl. 14. 11–14 (though the plinth is restored); Fränkel 1890 (*AvP* 8.1): nos. 21–28, 50, and 234; Jean Marcadé, *Recueil de signatures de sculpteurs grecs*, vol. 2 (Paris 1957): 79–81; Queyrel 1989: 287–88, fig. 31; Inga Schmidt, *Hellenistische Statuenbasen* (Frankfurt-am-Main 1995): vii, 10, fig. 99; Marszal 2000: 207.

18. Average height: See Sarah Bisel, "Health and Nutrition in Mycenaean Greece: A Study in Human Skeletal Remains," in Nancy C. Wilkie and William D. E. Coulson (eds.), *Contributions to Aegean Archaeology: Studies in Honor of Wiliam A. McDonald* (Minneapolis 1985): 197–209, at p. 203 (table 4); despite the essay's title, her statistics span the Neolithic through Roman periods.

19. On Greek metrology see esp. Mark Wilson-Jones, "Doric Measure and Architectural Design I: The Evidence of the Relief from Salamis," *AJA* 104 (2000): 73–94; for the use of the Attic foot on the Parthenon see Korres, "Der Plan des Parthenon," *AM* 109 (1994): 53–120, at pp. 62–64.

20. For the multiple dedication see Fränkel 1890 (*AvP* 8.1), nos. 21–28.

21. E.g., until $a(n_1) + 2A = b(n_2) + 2B = \ldots$, where a and A are the interior and end-block lengths, respectively, of one series, b and B of the next series, and so on.

22. Parthenon: See note 11 above and *LIMC* 4 (1988) s.v. "Gigantes," no. 18, with fig. on p. 201 (Francis Vian and Mary B. Moore).

23. Geoffrey B. Waywell, *The Free-Standing Sculptures of the Mausoleum at Halicarnassus* (London 1978): 57; Boardman 1995: fig. 17 (alternatives); Diodoros 17.115.

24. Pausanias 1.25.1; for copies of the Perikles see Stewart 1990: figs. 397–98.

25. Bohn 1885 (*AvP* 2): pl. 3 (foundations); Fränkel 1890 (*AvP* 8.1): nos. 21–28 (bases and inscriptions); Künzl 1971: 12–30, figs. 4–6, pl. 22.1; Wenning 1978: 37–42, pls. 17.3–20; Marszal 2000: 194–96, 204–09, fig. 76.

26. *IG* ii². 3272 (revisions, Korres 2000: 324, fig. 32), 4122, 4209. On the *demos* as their original donor, not the kings themselves, see Bringmann and von Steuben 1995: 446–47 (with bibliography). On these monuments see most recently Korres 2000; I am most grateful to Martin Kreeb for sharing his thoughts on them with me.

27. See Schmidt-Dounas 2000: 121–24 for the *comparanda*, with Polybios 18.16 (colossus of Attalos I erected by the Sikyon-

ians); cf. Habicht 1995/1997: 226 (Akropolis colossi erected by the Athenians).

28. Hölscher 1985: 124–28 and Pelling, *Plutarch, Life of Antony*, 265–66 argue that Dio misread Plutarch here, but Dio never mentions Plutarch, and used him, if at all, only for his Brutus, not for Antony (Fergus Millar, *A Study of Cassius Dio* [Oxford 1964]: 34, 56, 60). So did they consult a common source?

29. On the assassination attempt, see Livy 42.15–16; Appian, *Macedonian Wars* 11.4; Plutarch, *Moralia* 184B and 489F; Diodoros 29.34; Robert A. Bauslaugh, "The Unique Portrait Tetradrachm of Eumenes II," *ANS–MN* 27 (1982): 39–51; Otto Mørkholm, *Early Hellenistic Coinage* (Cambridge 1991): 171, no. 614; Hans-Dietrich Schultz, "The Coinage of Pergamon," in Dreyfus and Schraudolph 1997: 11–21, at p. 16, fig. 14; François Queyrel, "Le Portrait monétaire d'Eumène II: Problèmes d'interprétation et de datation," in Michel Amandry and Silvia Hurter (eds.), *Travaux de numismatique grècque offerts à Georges le Rider* (London 1999): 323–36 (with further bibliography, arguing for a date of 164–161).

30. Stewart 1993: 191–209, figs. 65–70; on Hellenistic kings in divine guise see Smith 1986: 38–45; Renate Thomas, "Eine posthume Statuette Ptolemaios' IV und ihr historischer Kontext," *Trierer Winckelmannsprogramm* 18 (2001): 1–103, esp. pp. 25–27 on the Attalids, but overlooking these colossi.

31. Oracle: Pausanias 10.15.3. Dionysos Kathegemon: Hansen 1971: 451–53. Precedents: Smith 1986: 41–42, pls. 4–5, 10, 55.5–7, 56.4–6, 74.4, 8, 76.2; Stewart 1993: 314–17, figs. 115–16; Andrew Stewart and Arthur Houghton, "The Equestrian Portrait of Alexander the Great on a New Tetradrachm of Seleucus I," *Swiss Numismatic Review* 78 (1999): 27–35 – though the identification as Alexander is now doubted, in my view unnecessarily, by Houghton and Catharine Lorber, *Seleucid Coins: A Comprehensive Catalogue* (New York 2003): 6–7; Thomas, "Eine posthume Statuette Ptolemaios' IV," 7, 11–14, pls. 5.2–3, 7.1.

32. First suggested for the battle groups by Michaelis 1901: 20–21, 469; followed, e.g., by Stewart 1979: 31 n. 81; Queyrel 1989: 278; *contra*, Habicht 1990: 563 n. 8; Bringmann and von Steuben 1995: 60–61, K26a. On the decree and its date see Culley 1975: 217; P. Baldassarri, ΣΕΒΑΣΤΩΙ ΣΩΤΗΡΙ: *Edilizia Monumentale ad Atene durante il Saeculum Augustum* (Rome 1998): 242–46; J. C. Burden, *Athens Remade in the Age of Augustus: A Study of the Architects and Craftsmen at Work* (Ph.D. dissertation, U.C. Berkeley 1999): 213 n. 563 (18 BC, by pers. comm. from Sarah Aleshire). On *agalmata* see David M. Lewis and Ronald S. Stroud, "Athens Honors King Euagoras of Salamis," *Hesperia* 48 (1979): 180–93, at 193 n. 24: "In Attic decrees after 403 BC, *agalma* designates exclusively statues of divinities and those given divine honors."

33. Stoas and pillar monuments: See Travlos 1971: 483, 505–26; Bringmann and von Steuben 1995: K28–29, 377, figs. 6–14, 169–70; Hurwit 1999: 271–72, figs. 220–21; Korres 2000: 314–29; Schmidt-Dounas 2000: 216–19, 225–26, 228–29. Akropolis heads: The man is AkrM 2335, height 17 cm; the woman is AkrM 3628, height 26 cm; I thank Mrs. Ismene Trianti for allowing me to examine them in 1995. See G. Dontas, "Ein plastisches Attaliden-Paar auf der Akropolis," in *Kanon, Festschrift für Ernst Berger* (*AntK*, Beiheft 15, 1988): 222–31, pl. 61; Andreae 1990: 57 n. 36. If Andreae is right, they must date to 200 BC or shortly thereafter, when the Athenians made Attalos the eponymous hero of a new tribe and Apollonis the eponymous heroine of a new deme, and granted them both divine honors (Polybios 16.25.5–9; Livy 31.15.6; John S. Traill, *The Political Organization of Attica* [*Hesperia* Suppl. 14, 1975]: 30–31). *IG* ii². 885 at first sight seems to fit these sculptures perfectly, since it describes the foundation of a cult for Attalos and says that "they made him *synnaos*"; but as R. E. Allen, "Attalos I and Aigina," *BSA* 66 (1971): 1–12 has shown, it is probably not Attic but Aeginetan (synopsis, Allen 1983: 147).

34. Polybios 18.16; Fränkel 1890 (*AvP* 8.1): no. 246; in general, see Matthew W. Dickie, "What Is a Kolossos, and How Were Kolossoi Made in the Hellenistic Period?" *GRBS* 37 (1996): 237–58.

35. Universal history: I owe this insight to an unpublished paper by Josephine Crawley Quinn ("Forging Community through Universal History," 1999). High–low: cf. Sassi 1988/2001: 19–33 with Stallybrass and White 1986: 3: "The high/low opposition in each one of our four symbolic domains – psychic forms, the human body, geographical space, and social order – is a fundamental basis to mechanisms of ordering and sense-making in European cultures."

36. Brunn 1870: 317.

37. See most conveniently Hurwit 1999: 169, fig. 133 (after Korres).

38. Delphi: Cf. Pausanias 10.19.4, 23; Kallimachos, *Hymn to Delos* (4) 171–88; cf. Herodotos 8.37–39. Egypt: See Lloyd-Jones and Parsons 1983: no. 958, with nos. 723 and 560–61 for Antiochos and Attalos. On these early Gallic wars and their poetic and monumental legacies see Karl Strobel, "Keltensieg und Galatersieger," in E. Schwertheim (ed.), *Forschungen in Galatien* (Asia Minor Studien 12, 1994): 67–96; Schmidt-Dounas 2000: 293–312; and esp. Barbantani 2001.

39. See *LIMC* 4 (1988) s.v. "Gigantes," no. 389 and pp. 253–54 for commentary (Francis Vian and Mary B. Moore); and on Roman Gigantomachies, Maderna-Lauter 2000.

40. For the tale see esp. Apollodoros 1.6.1–2, with Pindar, *Pythian Ode* 8.12–18, for Porphyrion as king of the Giants, and Aristophanes, *Birds* 553, 1249–52, for his leopard-skin cloak; cf. *LIMC* 4 (1988) s.v. "Gigantes" (Francis Vian and Mary B. Moore) and 7 (1994) s.v. "Porphyrion" (Francis Vian). Hera first finishes him off on the Siphnian Treasury frieze of ca. 525 BC: *LIMC* 4 (1988) s.v. "Gigantes," no. 2 (Vian and Moore).

41. Metopes: Frank Brommer, *Die Metopen des Parthenon* (Mainz 1967): 198–99, figs. 16–17, pls. 39–82. Shield: See Neda Leipen, *Athena Parthenos: A Reconstruction* (Toronto 1971): 46–50, figs. 84–87, and fig. 222.

42. Volker Kästner, "Gigantennamen," *Istanbuler Mitteilungen* 44 (1994): 125–33, pl. 21.

43. Ny Carlsberg 1669; ex-Alba Collection, provenance unknown; height 74 cm. *EA* 1799–1800; Carl Jacobsen, *Catalogue de la Glyptothèque Ny Carlsberg* (Copenhagen 1907): no. 193, pl. 14; Bienkowski 1908: 60–61, figs. 73a,b; F. Poulsen, *Catalogue of Ancient Sculpture in the Ny Carlsberg Glyptothek* (Copenhagen 1951): no. 193: Schober 1951: 132; Palma 1981: 68, no. 12, fig. 12.

44. Badisches Landesmuseum, from Marino, Villa of Voconius Pollio; height 72 cm. *EA* 1440; Farnell 1890: 206–07, fig.

4; Schober 1951: 132, fig. 104; Palma 1981: 67, no. 11, fig. 11; Neudecker 1988: 46–7, 169, no. 25.10; Smith 1991: fig. 125; Michael Maass and Johanna Fabricius (eds.), *Badisches Landesmuseum, Karlsruhe: Antike Kulturen* (Karlsruhe 1995): 144, no. 132 and color ill., 170. Its facial expression recalls the Gaul's head from Delos, A4195: Marcadé 1969: pl. 79.

45. Rhode Island School of Design 25.064; provenance unknown; height 54.3 cm. Brunilde S. Ridgway, *Classical Sculpture: Museum of Art, Rhode Island School of Design* (Providence, R.I., 1972): no. 25; Ridgway 1990: 292, pl. 150a,b.

46. Geneva, Musée de l'Art et de l'Histoire inv. C 1729, unprovenanced; Waldemar Deonna, "Notes sur quelques antiquités des musées de Genève," *RA* 13 (1909): 233–49, at 246, no. 2, fig. 3; id., *Catalogue des bronzes antiques* (Geneva 1915–16): no. 70; Bienkowski 1928: 75–76, fig. 125.

47. See *LIMC* 4 (1988) s.v. "Gigantes," nos. 18, 24 (Francis Vian and Mary B. Moore); Pausanias 1.2.4.

48. Dress: against, e.g., Mayer 1887: 85 n. 34 (Gallic), see Michaelis 1893: 125 and Reinach 1894 (Amazonian); cf. Ridgway 1990: 294–95; reprise, Kaminski 1999: 99 (Amazonian); Andreae 1998: 189–90; 2001: 168 (Gallic, because of the baby). Weapons: doubted by Habich 1896: 15–16; followed by Palma 1981: 57–8, no. 2; and Ridgway 1990: 294; *contra*, Kaminski 1999: 98–99, with pp. 101–02 on her hairdo, which Marszal 2000: 203–04 predictably wants to be Roman. For Artemis with the topknot see, e.g., *LIMC* 2 (1984) nos. 133, 140, 162, 212, 224, 230, 274, 752, 756, 759 (Lily Kahil); as *euopis* and *euplokamos*, Homer, *Odyssey* 20.80; Kallimachos, *Hymn to Artemis* 204. Akropolis cults: See Pausanias 1.23.7, 26.4.

49. Klügmann 1876; see Chapter 1, §3, for the controversy, and most recently Ridgway 1990: 294 (pro-baby) and Kaminski 1999: 103 (anti-baby).

50. Livy 1.26.2: "cui [sc. Horatio] soror virgo, quae desponsa uni ex Curiatiis fuit, obvia ante portam Capenam fuit. . . ."

51. Noted over a century ago by Bruno Sauer: Michaelis 1893: 123–24, fig. 4.

52. Pliny, *Natural History* 35.98: "huius [sc. Aristidi] opera . . . oppido capto ad matris morientis ex uolnere mammam adrepens infans, intellegiturque sentire mater et timere, ne e mortuo lacte sanguinem lambat. quam tabulam Alexander Magnus transtulerat Pellam in patriam suam." Cf. Michaelis 1893: 133. Alexander presumably took it after sacking Thebes in 336 BC.

53. So, e.g., Michaelis 1893: 125–29 (for the ensuing controversy, see Chapter 1, §3); *contra*, Herodotos 4.117; Hippokrates, *Airs, Waters, Places* 17; Diodoros 3.53–54 (from Dionysios Skytobrachion, *FGH* 32 F 6).

54. Michaelis 1893: 128 hints at this solution only to dismiss it; Moreno 1994: 590; *contra*, by implication, Kaminski 1999: 112 n. 65. For her career, tomb, and stele, see Euripides, *Hippolytos* 10–11, 304–10; pseudo-Plato, *Axiochos* 364d–365a; Diodoros 4.16.4, 28.1–4; Plutarch, *Theseus* 26–27; Pausanias 1.2.1; Judeich 1931: 386; Travlos 1971: 160, 290–91, fig. 379, no. 188; *LIMC* 1 (1981) s.v. "Antiope II" (Aliki Kauffmann-Samaras); Keith Dowden, "The Amazons: Development and Function," *RhM* 140 (1997): 97–128, at pp. 101–03.

55. Troezen: Euripides, *Hippolytos* 1423–30; Pausanias 2.32.1–4. Aphrodite "at Hippolytos": Euripides, *Hippolytos* 29–34; *IG* i².310 line 280; 324 line 69; Diodoros 4.62; Pausanias 1.22.1–3; Luigi Beschi, "Contributi di topografia ateniese," *ASAtene* 45–46 (1967–68): 511–36, at p. 515; Rachel Rosenzweig, "Aphrodite in Athens: A Study of Art and Cult in the Classical and Late Classical Periods" (Ph.D. dissertation, University of Oregon 1999): 129–31; the shrine is probably the rectangle situated just to the west of ΗΟΡΟΣ ΚΡΕΝΕΣ in Travlos 1971: fig. 91 (Judith Binder, pers. comm.).

56. *LIMC* 1 (1981) s.v. "Antiope II," nos. 16–21 (Aliki Kauffmann-Samaras).

57. See Evelyn B. Harrison, "Pheidias," in Olga Palagia and Jerome J. Pollitt (eds.), *Personal Styles in Greek Sculpture* (*Yale Classical Studies* 30, Cambridge 1996): 16–65, at p. 47 n. 143; Harrison, pers. comm.; cf. Stewart 1990: fig. 369.

58. See Palma 1981: nos. 18–20, figs. 18–20; and, most recently, Spinola 1996: 65–91.

59. See, e.g., Mayer 1887; Habich 1896; Schober 1933; Palma 1981: nos. 17 and 21–22, figs. 17, 21–22. I thank the custodians of Wilton House for allowing me to examine their Amazon in 1997: see Appendix 2, §3(iii). First documented in a Peruzzi drawing of ca. 1525 (Frommel 1967–68: pl. 95b) and attributed by Brunn 1870: 313, she was rejected by Michaelis 1882: 667–68 and 708, no. 170; as he realized, she is at least 10 percent too large. She was part of a group including a fallen horse at her left and perhaps a victorious opponent as well; her style suggests a late-classical original rather than a Hellenistic one.

60. *LIMC* 1 (1981) s.v. "Amazones," nos. 232–44 (Pierre Devambez and Aliki Kauffmann-Samaras).

61. See Bittner 1985: 165–66, 171–73, pl. 12.4; Curtius 8.14.29 (*kopis*).

62. Thus, e.g., Ridgway 1990: 293, 295; Marszal 2000: 204. On the *tiara* see Bittner 1985: 193–98, pls. 34.3–4, 38–39.

63. See Volkmar von Graeve, *Der Alexandersarkophag und seine Werkstatt* (*Istanbuler Forschungen* 28, Berlin 1970): 95–100; Tonio Hölscher, *Griechische Historienbilder des 5. und 4. Jahrhunderts v. Chr.* (*Beiträge zur Archäologie* 6, Würzburg 1973): 40–43; Wulf Raeck, *Zum Barbarenbild in der Kunst Athens im 6. und 5. Jahrhundert v. Chr.* (Bonn 1981): 101–03; Bittner 1985: 63–64; Michael Pfrommer, *Untersuchungen zur Chronologie und Komposition des Alexandermosaiks auf antiquarischer Grundlage* (Mainz 1998). For the Brescia sarcophagus, etc., see Vanderpool 1966: 105, pl. 35; Harrison 1972: 365, pls. 75, 77; Koch and Sichtermann 1982: 412, 414, nos. 22–23, fig. 446. For the Persian army's diversity see Aischylos, *Persae* 12–64; Herodotos 7.61–96; for the facts see esp. Bittner 1985; on Roman Orientals, who are differently attired, see Schneider 1998: 98, 104, 109.

64. Aristotle, *Physiognomonica* 69,812b35: οἱ ἐπὶ τῆς κεφαλῆς προσπεφυκυίας ἔχοντες τὰς τρίχας ἐπὶ τοῦ μετώπου κατὰ τὴν ῥῖνα ἀνελεύθεροι· ἀναφέρεται ἐπὶ τὴν ἐπιπρέπειαν, ὅτι δουλοπρεπὲς τὸ φαινόμενον; cf. Euripides, *Helen* 276 (the quotation) with Aristotle, *Politics* 1.1.5,1252b5–9; 7.6.1, 1327b23–6; Sassi 1988/2001: 104, 108, 114–16. On slavish nakedness see most conveniently Larissa Bonfante, "Nudity as a Costume in Classical Art," *AJA* 93 (1989): 543–70, at pp. 544–47, 555–56, fig. 4.

65. The Gaul cowering before Herakles on the Kyzikos stele of ca. 275 (Istanbul 564: Wenning 1978: pl. 1.1; Smith 1991:

fig. 211; Marszal 2000: fig. 72) also adopts this "Persian" posture and directly anticipates the Aix Persian. On the Santacroce Amazon and Torlonia Persian see Appendix 2, §3(ii) and (iv).

66. Pausanias 1.15.3; cf. Harrison 1972: 370–78 on the other sources for the painting's iconography.

67. Wounds: Malmberg 1886. *Comparanda:* Bienkowski 1928: figs. 44, 117, 125–27, 146, etc.; Marszal 2000.

68. For the *thyreoi* ("doorlike shields") see Pausanias 1.13.2 (Pyrrhos' dedicatory epigram); Polybios 2.30.3; Diodoros 5.30.2; Livy 38.21.4; cf. Bohn 1885 (*AvP* 2): 107, 131–32, pls. 43 (oval), 47.1 (*thyreos*, part only); Polito 1998: 91–95, figs. 27–31; Stewart 2000: fig. 15 (oval). For numerous examples of each see Bienkowski 1908 and 1928; Desnier 1991: fig. 2, etc.; Moscati 1991: 321–31; Green 1995: 47–51, figs. 4.2–4; Marszal 2000. For good drawings and photographs of the Capitoline and Ludovisi shields, see Paola Santoro (ed.), *I Galli e l'Italia* (Rome 1978): 235–47; Mattei 1987: figs. 31, 48, pls. 24, XVI, XL, LIV–V.

69. Polybios 2.33.5, 3.114.3; Diodoros 5.30.3; comments in Bohn 1885 (*AvP* 2): 111, 132–33 (Hans Droysen); the change in sword type occurs early in the La Tène II period, around 350–300: See Green 1995: 47, with Santoro (ed.), *I Galli e l'Italia*, for the Italian graves. Belts: Green 1995: 418–19. Cf. Kallimachos, *Hymn to Delos* (4) 183–84: φάσγανα καὶ ζωστῆρας ἀναιδέας ἐχθομέναις τε/ἀσπίδας, αἳ Γαλάτῃσι κακὴν ὁδὸν ἄφρονι φύλῳ/στήσονται.

70. All correctly noted by Bienkowski 1908: 38, 53.

71. So Reinach 1889: 11; Bienkowski 1908: 43–44; demolished by Schober 1939: 83.

72. For the three-figured group see, e.g., the Vienna Amazon sarcophagus, Bieber 1961: fig. 252; Ridgway 1990: pls. 18–19; Boardman 1995: fig. 136.2; but cf. Malmberg 1886.

73. Polybios 2.30.4; 3.43.12; Caesar, *Gallic War* 3.19.6; Livy 7.12.11, 26.9; 10.28.2; 38.17.7, 21.14, 23.1, 25.15, 27.1; Tacitus, *Germania* 4; Dio Cassius 12.50.3; etc.; cf. Kremer 1994: 31–39.

74. Brunn 1870: 305.

75. So Künzl 1971; Wenning 1978 (who dismisses the Persian); and, e.g., Pollitt 1986: 83–90, figs. 85–88; Mattei 1987; Ridgway 1990: 284–90, pls. 141–43; Stewart 1990: 205–7, 301–2, figs. 667–75; Smith 1991: 99–102, figs. 118–22; Andreae 2001: 92–93, pls. 46–48; Pirson 2002 (*non vidi*); with Fränkel 1890 (*AvP* 8.1): nos. 21–28 for the Long Base, and Michaelis 1893: 129–34 on Isigonos/Epigonos. Marszal 2000: 192–97 adroitly summarizes the scholarship.

76. Kubler 1962: 39–40.

77. Doubters: Ridgway 1990: 295; Marszal 2000: 221–22; Marvin 2002. On attitudes to suicide in classical antiquity see Dover 1974: 168–69; on Gallic suicide see Anton J. L. van Hooff, *From Autoktonia to Suicide: Self-Killing in Classical Antiquity* (London and New York 1990), which, however, omits several of the following Hellenistic/Roman republican cases: (1) Diodoros 22.9.2–3; Pausanias 10.23.12; Justin 24.8.11 (Brennus, 279 BC); (2) Pausanias 1.7.2 (Celts in Egypt, 275: cf. Hans Peter Laubscher, "Ein ptolemaisches Gallierdenkmal," *AntK* 30 [1987]: 131–54); (3) Justin 26.2.1–6 (Gauls kill their families to placate the gods before fighting Antigonos Gonatas in 266); (4) Polybios 2.31; Diodoros 25.13 (Gauls in Italy, 225); (5) Plutarch, *Marius* 27.2; Orosius, *Historium adversum paganos* 5.16.19 (Cimbri and Teutones in Gaul, 101: their wives commit suicide and kill their children too); (6) Caesar, *Gallic War* 3.22.3; Valerius Maximus 2.6.11 (Aquitanians and Celtiberians commit suicide if their commander falls). Unfortunately, we know no details whatsoever about any of Attalos' Gallic campaigns (cf. Hansen 1971: 31–35; Allen 1983: 29–35, 194–99), which could well have included the ravaging of encampments, so arguments *contra* are egregiously *e silentio*. Trumpet: This is not an orthodox Gallic *carnyx* (Bohn 1885 [*AvP* 2]: 113, pls. 45.1, 46.2; Christophe Vendries, "La Trompe, le gaulois, et le sanglier," *REA* 101 [1999]: 367–91) but a different, curved type: See Moscati 1991: figures on pp. 94, 407, from Italy and Spain, respectively. Marszal 2000: 222 objects that it is presently unattested in the East, but except for the Pergamene weapons friezes, cited above, the iconographic record there is almost nonexistent. The argument that a Gallic noble (suggested by the torque) would not be a trumpeter is equally specious, for like fifth-century Athenians, Pergamenes surely cared little about such fine social distinctions among barbarians. The torque resembles a common type in male burials during the La Tène II and III periods (ca. 350–150 and 150–50 BC): See Green 1995: 413–14 for details. It is indexical, signaling "Gaul" just like long hair and a mustache. Nicola F. Parise, "Galati suicidi: Onore e morte presso i Celti," *Origini* 15 (1990–91): 369–74 bizarrely argues from Athenaios 4,154a–c (after Poseidonios) that the Trumpeter has voluntarily submitted to die after losing a duel at a banquet. But his throat is not cut, and he is not lying on his back on his shield (so Athenaios); and why the trumpet?

78. Marszal 2000: 207–08.

79. Polybios 16.1.5–6, 32.15, 33.12–13; Diodoros 31.35; Appian, *Mithradatic Wars* 3; cf. Hansen 1971: 55–56, 71, and 133–35; Allen 1983: 82, 123–25.

80. Hansen 1971: 292–94 (summary of earlier scholarship, some of whose conclusions have now been revived); Schalles 1985: 104–23; George Roux and Olivier Callot, *Fouilles de Delphes*, II.17: *La Terrasse d'Attale I* (Paris 1987): 115–23 (base), 139 (decree, which is Wilhelm Dittenberger, *Sylloge inscriptionum graecarum*, 4 vols. [3rd ed., Leipzig 1915–24]: no. 523); Bringmann and von Steuben 1995: K91; Gruen 2000: 21, 24–25, examines Attalos' political motives in erecting it.

81. Anne Jacquemin and Didier Laroche, "Les piliers attalides et la terrasse pergaménienne à Delphes," *RA* (1990): 215–21, and "La Terrasse d'Attale Ier révisitée," *BCH* 116 (1992): 229–55; Hoepfner 1997b: 128–34, figs. 20–21 (whence Figure 247). Jacquemin and Laroche argue that it was not a base at all but a huge altar to the hero Neoptolemos, citing Heliodoros, *Aethiopica* 3.1–6; Marszal 2000: 206 agrees. Yet (1) it is too lofty to use for butchery, which in any case the spikes would preclude; (2) immediately behind these spikes stood an elevated platform like that on the Akropolis Dedication's pedestals, figs. 218–19, 264–66, 286; (3) Neoptolemos' altar was for burnt sacrifices, but the regulatory decree sensibly prohibits fire anywhere inside the precinct; and (4) Neoptolemos' altar was circled during the ritual by squadrons of Thessalian cavalry, but the *massif* stands on a narrow terrace right up against the stoa's steps.

82. For arguments pro and con see Bienkowski 1908: 4–6; Künzl 1971: 9–10; Wenning 1978: 11–12; and Ridgway 1990: 290.

83. On the Persians and Delphi see Herodotos 8.31-38, 50; cf. Propertius 2.31.12-13; Zanker 1988: 85-87, fig. 70.

84. Pergamon: Pausanias 1.4.6. Delphi: See Roux and Callot, *Fouilles de Delphes*, II.17: *La Terrasse d'Attale I*, 63-67; Schalles 1985: 108 n. 651; Marszal 2000: 206.

85. For Gallic spoils dedicated at Pergamon see Pausanias 1.4.6, 10.21.6; cf. Bohn 1885 (*AvP* 2): pls. 43-50; Stewart 2000: 48-49, figs. 14-16; Polito 1998. A fortiori, a quadruple appropriation is even less likely; for the Big Barbarians include no obvious Giants or Amazons, and the evidence for a quartet of precedents for the Little Barbarians at Pergamon (Brunn 1870: 320; Milchhöfer 1882: 28-29; Lippold 1923: 112; Andreae 1956/1973: 74-83; Andreae 1968-69: 153; etc.) is nil.

86. Palma 1981: nos. 24-32, figs. 24-32. Her no. 24 is the Athens frieze, figs. 208-10, discussed in Chapter 3.

87. Vatican 602, Sala dei Busti 384a; provenance unknown; height 52 cm. Walther Amelung, *Die Sculpturen des vaticanischen Museums*, vol. 2 (Berlin 1908): 569, no. 384a, pl. 66; Künzl 1971: 4, 31-32, pl. 16.1; Wenning 1978: 20-21, pl. 10.1-3; Palma 1981: no. 27, fig. 27. For the Mantua relief, see Künzl 1971: 4-5, 32, pl. 16; Kleiner 1992: 86, fig. 66; Kuttner 1995: 169; Marszal 2000: 219, fig. 82.

88. See Christian Habicht, *Pausanias' Guide to Ancient Greece* (Berkeley and Los Angeles 1985): 131, 134-35.

89. Brunn 1870: 322-23; Schober 1939: 89-91; Schober 1951: 124-26; Andreae 1956/1973: 81; Stewart 1979: 23; Andreae 1980: 42-44; Queyrel 1989: 291; Andreae 1990: 65-69; Queyrel 1992: 380; Schmidt-Dounas 2000: 235-38, 256, 258.

90. On all of this see Alexander Nehamas, "Writer, Text, Work, Author," in Anthony Cascardi (ed.), *Literature and the Question of Philosophy* (Baltimore 1987): 265-91; and Richard T. Neer, "Pampoikilos: Representation, Style, and Ideology in Attic Red-Figure" (Ph.D. dissertation, U.C. Berkeley 1998): 2-28, esp. p. 25, paraphrased here; Neer 2002: 53 condenses his earlier remarks.

91. Michaelis 1893.

92. For Epigonos see Fränkel 1890 (*AvP* 8.1): nos. 12, 22b, 29, 31-32, 307(?); *AM* 33 (1908): 416-18, nos. 58-59; AT3b. Discussions: Michaelis 1893; Schober 1938; Künzl 1971; Wenning 1978: 42-43; Stewart 1990: 301-2; Hoepfner 1997b. Heinz Kähler, *Der grosse Fries von Pergamon* (Berlin 1948): 187 n. 47 demolished Fränkel's attempt in *Die Inschriften von Pergamon* (*AvP* 8.1): nos. 10-12 to credit Epigonos with a chariot group dedicated by Attalos, brother of Philetairos, before the latter's death in 263, showing that the critical block with his signature, *AvP* 8.1: no. 12, was recut to fit the other two at a later date when all three were recycled for another monument. For the Long Base and Epigenes monument see Fränkel 1890 (*AvP* 8.1): nos. 21-28, 29 (with Fränkel's commentary) and §1, above.

93. Michaelis 1893: 130; *contra*, e.g., Petersen 1893; Habich 1896; Schober 1938: 137; Wenning 1978: 43 n. 277; and by implication, Kaminski 1999: 107.

94. So Michaelis 1893.

95. So Reinach 1894.

96. The Gallic woman's head is Antiquario Palatino inv. 4283, from the Palatine Stadium: Tomei 1997: no. 126, with this conjecture; *contra*, Wenning 1978: 60. Farnell 1890: 200-01 made the same suggestion re the so-called Ludovisi Fury; whence, e.g., Giuliana Calcani, "Galati modello," *RIA* 10 (1987): 153-74, at p. 170; but this head is even bigger than the Big Barbarians. On all of these conjectures see Wenning 1978: 43 n. 277; and on the Trumpeter see, e.g., Schober 1938: 137; Schober 1951: 68; Andreae 1956/1973: 65-7; *contra*, Wenning 1978: 61.

97. E.g., Andrew S. F. Gow and Denys L. Page, *The Greek Anthology: The Garland of Philip* (Cambridge 1968): vol. 2: 13-16, at p. 14 for this epigram.

98. Donald William Bradeen, *The Athenian Agora*, 17: *Inscriptions: The Funerary Monuments* (Princeton 1974), no. 865; Peter M. Fraser and E. Matthews (eds.), *Lexicon of Greek Personal Names*, vol. 2: *Attica* (ed. Michael J. Osborne and S. G. Byrne, Oxford 1994): s.v. Ἰσίγονος. Andreae 1998: 185 is only the latest of many to take it seriously; Ridgway 1990: 287 and 289 mistakenly reads "Isogonos."

99. On Phyromachos see esp. Wenning 1978: 43-45 (citing the earlier literature); Stewart 1979: 6-25 (high chronology); Andreae 1980 (citing the inscriptions and texts on pp. 61-62); Andreae 1990; Stewart 1990: 302-3; Queyrel 1992 (review of Andreae 1990); Stewart, *Gnomon* 65 (1993): 710-16 (ditto); Andreae 1998: 97-102, 118-67, 182-93; Andreae 2001: 132-36, pls. 103-05.

100. Pliny, *Natural History* 34.51: cxxi "[sc., Olympiade floruerunt] Eutychides, Eutycrates, Laippus, Cephisodotus, Timarchus, Pyromachus. cessavit deinde ars et rursus Olympiade clvi revixit cum fuere longe quidem infra praedictos, probati tamen, Antaeus,"

101. On the Ionic temple see Oskar Ziegenaus et al., *Das Asklepieion*, vol. 1: *Der südliche Temenosbezirk in hellenistischer und frühromischer Zeit* (Berlin 1968) (*AvP* 11.1): 77-79, pls. 33-34; 11. 2: 8-16, pls. 85-94; Gioia de Luca, "Zur Hygieia in Pergamon," *Istanbuler Mitteilungen* 41 (1991): 325-62, at pp. 333-40; Wolfram Hoepfner, "The Architecture of Pergamon," in Dreyfus and Schraudolph 1997: 23-58, at p. 52 and n. 100, with foldout. On the 201 sack, see Polybios 16.1 (not explicitly mentioning the Asklepieion, but the destruction is well attested on site); and on that of 156, Polybios 32.15; Diodoros 31.35; cf. Appian, *Mithradatica* 3.

102. (1) *Natural History* 35.135: "Est nomen et Heraclidi Macedoni. initio naves pinxit captoque Perseo rege Athenas commigravit. . . ." (2) Ibid. 35.146: "Sunt etiamnum non ignobiles quidem in transcursu tamen dicendi Androcydes, . . . Heracleides Macedo, Milon Soleus, Pyromachi statuarii discipuli,"

103. On Nikeratos see esp. Stewart 1979: 7-8; Queyrel 1989: 286-91; Andreae 1990: 61-63 (quoting the sources); Stewart 1990: 302; Queyrel 1992: 379-80; Barbantani 2001: 86 (arguing that the Delian epigram's description of Philetairos as *makar* or "blessed" need not imply a posthumous honor; but this is standard Hellenistic usage). Iphigenia K. Lebendi, "He Hygeia tou Nikeratou tou Athenaiou: Symbole ste melete tes proimes glyptikes tou Pergamou," in Palagia and Coulson 1998: 101-16, tries to identify copies of his Hygieia and Asklepios.

104. For the first solution see Queyrel 1992 (documenting the other Phyromachoi) and for the second, Stewart 1979: 8-9 and 1990: 238, 302. On Asklapon, son of Phyromachos, active on Rhodes between 223 and 215, see now Christine Kantzia, "Chronika: KB' Ephoreia Proistorikon kai Klasikon Archaiote-

ton: Odos P. Mela," *Archaiologikon Deltion* 44.B2 (1989; published 1995): 480–82; *SEG* 40 (1990): no. 1726 (neatly summarizing the Phyromachos problem) and 45 (1995): no. 1066. His work there is dated by his collaboration with Phyles, son of Polygnotos of Halikarnassos, who uses the title *euergetes*; Phyles gained this title in 223, and signed his latest dated work in 215: Marcadé, *Receuil de signatures*, 87–97; *SEG* 28 (1978): no. 688.

105. On the Antisthenes see Gisela M. A. Richter, *The Portraits of the Greeks*, 3 vols. (London 1965): vol. 2, 179–81, figs. 1037–56, and *Supplement* (London 1971): 7, fig. 1055a; id., "New Signatures of Greek Sculptors," *AJA* 75 (1971): 434–35, pl. 95 (the inscription); Stewart 1979: 8–12, pls. 3d–4a; Andreae 1980; Andreae 1990: passim and pls. 1–7 (heads), 36 (inscriptions), 44–46 (terra-cotta); Stewart 1990: 207–8, figs. 678–79; Smith 1991: 36, fig. 34; Ralf von den Hoff, *Philosophenporträts des Früh- und Hochhellenismus* (Munich: 1994): 126–50, figs. 140–58; Zanker 1995: 102–8 on "the thinker's tortured body," 174–76, fig. 93; Andreae 1998: 97–102, 182–84; Ridgway 2000: 285–8; Andreae 2001: 132–36, pl. 104.

106. Zanker 1995: 176.

107. On the coin and Asklepios see Stewart 1979: 12–16, pl. 7; Andreae 1990: passim and pls. 20–37; Queyrel 1992: 368–71; Schultz, "Coinage of Pergamon," 19–21, figs. 22–23; Andreae 1998: 118–22; Andreae 2001: 132–36, pl. 105, figs. 93–99. I omit Andreae's attribution of the colossal bearded head in Syracuse (Andreae 2001: 132–36, pl. 105, figs. 93–99) not because I necessarily disbelieve it but because it introduces needless complications into the equation.

108. For what little is known of Antigonos the sculptor and art historian see Pliny, *Natural History* 1.34, 35.67–68; Zenobios 5.82 (?); Stewart 1990: 303; cf. Ulrich von Wilamowitz-Moellendorff, *Antigonos von Karystos* (Berlin 1881); conveniently summarized by Hansen 1971: 397–403.

109. For Stratonikos see Stewart 1990: 303, with Pliny, *Natural History* 34.85, 90; Athenaios 11, 782b. For Euboulides see Pliny, *Natural History* 34.88; Stewart 1979: 21–22 and Appendix; Zanker 1995: 97–102 (not mentioning Euboulides, whose authorship of the Chrysippos remains conjectural).

110. Roland Barthes, "The Death of the Author," in *Image-Music-Text* (London 1977) (ed. and tr. Stephen Heath): 142–48; Terry Eagleton, *Literary Theory: An Introduction* (2nd ed., Minneapolis 1996): 120–21; cf. Nehamas, "Writer, Text, Work, Author."

111. Howard S. Becker, "Art Worlds and Social Types," *American Behavioral Scientist* 19.6 (1976): 703–19, at pp. 703–04; cf. id., "Art as Collective Action," *American Sociological Review* 39.6 (1974): 767–76; id., *Art Worlds* (Berkeley 1982): 1–39.

112. Bourdieu, *Outline of a Theory of Practice* (1972; tr. Richard Nice, Cambridge 1977); id., *The Field of Cultural Production* (ed. Randal Johnson, New York 1993): esp. 34–35.

113. For Athena's epiphany in 167 see Fränkel 1890 (*AvP* 8.1): no. 165, completed by *AM* 27 (1902): 90, no. 74; for others, see W. Kendrick Pritchett, *The Greek State at War*, vol. 3: *Religion* (Berkeley and Los Angeles 1979): 30–34.

114. Carol C. Mattusch, *Classical Bronzes: The Art and Craft of Greek and Roman Statuary* (Ithaca, N.Y., 1996): 36; Ridgway 2000: 9. Both this and the Barthesian approach are thoughtfully critiqued by Jeffrey M. Hurwit, *AJA* 101 (1997): 587–91 (review of Mattusch); Claude Rolley, a bronze specialist, will have none of them: Rolley 1999: 17, 44, and 143.

115. Brunn 1870: 321; Lippold, *Göttinger gelehrte Anzeiger* 1914: 352–53; retraction, Lippold 1950: 353–54.

116. Krahmer 1927: 71 n. 1; della Seta 1930: 523–29; Horn 1937: 150–62; Andreae 2001: 168; comments, Stewart 2000: 33; Peter Green, "Pergamon and Sperlonga: A Historian's Reactions," in de Grummond and Ridgway 2000: 166–90, at pp. 170, 177–79.

117. Andreae 2001: 168; but see Allen 1983: 30–31, 195–99 for the battle and its location. Also, Pausanias 1.8.1 shows that he knew that the Gauls were not annihilated in 166, and id. 10.9.7 shows that *phthora* need not mean "total annihilation." On the later Attalids see, e.g., Lawrence 1929: 295; occasionally conceded by adherents of the later date, such as Bringmann 2000: 75–76.

118. See esp. the following reliefs: (1) the battle frieze from the Akropolis, now divided between there and Oxford (Schäfer 2000); (2) the Limyra metopes (see below in this section); (3) the coffers of the Belevi Mausoleum (Ridgway 1990: pls. 89–94; Stewart 1990: figs. 652–55; Smith 1991: pl. 203; Webb 1996: figs. 33–36); and (4) the Kyzikos Gallic relief (Smith 1991: pl. 211). Echoes: Stewart 1979: 20–23; on the Agora deposit in question (N 18:3) see now Susan Rotroff, *The Athenian Agora*, 29.1: *Hellenistic Pottery: Athenian and Imported Wheelmade Tableware* (Princeton 1997): 463. The Paris Gaul's head also closely resembles the "Epiphanes" from the Villa dei Papiri, Naples 5596 (Smith 1986: 76–77, cat. no. 25, pl. 20. 1–2; Smith 1991: fig. 16), but since its subject and date are uncertain, this gets us no further.

119. On the classicism of the Gigantomachy see, e.g., Krahmer 1927: 74–75. Cf. Smith 1991: 17–18 and esp. 103: "The use of varied formal styles here clearly has nothing to do with chronology: they simply express different things."

120. So, e.g., Bienkowski 1908: 79–85; Dohrn 1961; Brendel 1967; and most recently Steingräber 2000: 243, 247, and 248.

121. *Pace* Ridgway 2000: 15 n. 14, endorsing a proposal by Mark Fullerton made during a lecture at Bryn Mawr.

122. See Stewart 1979: 65–78.

123. On Chrysippos see Horn 1937: 152, pl. 35; Richter, *Portraits of the Greeks*, vol. 2: 190–94, figs. 1111–48; Stewart 1979: 21, pl. 8; Stewart 1990: 210, 219, figs. 716–17; Smith 1991: 36, fig. 33; von den Hoff, *Philosophenporträts* 96–110, figs. 83–104; Zanker 1995: 97–102 and 108–13, figs. 54–56, 60.

124. Ridgway 1990: 196, pl. 95; Jürgen Borchhardt, "Ein Ptolemaion in Limyra," *Revue Archéologique* 1991: 309–22; Jürgen Borchhardt and Brigitte Borchhardt-Birbaumer, "Zum Kult der Heroen, Herrscher und Kaiser in Lykien," *Antike Welt* 23 (1992): 99–116, at pp. 105–08, figs. 12, 14, 16–19; Günther Stanzl, "Das sogennante Ptolemaion in Limyra: Ergebnisse der Ausgrabungen 1984–89," in Jürgen Borchhardt and Gerhard Dobesch (eds.), *Akten des II. Internationalen Lykien-Symposiums, Wien 6–12 Mai 1990*, vol. 2 (Vienna 1993): 183–90, pls. 43–49; Jürgen Borchhardt, *Die Steine von Zemuri*

(Vienna 1993): 79–84, pls. 36–53; Webb 1996: 125–26, figs. 98–99.

125. Bassai and Halikarnassos: Stewart 1990: fig. 453, 532–33: Boardman 1995: fig. 21.3. Ilion: Ridgway 1990: pl. 71; Stewart 1990: fig. 651; Webb 1996: fig. 2. Belevi: Ridgway 1990: pls. 89–94; Stewart 1990: figs. 652–55; Smith 1991: fig. 203; Webb 1996: figs. 33–36. Akropolis frieze: Schäfer 2000.

126. Polybios 15–16; Diodoros 26–28; Livy 26–32; the exact sequence of events is sometimes uncertain. The best modern histories (with differing reconstructions of the chronology and interpretations of events) are Gruen 1984: 382–98; A. E. Astin et al. (eds.), *Cambridge Ancient History,* vol. 8 (2nd ed., Cambridge 1989): 244–74; Green 1990: 296–311; R. M. Errington, *A History of Macedonia* (Berkeley 1990): 196–204; Habicht 1995/1997: 194–208; Mikalson 1998: 186–94.

127. Polybios 16.28.3: διὸ καὶ τότε δικαίως ἄν τις τὴν μὲν Ἀττάλου καὶ Ῥοδίων ὀλιγοπονίαν καταμέμψαιτο . . . ; cf. Livy 31.15.9–11.

128. Livy 31.24. 18: "dirutaque non tecta solum sed etiam sepulchra, nec divini humanique iuris quicquam prae impotenti ira est servatum"; cf. Diodoros 28.7.

129. Livy 31.26.9–12: "cum priorem populationem sepulchris circa urbem diruendis exercuisset, ne quid inviolatum relinqueret, templa deum, quae pagatim sacrata habebant, dirui etque incendi iussit; et ornata eo genere operum eximie terra Attica et copia domestici marmoris et ingeniis artificum praebuit huic furori materiam. neque enim diruere modo ipsa templa ac simulacra evertere satis habuit, sed lapidis quoque, ne integri cumularent ruinas, frangi iussit."

130. Livy 31.44.1–9, 47.1–2; 32.23.13.

131. Holmes, in "The Disappearance of Lady Frances Carfax."

132. Most recently by Hurwit 1999: 269.

133. See Gruen 2000.

134. Allen, "Attalos I and Aigina," esp. 2 n. 8; Hansen 1971: 396–97; Allen 1983: 147; Habicht 1995/1997: 109, 224. Diogenes Laertius 4.60, 5.67 records that he also made presents to Lykon of Troas (d., 226/224), head of the Peripatetics, and to Lakydes of Kyrene (d., 206/5), who directed the Academy, but since they were non-Athenians and the philosophical schools were private entities, these presents would not be described as gifts to the demos.

135. Schalles 1985: 60–64, 104–36; Bringmann and von Steuben 1995: K91–92, 172–74.

136. See Bringmann 1995: passim; Schmidt-Dounas 2000: 127–28; on the Granikos group see Stewart 1993: 123–30.

137. Apollodoros 1. 34; for other sources see August Friedrich von Pauly, *Realencyclopädie der Classischen Altertumswissenschaft* (ed. Georg Wissowa, Stuttgart, 1903–78) *Supplement* 3: cols. 661–63.

138. Chremonides' decree: *IG* ii². 687, lines 7–13; see Dittenberger, *Sylloge inscriptionum graecarum,* no. 434/5 for the entire text, with Habicht 1995/1997: 144 for its date. Mercenaries: Pausanias 1.13.2–3; *Palatine Anthology* 6.130; Justin 26.2; Plutarch, *Aratos* 38; Polybios 2.65.2; etc.; see most recently Barbantani 2001: 208.

139. Alkaios of Messene in *Palatine Anthology* 16.5: Ἄγαγε καὶ Ξέρξης Πέρσαν στρατὸν Ἑλλάδος ἐς γᾶν, / καὶ Τίτος εὐρείας ἄγαγ' ἀπ' Ἰταλίας· / ἀλλ' ὁ μὲν Εὐρώπα / δοῦλον ζυγὸν αὐχένι θήσων / ἦλθεν, ὁ δ' ἀμπαύσων Ἑλλάδα δουλοσύνας. Cf. Plutarch, *Flamininus* 11.3–4; Livy 33.20.3. For earlier remarks about Amazonian, Persian, Macedonian, and Gallic slavery see Lysias 2.5 (Amazons), 21, 33, 47 (Persians); Plato, *Menexenos* 239b (Amazons), 239D–240C (Persians); Hypereides, *Epitaphios* 17, 20, 24 (Macedonians); Lloyd-Jones and Parsons 1983: no. 958 line 12 (Gauls); Barbantani 2001: 161–62.

140. See Polybios 7.11.10–12; 9.30; 16.1; 18.3, 33; and Plutarch, *Aratos* 49, 51 on the degeneration of Philip's character; cf. Green 1990: 298. Some also surely recalled that his ancestor, namesake, and idol, Philip II, had gone to war against the Persians in 337 precisely to avenge their profanation of Greek shrines: Diodoros 16.89.

141. Livy 31.30: "Athenienses, qui foeda passi iustius in crudelitatem saevitiamque regis invehi poterant, introducti sunt. deploraverunt vastationem populationemque miserabilem agrorum: neque id se queri, quod hostilia ab hoste passi forent; esse enim quaedam belli iura, quae ut facerem ita pati sit fas: sata exuri, dirui tecta, praedas hominum pecorumque agi misera magis quam indigna patienti esse; verum enim vero id se queri, quod is qui Romanos alienigenas et barbaros vocet adeo omnia simul divina humanaque iura polluerit, ut priore populatione cum infernis deis, secunda cum superis bellum nefarium gesserit. omnia sepulchra monumentaque diruta esse in finibus suis, omnium nudatos manes, nullius ossa terra tegi. delubra sibi fuisse, quae quondam pagatim habitantes in parvis illis castellis vicisque consecrata ne in unam urbem quidem contributi maiores sui deserta reliquerint. circa ea omnia templa Philippum infestos circumtulisse ignes; semusta, truncata simulacra deum inter prostratos iacere postes templorum. qualem terram Atticam fecerit, exornatam quondam opulentemque, talem eum si liceat Aetoliam Graeciamque omnem facturum. urbis quoque suae similem deformitatem futuram fuisse, nisi Romani subvenissent. eodem enim scelere urbem colentes deos praesidemque arcis Minervam petitam, eodem Eleusine Cereris templum, eodem Piraei Iovem Minervamque; sed ab eorum non templis modo sed etiam moenibus vi atque armis repulsum in ea delubra, quae sola religione tuta fuerint, saevisse."

142. On these sentiments see Barbantani 2001: 147–60, esp. re Gallic *hybris* and *atasthalia,* and their *misthos.*

143. Pausanias 10.22.4; Plutarch, *Pyrrhos* 26.6.

144. Lysias 2.4–60; Plato, *Menexenos* 239B–242; Demosthenes 60.8–11; cf., e.g., Herodotos 9.27; Isokrates 4.66–72. In Thucydides 2.36.4, Perikles merely alludes to these precedents in order not to bore his audience, and Hypereides, *Epitaphios* 4–5, explicitly omits them to focus on the present; both authors therefore presume their normal inclusion in the genre. See in general Loraux 1981/1986; cf. Benedict Anderson, *Imagined Communities: Reflections on the Origin and Spread of Nationalism* (2nd ed., London and New York 1991): 205–06.

145. Leon: *IG* ii². 11960; Habicht 1995/1997: 162. Sulla: Plutarch, *Sulla* 13.1. See Loraux 1981/1986: 252–56 for a pessimistic assessment of the Hellenistic orations; but in 229 Athens had regained her freedom and democracy; the war dead were still buried in the *demosion sema* (Pausanias 1.29.10, 14); and by the late second century the Epitaphia were performed

annually (*IG* ii². 1006 line 22, 1008 line 17, 1009 line 4, and 1011 line 10).

146. Parthenon: Demosthenes 22.13; thus in 334 they had hung the Persian shields from the Granikos on its eastern architrave, directly under the metopes of the Gigantomachy: See Figure 227. Poikile: Pausanias 1.15, etc.; first noted by Brunn 1870: 317. Delphi: Pausanias 10.10.1–2, 11.5–6, 19.4, 21.5; on the Athenian Treasury see Stewart 1990: 131–33, figs. 211–17. The Athenian local historians or Atthidographers treated the same material: See Felix Jacoby, *Atthis: The Local Chronicles of Ancient Athens* (Oxford 1949); Phillip Harding, *Androtion and the Atthis* (Oxford and New York 1994); cf. Loraux 1981/1986: 84 and 133–34.

147. Bal, Crewe, and Spitzer 1999: vii; cf. Pierre Nora (ed.), *Les Lieux de mémoire* (3 vols., Paris 1984–92); id., "Between Memory and History: *Les Lieux de mémoire*," *Representations* 26 (1989): 7–25; Nancy Wood, "Memory's Remains: *Les Lieux de mémoire*," *History and Memory* 6.1 (1994): 123–49; and see also Jacques LeGoff, *History and Memory* (New York 1992).

148. Bal et al. 1999: viii–ix.

149. Ibid.: x.

150. Cf., e.g., Herodotos 8.143–44 with *Palatine Anthology* 16.5 and Plutarch, *Flamininus* 11; cf. Anderson, *Imagined Communities*, 141–43.

151. Mikalson 1998: 192.

152. Polybios 16.1.

153. Cathy Caruth, quoted by Irene Kacandes, "Narrative Witnessing as Memory Work," in Bal et al. 1999: 55–71, at 67.

154. Cf., e.g., Anthony Cohen, *The Symbolic Construction of Community* (London 1985): 50: "The symbolic construction of community and its boundaries increases in importance as the actual social boundaries of the community are undermined, blurred, or otherwise weakened."

155. Fränkel 1890 (*AvP* 8.1): nos. 20, 21, 29.

156. On prices see Stewart 1990: 67; a life-size bronze statue cost 3,000 dr. or half a talent. A two-thirds life-size statue has 66% of a full-size one's surface area squared (43.5%) and 66% of its volume cubed (28.7%). So our monument's 132+ figures would have cost less than a third of this basic price, around 900 dr. each: in toto, around 20 T; 88 life-size figures, however, could have cost as much as 44 T, and 66 over-life-size ones an impressive 80 T. Compared with these sums the cost of the pedestals was minimal: about 10,000 dr. or at most 2 T (see Korres's Essay, n. 72).

157. See Polybios 16.26.1–5 for the entire text; cf. Gruen 2000.

158. On *soteria* see P. J. Rhodes, *The Athenian Boule* (Oxford 1972): 231–35; Emily Kearns, "Saving the City," in Oswyn Murray and Simon Price (eds.), *The Greek City from Homer to Alexander* (Oxford 1990): 323–44. *Soter* is a common epithet of Poseidon, Apollo, Artemis, and the Dioskouroi (Faraone 1992: 60–64) and was soon appropriated by the Hellenistic kings, Attalos I included (after the Kaïkos victory). For *soteria* from the Persians see Plato, *Menexenos* 240E; Demosthenes 60.10–11; cf. *SEG* 44, no. 42 (a desperate measure during the Lamian War?); and from the Gauls in 277, *IG* ii². 677 (honoring Antigonos Gonatas for his victory at Lysimacheia); Delphi commemorated their annihilation in 279 with the Festival of the Soteria. From ca. 322 (*IG* ii². 410), Athenian decrees regularly honor priests and others for "offering sacrifice for the health and safety (*soteria*) of the *boule*, the *demos*, and the children, women, and other possessions [sic!] of the Athenians." This formula is common after 300, particularly at times of crisis (e.g., *IG* ii². 689 [262/1]). In our period see esp. *IG* ii². 650, a decree of 287/86 honoring the Ptolemaic admiral Zenon for "fighting alongside us for the *soteria* of the demos"; *Hesperia* 5 (1936): 419–28, no. 15, line 23, a decree of 196 honoring Kephisodoros; and *IG* ii². 886, honoring an unknown Pergamene for leaving his studies of philosophy (presumably in 200) to help defend "the City and the Piraeus and . . . ;" the next line reads [. . . μ]ένος τὴν σωτηρίαν τῶν σ[. . .]; cf. Habicht 1995/1997: 198 n. 13, 199 n. 19.

159. *Asphaleia*: Because of this phrase, Habicht 1990: 563 n. 8 doubts the connection between inscription and monument, followed by Bringmann and von Steuben 1995: 61; a Pandora search turned up no parallels, though cf. *SEG* 22: 127, line 17 (restored). For the city's *asphaleia* see, e.g., Isokrates 8.20; id., *Letter to Philip* 1.5; Demosthenes 18.201; Aristotle, *Politics* 6.3.1, 1319b39; and *SEG* 22: 127, line 17.

160. *IG* ii². 1035 lines 48, 52, 53; see Geoffrey Schmalz, *Athens after Actium*, chap. 1 (forthcoming), to whom I am indebted for this insight. *SEG* 44: no. 42, mentioned above in note 48, records an emergency sacrifice to Agathe Tyche around 320 "to ensure the safety of the demos of the Athenians"; Hyakinthos' daughters sacrificed themselves to save the city from Minos, a legend invoked in 335 after Alexander sacked Thebes (Demosthenes 60.27–31 and Diodoros 17.15.2); and according to Pausanias 1.14.5, Eukleia's cult was founded in honor of the "fair fame" won at Marathon; see in general Parker 1996: 155–56, 252.

161. Faraone 1992: 4; see also Deborah T. Steiner, *Images in Mind: Statues in Archaic and Classical Greek Literature and Thought* (Princeton 2001): 168–81 – though *apotropaia* had other functions too. Compare, for example, the Zeus in the Bouleuterion at Olympia, "of all the images of Zeus the one most likely to strike terror into the hearts of sinners" (Pausanias 5.24.9). Holding thunderbolts in both hands, he presided over the oaths taken by all Olympic athletes, their trainers, and their families.

162. Solon fr. 4.1–4 West; *SEG* 18: no. 153; *SEG* 19: no. 319, lines 4–6 (ἡ Ἀθηνῶν μεδέουσα); Plutarch, *Themistokles* 10.2; John M. Mansfield, "The Robe of Athena and the Panathenaic Peplos" (Ph.D. dissertation, U.C. Berkeley, 1985): 135–37 with n. 15, 174–77; Faraone 1992: 7, 66, 123 n. 12; Parker 1996: 69, 144; Hurwit 1999: 20–21.

163. See Judeich 1931: 219; Ira S. Mark, *The Sanctuary of Athena Nike in Athens* (*Hesperia Supplement* 26, 1993): 12–14, 69, frontispiece and pl. 8; for numerous *comparanda*, see Faraone 1992: 8; Hurwit 1999: 209, fig. 55.

164. Pausanias 3.15.7; see Judeich 1931: 222; Faraone 1992: 77; Mark, *Sanctuary of Athena Nike*, 93–98; Hurwit 1999: 105–6.

165. Hesychios s.v. καταχήνη; Faraone 1992: 41–42, 125–27.

166. Plutarch, *Perikles* 13.12–13; Pausanias 1.23.4; Judeich 1931: 242–44; Parker 1996: 175 ("essentially prophylactic"); Hurwit 1999: 199, fig. 172. Robertson, "Athena's Shrines and

Festivals," 47–48, wrongly identifies it with the archaic striding "Promachos" type (its base is preserved, and the footprints do not match) and also suggests that Dio Cassius 54.7.3 refers, describing another portent before Actium whereby an Athena on the Akropolis turned from east to west and spat blood; but Mansfield, "Robe of Athena": 174–77 and Hurwit 1999: 263–64 identify her as the Polias.

167. Herodotos 7.140–42, 8.51–53; cf. Hurwit 1999: 135–36.

168. Judeich 1931: 209–11; H. Drerup, "Parthenon und Vorparthenon: Zum Stand der Kontroversie," AntK 24 (1981): 21–38, at p. 32; H. Wrede, "Waffen gegen die Perser," AA 1996: 37–41; Hurwit 1999: 159, fig. 35.

169. The epithet "Promachos" is late: Scholiast to Demosthenes, *Against Androtion* 13, p. 597.5 Reiske; and esp. Alkiphron 3.15.4 (where she is also called "bulwark of the city") and Zosimos 5.6.2 (re Alaric's invasion and siege of AD 396), describing her as "armed and as if ready to stand against invaders"; Judeich 1931: 234–35; Stewart 1990: 261; Evelyn B. Harrison, "Pheidias," in Olga Palagia and Jerome J. Pollitt (eds.), *Personal Styles in Greek Sculpture* (*Yale Classical Studies* 30, Cambridge 1996): 16–65, at pp. 28–34; Hurwit 1999: 23–25, 151–52; *comparanda*, Faraone 1992: 7.

170. Pausanias 1.24.8; Judeich 1931: 80, 255; Stewart 1990: 262; Faraone 1992: 125–27.

171. Pausanias 1.22.8 (omitting Alkamenes); Judeich 1931: 224; Stewart 1990: 165, 267–69, fig. 400 (inscribed herms from Ephesos and Pergamon); Hurwit 1999: 250; Andrew Stewart, "Alkamenes at Athens and in Ephesos," *Zeitschrift für Papyrologie und Epigraphik* 143 (2003): 101–03; *comparanda*, Faraone 1992: 7.

172. Pausanias 2.30.2; Judeich 1931: 223–24; Stewart 1990: 165, 267–69; Faraone 1992: 8–9; Hurwit 1999: 250.

173. Pausanias 1.21.3, 5.12.4; Judeich 1931: 258; Stewart 1979: 47; Janer Belson, "The Medusa Rondanini: A New Look," *AJA* 84 (1980): 373–78; Peter Callaghan, "The Medusa Rondanini and Antiochos III," *BSA* 76 (1981): 59–70; Bringmann and von Steuben 1995: 53–55, K23, figs. 1–3; Habicht 1995/1997: 222; *LIMC* s.v. "Gorgo, Gorgones," 329; Hurwit 1999: 273–74; Bringmann 2000: 155; Schmidt-Dounas 2000: 133–34.

174. Vitruvius 2.8.15; Faraone 1992: passim.

175. Faraone 1992: 57–66, 118–22.

176. Livy 31.30, quoted in the previous section. The parallel between the Persian Wars and the Gallic invasions became a commonplace after 279: see W. Ameling, "Pausanias und die hellenistische Geschichte," in Jean Bingen (ed.), *Pausanias Historien* (Fondation Hardt, *Entretiens* 41, Geneva 1996): 117–66, at p. 150.

177. A subject too complex to discuss here: See Stewart 1997: 224–28 with references.

178. See Andrew Stewart, "Narration and Allusion in the Hellenistic Baroque," in Peter J. Holliday (ed.), *Narrative and Event in Ancient Art* (Cambridge 1993): 130–74, at pp. 133–37, summarized here with some additions and corrections. On Asian rhetoric see Dionysios of Halikarnassos, *On the Ancient Orators* 1–4; id., *de Compositione Verborum* 18; Cicero, *Brutus* 51, 286, 325; id., *Orator* 25, 231; id., *de Oratore* 2.58; Quintilian 12.10.16–19; cf. Ulrich von Wilamowitz-Moellendorf, "Asianismus und Attizismus," *Hermes* 35 (1900): 1–52; Eduard Norden, *Die antike Kunstprosa* (5th ed., Stuttgart 1958): 131–49; George Kennedy, *The Art of Persuasion in Greece* (Princeton 1963): 301–3, 330, 337–38.

179. Polybios 5.77.2–78.5, 5.111.2 (Attalos); Livy 38.18.1 (Eumenes). On Greeks and barbarians in general, see, e.g., Edith Hall, *Inventing the Barbarian: Greek Self-Definition through Tragedy* (Oxford 1989); Paul Cartledge, *The Greeks: A Portrait of Self and Others* (Oxford 1993); John E. Coleman and Clark A. Walz, *Greeks and Barbarians* (Ithaca, N.Y., 1997); Jonathan Hall, *Ethnic Identity in Greek Antiquity* (Cambridge 1997); Irad Malkin (ed.), *Ancient Perceptions of Greek Ethnicity* (Cambridge, Mass., 2001). Unfortunately, none of them discusses the Gauls.

180. Hölscher 1985: 130 first suggested the connection; for a measured account of these historians' aims and methods, see Frank E. Walbank, "Tragic History: A Reconsideration," *BICS* 2 (1955): 4–14; and id., "Tragedy and History," *Historia* 9 (1960): 216–34. (I thank Erich Gruen for these references.) Cf. Polybios 2.56 on Phylarchos' purple prose: ". . . clinging women with hair disheveled and breasts bare, and crowds of both sexes together with their children and aged parents weeping and lamenting as they are led into slavery," with Pausanias 10.22.3, evidently paraphrasing a Hellenistic historian: "Every male the Gauls put to the sword, butchering old men equally with babes at the breast, the plumper of which they killed, drinking their blood and eating their flesh."

181. Mikhail Bakhtin, *The Dialogic Imagination* (ed. and tr. C. Emerson and M. Holquist, Austin 1981): 281. Clark quoted in Stewart, "Narration and Allusion," p. 132.

182. Aristotle, *Nicomachean Ethics* 3.7.7–13,1115b25–29; Lloyd-Jones and Parsons 1983: no. 958 (where they are *hybristai* and *aphrones*, "mindless"); Kallimachos, *Hymn to Delos* (4) 184 (ditto); Polybios 2.28–30; Diodoros 5.24–31; cf. Barbantani 2001. On the reality, see Strobel, "Keltensieg und Galatersieger"; id., *Die Galater: Geschichte und Eigenart der keltischen Staatenbildung auf dem Boden des hellenistischen Kleinasiens*, 1: *Zur Geschichte und historischen Geographie des hellenistischen und römischen Kleinasien* (Berlin 1996); and esp. Gareth Darbyshire, Stephen Mitchell, and Levent Vardar, "The Galatian Settlement in Asia Minor," *AnSt* 50 (2000): 75–98; Jeremiah R. Dandoy, Page Selinsky, and Mary M. Voigt, "Celtic Sacrifice," *Archaeology* 55 (2002): 44–49.

183. Pausanias 10.19–23, esp. 19.12 (the quotation).

184. Cicero, *de Finibus* 3.61 (the Stoic view); Diogenes Laertius 10.119–20 (the Epicurean one).

185. Livy 38.21.

186. Cf. most recently Pirson 2002 (*non vidi*). This passage is drawn from Stewart 1997: 220.

187. Philipp Fehl, *The Classical Monument* (New York 1972): 32–33; cf. Loraux 1981/1986: 141–45; and on the "beautiful death" see esp. Loraux 1981/1986: 98–118; Jean-Pierre Vernant, "A 'Beautiful Death' and the Disfigured Corpse in Homeric Epic," in *Mortals and Immortals: Collected Essays* (Princeton 1991): 50–74; Shanks 1999: 109–19. On the Dexileos monument see Stewart 1990: 172–73; Boardman 1995: figs. 112.1, 120; and esp. the careful, well-illustrated account by Brunilde S. Ridgway, *Fourth-Century Styles in Greek Sculpture* (Madison 1997): 3–7.

188. Lysias 2.24; for the same sentiment see Demosthenes 60.18–19; Isokrates 4.92. On redescription and war see Scarry 1985: 66–81.

189. Aristotle, *Politics* 1.1.12,1253a27–29; Isokrates 12.163.

190. E.g., Plato, *Republic* 5,470b–471b; Isokrates 4.16–18, 12.13–14; *Epistles* 3.11; Aristotle, *Politics* 7.6, 1327b29–33; Polybios 5.104; Livy 31.29.15–16; Plutarch, *Flamininus* 11.2–4.

191. Scarry 1985: 45–53, 127–33.

192. Aristotle, *Nicomachean Ethics* 3.7.7–13,1115b25–29; Lloyd-Jones and Parsons 1983: no. 958; Polybios 2.28–30; Diodoros 5.24–31. On citizen desire, see Stewart 1997: 7–10, 63–85.

193. On Gallic slavery see Lloyd-Jones and Parsons 1983: no. 958, line 12, probably celebrating Ptolemy II's Gallic campaign of 275; Barbantani 2001: 161–62.

194. Gallic character: Lloyd-Jones and Parsons 1983: no. 958 (*hybristai* and *aphrones*, "mindless"); Kallimachos, *Hymn to Delos* (4) 184 (ditto); Polybios 2.28–30, 35.3, 6; Diodoros 5.24–31. A topos with Roman-period authors: See, e.g., Livy 7.12.11, 10.28.2–4, 38.17.7; Tacitus, *Germania* 4; Dio Cassius 12.50.2–3; etc.; cf. Kremer 1994: 31–39; Barbantani 2001. Dio's remarks are typical: "They are men of ungoverned passion and uncontrollable impulse.... If they suffer a setback, they are plunged into a state of panic corresponding to their previous fearless daring. In brief time they rush abruptly to the very opposite extremes since they can furnish no sound motive based on reason for either course." Contrast the accounts of the democratic citizen's courage and its foundations by, e.g., Thucydides 2.40.2–3; Demosthenes 60.17; and Hypereides fr. A4; see Joseph Roisman, "The Rhetoric of Courage in the Athenian Orators," in Ralph M. Rosen and Ineke Sluiter (eds.), *Andreia: Studies in Manliness and Courage in Classical Antiquity* (Leiden and Boston 2003): 128–42.

195. Ugly = comic: Aristotle, *Poetics* 5, 1449a32–36; cf. Plato, *Republic* 5,452d; *Laws* 7,816d–e. "Disgust": cf. Plato, *Republic* 10,605e, with, e.g., Aristophanes, *Acharnians* 586; id., *Wasps* 792. Impotence, harm, and rejoicing with impunity: Plato, *Philebos* 49b–d. On this complex of ideas see Dover 1974: 71–72, 85, 180–84, 281; Stewart 1997: 254–58.

196. Diodoros 5.28.2, quoted in Chapter 3, §§1, 4; on the fascination of the Gorgon, satyr, and grotesque see Stewart 1997: 182–91, 225–28.

197. Stallybrass and White 1986: 4–5.

198. Harpokration s.v. "Mikon," citing the fourth-century statesman Lykourgos' *On the Priestess* (fr. 30 Blass), an impeccable source; Sopater Rhetor 8, 126–45 Walz. Allegedly he made the Persians bigger than the Athenians.

199. Cf. Scarry 1985: 88.

200. See Stanley Fish, *Is There a Text in This Class? The Authority of Interpretive Communities* (Cambridge 1980); Jauss 1982; Richard H. Davis, *Lives of Indian Images* (Princeton 1997): 8. Loraux 1981/1986: 79–80 recognizes the same problem but finesses it.

201. Reflected, e.g., in Pausanias 1.4.2–4; 10.20.5, 21.5; cf. Ameling, "Pausanias und die hellenistische Geschichte," 150–51.

202. Herb Caen, quoted by Leo Spitzer, "Back through the Future" (on the healing effects of nostalgia), in Bal et al. 1999: pp. 87–104, at 87.

203. Nora (ed.), *Les Lieux de mémoire*, 1: *La République*, 651.

204. Brilliantly characterized by Ferguson 1911: 307–11; cf. Habicht 1995/1997: 170–72, 220–45, 287–96; and as regards the art, Stewart 1979: 34–64; Pollitt 1986: 164–84; Green 1990: 566–85; Stewart 1990: 219–21; Bringmann and von Steuben 1995. On the Epitaphia and Marathon see Loraux 1981/1986: 37–39, 255; and esp. Mikalson 1998: 184–85, 243–48; see, e.g., *IG* ii². 1006, lines 13–14, 17; and the unpublished ephebic decree quoted here.

205. On Apollodoros see *Der Neue Pauly* q.v. (6) and Habicht 1995/1997: 119–21; on "cessavit ars" (Pliny, *Natural History* 34.51) see most recently Stewart 1990: 21, 220, 238; Jacob Isager, *Pliny on Art and Society: The Elder Pliny's Chapters on the History of Art* (London 1991): 98–102; Alice Donohue, "Winckelmann's History of Art and Polyclitus," in Warren G. Moon (ed.), *Polykleitos, The Doryphoros, and Tradition* (Madison 1995): 327–53, at pp. 341–44; Ridgway 2000: 10–11.

206. Livy 35.37.4–39.2, 35.50.4; Hansen 1971: 77–79; Habicht 1995/1997: 208.

207. On Antiochos and Athens see Habicht 1995/1997: 222–24, now noncommittal after his earlier preference for Antiochos III as the aegis's dedicator.

208. Plutarch, *Sulla* 14; *Palatine Anthology* 7.312; Habicht 1995/1997: 306–07.

209. On these events see Habicht 1995/1997: 356–65, inadvertently repeating Dinsmoor's (1920) error of conflating the colossi with the statues on the "Agrippa" monument outside the Propylaia; contrast Habicht's p. 226.

210. The Greek reaction to Roman intrusion is exhaustively scrutinized by Gruen 1984: 325–56; cf. Jean-Louis Férrary, *Philhellénisme et imperialisme: Aspects idéologiques de la conquête romaine du monde hellénistique* (Bibliothèque des Écoles françaises d'Athènes et de Rome 271, Rome 1988). On Attalos in 200 see Polybios 16.28, quoted in note 127, and Livy 31.15.9–11.

211. Livy 34.23.1–24.4: "[The Athenians] libertatis quondam duces et auctores, adsentationis propriae gratia communem causam prodentes.... [The Aitolians] linguam tantum Graecorum haben sicut speciem hominum; moribus ritibusque efferatioribus quam ulli barbari, immo quam immanes beluae vivunt."

212. Polybios 31.6.6; Gruen 1984: 583–84 is skeptical.

213. W. Oberleitner, "Ein hellenistischer Galaterschlachtfries aus Ephesos," *Jahrbuch der Kunsthistorischen Sammlungen in Wien* 77 (1981): 57–104; Smith 1991: 186, fig. 208; Hannestad 1993: 15–38, at 38 n. 63 (Roman); Moreno 1994: 252–53 (Vulso); Ridgway 2000: 115–17, pls. 37–38. Cf. Polybios 21.40.1; Livy 37.2–6, 38.27.9. For another possible Ephesian echo of the Attalid monument, see now Dirk Lenz, "Ein Gallier unter den Gefährten des Odysseus," *Istanbuler Mitteilungen* 48 (1998): 237–48, pls. 22–25.

214. Diodoros 3.55.5, from the second-century mythographer Dionysios Skytobrachion (*FGH* 32 F7), surely after a Pergamene source.

215. See Stewart in de Grummond and Ridgway 2000: 40.

216. Polybios 18.37.9, at a conference in 198.

217. *IG* xi.4: no. 1056 (ID 1497 bis); cf. Hansen 1971: 97–106 on the two dynasties and Pergamon; Habicht 1995/1997:

226–27. Ptolemies: Livy 31.9.1–5; Pausanias 1.38.5–6; Habicht 1995/1997: 196, 220–22.

218. Livy 32.8.9–16, 32.27.1.

219. *OGIS* 248; cf. Appian, *Syrian Wars* 233–34; Habicht 1995/1997: 223. On Antiochos IV see Astin et al. (eds.), *Cambridge Ancient History*, vol. 8: 338–53; Green 1990: 429–39; and Stewart 1979: 47 and 1990: 221 on his artistic tastes and benefactions.

220. Urns: See esp. Bienkowski 1908: 79–85; Dohrn 1961; Brendel 1967; and most recently Steingräber 2000: 243, 247, 248. Roman republic and the Attalids: See esp. Kuttner 1995, with references. Delos Gaul (Athens NM 247, from niche 41 on the north side of the Agora of the Italians): See esp. E. Lapalus, *Exploration archéologique de Délos* (Paris 1939): 52, figs. 2, 6; Marcadé 1969: 119–27, cf. Stewart 1990: 227; Marszal 2000: 216; Ridgway 2000: 319; Andreae 2001: 204–06, pl. 195. Mutatis mutandis, the same is true for the republican-period head of the German or Gaul from Rome in Brussels published by Hölscher, "Beobachtungen zu römischen historischen Denkmälern II," *AA* 1984: 283–91, figs. 1–4; Krierer 1995: pl. 150, 479; Kuttner 1995: 169–70. Coins: Desnier 1991: figs. 1–3, 8, and esp. 2e (Capito).

221. Livy 45.27.11–28.1; Pliny, *Natural History* 34.54, 35.135.

222. Plutarch, *Sulla* 13.1.

223. Pausanias 1.6.1.

CONCLUSION. "THE TRUTH IN SCULPTURE"

1. See Frederic Jameson, *The Prison-House of Language* (Princeton 1972): 48–54, who remarks apropos this concept (the Russian formalist notion of *ostranenie*) that it (1) segregates literature and art from other, more mundane modes of communication; (2) constitutes all their devices (i.e., their form) as a means to this end; and (3) designates the history of genres as a series of estranging ruptures with the past.

2. See Stewart 1997: 13–14, with references.

3. See Jean-Paul Sartre, *Being and Nothingness: An Essay on Phenomenological Ontology* (1943; tr. Hazel E. Barnes, New York 1966); Maurice Merleau-Ponty, *The Phenomenology of Perception* (1945; tr. Colin Smith, London 1962) and *The Visible and the Invisible* (1964; ed. Claude Lefort, tr. Alphonse Lingis, Evanston, Ill., 1968); Jacques Lacan, *The Four Fundamental Concepts of Psycho-Analysis* (1964; ed. Jacques-Alain Miller, tr. Alan Sheridan, New York 1981); commentary, Jay 1993: 263–370.

4. See esp. Françoise Frontisi-Ducroux, "Eros, Desire, and the Gaze," in Natalie B. Kampen (ed.), *Sexuality in Ancient Art* (Cambridge 1996): 81–100.

5. Sophokles, *Ajax* 450.

6. For Attalos' Gallic allies see Polybios 5.77.2, 78.1–5; for Eumenes', see Livy 38.18.1; on Greek attitudes to Roman "barbarism" see Gruen 1984: 325–43; Green 1990: 216–17, 279–80, 300, 318–19, 383, 436, 563.

7. On orifices see Stallybrass and White 1986: 22; and on pain and power, Scarry 1985: 56.

8. These remarks paraphrase Shanks 1999: 105, quoting René Girard, *Violence and the Sacred* (Baltimore 1977): 51; and Klaus Theweleit, *Male Fantasies,* vol. 2: *Male Bodies: Psychoanalyzing the White Terror* (Cambridge 1989): 51.

9. Thucydides 2.43.1; Aristophanes, *Knights* 732–40; Plato, *Alkibiades I*, 132a; Aristotle, *Rhetoric* 1.7.34,1365a31–33, 3.10.7,1411a1–4, etc.; cf. Stewart 1997: 80–83.

10. Mieke Bal, *Reading Rembrandt* (Cambridge 1991): 148.

11. Barton 2001: 249.

12. On torture and truth see Antiphon 5.31–32; Demosthenes 30.37; Isaios 8.12; Lykourgos, *Against Leokrates* 29–32; Aristotle, *Politics* 1.2.14–15,1254b25–40; Auctor ad Herennium 2.7,10; Cicero, *Topica* 74; etc., with Propertius 3.5.39 on the Giants; cf. Page DuBois, *Torture and Truth* (New York 1991).

13. See Barkan 1999: xxxii, 8–10, 17–42, etc.

14. Bibliotheca apostolica vaticana, Chigi L.V. 178, fol. 104–06; Barkan 1999: 3, 341 n. 13, with modernized text; Salvatore Settis (ed.), *Laocoonte: Fama e stile* (Rome 1999): 110–11: "Et visto, ci tornamo a desinare." See also Barkan 1999: 3, 8–9, 308–9, etc.

15. The sequence can easily be extended further: See, e.g., the Cavaliere d'Arpino's magnificent frescoes of 1595–1640 for the Sala degli Orazi e Curiazi in the Palazzo dei Conservatori; Poussin's *Taking of Jerusalem* (1638) in Vienna and *Moses Strikes the Rock* (1649) in St. Petersburg; François Perrier's *Plague of Athens* (1649) in Dijon; Pierre Lemaire's *Landscape with Ancient Ruins and the Colosseum* (ca. 1660) in Puy de Dome; etc.

16. Michel Foucault, *The Archaeology of Knowledge* (1969; tr. Alan Sheridan, New York 1972): 128; cf. Morris 1994: 27.

17. Friedrich Nietzsche, "On Truth and Lies in a Nonmoral Sense," in *Philosophy and Truth: Selections from Nietzsche's Notebooks of the Early 1870s* (ed. and tr. Daniel Breazeale, Atlantic Highlands, N.J., 1979): 85.

18. For naturalism as positivism's correlate see Jay 1993: 137, 146–47; cf. Neer 2002: 28–30.

19. Compare, more spectacularly, the Laokoon, whose status as the supreme irritant is well summarized by Beard and Henderson 2001: 65–82.

20. Plato, *Philebos* 49b–d; on the fear of death in battle, see Stewart 1997: 91–92.

21. Cf. Dover 1974: 116–29 on "understanding."

22. Polybios 5.77.2, 78.1–5; Livy 38.18.1.

ESSAY: THE PEDESTALS AND THE AKROPOLIS SOUTH WALL

1. E. Hansen, "Versetzen von Baugliedern am griechischen Tempel," in Adolf Hoffmann et al. (eds.), *Bautechnik der Antike* (Mainz 1991): 72–79.

2. Likewise horses and other animals, if included.

3. Though the projection of the figures and the positioning of their presumed tenons could be improved, and the tops of Γ12 and 13 need to be made accessible for study.

4. The southern unused strip resulted from the need to accommodate the preexisting shrine and cult image of Athena Ergane within the Parthenon's north colonnade, which in turn determined the location of every longitudinal element of the temple's plan. The eastern one was left in order not to cramp

the already narrow passage around the temple's northeast corner any further.

5. It was first discussed by Penrose 1851/1888: 19 ("external pavement in front of the Parthenon"), pl. 9 (section at left-hand side: "Line of pavement, originally in front of Parthenon"); cf. also pl. 16; see also the section of the south krepis and subbasement in Karl Bötticher's *Untersuchungen auf der Akropolis* (Berlin 1863).

6. The rock-cut steps were discovered soon after the middle of the nineteenth century after the removal of the large cistern built against them in late antiquity. For the first detailed measurements and drawing by Robert Koldewey in 1883, see Bundgaard 1974: pls. 182–84; the first detailed study and restored section by Stevens 1940: 24–40, fig. 21; for a different, less probable restoration with a solid wall along the upper part, see Kavvadias and Kawerau 1906; William B. Dinsmoor, "The Hekatompedon on the Athenian Acropolis," *AJA* 51 (1947): 109–51, at 135–36, nn. 141–42, fig. 5; for the curvature of the steps, see Manolis Korres, "Refinements of Refinements," in Lothar Haselberger (ed.), *Appearance and Essence: Refinements of Classical Architecture* (Philadelphia 1999): 85–92 (with relevant literature), figs. 3.10–3.14.

7. Stevens 1936: 480–81 (retaining wall parallel to the street and not to the Parthenon); Bundgaard 1976: pl. K prefers a stepped retaining wall (similar to the one on the west side) parallel to and contemporaneous with the Parthenon (his period 5) and following the street; the eastward ascent of the street lessens the number and width of the steps. See Korres, "Refinements of Refinements," 86, for visual corrections.

8. Marie-Christine Hellmann and Philippe Fraisse (eds.), *Paris–Rome–Athènes: Grèce des architectes français aux XIX*e *et XX*e *siècles* (Paris 1982): 256, no. 5 (state plan), 257, no. 6 (restored plan) (originals are at 1:200 scale).

9. Dörpfeld 1902: 385, figs. 2, 3.

10. Stevens 1940: 44.

11. Ibid.: 43, figs. 33, 36.

12. Travlos 1971: fig. 91.

13. Bundgaard 1976: 14, pl. B. Bundgaard presented a sequence of five plans that divided the landscaping and construction on the Acropolis into five periods, as follows: (1) before 479 BC; (2) 479–454; (3) 454–448; (4) 448–438; (5) 438–434; he dated wall S2 to his period 2.

14. Bundgaard 1976: pl. K.

15. Ibid.: pl. K, period 5.

16. Kavvadias and Kawerau 1906: pl. Z´; Bundgaard 1974: 20–21.

17. Bundgaard 1974: pl. 157.

18. Ibid.: figs. 51, 52, 53 (DAI photographs).

19. Ludwig Ross, "Berichte von den Ausgrabung der Akropolis von Athen," *Tübinger Kunstblätter* 1835, no. 31: 121–22; reprinted in Ross, *Archäologische Aufsätze* (Leipzig 1855): 88–92, pl. 5; Schaubert's section ". . . was in 1888, as it remains today, the only record of the three metres at the top of the fill which had been removed in the meantime . . ." (Bundgaard 1974: 19).

20. All these interventions are relatively recent, for around 1480 a Venetian traveler described the South Wall as ashlar masonry: E. Ziebarth, "Ein griechischer Reisebericht des fünfzehnten Jahrhunderts," *AM* 24 (1899): 72–88; Luigi Beschi,

"L'Anonimo Ambrosiano: un itinerario in Grecia di Urbano Boliziano," *Atti della Accademia Nazionale dei Lincei: Rendiconti* 39 (1984): 3–22. For reports of and observations on repairs to the Akropolis' walls, see Manolis Korres, "Der Parthenon bis 1687: Reparatur – Kirche-Moschee-Pulvermagazin," in Hayo Heinrich (ed.), *Die Explosion des Parthenon: Eine Ausstellung des Kulturministeriums Griechenlands, 23 Juni–23 September 1990* (Berlin 1990): 17–32, at p. 33; N. Ambraseys and C. Finkel, "The Seismicity of the Eastern Mediterranean during the Turn of the Eighteenth Century," *Istanbuler Mitteilungen* 42 (1992): 323–43; Manolis Korres, "Seismic Damage to the Monuments of the Athenian Acropolis," in S. Stiros and R. E. Jones (eds.), *Archaeoseismology* (Athens 1996): 69–74, at 73; for the positions of the buttresses according to Kawerau's measurements, see Bundgaard 1974: pl. 136.

21. Penrose 1851/1888: 3.

22. The basic structure of the eastern half of the top of this stretch, ca. 42 m long, was shown cleaned in Lambert's large state plan in 1877; a smaller part of the same, ca. 20 m long, ending at the southeast outer corner, was drawn by N. Toganides in 1984.

23. Kawerau in Kavvadias and Kawerau 1906: 116.

24. Bundgaard 1974: pl. 145,1. In 1989 the visible part of the inner extension in the museum's entrance court (now encased by protective sheeting), was drawn by P. Koufopoulos.

25. Ibid.: pls. 172–74.

26. Ibid.: figs. 81–84, 86–94 (DAI photographs), pl. 194.

27. Theodor Wiegand, *Die archaische Poros-architektur der Akropolis zu Athen* (Leipzig 1904): passim; also the recent, largely unpublished study by Immo Beyer.

28. For the terminology see *IG* ii².463, lines 55, 59; 29 2.8.17.

29. The highest course would have been of headers in order to stabilize the parapet. The use of a single but very wide (ca. 1 m) row of stretchers along the Brauroneion and the westernmost 10 m of the Chalkotheke is exceptional.

30. Manolis Korres, "On the North Acropolis Wall," in Maria Stamatopoulou and Maria Yerolanou (eds.), *Excavating Classical Culture* (Oxford 2002): 179–86. More serious complications arise concerning its relation to the North Wall, for while some attribute both walls entirely to Kimon, others give large parts of them to Perikles. But this particular problem is extraneous to the present essay.

31. Manolis Korres, "Die Athena-Tempel auf den Akropolis," in Hoepfner 1997a: 218–43.

32. Bungaard 1974: 26–27 explains its great thickness here as the result of the preexisting Mycenean Akropolis wall on the same site (see also Bundgaard 1976: pl. K1, against Spyridon E. Iakovides, *He Mykenaike Akropolis ton Athenon* (Athens 1962): 161, figs. 33, 38.

33. Stevens 1940: 13, fig. 6, point (a); in fig. 10 he rightly explains a cutting in the Chalkotheke area as part of a slipway for construction on the southern part of the Akropolis, the Wall in particular.

34. Since no records have been kept of the South Wall's interior face, to ascertain their sizes and construction sequence will be the aim of a forthcoming documentation campaign.

35. A. Lindenlauf, "Der Perserschutt der Athener Akrop-

olis," in Hoepfner 1997a: 46–115, with reference to a possible dating of the South Wall's lowest part before Kimon; see also Korres, "Die Athena-Tempel auf den Akropolis," p. 225.

36. Kawerau, in Kavaddias and Kawerau 1906: 118 states that both the South and East Walls were built together.

37. Michaelis 1877: 14: "... bei einer Höhe der Basis von beispielsweise vier, der Brustwehr von fünf oder sechs Fuss..."; Judeich 1931: 211 n. 2; Hölscher 1985: 126 n. 39. [But cf. the evidence from Lucian's *Piscator* discussed in Chapter 4, §1 – AS.] On the North Wall see Korres, "On the North Acropolis Wall."

38. W. Dörpfeld, "Die Propyläen der Akropolis von Athen II," *AM* 10 (1885): 131–44, at p. 139, dating this addition to the sixth century BC; see also Kavaddias and Kawerau 1906: 130. On the base of astronomical-cultural considerations, W. B. Dinsmoor, "Archaeology and Astronomy," *Proceedings of the American Philosophical Society* 80 (1939): 156–62, fig. 10, restored a highly improbable wall rising many meters above the roof of the southwest wing; equally improbable is Stevens's belief (1936: 26) that the Brauroneion's western wall was higher than its southern one. He also believed that a ring road unobstructed by steps was necessary for the Akropolis' defense. In his plans (1936: figs. 20, 22) the stoa of the Brauroneion is not parallel to the South Wall, and the restoration of a separate parapet appears justified, but in fact it was exactly parallel to it. He was using Kawerau's plan (his fig. 10), where the stoa's east side is erroneously not placed at right angles to the South Wall. Furthermore, no distinct foundation for a separate Brauroneion wall has been found inside the South Wall, and the latter is too thin at this point to carry both it and the parapet. True, foundations of lightly constructed outer walls and partitions were made of well-compacted fills of stone chips: the justification for the 1985 plan reproduced in M. Korres, G. A. Panetsos, and T. Seki (eds.), *The Parthenon: Architecture and Conservation* (Athens 1996): 11, fig. 1. But it is more probable that the stoa's wall was identical with or replaced the high parapet, as supposed by Kawerau in Kavvadias and Kawerau 1906: 142. The isolated piece of foundation near the South Wall's western end (Kavvadias and Kawerau 1906: 85, pl. H; Stevens 1936: 457, fig. 10 at J) could be interpreted as an inner extension similar to the one at the Wall's eastern end (see §8).

It is perhaps no coincidence that the highest point of the southwest wing's roof already mentioned as a lower limit for the Brauroneion precinct wall exactly corresponds to the South Wall's highest course stretching from the angle to the southeast corner.

39. Bundgaard 1974: pl. 174 (highest course preserved).

40. Penrose 1851/1888: 2: "At this point twenty-nine courses remain, making a height of 45 feet"; see also Judeich 1931: 210.

41. Kavvadias and Kawerau 1906: 115.

42. Ibid.: pl. O; Bundgaard 1974: figs. 63–64 (DAI photographs), pl. 163,1; Bundgaard 1976: pl. C.

43. Bundgaard 1974: pl. 145.

44. In places the maximum settlement is 30 cm and the inward slope averages 1 in 21 (5.5%).

45. Bundgaard 1974: fig. 50.

46. Ibid.: figs. 54, 63, 64. Does this mean that the Ergasterion antedates the wide summit? Kawerau's drawings offer nothing to help resolve this question.

47. The extension's subsidence makes this explanation the least probable; see also Kavvadias and Kawerau 1906: 116.

48. Ibid.

49. Dörpfeld 1902: 401: "... erst nach Fertigstellung des jüngeren Parthenon, als die kimonische Südmauer erhöht und verbreitert wurde ..."; Rudolf Heberdey, *Altattische Porosskulptur* (Vienna 1919): 234; Judeich 1931: 209.

50. After Dörpfeld 1902: 394, fig. 3. For an analysis of the stratigraphy south of the Parthenon see Lindenlauf, "Der Perserschutt der Athener Akropolis," 55–69; cf. Kavvadias and Kawerau 1906: 58.

51. Plan corrected in Bundgaard 1976: pl. A. This stratigraphy also dates the Ergasterion (building VI) later than the main part of the temple's construction; perhaps it was built for its pedimental sculpture.

52. The basic angle of the South Wall to the East Wall is 71.5 degrees. To strengthen the corner and soften the angle, the corner of the wall is beveled by 6.5 degrees over a length of ca. 13 m on the south and by 12 degrees over a length of just 4 m on the east, increasing the angle at the corner to 90 degrees and enabling the use of normal (right-angled) corner stones. The uppermost corner stone has an angle of 78 degrees and so probably belongs to the transition from the beveled part to the main section of the East Wall. The lowest visible course of the inner extension along the East Wall corresponds to the second course of the South Wall's inner extension.

53. In the mid-eighteenth-century illustrations (James Stuart and Nicholas Revett, *The Antiquities of Athens*, 4 vols. [London 1762–1816]; Julien-David LeRoy, *Ruines des plus beaux monuments de la Grèce* [Paris 1758]) the collapsed part is still in ruins.

54. Contrast, e.g., Martin L. D'Ooge, *The Acropolis of Athens* (London 1908): 294: "The southeast corner of the Acropolis appears to have been considerably higher in ancient days, possibly as high as the roof of the modern museum, forming a large plateau." This should have been the section of the Wall that remained open and led to the employment of Kallikrates to make a temporary barrier to deter thieves (*IG* i^2 44). Judeich's assumption (1931: 78, 211) that this decree refers to part of the Kimonian Wall that had had to be temporarily removed to facilitate transport of materials for the Parthenon is impossible, as is Bundgaard's theory that a large part of the South Wall was first built – from the ground up – in late Periklean times (Bundgaard 1976: pl. K, period 5).

55. Pandion: *IG* ii^2 1136, 8; 1144, 9; 1148, 13; 1152, 12 (inscriptions of Pandionis); Pausanias I.5.4; Michaelis 1901: pl. 7, no. 31: "eiusdem aedificii bipartiti uestigia"; Gorham P. Stevens, "The Northeast Corner of the Parthenon," *Hesperia* 15 (1946): 1–25, at pp. 21–25, accepted this identification and restored it as a double precinct with propylon. A small part of its south wall, uncovered before 1847, is noted as a "Piraean stone wall" in Penrose's plan (1851/1888: pl. 2; here fig. 26a). Kavvadias and Kawerau 1906: 98 and Bundgaard 1976: 76 identified it as the workshop for the *Older* Parthenon; Stevens 1940: 46 n. 28 originally agreed; see also Ida C. T. Hill, *The Ancient City of Athens* (London 1953): 146; Hurwit 1999: 188–89. On the material discovered within it in 1864–65, see Hurwit, "The Kritios Boy," *AJA* 93 (1989), 41–80, at pp. 44–48, 62–63, n. 74.

56. Like other post-Herulian fortifications, it made extensive use of architectural members taken from other buildings.

57. Penrose 1851/1888: 3; Beulé 1854: 212 describes his "two plain marble slabs" as "... des assises en marbre de l'Hymette...."

58. Penrose 1851/1888: pl. 2.

59. "Elles ne s'étaient point sur le mur lui même ... mais probablement des grands piédestaux ... ces piédestaux étaient appliqués au mur de la fortresse et peut-être plus élevés": Beulé 1854: 211–12 n. 1, without mentioning Ross or Penrose. Since his plan was drawn by the excellent architect Prosper Desbuisson, who was in Athens in 1848, the inaccuracies must be attributed to its limited purpose.

60. Gottfried Semper, "Briefe aus der Schweiz: Die neben den Propylaeen aufgefundenen Inschrifttafeln," *Deutsches Kunstblatt* 6 (1855): no. 38; republished in his *Kleine Schriften* (Berlin and Stuttgart 1884): 130, fig 1.

61. "... es möchte dieses Bathron das erste sein welches die Reihe nach Osten hin begann ... Erzgruppen mit geringer Intervalle ...": Bötticher, *Untersuchungen auf der Akropolis*, 98–99, without mentioning Ross, Penrose, or Beulé.

62. "... Karl Boetticher glaubte in ihnen das Fundament des am meisten nach Westen gelegenen Bathrons gefunden zu haben. Bei dem gegenwärtigen Zustände Schlüsse auf die einstige Anordnung der Figuren ziehen zu wollen, würde voreilig sein": A. Bötticher, *Die Akropolis von Athen* (Berlin 1888): 279, also without mentioning Ross, Penrose, or Beulé.

63. E.g., Martin Schede, *Die Burg von Athen* (Berlin 1922): fig. 1.

64. Mostly column drums found by Ross in 1835–36; shifted in 1864 when the museum was begun and again during the Great Excavation in 1888, they reached their present position when the museum extension was built.

65. DAI photograph in Bundgaard 1974: fig. 23 (the marble block in front of the man).

66. Because the cornice blocks functioned as wall architraves, their lower fasciae had to overhang the face of the wall slightly.

67. These blocks bear conspicuous evidence of reuse in the Christian Parthenon's presbyterium, where they formed the base of the baldacchino (eleventh century AD?). They must have been removed from there in the 1860s.

68. This almost exactly corresponds to the intentional rise of the Parthenon's south side toward the west with a gradient of ca. 5 cm in 70 m.

69. "Non avrà superato l'altezza di un uomo ..." (Brunn 1870: 316); "... bei einer Höhe der Basis von beispielsweise vier ... Fuss ..." (Michaelis 1877: 14). The rediscovery of the pedestals means, of course, that the figures cannot have stood directly (and dramatically) on the ground or directly on the parapet (see Figures 89–90).

70. Several flat blocks 79 cm wide are lying around in the same area but cannot belong to our pedestals. They are stelelike blocks of Hymettan marble, ca. 143 cm tall, measuring 20 × 79 cm below and 18 × 20 cm above.

71. The orthostates' peculiar construction was the most suitable for the marble used, enabling economy in quarrying, transport, and handling during carving and positioning.

If the pedestals' total length was 100 m or slightly more, the monument could have consisted of the following: 80 base blocks (weighing ca. 800 kg each), 160 orthostate stretchers (ca. 700 kg each), 80 orthostate headers (ca. 450 kg each), 80 horizontal wall blocks (ca. 550 kg each), 80 entablature blocks (ca. 1,250 kg each), 600–800 iron clamps, and up to 660 dowels; i.e., 480 blocks in toto, weighing 350 tonnes (420 tonnes at the quarry and on the wagons), ca. 400 kg of iron, and ca. 1,200 kg of lead. Quarrying and preliminary shaping could have taken two masons between one and six days per block, depending upon each block's size and complexity; i.e. (averaging three days per block), 2,700 man-days in toto, plus casual hires. Transport could have taken forty to sixty days with two to four wagons of two to three tonnes capacity, involving one to two dozen mules and as many people, or around a hundred days with only one wagon, involving six mules and as many people: i.e., 1,400 day wages in toto plus the hire and maintenance of the vehicles. Hauling them up the ramp to the Akropolis could have been effected by making the cars counterweight each other, using strong tow ropes and tackles. The final dressing of the stone could have taken seven man-days for each base block; the same for each horizontal wall block; three man-days for each orthostate; and twenty man-days for each entablature block: i.e., 3,600 man-days in toto, or one year for two eight-man teams (feast days included). Two four-man teams could have assembled the monument at two to four blocks a day each; so each pedestal would have taken twenty-five to forty days to build, and the monument 700–1,000 man-days in toto. In sum, the four pedestals would have consumed 8,500 man-days plus casual hires (perhaps equivalent to one tenth of the total). For comparison, an exterior column of the Parthenon contains about the same amount of marble as one of the pedestals, and would have required double the amount of labor needed for all four of them combined!

72. Attached to the parapet: Brunn 1870: 316: "... fosse posta all'aria libera, sia tra I merli, sia sopra al muro stesso..."; Jane E. Harrison in Margaret de G. Verrall and Harrison, *Mythology and Monuments of Ancient Athens* (London 1890): 475: "... against the outside of the Acropolis wall..."; Schede, *Die Burg von Athen*, 120: "... hard an der Mauer Aufstellung fanden..."; Schober 1939: 88, "... in der Nähe der Südmauer in der Gegend des jetzigen Museums..."; Andreae 1993: 97–98, pl. 16: on the parapet. Freestanding: Penrose 1851/1888: 3; Beulé 1854: 211–12 n. 1; Michaelis 1877: 14: "... als Standort der Statuen müssen Basen gelten, welche sich an der Burgmauer hinzogen"; D'Ooge, *Acropolis of Athens*: 295: "... close to the South Wall...."

73. E.g., Harrison in Verrall and Harrison, *Mythology and Monuments*, 475: "they seem in some cases to have been composed for a side view only"; Hölscher 1985: 123–28; etc.

74. My own long experience on the Akropolis and a wealth of information (archival and oral) about storms there also contradict this story as Plutarch reports it. Michaelis 1877: 13 judiciously cites the 1852 tornado, in which one column of the Olympieion and several of the Erechtheion collapsed. Yet strong as it was, this storm served only as the trigger for these columns' collapse. Though it induced motion at the columns' resonant frequencies, they actually fell for quite different reasons. In the

former case a foundation block had been severely damaged by centuries of water seepage; in the latter, the columns had been restored poorly. A bronze statue, though hollow, is heavy and rigid enough to withstand even a tornado if fastened with tenons set in leaded sockets so that it and its base behave as a single rigid body. A statue fastened with three tenons in a triangular configuration, as on the Attalid Dedication (see Figure 279), would be absolutely secure; one fastened with two would fall only if wrenched back and forth over time, progressively weakening the tenons. Contemporary statues, usually fastened with screws and with some degree of tolerance in the joints, are much more vulnerable.

75. Provided that the capping element were omitted and the parapet proper consisted of two 1.5-foot-high courses (like most of the standard courses in this wall).

76. Other possibilities, all too hypothetical to be discussed here, include the following: (1) the pedestals' plinths were two-stepped (some candidates for a lower step do exist); (2) the still-missing course above the orthostates was higher than estimated; (3) the Parthenon terrace terminated at a low retaining wall along the inner extension's northern face, so that the monument stood in a kind of trench; (4) the parapet was higher and/or the monument stood right up against it (so the Hymettan slabs seen by Penrose would indeed have belonged to its a lower step, as suspected earlier in this section).

BIBLIOGRAPHY

Ajello, Rafaelle, Francis Haskell, and Carlo Gasparri. 1988. *Classicismo d'età romana: La collezione Farnese.* Naples.
Aldrovandi, M. Ulisse. 1556/1558 (2nd ed.). *Delle statue antiche che per tutta Roma, in diverse luoghi, et case si veggono.* In Lucio Mauro, *Le Antichità della città di Roma brevissimamente raccolte.* Venice. Printed from a MS completed in 1550.
Allen, R. E. 1983. *The Attalid Kingdom: A Constitutional History.* Oxford.
Ames-Lewis, Francis. 1986. *The Draftsman Raphael.* New Haven.
Andreae, Bernard. 1956/1973 (2nd ed.). *Motivgeschichtliche Untersuchungen zu den römischen Schlachtsarkophagen.* Berlin.
Andreae, Bernard. 1968–69. "Imitazione e originalità nei sarcophagi Romani." *RPAA* 41: 145–66.
Andreae, Bernard. 1980. "Antisthenes Philosophos Phyromachos Epoiei." In *Eikones: Studien zum griechischen und römischen Bildnis, Hans Jucker zum sechzigsten Geburtstag gewidmet.* Pp. 40–48. Basel. (*AntK*, Beiheft 12.)
Andreae, Bernard (ed.). 1990. *Phyromachosprobleme.* Berlin. (*RM Ergänzungsheft* 31.)
Andreae, Bernard. 1993. "Laurea Coronatur. Der Lorbeerkranz des Asklepios und die Attaliden von Pergamon." *RM* 100: 83–106.
Andreae, Bernard. 1998. *Schönheit des Realismus: Auftraggeber, Schöpfer, Betrachter hellenistischer Plastik.* Mainz.
Andreae, Bernard. 2001. *Skulptur des Hellenismus.* Munich.
Anti, Carlo. 1930. *Il Regio Museo Archeologico nel Palazzo Reale di Venezia.* Rome.
Bal, Mieke. 1999. *Quoting Caravaggio: Contemporary Art, Preposterous History.* Chicago.
Bal, Mieke, Jonathan Crewe, and Leo Spitzer (eds.). 1999. *Acts of Memory: Cultural Recall in the Present.* Hanover, N.H., and London.

Barbantani, Silvia. 2001. *Phatis Nikephoros: Frammenti di elegia encomiastica nell'età delle Guerre Galatiche – Supplementum Hellenisticum 958 e 969.* Milan.
Barkan, Leonard. 1999. *Unearthing the Past: Archaeology and Aesthetics in the Making of Renaissance Culture.* New Haven.
Barton, Carlin A. 2001. *Roman Honor: The Fire in the Bones.* Berkeley and Los Angeles.
Baxandall, Michael. 1985. *Patterns of Intention.* New Haven.
Beard, Mary, and John Henderson. 2001. *Classical Art: From Greece to Rome.* Oxford.
Benndorf, Otto. 1876. "Bemerkungen zur griechischen Kunstgeschichte IV: Zu den Galliern des Attalos." *AM* 1 (1876): 167–71.
Bernari, Carlo. 1970. *L'opera completa di Tintoretto.* Milan.
Beulé, Charles E. 1854. *L'Acropole d'Athènes.* Paris.
Bieber, Margarete. 1961. *The Sculpture of the Hellenistic Age.* New York. 2nd ed.
Bienkowski, Piotr R. von. 1908. *Die Darstellungen der Gallier in der hellenistischen Kunst.* Vienna.
Bienkowski, Piotr R. von. 1928. *Les Celtes dans les arts mineurs gréco-romains.* Cracow.
Birley, Anthony R. 1997. *Hadrian: The Restless Emperor.* London and New York.
Bittner, Stefan. 1985. *Tracht und Bewaffnung des persischen Heeres zur Zeit der Achaimeniden.* Munich.
Boardman, John. 1985. *Greek Sculpture: The Classical Period.* London.
Boardman, John. 1995. *Greek Sculpture: The Late Classical Period.* London.
Bober, Phyllis P. 1957. *Drawings after the Antique by Amico Aspertini: Sketchbooks in the British Museum.* London. (*Studies of the Warburg Institute* 21.)
Bober, Phyllis P., and Ruth Rubinstein. 1986. *Renaissance Artists and Antique Sculpture: A Handbook of Sources.* London and Oxford.

Bohn, Richard. 1885. *Das Heiligtum der Athena Polias Nikephoros*. Berlin. (*AvP* 2.)
Bol, Peter C. (ed.). 1999. *Hellenistische Gruppen: Gedenkschrift für Andreas Linfert*. Mainz.
Boucher, Bruce. 1991. *The Sculpture of Jacopo Sansovino*. New Haven and London. 2 vols.
Brendel, Otto J. 1955. "Borrowings from Ancient Art by Titian." *ArtB* 37: 113–25.
Brendel, Otto J. 1967. "A Kneeling Persian: Migrations of a Motif." In Douglas Fraser, Howard Hibbard, and Milton J. Lewine (eds.), *Essays in the History of Art Presented to Rudolph Wittkower*. Pp. 62–70. London.
Bringmann, Klaus. 2000. *Geben und Nehmen: Monarchische Wohltätigkeit und Selbstdarstellungen im Zeitalter des Hellenismus*. Berlin. (Bringmann and von Steuben [eds.] 1995–2000: vol. 2.1.)
Bringmann, Klaus, and Hans von Steuben. 1995. *Schenkungen hellenistischer Herrscher an griechische Städte und Heiligtümer: Zeugnisse und Kommentare*. Berlin. (Bringmann and von Steuben [eds.] 1995–2000: vol. 1.)
Bringmann, Klaus, and Hans von Steuben (eds.). 1995–2000. *Schenkungen hellenistischer Herrscher an griechische Städte und Heiligtümer*. Berlin. 3 vols.
Brunn, Heinrich. 1870. "I doni di Attalo." *Annali dell'Istituto di Corrispondenza Archeologica*, 292–323 (= Brunn, *Kleine Schriften* ii [Leipzig–Berlin 1905]: 411–30).
Bundgaard, Jens A. 1974. *The Excavation of the Athenian Akropolis*. Copenhagen.
Bundgaard, Jens A. 1976. *The Parthenon and the Mycenaean City on the Heights*. Copenhagen.
Carpenter, Rhys. 1960. *Greek Sculpture: A Critical Review*. Chicago.
Cima, Maddalena, and Eugenio La Rocca (eds.). 1998. *Horti Romani*. Rome. (*Bullettino della Commissione archeologica communale di Roma*, Supplementi 6.)
Clarac, Charles, comte de. 1851. *Musée de sculpture antique et moderne*. Volume 5. Paris.
Coarelli, Filippo. 2000. *The Column of Trajan*. Rome.
Cohen, Charles E. *The Art of Giovanni Antonio da Pordenone: Between Dialect and Language*. 2 vols. Cambridge, 1996.
Collingwood, R. G. 1946. *The Idea of History*. Oxford.
Culley, G. R. 1975. "The Restoration of Sanctuaries in Attica, IG ii², 1035," *Hesperia* 44: 207–23.
Curtius, Ludwig. 1954. "Wirkung in die Ferne." In Reinhard Lullies (ed.), *Neue Beiträge zur klassischen Altertumswissenschaft: Festschrift für Bernhard Schweitzer*. Pp. 378–80. Stuttgart.
Dacos, Nicole. 1977/1986 (2nd ed.). *Le logge di Raffaello: Maestro e bottega di fronte all'antico*. Rome.
Davidson, Bernice F. 1985. *Raphael's Bible: A Study of the Vatican Logge*. University Park and London.
de Franciscis, Alfonso. 1946. "Restauri di Carlo Albacini a statue del Museo Nazionale di Napoli." *Samnium* 19: 96–110.
de Grummond, Nancy, and Brunilde Ridgway (eds.). 2000. *From Pergamon to Sperlonga*. Berkeley and Los Angeles.
della Seta, Alessandro. 1930. *Il nudo dell'arte*. Rome.
Desnier, Jean Luc. 1991. "Le Gaulois dans imaginaire monétaire de la république romain: Images plurielles d'une réalité singulaire," *Mélanges des Écoles françaises d'Athènes et de Rome* 103: 605–54.
Dinsmoor, William B. 1920. "The Monument of Agrippa at Athens." *AJA* 24: 83.
Dörpfeld, Wilhelm. 1902. "Die Zeit des älteren Parthenon." *AM* 27: 379–416.
Dohrn, Tobias. 1961. "Pergamenisches in Etrurien." *RM* 68: 1–8.
Dover, Kenneth J. 1974. *Greek Popular Morality in the Time of Plato and Aristotle*. Berkeley and Los Angeles.
Dreyfus, Renée, and Ellen Schraudolph (eds.). 1996. *Pergamon: The Telephos Frieze from the Great Altar*. Volume 1. San Francisco.
Dreyfus, Renée, and Ellen Schraudolph (eds.). 1997. *Pergamon: The Telephos Frieze from the Great Altar*. Volume 2. Austin.
Duhn, Fritz von. 1885. "Paul von Limbourgs Paradies." In *Gesammelte Studien zur Kunstgeschichte (Festgabe für Anton Springer)*. Pp. 1–7. Leipzig.
Dussler, Luitpold. 1971. *Raphael: A Critical Catalogue of His Pictures, Wall-Paintings, and Tapestries*. London and New York.
Eco, Umberto, and Thomas A. Sebeok (eds.). 1983. *The Sign of Three*. Bloomington, Ind.
Faraone, Christopher. 1992. *Talismans and Trojan Horses: Guardian Statues in Ancient Greek Myth and Ritual*. Oxford.
Farnell, Lewis R. 1890. "Various Works in the Pergamene Style." *JHS* 11: 181–209.
Favaretto, Irene. 1990. *Arte antica e cultura antiquaria nelle collezioni venete al tempo della Serenissima*. Rome.
Fehl, Philipp. 1992. *Decorum and Wit: The Poetry of Venetian Painting*. Vienna 1992.
Ferguson, William S. 1911. *Hellenistic Athens*. London.
Fox, Stephen P. 1990. "Gli 'Orazi e Curiazi' del Palazzo Madama: Fortuna di un tipo iconografico." *Xenia* 20: 105–19.
Fränkel, Max, ed. 1890. *Die Inschriften von Pergamon*, vol. 1. Berlin. (*AvP* 8.1.)
Freedman, Luba. 1997. "The Falling Gaul as Used by Cinquecento Painters in Rome and Venice." *Acta Historiae Artium Academiae Scientarum Hungaricae* 39: 117–30.
Frommel, Christoph Luitpold. 1967–68. *Baldassare Peruzzi als Maler und Zeichner*. (*Römisches Jahrbuch für Kunstgeschichte*, Beiheft 11.)
Gallottini, Angela. 1998. *Le sculture della collezione Giustiniani*. Vol. 1. *Documenti*. Rome.
Gasparri, Carlo. 1980. *Materiali per servire allo studio del Museo Torlonia*. Rome. (*Atti della Accademia Nazionale dei Lincei: Memorie, Classe di Scienze morali, storiche e filologiche*, series 8, vol. 24, fasc. 2.)
Gazda, Elaine K. 1995. "Roman Sculpture and the Ethos of Emulation." *HSCP* 97: 121–56.
Gazda, Elaine K. (ed.). 2002. *The Ancient Art of Emulation: Studies in Artistic Originality and Tradition from the Present to Classical Antiquity*. Ann Arbor.
Gerhard, Eduard. 1850. "Archäologische Thesen." *AZ* 8: 203–04.
Giustiniani, Vincenzo. 1631. *Galleria Giustiniana*. Volume 1. Rome.
Gleason, Maud W. 1995. *Making Men: Sophists and Self-Presentation in Ancient Rome*. Princeton.

Green, Miranda J. (ed.). 1995. *The Celtic World*. London.
Green, Peter. 1990. *Alexander to Actium: The Historical Evolution of the Hellenistic Age*. Berkeley.
Gros, Pierre. 1998. "Le Barbare humanisé, ou les limites de l'humanitas." In Clara Auvray-Asseyas (ed.), *Images Romains*. Pp. 143–59. Paris.
Gruen, Erich S. 1984. *The Hellenistic World and the Coming of Rome*. Berkeley and Los Angeles.
Gruen, Erich S. 2000. "Culture as Policy: The Attalids of Pergamon." In de Grummond and Ridgway 2000: 17–31.
Habich, Georg. 1896. *Die Amazonengruppe des attalischen Weihgeschenks*. Berlin.
Habicht, Christian. 1990. "Athens and the Attalids in the Second Century B.C." *Hesperia* 59: 561–77.
Habicht, Christian. 1995/1997. *Athens from Alexander to Antony*. Cambridge, Mass. Tr. Deborah Lucas Schneider.
Hansen, Esther V. 1971. *The Attalids of Pergamon*. Ithaca, N.Y. 2nd ed. (*Cornell Studies in Classical Philology* 36.)
Hannestad, Lise. 1993. "Greeks and Celts: The Creation of a Myth." In Per Bilde, Troels Engberg-Pedersen, Lise Hannestad, Jan Zahle, and Klaus Randsborg (eds.), *Center and Periphery in the Hellenistic World*. Pp. 15–38. Aarhus.
Harris, Marvin. 1968. *The Rise of Anthropological Theory*. New York.
Harrison, Evelyn B. 1972. "The South Frieze of the Nike Temple and the Marathon Painting in the Painted Stoa." *AJA* 76: 353–78.
Hodder, Ian, Michael Shanks, Alexandra Alexandri, Victor Buchli, and John Carman (eds.). 1995. *Interpreting Archaeology: Finding Meaning in the Past*. London and New York.
Hoepfner, Wolfram (ed.). 1997a. *Kulte und Kultbauten auf der Akropolis*. Berlin.
Hoepfner, Wolfram. 1997b. "Hermogenes und Epigonos." *JdI* 112: 109–48.
Hölscher, Tonio. 1985. "Die Geschlagenen und Ausgelieferten in der Kunst des Hellenismus." *AntK* 28: 120–36.
Hölscher, Tonio (ed.). 2000. *Gegenwelten zu den Kulturen Griechenlands und Roms in der Antike*. Munich.
Horn, Rudolph. 1937. "Hellenistische Köpfe 1: Zur Datierung des 'kleinen attalischen Weihgeschenkes.'" *RM* 52: 140–63.
Hülsen, Christian, and Hermann Egger. 1913–16. *Die römischen Skizzenbücher von Marten van Heemskerck*. Berlin. 3 vols. Repr. 1975.
Hurwit, Jeffrey M. 1999. *The Athenian Akropolis*. Cambridge.
Jauss, Hans Robert. 1982. *Towards an Aesthetic of Reception*. Minneapolis. Tr. Timothy Bakhti.
Jay, Martin. 1993. *Downcast Eyes: The Denigration of Vision in Twentieth-Century French Thought*. Berkeley and Los Angeles.
Jestaz, Bertrand, ed. 1994. *Le Palais Farnèse*, iii.3: *L'Inventaire du Palais et des propriétés farnèse à Rome en 1644*. Rome.
Judeich, Walther. 1931. *Topographie von Athen*. Munich. 2nd ed.
Kalveram, Katrin. 1995. *Die Antikensammlung des Kardinals Scipione Borghese*. Worms. (*Römische Studien der Bibliotheca Hertziana* 11.)
Kaminski, Gabriele. 1999. "Amazonen in hellenistischen Gruppen: Überlegungen zur Neapler Amazone des sogennnanten Kleinen attalischen Weihgeschenks." In Bol (ed.) 1999: 95–113.
Kavvadias, Panagiotis, and Georg Kawerau. 1906. *Die Ausgrabung der Akropolis vom Jahre 1885 bis zum Jahre 1890 / He anaskaphe tes Akropoleos apo ton 1885 mechri tou 1890*. Athens. (*Bibliotheke tes en Athenais Archaiologikes Hetaireias* 13.)
Kleiner, Diana E. E. 1992. *Roman Sculpture*. New Haven.
Klügmann, A. 1876. "Zu den attalischen Statuen." *AZ* 34: 35–37.
Koeppel, Gerhard. 1972. "A Roman Terracotta Cantharus with Battle Scenes in Mainz." *Jahrbuch der römisch-germanischen Zentralmuseums Mainz* 19: 188–201.
Koch, Guntram, and Helmut Sichtermann. 1982. *Römische Sarkophagen*. Munich.
Koortbojian, Michael. 1995. *Myth, Meaning, and Memory in Roman Sarcophagi*. Berkeley.
Korres, Manolis. 1994. *Meleti apokatastaseos tou Parthenonos*. Volume 4. Athens.
Korres, Manolis. 2000. "Anathematika kai timetika tethrippa sten Athena kai stous Delphous." *BCH Supplement* 36 (2000): 293–329.
Krahmer, Gerhard. 1927. "Die einansichtige Gruppe und der späthellenistischen Kunst." *Nachrichten von der Gesellschaft der Wissenschaften zu Göttingen, Phil.-Hist. Klasse* 1: 53–91.
Kremer, Bernhard. 1994. *Das Bild der Kelten bis in augusteischer Zeit*. Stuttgart. (*Historia Einzelschriften* 88)
Krierer, Karl R. 1995. *Sieg und Niederlage: Untersuchungen physiognomischer und mimischer Phänomene in Kampfdarstellungen der römischen Plastik*. Vienna.
Kubler, George. 1962. *The Shape of Time: Remarks on the History of Things*. New Haven.
Künzl, Ernst. 1971. *Die Kelten des Epigonos von Pergamon*. Würzburg. (*Beiträge zur Archäologie* 4.)
Kuttner, Ann. 1995. "Republican Rome Looks at Pergamon." *HSCP* 97: 157–78.
Lanciani, Roberto. 1902/1989–2000 (revised, expanded ed.). *Storia degli scavi di Roma*. Rome. 6 vols.
Lanciani, Roberto. 1906. "Il Gruppo dei Niobidi nei giardini di Sallustio." *Bullettino della Commissione Archeologica di Roma* 34: 157–85.
La Rocca, Eugenio. 1994. "Ferocia barbarica: La rappresentazione dei vinti tra Medio Oriente e Roma." *JdI* 109: 1–40.
Lawrence, Arnold W. 1929. *Classical Sculpture*. London.
Leake, William M. 1821/1841 (2nd ed.). *The Topography of Athens and the Demi*. London.
Lippold, Georg. 1923. *Kopien und Umbildungen griechischer Statuen*. Munich.
Lippold, Georg. 1950. *Die griechische Plastik*. Munich. (*Handbuch der Archäologie* III.1.)
Lloyd-Jones, Hugh, and Peter J. Parsons. 1983. *Supplementum Hellenisticum*. Berlin and New York.
Loraux, Nicole. 1981/1986. *The Invention of Athens: The Funeral Oration in the Classical City*. Cambridge, Mass. Tr. Alan Sheridan.
MacDonald, William A., and John Pinto. 1995. *Hadrian's Villa and Its Legacy*. New Haven.
Maderna-Lauter, Caterina. 2000. "Unordnung als Bedrohung: Der Kampf der Giganten gegen die Götter in der Bildkunst

der hellenistischen und römischen Zeit." In Hölscher 2000: 435–66.
Malmberg, W. 1886. "Über zwei Figuren aus dem Weihgeschenke des Attalos." *JdI* 1: 212–14.
Marcadé, Jean. 1969. *Au musée de Délos*. Paris. (*Bibliothèque des Écoles françaises d'Athènes et de Rome* 215.)
Marchand, Suzanne L. 1996. *Down from Olympus: Archaeology and Philhellenism in Germany, 1750–1970*. Princeton.
Marszal, John. 1998. "Tradition and Innovation in Early Pergamene Sculpture." In Palagia and Coulson 1998: 117–27.
Marszal, John. 2000. "Ubiquitous Barbarians: Representations of the Gauls at Pergamon and Elsewhere." In de Grummond and Ridgway (eds.) 2000: 191–234.
Marvin, Miranda. 2002. 'The Ludovisi Barbarians: The Grand Manner." In Gazda (ed.) 2002: 205–23.
Mattei, Marina. 1987. *Il Galata Capitolino*. Rome 1987.
Mayer, Maximilian. 1887. "Amazonengruppe." *JdI* 2: 77–85.
Michaelis, Adolf. 1877. "Bemerkungen zur Periegese der Akropolis von Athen, V–VII." *AM* 2 (1877): 1–37, 85–106.
Michaelis, Adolf. 1882. *Ancient Marbles in Great Britain*. Cambridge.
Michaelis, Adolf. 1893. "Der Schöpfer der attalischen Kampfgruppen." *JdI* 8: 119–34.
Michaelis, Adolf. 1901. *Arx Athenarum a Pausania descripta*. Bonn.
Mikalson, Jon D. 1998. *Religion in Hellenistic Athens*. Berkeley and Los Angeles.
Milchhöfer, Arthur. 1882. "Die Befreiung des Prometheus: Ein Fund aus Pergamon." *Berliner Winckelmannsprogramm* 42.
Moreno, Paolo. 1994. *Scultura ellenistica*. Rome. 2 vols.
Morris, Ian. 1994. "Archaeologies of Greece." In Morris (ed.), *Classical Greece: Ancient Histories and Modern Archaeologies*. Pp. 8–47. Cambridge.
Moscati, Sabatino (ed.). 1991. *I Celti*. Milan.
Neer, Richard T. 2002. *Style and Politics in Athenian Vase-Painting*. Cambridge.
Neudecker, Richard. 1988. *Die Skulpturenausstattung römische Villen in Italien*. Mainz.
Nichols, Tom. 1999. *Tintoretto*. London.
Oberhuber, Konrad. 1999. *Raphael: The Paintings*. New York.
Overbeck, Johannes. 1882. *Geschichte der griechischen Plastik*. Vol. 2. Leipzig. 3rd ed.
Marszal, John. 1998. In Olga Palagia and William D. E. Coulson (eds.), *Regional Schools in Hellenistic Sculpture*. Pp. 117–27. Oxford.
Pallucchini, Rodolfo, and Paola Rossi. 1982. *Tintoretto: Le opere sacre e profane*. Milan.
Palma, Beatrice. 1981. "Il piccolo donario pergameno." *Xenia* 1: 45–84.
Palma, Beatrice. 1984. "Appunti preliminari ad uno studio sul piccolo donario pergameno." In *Alessandria e il mondo greco-romano: Studi in onore di Achille Adriani*. Pp. 772–82. Rome.
Panofsky, Erwin. 1969. *Problems in Titian: Mostly Iconographic*. New York.
Parker, Robert. 1996. *Athenian Religion: A History*. Oxford.
Pedrocco, Filippo. 2001. *Titian: The Complete Paintings*. London.

Penrose, Francis C. 1851/1888 (2nd, enlarged ed.). *The Principles of Athenian Architecture*. London.
Perry, Marilyn. 1978. "Cardinal Domenico Grimani's Legacy to Venice." *JWCI* 41: 215–44.
Perry, Marilyn. 1980. "On Titian's 'Borrowings' from Ancient Art: A Cautionary Case." In *Tiziano e Venezia: Convegno internazionale di studi, Venezia, 1976* (Vicenza 1980): 187–91.
Petersen, Eugen. 1893. "Amazzone madre." *RM* 8: 251–58.
Pietrangeli, Carlo. 1951–52. "Il Museo Pio-Clementino Vaticano." *RPAA* 27: 87–109.
Pietrangeli, Carlo. 1956. Supplement to W. Amelung and G. Lippold, *Die Skulpturen des vatikanischen Museums*, vol. 3.2. P. 556, no. 32. Berlin.
Pietrangeli, Carlo. 1996. *Paintings in the Vatican*. Boston and New York.
Pirson, Felix. 2002. "Vom Kämpfen und Sterben der Kelten in der antiken Kunst." In H.-U. Cain and S. Rieckhoff (eds.), *Fromm-fremd-barbarisch: Die Religion der Kelten*. Mainz. Pp. 71–81.
Polito, Eugenio. 1998. *"Fulgentibus Armis": Introduzione allo studio dei fregi dei armi antichi*. Rome. (*Xenia* monograph 4.)
Polito, Eugenio. 1999. *I Galati vinti: Il trionfo sui barbari da Pergamo a Roma*. Rome.
Pollitt, Jerome J. 1986. *Art in the Hellenistic Age*. Cambridge.
Pozzi, Enrica, Renata Cantilena, Eugenio La Rocca, Ulrico Pannuti, and Lucia Scatozza. 1989. *Le collezioni del Museo Nazionale di Napoli*. Vol. 1.2: *La scultura greco-romana*. Milan.
Queyrel, François. 1989. "Art pergaménien, histoire, collections: Le Perse du Musée d'Aix et le petit ex-voto attalide." *RA* (1989): 253–96.
Queyrel, François. 1992. "Phyromachos: problèmes de style et de datation." *RA* (1992): 367–80.
Reinach, Salomon. 1889. "Les Gaulois dans l'art antique et le sarcophage de la vigne Ammendola: Deuxième article." *RA* 13: 11–22.
Reinach, Salomon. 1894. "L'ex-voto d'Attale et le sculpteur Epigonos." *REG* 7: 37–44.
Ridgway, Brunilde S. 1990. *Hellenistic Sculpture I: The Styles of ca. 331–200 B.C.* Madison.
Ridgway, Brunilde S. 2000. *Hellenistic Sculpture II: The Styles of ca. 200–100 B.C.* Madison.
Ridgway, Brunilde S. 2002. *Hellenistic Sculpture III: The Styles of ca. 100–31 B.C.* Madison.
Riebesell, Christina. 1989. *Die Sammlung des Kardinal Alessandro Farnese. Ein 'studio' für Künstler und Gelehrte*. Weinheim.
Robert, Carl. (ed.). 1890–1939. *Die antiken Sarkophagreliefs*. Berlin. 5 vols.
Rolley, Claude. 1999. *La Sculpture grecque*. Vol. 2. *La période classique*. Paris.
Ruesch, A. 1911. *Guida del Museo Nazionale di Napoli*. Naples.
Sassi, Maria Michela. 1988/2001. *The Science of Man in Ancient Greece*. Chicago and London. Tr. Paul Tucker.
Sauer, Bruno. 1894. "Die tote Amazone des Neapler Museums." *RM* 9: 246–48.
Scarry, Elaine. 1985. *The Body in Pain: The Making and Unmaking of the World*. Oxford.

Schäfer, Thomas. 2000. "Ein Schlachtfries von der Akropolis." *AM* 115: 281–358.

Schalles, Hans-Joachim. 1985. *Untersuchungen zur Kulturpolitik der pergamenischen Herrscher im dritten Jahrhundert v. Chr.* Tübingen. (*Istanbuler Forschungen* 36.)

Schmidt-Dounas, Barbara. 2000. *Geschenke erhalten die Freundschaft: Politik und Selbstdarstellung im Spiegel der Monumente*. Berlin. (Bringmann and von Steuben [eds.] 1995–2000: vol. 2.2.)

Schneider, Rolf M. 1986. *Bunte Barbaren: Orientalenstatuen aus farbigen Marmor in der römischen Representationskunst*. Worms.

Schneider, Rolf M. 1998. "Die Faszination des Feindes: Bilder der Parther und des Orients in Rom." In J. Wiesehöfer (ed.), *Das Partherreich und seine Zeugnisse / The Arsacid Empire: Sources and Documentation*. Pp. 95–146. Stuttgart. (*Historia Einzelschriften* 122.)

Schober, Arnold. 1933. "Zur Amazonengruppe des attalischen Weihgeschenks." *ÖJh* 28: 102–11.

Schober, Arnold. 1938. "Epigonos von Pergamon und die frühpergamenische Kunst." *JdI* 53: 126–49.

Schober, Arnold. 1939. "Zu dem Weihgeschenke eines Attalos in Athen." *RM* 54: 82–98.

Schober, Arnold. 1951. *Die Kunst von Pergamon*. Innsbruck and Vienna.

Settis, Salvatore (ed.). 1984–86. *Memoria dell'antico nell'arte italiana*. Turin. 3 vols.

Settis, Salvatore. (ed.). 1988. *La Colonna Traiana*. Turin.

Shanks, Michael. 1999. *Art and the Early Greek State: An Interpretive Archaeology*. Cambridge.

Shearman, John K. G. 1972. *Raphael's Cartoons in the Collection of Her Majesty the Queen, and the Tapestries for the Sistine Chapel*. London.

Sichtermann, Helmut. 1996. *Kulturgeschichte der klassischen Archäologie*. Munich.

Smith, Roland R. R. 1986. *Hellenistic Royal Portraits*. Oxford.

Smith, Roland R. R. 1991. *Hellenistic Sculpture*. New York.

Spawforth, Anthony. 1994. "Symbol of Unity? The Persian Wars Tradition in the Roman Empire." In S. Hornblower (ed.), *Greek Historiography*. Pp. 233–69. Oxford.

Spinola, Giandomenico. 1996. "Il 'Commodo'-Amazone della Sala degli Animali." *Bollettino dei Monumenti, Musei, e Gallerie Pontificie* 16: 65–91.

Stallybrass, Peter, and Allon White. 1986. *The Politics and Poetics of Transgression*. Ithaca, N.Y.

Steinby, Eva Margareta. 1993–2000. *Lexicon topographicum urbis Romae*. Rome. 6 vols.

Steingräber, Stefan. "Pergamene Influences on Etruscan Hellenistic Art." In de Grummond and Ridgway 2000: 235–54.

Stevens, Gorham P. 1936. "The Periclean Entrance Court of the Acropolis of Athens." *Hesperia* 5: 443–520.

Stevens, Gorham P. 1940. *The Setting of the Periclean Parthenon*. (*Hesperia* Supplement 3.)

Stewart, Andrew. 1979. *Attika: Studies in Athenian Sculpture of the Hellenistic Period* (*JHS* Supplementary Paper 14).

Stewart, Andrew. 1990. *Greek Sculpture: An Exploration*. New Haven.

Stewart, Andrew. 1993. *Faces of Power: Alexander's Image and Hellenistic Politics*. Berkeley and Los Angeles.

Stewart, Andrew. 1997. *Art, Desire, and the Body in Ancient Greece*. Cambridge.

Stewart, Andrew. 2000. "*Pergamo ara marmorea magna*: On the Date, Reconstruction, and Functions of the Great Altar of Pergamon." In de Grummond and Ridgway 2000: 32–57.

Summers, David. 1972. "*Maniera* and Movement: The *Figura Serpentinata*." *Art Quarterly* 35: 269–301.

Tomei, Maria A. 1997. *Museo Palatino*. Milan.

Traversari, Gustavo. 1986. *La statuaria ellenistica del Museo Archeologico di Venezia*. Rome.

Travlos, John. 1971. *Pictorial Dictionary of Ancient Athens*. London.

Vanderpool, Eugene. 1966. "A Monument to the Battle of Marathon." *Hesperia* 35: 93–106.

Vermeule, Cornelius C. 1966. "The Dal Pozzo–Albani Drawings of Classical Antiquities in the Royal Library at Windsor Castle." *Transactions of the American Philosophical Society* n.s. 56.2.

Vermeule, Cornelius C. 1977. *Greek Sculpture and Roman Taste*. Ann Arbor.

Ville, Georges. 1981. *Le Gladiateur en occident des origines à la mort de Domitien*. Paris. (*Bibliothèque des Écoles françaises d'Athènes et de Rome* 245.)

Webb, Pamela. 1996. *Hellenistic Architectural Sculpture*. Madison.

Wenning, Robert. 1978. *Die Galateranatheme Attalos I*. Berlin. (*Pergamenische Forschungen* 4.)

Wethey, Harold E. 1969. *The Paintings of Titian*. London. 3 vols.

Wollheim, Richard. 1980. *Art and Its Objects*. 2nd ed. Cambridge.

Zanker, Paul. 1988. *The Power of Images in the Age of Augustus*. Ann Arbor. Tr. Alan Shapiro.

Zanker, Paul. 1995. *The Mask of Socrates: The Image of the Intellectual in Antiquity*. Berkeley.

Zanker, Paul. 1998. "Die Barbaren, der Kaiser, und die Arena: Bilder der Gewalt in der römischen Kunst." In R. P. Sieferle and H. Breuninger (eds.), *Kulturen der Gewalt: Ritualisierung und Symbolisierung der Gewalt in der Geschichte*. Pp. 53–86. Frankfurt and New York.

Zanker, Paul. 2000. "Die Gegenwelt der Barbaren und die Überhöhung der häuslichen Lebenwelt. Überlegungen zum System der kaiserzeitlichen Bilderwelt." In Hölscher 2000: 409–34.

INDEX OF SOURCES
GREEK, LATIN, AND BIBLICAL

෴ ෴ ෴

Note: An asterisk (*) indicates a quotation in English, however brief; two asterisks (**) indicate a quotation in the original language.

Adamantios, *Physiognomonica* (ed. Foerster)
 1.4 (1: 306F): 319n69
 1.6 (1: 309F): 318n57
 1.7–8 (1: 312–13F): 319n70
 1.11 (1: 317–18, 321F): 319n70
 1.18 (1: 341F): 318nn57,62
 2.1 (1: 348F): 318n55
 2.2 (1: 350F): 319n70
 2.16 (1: 363–64F): 318n60
 2.24 (1: 374F): 318n57
 2.28 (1: 380F): 318n62
 2.29 (1: 380F): 318n62, 319n69
 2.31 (1: 384–85F): 318n66
 2.37 (1: 392–93F): 157*, 318nn57,60,63,66**
 2.47 (1: 412F): 318n57
 2.51 (1: 415F): 318n61
 2.60 (1: 424–25F): 318nn60,62, 319n69
Aemilianus of Nicaea, *see* Palatine Anthology
Aischylos, *The Persians*, 12: 325n63
Alkaios of Messene, *see* Palatine Anthology
Alkiphron, 3.15.4: 331n169*
Anonymous (1), *de Physiognomonica* (ed. Foerster)
 14 (2: 23F): 318n66, 319n68
 18 (2: 29–30F): 318n61
 34 (2: 51–52F): 319n77
 40 (2: 57–58F): 318n54
 91 (2: 120F): 318n61

 97 (2: 122–23F): 318n61
 124 (2: 139F): 318n62
Anonymous (2), *de Physiognomonica* (ed. Foerster)
 8 (2: 228F): 318n62
 14 (2: 229F): 318n57
Anonymus Alexandrinus, *Expositio totius mundi et gentium*, 52: xvii, 13, 24, 36, 192, 288 (AT8)**
Antiphon, 5.31–32: 333n12
Apollodoros
 1.6.1–2: 324n40
 1.34: 329n137
Appian
 Civil Wars, 2.102: 320n98
 Macedonian Wars, 11.4: 324n29
 Mithradatic Wars, 3: 326n79, 327n101
 Syrian Wars, 233–34: 333n219
Aristophanes
 Acharnians, 586: 332n195
 Birds
 553: 324n40
 1249–52: 324n40
 Knights, 732–40: 333n9
 Lysistrata, 677–78: 323n12
 Wasps, 792: 332n195
Aristotle
 Generation of Animals, 1.19, 727a22–25: 319n66
 Nicomachean Ethics, 3.7.7–13, 1115b25–29: 318n65, 331n182, 332n192

 Poetics, 5, 1449a32–36: 319n70, 332n195
 Politics
 1.1.5, 1252b5–9: 325n64
 1.1.12, 1253a27–29: 230*, 332n189
 1.2.14–15, 1254b25–40: 333n12
 6.3.1, 1319b39: 330n159
 7.6.1, 1327b20: 318n66
 7.6.1, 1327b23–26: 325n64
 7.6.1, 1327b27: 318n60
 7.6.1, 1327b29–33: 332n190
 Problems
 10.24, 893b10–17: 318n57
 14.8, 909b9–24: 318n66
 Rhetoric
 1.7.34, 1365a31–33: 333n9
 3.10.7, 1411a1–4: 333n9
[Aristotle], *Physiognomonica* (ed. Foerster)
 9, 806b7 (1: 28F): 318n60
 9, 806b15–16 (1: 18–20F): 318nn60,66
 13, 807a32–33 (1: 26F): 318n63, 319n69
 13, 807b1 (1: 26F): 319n70
 13, 807b5 (1: 28F): 318n60
 14, 807b10–11 (1: 28F): 318nn60,61
 20, 808a8–13 (1: 32F): 318n60
 23, 808a20 (1: 34F): 318n65, 319n69

 23, 808a23 (1: 34F): 318n57
 39, 809a34 (1: 46F): 318n65
 41, 809b19 (1: 48F): 319n70
 41, 809b23 (1: 50F): 318n68
 42, 810a2 (1: 52F): 318n57
 57, 811a4 (1: 62F): 318n60
 59, 811a14 (1: 64F): 318n65
 60, 811a24 (1: 64F): 318n57
 61, 811b3 (1: 66F): 318n65
 62, 811b5 (1: 66F): 318n58
 63, 811b14 (1: 68F): 319n69
 64, 811b29–812a1 (1: 70F): 318n57
 66, 812a10 (1: 72F): 318n62, 319n69
 68, 812b6 (1: 76F): 319n70
 69, 812b35 (1: 80F): 155, 318n59**, 319n68, 325n64**
 73, 814b4 (1: 90F): 318n55
Athenaios
 4, 154a: 321n102, 326n77
 11, 782b: 217*, 328n109
Auctor ad Herennium
 2.7,10: 333n12
 3.5,9: 317n38
 4.45,59: 146*, 316n27**, 317n38
 4.49,62: 160*, 319n72**
Augustus, *Res Gestae*, 23: 320n98
Acts of the Apostles
 3.1–11: 115
 5.1–5: 103
 7.58: 105

Caesar, *Gallic War*
 1.39: 319n70
 1.40.5: 320n98
 2.13: 319n67
 3.8.3: 319nn67,82
 3.10.3: 319n67
 3.19.6: 319n67, 326n73
 3.22.3: 326n77
Cassius Dio, *see* Dio Cassius
Cicero
 Brutus
 51: 331n178
 286: 331n178
 325: 331n178
 de Domo sua, 60: 161, 319n78
 de Finibus, 3.61: 331n184
 de Oratore
 2.58: 331n178
 2.194–95: 321n103
 2.236: 319n70
 2.239: 319n70
 2.266: 152*, 317n48**, 319n70
 Orator
 25: 331n178
 231: 331n178
 Philippics, 3.14.3–5: 309n24
 Topica, 74: 333n12
 Tusculan Disputations,
 2.17.41: 309n24, 321n111
 Verrines
 2.5.3: 321n103
 2.25.32: 321n103
Clement of Alexandria, *Paedagogus* (ed. Foerster), 3.3.24
 (2: 306F): 157*, 318n66**
Curtius (Q. Curtius Rufus),
 8.14.29: 325n61

Demosthenes
 18.67: 321n103
 18.201: 330n159
 22.13 (schol.): 330n146, 331n169*
 30.37: 333n12
 60.8–11: 224, 329n144, 330n158
 60.17: 332n194
 60.18–19: 332n188
 60.27–31: 330n160
Dio Cassius
 12.50.3: 318n65, 319n67, 326n73, 332n194*
 43.23.3: 320n98
 50.15.2: XVII, 36, 68, 72, 182, 188, 196, 198*, 200, 233, 237, 288 (AT7)**
 51.22.4–9: 320n98
 54.7.3: 331n166
 55.10.7: 320n98
 60[61].30.3: 320n99
 61.9.5: 164, 320n99
 61.17.3: 321n102
 62[63].3.1: 321n102
 66.25.1: 165–66*, 321n102
 66.25.3–4: 321n100
 67.8.1–2: 321n100
 67.8.4: 321n102
 68.15.1: 321n100
 68.25.4: 163
 69.1.3: 321n100
 69.2.5–6: 320n85
 69.4.1: 315n17, 322n125
 69.23.2–3: 320nn85,86
 73.20.3: 320n97
 76.16.1: 321n102
Dio Chrysostom
 3.43: 162*
 12.20: 162*, 320n86**
Diodoros Siculus
 3.53–54: 325n53
 3.55.5: 332n214
 4.16.4: 325n54
 4.28.1–4: 325n54
 4.62: 325n55
 5.24–31: 318n65, 331n182, 332nn192,194
 5.28.1–3: 137, 157*, 315n7**, 318n64**, 332n196
 5.30.2: 326n68
 5.30.3: 326n69
 12.70.5: 321n104
 16.89: 329n140
 17.15.2: 330n160
 17.115: 197
 22.9.3: 326n77
 25.13: 326n77
 26–28: 220, 329n126
 29.34: 324n29
 31.35: 326n79, 327n101
 37.1.5: 319n79
Diogenes Laertius
 1.33: 153*, 318n5
 4.60: 329n134
 5.67: 329n134
 10.119–20: 331n184
Dionysios of Halikarnassos
 de Compositione Verborum, 18: 331n178
 On the Ancient Orators, 1–4: 331n178
 Roman Antiquities, 3.12–22: 309n24
Dionysios Skytobrachion (*FGH* 32)
 F6: 325n53
 F7: 332n214

Epiktetos, 2.22.21–22: 163, 320n89**
Euripides
 Helen, 276: 156*, 205*, 325n64
 Hippolytos
 10–11: 325n54
 29–34: 325n55
 304–10: 323n12, 325n54
 1423–30: 325n55

Galen, *de Temperamentis*, 2.6
 (1: 627 Kühn; 2: 288–89 Foerster): 319n66
Genesis, 49.27: 105

Harpokration, *Lexicon*, s.v.
 "Mikon": 332n198

Heliodoros, *Aethiopica*, 3.1–6: 326n81
Herodotos
 4.117: 325n53
 5.95: 321n104
 7.61–96: 325n63
 7.140–42: 331n167
 8.31–38: 327n83
 8.37–39: 324n38
 8.50: 327n83
 8.51–53: 331n167
 8.143–44: 330n150
 9.27: 329n144
Hesychios, *Lexicon*, s.v.
 καταχήνη: 330n165
Hippokrates
 Airs, Waters, Places, 17 (2: 66–68 Littré): 325n53
 Concerning Women, 1.1 (8: 12 Littré): 319n66
 Epidemics, 2.6.19 (5: 136 Littré): 319n66
 On the Nature of Women, 1 (7: 312 Littré): 319n66
Historia Augusta
 Commodus, 9.6: 320n97
 Hadrian
 5.2: 163*, 320n91**
 6.3: 321n100
 7.12: 321n100
 9: 315n17
 10.2: 160*
 19.10: 145, 163*, 315n17
 25.6–7: 320n86
 Maximinus et Balbinus, 8: 309n24, 321n111
Homer
 Iliad
 6.70–71: 321n104
 11.91–121: 321n104
 16.498–500: 321n104
 Odyssey, 20.80: 325n48
Horace
 Epodes, 16.7: 319n70
 Odes
 1.2.22: 161, 319n78
 1.15.21–24: 161, 319n78
 1.21.13–16: 161, 319n78
 2.2.17: 161, 319n78
 2.4.40–80: 319n79
 3.1.6–8: 319n79
Hypereides
 Epitaphios
 4–5: 329n144
 17: 329n139
 20: 329n139
 24: 329n139
 Fragments (ed. Blass), A4: 332n194

Isaios, 8.12: 333n12
Isokrates
 Epistles
 2.5: 330n159
 3.11: 332n190
 Orations
 4.16–18: 332n190
 4.66–72: 329n144
 4.92: 332n188

 8.20: 330n159
 12.13–14: 332n190
 12.163: 230*, 332n189

Josephus, *Jewish Wars*, 6.9.418: 321n100
Justin
 24.8.11: 326n77
 26.2.1–6: 326n77, 329n138
Juvenal, *Satires*
 1.22–23: 321n102
 2.53: 321n102
 6.246–67: 165*, 321n102**
 13.64: 319n70

Kallimachos
 Hymn to Artemis (3), 204: 325n48
 Hymn to Delos (4)
 171–88: 324n38
 183–84: 206*, 230*, 326n69**, 331n182*, 332n194

Livy
 Praefatio 10: 150*, 317n38**
 1.10.4–6: 321n104
 1.24–28: 85, 202
 4.20.2: 321n104
 6.7.3: 319n75**
 7.12.11: 319n67, 326n73, 332n194
 7.26.6: 321n104
 7.26.9: 319n67, 326n73
 10.28.2: 319n67, 326n73, 332n194
 22.51.5–7: 168*
 23.12.14: 321n104
 23.46.14: 321n104
 26–32: 220, 329n126
 26.2: 325n50**
 31.9.1–5: 333n217
 31.15.6: 324n33
 31.15.9–11: 329n126, 332n210
 31.24.18: 222, 329n126**
 31.26.9–12: 222, 329n126**
 31.29.15–16: 332n190
 31.30: 224*, 329n141**, 331n176
 31.44.1–9: 329n126
 31.47.1–2: 329n126
 32.8.9: 333n218
 32.23.13: 329n126
 32.27.1: 333n217
 33.20.3: 329n139
 34.23.1–24.4: 233*, 332n211**
 35.37.4–39.2: 332n206
 35.50.4: 332n206
 37.2–6: 332n213
 38.14: 304n12
 38.17–21: 318n65
 38.17.7: 319n67, 326n73, 332n194
 38.18.1: 241*, 331n179, 333nn6,22
 38.21: 331n185

38.21.4: 326n68
38.21.9–10: 169*, 229*, 321n110**
38.21.14: 319n67, 326n73
38.23.1: 319n67, 326n73
38.23.10: 321n104
38.25.15: 319n67, 326n73
38.27.1: 319n67, 326n73
38.27.9: 332n213
39.22: 68
42.15–16: 324n29
45.27.11–28.1: 333n221
45.39.17: 321n103
Epitome 97: 320n98
Lucan, *Civil War*, 1.33–50: 319n79
Lucian
 Anacharsis, 37: 309n24
 Iuppiter Tragoedus, 33: 315n15
 Piscator
 44: 184–85, 323n6
 47–51: 184–85, 323n6
Luke, 7.1–10: 127
Lykourgos
 Against Leokrates, 29–32: 333n12
 Fragments (ed. Blass), 30: 332n198
Lysias
 2.4–60: 224, 329n144
 2.5: 329n139
 2.21: 329n139
 2.24: 332n188
 2.33: 329n139
 2.47: 329n139
 2.24: 230*

Martial
 de Spectaculis
 3: 164, 320n96**
 6: 165*, 321n102
 7: 321n101
 Epigrams
 2.14.5–6: 315n20
 8.49(50).1–6: 319n79
 8.78.1–6: 319n79
 11.52.17: 319n79
 14.182: 319n70
Matthew
 8.5–13: 127
 17.2–6, 14–15: 110, 114

Orosius, *Historiarum adversos paganos*
 5.16.19: 326n77
 5.24: 320n98
Ovid
 Amores, 2.11.64: 315n23
 Ars Amatoria
 1.73–74: 315n23
 1.166: 169*, 309n24, 321n111**
 1.171–72: 320n98
 Fasti
 1.385: 161, 319n78
 3.430–48: 319n79
 Tristia ex Ponto
 2.69–74: 319n79

2.331–40: 319n79
3.1.61: 315n23

Palatine Anthology
 6.130: 329n138
 7.312: 233, 332n208
 7.623: xvii, 214, 288 (AT4)**
 16.5: 223*, 329n139**, 330n150
 16.265–66: 318n62
Pausanias
 1.2.1: 325n54
 1.2.4: 325n47
 1.4.2–4: 332n201
 1.4.6: 68, 307n102, 321n104, 327n85
 1.5.4: 335n55
 1.6.1: 236, 333n221
 1.7.2: 326n77
 1.8.1: 219, 328n117
 1.13: 321n104, 326n68, 329n138
 1.14.5: 330n146
 1.15: 330n160
 1.15.3: 326n66
 1.18.8–9: 322n134
 1.21.3: 149*, 227*, 316n33, 331n173
 1.22.1–3: 325n55
 1.22.8: 331n171
 1.23.4: 330n166
 1.23.7: 182, 325n48
 1.24.3: 182
 1.24.4–5: 182
 1.24.8: 331n170
 1.25.1: 223, 323n24
 1.25.2: xvii, xviii, 13, 14*, 19, 23, 36, 65*, 68, 72*, 147, 150–51, 152, 181*, 182*, 186, 189, 192*, 200, 204, 210, 213, 218, 219, 220, 222–23*, 269, 288 (AT6)**
 1.25.2–26.3: 182
 1.26.4: 325n48
 1.26.5: 182
 1.29.10, 14: 329n145
 1.32.4: 189*, 323n13
 1.38.5–6: 333n217
 2.30.2: 331n172
 2.32.1–4: 325n55
 3.15.7: 330n164
 5.12.4: 227*, 331n173
 5.24.9: 330n161*
 7.27: 316n36
 8.52.1: 219*
 10.9.7: 328n117
 10.10.1–2: 330n146
 10.11.5–6: 330n146
 10.15.3: 199*, 324n31
 10.19.4: 324n38, 330n146
 10.19.12: 229*, 331n183
 10.19.28: 324n38
 10.20.5: 332n201
 10.20.7: 304n12
 10.21.3: 318n65
 10.21.5: 330n146, 332n201
 10.21.6: 321n104, 327n85
 10.22.3: 228, 331n180

10.22.4: 329n143
10.23.12: 326n77
Persius, Schol. 2.56: 315n24
Petronius, *Satyricon*, 45.7: 321n102
Philostratos the Elder
 Epistles, 1: 321n103
 Imagines, 1.1.2: 318n55
Philostratos the Younger, *Imagines*
 Praefatio 3: 318n55
 Praefatio 6: 317n43
 2: 150
Pindar, *Pythian Odes*, 8.12–18: 324n40
Plato
 Alkibiades I, 132a: 333n9
 Laws, 7,816d–e: 319n70, 332n195
 Menexenos
 239B–242: 224, 329nn139,144
 240E: 330n158
 Philebos
 48c–d: 319n70
 49c–d: 231, 241, 319n70, 332n195, 333n20
 Republic
 5,452d: 332n195
 5,470b–471b: 332n190
 10,596d–e: 308n133
 10,605e: 332n195
 Symposion, 194e–197e: 308n119
[Plato], *Axiochos*
 364d–365a: 325n54
Pliny the Elder, *Natural History*
 1.34: 328n108
 3.39: 152, 317n46**
 6.41: 161*, 319n78**
 7.101–06: 321n103
 8.22: 320n98
 34.24: 70
 34.51–52: 215*, 232*, 304n18, 327n100**, 332n205
 34.52: 62*, 306n67
 34.53: 169, 321n109
 34.54: 333n221
 34.54–67: 65
 34.55–56: 94
 34.62: 315n20
 34.74: 169*
 34.84: xvii, 16*, 17, 23, 24, 36, 68, 207*, 213–14*, 215*, 216–17*, 287 (AT3a)**
 34.85: 217*, 328n109
 34.88: xvii, 36*, 163, 203*, 207*, 213–14*, 217, 288 (AT3b)**, 327n92
 34.90: 217*, 328n109
 35.26: 315n20
 35.67–68: 328n108
 35.98: 203*, 214, 305n45*, 325n52**
 35.104–05: 312n86
 35.135: 215*, 327n102*, 333n221

35.146: 68, 215, 327n102**
36.28: 145*
36.29: 315n20
Pliny the Younger, *Panegyricus on Trajan*
 17.3: 321n104
 33.1: 309n24, 321n111
 52: 320n86
Plutarch
 Antony, 60.4: xvii, 14*, 30, 36, 68, 72, 147, 182*, 188, 196, 198*, 199, 200, 202, 233, 236, 288 (AT5)**
 Aratos
 38: 329n138
 49: 329n140
 51: 329n140
 Coriolanus, 14.1–15.1: 321n103
 Crassus
 8.1: 320n98
 9.5: 320n98
 Flamininus, 11.2–4: 329n139, 330n150, 332n190
 Marius
 23: 319n79
 27.2: 326n77
 Moralia
 184B: 324n29
 276C–D: 321n103
 327A–B: 321n103
 342A–C: 321n103
 489F: 324n29
 650F: 319n66
 997C–E: 309n24
 Perikles, 13.12–13: 330n166
 Pyrrhos, 26.6: 329n143
 Sulla
 13.1: 329n145, 333n221
 14: 332n208
 Themistokles, 10.2: 330n162
 Theseus, 26–27: 325n54
Polemon, *Physiognomonica* (ed. Foerster)
 1 (1: 108–10F): 319n69
 1 (1: 112F): 318n57
 1 (1: 116–18F): 319n70
 1 (1: 120F): 319n70
 1 (1: 136F): 318n57
 1 (1: 148F): 154, 161*, 318nn54,56, 319n77**
 1 (1: 152F): 318nn57,62
 1 (1: 160–62F): 154
 1 (1: 166–68F): 318n55
 2 (1: 174F): 318n62
 25 (1: 226F): 318nn57,62
 27 (1: 230F): 318n57
 28 (1: 232F): 156, 318n62
 29 (1: 234F): 319n69
 31–34 (1: 236–40F): 318n66
 40 (1: 248F): 318nn57,63
 41 (1: 250F): 318n66
 60 (1: 276F): 318n61
 68 (1: 284F): 318n61
Polybios
 2.28–30: 318n65, 331n182, 332nn192,194
 2.30.3: 326n68

2.30.4: 318n65, 319n67, 326n73
2.31: 326n77
2.32.8: 319n67
2.33.5: 326n69
2.35.3: 318n35, 319n67, 332n194
2.35.6: 332n194
2.56: 331n180
2.65.2: 329n138
3.43.12: 319n67, 326n73
3.114.3: 326n69
5.77.2–78.5: 331n179, 333nn6,22
5.104: 332n190
5.111.2: 331n179
7.11.10–12: 329n140
9.30: 329n140
15–16: 220, 329n126
16.1: 327n101, 329n140, 330n152
16.1.5–6: 326n79
16.25.5–9: 324n33
16.26.1–5: xvii, 36, 222, 223*, 227, 287 (AT1)**, 330n157
16.28.3: 222, 233, 329n127**, 332n210
18.3: 329n140
18.16: 200, 323n27, 324n34
18.33: 329n140
18.37.9: 234*, 332n216
21.40.1: 332n213
31.6.6: 233, 332n212
32.15: 326n79, 327n101
33.12–13: 326n79
Poseidonios, *Fragments* (ed. Theiler)
169: 157, 318n65
440: 318n65
Propertius
2.20.7: 316n34, 317n39
2.31.3–4: 315n23
2.31.12–13: 148*, 316n32**, 327n83
3.5.39: 333n12
3.13.51–54: 317n39**
Prudentius, *Passio Sancti Laurentii*, 509–14: 313n113*

Quintilian, *Institutio Oratoria*
2.13.8: 104, 311n65**
5.11.1–21: 317n38
6.2.29: 151*, 317n43**
12.4.1: 150*, 317n38**
12.10.16–19: 331n178

Seneca
de Constantia Sapientis, 16.2: 309n24, 311n111
de Ira, 2.19: 318n65
de Providentia, 1.4.4: 321n103
Epistles
7.3–5: 309n24, 311n111
30.8: 309n24
Silius Italicus, 4.190: 318n65
Solon (ed. West), 4.1–4: 330n162
Sopater Rhetor (ed. Walz), 8, 126–45: 332n198
Sophokles, *Ajax*, 450: 333n5
Statius, *Silvae*
1.1.74–83: 319n79
1.6.51–56: 166*, 321n102**
2.1.169: 161*
4.2.52–56: 319n79
5.3.183–87: 161, 163, 319n78, 320n89
5.3.195–202: 319n79
Strabo, 7.3.8: 318n65

Suetonius
Augustus
23.1: 320n98
43.1: 320n98
Caesar, 39: 320n98
Caligula, 18.1: 320n99
Claudius
1.4: 321n104
21.4: 320n99
21.6: 320n99
Domitian
4.1: 321n102
5: 315n17
Nero, 12: 164*, 320n99
Supplementum Hellenisticum (ed. Lloyd-Jones and Parsons)
560–61: 201*, 324n38
723: 201*, 324n38
958: 201*, 230*, 318n65, 324n38, 329n139, 331n182, 332nn192–94

Tacitus
Agricola
12: 317n46
15.3: 317n37, 321n104
16.1: 319n79
30–32: 319n82
30.2: 316n37
30.3: 152, 317n45**
Annals
12.56.2: 320n99
14.15.3: 320n98
14.29–39: 319n79
15.32.3: 321n102
Germania
4: 160, 318n66, 319nn67,70, 326n73, 332n194
8.1: 317n37
23–25: 320n85

27: 320n85
33: 317n46
37: 319n82
43: 160, 319n70
Histories, 1.68: 318n51**
Thucydides
2.36.4: 329n144
2.40.2–3: 332n194
2.43.1: 239, 333n9
3.112.8–114: 321n104
Tibullus, 5.137–46: 161
Tyrtaios (ed. West)
5.37–46: 319n78
12.23–32: 168*

Valerius Maximus, 2.6.11: 326n77
Velleius Paterculus, 2.100.2: 320n98
Vergil
Aeneid
6.851–53: 161–62*, 163, 172*
8.704–6: 317n46
Georgics, 5.211: 161, 319n78
[Vergil], *Aetna*, 41–47: 319n79
Vitruvius
1.1.4: 150*, 317n37
2.8.15: 228, 331n174
6.1.3: 318n66, 319n70
6.1.9: 318n66

Xenophon
Agesilaos, 6: 308n119, 321n103
Hellenica, 2.4.19: 321n104
Memorabilia of Sokrates, 3.4.1: 321n103

Zenobios, 5.82: 328n108
Zosimos, 5.6.2: 331n169*

INDEX OF INSCRIPTIONS

Note: An asterisk (*) indicates a quotation in English, however brief; two asterisks (**) indicate a quotation in the original language.

Agora 17, 865: 214, 327n98
AJA 75 (1971) 434–35: 70, 215*
AM
 27 (1902) 90, no. 74: 218, 328n113
 33 (1908) 416–18, nos. 58–59: 213, 327n92
Archaiologikon Deltion 44 B2 (1989) 480–82: 215, 328n104
AvP 8
 10–12: 327n92
 12: 213, 305n44, 327n92
 20: 330n155
 21–28: 207, 226*, 305n44, 323nn17,20,25, 326n75, 327n92, 330n155
 29: 213–14*, 217*, 226*, 305n44, 327n92, 330n155
 31–32: 213, 305n44, 327n92
 38: 307n102*
 50: 323n17

 165: 218, 328n113
 234: 323n17
 246: 200, 324n34
 307: 213, 327n92

Fasti Ostienses, AD 116, 11–12: 321n100

Hesperia 5 (1936) 419, no. 15, line 23: 330n158

IG i²·44: 335n54
IG ii²
 310, 280: 325n55
 324, 69: 325n55
 410: 330n158*
 650: 330n158*
 677: 330n158
 687, 7–13: 223*, 329n138
 689: 330n158
 833: 305n45*
 885: 324n33*
 886: 330n158**

 1006, 13–14, 17: 332n204
 1006, 22: 330n145
 1008, 17: 330n145
 1009, 4: 330n145
 1011, 10: 330n145
 1035: xvii, 36, 73, 199–200*, 222*, 226*, 227*, 233*, 236, 287 (AT2), 330n160
 1136, 8: 335n55
 1144, 9: 335n55
 1148, 13: 335n55
 1152, 12: 335n55
 3272: 198, 323n26
 4099: 320n93
 4122: 198, 323n26
 4209: 198, 323n26
 11960: 224, 329n145
IG xi.4.1056: 332n217
Inscriptions de Délos, 1497 bis: 332n217

OGIS, 248: 333n219

SEG
 18 (1962), no. 153: 330n162
 19 (1963), no. 319: 330n162**
 22 (1967), no. 127: 330n159
 26 (1976–77), no. 121: xvii, 36, 73, 199–200*, 222*, 226*, 227*, 233*, 236, 287 (AT2)**, 330n160
 28 (1978), no. 688: 328n104
 40 (1990), no. 1726: 215, 328n104
 44 (1994), no. 42: 330n158, 330n160*
 45 (1995), no. 1066: 215, 328n104
*SIG*³
 434/5: 223*, 329n138
 523: 210, 326n80

ZPE 30 (1978) 263, no.12: 303, 304n17

# GENERAL INDEX

Note: Pages in bold italics indicate illustrations.

abduction, *see* induction, deduction, abduction
Achilles–Penthesileia group, 150
Actium, battle of, 14, 17, 152, 161, 164, 235
Adam, Lambert-Sigisbert, 93, 297
Adamantios, 157
Aelst, Pieter van, 100, *102, 103, 105*
Aemilianus of Nicaea, 214, 288 (AT4)
Agrippa, 144, 198, 200; *see also* Rome, ancient monuments: Agrippa, Baths of
Aigina, 221–23
Aitolia, 220, 222, 224, 233
Akarnania, 221
Akropolis, and Pausanias' route, 14, 181–82; *see also* Athens, ancient monuments: Akropolis, Erechtheion, Parthenon, etc.; Pausanias
Albacini, Carlo, 88, 294–97, 299
Albert V of Bavaria, 87
Albertinelli, Mariotto: *Creation, Temptation, and Fall,* 90, *90,* 94, 115, 142
Aldrovandi, M. Ulisse, 23, 30, 86, 87–88, 290 (RT6), 301
Alexander Mosaic, *see* Naples, Museo Nazionale
Alexander the Great, 158, *159,* 161, *191,* 199, 203, 216, 223, 229, 231; *see also* Istanbul; Naples, Museo Nazionale
Alinari brothers, 56
Althusser, Louis, 79, 116
Amazons, 30, 36, 40, *50, 61, 67,* 67–68, 72, 77, 150, 164, 165–66, 169, 171–72, *173,* 181, 188, *190,* 203, 224–26, 234; *see also* Antiope; Naples, Museo Nazionale; sarcophagi; Tivoli; Wilton House
Anderson, James, 56
Andreae, Bernard, 68–69, 70–72, 174–76, 199, 219

Anonymous Alexandrinus, 288 (AT8)
Antigonos (sculptor), 16, 17, 213, 217, 287 (AT3a)
Antigonos of Karystos, 217
Antiochos I of Syria, 201
Antiochos III of Syria, 222, 232, 234
Antiochos IV of Syria, 232, 234–35
Antiope, *190*
 in Lesser Attalid Dedication, 75, 203, 238
antiqua Romanitas, 98
Antisthenes, *see* Phyromachos of Athens
Antoninus Pius, 152, 154
Antonius, Marcus, 72, 198–200, 233, 235, 288 (AT5, 7); *see also* Athens, ancient monuments: Attalid colossi
Antony, Mark, *see* Antonius, Marcus
Apelles, 126
 Alexander *Keraunophoros,* 199
 Calumny, 115
Aphrodisias, 138
Apollodoros of Athens, 232
Apollodoros of Damascus, 173–74
Apollonis, 222
 portrait on Akropolis(?), 199, *199*
apotropaia, 227–28, 238
archaeology, cardinal virtues/deadly sins, 76
arena, Roman, *see* gladiators
Aretino, Pietro, 122
Aristainos, portrait of, *see* Delphi
Aristeas and Papias of Aphrodisias, 138
Aristeides of Thebes (painter), 36, 203, 214
Aristotle, 152, 240
Arpino, Cavaliere d', 88, 333n15
Artemis, Rospigliosi type, 69
Artemisia, 228
Aspertini, Amico
 Adoration of the Shepherds, 93, 93–94
 drawings of Little Barbarians, 75, 91, *92,* 94, 142, 240, 299–300

Aspetti, Tiziano, restorations of Venice Gauls, 91–92, 122, 133, 171–72, 292 (RT12), 298–99, 300
 of V. Falling Gaul, 75, 122, 130, 171–72, 190, 299
 of V. Kneeling Gaul, 68, 158, 171–72, 298
asphaleia, 227
Atalanta, 165
Athena, in Lesser Attalid Dedication(?), 188, 194, 202; *see also* Athens, ancient monuments
Athens
 attacked by Philip V, 181, 221–24
 Attalos I visits, 70, 181, 222, 239, 287 (AT1)
 decree for restoration of sanctuaries, 36, 73, 199–200, 226, 227, 233, 287 (AT2)
 Eumenes II visits, 222, 232
 Hadrian visits, 163
 Sullan sack of, *see* Sulla
Athens, ancient monuments
 Academy, 222
 aegis and Gorgoneion, 227–28, 232, 234–35
 Agathe Tyche shrine, 227
 Agrippa Monument, *see* s.v. Attalid pillar monuments
 Akropolis, 14, 16, *51, 71,* 181–236 passim, *183, 205*
 East Wall, *13, 183,* 278, 281
 North Wall, 278–79, 280, 281, 334n30
 South Wall, *13,* 14, *51, 71,* 82–85, *183, 185,* 186, *187,* 188, *193–96,* 196, 203, 242–84, *273–75, 277, 279,* 288 (AT6)
 Antiope Monument, 203
 Apollo Parnopios, 227
 apotropaia and talismans, 227
 Artemis Brauronia, shrine of, 182, 202, 276–80

351

Artemis Leukophryene, 202
Asklepieion, 203
Athena Ergane, shrine of, *273*, 333n4
Athena Hygieia, 227
Athena Nike, Temple (and statue) of, *191*, 194, 227; *see also* London, British Museum
Athena Parthenos, 189, *190*, 201, 203–04, 207, 224–25
Athena Polias, 227
Athena Promachos, 227–28
Attalid colossi, 68, 72, 182, 185, *194–96*, 198–200, 223, 226, 233–35, 288 (AT5, 7)
Attalid Dedication, *see* Lesser Attalid Dedication
Attalid pillar monuments, *194–96*, 197–98, 199–200, 234
Brauroneion, *see* s.v. Artemis Brauronia
Chalkotheke, 186, 277, 278
Erechtheion, 30, 200, 215, 336n74
Ergasterion/Building VI, 274, 280, 335n51
Eukleia, shrine of, 227
Eunomia, shrine of, 227
Ge, shrine of, 182
Gorgoneion, *see* s.v. aegis and Gorgoneion
Hekate Epipyrgidia, 227
Hekatompedon/H Architecture, *273*, 276, 277, *279*
Hermes Propylaios, 227
Hippolytos Monument, 203
Hyakintheion, 227
Itonian Gate, 203, *205*
Kynosarges, 222
Lykeion, 222
Mouseion Hill, 182
Older Parthenon, 227, 272, *273*, 279
Old Temple of Athena, 227
Olympieion, 30, 180, *205*, 234–35, 336n74
Panathenaic Way, 272, 277
Panhellenion, 180
Parthenon, *13*, 24, *51*, *71*, 140, 182, *183*, 184, *187*, *194–96*, 196–97, 200, 218, 238, 239, *239*, 272–81, *273*, 284
east metopes, 188, 194, 196, 197, 200–02, 224–25, *227*
frieze, 239, *239*
mentioned, 207, 226, 232, 234
see also Athens, Akropolis Museum; London, British Museum
Philopappos Monument, 182
"Precinct of Pandion"/Southeast Building/Buildings IV–V, *194–96*, 196, 197, *279*, 281
Propylaia, 182, 198, 277–78
Stoa of Attalos, 60, 181, 198, 219, 234
Stoa of Eumenes, *51*, 198, 234
Stoa Poikile, 17, 180, 200, 205, 218, 225, 231, 238
Theater of Dionysos, 14, 17, *51*, 163, 180, 182, *193*, *196*, 242, 284
Thrasyllos Monument, *51*, 149
Zeus Polieus, shrine of, 182, *196*
Athens, museums
Agora Museum
barbarian head, 178, *178*
emperor statue (Trajan?), 156, 163, *177*, 177–78
Roman torso, 322n133
shield reliefs of Athena Parthenos, 322n133
terra-cotta heads, 70, 219
Akropolis Museum
battle frieze, 220, 328n118
Nike temple parapet, 140
Parthenon frieze, 140, 239, 314n130
Pergamene portraits, 199, *199*
Kerameikos Museum
Dexileos stele, 229–31, *231*, 238, 239, 241
shield reliefs of Athena Parthenos, 322n133
National Museum
"Ariadne"/Dionysos, 316n33
Fallen Gaul from Delos, 23, *52*, 148, 235
Priam from Epidauros, 156, *157*, 220
Roman frieze(s), 36, 40, *177–78*, 178–80
Attalid Dedication on Akropolis, *see* Lesser Attalid Dedication
Attalos I of Pergamon, 198–200, 213, 221–26, 239
Athenian tribe named after, 222
benefactions to Athens, 222–23, 233, 287 (AT1)
death of, 222
dedications on Delos, *see* Delos
dedications at Delphi, *see* Delphi
Kaïkos victory, 36, 181, 189, 192, 197, 199, 201, 212–13, 219, 227, 234
and Lesser Attalid Dedication, 16, 17, 70, 181, 192, 218–20, 224, 226, 238
letter to the Athenians, 222, 227, 287 (AT1)
portrait on Akropolis(?), 199, *199*
propaganda of, 69, 72, 226–27
victory dedications at Pergamon, 17, 192, 197, 213
visits Athens, 70, 181, 222, 239, 287 (AT1)
see also Athens, ancient monuments: Attalid colossi, Attalid pillar monuments
Attalos II of Pergamon, 60, 66, 181, 198–200, 218–20, 223
portrait on Akropolis(?), 199, *199*
see also Athens, ancient monuments: Attalid colossi, Attalid pillar monuments, Stoa of Attalos
Attalos III of Pergamon, 198, 218–20
Augustus, 127, 152, 161, 164, 165, 233

Babylon, Hephaistion's pyre at, 68, 197
Baiae, casts from, 306n66
Bakhtin, Mikhail, 99, 120
Bal, Mieke, 98–99, 116, 170
Bandinelli, Baccio, 94, 104, 120
barbarians
arena and, 163–70
Greek attitudes toward, 152–60, 224–25, 228–31, 238
Roman attitudes toward, 150, 152–70, 180
Rome and, 160–63, 180
types of, 160–61, 163, 180
see also Dacians; Gauls; gladiators; Parthians; Persians
Barkan, Leonard, 104, 126
Bar-Kochba, revolt of, 180
baroque, Hellenistic, 62, 73, 96, 216, 219–20, 228, 232, 240; *see also* Berlin, Gigantomachy frieze from Great Altar; Big Barbarians/Gauls; Lesser Attalid Dedication; Rome, museums: Vatican, Laokoon
Barthes, Roland, 98, 205, 218
Barton, Carlin, 146, 160
Basel Anonymous, *see* Floris, Frans
Bassai, *see* London, British Museum
Baxandall, Michael, 11, 76, 97–98
Bayard, Hippolyte, 50, 56
Beard, Mary, 73, 74–75, 78
Becker, Howard, 218
Belevi, Mausoleum at, 220, 328n118
Bellièvre, Claude, 23, 30, 84, 86, 93, 120, 142, 206, 289 (RT2)
and Amazon's baby, 23–24, 30, 84, 202–03, 289 (RT2), 294
and statue "sent to the Pope," 30, 84, 86, 93, 96, 142, 147, 289 (RT2), 300
Benndorf, Otto, 36
Berlin, Staatliche Museen
Asklepios Soter coin, 216, *217*
Gigantomachy frieze from Great Altar of Pergamon, 23, *52*, 73, 75, 156, 188, 190, 201, 206, 207, *207*, 234, 239, 241
and date of Little Barbarians, 22, 60, 66–67, 73, 75, 76, 137–38, 219–20
Prometheus group from Pergamon, 23
Telephos frieze from Great Altar of Pergamon, 180, 233
tetradrachm of Philip V, *221*, 223
Beschi, Luigi, 69
Beulé, E., 281–82
Bianchi, Giovanni Battista (Giambattista) de', 88–89, 126, 291 (RT10), 294, 296, 297, 300
Bieber, Margarete, 70
Bienkowski, Piotr, 40, 60
Big Barbarians/Gauls, *14–15*, 16, 36, *60*, 135, *207–12*, *208–11*, 226, 229
copies, date of, 60–61
findspots of, 147–48
and Little Barbarians, 17, 36, 60, 76, 136–37, 162, 206–12, 214, 218, 238
originals
date of, 207–12
location of, 148, 149, 207–12
victors, 23, 72, 74, 147, 148–51, 208
see also Delphi, Attalid Terrace; Dresden; Pergamon, Long Base; Rome, museums: Capitoline, Palazzo Altemps, Vatican
Boas, Franz, 40
Bober, Phyllis, 76
Bode, Wilhelm von, 56
Bötticher, A., 282
Bötticher, Karl, 17, 272, 282
Boissard, Jean Jacques, 30, 86, 292 (RT13), 300–01
Bon, Michele, 131
Borghese family
collection of, 30, 88, 298
Scipione, 88

borrowing, 97–100, 100–35 passim, 136, 170
Botticelli, Sandro, 100
Boudicca, 161
Bourdieu, Pierre, 218
Bouts, Dierick, 69
Bramante, 85
Brendel, Otto, 69, 75, 93, 122–24
Brennos, 223
Brescia, Museo Civico: Marathon(?) sarcophagus, 180, 204
Brunn, Heinrich
and Little Barbarians, 16–18, 22–23, 60, 81, 89, 182, 218, 240
mentioned, 30, 36, 40, 50, 56, 65, 70, 73, 88
Brutus and Cassius, 233
Bufalini, Maria, 116
Bundgaard, J. A., 272–74, 280
Byron, Lord, 162, 163

Caesar, Julius, 164, 233, 235
Calcani, Giuliana, 75
Caligula, 162
Callaghan, Peter, 75
Cambridge, Fitzwilliam Museum: Roman torso from Athens, 322n133
Capito, P. Fonteius, 235
Capitoline (Dying) Gaul, see Rome, museums: Capitoline
Caravaggio, 75
Carpenter, Rhys, 65, 70, 218
Carthage, 221
Cassius Dio, see Dio Cassius
casts, plaster, 16, 18, 56
Cavaceppi, Bartolommeo, 69
Celts, see Gauls
Cézanne, Paul, 80
Chatsworth House
design for Raphael's *Transfiguration*, 112, 114
document-carriers relief, 140
Chigi family, 115; see also Raphael
Choisy, Auguste, 272
Chremonides, 223
chronology, Hellenistic, xxiii–xxiv, 18, 61–66, 219–20
Chrysippos, 66, 67, 70, 217, *217*, 219–20; see also Florence, Uffizi; London, British Museum
Cicero, 94, 152, 161
Civitalba, Galatomachy from, 235
Clarac, comte de, 17
Clark, T. J., 78, 229
classicism, Roman, see neoclassicism, Roman
Claudius, 164, 165, 198, 200
Clement of Alexandria, 157
Clement VII, 110, 117
Coarelli, Filippo, 68, 74
Collingwood, R. G., 18
Commodus, 164
Comte, Auguste, 16
Condivi, Ascanio, 120
Constantinople, 192; see also Istanbul
contrapposto, 94–96, 104, 105, 117, 120, 130
Conze, Alexander, 40, 56

Copenhagen, Ny Carlsberg Glyptotek
Dionysos, 69
Giant, 201–02
Niobids, 149
copies and *Kopienkritik*, 60, 142
corpus, the, 40
Cosius, Lucius, 165, *165*
Croce, Benedetto, 11
Curtius, Ludwig, 69, 76

Dacians, 140, *141*, 150, 160, 163, 165, *165*, 171, 172–78, *175*–78
Dacos, Nicole, 75
Danaids, 145, 150; see also Rome, ancient monuments: Apollo Palatinus, Temple of
David, Jacques-Louis: *Oath of the Horatii*, 89
Davis, Whitney, 62
Decebalus, *164*–65, 165, 173, *175*, 177
deduction, see induction, deduction, abduction
deixis, 152, 154
Delos
Agora of the Italians, 148
dedications of Attalos I, 223
Fallen Gaul from, see Athens, museums: National Museum
Philetairos monument, 192
portraits on, 219
Delphi
Aemilius Paullus base, 233
Aristainos base, 186–88, *188*, 251, 263
Athenian Treasury, 203, 225
Attalid terrace, stoa, and *massif*, 210–12, *211*, 223
Gallic attack on, 149, 201, 206, 228, 232, 241
Kydias monument, 225
Marathon Monument, 225
Siphnian Treasury, 168, 324n40
Demetrios Poliorketes, 199, 223
Derrida, Jacques, 40
Dewey, John, 79
Dexileos, see Athens, museums: Kerameikos
Didi-Huberman, Georges, 22
Dinsmoor, William B., 61, 272
Dio Cassius, 163, 198
Dio Chrysostom, 162
Diodoros Siculus, 197, 220
and Gauls, 16, 157
Dion, 234
Granikos group by Lysippos at, 223
Dionysios the Areopagite, 94
Dionysos, in Lesser Attalid Dedication, 17, 69, 72, 188, 202, 288 (AT5)
falls into Theater of Dionysos, 14, 17, 30, 36, 72, 182, 200, 233, 236, 284, 288 (AT5)
see also Lesser Attalid Dedication
Dionysos, Theater of, see Athens, ancient monuments: Theater of Dionysos
Dioskouroi, 199
in Lesser Attalid Dedication(?), 188, 195, 202
Dohrn, Tobias, 69, 93
Dolce, Lodovico, 126–27
Domitian, 162, 163, 164, 165
Dontas, Georgios, 199

Dörpfeld, Wilhelm, *183*, 272, 280–81
Dosio, Giovanni: drawing of Wilton Amazon, 75, *77*
Dresden, Antikensammlungen: Gaul, 147–48, 207, *210*, 316n28
Droysen, Johann Gustav, 18
Duhn, Fritz von, 36, 69, 75, 76
Dying Trumpeter, see Rome, museums: Capitoline

Eagleton, Terry, 79, 218
Echetlos, 205
Einstein, Albert, 22, 79
Eleusis, 222, 224, 233
Ephesos
Amazons at, 150, 169
Galatomachy frieze from, see Selçuk Museum
Epidauros, Priam from, see Athens, museums: National Museum
Epigonos, 36, 213–14, 232, 287–88 (AT3)
and Big Gauls, 36, 207
Infant Pitiably Caressing Its Slain Mother, 36, 203, 214, 288 (AT3b)
and "Isigonus," 36, 214, 287 (AT3a)
and Lesser Attalid Dedication, 36, 213–14
signatures of, 36, 207, 213
Trumpeter, 36, 207, 214, 288 (AT3b); see also Big Barbarians/Gauls; Pergamon, Long Base; Rome, museums: Capitoline: Dying Gallic Trumpeter
Epiktetos, 163
Epitaphia, see funeral speeches
Eretria, Temple of Apollo Daphnephoros, 149
error, sociology of, 11
Etruscan urns, 68–69, *69*, 75, 84, 219
Euboulides (sculptor), 217; see also Chrysippos
euchrony, 22, 66
Eumenes I of Pergamon, 213
Eumenes II of Pergamon, 17, 198–200, *198*, 213, 217, 222, 223, 234
alleged mythopropaganda of, 69
and Great Altar, 23, 60, 75
and Rome, 217, 233, 235
suppresses Gallic revolt, 68, 75, 198, 218, 219, 233
tetradrachm of, *198*, 198–99
visits Athens, 222, 232
see also Athens, ancient monuments: Attalid colossi, Attalid pillar monuments, Stoa of Eumenes
Euripides, 156
exempla, 150, 160

Faraone, Christopher, 228
Farnell, Lewis, 36–40
Farnese family
Alessandro, 75, 88–89
collection and inventories of, 30, 36, 75, 88–89, 291 (RT10)
Odoardo, 89
Ottavio, 88
Favorinus, 154
Fehl, Philipp, 126, 230
Ficino, Marsilio, 94
field of (cultural) production, 218, 238

figura serpentinata, 94–96, 104, 105, 117, 120, 123, 130; *see also contrapposto*
Flamininus, Titus Quinctius, 222, 223, 232, 233, 234
Florence
　Loggia dei Lanzi: "Thusnelda," 314n4
　Uffizi
　　Chrysippos, *66*, 67, 70, 217, 219–20
　　Niobids, 145, *146*, 149
　　Scythian Knife-Grinder, 17, 23, 150
Floris, Frans, 30, *53*, 88, 240
Foix, Gaston de, 85–86
form of life, 79
formalism, 61, 62–66, 69, 78, 218–19, 220
　new, 79
Foucault, Michel, 18, 40, 99, 237
Fox, Stephen, 75–76
Fox Talbot, Henry, 56
Fra Bartolommeo, 90
Francesca, Piero della, 96
Francesco I of Tuscany, 87
Frascati, 93
Freedman, Luba, 76, 130
funeral speeches, 224
furor Celticus, 157; *see also* Gauls, appearance and character of
Furtwängler, Adolf, 50, 60, 61

Galatians, *see* Gauls
Gallottini, Angela, 75
Gasparri, Carlo, 75, 144
Gauls
　appearance and character of, 137, 152, 156–60, 164, 169, 201, 206–13, 224–25, 229–31, 238, 241
　atrocities, 229
　dress, 36, 202
　invade Greece and attack Delphi, 149, 201, 206, 228, 232, 241
　Kaïkos defeat, *see* Attalos I
　as mercenaries, 223, 228, 241
　nakedness of, in battle, 169
　revolt of, *see* Eumenes II
　Romans and Attalids attack, 68, 75, 217, 233
　and Rome, 235
　suicide and, 208
　see also barbarians; Big Barbarians/Gauls
gaze and glance, 150, 161, 162, 237–41
Geneva, Musée de l'art et d'histoire: Giant, 170–71, 202, *203*
genre styles, 65, 219
Gerhard, Eduard, 18, 40, 56
Germans, *see* barbarians
Ghirlandaio, 100
Giants, 154–55, 164, 171–72, 188–89, *189*, 200–02, 223, 224–25, 239
Giulio Romano, 94, 106, 108
　Battle of Constantine, 97
　Resurrection, 313n97
Giustiniani family, collection of, 69, 75, 86, 88, 205, 296, 302
gladiators, Roman, 136, 163–66, 169
　female, 165–66
glance and gaze, *see* gaze and glance
Great Altar, *see* Berlin; Pergamon

Grimani family
　collections and inventories of, 23, 89, 90–91, 106, 122, 128, 130, 142, 289–91 (RT3–5, 11), 298–99, 300
　Domenico, 89, 91–92, 106, 122, 144, 289 (RT3–5), 292 (RT12)
　Giovanni, 91–99, 121, 133
　Marino, 89, 91, 122
　Vettor, 121
　see also Venice, palaces: Palazzo Ducale; Venice, libraries and museums: Biblioteca Marciana, Statuario Pubblico
Gritti, Andrea, 121

Habich, Georg, 40, 67
Hadrian, 143–44, 152, 154, *154–55*, 160, 161–63, 165, 180
Halbwachs, Maurice, 225
Halikarnassos
　gladiator relief from, *see* London, British Museum
　Mausoleum at, 17, 196, 220, 315n23
Hall, Jonathan, 18
Hannestad, Lise, 73
Hannibal, 221
Hansen, Esther, 69
Hawthorne, Nathaniel, 137
Heemskerck, Maarten van, 30, *53*, 87–88, 202, 240, 298
Hegel, G. W. F., 11
Helvetii, 153
Henderson, John, 73, 74–75, 78
Hephaistion, funeral pyre of, *see* Babylon
Herakleides of Macedon, 215
Herakleion Museum: Niobe and Artemis, 149
Herakles, in Lesser Attalid Dedication(?), 188, 194, 202
Herculaneum, Villa dei Papiri, 145, 315n23
Herodes Atticus, 154
Herulians, 192
Hierapytna, Hadrian from, *see* Istanbul, Archaeological Museum
Hildebrand, Adolf, 62, 64
Hippolyte, *see* Antiope
Hippolytos, 75, 203
Hirsch, E. D., 76
Hoepfner, Wolfram, 72
Holmes, Sherlock, 64, 81, 136, 152, 158, 181, 223
Hölscher, Tonio, 72
Horace, 161
Horatii and Curiatii, *see* Little Barbarians
Horn, Rudolf, 66–67, 70, 137, 219
Huebner, P. G., 110
Humann, Karl, 23
Hurwit, Jeffrey, 73

induction, deduction, abduction, 18, 22–23, 40, 64
influence, *see* borrowing
interpellation, 116, 152
interpretive communities, 231–36
intertextuality, 99, 151, 203–04, 212, 218
Isigonus (sculptor), 16, 36, 207, 213–14, 287 (AT3a); *see also* Epigonos
Istanbul, Archaeological Museum
　Alexander Sarcophagus, 190, *191*, 204, 213, 220, 241

Hadrian from Hierapytna, 154, *154*, 161, 163, 180
Kyzikos stele, 325n65, 328n118
Magnesia frieze, *see* Magnesia, Temple of Artemis

James, William, 79
Jerusalem, 165
Israel Museum: Amazonomachy amphora, 203
Julius II, 85

Kaïkos, battle of, *see* Attalos I
Kallikrates, 335n54
Kallimachos (poet), 206
Kallimachos (Athenian polemarch), in Lesser Attalid Dedication(?), 205
Karlsruhe, Badisches Landesmuseum: Giant, 40, *201*, 201–02
Kassel, Staatliche Kunstsammlung: Gnathia jug with Gorgoneion, *229*
Kawerau, Georg, 274, 276, 280, 281
Kimon, 274, 276, 281
Kleisthenes, 272
Klügmann, A., 23–24, 36, 40, 202
Koehler, Ulrich, 36
Kopienkritik, *see* copies
Korres, Manolis, 17, 65, 72, 74, 182, 185–86
Krahmer, Gerhard, 62–66, 67, 218
Kresilas, 169
Kroeber, Alfred, 63
Kubler, George, 207
Kynegeiros, 205
Kynoskephalai, battle of, 222
Kyzikos, Gallic relief from, *see* Istanbul Museum

La Graufesenque, bowls from, *164–65*, 165
Lacan, Jacques, 237–38
Lambert, Marcel, 272
Lanciani, Rodolfo, 149
Laokoon, *see* Rome, museums: Vatican
Larique, David, 298
Lawrence, A. W., 69
Leake, Colonel William, 12, *13*, 16, 30, 281
Lemaire, Pierre, *Landscape with Ancient Ruins and the Colosseum*, 333n15
Leo X, *see* Medici
Leon, epitaph of, 224
Leonardo da Vinci, 94, 96
　Saint John the Baptist, 116
Lesser Attalid Dedication
　ancient sources on, 287–88 (AT1–8)
　and Attalid colossi, 68, 72, 182
　and Attalos I, 16, 17, 70, 181, 192, 218–20, 224, 226, 238
　bases/pedestals of, 65, 72, 74, 80, 147, *184–87*, 185–88, 192–96, *193*, 242–72, *243–68*, 281–84, *283*, *285*
　composition of, 65, 186–90, *194–95*, 200, 201–06, 271
　earlier theories about, 14, 17, 30, 36, 61, 65, 67–68, 72
　copies of, *see* Little Barbarians
　cost of, 226, 336n71
　date of, 17, 23, 36, 43–44, 60, 62, 66–67, 68, 69, 72, 73, 218–20, 222–23; *see also* Little Barbarians, style and date

duplicate (alleged) at Pergamon, 17, 22–23, 36, 44, 60–61, 68, 72, 73, *73*
functions of, 224–28, 238, 241
location of, *13*, 13–16, 30, 65, *71*, 72, 181–83, *187*, 192, *193–96*, 281–84
pedestals of, *see* s.v. bases/pedestals of
reconstruction of, *see* s.v. composition
scholarship on, 11–76
sculptors of, 16, 213–18
size of, 17, 192–96, 226, 271
victors in, 186, 188–90, 202, 204, 205, 206, 213
visibility of, 184–85, 192, *193*, 284
see also Dionysos, in Lesser Attalid Dedication
Lessing, G. W. F., 78
Limyra, Centauromachy from, 220, *221*
Lippold, Georg, 43–44, 68, 69, 75, 218
Little Barbarians (Lesser Attalid Dedication, copies), *2–10, 19–21, 24–29, 31–35, 37–39, 41–49, 57–59*
and bases of Akropolis, 185–94, 247–67, 271
and Big Barbarians/Gauls, 17, 60–61, 76, 136–37, 206–12, 229
catalog of, 294–300
fidelity to originals, 201–12, 220
findspots, 24, 30, 82–84, 92–93, 142–44
iconography, 74, 201–12
identified as gladiators, 11, 13, 36, 88–91, 92, 104, 122, 123, 128, 135, 163, 291 (RT9), 292 (RT12), 294–300
identified as Horatii and Curiatii, 11, 24, 81, 84–86, 93, 96, 104, 147, 202, 240, 288–91 (RT1–2, 6–8), 292 (RT13), 294–99
marble of, 17, 23, 44, 60–61, 68, 136, 142
museum locations, 294–300
peregrinations of, 86–94
and physiognomics, 136, 152–60
Renaissance sources on, 288–92 (RT1–13)
restorations, 1–9, 74, 80, *84*, 88, 91–92, 96, 130, 133, 158, 171, *171*, 202–03, 206; *see also* Aspetti, Tiziano; Bianchi, Giovanni Battista de'; Larique, David; Sibilla, Gasparri
and rhetoric, 228–32
style and date of, 60–61, 67, 68–69, 136–42, 219, 220, 240
style and date of their originals, 23, 43–44, 62, 66–67, 72, 73, 218–20
technique of, 136–42, 219
ugliness of, 161, 169, 229–31
victors, absence of, 23, 61, 72, 73, 74, 136, 147–52, 151, 170
workshop of, 60–61, 136–42
wounds, 30, 72, *166–67*, 166–70, 192, 230
Livy, 150, 168, 220, 233
and Gauls, 16, 169
and Horatii and Curiatii, 85, 202
Lomazzo, Giovanni, 94, 96
London
British Museum
Bassai frieze, 220
Chrysippos, 217, *217*, 219–20
gladiator relief from Halikarnassos, 165
Mausoleum friezes, 220

Nike temple frieze, 140, 189, 190, *191*, 194, 205
Niobid disk, 149, *149*
Parthenon frieze, 140, 239, *239*
Courtauld Gallery, *see* Albertinelli, Mariotto
Lucian, 115, 184–85
Ludovisi (Suicidal) Gaul, *see* Big Barbarians/Gauls; Rome, museums: Palazzo Altemps
Lysias, 230
Lysippos, 65, 214–15
Apoxyomenos, 144
see also Dion, Granikos group at

Macchiavelli, Niccolò, 86
Macedonian Wars
First, 220
Second, 198, 220–24
Third, 232
see also Macedonians; Philip V
Macedonians, 220–24, 226, 228, 234, 238
see also Macedonian Wars; Philip V
Macpherson, Robert, 56
Maderno, Stefano, 94,
Madrid, Prado: Poseidon by P. Licinius Priscus of Aphrodisias, 139
Maevia, 165
Magnesia, Temple of Artemis, frieze, 40, 65, 67, 233
Mailer, Norman, 12, 76
Mainz, Römisch-Germanisches Zentralmuseum: relief kantharos with Galatomachy, 148, *149*, 206
Malmberg, W., 30, 42, 206
Mancia, Helvius, 152
Mantegna, Andrea, *Resurrection*, 84
Mantua, Palazzo Ducale: Gallic battle frieze, 212–13
Marathon, Battle of, 14, 180, 189, 205, 225, 226, 234, 288 (AT6); *see also* Athens, ancient monuments: Stoa Poikile; Lesser Attalid Dedication; Miltiades; Persians
Margaret ("Madama") of Austria, 87–88, 290–91 (RT8, 10)
Marignano, Battle of, 86
Marino, Villa of Voconius Pollio, 40
Marius, Caius, 152, 160, 161, 235
Mark Antony, *see* Antonius, Marcus
Marsyas, Hanging type, 17, 150
Marszal, John, 73, 208
Martial, 164
Marvin, Miranda, 73, 74
Maximilian II, Holy Roman Emperor, 87
Mayer, Maximilian, 36, 67
Mazarin, duc de, 301
Medici family
Alessandro de' ("The Moor"), 87–88
Caterina de', 88
Giuliano de', 106
Giulio de', 110
Leo X, 84–87, 93–94, 97, 100, 102, 105, 106, 114, 142
Lorenzo de', 114, 288–89 (RT1), 290 (RT7)
Piero de', 81
see also Orsini, Alfonsina; Rome, palaces: Medici–Madama
Megiddo, 237
memory, 225–26, 232

Merleau-Ponty, Maurice, 237
Michaelis, Adolf, 30–36, 56–60, 62, 81, 202, 203, 207, 213–14
Michelangelo, 94, 95–96, 100, 104, 116, 117–20, 121, 122, 124, 240, 308n128
Bruges *Madonna*, 104
Last Judgment, 100, 117–20, *118–19*, 124, 132
River God, 117
Sistine Chapel ceiling, 100–01, 104
Michiel, Marcantonio, 106
Mikon, 231
Milchhöfer, Arthur, 23, 36, 60, 61, 68, 73
Miltiades, 219
in Lesser Attalid Dedication(?), 205
mimesis, mirror theory of, 79
Mitchell, Lucy, 16, 23, 60
Mithradates VI of Pontos, 233
Molpadia, *190*, 203
Mommsen, Theodor, 40
Morelli, Giovanni, 50
Moreno, Paolo, 75, 203
Morris, Ian, 78
Munch, Edvard, *The Scream*, 97, *97*
Munich, Glyptothek
Alexander (Schwarzenberg), 158, *159*
Barberini Faun, 150
dying warrior from Aigina, 168, *169*
Rondanini Medusa, 304n28
Müntz, Eugen, 24
Murano, S. Chiara, 89, 289 (RT4)
Myrina (Amazon queen), 234
Myron (sculptor), 65, 214

Naples, Museo Nazionale, 88
Alexander Mosaic, 16, 68, 158, *159*, 161, 204, 213
Amazon falling off her horse, 17, *61*, 72, 204
"Antiochos Epiphanes" from Herculaneum, 328n118
Antisthenes (terra-cotta), *215*, 216
"Dancers" (Danaids?) from Herculaneum, 145
Farnese Bull, 68, 89, 126
Farnese Gladiator, 89, 169
Farnese Hercules, 95, 117
Gigantomachy krater, 188, *189*
Harmodios and Aristogeiton, 89
Perseus, 89
warriors, 89
Napoleon, 88
neoclassicism, Roman, 72, 74
Nereid Monument, *see* Xanthos, Nereid Monument
Nero, 162, 164, 212
Nerva, 139, *139–40*
Neudecker, Richard, 74
"New Formalism," 79; *see also* formalism
New Historicism, 79
Nietzsche, Friedrich, 240
Nikeratos (sculptor), 215
Niobids, 145, *146*, 149, *149*, 150
Nora, Pierre, 232

Olympia, 23
bronze spearhead from, 168
Olympiodoros, *see* Oslo
one-sided groups, 62, 64, 284

355

Orsini, Alfonsina, 23, 69, 81, 84, 86–87, 90, 93, 106, 142, 202, 289 (RT2); *see also* Rome, palaces: Medici–Madama
Orwell, George, 239
Oslo, National Gallery: Olympiodoros, 182, *182*, 223, 288 (AT6)
Ostia, *see* Phyromachos of Athens: Antisthenes
Overbeck, Johannes, 23, 60
Ovid, 90, 126, 145, 161, 169
Oxford, Ashmolean Museum: battle frieze from the Akropolis, 220, 328n118

Pallene, Isthmus of, 223, 288 (AT6)
Palma Vecchio, 81
Palma, Beatrice, 72, 74, 76, 81, 144
Panofsky, Erwin, 126
Paris
 Bibliothèque Nationale: Eumenes tetradrachm, *198*, 198–99
 Musée du Louvre
 Borghese Warrior, 23
 Dacian relief, 140
 Magnesia frieze, *see* Magnesia, Temple of Artemis
 Nike of Samothrace, 62
 Niobid krater, 149
 Old Centaur, *138*, 138–39
 Roman torso, 322n133
Parma, 88, 290 (RT8)
Parmigianino, Francesco, *Vision of Saint Jerome,* 116–17, *117*, 120, 122, 152
Parthenon, *see* Athens, ancient monuments: Parthenon
Parthians, 161, 163, *164*, 164–65, 171, 178, 235
Pasquino group, 150; *see also* Rome, ancient monuments: Pasquino
Pathosformel, 76, 96–97, 124, 225
Paullus, Aemilius, 235
Pausanias, 19, 149, 182, 189, 197
 and Attalids, 219, 235
 and Gauls, 16, 219, 228, 229
 and Lesser Attalid Dedication, 14, 16, 70, 72, 147, 181–82, 186, 192, 204, 213, 242, 269, 288 (AT6)
 and Pergamon, 68, 168
Pedrocco, Filippo, 126
Peirce, Charles Sanders, 64, 79, 98
Peirithoos, in Lesser Attalid Dedication(?), 204
Penrose, Francis, *13*, 14, 30, 182, 276, 280, 281–82, *283*, 284
Pergamon
 Asklepios, Temple of, 200, 215; *see also* Phyromachos of Athens
 Athena Polias Nikephoros, Sanctuary of, 168, 197, *197*, 206, *207*
 Long Base in, 36, 148, *191*, 192, 197, *197*, 207–12; *see also* Epigonos
 Round Base in, 197, *197*, 207
 destructions at, *see* Philip V; Prousias II
 excavation of, 18, 23, 36
 Galatomachy plaque (lost), 148, *148*, 206
 Great Altar, 23, *52*, 60, 69, 72–73, *73*, 75, *207*, 234, 239; *see also* Berlin
 Great Dedication, *see* s.v. Athena Polias Nikephoros, Long Base
 Little Barbarians allegedly at, *see* Lesser Attalid Dedication
 Nikephoria festival, 75
 Nikephorion, 209–10
 Oreos dedication, 192
 paintings at, 68, 176
 spoils dedicated at, 72, 168, 212
 victory dedications at, 17, 23, 36, 68, *191*, 192, *197*, 197, 226
Perikles, 183, *194*, 200, 223, 278, 281
Perrier, François, *The Plague of Athens,* 333n15
Perry, Marilyn, 75, 81, 122, 123
Perseus of Macedon, 215, 232
Persians, 155–56, 160, 163–64, 166, 180, 181, *191*, 200–01, 204, 212, 223–25, 228, 230, 235; *see also* barbarians; Big Barbarians/Gauls; Lesser Attalid Dedication; Marathon, Battle of
Perugia, Museo Civico: Etruscan urn, 68–69, *69*, 75
Perugino, 100
Peruzzi, Baldassare, 90, 94, 115–16
 Allegory of Mercury, 116
 Calumny of Apelles, 115
 Creation of Eve, 114, 115
 Farnesina frescoes, 115
 Presentation of the Virgin, 115, 115–16
 Wilton Amazon (drawing), 75
Petrarch, 85
Pharnakes I of Pontos, 234
Pheidias, 19; *see also* Athens, ancient monuments: Athena Parthenos, Athena Promachos, Parthenon
Philip II of Spain, 126–27
Philip V of Macedon, 70, 209, 215, 220–26, *221*, 230
Philopoemen, 219
Philoumenos (sculptor), 17
Phlegra, 223
photography, and archaeology/art history, 40, 44–60, 62
Phylarchos, 228
Phyromachos of Athens (sculptor), 16, 17, 68, 70, 72, 176, 213, 214–17, 232, 287 (AT3a)
 Antisthenes herms, 70, *70*, 214–15, 215–16
 Asklepios, 215–16, *217*(?)
 and Lesser Attalid Dedication, 214–17
 signatures of, 70, 215
Phyromachos of Kephisia (sculptor), 215
physiognomics, 152–60, 225
Pietrangeli, Carlo, 69
Piraeus, 222, 224
Pius V, 87, 88, 300
Plataia, Battle of, 180
Plato, 241
Pliny the Elder, 18, 24, 36, 65, 70, 90, 94, 152, 161, 203, 240
 "cessavit ars," 62, 215, 232
 and Pergamene sculptors, 16, 17, 36, 68, 207, 213–17, 287–88 (AT3)
Plutarch, and Lesser Attalid Dedication, 14, 17, 30, 72, 147, 182, 288 (AT5)
 and Attalid colossi, 72, 182, 198, 288 (AT5)
Polemon of Glykeia (*periegete*), 17

Polemon of Laodicea (physiognomer), 152, 153, 156, 161
Polignac, Cardinal de, 92, 94, 297
Pollitt, Jerome J., 73, 151
Polybios, 200, 220, 222, 233
Polykleitos (sculptor), 65, 94, 215
Pompeii
 forum, 145
 fresco with tripod and Niobids, 149
Pordenone, Giovanni Antonio, 81, 89, 94, 122–23, 240
 Christ Nailed to the Cross, 123
 Martyrdom of Saint Peter Martyr, 81, *82*, 122
Porphyrion, *189*, 201, 223
portraits, Hellenistic, 22, 219
Poseidon, in Lesser Attalid Dedication(?), 188, 202
Poseidonios of Apameia, 157
positivism, 16, 18–23, 30, 40, 44, 74, 78, 79
positivist fallacy, 19
Poussin, Nicolas, 76
 Moses Strikes the Rock, 333n15
 Rinaldo and Armida, 106
 Taking of Jerusalem, 333n15
Pozzo, Cassiano dal, 30, 36, *54–55*, 88, 204, 294–96, 297, 299–300
Praxiteles, 74
Preziosi, Donald, 18
Propertius, 148
Prousias I of Bithynia, 233, 234
Prousias II of Bithynia, 209, 215, 234
Providence, Rhode Island, School of Design: Giant, 201–02
Ptolemy II of Egypt, 201, 220
Pyromachus, *see* Phyromachos of Athens
Pythagoras of Rhegion (sculptor), 65

Queyrel, François, 73, 75, 92, 93
Quintilian, 94, 104, 151

Raphael, 75, 100–14, 124, 126, 240
 Chigi *Resurrection,* 84, *85*, 103, 104
 pupils of, *see* s.v. Vatican *logge; see also* Giulio Romano
 tapestry cartoons, 75, 94, *94*, *101*, 101–06, 114, 116; *see also* Aelst, Pieter van
 Transfiguration, 110–14, *113–14*
 Vatican *logge,* 75, 87, 106–10, *107–12,* 115
 Vatican *stanze,* 84, 86, *87*, 104
Ravenna, Battle of, 85, 86
Reinach, Salomon, 30, 42, 60, 86, 173, 202
rhetoric, 146, 228–32
 Asian, 228
Rhodes, 221–22, 228
Richter, Gisela, 70
Ridgway, Brunilde, 73–74
Riebesell, Christina, 75, 81
Riegl, Alois, 62, 65
Robert, Carl, 36, 40
Robertson, Noel, 181–2
Rodin, Auguste, 308n128
Rome, ancient monuments
 Agrippa, Baths of, *142–43*, 143–44, 145
 Alexander Severus, Baths of, *see* s.v. Nero and Alexander Severus
 Apollo Palatinus, Temple of, 145, 148–49, 212

Apollo Sosianus, Temple of, 145, *151*
Atrium Vestae, 145
Campus Martius, 83, 142, *142–43*, 164, 174
Circus Maximus, 165
Coliseum, 164
Constantine, Arch of, 104
Crypta Balbi, *142*, 143
Dioscuri of Monte Cavallo, 90
Domus Aurea, 106
Great Trajanic Frieze, *139*, 139–40, 160
Hadrian, Temple of, 126
Horti Lamiani, 145
Horti Sallustiani, *see* s.v. Sallust, Gardens of
Isis and Serapis, Temple of, 143–44
Marcus Aurelius, Column of, 84, 160, 172
Mars Ultor, Temple of, 164
Matidia, Temple of, 143
Neptune, Basilica of, 143
Nero and Alexander Severus, Baths of, 24, 83, *83*, 142, *142–43*, 290 (RT6)
Palatine Palaces, 93
Pantheon, *83*, *142–43*, 143
Pasquino, 108
Saepta Julia, *83*, *142–43*, 143–44, 145, *145*, 164
Sallust, Gardens of, 145, 147–48, 162
Trajan
 Arch of, 161
 Column of, 84, 96, 108, 140, *153*, 160, 162, 168, *172*, 172–77, *174–76*
 Forum of, 143, 173
Rome, churches
 S. Eustachio, 289 (RT2)
 S. Giovanni in Laterano, 145
 S. Salvatore in Lauro, 116
 SS. Stimmate di San Francesco, 144
 Sta. Caterina da Siena, 144
 Sta. Chiara, 144
 Sta. Maria della Pace, 115–16
 Sta. Maria sopra Minerva, 144
Rome, museums
 Antiquario Palatino
 Gallic woman, 147–48, 207, *211*, 214, 316n28
 hip herms (Danaids?), 145
 Persian, 147–48, 205, 207, *211*, 316n28
 Capitoline
 Amazon sarcophagus, 172, *173*
 "Ammendola" battle sarcophagus, 174, *176–77*, 206, 298
 Centaurs from Tivoli, 138, 142
 Dying Gallic Trumpeter, *14*, 16, 137, *147*, 147–48, 162, 163, 206–12, *209*, 214, 253, 316n28; *see also* Big Barbarians/Gauls
 "Fauno Rosso," *137*, 137–38, 142
 Venus, 115
 Conservatori: frieze of Temple of Apollo Sosianus, 150, *151*
 Nazionale (Terme)
 Amazon fighting a Gaul, 67, *67*, 72, 204
 Boxer, 168–69
 Crouching Aphrodite/Venus, 117
 Hadrian, 154, *155*, 161
 Nerva (two), 139, *139–40*
 Niobid, 149
 sculptures attributed to the Templum Gentis Flaviae, 139–40
 see also Palazzo Altemps
 Palazzo Altemps
 Ludovisi "Fury," 327n96
 Ludovisi (Suicidal) Gaul, *15*, 16, *60*, 137, 147–48, 162, *173*, 206–12, *208*, 214, 229, 316n28; *see also* Big Barbarians/Gauls
 Palazzo Doria Pamphili: warrior, 42
 Pavilion of the Farnese Gardens (Palatine): Dacian, 140, *141*
 Torlonia
 barbarians, 17
 Giustiniani Persian, 17, *50*, 75, 205, 301–02
 Vatican
 Antisthenes herms (two), *70*, 214–15, *215*; *see also* Phyromachos of Athens
 Belvedere Apollo, 87, 95, 117
 Belvedere Torso, *95*, 95–96
 "Commodus," 75
 Gaul, 147–48, 207, *210*, 316n28
 Laokoon, 62, *63*, 64, 65, 67, 69, 87, *95*, 95–97, 100, 122, 156, 240, 333n19
 Sleeping Ariadne ("Cleopatra"), 95, 116
 warrior group, 212–13
 Villa Albani
 Antinous, 142
 Roma relief, 140, *141*
 Villa Medici
 Dacian relief, 139–40, *140*
 sarcophagus, 90
Rome, palaces
 Cancelleria, 115
 Farnese, 88–89, 291 (RT10), 294–97, 299
 Giustiniani, *see* Giustiniani family, collection of
 Grimani, 89, 122, 298–99
 Medici-Madama, 23, 24, 30, *53*, *83*, 84, 87–88, 106, *142–43*, 202, 289–91 (RT2, 6–8, 10), 294–99
 Santacroce, 30, 205, 301
 Savelli, 301
 Vatican, 86–87, *87*, 106, *107*
 see also Rome, museums
Rome, Sack of (1527), 86, 100, 116, 120
Rome, Vatican, *see* Raphael, *logge* and *stanze*; Rome, museums: Vatican
Rome, villas
 Borghese, *see* Borghese family, collection of
 Farnesina alla Lungara, 115, 294–97, 299
 Madama on Monte Mario, 106, 301
 see also Rome, museums
Ross, Ludwig, 14, 182, 274, *274*, 275–76, 281
Roux, Georges, 210
Rubinstein, Ruth, 76
Ruskin, John, 56

Salamis, Battle of, 161, 164
Sangallo, Francesco da, 240
Sansovino, Jacopo, 89, 92, 94, 121, 127
 Entombment and *Resurrection* (S. Marco sacristy doors), *121*, 121–22

Sanuto, Marino, on Little Barbarians, 289–90 (RT3, 5)
sarcophagi, Roman
 Amazon, 68, 166, 172, *173*, 180
 battle, 36, 68, 160, 171, 174, *176–77*
 Giant, 172, 180
 Marathon(?), 180, 204
 Niobid, 149
Sartre, Jean-Paul, 237
Sauer, Bruno, 36
Schaubert, E., 274, *274*, 275, 281
Schober, Arnold, 67–68, 69, 171, 173
Schweitzer, Bernhard, 67–68
Sebastiano del Piombo, 110
Selçuk Museum
 Belevi sculptures, 220, 328n118
 Galatomachy frieze, 206, 213, 233–34, 235, *235*
 Trajan, 139–40
Seleukos I Nikator, 199
Semper, Gottfried, 282
Seneca, 90
Sergardi, Filippo, 115
Seta, Alessandro della, 66, 219
Severus, Septimius, 165
Shearman, John, 75
Sibilla, Gasparre, 296
Side, *kaisareion*, 144
Sikyon, *kolossos* of Attalos I at, 200
Silverman, Kaja, 238
Smith, R. R. R., 73
soteria, 227
Spartacus, 164
Sperlonga sculptures, 69
Spinola, Giandomenico, 75
Stallybrass, Peter, 231
Statius, 161, 163
Statuario Pubblico, *see* Venice, libraries and museums
Stevens, Gorham Phillips, 272–74
Stilphasen, 62–66
Stratonike, 198
 portrait on Akropolis(?), 199, *199*
Stratonikos (sculptor), 16, 213, 217, 287 (AT3a)
Strozzi, Filippo, 30, 82, 84, 142, 288 (RT1)
style, theory of, 62–64
Suetonius, 90
Suicidal Gaul, *see* Big Barbarians/Gauls; Rome, museums: Palazzo Altemps
suicide, Gallic, 208
Sulla, L. Cornelius, 192, 212, 224, 232, 235
Summers, David, 94
Svoronos, Joannes, 36
Swiss Guards, 86, 93, 292 (RT13)
Syracuse, Museo Nazionale: "Asklepios" head, 328n107

Tacitus, 152, 160
Thales, 153
Themiskyra, 203
Thermopylai, Battle of, 200
Theseus, *190*, 203
 in Lesser Attalid Dedication(?), 204, 226
Theweleit, Klaus, 238
Thiersch, Friedrich, 272
Tiberius, 162, 198, 200
Tibullus, 161

Tintoretto, Jacopo, 89, 94, 127, 130–34
 Adoration of the Golden Calf, 132–33
 Apollo and Marsyas, 130–31
 Cain and Abel, 130
 Gonzaga cycle, 130
 Last Judgment, 130, 132–33, *134–35*
 Martyrdom of Saint Lawrence, 130
 Origin of the Milky Way, 308n128
 Saint Augustine Healing the Forty Cripples, 130, *131*
 Saint Mark Saving a Saracen from Shipwreck, 130–31, *133*
 Saint Michael and the Devil, 130–31, *134*
 Scuola Grande di San Rocco, 92, 130
 Tarquin and Lucretia, 308n128
 Temptation of Saint Anthony, 130
 Theft of Saint Mark's Body, 130–31, *132*
 Venus, Vulcan, and Mars, 314n137
Titian, 81, 89, 94, 116, 122–27, 240
 collection of, 122
 Abraham and Isaac, 123
 Cain Slaying Abel, 122, 123, *123*
 Fall of Man, 126
 La Gloria, 122
 Martyrdom of Saint Lawrence, 75, 96, 122, 124–26, *125*, 128, 130
 Martyrdom of Saint Peter Martyr, 81, 82, 122, 124, 125, 128
 Rape of Europa, 126–27, *127*
 Saint John on Patmos, 123
 Tantalus, 122, 124, *124*
 Tityus, 124
Titus, 165
Tivoli, Hadrian's Villa, 56, 138, 140–42, 145, 162
 Amazons from, 145
 caryatids and sileni from, 142
 centaurs from, *see* Rome, museums: Capitoline
 Gaul from, *see* Dresden
 Tyrannicides Harmodios and Aristogeiton from, 162

torture, 239
tragic history, 228
Trajan, 143, 152, 154, 161–63, 165;
 see also Athens, Agora Museum; Rome, ancient monuments; Selçuk Museum
Travlos, John, 272
Très Riches Heures du duc de Berry, 36
Troizen, 203, *205*
Tyrtaios, 168

universal history, 200
Ut, Nguyen Kong ("Nick"), *Terror of War*, 97, *99*

Vasari, Jacopo, 94, 115, 116, 121, 122, 123, 130
 and art history, 18, 65, 240
 and *terza maniera*, 95–96
Vatican, *see* Rome, museums
Venice, churches
 Madonna del Orto, 130
 S. Giuseppe di Castello, 130
 S. Sebastiano, 129
 S. Spirito in Isola, 122
 S. Trovaso, 130
 SS. Giovanni e Paolo, 81, 122
 Sta. Maria della Salute, 122, 123
Venice, libraries and museums
 Biblioteca Marciana, 92, 121
 Statuario Pubblico, 92, 298–99, 300
 Museo Archeologico
 Aphrodite/nymph, 128
 Odysseus/Ulysses, 2, 91, *91*, 92
 sarcophagus, 91
Venice, palaces
 Palazzo Ducale, Sala delle Teste, 89, *89*, 91, 122, 130, 133, 289–91 (RT3, 5, 9), 298–99
 Palazzo Grimani at Santa Maria Formosa, 91, 122, 130, 291–92 (RT11), 298–99, 300; *see also* Grimani family

Venice, *scuole*
 Scuola di San Pietro Martire, 81, 122
 Scuola di San Rocco, 92, 130
 Scuola Grande di San Marco, 130
Vergil, 161, 163, 172
Veronese, Paolo, 89, 127–30
 Christ and the Centurion, 92, 127–28, *128*, 158
 Four Allegories of Love, 96, *129*, 129–30
 Good Samaritan, 129
 Jupiter Smiting the Vices with Lightning, 129
 Martyrdom of Saint George, 127
 Saint Jerome in the Desert, 127
 Saint Sebastian Beaten and Martyred, 129
 Transfiguration, 129
Visigoths, 192
Viti, Timoteo, 84
Vitruvius, 150
Vulso, Manlius, 217, 233

Warburg, Aby, 96–97, 225
Welcker, Friedrich, 16, 30, 36
White, Allon, 231
Wilamowitz-Moellendorff, Ulrich von, 217
Wilton House, Salibury: Amazon, 17, 30, 50, 75, 77, 204, 301, 312n77
Winckelmann, Johann Joachim, 16, 18, 62, 65, 78, 240
Wittgenstein, Ludwig, 79
Wölfflin, Heinrich, 62, 64, 67, 78, 218
Wollheim, Richard, 62
wounds, *see* Little Barbarians

Xanthos, Nereid Monument, 17, 315n23
Xenokrates of Athens, 18, 62, 65
Xerxes, 223

Zanker, Paul, 74, 216
Zeus, in Lesser Attalid Dedication(?), 188, 195, 202
Zeuxis, 126

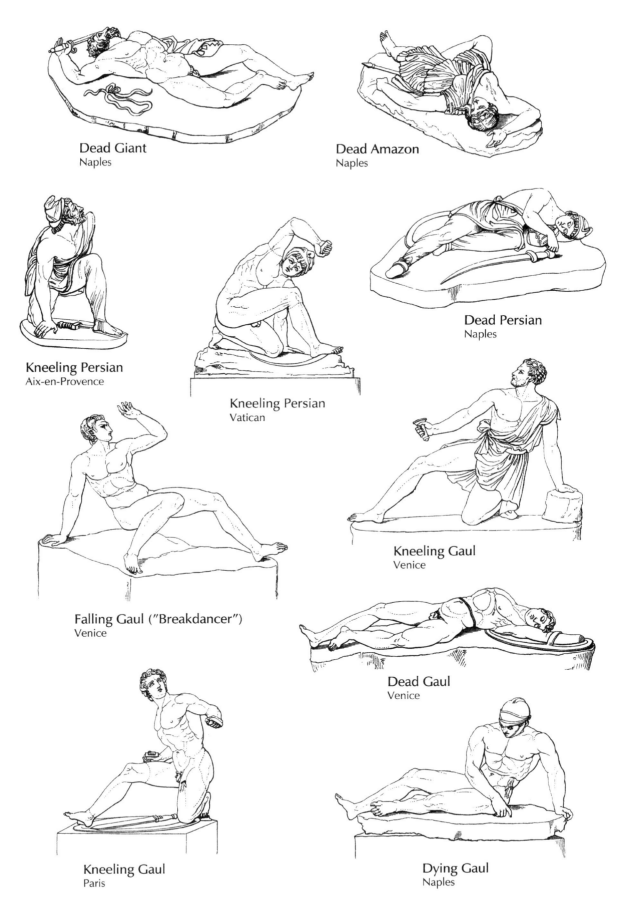

The Ten Little Barbarians. Adapted by Erin Dintino from Johannes Overbeck, *Geschichte der griechischen Plastik*, vol. 2 (3rd ed., Leipzig 1882): fig. 124.

www.ingramcontent.com/pod-product-compliance
Ingram Content Group UK Ltd.
Pitfield, Milton Keynes, MK11 3LW, UK
UKHW051826190125
453752UK00008B/95